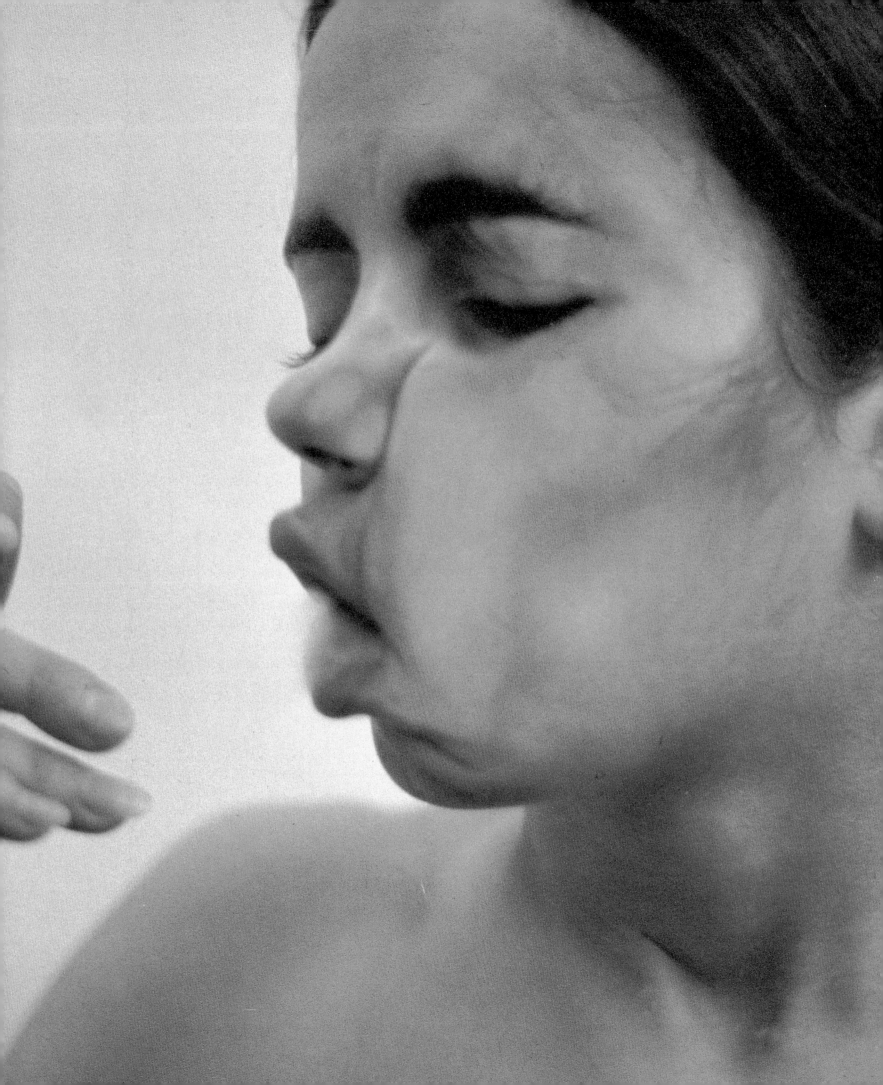

Phaidon Press Limited
Regent's Wharf
All Saints Street
London N1 9PA

Phaidon Press Inc.
180 Varick Street
New York, NY 10014

www.phaidon.com

First published 2001

ISBN 0 7148 3529 3

A CIP catalogue record of this book is
available from the British Library.

Designed by: SMITH
Printed in Hong Kong

cover, Geneviève Cadieux
Hear Me with Your Eyes (detail)
1989
Black and white resin coated prints and
chromogenic print mounted on wood
screen
Triptych, 249 × 310 cm [98 × 122 in] each

inside flap, Yoko Ono
Cut Piece
1964
Yamaichi Concert Hall, Kyoto

pages 2–3, Ana Mendieta
Untitled (Glass on Body Imprints)
1972
University of Iowa

page 4, Lynda Benglis
Fling, Dribble and Drip
1969
Poured pigmented latex
Dimensions variable
Work in progress, Bykert Gallery, New
York

back cover, Nancy Spero
Codex Artaud VI (detail)
1971
Typescript, painted collage on paper
52 × 316 cm [20.5 × 124.5 in]

EDITED BY HELENA RECKITT
SURVEY BY PEGGY PHELAN

ART AND FEMINISM

IDENTITY CRISES page 134

CORPOREALITY page 156

FEMMES DE SIÈCLE page 176

DOCUMENTS page 190

TOO MUCH page 193

PRE-
FACE

BY HELENA RECKITT

The title *Art and Feminism* suggests a relationship between the demands of feminist politics, the debates of feminist theory and the explorations of artists informed by these concerns. The project tracks that which lies 'between' feminism and art, surveying what these categories have, and had, in common. In focusing on artists' responses to feminism the book sets up a series of tensions – between politics and poetics; content and form; feminists and women; feminism and 'the feminine'. It also reflects the tension between those who define feminism in terms of the concerns of women exclusively and those who see it as an enquiry into sexual difference that challenges gender distinctions.

One of my aims in this collection has been to identify struggles and differences between feminist artists of different generations. With this in mind the collection has been organized into broadly historical sections in order to present the experiences, ideas and voices of key practitioners within their original time frame. I have also tried to show how certain art historical clichés – that all feminist art in the early 1970s celebrated 'central core' imagery, that the 1980s were concerned exclusively with strategies of appropriation – do not reflect the diversity of artistic responses at any given time. The book's extensive Works section juxtaposes projects by many artists who are not usually shown or discussed together. This offers the chance to open up new connections between key figures and to capture a cross-section of formal strategies pursued by women artists in different times and places.

In the mid 1970s and 1980s, many feminist artists who were influenced by poststructuralism, psychoanalysis and subaltern theory distanced themselves from aspects of the early women's art movement. They criticized the celebration of innate femininity, and the retrieval of traditional female culture, for confining women to separate biological and cultural spheres. They doubted the subversive potential of the 'feminine', fearing that women would be placed on the negative side of language at their peril. And they criticized the emphasis on personal experience as narrowly individualistic and lacking an account of the unconscious.

In the 1990s, however, a subsequent generation of feminists started to rediscover women's work of the 1960s and 1970s. This revival of interest was stimulated in part by the conservative political climates in 1980s Britain and the United States which feminist theory had apparently done little to counter. This 'return' can also be seen as a reaction against the work of artists influential in the 1980s, such as Mary Kelly, Barbara Kruger and Sherrie Levine. '1980s' artists who, among other things, critiqued phallocentric bias within figurative and gestural traditions, and exposed masculine investments in representations of the female body, were now criticized for their didacticism and emotional restraint. Looking back to feminist art's originators, young women in the 1990s discovered a refreshing spirit of political radicalism, a visceral pleasure in images and materials, and a direct articulation of subjective experience.

Interest in the early women's art movement informed numerous curatorial and critical projects in the 1990s. The British 'Bad Girls' show of 1993 traced a lineage in the work of contemporary women artists to precursors such as Louise Bourgeois and the Surrealist Meret Oppenheim, and to the 'aggressive camp' of Judy Chicago's monumental collaborative sculpture *The Dinner Party* (1974–79). The exhibition 'Sexual Politics: Judy Chicago's *Dinner Party* in Feminist Art History' provoked both praise and dissent for placing Judy Chicago centre stage.[1] Critic and curator Laura

Cottingham explored the legacy of feminist art from the 1970s in two exhibitions in Denmark and France,[2] a comprehensive video essay, *Not For Sale: Feminism and Art in the USA During the 1970s* (1998), and a collection of texts, *Seeing Through The Seventies: Essays on Feminism and Art* (2000).

In the 1990s, feminist art historians and critics including Jane Blocker and Mira Schor re-examined the debate on essentialism that had divided the women's movement. They argued that many feminists dismissed as 'essentialist' had in fact employed a knowing form of strategic essentialism that was far from straightforward. In discussing Ana Mendieta's use of identity categories, Blocker noted that she played 'between the one and the many, between essence and inessence. Rather than positioning the self on one side or another, she worked strategically with the inherent contradiction of the essential.'[3]

These revisionist projects give a vivid sense of the audacity, complexity and diversity of the early women's art movement, of a feminist art 'that is not one'. I hope that they also help put an end to one especially crude version of American feminist art history which suggests that all the conceptual (read 'smart') work was made on the East coast, and all the intuitive and activist (read 'non-intellectual') work on the West coast. There are, however, some potential pitfalls for feminists seeking to retrieve the work of earlier generations. There's the danger of creating a version of the star system so beloved of the art market, which prizes individual 'genius' and ignores dialogue and collaboration between women. And there's the trap of heroine worship, in which the achievements of women are uncritically celebrated in an understandable but counterproductive effort to compensate for years of neglect.

This collection reflects the diversity of feminist art from the 1960s to the end of the twentieth century. Some of the work included gives striking aesthetic form to political imperatives. Suzanne Lacy and Leslie Labowitz' *In Mourning and in Rage* (1977) and the Guerrilla Girls' accusatory graphic activism of the late 1980s and early 1990s mark moments of protest against the oppression and marginalization of women, and the demand for political change. Other works, while less obviously didactic, also expose the politics of the personal: the therapeutic photo works of Jo Spence and street performance actions of Mona Hatoum in the 1980s employ first person narratives to conceptually sophisticated ends. The impetus to retrieve female cultural histories is visible in the work of artists such as Christine and Irene Hohenbüchler, Betye Saar and Miriam Schapiro. Others, from Eva Hesse to Ana Mendieta and Susan Hiller, seek less to express overt political concerns than to articulate the experience of living in a particular body – coded as female – in a specific time and place. Some of the work from the 1990s included in this collection, while not appearing overtly political, can be seen within a feminist lineage. Rachel Whiteread's sculpture, for example, addresses issues of private, domestic and public space, forgotten and negative space, which have been important feminist concerns. Her work evidences an implicit debt to feminism.

A number of prominent women artists – from Louise Bourgeois to Chantal Akerman – have at times denied being feminists. This should not mean, however, that their work is necessarily 'not-feminist', that it has not influenced feminist artists, or cannot be interpreted within a feminist perspective. Sometimes the work's implicit feminism

contradicts the artist's words. Why might a woman artist whose work shows affinities with feminism want to distance herself from the category? For some black women artists, the label 'feminist' is so caught up with the history of white women that they don't wish to be associated with it. For other artists the feminist label is restrictive, threatening to overshadow other elements in their work.

From Simone de Beauvoir to Germaine Greer, Luce Irigaray to Julia Kristeva, Audre Lorde to Judith Butler, feminist theorists have variously influenced, inspired and infuriated women artists. Art historians and critics such as Lucy R. Lippard, Linda Nochlin, Griselda Pollock and Rozsika Parker have provided both critical frameworks for the consideration of art made by women in history and critical commentary on contemporary work. Some of the strongest texts of feminist aesthetics are written by visual artists who are also writers and theorists, such as Judy Chicago, Susan Hiller, Mary Kelly, Barbara Kruger, Laura Mulvey, Trinh T. Minh-ha, Adrian Piper and Martha Rosler.

The focus of this volume is primarily on artworks and texts that have made a critical impact in Britain and the US. When artists from beyond these geographical limits are included this reflects the influence their work has had on British and US artistic and critical practice. To further expand the geographical scope would, I felt, have diluted its focus.

In presenting a range of art informed by feminism it's possible to identify a distinctly female art history: what Mira Schor calls 'matrilineage'. However, it would be a mistake to see feminist art as an entirely separate category, outside the trajectory of art history. The art world has been transformed by feminists at the same time as feminists have been among its chief critics. Indeed, feminism has redefined the very terms of late twentieth-century art: from exposing cultural assumptions about gender to politicizing the link between public and private, to exploring the nature of sexual difference, to stressing the specificity of bodies marked by gender, race, age and class.

Although the prospects for women artists have improved to some extent during the period surveyed, feminist artists still face numerous prejudices and obstacles. Their work is generally considered to be less marketable and collectable than men's. All too many of the major artists in this book are not adequately represented commercially and are unable to make a living from their art. Female artists are frequently expected to perform 'attractive' and 'youthful' personae, in a reductive equation of hot artists with hot art. The art world continues to be sparsely populated by artists of colour. There is evidence that when women and artists of colour are selected for shows or publications it is often out of tokenism or to meet funders' demands for representative cultural diversity. This suggests that the arts still need feminism, perhaps more than certain women artists suspect. As I hope this book shows, aesthetic responses to feminism have produced what is perhaps the most far-reaching artistic movement since World War II. And I hope the book brings pleasure too, for I agree wholeheartedly with Emma Goldman: 'It's not my revolution if I can't dance to it.'[4]

1 Amelia Jones, ed., *Sexual Politics: Judy Chicago's* Dinner Party *in Feminist Art History*, (Berkeley: University of California Press, in association with UCLA at the Armand Hammer Museum of Art and Cultural Center, 1996).

2 'NowHere', Louisiana Museum, Humlebaek, Denmark,1996; 'Vraiment feminisme et art', Magasin, Centre d'art contemporain, Grenoble, France, 1997.

3 Jane Blocker, *Where Is Ana Mendieta? Identity, Performativity and Exile* (Durham: Duke University Press,1999) 34.

4 Emma Goldman quoted by Susie Bright, *Angry Women*, ed. Andrea Juno and V. Vale (San Francisco: Re/Search Publications, 1991) 201.

SUR-
VEY

BY PEGGY PHELAN

A ferocious desire for independence is present in all the work ... a determination to survive at what- ever fragile level you can achieve.

Louise BOURGEOIS, *Louise Bourgeois*, The Museum of Modern Art, New York, 1982

Alluringly open, deceptively simple, art and feminism is a seductive subject. Among the most provocative of words for critical writing, the conjunction *and* compels an associative logic: art and feminism encompasses the radiating circles of Aboriginal Australian painter Emily Kame Kngwarreye and the 'dream-songs' of feminist manifesto writers; the potent political installations of Renée Green and the hauntingly flickering flames of Ana Mendieta's earthworks; the slow drip of blood leaking in Orlan's video documentation of her plastic surgery, and the quick dripping blood oozing from the injured arm of the ageing angel in Cecilia Edefalk's *Elevator Paintings* (1998); the exuberantly sexy sculptures

of Louise Bourgeois and the melancholy wit of Pipilotti Rist's videos; the animation of still life in Pat Steir's *Waterfalls* (1990) and the fatal stillness of Chantal Akerman's film *Jeanne Dielman, 23 Quai du commerce, 1080 Bruxelles* (1975); the guerrilla thrills of Valie Export and the stabbing statistics of the Guerrilla Girls. I realized I would need to limit, indeed radically short-circuit, some of the possibilities of the word *and* if I were ever to fashion an essay short enough to publish. I began to think more carefully about failure and feminism, the brutal betrayal and the still alluring promise of that seductive *and*. When exactly were the possibilities of romancing feminism and art abandoned, in favour of the theoretical condensations of feminist art?

Writing about art has traditionally been concerned with that which is interior to the frame, whereas feminism has focused primarily on what lies outside the frame of patriarchal logic, representation, history and justice – which is to say the lives of most women.[1] Feminist writing about art has tried, with varying degrees of success, to forge a language alert to the movement at the edge of the frame, across the hybrid border that marks the distinction between the visible and the invisible, the known and the unknown. *Art and Feminism* presents key works, both visual and

written, that have advanced the possibilities of feminism and art. From the 1960s to the end of the twentieth century, the works assembled here range across several generations, media, countries and political frameworks. The troublesome question emerges: what is feminism? When faced with such an amorphous and ambivalent term, the shrewd often answer that it must be plural – not feminism but feminisms. This would also be an accurate response to a similarly structured question: what is mannerism? But we rarely hear pleas for the plurality of mannerism. The ideological stakes in the question 'what is feminism?' have often led to increasingly sophisticated but, it must be admitted also, increasingly evasive responses. I prefer a bold, if broad, definition: *feminism is the conviction that gender has been, and continues to be, a fundamental category for the organization of culture. Moreover, the pattern of that organization usually favours men over women.*

Such a definition will not suit everyone who claims the identity 'feminist'. Nonetheless, it helps clarify the role of the writer in shaping the interpretation of predominantly non-verbal artworks. While the very act of creating verbal categories for artwork risks deforming and consolidating the art itself, the particular risks in invoking the term 'feminist art' expose the often hidden ideologies at work in the formation of art disciplines. Although there are nascent ideological meanings in descriptive terms such as neo-realist or Abstract Expressionist, the effect of the term 'feminist artist' is quite different. Moreover, the appellation 'feminist' is sometimes spurned by artists whose work seems sympathetic with a feminist project. The word suffers a certain critical opacity as well. Is feminist a meaningful conceptual or aesthetic category when applied to artworks that range from Rona Pondick's needlepoint to Helen Chadwick's *Piss Flowers* (1991–92)? From performance rituals dedicated to the Great Goddess to Adrian Piper's *Funk Lessons* (1982–84)? From work whose emotional range encompasses the gravity of vocalist Diamanda Galas' *Plague Mass* (1991) to the witty insouciance of Nicole Eisenman's painting *Betty Gets It* (1992)? Is feminism a useful descriptive term for art that employs radically different modes of address, aspiration and genre? The difficulty of answering these questions helpfully reminds us of the sharp difference between the conceptual possibilities and limitations of art discourse and the often anarchic specificity of art. Or to put it slightly differently, these persistent questions remind us that rationality gives us ways to make categories while art gives us ways to resist them.

Nonetheless, 'feminist artist' remains a useful term, in part because it allows us to see

connections across some of the most interesting work composed in the past four decades. Compare, for example, the work of the Aboriginal Australian painter Emily Kame Kngwarreye (*c.* 1910–96) to the photographic performances of United States artist Cindy Sherman. Both women have frequently been described as feminist artists. Framing them together allows us to see an immense range of geopolitical and aesthetic responses to the traditional conception of woman-as-nature.

For thousands of years Aboriginal dot paintings have recorded the dreamsongs – stories of the origin and history of the world – from the point of view of some of the most economically impoverished but enduring people on earth. The tradition of dot painting has been re-appropriated by some contemporary Aboriginal feminist artists such as Kngwarreye and Kathleen Petyarre to plot the ritual and performative practices of women's communities in the outback, and to address the violent history of colonialism.

Kathleen PETYARRE Storm in Atnangkere Country II, 1996
Tracy MOFFATT Up in the Sky (detail), 1997
Cindy SHERMAN Untitled (Film Still), 1979

 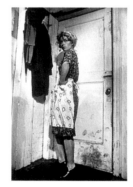

These paintings can illuminate Sherman's work, especially her celebrated *Untitled (Film Still)* works (1977–80). In these photographic documents of Sherman posed in cinematic *mise en scènes*, Hollywood film functions in one sense in the manner of the dreamsongs; both artists render mythological schemas as natural. Artists such as Kngwarreye, or Petyarre, and Sherman have used the most powerful imagistic systems in their respective cultures, dot painting and photography, to frame the logic of what we might call 'women's role'. These representational systems, and the ideological forces behind them, are staggeringly different, even at odds. Nonetheless, one can discern a similar habit of mind at work.

Admittedly, it might be more productive to think of Kame Kngwarreye's paintings in relation to other Aboriginal Australian feminist artists, such as filmmaker and photographer Tracy Moffatt, or the urban Aboriginal artist rea, whose Pop-inspired works revisit the idea of the multiple in a context of radical political difference.[2] When such comparisons are made by non-Australians, however, they can take on the perspective of visual anthropology, rather than art history. A supple definition of feminist art allows us to see connections across media and cultures that we might otherwise miss.

Full of strange overlays and shadows, the history of feminist art is often recited but still perplexing. Emerging in the 1960s and 1970s, feminist art was itself framed by simultaneously occurring art movements and by the discourses that surrounded it. Pop and Conceptual art, Minimalism, Happenings, body art, Land art, photography, experimental film and public art were all vying for attention when feminist art began to be recognized as a specific aesthetic practice, a recognition that was rooted in a political awakening. Sparked by the Civil Rights and anti-war movements in the US and the student demonstrations in France, the Women's Liberation Movement gave the first sustained momentum to the development of feminist art.

These historical categories and aesthetic labels are what we might call fictions of the frame; nonetheless, these frames focus what comes to define, for better or worse, a complex history.

In her video documentation of the New York and Californian feminist art movement in the 1970s, *Not for Sale* (1998), Laura Cottingham suggests that the only thing that feminist artists in the 1970s agreed on was the conviction that sexism distorted all aspects of art – from the writing of art history to the economy of the art market, to the blind spots of curators who seemed quite literally unable to see, never mind exhibit, art made by women.[3] Influenced by geographically and politically diverse situations, what constitutes feminist work is hard to pin down. Creating feminist art in Beijing is a radically different undertaking from making feminist art in London. As Griselda Pollock has argued, the shifting geographies of feminism must be taken into account in any history of feminist art.[4] At this point in history, however, it does seem possible to identify significant stages in the conjunction between feminism and art. Undoubtedly, the period from the late 1960s until the late 1980s in the US and Britain has been the most fecund of the areas I will consider here. Women artists prior to that period

cannot be described as 'feminist artists' although in the context of feminism *and* art their work is significant. As psychoanalytic and poststructuralist theory became the lingua franca of the academy in the late 1970s and throughout the 1980s, some feminist art and thinking of the early 1970s began to be seen as naive, narcissistic, *passé*. This accusation is a curious one, for even while feminist art historians and theorists were urging a more sophisticated reading of representational codes, many were denouncing, with a breezy simplicity, the art which made possible many of their own insights. In the 1990s, a new 'postfeminist' phase emerged. This is a complicated moment, and one not in any way past as I write in the early days of the twenty-first century. Some feminist theorists and artists have begun to re-examine the work of 1970s feminists, while others have joined feminism with other projects, most notably those inspired by post-colonial theory and trauma studies. This moment can also be understood as the next step in feminist poststructuralist logic. If the poststructuralist claim that all binary oppositions are in fact hierarchies is correct, then the structural oppositions which underwrite the sex/gender system must be abandoned before a non-sexist culture can be created. The first hierarchy to do away with, then, is male/female.[5] This aspect of postfeminism, a futuristic vision of a world where men and women are just two of many sex/gender possibilities, *in theory* comes a little closer every day. Risking setting up another hierarchy, I will simply note that *in practice*, however, exhilarating and catastrophic experiences of embodiment (in terms of gender, race, class *and* ...) continue to seek expression, even while the artistic and conceptual resources for such expression continue to be redefined.

Defining feminism as a conviction, I am trying to accent the notion that it is also a way of interpreting the world and the work. Lucy R. Lippard, one of the most prescient of feminist art theorists, has argued that feminist art is 'neither a style nor a movement' but rather 'a value system, a revolutionary strategy, a way of life'.[6] While feminism is a conviction, feminist criticism, as cultural theorist Tania Modleski has argued, is a promise.[7] As a promise, feminist criticism is structured like a performative speech act, an utterance that instantiates the thing being said. In his 1955 lectures at Harvard, *How to Do Things with Words*, the English philosopher J.L. Austin claimed that there are two kinds of speech act: constatives and performatives.[8] For Austin, performative speech acts cannot be evaluated according to their truth or falsity, but only by their success or failure; what he terms their felicities or infelicities.[9] Abandoning the traditional question philosophy proposes to language – is a statement true or false? – Austin opens up a new category for thinking about language and action. Following Austin, art can be understood as a specific kind of action and feminism a specific form of language. The promise of feminist art is the performative creation of new realities. Successful feminist art beckons us towards possibilities in thought and in practice still to be created, still to be lived.

The Well-rehearsed Plot

The story is well known but it is useful to trace it again in broad outlines; complications in this very neat narrative will follow. In the 1960s, inspired by the Civil Rights Movement and anti-war movements in the US, the student uprisings in Europe, and the intellectual and aesthetic stirrings of what has come to be called poststructuralism and Postmodernism, women woke up. Prompted by both Simone de Beauvoir's cold-eyed claim in *The Second Sex* (published in France in 1949 and translated into English in 1953), that women are not born but made, and Betty Friedan's analysis of 'the problem that has no name' in *The Feminine Mystique* (1963), women began consciousness-raising groups in which collective convers-ations began to illuminate broader patterns of discrimination. No longer seen in isolation, patterns in what had hitherto been understood as 'personal stories' began to be interpreted as the logical consequence of larger political structures. Sensing the possibility of becoming emancipated from the burden of their personal particulars, women began to work together to protest against the ways in which political systems deformed women's lives, aspirations, dreams. Awakened, in short, to activism, feminists soon began to 'talk back' to oppressive institutions and to create worlds more inclusive of the lives of women. In 1966, the National Organization of Women was founded; it helped give the women's liberation movement a symbolic and political legitimacy in the US.

Artists were especially inspired by de Beauvoir's analysis of 'made' reality. If the lives of women were not the result of some intractable 'natural law', then they could be remade, revised, altered and improved. Such transformations would require imagination, determination, will: habits of mind well known to most artists. As feminist artists took up the tenets

of women's liberation, they found in it a rationale and inspiration for a new art practice. While the Civil Rights and anti-war movements in the US and the student movement in Europe had also inspired political awakenings, they had tended to employ art as a way of advertising their political arguments rather than as an arena for the visceral expression and exploration of those convictions. But for feminists, art became the arena for an enquiry into both political and personal revision; art was both extraordinarily responsive to political illumination and productive of it.[10]

From protest at the lack of inclusion of women artists in galleries and museums, to resuscitation of the degraded languages of decorative and craft-based arts, the first phase of feminist art making was activist, passionate and especially concerned with altering art history. Early achievements included the establishment of the Feminist Art Program by Judy Chicago, first at Fresno, California, in 1970, and then, with the collaboration of Miriam Schapiro, at Cal Arts in

 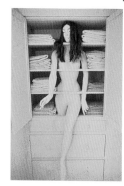 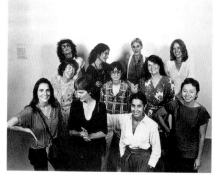

Judy CHICAGO Menstruation Bathroom, Womanhouse, 1972
Sandy ORGEL Linen Closet, Womanhouse, 1972
AIR Gallery, New York, 1972; l. to r. from back, Mary Beth Edelson, Sarah Draney, Nancy Spero, Donna Byers, Rachel Bas-Cohain, Dotty Attie, Anne Healy, Pat Lasch, Clover Vail, Ana Mendieta, Daria Dorosh

Valencia, California, in 1971. The first programme devoted to the making of art by and about women, the Feminist Art Program also produced a well-publicized exhibition entitled Womanhouse in 1972. Organized by Faith Wilding, Schapiro, and Chicago, along with Feminist Art Program students, including the painter and theorist Mira Schor, twenty-four women refurbished a house in Los Angeles. Radically revising the line between public and private, the exhibition space was domestic space, and conventional assumptions about suitable artistic subject matter were discarded; the bathroom and the dollhouse were appropriated as 'appropriate' exhibition spaces for feminist art. Womanhouse celebrated what had been considered trivial: cosmetics, tampons, linens, shower caps and underwear became the material for high art.[11] Covered extensively and often sensationally by the mainstream media, Womanhouse made it clear that there was a wide and passionate audience for feminist art.[12]

The exhibition included Chicago's *Menstruation*

Bathroom, Robin Schiff's *Nightmare Bathroom* and a witty but chilling installation by Sandy Orgel, *Linen Closet*. Orgel posed a female mannequin stepping out of a closet filled with carefully pressed and folded sheets. The mannequin, with long black hair and a plastic doll-like dead gaze, seemed herself caught in the threshold of a door – neither fully empowered to leave the closet (one of her legs is actually enclosed in a set of drawers), nor fully content to stay where she is (her neck is bisected by a horizontal shelf that has the effect of a guillotine) *Linen Closet* astutely consolidated the psychic architecture in which many early feminists found themselves caught. The closet was too confining, but what was outside lacked the secure comforts of well-pressed linen. Other students in the exhibition and the Feminist Art Program, most notably Schor and Wilding, went on to have important and influential careers as artists. Schapiro and Chicago remained figures central to the development of feminist art in the US throughout the 1970s and most of the 1980s, especially on the West Coast. Additionally, the creation of The Women's Building in Los Angeles in 1973 helped ensure and extend the work that Schapiro and Chicago had begun.

In New York, the inauguration of the women's art co-operative AIR (Artists-in-Residence) in 1972 provided an exhibition space for women's work in the tumultuous art scene there. In addition to exhibiting work, AIR also hosted a series of important talks that helped forge a language for feminist art that reflected the influence of the academy, the market and the studio. Together all of these institutional efforts helped create a new space for the development of feminism and art.[13]

Linda Nochlin's 1971 essay 'Why Have There Been No Great Women Artists?' plays, as we shall see, the role of 'progenitor' for the first phase of feminist art criticism and theory. Importantly, it assesses the political interests at work in the constitution of art history, a discipline predicated on implicit economic and ethical inequities, whose negative consequences for women are not far to seek. The flowering of this historical interest in art and the lives of women bloomed in Judy Chicago's ensemble piece *The Dinner Party* (1974–79), a large installation that advances a particular ideological and aesthetic relationship to the histories of art and of women. Astoundingly popular, *The Dinner Party*

provoked controversy in the feminist art world: were vulva-based dinner plates women's kitsch? Did Chicago exploit the work of the other artists who helped create the installation? Between the late 1960s and late 1970s, questions about who and what was responsible for systematic violence towards women had moved from an analysis of patriarchal history to the nitty-gritty of women's own collective public work.

While much of the art that emerged from the feminist movement in the US in the late 1960s and early 1970s tended to focus on and make use of women's bodies, the art that followed, much of which was created in Britain, tended to be rooted in debates about psychoanalysis and Marxism. The artist and theorist Mary Kelly's *Post-Partum Document* (1973–79) made a bid to shift feminist art making into an explicit conversation with Lacanian (and therefore necessarily Freudian) theories of sexual difference. Using her son's diapers as visual traces of the continuity and discontinuity between mother/creator and child/object, Kelly's installation

revisionism; *Thriller*, the ideological and economic under-pinnings of opera; *Jeanne Dielman*, the terrifying relationship between the banality of everyday domestic life and the violent pleasure of fatally shattering orgasm;[14] and *Journeys* considered movement as a kinaesthetic, political and psychoanalytic act. Eroding the difference between theory and practice, feminist filmmakers and theorists also initiated a responsive conversation across activities that had often been seen as distinct. Feminist film theory became the subject of many feminist films, and thus contributed to what came to be called 'the new talkie', the most influential aspect of avant-garde film practice in the 1970s and 1980s. In addition to Mulvey's essays, the work of Teresa de Lauretis, Mary Ann Doane, Linda Williams, Valerie Smith, Annette Kuhn and E. Ann Kaplan became central to this conversation.[15]

The erosion of the distinction between feminist film theory and practice helps illuminate one of the more distorting but nonetheless persistent features of the well-

Laura MULVEY, Peter WOLLEN Riddles of the Sphinx, 1976
Sally POTTER Thriller, 1979
Yvonne RAINER Journeys from Berlin/1971, 1979

created a space for a radical and intellectually rigorous interpretation of motherhood. In her extraordinarily influen-tial 1973 essay (published 1975) 'Visual Pleasure and Narra-tive Cinema' Laura Mulvey explicitly declares that she is employing 'psychoanalysis as a political weapon'. Her work, like Kelly's, is both theoretical and practical. Collaborating with Peter Wollen, Mulvey made a series of films advancing avant-garde film practice that intersected with strong and interesting work being done by feminist filmmakers in Europe, Britain and the US. Experimenting with camera rota-tion, narrative deconstruction and the fetishistic allure of the female screen star, films such as Chantal Akerman's *Jeanne Dielman, 23 Quai du commerce, 1080 Bruxelles* (1975), Mulvey and Wollen's *Riddles of the Sphinx* (1976), Sally Potter's *Thriller* (1979), Yvonne Rainer's *Journeys from Berlin/1971* (1979) and Margarethe von Trotta's *Marianne and Julianne* (1980), made feminism a point of departure for far-reaching topics. *Marianne and Julianne* examined German political

rehearsed story of feminist art's emergence. The story usually claims that artists in the US were allergic to theory, while those in Britain were Marxist-Althusserian-Lacanians before they became feminists. But the theory/practice divide is a false one: poststructuralist theory and feminism were taught and discussed frequently in both the US and Britain; by the end of the 1970s, theory and practice were explicitly entwined, producing the third phase of the emergence of feminist art.

The two most potent influences on feminist visual art in the early 1980s came from feminist literary criticism, heavily influenced by poststructuralism and French feminism, and psychoanalytically based feminist film theory. The art historians Rozsika Parker and Griselda Pollock explored some of the consequences of this theoretical work for art history in their still influential textbook *Old Mistresses: Women, Art and Ideology* (1981). This work helped articulate a growing discomfort with some feminist art made in the 1970s, especially work about women's bodies and

experiences of embodiment, whether erotic, abusive or metaphorical. In a nutshell, the claim was that such art was insufficiently savvy about the complex codes of representation that framed the female body; the work was declared 'essentialist'. But one of the unwitting consequences of this argument was that it produced false polarities. Body art had, like all expressive media, a theory. But what it did not have, perhaps, was an academic language. As critical writing became more theoretical, it also became (unwittingly) more monolingual in its approach to art; work that did not easily lend itself to established paradigms of poststructuralist thought was often dismissed as naive. Ironically, however, the most appealing aspect of poststructuralist thought came from its critique of hegemonic and elitist power structures.

Additionally, the early 1980s were dominated by the return of political conservatism in the form of Ronald Reagan's government in the US and Margaret Thatcher's in Britain. These stalled, if not completely halted, public funding for exhibition spaces, performance venues and alternative presses that had been instrumental in the development of feminist work in previous years.

While the conservative turn was taking hold in mainstream politics, the dominance of white women within feminism, especially within academic feminist theory, began to be denounced as its own form of conservatism. In 1981, *This Bridge Called My Back: Writings by Radical Women of Color* was published in the US. The anthology opened up the dialogue on race which had been dominated by a binary model of racial difference (whites and non-whites). It included writing by Third World women who were more interested in relationships between women than between the sexes; writing that moved between English and Spanish without translation, and from poetry to prose to prayer without stopping to explain.[16] A decade earlier, in 1971–72, significant exhibitions of the work of women of colour had been mounted. 'Where We At Black Women Artists' was shown in New York in 1971 and included work by Faith Ringgold, Kay Brown, Pat Davis, Jerrolyn Crooks, Dindga McCannon and Mai Mai Leabua, among others.[17] When AIR gallery and Soho 20 were founded, members said they were committed to eliminating both the sexism and racism characteristic of art galleries at the time. Howardena Pindell, an African-American feminist and an original founder of AIR, eventually grew disenchanted with feminism's persistent

racism and helped organize an important 1980 show at AIR: 'Dialectics of Isolation: An Exhibition of Third World Women Artists of the US'. In the catalogue introduction, the Cuban-born artist Ana Mendieta flatly stated what many women of colour had concluded after a decade of activism: 'American feminism is basically a white middle class movement.'[18]

Many also viewed it as basically heterosexual. The National Organization for Women was beginning to feel the deep fractures of the sexuality debates that had been percolating throughout the 1970s. Shere Hite's controversial study of female sexual practices in the US had appeared in 1976.[19] It brought mainstream attention to 'the myth of the female orgasm' and rekindled the debate about what was better: clitoral or vaginal stimulation before orgasm? This debate in turn highlighted other aspects of women's sexuality that had often been misunderstood. While often summarily described as a debate about lesbianism and heterosexuality in which the slogan 'feminism is the theory, lesbianism is the practice' collided with the perceived need to create a 'presentable' image for mainstream feminism, in fact the sexuality debates were more complicated. Ranging from arguments about whether or not pornography was (criminal) sexual abuse or a radical form of sexual pleasure, to anxieties about whether or not sadomasochistic relationships could be consensual, the sexuality debates reflected some of the most challenging aspects of women's liberation.[20] In 1980, NOW adopted their first 'gay and lesbian rights' platform. But the policy attempted to demarcate sex practices the organizers thought were compatible with feminism, and those they believed were harmful to women. Since the reasoning seemed largely to be based on the comfort zones of white heterosexual feminists, the platform was widely denounced by lesbians to whom it had been 'offered'. In the controversy that ensued, NOW overtly aligned itself with the aspirations of liberal feminism – to organize in order to produce specific legislative and economic changes that would ensure equal rights for women. While there was an air of *realpolitik* about this decision, many feminists who sought to question the very idea of economic equality under capitalism, or the concept of equal rights under patriarchy, felt betrayed by NOW's 'sell-out'.[21]

Another consequence of the argument about sexual practices was a new interest in developing a politically inflected psychoanalysis. Psychoanalysis had forged a language

to articulate links between sexual difference and sexual desire; feminists hoped it might provide an interpretive method for understanding the complexity of the recognition that for many heterosexual women life with men often produced both political domination and sexual pleasure. Psychoanalytic theories of sexual difference within representation dominated feminist art practice and theory in the early 1980s.

A slightly more explicit, if still not exactly efficacious, attention to issues of racial difference also began to be articulated more consistently in both discourse and exhibitions. Mona Hatoum, Adrian Piper, bell hooks, Lorna Simpson, Renée Green, Trinh T. Minh-ha, Coco Fusco and other theorist-artists explored the intertwining forces of racism and sexism. While Faith Ringgold, Michele Wallace, Judy Baca, Audre Lorde, Adrienne Rich and many others had insisted on this intersection from the earliest days of feminism, artists and theorists in the 1980s attempted to view race as something more than an 'additional' category

of difference to be appended to a list of qualifiers – 'class, gender and racial differences' as the litany often went. Kimberlè Williams Crenshaw, a legal theorist and cultural critic, helpfully suggested that a concept of 'intersectionality' might be employed as a way to understand the overlapping influences of racism and sexism.[22] Moving away from the false choice of analysing which was worse, Crenshaw's insistence on the simultaneity of both sexism and racism also opened up ways to think about heterosexism, classism, ageism and other 'isms' that continue to play a part in maintaining the status quo. Insertsectionality became a keystone for the development of a rigorous intellectual, political and aesthetic critique of the structure of oppression, the imperialist conquest of space and an investigation of masquerade, parody, repetition and mimicry as ways to intervene in the logic of representation. This critique was at the centre of much of feminist art criticism and theory in the 1990s.

In the early 1990s, feminism also began to be repositioned as something to be 'combined with' other political and theoretical projects. Important collaborations were undertaken with gay men who, in part because of the eviscerating epidemic of HIV infection and AIDS, recognized both that they had much to teach and much to learn from feminists and

the history of feminism. The critical writing of Craig Owens, Douglas Crimp, Simon Watney and Kobena Mercer was especially noteworthy.[23] Cindy Patton's two important books, *Inventing AIDS* (1990) and *Last Served?* (1994) helped keep the gender politics of the growing AIDS epidemic in focus.[24] The AIDS quilt, one of the most inspired works of collective art of the late twentieth century, brought focus to the fact that in the face of the epidemic and the hostility it generated, feminists, people of colour and gay men often found themselves on the same side of the battle lines.

Additionally, collaborations were forged between white feminists and people of colour who were articulating a theory of post-colonialism and hybridity. Common to these collaborative projects was a focus on the abjected body, the human body as a site of waste, abuse, disease, trauma.[25] Jana Sterbak's *Vanitas: Flesh Dress for Albino Anorexic* (1987), a red dress composed of sixty pounds of raw steak, Sue Williams' 1992 painting *A Funny Thing Happened* and Kiki Smith's wax and papier mâché sculpture *Tale* (1992) are especially resonant meditations on the visceral strength of the female body's abjective force. Risking replicating the structures of victimization and disease that haunt women in patriarchy, these works also offer an important rejoinder to the assumption that abjection produces only passivity and silence.

'The AIDS body' and 'the racialized body' both had significant overlaps with and differences from 'the woman's body' as it had been articulated and instantiated in feminist art theory and practice in the 1970s. The binary of sexual difference, once central to feminist psychoanalytic thought, began to be seen in the early 1990s as too simple an intellectual tool for understanding racial and sexuality differences. Not surprisingly, some of these recognitions prompted a much heralded 'return to the body'. A new generation of feminist artists attempted to unite the theoretical sophistication of feminist art of the 1980s with the passionate engagement with the question of embodiment that was the hallmark of feminist art of the 1970s. But whereas the dominant interpretive frame of the 1980s had been a politically inflected psychoanalysis, in the 1990s, political theory as such seemed to have collapsed into an exhausted heap. With the cold war 'won' by capitalism, international politics seemed increasingly to be a kind of rough drama of embodied economics. Women of the former Yugoslavia and

Jana STERBAK Vanitas: Flesh Dress for Albino Anorexic, 1987

elsewhere became enfleshed weapons in wars run by men: while there was much debate about military rape, both in the media and in war tribunals, the women themselves were often written off as anonymous victims of 'ethnic conflicts'.[26] The most searching writing being done by intellectuals in the 1990s might be best described as ethical rather than political. Attention to the traumatic force of the twentieth century's genocidal history, to the ethical responsibilities and challenges of witnessing, and to testimony as a specific kind of performative speech act, has been especially pronounced in the late 1990s.[27]

This abbreviated story conceals as much as it reveals. I want to return to several important and compressed details within this framework.

The History Before Us

World War II changed history in ways we are only now beginning to comprehend. A catastrophe of unspeakable

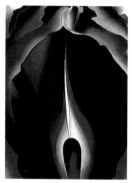

magnitude, the war, among other things, eroded beliefs in the autonomy of nation states, increased the importance of media production and circulation, and expanded the stage for representation more generally. In terms of art history, the post-war period is usually understood as the time when Abstract Expressionism emerged as a dominant advance in painting. Faced with the incoherence and incomprehensibility of massive death, a story in which the authenticity of images, the risks and responsibilities of seeing and the ethics of knowledge play an immense part, artists lost faith in the prospect of figuration in general. While Cubism had refracted the spatial plane of the canvas, after the war the line itself underwent a series of breakdowns, perhaps best dramatized by Jackson Pollock's all-over drip paintings. Pollock and the critic Clement Greenberg (with critic Harold Rosenberg playing the role of the *agent provocateur*) became the avatars of a new language, both visual and conceptual, for painting. Greenberg argued that Pollock's paintings were 'about' painting: flatness, opticality, colour. While this art historical era has attracted

much critical attention, the enormity of the transformation in the role and function of art criticism has been insufficiently remarked.[28] Part of the achievement of Pollock's drip paintings stemmed from the demands they made on the viewer; without figuration to ground the plot of painting, the art critic became an often essential mediator between the work and the viewer. In his celebrated 1952 essay 'The American Action Painters', Harold Rosenberg reflected on the interdependence of new art and new languages: '*To form a School in modern times not only is a new painting consciousness needed but a consciousness of that consciousness – and even an insistence on certain formulas. A School is the result of the linkage of practice with terminology – different paintings are affected by the same words.*'

Part of what a school requires, then, is the conscious decision to be one, a decision made possible by the resources of critical language. Rosenberg's coining of 'action painting' created the conceptual event that made it possible to consider painting as a performance, even while it inaugurated the need for a performance-minded criticism more broadly. While some disagree about the value of Pollock's innovations, most assent to the fact that his work inaugurated a different set of possibilities for post-war art practices and discourse in the US. These possibilities, as we shall see, both helped and hindered the reception of feminist art in the 1960s and 1970s.

Abstract Expressionism was not instantly dominant, however, nor was it the only game in town. Indeed in 1946, The Museum of Modern Art in New York for the first time in its history exhibited a retrospective of a woman artist, Georgia O'Keeffe (1887–1986). O'Keeffe's work was to some degree abstract, but there was a large figurative element to her painting. In her long relationship with the photographer Alfred Steiglitz, O'Keeffe had been both a captivating model and a keen observer of photography's possibilities and limitations. O'Keeffe did not aspire to photography's empirical verisimilitude in her painting. She wanted rather to find a visual language for emotion; her remarkably precise handling of colour was motivated by a desire to follow the way in which, say, the full purple feeling of satisfaction becomes diffused into the bruise of blue as the feeling fades. O'Keeffe's intense interest in colour as something living and ever in motion lent many of her paintings the aura of portraits. Her renderings of cala lilies and peonies, for example, are perhaps best understood as exploring a botany of the emotions,

showing a detailed study not so much of flowers' structures as of the dimensions of feelings provoked by flowers.[29]

Painting is one way to trace a falling towards and away from emotional insight; colour one way to express its force and its loss. O'Keeffe's pursuit of the colour of oscillating emotion contrasted sharply with the more hermetic struggles of artists such as Pollock and Willem de Kooning. Whereas their painting surfaces tended to be dense, layered and almost attacking, O'Keeffe's surfaces conveyed a sense of expanse, breath and musicality within the natural world. Some of these same lyrical qualities informed the work of Grace Hartigan, Elaine de Kooning, Helen Frankenthaler, Joan Mitchell and Lee Krasner, who are usually described as second generation Abstract Expressionists, which is somewhat false in terms of chronology but accurate in terms of the secondary treatment their work received. Elaine de Kooning and Lee Krasner, married to two of the superstars of Abstract Expressionism, de Kooning and Pollock

Wagner's argument in her essay 'L.K.' that Broude and Garrard ostensibly summarize in the introduction to their important 1989 anthology, *Expanding the Discourse*.[32] Wagner refuses to judge Krasner's choice to destroy so many of her canvases. 'I do not wish to end by adjudicating the rightness or wrongness of that move', Wagner concludes, 'but [Krasner's] entry into public identity as a painter ... happened in ways that are poignant and still problematic.'[33] Indeed. It's possible that Krasner's decision to destroy (or in fact to recycle, to paint over her paintings) had the opposite psychic valence than an act of 'critical self-erasure'. Might it be that the act of showing her paintings (and selling one of them to The Museum of Modern Art in New York) led Krasner to feel supremely confident in her own ability to create more and 'better' paintings? Perhaps her first solo show allowed her to take her painting as seriously as they each took his, and to refuse to settle for work that she viewed as short of her best. Thus destroying twelve paintings does not seem to me

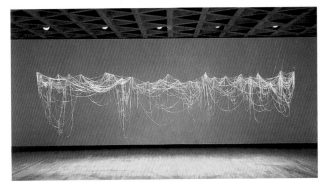

Elaine DE KOONING Protestant, 1956
Agnes MARTIN Untitled 10, 1990
Eva HESSE Right After, 1969

respectively, pursued different lyrical possibilities within abstraction. In Krasner's *The Seasons* (1957–58), there are echoes of Pollock's *Mural* (1943), although the sense of rolling interiority expanding across a horizontal landscape is more optimistic than Pollock's haunted vertical swirls.

The work of these women Abstract Expressionists has been treated sensitively by feminist art historians, but the difficulty of seeing their work independently of the achievements of their husbands continues to be a problem. Some feminist art historians have argued that Krasner's decision to destroy twelve of the fourteen paintings she exhibited in her first solo show in 1951 at Betty Parsons' gallery, where Pollock was also scheduled to show the following month, was a self-destructive act.[30] Norma Broude and Mary Garrard, for example, describe it as 'an act of critical self-erasure, a refusal of self-definition, that conflicts oddly with her intense ambition to position herself outside Pollock's orbit'.[31] However, their description 'conflicts oddly' with Anne

to be *necessarily* a gesture of 'critical self-erasure'. It's also plausible that it was a gesture of optimistic self-confidence.

The legacy of the second-generation Abstract Expressionists can be seen in the paintings of Agnes Martin and the sculptures of Eva Hesse, which are related to Minimalism. Born in Canada, Martin came to the US in her late teens. After studying painting and art education at Columbia University, Martin, like O'Keeffe, moved to New Mexico. Martin's paintings are elegant meditations on colour and time. Conveying an almost magisterial sense of calm, Martin's canvases suggest a kind of object-less still life, as if paint itself could be slowed in the manner of a photographic aperture, far enough to convey not only the expiration of light, but indeed the expiration of sight, breath, life. Rescued from morbidity by the distracting elegance of mathematics, Martin's paintings have a fierce courage. They invite the viewer to go to the very edge of stillness, to feel the eye's most protective blindness. What one finds

in Martin's paintings is not so much the absence of figure but the palpable presence of invisible but controlling number. Martin's surfaces are akin to equations that solve and dissolve time and space across a grid composed of lines one can count.[34]

Eva Hesse, whose art was at once mournful and radically expansive, jotted down a curious phrase on a dance programme in 1967: 'A girl being a sculpture.' Both Lippard and Anna C. Chave have read the sentence as a slip, suggesting that Hesse was actually thinking about her own femininity and its relationship to her decision to become a sculptor. They have demonstrated the importance of the question for Hesse throughout 1965 to her untimely death from a brain tumor in 1970 at the age of thirty-four.[35] But it might also be the case that Hesse wrote what she meant, that she was indeed thinking about a girl being a sculpture. If a sculpture gains its monumentality by holding still, and a girl registers her girlishness by dancing, then perhaps 'a girl

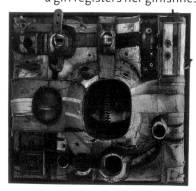

being a sculpture' might be a note about teaching a sculpture to dance – a much more engaging project than teaching a girl how to hold still. This girlish dancing can be seen in Hesse's sculptures made of rope, twine or fibreglass cord, in which gravitational force slowly erodes the sculpture's stillness.

This slow dripping away from stillness represents Hesse's attempt to accommodate accumulating loss, the central achievement of both her work and life. Born a Jew in Hitler's Germany in 1936, Hesse led a life dramatized by the terror of remaining still. Rosalind Krauss has suggested that Hesse's *Contingent* (1969) countered the formalist discourse of Minimalism with the message of expressionism: 'Hesse's expressionism carried the message that by kicking hard into the stone of inert matter, one would break through to an experience of self, a self that will imprint its image into the heart of that matter.'[36] Far removed from the conventions of portraiture, the 'sheets' of resin that comprise *Contingent* resemble immense pages of a blank book, a wordless letter

cloven from impassive, illegible silence.

Speaking with Cindy Nemser in 1970, who was asking Hesse about femininity and feminism in her art, Hesse was hesitant to claim any labels or categories for her work. She told Nemser: 'I don't value the totality of the image on these abstract or aesthetic points. For me, it is a total image that has to do with me and my life.'[37] Hesse's firm articulation of what she felt to be the complete integration between art and life was consonant with what came to be the major epistemo-logical and aesthetic force of feminist art in the 1970s.

While post-Minimalist art was forging a new form of personal expressiveness, other artists provoked by the memory of World War II, the US invasion of Cambodia and the violence of military dictatorships in South America began to develop an aesthetic vocabulary to respond to state violence. Employing industrial materials like wire and burlap, Lee Bontecou's creations, which critic Carter Ratcliff aptly dubbed 'organic machines', were conceived as sculptures but were designed to hang on walls like paintings. Bontecou's *Flit* (1959), made of welded iron, canvas and black velvet, emerged from the wall like a toxic assault. *Untitled* (1961), made from welded steel and canvas, featured an enormous orifice that looked like a cross between a steel toothy mouth and an exposed industrial shredder. Menacing and bracing, Bontecou's work was instrumental in establishing an aesthetic of rage that was developed further by other artists as the decade continued.

Niki de Saint-Phalle, in her 1961 piece *Tir à volonté (Fire at Will)*, made the connection between art, violence and war extraordinarily literal. Having attached bags of paint to large canvases, Phalle shot the bags with a .22 calibre rifle. She later commented:
'*I shot because it was fun and made me feel great. I shot because I was fascinated watching the painting bleed and die [...] Red, yellow, blue. The painting is crying the painting is dead. I have killed the painting. It is reborn. War with no victims.*'[38]

Yoko Ono's *Cut Piece* (1964), a performance in which audience members were invited to approach a passive Ono and cut away her clothes, helped initiate a language for the exploration of victimization and, perhaps more importantly, for survival, which began to sound the deepest notes in the next phase of feminist art.[39] Martha Rosler's series of photo-montages, *Bringing the War Home* (1967–72), in which she

took photographs documenting the war from mainstream US magazines and re-photographed them within photographs of the interior of middle-class homes, also helped initiate the deconstructivist logic of representation that dominated feminist art practice and theory in the 1980s.

Lygia Clark and Lygia Pape, working in Rio de Janeiro, began to devise important performance pieces in which a resistant political collectivity could be reanimated. Borrowing the grid and the over-all from painting, Pape made a vast cloth with regularly placed openings for heads. Entitled *Divisor* (1968), it becomes a kind of embodied sculpture when participants step into the cloth and create its form. Nancy Spero, throughout the 1960s and 1970s, was especially perceptive about the gendered nature of war. Her 1975 work *Torture of Women* also helped focus interest in covert US policies in South America.[40]

Minimalist performance art, especially the movement performances and dance pieces of Yvonne Rainer, Lucinda

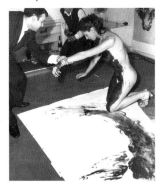 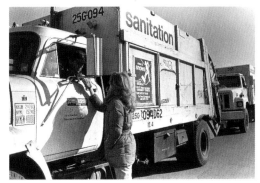

Childs and Trisha Brown in the 1960s, together with the commentary they inspired in writers such as Jill Johnston, laid the groundwork for more overtly political performance in the 1970s.[41] Painting and sculpture, the revered forms of high art, began to be increasingly jostled by the more unruly forms of photography, installation, film, video and electronic art and most especially performance art, sometimes called Happenings or Actions, in the next decades.

In the 1970s, Happenings and performance art were seen by women artists as new forms for the exploration of the intersection between the political and the personal. This is somewhat surprising given the sexism that marked the first manifestations of Happenings. Following up on Rosenberg's claim that painting had become an arena for action, Yves Klein, Alan Kaprow, the members of Fluxus and others had originally staged Happenings to enhance the performative dimensions of painting. In 1958, Klein first presented his *Anthropometry* performances in Paris. Employing three naked

women as his paintbrushes, Klein, dressed in a tuxedo, 'conducted' the composition of the painting, in which the women first sponged blue paint on their naked bodies and then imprinted their bodies onto the paper according to a rehearsed and choreographed plan. Klein later wrote: '*My models became living brushes! I had rejected the brush long before. It was too psychological ... Now, like a miracle, the brush returned, but this time alive. Under my direction, the flesh itself applied the colour to the surface ... I could dominate my creation continuously throughout the entire execution. In this way I stayed clean. I no longer dirtied myself with colour, not even the tips of my fingers.*'[42]

Klein's exuberant, clean domination of dirty women was not especially exceptional in 1958. It was not long after, however, that women themselves became interested in thinking through the politics of cleanliness and dirt more carefully. Feminist artists in the US were especially eager to redirect performance art's links with painting and actionism.

A decade after Klein's performance, Mierle Laderman Ukeles wrote her *Manifesto for Maintenance Art*, which served as a map for the investigation of maintenance as a largely unseen but crucial set of acts.[43] Two years later, working with a map of New York, Ukeles began a multi-year performance piece entitled *Touch Sanitation*, in which she shook hands with 8,500 sanitation workers in New York. Often unseen and under-appreciated, the sanitation workers were similar to women in the domestic sphere. *Touch Sanitation* celebrated this labour and created a point of contact between the working class and women, an infrequent connection in the US, where the illusion of a classless society remains a dominant fiction.

Adrian Piper, a Conceptual artist deeply opposed to the US military campaign in Vietnam, began a series of street performances in 1970 that she collectively called *Catalysis*. In *Catalysis III*, she painted her clothes with sticky white paint and wore a sign saying 'WET PAINT' over them. She then went to Macy's, shopping for gloves and sunglasses. At once an allusion to Klein's use of white naked women as his wet paintbrushes, and a comment on the amnesia provoked by consumerism, Piper's art was both arch and pointed.

Lygia CLARK Tunnel, 1973
Yves KLEIN Anthropometry of the Blue Epoch, 1960
Mierle Laderman UKELES Touch Sanitation, 1979–81

In *Catalysis IV*, the artist recalls:
'*I dressed very conservatively but stuffed a large white bath towel
into the sides of my mouth until my checks bulged to about twice
their normal size, letting the rest of it hang down my front and
riding the bus, subway and Empire State Building elevator.*'[44]
In 1970, such aberrations in the social field were less common
than they are today. Piper's performance is a catalyst that
seeks to inspire a new perception of what constitutes the
order of the social field, at the level of dress, sanity and
the distinction between private and public acts. In 1973,
Piper developed the *Mythic Being* series, a transforming
performance in which the artist, in the guise of a 'third world,
working class, overtly hostile male', gave vent to her 'feelings
of macho masculinity towards my male friends that even the
women's movement hadn't facilitated'.[45] She made these
feelings public art by taking out ads in the *Village Voice*.
Photographing herself as the Mythic Being (wearing an
afro wig and moustache), Piper's ads are witty 'masculinist'

fantasies of ambition, competition and compliment. In 1975,
Ntozake Shange's 'choreopoem', *for coloured girls who have
considered suicide/when the rainbow is enuf...*, a dramatic
performance in seven voices, opened at the Public Theater
in New York and transferred to Broadway the following year.
To this day, it remains one of the few Broadway shows in
history to give the stage to an ensemble of performers who are
all women of colour.[46]

Shange's play also showed some of the more exciting
possibilities of performance art in the mid 1970s. Abandoning
the traditional staple of character development, psychological
development and narrative coherence that had been the
hallmark of modern drama, performance art kept the intimacy
of live art and moved outside of the conventions of naturalism
and realism to express new forms of dramatic subjectivity
and emotional encounter. Performance art does not create
a discrete physical form; the acts that comprise it have no
independent status as objects; the art of performance exists

only as it is enacted. Performance, as object-less art, works
against (if never fully eliminating) the commodification of the
art object and the socio-economic and psychic violence the
object often fosters.[47] In the 1970s, Martha Wilson, Linda
Montano, Hannah Wilke, Carolee Schneemann, among many
others, began to explore performance as a way to remove the
metaphorical structure of art and to make it more direct.[48]
Montano, who began performing in 1971, has been devoted
to erasing the boundaries between art and life, suggesting
that art is not a matter of technique, or the mastery of the
history of formal innovations in the realm of the visual,
but rather a state of mind. Focusing on different mental
processes, from attitude to awareness of accent, posture and
gesture, Montano has created an enduring body of art across
several media: video, photography, performance art, ritual
performance and book making. Her 1978 performance,
Mitchell's Death, consists of a video monitor showing
Montano's face beneath a cross or plus sign, as she applies
white make-up and inserts acupuncture needles in her face.
While doing these acts, Montano also chants the story
of the death of Mitchell Payne, who was her ex-husband.
He died of a gunshot wound; Montano wonders whether
it was an accident or a suicide. Pauline Oliveros, playing
a Japanese bowl gong, and Al Rossi, playing a sruti-box,
amplify Montano's mourning. In the 1980s when AIDS was
wreaking havoc in the art world, many returned to *Mitchell's
Death* and came to regard it as a powerful instance of the
art of mourning.

Operating on the border between performance, sculpture
and photography, Eleanor Antin's *Carving: A Traditional
Sculpture* (1973) makes use of one of art history's favourite
tropes: the sculptor chiselling away at ill-shaped marble until
beautiful form emerges. Antin put herself on a diet for thirty-
six days and took Polaroid photographs of herself naked,
carefully noting the time of day each photograph was taken.
Composed of 144 of these photographs arranged in chrono-
logical sequence, *Carving* presents Antin's body in the same
four poses day after day. As the photographs accumulate and
give body to the sculpture called *Carving*, the artist's own form
diminishes. A comment on the ideology of dieting, the
combined force of aesthetic and social conventions about the
'attractive' female, the piece has also been more recently read
as a response to the specific violence of the message of
'thinness' to Jewish women. The dwindling, vanishing body

of Antin might be seen as a response to the history of the catastrophic disappearance of Jewish bodies during World War II.[49] *Carving* also stages the crossing of the trajectories of photography and performance that has been decisive for the development of both feminist and postmodern art.

At the heart of consciousness-raising was a belief in the power of repetition as a way to revise life stories. Personal experiences, many of which had been the source of personal shame, were seen anew as symptoms of larger political factors. Susceptible to revision, these experiences became inspirations for artwork as well. Underlying this belief in revision was a faith in the possibility of change – indeed, a belief in changing the world. This change, however, was seen to require going over the past rather than abandoning it in a courageous jump towards the new. In addition to fostering a focus on art history, this attitude also encouraged a sense of solidarity among women, especially in relation to suffering and abuse. Among the most important conse-

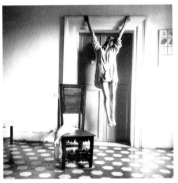 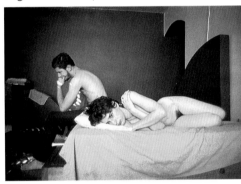

quences of this collective historical consciousness were the politically charged collective performances protesting against rape and other sanctioned forms of sexual terrorism towards women, such as Suzanne Lacy and Leslie Labowitz's 1977 performance *In Mourning and in Rage*. This piece helped inspire 'take back the night' marches and other political demonstrations against rape.

But as the often messy hurly-burly action of performance art entered the frame of art history, it was converted first into photography. This conversion is often overlooked.[50] Given the ephemeral nature of performance art in relation to the staying reproductive power of print, performance art was especially dependent on 'good pics' for photographic documentation.[51] While video, and now also the World Wide Web, can accurately record the temporal dimension of live performance, still photography frames its visual potency. Thus, for example, Carolee Schneemann's 1975 performance *Interior Scroll* has entered art history through the photograph Anthony McCall

took of it. Many more people have seen the photographic reproduction of *Interior Scroll* than saw the 'original' performance. The photograph, depicting a statuesque naked white woman, is unable to convey the central jolt that the performance enacted: a woman reading from a text that, like an encrypted umbilical cord, emerged from her vagina. Witty, sarcastic, and above all literate, Schneemann's performance dramatized what might be required for an audience to absorb the force of a paint-smeared naked white woman *reading* in public; it upset the traditional patriarchal assumption that women are those who must be read, interpreted, understood. As Moira Roth notes, the audiences were almost all women.[52] But the photograph cannot amplify the dramatic sound of Schneemann reading: instead, it renders the scroll as a kind of mirror. Reframed by photography, performance becomes an exclusively visual event. Ephemeral art becomes commodified by the photograph; photographic documentation displaces performance and becomes something more than a transparent index of an event.[53]

This supplement within the photograph allowed the eventness of performance, in its turn, to help dramatize the performative dimensions of photography, especially portrait photography. Francesca Woodman's photographic enquiries into the erotic-spiritual in her series *On Being an Angel* (1977) mined some of the possibilities of photography as a tool for capturing the expanding space between documentary and fantasy, history and dream. Nan Goldin transferred her photographs, which explore the rich space between documentary record and personal diary, into a slide show, set it to music and exhibited it under the title *The Ballad of Sexual Dependency*, in a great variety of venues, from seedy bars to respected galleries and museums from 1981 to the present.[54] The live presentations vary, but in 1986 she published it in book form, establishing one 'definitive' version of the work.

Cindy Sherman's *Untitled (Film Still)* series (1977–80) and *History Portraits* (1989–90) helped to suggest that memory itself might be an edited version of a picture never made. Alluding to a well-known image, either in celluloid or paint, Sherman's photographic performances are never exact replications. Altered, distorted, theatrical, her photographs return to events that did not occur in empirical history, yet somehow possess the charge of vivid memories.

Francesca WOODMAN Untitled (from On Being an Angel), 1977

Nan GOLDIN Couple in Bed, Chicago, 1977 (from The Ballad of Sexual Dependency), 1977

A photograph refers to a moment distinct from the one in which the image is seen. Photography's intimacy with the past tense has been (and remains now) both a lure and a problem for feminist art and theory. In so far as the photograph refers back to an 'original' – however staged or phantasmatic that original might be – photography supports the metaphysics of presence and original source. But in so far as the photograph is the effect of the copy, subject to edits, cropping and other manipulations, it works to erase the security of the original, the normative, the natural. This dilemma served as the impetus for critical discussion of Cindy Sherman's photographic performances in the late 1970s and early 1980s, but the themes and tensions of the problem emerged earlier.

Joan Riviere's essay, 'Womanliness as a Masquerade', written in 1929, suggested that: '*Womanliness [...] could be worn as a mask [...] The reader may ask where I draw the line between genuine womanliness and the masquerade. My suggestion is [...] that there is no such difference; whether radical*

Claude CAHUN Self-portrait, c. 1928

or superficial, they are the same thing.'[55] The writer, photographer and performance artist Claude Cahun (born Lucy Schwob, 1894–1954) devoted her art to forging a response to the consequences of such masking for a French Jewish lesbian. Much of her work was destroyed by Nazis during World War II, but what remains reminds us of the psychic and aesthetic possibilities photography and collage offer for an investigation of the authentic and the copy, for genuine performances and coercive masquerades.[56] Too often in the US, gender masquerade is seen as voluntary. Cahun's work reminds us of the cost of the performance. Part of what is striking about Cahun's photography is the eroticism of her pose. Cahun's photographs of herself, dressed sometimes as a man and sometimes as a woman, expose the density of women's sexuality for both viewers and models.[57] Dramatizing the difficulty of the distinction between desire and identification that informs the ways in which women approach images of women, Cahun's photography anticipates some of the trickiest conversations feminists have had about sexual pleasure and the visual. Does visual pleasure for women come from the desire to be the woman in the image? Or does it come from the desire to desire her, as Mary Ann Doane put it?[58] Do heterosexual women spectators

perform a kind of identificatory transvestism when they view images of sexually alluring women? Do they become temporary lesbians in the moment of visual pleasure produced by looking? Or do women, comparing themselves to the image, suffer or delight in their own intimacy or distance from it? These questions were (and are) extraordinarily vexing and helped heighten the reception of feminist psychoanalytic theory as it emerged in the mid 1970s.

Feminist artists in the 1970s began to consider the proposition that if women were associated with the sexual above all else, how might this association be used to serve, rather than to oppress women? While the ability to control pregnancy became widespread after the invention, approval and widespread dissemination of the birth control pill in 1960, it took a while before women's sexuality itself became a zone for creativity, play and reinvention. Feminism in the 1970s propelled a new interest in women's sexual pleasure and with it a new interest in both the image of the female body and the politics of embodiment. Feminist erotic art, heterosexual, lesbian and bisexual, became one of the arenas in which this interest was most explicitly expressed.[59]

In her 1976 book *Of Woman Born*, lesbian poet and theorist Adrienne Rich argued, 'The repossession of our bodies will bring essential change to human society. We need to imagine a world in which every woman is the presiding genius of her own body.'[60] To claim this genius, however, new conceptualizations of what the erotic might be were needed. Audre Lorde's 1978 essay 'Uses of the Erotic' defined the erotic as 'a sharing of joy', and suggested that the assumption that the erotic was merely another word for the physically sexual limited the expansive possibilities of women's erotic lives. 'There is', Lorde wrote, 'for me no difference between writing a good poem and moving into the sunlight against the body of a woman I love.'[61] Harmony Hammond was one of the first to begin to craft lesbian desire in her fabric pieces. Joan Semmel and Sylvia Sleigh composed figurative erotic paintings from a heterosexual woman's point of view.

Fuelled by the energy of new vision, much feminist art of this period was deeply witty and bitingly satirical, especially in relation to images of women in popular culture. Alice Neel, Ida Applebroog and others poked fun at the visual stereotypes that conveyed women as mother, as prostitute, as asexual – sometimes all in the same image. Additionally, art forms that had previously been seen as 'craft' rather than 'high art',

forms such as weaving, quilting and embroidery, were reclaimed as fluent and accessible languages for seriously pointed art making. Known as the Pattern and Decoration Movement, the work moved across painting, design and fabric architecture. Kim MacConnel, Amy Goldin, Miriam Schapiro, Valerie Jourdain and Joyce Kozloff were among the most significant feminist artists doing this work in the 1970s and early 1980s. Kozloff's well known public art, which now adorns subways, train stations and the San Francisco Airport, grew out of her earlier passion for pattern and decoration.[62]

In addition to exploring the intricate artifice of the Pattern and Decoration Movement, feminist artists of the 1970s were also fascinated by the connections between women and nature. Ana Mendieta, a Cuban-born artist living in the US, performed a series of actions she called earthworks throughout the 1970s. For Mendieta, the female body was deeply connected to the eternal grandeur of the land. Believing that Western capitalist culture was in danger

of losing this connection, Mendieta traced the outline of her body 'attached' to the earth, using mud, fire and blood to leave traces of this fading connection. These tracings, a kind of earth writing, were in turn documented in photographs which framed the trace of that trace. Mendieta's art pointed to animating systems of beliefs, indeed convictions, about geophysical and spiritual history. 'My works', she said, 'are the reactivation of primeval beliefs at work within the human.'[63] Often described as 'essentialist', Mendieta's works are actually powerfully astute gestures that comment on the nature of reactivating nature, elegant responses to the longing to return to a past that can only be reanimated through absence.

Mary Beth Edelson and other artists associated with what has come to be called eco-feminism – a term used for convictions ranging from native beliefs about the divinity of the earth as mother to Jungian-based notions of anima and psyche – pursued connections between femininity, the earth

and 'the Great Goddess'.[64] Some of these ideas were explored in Susan Griffin's widely read 1978 book, *Woman and Nature: The Roaring inside Her*. Griffin explored patriarchy's desire to tame both women and nature and suggested the political and ethical importance of insisting on honouring the connections between women and nature.[65] Edelson used her own investigations in matriarchal traditions to compose ritual performances in which women chanted and spoke of their ties to nature, to time and 'the spirit of the earth'. Similarly, Yolanda Lopez, Betye Saar, Nancy Azara and Judy Baca investigated spiritual and folk narratives about women with special powers, from the Virgin of Guadalupe to Kali, whom Azara used as the inspiration for wood sculpture. Saar was interested in following connections between Haitian and African traditions of black women's power. Her *Voo Doo Lady with Three Dice* (1973), a collage on red fabric, suggests that the 'Voo Doo Lady' plays with the sea, the sun and the stars. Saar's most famous piece is *The Liberation of Aunt Jemima* (1972). Placing a rifle and a black fist within the traditional iconographic representation of Aunt Jemima with her broom and head rag, Saar's mixed media portrait also wryly alludes to Warhol's silkscreens of Marilyn Monroe, replacing copies of the Hollywood star with images of Aunt Jemima's smiling face. Faith Ringgold similarly commented on the flags of Jasper Johns in her 1969 painting *Flag for the Moon: Die Nigger*. Best known now for her extraordinary quilts chronicling black life in Harlem, Ringgold was also a tireless advocate of racial equality in the art world throughout feminism's first decade.

Deeper Awakening

Central to the story of the birth of feminism is a kernel of the myth of Sleeping Beauty, except rather than a prince's kiss awakening a single protagonist, the force of a thundering insight makes many women bolt upright at the same time. As a generative myth, this history of collective wakening can also be understood as a revolutionary change in the frame of reference. A Foucauldian theorist, for example, might treat this historical moment in quite a different way, suggesting that in the tumult of the new world order that emerged in the post-war period, a dialectical turn from an international, external focus towards an awareness of the challenges of the domestic and internal occurred.[66] Common to both the Sleeping Beauty story and the Foucauldian fairy tale is a new

framing of the relationship between the public and the private. This new framing underscores the porosity of the border between two modes of being, two kinds of reference that converge in a generative vision. The ooze between the public and the private, in other words, resembles something like the shift from waking to sleeping that characterizes everyday human activity. What helped make this shift revolutionary, rather than everyday, was precisely the doubling of awareness that made it possible. Women awakened, in other words, to the consciousness of their own awakening consciousness. (Rosenberg: 'To form a School in modern times not only is a new painting consciousness needed but a consciousness of that consciousness.') Thus feminist awakening was something fundamentally personal and social at once; it was a kind of mutual understanding of what it had meant to feel oneself alone, and a declaration of a new collectivity. Sleeping Beauty was transformed from her self-reference as 'woman' to her self-reference as 'feminist'.

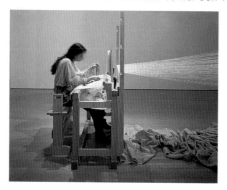

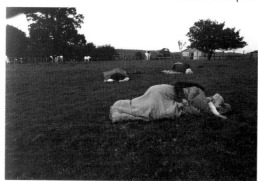

Janine ANTONI Slumber (detail), 1994
Susan HILLER Dream Mapping, 1974

And this changed, among other things, the history and theory of contemporary art.

Fairy tales have played a large role in feminist theory and art practice, becoming rewritten as a way to imagine myths contemporary women might live by. One of the more salient treatments of myth's centrality to feminist art history is Janine Antoni's *Slumber*. In this piece, performed in various galleries between 1994 and 1996, Antoni spent the night in the gallery space, covered by a very long white blanket extending across the floor to a loom 'custom designed to enable the weaving of a potentially endless blanket'.[67] Before she sleeps, she attaches herself to a medical device that records her rapid eye movement. During the day, she uses coloured strips from her nightgown to weave the REM pattern recorded by the machine into the blanket. A performance dedicated to what it might mean to make art from a woman's dreams, *Slumber* also meditates on the frame between private and public consciousness and unconsciousness, between

historical forgetting and contemporary REMembering.

Antoni's performance alludes to Robert Morris' 1963 *Self-portrait (EEG)*, as art historian Ewa Lajer-Burcharth has noted, and 'inject[s] the idea of sexual difference into the problematic of body/object relation that concerned Morris in the mid-1960s'.[68] Additionally, Antoni's interest in sleep echoes Susan Hiller's 1974 piece *Dream Mapping* (first exhibited in 1986) in which the artist invited ten participants to develop a 'graphic system for writing their dreams'.[69] Then the group slept outside in the Hampshire countryside for three nights. They slept in visual patterns that, it was thought, might influence the patterns of their dreams. Employing the graphic system they had learned, upon awakening the participants recorded their dreams, attempting to discern patterns and repetitions. *Slumber* implicitly maps the political and historical journey from Hiller's group campsite to Antoni's single bed. It invites the viewer to contemplate the history of her own awakenings. Antoni's response to the question, 'What will I do when I wake up?' reminds the viewer of the political risks in dedicating, or failing to dedicate, oneself to weaving and/or recording dreams. The dream pattern being woven into the blanket increases in complexity, while its source, Antoni's nightgown, becomes increasingly threadbare. Antoni asks her viewers to return to the dreams we often lose when we are too rushed to remember them. *Slumber* reframes the awakening of feminism as something still to be interpreted, as a dream that is still being woven, although perhaps without the collectivity it once had.

What women awakened to in the late 1960s and early 1970s was the consciousness of misogyny; of cultural frameworks in which their labour was devalued, their art largely ignored and their bodies overly idealized, system-atically abjected and/or subject to intense policing. Literary critic Cathy Caruth has suggested that sudden awakenings can themselves become traumatic.[70] All these women waking up and realizing all together that they had been sleeping for years, if not centuries, might best be addressed as an experience of collective trauma. It rarely is, however. Why did so many women have the conviction that art could be a politically useful response (and perhaps a psychically reassuring one) to the experience of awakening? 'Why art?' seems a far more baffling question than 'why feminism?'

The 'raising' of women's consciousness, it seems clear now, although perhaps it could not quite be articulated or grasped then, had something of Hegel's *aufhebung* about it. *Aufhebung* connotes simultaneously a lifting and a renunciation. This double process has often been obscured in histories of the feminist movement, in part because we tend to think of lifting and renouncing as opposing acts. The German word usefully reminds us that openings and closings, saying yes and saying no, can occur in the same event. Indeed, it is perhaps this doubleness that produces the formations and deformations that constitute epistemological and psychic change. The 'raising' in consciousness-raising involves an elevation and lifting of awareness, even as it also entails a renunciation of passive acceptance, a new intolerance towards unconsidered 'going along'. Part of the hostility feminists met with stemmed from the threatening nature of the renunciations integral to consciousness-raising. This hostility was not only directed at feminists by men, some of

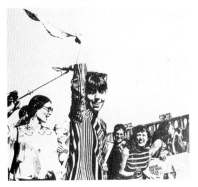

whom saw the ways in which the refusal of women to go along might influence their own lives, but also from women who benefited, explicitly and implicitly, from going along with the structure of sexist society. The hostility that greeted feminists needs to be analysed more carefully.

The 1968 protest against the *Miss America* contest in Atlantic City, for example, became a particularly haunting image for conservatives. Near the end of the march down the boardwalk, feminist protesters took off various sartorial symbols of women's submission – bras, girdles, stockings, shoes – to protest against narrow but violently enforced notions of physical beauty. They threw these articles into a trash container labelled 'Freedom', then burned the trash container. By today's standards, a fairly mild protest. But the demonstration became a fixed and fearsome image. In the popular media, feminists became 'bra-burning women's libbers'. From that image, it was a short step to the others: feminists are against beauty, are all lesbians, are trying to destroy the family. Some feminists are, but such conclusions reveal more about how deeply feminism panics mainstream culture than the demonstration revealed about the connection between sartorial constraints and political oppression.

A significant part of that threat is rooted in the ideologies within images, particularly images of women's bodies.

Most people who write about feminism and art do so from a celebratory perspective. The few who do not are lamenting the fact that high art lost its dignity (that is to say, some of its elitism) because of feminism. But thinking of the second phase of feminism as a traumatic awakening enables a more honest response to the history of violence and vilification that is woven into the legacy of the feminist art movement. Quite apart from the inevitable 'personality conflicts' that dog any social and political group, the trauma that helped initiate the awakening of feminist consciousness was, in and of itself, wounding. Psychoanalysis reminds us that traumas produce distortions, repression, fictions of various sorts. Repressed traumas often inspire repetitions. Therefore, rather than sticking to the smooth narratives offered by either celebratory or denunciatory attitudes towards the history of feminism, it would be useful to develop the capacity to fashion a more complicated, indeed a more honestly ambivalent perspective upon this history.

To think of the history of feminist awakening in terms of trauma might also help illuminate the strangely persistent fascination with art history as a discourse. Trauma is a break in the mind's experience of time. History writing seems to promise a way to suture events that might initially appear to be ruptures. In 1974, Julia Kristeva wrote, 'I would call "feminine" the moment of rupture and negativity which conditions the newness of any practice.'[71] Thus the newness of a specifically feminist movement might well have been perceived as doubly negative: for if newness in general is a mark of the feminine, new practices of femininity are especially rupturing. The consolations of histories that promise continuities, rather than ruptures, become then especially prized. Linda Nochlin's essay 'Why Have There Been No Great Women Artists?' scans the history of art, looking for a place to begin writing a history of great women artists. Ironically, Nochlin's essay itself now serves as the origin, the place to begin writing the history of feminist art history.

Greatness

While 'the personal is the political' was the rallying cry for feminist politics in the broadest sense, Nochlin's 1971 essay was its scholarly articulation.[72] Indeed, in their superb review of the development of feminist art history, Thalia Gouma-

Robin MORGAN throwing away a bra, Miss America Pageant, Atlantic City, New Jersey, 1968

Peterson and Patricia Matthews bluntly declare that 'feminist enquiry in art history began' with the publication of Nochlin's essay.[73] Answering her own question, Nochlin coolly asserts that indeed 'the fact of the matter is that there have been no supremely great women artists, as far as we know, although there have been many interesting and very good ones who remain insufficiently investigated or appreciated'. Illustrating the institutional and structural forces, from the lack of access to nude models, to the patriarchal system of education and patronage fundamental to the history of high art, that made it exceedingly difficult, if not impossible, for individual women to achieve greatness, Nochlin concluded:

'*The fault lies not in our stars, our hormones, our menstrual cycles or our empty internal spaces, but in our institutions and our educations – education understood to include everything that happens to us from the moment we enter, head first, into this world of meaningful symbols, signs and signals.*'

Appearing the year after such ground-breaking texts as

Miriam SCHAPIRO Mary Cassatt and Me, 1975

Shulamith Firestone's *A Dialectic of Sex*, a fiery manifesto proclaiming a world in which reproduction was not tied to women's bodies, Kate Millet's *Sexual Politics*, a study of the ways in which literature aided and abetted sexism, and the wide-ranging anthology *Sisterhood Is Powerful*, edited by Robin Morgan, Nochlin's essay helped demonstrate how important art and its interpretation are to the politics of culture.

'Greatness', Nochlin claimed, is 'an honourific attested to by the number of scholarly monographs devoted to the artist in question.' On the one hand, Nochlin's definition is a candid assessment of the interplay between artwork and commentary, a kind of pragmatic assessment of the ways in which the image is dependent upon the word. On the other, it does little to advance a more radical, less institutional set of possibilities about what artistic achievement might mean or come to mean. Behind the idea of greatness lies a complex nexus of ideas about production and visibility that are in keeping with traditional ideas of artistic development and exhibition related to traditional models of artistic success.[74] Dora Carrington, for example, as Mary Ann Caws has shown, was a painter who did not want to show her work.[75] Her works have survived and we consider some of them 'great', but their claims to greatness are of a remarkably subtle kind.

The question of greatness in relation to art tends to be bound up with the logic of the market. The Marxist feminist art historian Carol Duncan, in her witty and smart 1975 essay, 'When Greatness Is a Box of Wheaties', wrote perceptively about the muddle concepts of greatness can produce.[76] For Nochlin in 1971, however, it seemed clear that if feminist art history were to be taken seriously as a discipline, it first needed to find its history; nascent feminist art historians, in other words, should produce scholarly monographs devoted to discovering or reclaiming neglected women artists of the past. Following this logic, Nochlin, in collaboration with Ann Sutherland Harris, curated the exhibition 'Women Artists: 1550–1950'. The show, which opened in Los Angeles in 1976, travelled to Austin, Texas, Pittsburgh, Pennsylvania and Brooklyn, New York. The exhibition introduced many people to the work of Artemisia Gentileschi, Angelica Kauffman and Rosalba Carriera, among others. The catalogue complemented previous efforts to unearth and consider carefully hitherto neglected women artists undertaken by Eleanor Tufts, Hugo Münsterberg, Germaine Greer, Karen Peterson and J.J. Wilson.[77] These early efforts gave a new legitimacy to the work of neglected women artists and enriched the canon of Western art history.

Institutionalization, however, is rarely benign. Implicit in Nochlin's argument was another more deeply rooted assumption: that art history is itself a 'great' way to discuss art. Many people think this, perhaps especially art historians. But like all genres of writing, art history carries meanings in excess of its ostensible subject matter. For example, at the level of the subtle language of pronouns, Nochlin's essay skitters back and forth between 'us' and 'they'. Great artists are excluded from the 'we' who confer and adjudicate great-ness. The fault is not in 'our' stars; women artists have not been great because 'they' have not been given access to institutional power.[78] This kind of splitting also informed the ways feminist artists approached traditional art history – sometimes it was a source of inspiration, at other times it was a chronicle of oppression and misogyny.

Re-reading and revising great masterpieces, feminist artists in the 1970s illuminated the power of the past to shape the development of contemporary art. Mary Beth Edelson's poster *Some Living American Women Artists/Last Supper* (1972) replaces the apostles and Jesus with artists ranging from Lee Krasner to Yoko Ono. O'Keeffe has pride of place.

Similarly, describing her work as 'femmage', to invoke the Matisse-like possibilities of collage in the service of a new approach to women's art, Miriam Schapiro returned to other neglected art traditions and created aprons, fans, doll houses and in 1976 her fifty-foot *The Anatomy of a Kimono*. Her *Collaboration* series of 1975–76 is perhaps best understood as visual performances in which Schapiro restages the quality and feeling of paintings by Gauguin, Delacroix, Courbet, Berthe Morisot and Mary Cassatt (among others), through her own feminist artwork.[79]

Schapiro's work suggests that (art) history is something one enters, as one might enter a room, from a door within the present. As the work of alternative art historical traditions began to emerge in the early 1970s, feminist artists, logically enough, wanted to learn ways to think and speak about it. Was there, as Judy Chicago put it, a female core imagery in women's artwork? Was there something 'uniquely' feminine in the work of women artists that made it fundamentally different from the work of male artists? Chicago, Schapiro and Lippard, among others, thought there might be.

Essentialism: Language and the Body

'In the beginning was the word
And the word became flesh
And it never healed.'
– Benjamin Breytenbach

What has come to be called the essentialism debate might be better understood as a series of investigations into the relationship between female bodies and subjectivity, a relationship that is enframed by language. At the heart of the language of feminism is a complicated attempt to address embodiment, politically, aesthetically, historically, psychoanalytically. Interest in the body of the woman, as image, as icon, as goddess, as worker, as mother, as daughter, as narcissist, as martyr, has been central to both feminist art making and to feminist art theory and criticism. Behind this interest there lies an often noted but infrequently examined relationship, the one between language and the body. This relationship, as the literary critic Shoshana Felman puts it, 'consists at once of incongruity and inseparability'.[80] Bodies and languages constitute each other even as they miss one another. Rushing to make points about the specificity of female embodiment, feminist art theorists have tended to gloss over the deeply paradoxical relationship between language and the body.

Describing her painting series *The Pasadena Lifesavers* (1969–70), Judy Chicago says it is an attempt to make visible 'the dissolving sensation that occurs during orgasm'.[81] Trying to create a visual image for dissolution is an interesting and complicated visual (and psychic) ambition. Unencumbered by Lacan's seminars on *jouissance*, Chicago confidently assumes her interlocutors can grasp her language of 'dissolving sensation' without difficulty. Going further too, Chicago not only wants to build her own art projects around her somatic-eroticism, she also wants to create a general theory of women's art. Dedicated to developing imagery 'organized around a central core, my vagina, that which made me a woman',[82] Chicago attempted to examine how this central core is the hidden content in the work of other women artists. Working with Miriam Schapiro in 1970, Chicago declared Georgia O'Keeffe's flower paintings as 'the first recognized step into the darkness of female identity'.[83] They also placed their own work in the tradition of O'Keeffe, and saw Lee Bontecou, Louise Nevelson and Deborah Remington as part of a lineage of women artists who had 'defined a central orifice whose organization is often a metaphor for a woman's body'.[84] Lippard concurred with Chicago and Schapiro, and proposed Eva Hesse as another artist who was engaged in creating core images and forms as a way to express her femininity. She called these 'eccentric abstractions'.[85]

Nochlin argued that O'Keeffe's flower paintings are 'strong schematic metaphors for female sexuality, universalized by their separation of any locale or visual context'. However, Nochlin also noted, this separation tends to make O'Keeffe's paintings:

'basically apolitical, if not downright conservative [...]
Paradoxically, however, in the context of today's feminist
activism, such imagery has acquired potent political implications
[...] Nothing could better demonstrate the complexity, and the
basic ambiguity, of what constitutes a valid 'feminist imagery'
than the recent transformation of [O'Keeffe's] placid iris into
a fighting symbol.'[86]
O'Keeffe, still alive and well, had already been through this eroticization of her paintings. She did not like it when it happened in the 1920s, nor had she changed her mind when it was repeated in the 1970s. O'Keeffe's resistance to being

read as a feminist artist has been perceptively discussed by Barbara Buhler Lynes.[87] Part of what O'Keeffe objected to was what she took to be an effect of minimizing and limiting the meaning of her art. She was more concerned with colour and form, she maintained, than with depicting 'a central orifice' as a metaphor for a woman's body. But for Chicago, the notion of a central connection between women was the motivation for feminist art.

This epistemology organizes the logic of *The Dinner Party* as well. An installation centred on thirty-nine dinner plates arranged on top of a triangular table covered with embroidery recounting the history of the lives of thirty-nine great women of history, *The Dinner Party* renders women's history as variations on forms of the vulva. Severely criticized for its racist and heterosexist view of history,[88] *The Dinner Party* was also one of the most popular feminist installations of all time, attracting one thousand visitors in San Francisco, and 'tens of thousands' throughout Europe.[89] But the installation,

and its fourteen showings to date, set off a backlash against 'essentialist' art within feminist art theory.

Griselda Pollock and Rozsika Parker's 1981 book *Old Mistresses* argued that images of women can be 'easily retrieved and co-opted by a male culture [if] they do not rupture radically meanings and connotations of woman in art as body, as sexual, as nature, as an object for male possession'.[90] They illustrate their claim by placing a photograph from the 'men's magazine' *Penthouse* beneath one of Chicago's flowers. Parker and Pollock joined Judith Barry and Sandra Flitterman-Lewis' call the previous year for a feminist art alert to the logic of representation.[91] They proposed a 'feminist re-examination of the notions of art, politics, and the relations between them, an evaluation which must take into account how "femininity" is itself a social construction with a particular form of representation under patriarchy.'[92] Influenced by Lacan's theory of the Symbolic – the network of myths, linguistic, visual *and* ideological codes through which we experience 'reality' – feminist art and theory in the 1980s set about critiquing how the Symbolic systematically deformed the psychic and political realities of women.

At the heart of this deformation was a fundamental lack

between the affective force of experience and the capacity of language (verbal, visual, mythic, somatic) to express, or to comprehend fully, that experience. The relationship between verbal language and visual image played a crucial, but still often unmarked, antagonistic role in the essentialist debates. The accusation 'essentialism' was mounted in the 1980s, when theory displaced history as the dominant discourse of feminist writing. Having duly observed this lag time, however, historians then ignore it, and go on to talk about the logic of representation, a logic that makes a statement like Chicago's 'a vagina, that which makes me who I am', seem naive, even embarrassing. But the lag time is crucial to the accusation, both in its content and in its desire to be distant from and superior to 'feminist essentialists'. The accusation, in other words, has a quality of Freudian afterwardness about it, suggesting that there may well have been something traumatic in the original source. In a misogynistic culture, especially one like academia in the early 1980s, it behoves us to consider carefully the vehemence of the denunciation of this work, if only as a symptomatic repression of something threatening. The repetitious references to the essentialism debates within the critical literature also suggest that something still-to-be-interpreted remains.[93]

The initial critique of essentialism in the early 1980s rested on the impossibility of a 'universal' feminine, a central system of expression that could be discerned across culture and across media. This seems absolutely true and valid. But the critique in the 1980s, like the rescue attempt in the 1990s, misses what remains interesting about the questions posed by 'the essentialists' who had the temerity to insist that it was possible to make a connection between visual images and the experience of embodiment. Quite apart from the universalizing aspect of the search for a specifically feminine art (an aspect of the project that I agree is unsustainable and symptomatic of cultural arrogance) there is an intriguing return, an incessant worrying over the difficulty of bringing language and embodiment into alignment. While some have come to be comfortable with the recognition that the relationship between the body and *verbal language* consists at once of incongruity and inseparability, it has been harder to acknowledge that this might be the case with *visual language* as well. Just as the verbal signifier pre-exists an individual speaker's use of it, so too does the visual image frame feminists' response to it.

In her 1998 book *Body Art: Performing the Subject*, the art historian Amelia Jones revisits feminist body art and the essentialist debate.[94] Jones gives a vivid and persuasive account of the work of many body artists. Her discussion of Hannah Wilke is especially inspired. But Jones sometimes misses the drama between the complexity of verbal language and a still-not-interpreted language of the body. I am not suggesting that there is some deep occult somatic language that we can somehow translate and employ. Rather, I am trying to frame the space that slips away, the words that fail and the images that melt, when one attempts to represent embodiment. As early as 1947, the seemingly indefatigable Louise Bourgeois began to frame this elusive space for a specifically feminist art.

He Disappeared into Complete Silence, Bourgeois' 1947 print series, is a brilliant response to the gap between words and images. Composed as facing panels, one side text, one side image, *He Disappeared* frames the space between words

Plate 5

Once a man was waving to his friend from the elevator.
He was laughing so much that he stuck his head out and the ceiling cut it off.

and images as the vanishing point of Bourgeois' own art. There is no logical explanation of the relationship between the text and the image, and this slippage has led Rosalind Krauss to describe the artist as a Surrealist. But she is not one. Bourgeois' works are at least as deeply philosophical, indeed existential, as they are aesthetic or psychoanalytic. In a remarkable self-appellation, Bourgeois claimed: 'I am Descartes' daughter: I think therefore I am, I doubt therefore I am, I am disappointed therefore I am.'[95] What she doubts most, most inspires her: the space between the word and the sculptural form, the form that cannot be made solid by the deceptive promises of words. The titles of Bourgeois' works often stage the paradox of the gap between the artwork and the signifier with astonishing precision. *Fillette,* for example, French for 'little girl', is the title of a sculpture that resembles a large phallus. The little girl is not the same as the phallic sculpture, but maybe the act of calling the phallus a little girl can disempower the force of the phallic signifier. The tender place between the little girl and the heavy phallus is the space that

the sculpture, sheathed by its title, animates. The disjoin between the title and work induces a certain doubt about the stability of both word and form. People who write about art often prefer to be certain, rather than daunted by all there is to doubt. Writing about art often prefers to coddle the phallic signifier in its own hands rather than expose it as the fiction it is. Like the accomplices of the Wizard of Oz, art critics and theorists sometimes want to stand behind a curtain generating clouds that might or might not allow the Cowardly Lion to take heart. What would art writing not employed by the Wizard look like?

A Digression on Wishes

Language that calls attention to itself, like a flirty girl, is called catachresis. It has been defined as 'abusive or far-fetched metaphor, like "leg of a table" or "face of a mountain". [I]t is at once a "figurative" expression because it is transferred from elsewhere and "literal" because there is no other way to say it, it is the "proper name" of the thing.'[96] Catachresis, in other words, is that funny turn in language when it joins art and yells, 'Look Mom, no hands!'

Faced with the catachresis that art is, writers elucidate the reasons why a leg belongs on a table, and why a mountain needs a bit more make up, often called, in the language of the philosophical sublime, clouds. Of course, very often this is immensely useful. But it is also fundamentally distorting. Robert Frost claimed that 'all that gets lost in the translation of poetry is the poetry'. I sometimes fear that art criticism and theory want to take the art out of art. I want less writing about art, more writing with art. OK, enough. I once again step behind the curtain and rejoin the ranks of the Wizard's accomplices. (But how I dream of another frame to write in, to sleep and dream in ...)

The charge of essentialism might well have stood in for the other disappointments feminists felt at the beginning of the 1980s. The conservative retrenchment undertaken by Reagan, Thatcher and other world leaders hit the Left and the alternative art world hard, at a time when it was also being ravaged by the AIDS epidemic. *The Dinner Party* was repudiated for its racism, its heterosexism and its vulva imagery, but it may well be that what most rankled was Chicago's sense that her installation was a 'celebration' of women's history. Thirty-nine women, thirty-eight of whom were white, regardless of whether one viewed them

'as metaphors' or 'as real (dead) women' hardly seemed like a satisfying contribution to history's long banquet. If this were the best feminist *history* could do after a decade of support, then why not give it up for the heady promises of seductive critical *theory*? Of course history is theoretical, and theories are inevitably historical, but history and theory at the beginning of the 1980s seemed to promise different ways to nurture feminist work. Most academic feminists picked the theory behind door number one.

In Theory

Laura Mulvey's essay 'Visual Pleasure and Narrative Cinema', published in *Screen* in 1975, had an enormous influence on the development of feminist theory. Analysing the structure of the male gaze in cinema in psychoanalytic terms, Mulvey introduced a shift away from historical research into the lives of women, to a more explicitly theoretical inquiry into the logic of representation. Mulvey argued that within Hollywood film the woman is constructed as spectacle and symptom; she is, in Mulvey's formulation, the passive object of an active and powerful male gaze. Moreover, Hollywood film revealed and left intact the logic of sexual difference as elucidated by Lacanian and Freudian psychoanalysis: '*Woman […] stands in patriarchal culture as signifier for the male other, bound by a symbolic order in which man can live out his fantasies and obsessions through linguistic command, by imposing them on the silent image of woman still tied to her place as bearer of meaning, not maker of meaning.*' Mulvey's argument, and the responses it generated, particularly in relation to questions of women's pleasure and cross-gendered spectatorial identification, helped focus both art making and art theory for the next decade around the psychoanalysis of desire, a new erotics of pleasure, the problems and possibilities of the visual, politically and aesthetically.

Primarily rooted in psychoanalytically based readings of representation, which had developed its deepest roots in England and France through theorists such as Jacqueline Rose, Juliet Mitchell, Hélène Cixous, Julia Kristeva and Luce Irigaray, feminist artists in the 1980s were praised for intervening in the complex codes of representation. As psychoanalysis became a primary interpretative metho

dology, renderings of the partial object, and especially of the genitals, that had been crucial to the work of Chicago and others, were seen more often than not to play into the logic of the fetish, whether they were composed by men or women.

Mary Kelly's *Post-Partum Document* (1973–79) intimated the turn towards theory so central to contemporary art in the 1980s. Kelly's installation recorded her first encounters with her own maternity and in this sense was 'historical'. Framed by Lacanian theory, especially his concept of the mirror phase, *Post-Partum Document* emphasized the importance of interpretation and mediation as the key to transforming the Symbolic.[97] By focusing on her experience as a mother, Kelly pointed to the dearth of artworks exploring the mother/son relationship undertaken by mothers themselves. This is one of *Post-Partum Document*'s most important insights, for it underscores how little attention we give to the ties that are familial and yet not quite familiar. Faith Ringgold and Michele Wallace have reflected on the mother/daughter relation, as have Allison and Betye Saar, and Hannah Wilke's homage to her mother, in both her life and death, is writ large in her photographic series *So Help Me Hannah Series: Portrait of the Artist with Her Mother, Selma Butter* (1978–81), and more subtly in her 1991–92 *Intra-Venus* series, which included photographs, works on paper and sculpture documenting the end of her own life. The sisters Mira and Naomi Schor have worked brilliantly, but separately, on issues of essentialism, while the art historians Amelia and Caroline Jones are doing much to transform interpretations of postwar art history.[98] The performance artist Diane Torr has suggested that her brother inspired her to develop her Drag King performances in the mid 1990s; the filmmaker Jennie Livingston dedicated her study of urban cultures of crossdressing, *Paris Is Burning* (1994), to her brother; and the vocalist Diamanda Galas performed *Plague Mass* (1991) in memory of her brother. Sonia Lins, the Brazilian writer, made an evocative memoir/artist's book, *Artes,* upon the death of her sister, the artist Lygia Clark, in 1988.[99] The photographer Nan Goldin has frequently spoken of her sister's suicide and how it prompted her to begin taking photographs.[100] The mourning at the heart of familial love (especially as it inspires collaboration and/or rivalry) is an important and underappreciated force in the production of art. Feminist artists' emphasis on the everyday, the familiar and the emotional helped create an important discussion about the

complexity of this love in both psychic and creative life. Kelly's *Post-Partum Document* boldly underlined just how how rich the familial field is.

Luce Irigaray's suggestion that 'women's desire does not speak the same language as men's' has been taken up by feminist literary theorists to help translate and promote the idea of *écriture feminine*. Irigaray called for a feminine writing that mimicked the patriarchal Symbolic so aggressively that its sheer repetitive miming might begin to destabilize reality itself. In her evocative paintings, especially *Light Flesh;* (1994) and *Slit of Paint* (1994), Mira Schor illuminates some of the complex intersections between painting, writing and embodiment for women. Her book *Wet: On Painting, Feminism and Art Culture* is among the most provocative, useful collections of feminist art writing published in recent years.[101]

At the root of the appeal of mimicry for feminist art was a shift away from the 'originality' of painting and sculpture, to the repetitions of photography, film and video. This

appropriations of Levine, emphasized the reproductive and iterative properties of speech acts, advertising and photographic posing. Kruger's short, bold-faced statements laid out like the typeface of advertisements, attempted to 'talk back' to dominant culture. In her untitled work of 1981, a text reading 'Your gaze hits the side of my face' marches down the left side of a photographed stone carving of a woman's face, effectively animating the lifeless and formerly mute effigy.

But the most important shift in feminist art in the 1970s and 1980s was rooted in a recognition that no single act or 'original' artwork could be interpreted without recourse to the frames in which it was enacted and made. This shift can be illustrated by considering Lynn Hershman's alter ego of the 1970s, Roberta Breitmore, in relation to the masquerades of femininity that Cindy Sherman captured in her photographs of the late 1980s, particularly the *History Portraits*. Hershman created Roberta Breitmore as a distinct social agent; she went for job interviews and even filed for her own identification

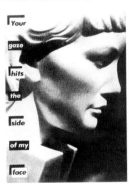

shift was in keeping with Postmodernism more generally. As theorists from Walter Benjamin to Fredric Jameson have demonstrated, the 'aura' of the original wanes in an age of mechanical reproduction; Postmodernism is the recognition that representations of the real have become more powerful than the real precisely because of the density of their repetitions.[102] Thus the four most critically celebrated women artists of the 1980s, Sherrie Levine, Barbara Kruger, Jenny Holzer and Cindy Sherman, tend to be labelled 'Postmodernists' rather than 'feminists' – presumably because their work 'transcends' the putatively narrow frame of feminism. But as Laura Cottingham has demonstrated, their work emerged amid the feminist art of the 1970s:

'*If their works do not formally resemble the raw, visceral, emotive practices most often associated with 1970s feminist art, their strategies are nonetheless derived from intellectual and aesthetic concerns that preoccupied first-generation feminist artists.*'[103] The text-based strategies of Holzer and Kruger, and the

number. Hershman's performance eroded the line between the artistic and the real. It was an important predecessor for other feminist performance artists: a decade later, Orlan's serial plastic surgeries make literal a morphological design derived from art history's beliefs about women's beauty.[104]

Sherman's work examines the line between the real and the representational within photography. Posing for a photographic shoot of a dissection is a different kind of performance than undergoing plastic surgery. While all three artists are concerned with different forms of inscription and the body, Sherman's work is about a kind of textualization and mode of reading art, while Orlan's and Hershman's works attempt to move outside the frame of 'art' towards 'reality'. Sherman's photographic performances suggested that there is no way to be outside the frame of representation.

The possibility that representation was often responsible for women's oppression was originally greeted with a kind of optimism. It seemed much easier to intervene in the

conventions of representation than to overthrow a form of scientifically 'factual' or 'natural' set of laws. This initial optimism, however, led to political divisiveness within feminism in general. Gone were the days of talking about 'the personal' without quotation marks. Instead, difficult texts of Lacan, Derrida and other (often French) theorists were parsed for what insight they might offer on the condition of women within what came to be called phallogocentrism. This new emphasis initiated a change in the frame of reference of art history, although for the first time the historical period up for a revisionary interpretation was not only the canon of Western art, but also the work of 1970s feminists. Upholding the dominant notion that history is ever advancing, feminist work of the 1980s was celebrated as 'greater' than the work of the preceding decade. The irony of this is worth underlining: in order to proclaim the radicality and sophistication of the more explicitly theoretically informed work of the 1980s, feminist art critics (perhaps unwittingly) assented to the narrative of linear progress characteristic of the most conservative beliefs about history and historiography.

In the midst of the discourse on deconstructing the regime of the visual, however, an ever more powerful critique of whiteness as the unmarked category of feminism and feminist theory began to bear fruit. The 1981 publication of the angry, lyrical and deeply passionate *This Bridge Called My Back* had an enormous influence on subsequent dialogues about race and racism, especially the racism within the feminist movement. Edited by Cherríe Moraga and Gloria Andzaldúa, with a foreword by Toni Cade Bambara, *This Bridge* brought together writing by Chrystos, Audre Lorde, Barbara Smith, Cheryl Clarke and other women of colour whose work inspired some of the best subsequent political writing in the US. The voices of Native Americans, Filipinos, Cuban Americans and Asian Americans added much complexity to the conversation about racism in the US, which had tended to be seen as a conversation primarily between African Americans and whites. Organized in six sections, one of which was called 'And when you leave take your pictures with you: racism in the women's movement', *This Bridge* examined class, homophobia and first and third world politics; it was an extremely influential anthology throughout the decade.

Gayatri Spivak's helpful phrase, 'strategic essentialism', the notion that one might in some circumstances insist on the force of a consolidated political identity such as 'the subaltern' or 'the lesbian', also helped to reanimate some of the activist elements of feminism that had become latent when theory was the main game in town. Trinh T. Minh-ha's 1991 book *When the Moon Waxes Red: Representation, Gender and Cultural Politics* usefully helped unsettle the ease of a too simple litany of 'race, class, gender and sexuality differences', which was iterated more often than analysed. Lucid, theoretically sophisticated and politically astute, Trinh's work provided a context for Coco Fusco's important 1995 book *English Is Broken Here: Notes on Cultural Fusion in the Americas.* Whereas some women of colour in the 1970s often felt they were asked to choose between their identifications as women and their racial identifications, Fusco, along with bell hooks, Kimberlè Williams Crenshaw, Valerie Smith, Patricia Williams, Toni Morrison, Adrian Piper and others, worked to show the ways in which racism and sexism are intertwined pathologies which have distorted our lives.

Central to this work has been a significant rethinking of the binary habits of racial difference. While it was pretty easy to see that the habitual white/non-white would not be sustainable, it was harder to notice that the ubiquitous 'third term' that structures critical theory is problematic as well. Thinking about the possibilities of interracial and inter-ethnic alliances and tensions has been difficult in part because logic tends to be dialectical. Interracial and inter-ethnic analysis and activism, often called critical race theory in the academy, pushes conceptual habits to develop new logics. Moving away from the consolidations of identity politics, to consider shifting politics of alliance, critical race theory reminds feminists why we still need to rethink the binary of masculinity and femininity, without concluding the problem is 'solved' via the invocation of transsexuality.

Drawing on the important work of the Sankofa film and video collective in the 1980s, which included the historically resonant films of Isaac Julien and of Martine Attille, in the 1990s visual artists such as Zarina Bhimji, Sutapa Biswas, Sonia Boyce, Mona Hatoum and Pratiba Parmar have helped keep the intersectionality of race, sex, class and gender at the forefront of progressive contemporary art in Britain. Cultural theorists Stuart Hall, Homi K. Bhabha, Jean Fisher and Kobena Mercer, among others, have provided an important critical frame for this work.[105]

The destructive explosions of 'the culture wars' in the late

1980s and early 1990s in the US remind us what is still at stake in the debate over high and popular culture, dominant and marginal art practices and public policy for the arts – all issues first framed by the feminist art movement. The Guerrilla Girls, who dubbed themselves the 'conscience of the art world', continue to insist on pointing out the mutually determining forces of sexist and racist structures in art exhibitions and theory. Kara Walker, an African-American artist whose silhouette black cut-outs of stereotypical imagery of African Americans have been heralded by some as profound exposures of the shadowy legacy of slavery beneath contemporary racism, and denounced by others as insufficiently critical about precisely that legacy, has been the target of an alarming new censorship. While it seems possible that Walker's art might be vulnerable to racist readings, it is also possible that the Walker debate is a repetition of the essentialist feminist debate – although this time played out in relation to the historical trauma of slavery. The best response to allegedly

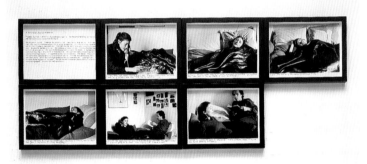

offensive art can only be better art. Education alert to the nuances of the histories of art, racism and sexism needs to be joined with theories of representation. Censorship is dangerous not only because it can so easily produce chilling effects that far exceed the initial target, but also because censorship produces a kind of sensational journalistic attention and does little to address the complexity provoked by powerful art.

An important aspect of feminist art in the 1980s was the investigation of what might be called the trace of absence that constitutes the illusion of presence. The French artist Sophie Calle made a beautiful series of photographs entitled *The Sleepers* (1979) in which the pleats and folds left in the bedclothes after the sleeper wakes and leaves register the melancholic trace of the repeatedly missed figure. Artists such as Nan Goldin, Felix Gonzalez-Torres and Peter Hujar used photography to capture the traces of friends and lovers who were dying from AIDS in the epidemic of the 1980s.

Rachel Whiteread's 'inversion' of houses and libraries, casts that both evoke and haunt the absent object, similarly makes vivid what is normally lost to sight. Rosalind Krauss' 1986 essay on Bataille, 'Antivision', proposes that disruption of the prerogatives of the visual system fundamental to art theory and criticism would yield 'another description of the goals of representation, another ground for the very activity of art'.[106]

After Irigaray suggested that 'women's desire most likely does not speak the same language as man's desire', she went on to claim that it 'probably has been covered over by the logic that has dominated the West since the Greeks. In this logic, the prevalence of the gaze, discrimination of form and individualization of form is particularly foreign to female eroticism.'[107] If the gaze is not the erotic drive for women, what other senses might be? The notion of a haptic art began to emerge in the 1990s. A more intimate and tactile address between viewer and artwork is part of the achievement of Helen Chadwick's *Loop My Loop* (1989), a soft sculpture that

renders hair a kind of formal grammar for female connection itself. Maureen Connor's *The Senses* (1991), a five-part installation that addresses the logic of each of the senses, displaces the singularity of the visual in the act of beholding. In the installation devoted to sight, *Limited Vision*, a wall covered with Mylar emerges from behind a curtain. Each time the looker 'sees', what she confronts is her own gaze.

Sound art, from all-girl garage bands and 'riot grrls', to the more sophisticated technological performances of Laurie Anderson, has not been given sufficient attention in accounts of feminism and art. Kaja Silverman, a feminist film theorist, has explored the possibilities of identification with the female voice, rather than the body, in the films of Yvonne Rainer and Chantal Akerman.[108] As electronic-based forms of art become prevalent, this kind of thinking will become more central for understanding feminist art. Pipilotti Rist, one of the most talented new artists to emerge in the 1990s, spent six years (1988–94) playing in the rock band Les Reines Prochaines, and has made beautiful, melancholy works in a pop video style, such as *I'm Not the Girl Who Misses Much* (1986) and *Ever Is Over All* (1997). A more sophisticated analysis of sound art and haptic theory will need to be developed in order to assess these new forms.

Sophie CALLE The Sleepers (X. Baby-sitter), 1979
Maureen CONNOR The Senses (detail), 1991

Up to and Including Our Limits [109]

In the early 1990s, queer theory emerged as one of the most innovative and exciting disciplines in contemporary thought. The work of writers and theorists such as Eve Kosofsky Sedgwick, Judith Butler, Judith Halberstam, Lynda Hart, Catherine Lord, Terry Castle, Mandy Merck, Elisabeth Grosz, Liz Kotz, Laura Cottingham and others helped to bring new attention to the work of lesbian artists. The photographic work of Catherine Opie, Nan Goldin, Della Grace, the paintings of Nicole Eisenman and perhaps most especially the performance work of Holly Hughes, The Five Lesbian Brothers and Split Britches helped to foster the development of lesbian and queer art in many guises. Moreover, it also helped to clarify some of the less helpful impasses within feminist theory. Butler's influential book *Bodies That Matter: On the Discursive Limits of 'Sex'* (1993), for example, returned to the essentialism debate in a way that might finally allow people to let it go. [110] Jane Gallop's 1988 *Thinking through the*

exposed by the similar erosion of the line between reality and representation central to Postmodernism. Compulsively engaged in copying, postmodern representation lends the real a density it previously lacked. Thus what gives gender performances their almost ontological force is precisely their ability to be recited, repeated, reproduced. Women, as the agents of reproduction, are thus at once both the avatars and the objects of the logic of repetition and reproduction utterly central to Postmodernism. Photography was especially fluent in making this connection apparent.

In addition to the work of Cindy Sherman and Nan Goldin, important photographic work in the 1980s and 1990s included Carrie Mae Weem's photographic short stories devoted to framing the miscommunications which characterize romance and racism; Lorna Simpson's police-like photographic interrogations of 'guarded conditions' around racial categories and loaded phrases; Zoe Leonard's medico-erotic photographic investigation of lesbian desire;

WOMAN WITH CHICKEN

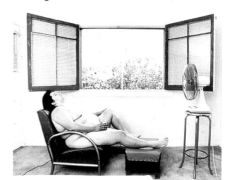

Body, Diana Fuss' 1989 *Essentially Speaking* and Naomi Schor's detailed re-examination of Irigaray's writing in her essay 'The Essentialism Which Is Not One' helped pave the way for the reception of Butler's argument. [111] Crucially though, Butler accented the language of performance and performativity more loudly than the accents of psychoanalysis which had been fundamental to the arguments of the 1980s. Placing her emphasis on the process of enactment and iteration, Butler demonstrated that gender identity was necessarily unstable and unfinished, a performance forever in process. Therefore dis-identification with representational history could be rethought as a politically effective strategy for interventions in cultural interpellation. This of course is what feminist artists had demonstrated in the 1980s.

Extending Joan Riviere's insight about the lack of distinction between 'genuine femininity' and the 'masquerade' of femininity, feminist performance artists and photographers suggest that the erosion of that line is itself

Sheree Rose's passionate documentation of body artists and s/m practitioners; Catherine Opie's documentary portraits of drag kings in the series *Being and Having* (1990–91) and Laura Aguilar's *Latin Lesbian Series* (1990–91). All of these artists use photography to frame the crossings between the public and the personal, the theatrical and the real, in order to complicate ideas about race, romance and sexuality.

While feminist theorists in the 1980s were especially interested in the psychoanalytic work of Freud and Lacan, in the 1990s the work of Melanie Klein began to be reinvestigated by feminist art historians. Mignon Nixon, for example, offered a provocative reading of Janine Antoni, Louise Bourgeois and Eva Hesse, which employed Klein's ideas about the oral drive and transitional objects. [112] Nixon's essay suggests a generative way to move beyond the analysis of the gaze, while retaining the crucial role of the unconscious in the creation and interpretation of art.

Attempts to revise art history have continued in

exhibitions of the 1990s. Several coincidentally titled 'Bad Girls' exhibitions in 1993–94, one curated by Marcia Tucker at the New Museum of Contemporary Art, New York,[113] another curated by Emma Dexter and Kate Bush at the Institute of Contemporary Arts, London, sought to survey the diversity of current practice in its own terms but attracted some negative critical responses. The 1996 'Inside the Visible' exhibition attempted to contextualize work of the 1990s by setting it alongside two germinal periods in the development of art by women in the twentieth century: the 1930s to 1940s and the 1960s to 1970s.[114] The show was curated by M. Catherine de Zehger of the Kanaal Art Foundation, Kortrijk, Belgium; when it travelled to the Institute of Contemporary Art, Boston, the director, Milena Kalinowska, commissioned programmes of poetry readings and film screenings to extend the parameters of the exhibition. The catalogue, subtitled *an elliptical trace of 20th century art: in, of, and from the feminine,* demonstrates the continuing need for combining both theoretical and historical accounts of feminism and art. *Stopping the Process? Contemporary Views on Art and Exhibitions* (1998), published in Helsinki, took up the increasingly important role of curators in the development of contemporary art.[115] Both publications suggest that the US and Britain may no longer be the dominant centres for innovative thinking about feminism and art.

In the mid 1990s some feminist writers began to feel the constraints of art history as a discourse and began to create a slightly different scholarly project, one usually called 'visual culture'. Lisa Bloom's 1999 edited anthology *With Other Eyes: Looking at Race and Gender in Visual Culture* is one of the more exciting volumes to emerge from this project.[116] The distinction between the discipline of art history and visual culture has to do not only with the object of study – visual culture ruminates on such disparate topics as comic books, advertising images and national guidebooks – but also with the mode of address to the reader. This address is more intimate and, while critically informed, tends to be less determined (or perhaps less desperate) to display its theoretical mastery. Influenced by Patricia Williams' brave and brilliant book *The Alchemy of Race and Rights: A Diary of a Law Professor,* the exemplars of this new work, who include Irit Rogoff, Carol Becker, Jane Blocker, Moira Roth, Carol Mavor, Della Pollock, Joanna Frueh, Lucy R. Lippard and Hélène Cixous, do not honour the distinctions between 'theoretical' and 'personal' knowing.

In 1995, *October* magazine published a round table discussion on feminism, responding to the growing sense that feminism and feminist theory had been played out.[117] For readers of *October*, what was worth remarking was critical theory's own apparent disenchantment with theories of sexual difference as a mode of analysis for cultural representation. A shift seemed to have taken place in which questions of the political had been subtly surmounted by questions of the ethical.

One of the main motivations for this shift came from the emerging field of trauma studies. An interdisciplinary and international attempt to return to some of the questions raised by World War II quickly led to a wider inquiry into the nature of trauma and its reverberations in both psychic and cultural history. As information and documentation of subsequent genocides in Cambodia, Rwanda, East Timor, Kosovo, Bosnia *and* ... accumulate, questions of trauma and catastrophe become ever more urgent. Judith Lewis Herman's 1992 *Trauma and Recovery*, Shoshana Felman and Dori Laub's 1992 *Testimony* and Cathy Caruth's edited 1995 collection *Trauma: Explorations in Memory* are among the most germane texts in this literature.[118] Much of this theory is derived from clinical psychoanalysis or psychoanalytically minded interpretations of literature, but it has serious implications for feminist art history. Not only because, as I suggested earlier, one theme of the notion of a collective feminist awakening allows us to see that awakening as traumatic, but also because so much powerful feminist art has been devoted to the examination of pain and trauma. From Suzanne Lacey and Leslie Labowitz's *In Mourning and in Rage* to some of the experiments in 'ordeal art' undertaken by artists such as Gina Pane, Linda Montano, Marina Abramovic, Angelika Festa and Orlan, feminist art has been dedicated to exploring the consequences of the specific forms of physical violence women experience in a world run by men. Pane's body art in the 1970s, for example, involved cutting her skin with knives, razor blades or glass in gallery settings. Commenting on this work in 1985, Pane remarked: 'We live in continuous danger, always. So [my body art investigates] a radical moment, the moment most loaded with tension and the least distant from one body to the other, the [moment] of the wound.'[119] Crucial to this investigation is the presence of the spectator. Carefully choreographed and performed in the

company of witnesses, Pane's body art solicits a call for compassion and response. Linda Montano and Tehching Hsieh's performance work *A Year Tied Together at the Waist*, also known as *Rope Piece* (1983–84), is often described as 'ordeal art'. The two artists were tied together at the waist by an eight-foot rope for a year while they observed a strict 'no touching' rule the whole time.[120] Usually associated with acts of physical pain and difficulty, 'ordeal art' does not fully capture the emotional and political drama of intimacy and repulsion, co-operation and resistance that this work makes vivid. Tehching Hsieh's experience as a Cambodian refugee who speaks English only with difficulty, seen in relation to Montano's eloquent feminism, makes the power dynamics at the heart of the performance richly complicated and extremely difficult to address critically. Resisting the easy conclusion that it illuminates what it means for women to be tied to men, the performance invites a more patient view of the ties that bind and blind us to each other's dramas.

expressive system often overlooked by philosophers attempting to account for the capacities and incapacities of language.[123] The increasingly theatrical flair of contemporary installation, painting and sculpture might be understood as an attempt to make this pain something to be shared. Theatre exists for a witness. In returning to the agony of trauma, art might provide a means to approach its often radical unknowability, in part because art does not rely exclusively on rational language, narrative order or naive beliefs in therapy. Moreover, art theorists might remind theorists of trauma that creativity is central to any theory of survival.

The realization, slow but decisive, that worlds outside major urban centres are culturally rich, complicated and much neglected in terms of critical attention, is finally beginning to take hold. Seeing the multiple blindnesses that framed Western art history, some feminists began to explore art forms from other cultures. Joyce Kozloff's *Patterns of Desire* (1990), a book of thirty-two watercolours copying

Linda MONTANO (with Tehching Hsieh) A Year Tied Together at the Waist, 1983-84
Magdalena ABAKANOWICZ Backs, 1981
Joyce KOZLOFF Pornament Is Crime No. 12: Revolutionary Textiles, 1987
Cecilia EDEFALK Elevator Painting, 1998

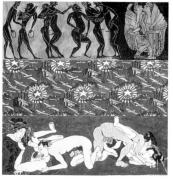

In a less literal way, Marlene Dumas' early paintings, such as the self-portrait *Evil Is Banal* (1984), which reflected upon South African apartheid; Magdalena Abakanowicz' burlap *Backs* series of the early 1980s; and Mona Hatoum's sculpture *Silence* (1994), a crib for an infant made of glass, represent important responses to political violence. Abakonowicz' *Backs* is at once theatrical and traumatic. In 1977 she showed twenty of them together under the title *The Session*. The installation staged a Nietzschean and psychoanalytic attention to political life's *hinterfrage*, the 'back-question' that is not only collectively historical but also intensely private, indeed, utterly agonizing.[121] As Elaine Scarry has argued:

'*Pain is resistant to language; to move out beyond one's body to share is that which pain is incapable of. It is not of or for anything. It is precisely because it takes no object that it, more than any other phenomenon, resists objectification in language.*'[122] Performance, which also 'takes' no object, is an important

and transposing famous erotic iconographies from Japan and China, from gay and lesbian art sources, audaciously employs these erotic couplings as decorative elements in her own works. Subtitled *Pornament Is Crime*, Kozloff's series of watercolours represents one of the richest responses to the often contradictory 'perspectives' Western feminists take up in relation to the dense and varied history of erotic art.[124] Similar projects undertaken by non-Western artists still need more critical attention.

Additionally, artists working outside the main centres of international art are beginning to receive critical attention. Cecilia Edefalk, a painter from Stockholm, has extended interest in figuration, repetition and size to a consideration of that which cannot be measured. Her *Elevator Paintings* (1998) examine the space between fullness and emptiness, between the lost wooden arm of a statue of an ancient angel and the suturing possibility of paint as replacement. The angel with the wounded arm pivots in a white dress

dotted with blood within and across the frames of five paintings composed as a series of the 'same' painting, done in different sizes and with differing amounts of detail. The whitish brushstrokes on the bottom of the paintings move upwards and stop at the angel's outstretched arms. What would it take to perform once again the double lifting and dropping action conveyed by the German *aufhebung*, even with a broken arm? The attempt, Edefalk gently reminds us, will take time as well as space.[125]

Denise Stoklos, the Brazilian performance artist, has recently completed an important theatre piece entitled *Louise Bourgeois: I Do, I Undo, I Redo* (2000). Stoklos' performance challenges the hierarchies of first world art commentary. Her Bourgeois is very far from Rosalind Krauss' and the future of that difference will be telling. For Krauss, Bourgeois is, supremely, a master of sculpture, who uses her history as inspiration. For Stoklos, Bourgeois is, primarily, a woman trying to survive (her own) history, who uses her art as a way to

record and advance that survival.

The questions that have been at the heart of art commentary have been fundamentally rooted in an assumption about the link between the artist and the made thing, be it as ephemeral as performance or as solid as a monument. But as concepts of identity become increasingly less stable, the assumption that gender identity is itself fixed enough to become oppressive *seems* to disappear. In my view, we are a long way from such a sense of lived instability – the psyche is a well-practised resister – although I think we have arrived at a theoretical one, buttressed by the terrain of the virtual and the electronic. Del LaGrace Volcano, the female to male transgendered photographer formerly known as Della Grace, articulates the gap between what is conceptually and technologically possible in regard to gender transformation, and what is still messy at the level of lived experience.[126] Describing the experience of modelling for the painter Jenny Saville, Del LaGrace remarked:

'Jenny Saville paints women. I no longer identify as "woman" and feel uncomfortable being read as female. I am intersex by design, an intentional mutation, and need to have my gender specified as existing outside of the binary gender system, rather than [as] an abomination of it [...] My fear is that I will be read as only female and this painting may have the power to dislocate and /or diminish my transgendered maleness in the eyes of others and quite possibly my own.'[127]

This is a bold and honest statement. It's also exceedingly complicated. Having decided no longer to 'identify' as 'only female' which is not the same thing as having chosen to identify as a man, Del LaGrace worries s/he will somehow be re-gendered as a woman, because Saville paints women. Not only is s/he at risk from the mis-seeing eyes of anonymous spectators of Saville's paintings of women, but also Del LaGrace is 'quite possibly' at risk of being betrayed by his/her own eyes.

Saville's paintings inscribe her models into an economy we can call 'Saville's women' (quite often her models are her sister or herself). But Saville's work is framed by the history of high art; her paintings refer to gestures of the figure undertaken by artists from Gustave Courbet to Lucian Freud. As Johanna Burton has pointed out, the intertext of Saville's *Matrix* (1999) is Gustave Courbet's *L'Origine du monde* (*The Origin of the World*, 1866),[128] a painting that Nochlin, in a virtuoso display of her 'greatness' as an art historian, discusses in relation to its provenance. It was owned for a time by the great theorist of sexual difference Jacques Lacan.[129] As Saville makes her bid to enter the pantheon of great figurative painters, she returns to Courbet's *Origin* and paints it again. But Saville, unlike Courbet, includes her model's face, and the catalogue of the show contains an interview about the model's experience of her performance. Saville's model, in short, is not art history's nude woman, but contemporary art's former-woman.

Those of us lucky enough to have endured the trauma and the possibility of feminist awakening have a particularly charged, and decidedly ambivalent, response to becoming (again) former-women. In memory of that history still before us, I hereby put these words to bed, still muttering *and, and, and* ...

Jenny SAVILLE Matrix, 1999

1 For interesting discussion of the frame see Jacques Derrida, *The Truth in Painting*, trans. Geoffrey Bennington and Ian McLeod (Chicago and London: The University of Chicago Press, 1987) 37–82; *The Rhetoric of the Frame: Essays Towards a Critical Theory of the Frame*, ed. Paul Duro (New York and Cambridge: Cambridge University Press, 1997). See especially Amelia Jones' essay 'Interpreting Feminist Bodies: The Unframeability of Desire' (223–41).

2 Anne Marsh, *Body and Self: Performance Art in Australia: 1969–1992* (Sydney: Oxford University Press, 1993) is the best work on Australian contemporary art and feminism. While the 'ordeal artist' Stelarc remains Australia's best known performance artist, Marsh makes clear that the work of feminist artists, especially the captivating and challenging work of Jill Orr, is stunningly powerful. See Marsh's chapter 'Ritual Performance and Ecology: Feminist and Activist Performance', 141–83. A good discussion of the development of nineteenth- and twentieth-century Australian women painters can be found in *Strange Women: Essays in Art and Gender*, ed. Jeannette Hoorn (Carlton, Vicoria: Melbourne University Press, 1994). Feminist theatre and performance are usefully documented and analysed in Peta Tait's *Converging Reality: Feminism and Australian Theatre* (Sydney: Currency Press, 1994) and in Tait's *Australian Women's Drama: Texts and Feminisms* (Sydney: Currency Press, 1997).

3 Laura Cottingham, *Not for Sale: Feminism and Art in the USA during the 1970s*. Video, 90 mins., colour (New York: Hawkeye Productions, 1998).

4 Griselda Pollock, *Generations and Geographies in the Visual Arts: Feminist Readings* (New York and London: Routledge, 1996).

5 After the elimination of the male/female opposition, the even more fundamental opposition between life/death comes into view as the next project. For a full discussion of the often repressed relationship between sex and death see Jean Laplanche, *Life and Death in Psychoanalysis*, trans. Jeffrey Mehlman (Baltimore and London: The Johns Hopkins University Press, 1976; original publication in France, 1970).

6 Lucy R. Lippard, 'Sweeping Exchanges: The Contribution of Feminism to the Art of the 1970s', *Art Journal* (Fall–Winter 1980) 362.

7 See Tania Modleski, 'Some Functions of a Feminist Criticism, or the Scandal of the Mute Body', *October*, 49 (Summer 1989) 3–24.

8 J.L. Austin, *How to Do Things with Words*, ed. O.J. Urmson and Marina Sbisà (Cambridge, Massachusetts: Harvard University Press, 2nd edition 1975). This text is based on Austin's 1955 lectures at Harvard.

9 The best reading of *How to Do Things with Words* is Shoshana Felman's *The Literary Speech Act: Don Juan with J.L. Austin, or Seduction in Two Languages*, trans. Catherine Porter (Ithaca, New York: Cornell University Press, 1983).

10 See Griselda Pollock and Roszika Parker, ed., *Framing Feminisms: Art and the Women's Movement, 1970–85* (London: Pandora Press; New York: Routledge & Kegan Paul, 1987) for a fuller discussion of the particular uniqueness of feminist art as a movement. Socialist Realism is sometimes proposed as an art movement comparable to feminist art.

11 There are many discussions of Womanhouse but perhaps the most interesting is Miriam Schapiro's 'The Education of Women as Artists: Project Womanhouse'. (Reprinted in this volume, 208–9). It is clear from her account that a new pedagogy was also (perforce) being created in these collaborative projects. This aspect of feminist history and art needs more attention. Arlene Raven's '*Womanhouse*' in Norma Broude and Mary D. Garrard, eds., *The Power of Feminist Art: The American Movement of the 1970s, History and Impact* (New York: Abrams, 1994) 48–65, is also an excellent documentation and analysis of the exhibition.

12 The reverberations of this exhibition continue to this day: Womenhouse, a site on the World Wide Web, was inspired by it. See http://www.cmp.ucr.edu/womenhouse. Faith Wilding is a participant.

13 For more on the history of galleries and other feminist spaces see Judith K. Brodsky, 'Exhibitions, Galleries and Alternative Spaces', in *The Power of Feminist Art*, op. cit., 104–19.

14 For an excellent discussion of Akerman's work see Ivone Margulies, *Nothing Happens: Chantal Akerman's Hyperrealist Everyday* (Durham, North Carolina: Duke University Press, 1996).

15 The work of feminist film theorists indebted to Mulvey is far too extensive to cite here. But some of the most influential books would include: E. Ann Kaplan, *Women and Film: Both Sides of the Camera* (New York and London: Methuen, 1983); Judith Mayne, *The Woman at the Keyhole: Feminism and Women's Cinema* (Bloomington: Indiana University Press, 1990); Teresa de Lauretis, *Alice Doesn't: Feminism, Semiotics, Cinema* (Bloomington: Indiana University Press, 1984); Mary Ann Doane, *The Desire to Desire: The Women's Film of the 1940s* (Bloomington: Indiana University Press, 1987) and *Femmes Fatales: Feminism, Film Theory and Psychoanalysis* (New York and London: Routledge, 1992); Valerie Smith, *Not Just Race, Not Just Gender: Black Feminist Readings* (New York and London: Routledge 1998). Additionally, popular books such as Molly Haskell's *From Reverence to Rape: The Treatment of Women in the Movies* (New York: Holt, Rinehart and Winston, 1974) and Jeanine Basinger's *A Woman's View: How Hollywood Spoke to Women, 1930–1960* (New York: Alfred Knopf, 1993), helped articulate the powerful role films, especially Hollywood films, played in both influencing and reflecting public imagination. B. Ruby Rich, *Chick Flicks: Theories and Memories of the Feminist Film Movement* (Durham, North Carolina: Duke University Press, 1998) is a lively history of the development of both the academic and journalistic history of the field.

16 Cherríe Moraga and Gloria Anzaldúa, ed., *This Bridge Called My Back: Writings by Radical Women of Colour* (Watertown, Massachusetts: Persephone Press, 1st edition 1981; New York: Kitchen Table: Women of Colour Press, 2nd edition 1983).

17 The exhibition was held at Acts of Art Gallery, 15 Charles Street, New York. The show led to an organization of seventeen women under the name 'Where We At'. For a fuller discussion see Kay Brown, 'Where We At Black Women Artists', *Feminist Art Journal*, 1 (April 1972).

18 Quoted in Brodsky, op cit., 118.

19 Shere Hite, *The Hite Report: A Nationwide Study on Female Sexuality* (New York: Macmillan, 1976). She did a follow-up study that appeared in 1987.

20 For a good overview of the sexuality debates in the early 1980s, see Carol S. Vance, ed., *Pleasure and Danger: Exploring Female Sexuality* (Boston: Routledge and Keagan Paul, 1984).

21 The best discussion of this complicated story can be found in Lynda Hart's *Between the Body and the Flesh: Performing Sadomasochism* (New York: Columbia University Press, 1998) 36–82. See also Lisa Duggan and Nan Hunter, *Sex Wars: Sexual Dissent and Political Culture* (New York and London: Routledge, 1995).

22 Kimberlè Williams Crenshaw, 'Beyond Racism and Misogyny: Black Feminism and 2 Live Crew', for a shrewd discussion of structural, political and representational intersectionality, in Mari J. Matsuda et al., eds., *Words that Wound: Critical Race Theory, Assaultive Speech and the First Amendment* (Boulder, Colorado: Westview Press, 1993) 111–32.

23 Craig Owens, *Beyond Recognition: Representation, Power and Culture*, ed. Scott Bryson, Barbara Kruger, Lynne Tillman and Jane Weinstock, (Berkeley and Oxford: University of California Press, 1992); see especially his important essay, 'The Discourse of Others: Feminists and Postmodernists' 166–90, reprinted in this volume, 234–8. Douglas Crimp, *On the Museum's Ruins* (Cambridge, Massachusetts and London: MIT Press, 1993); Crimp, *AIDS Demo Graphics*, with Adam Rolston (Seattle: Bay Press, 1990); and Crimp, ed., *AIDS: Cultural Analysis/Cultural Activism* (Cambridge, Massachusetts, and London: MIT Press, 1988). Simon Watney, *Policing Desire: Pornography, AIDS and the Media* (Minneapolis: University of Minnesota Press, 1987); and Watney, *Practices of Freedom: Selected Writings on HIV/AIDS* (Durham, North Carolina: Duke University Press, 1994). Kobena Mercer, *Welcome to the Jungle: New Positions in Black Cultural Studies* (New York and London: Routledge, 1994).

24 Patton, *Inventing AIDS* (New York and London: Routledge, 1990) and *Last Served? Gendering the HIV Pandemic* (Bristol, Pennsylvania: Taylor & Francis, 1994).

25 The 'abject', a term derived from Julia Kristeva's important discussion in *The Powers of Horror: An Essay on Abjection*, trans. Leon S. Roudiez (New York: Columbia University Press, 1982), was the point of departure for two fascinating exhibitions and catalogues in the early 1990s. *Dirt & Domesticity: Constructions of the Feminine* (New York: Whitney Museum of American Art at the Equitable Center, 1992) and *Abject Art: Repulsion and Desire in American Art* (New York: Whitney Museum of American Art, 1993).

26 See Gertrud Koch's 'Blood, Semen, Tears', an important and complicated commentary on Helke Sander's film *Liberators Take Liberties: War, Rapes, Children* (1992), in *October*, 72 (Spring 1995) 27–41. Koch astutely connects the crisis in contemporary Eastern Europe with the history of racism in the US. With a somewhat surprising optimism, she also suggests that the anti-racist and feminist theory that emerged from that struggle might be applicable to the situation in Kosovo.

27 For discussion on these difficult subjects I am especially indebted to Robert Sember and Chris Mills.

28 Some of the most influential post-Greenberg writing about Pollock includes: Francis Frascina, ed., *Pollock and After: The Critical Debate* (New York: Harper & Row, 1985); Michael Leja, *Reframing Abstract Expressionism: Subjectivity and Painting in the 1940s* (New Haven: Yale University Press, 1993); and Kirk Varnadoe and Pepe Karmel, ed., *Jackson Pollock: New Approaches* (New York: The Museum of Modern Art, 1999).

29 In a 1915 letter to her good friend Anita Pollitzer, O'Keeffe asked, 'Do you feel like flowers sometimes?' Reversing conventional attempts to anthropomorphize the natural world, O'Keeffe's startling question suggests that flowers, with their alternating blushing and fading, might be human emotional mirrors, thereby suggesting that flowers comprehend human life more precisely than humans see flowers. Quoted in *Lovingly, Georgia: The Complete Correspondence of Georgia O'Keeffe and Anita Pollitzer*, ed. Clive Giboire (New York: Simon and Schuster, 1990) 46.

30 Anne W. Wagner's 'L.K.' is the best writing on Krasner and feminism I know. *Representations*, 25 (Winter 1989) 42–56. It was reprinted in Norma Broude and Mary D. Garrard's anthology, *The Expanding Discourse: Feminism and Art History* (New York: Icon Editions, Harper Collins, 1989) 425–36.

31 Broude and Garrard, *The Expanding Discourse*, op cit., 16.

32 This volume is the sequel to their first anthology, *Feminist Art History: Questioning the Litany* (New York and London: Harper & Row, 1982). See also the excellent volume *Feminist Art Criticism: An Anthology* ed. Arlene Raven, Cassandra Langer and Joanna Frueh (Michigan: UMI Research Press, 1988).

33 Wagner, 'L.K.' in *Expanding the Discourse, op. cit.*, 434.

34 Rosalind Krauss has a nice essay on Agnes Martin in *Bachelors* (Cambridge, Massachusetts: MIT Press, 1999).

35 See Lucy R. Lippard, *Eva Hesse* (New York: De Capo Press, 1992; originally published in 1976). Anna C. Chave's article 'Eva Hesse: A Girl Being a Sculpture', in *Eva Hesse: A Retrospective* (New Haven: Yale University Press, 1992) 99–118, is also excellent, particularly in regard to the connections between Hesse's illnesses and art making. Both Lippard and Chave quote extensively from Hesse's diaries. In them, Hesse has some wonderful reflections on reading *The Second Sex*.

36 Rosalind Krauss, 'Eva Hesse: Contingent', *Bachelors, op. cit.*, 91–100, 94. (Reprint of an essay that appeared first in 1979.) This is the best discussion of the force of death in Hesse's art I've read: 'Hesse is not focused on the boundaries within a painting or a sculpture, but rather

on the boundary that lies between the institutions of painting and sculpture [...] We are positioned at an edge from which the meaning of death is understood literally as the condition of the world disappearing from view' (100). But for Hesse, it is necessary to repeat that the accumulation of these disappearances was fundamental to the way she understood the meaning of her life and art.

37 Hesse, quoted in Lippard, *Eva Hesse, op. cit.*, 5.

38 Quoted in Carla Schulz-Hoffman, *Niki de Saint-Phalle* (Bonn: Prestel Verlag, 1987) 53.

39 For an excellent analysis of the development of painting and performance art in relation to World War II see Paul Schimmel, ed., *Out of Actions: Between Performance and the Object, 1949–1979* (Los Angeles: The Museum of Contemporary Art, 1997). Note especially the essay by Kristine Stiles, which has a long discussion of feminist art, pain and survival: 'Uncorrupted Joy: International Art Actions', 227–329.

40 See Benjamin H.D. Buchloh's 'Spero's Other Traditions' for a shrewd reading of Spero's *Codex Artaud*, in *Inside the Visible: an elliptical traverse of 20th Century Art/in, of, and from the feminine*, ed. M. Catherine de Zegher (Cambridge, Massachusetts: MIT Press, 1996) 239–46. Additionally, see Jo Anna Isaak, 'Notes toward a Supreme Fiction: Nancy Spero's Notes in Time on Women', in Maurice Berger, *Notes in Time: Leon Golub and Nancy Spero* (Baltimore County: Fine Arts Gallery, University of Maryland, 1995) which has an especially useful account of Spero's early work. Finally, see Jon Bird, Jo Anna Isaak, Sylvère Lotringer, *Nancy Spero* (London: Phaidon Press, 1996).

41 For a fuller discussion of the Judson Dance Theater see Sally Banes, *Democracy's Body: Judson Dance Theater, 1962–64* (Ann Arbor, Michigan: UMI Research Press, 1983). For more on Yvonne Rainer see her *Work: 1961–73* (Halifax, Nova Scotia: Nova Scotia College of Art and Design, 1974) and my essay 'Yvonne Rainer: From Dance to Film', in *Rainer, A Woman Who ... Essays, Interviews, Scripts* (Baltimore: Johns Hopkins University Press, 1999) 3–21. Jill Johnston's reviews of the new dance were mainly published in the *Village Voice*. Some of the best were reprinted in Johnston's *Marmalade Me* (New York: Dutton, 1971).

42 Yves Klein, from an essay originally published in *Zero*, 3 (July 1961) and quoted in Sandra Stich, *Yves Klein* (Stuttgart: Cantz Verlag, 1994) 176–77.

43 Mierle Laderman Ukeles, 'Manifesto for Maintenance Art', in Gregory Battcock, ed., *Idea Art* (New York: E.P. Dutton, 1973).

44 Adrian Piper, *Out of Order, Out of Sight, Vol. 1: Selected Writings in Meta-Art, 1968–1992* (Cambridge, Massachusetts: MIT Press, 1996) 43.

45 *Ibid.*, 147. *The Mythic Being* series has a complicated evolution. See Piper's own documentation and interpretation. *Ibid.*, 91–150.

46 Anna Deavere Smith's *Twilight, Los Angeles 1992* went to Broadway in 1994, but it is a solo piece.

47 See my *Unmarked: The Politics of Performance* (New York and London: Routledge: 1993), Schimmel's *Out of Actions* (op. cit.) and Henry M. Sayre's *The Object of Performance: The American Avant-garde since 1987* (Chicago: University of Chicago Press, 1989) for a fuller discussion of performance and the object.

48 See Moira Roth's *The Amazing Decade: Women and Performance Art in America, 1970–1980* (Los Angeles: Astro Artz, 1983). This is a valuable resource of primary material for the explorations of performance art undertaken by feminists throughout the 1970s.

49 Lisa Bloom suggests that feminist art historians have consistently overlooked Antin's Jewishness in discussions of *Carving*. 'Contests for Meaning in Body Politics and Feminist Conceptual Art: Revisioning the 1970s through the work of Eleanor Antin', in Amelia Jones and Andrew Stephenson, ed., *Performing the Body/Performing the Text* (London and New York: Routledge, 1999) 153–69.

50 See my *Unmarked: The Politics of Performance* (op. cit.) for a discussion of these transformations and their epistemological and aesthetic consequences. See especially 'Developing the Negative' and 'The Ontology of Performance'.

51 See Amelia Jones, '"Presence" in Absentia: Experiencing Photography as Documentation', *Art Journal*, 56: 4 (Winter 1997) 11–18, for a good discussion of photographic documentation of performances one has not witnessed.

52 Moira Roth, *The Amazing Decade* (op. cit.) 14. See Rebecca Schneider for an interesting discussion of Schneemann and Annie Sprinkle (among others), *The Explicit Body in Performance* (New York and London: Routledge, 1997).

53 For good illustrations of the complex relationship between performance and photography see *Photography as Performance: Message through Object and Picture* (London: Photographers' Gallery, 1986) and *Photography & Performance* (Boston: Photography Resource Center, 1989).

54 The slide show is now linked with rock music on a computerized disk. It also exists in book form: Nan Goldin, *The Ballad of Sexual Dependency* (New York: Aperture Foundation, 1986).

55 Joan Riviere, 'Womanliness as a Masquerade', *The International Journal of Psychoanalysis*, 9; 303–13, reprinted in *The Inner World and Joan Riviere: Collected Papers, 1920–1958*, ed. Athol Hughes (London and New York: Karnac Books, 1991) 90–101.

56 For more on Cahun's life and work see *Inverted Odysseys: Claude Cahun, Maya Deren, Cindy Sherman*, ed. Shelley Rice (Cambridge, Massachusetts: MIT Press, 1999).

57 Diana Fuss has taken up this aspect of women's eroticism in her essay 'Fashion and the Homospectatorial Look', *Critical Inquiry*, 18 (Summer 1992) 713–37.

58 Mary Ann Doane, *The Desire to Desire, op. cit.*

59 Joanna Frueh's *Erotic Faculties* (Berkeley: University of California Press, 1996) is one of the most interesting performative and theoretical responses to this work.

60 Adrienne Rich, *Of Woman Born: Motherhood as an Experience and Institution* (New York: Bantam Books, 1976) 292.

61 Audre Lorde, 'Uses of the Erotic: The Erotic as Power' in *The Audre Lorde Companion: Essays, Speeches, Journals* (New York and London: Harper Collins, 1978) 106–12; quote from 110–11.

62 Norma Broude's essay, 'The Pattern and Decoration Movement', has a nice discussion of the continuities between Minimalism and the Pattern and Decoration Movement. In *The Power of Feminist Art, op. cit.*, 208–25.

63 Mendieta quoted in Jane Blocker, *Where Is Ana Mendieta? Identity, Performance and Exile* (Durham, North Carolina: Duke University Press, 1999) 61. This is a useful history of Mendieta's work and considers carefully the challenge of her death.

64 See Gloria Feman Orenstein, 'Recovering Her Story: Feminist Artists Reclaim the Great Goddess', in Garrard and Broude, *The Power of Feminist Art, op cit.*, 174–89.

65 Susan Griffin, *Women and Nature: The Roaring inside Her* (New York: Harper & Row, 1978).

66 See Michel Foucault, *The Order of Things: An Archaeology of the Human Sciences* (New York: Random House, 1971) for an account of historical transformation in human perception and epistemology.

67 Jennifer Fisher, 'Interperformance: The Live Tableaux of Suzanne Lacy, Janine Antoni and Marina Abramovic', *Art Journal* (Winter 1997) 27–33.

68 Ewa Lajer-Burcharth, 'Antoni's Difference', *Differences*, 10: 2 (Summer 1998) 129–70.

69 Rebecca Dimling Cochran, 'Catalogue', in *Susan Hiller* (Liverpool: Tate Gallery, 1996) 52.

70 Cathy Caruth, *Unclaimed Experience: Trauma, Narrative, History* (Baltimore: The Johns Hopkins University Press, 1996). See especially the chapter entitled 'Traumatic Awakenings (Freud, Lacan, and the Ethics of Memory)', 91–112.

71 Kristeva, quoted in *Inside the Visible, op. cit.*, epigraph.

72 Nochlin's essay originally appeared in a special issue of *Art News*, 69: 9 (January 1971). It included the response of ten contemporary 'great' women artists including Elaine de Kooning, Louise Nevelson, Eleanor Antin and Lynda Benglis. The issue was reprinted in book form as *Art and Sexual Politics: Women's Liberation, Women Artists and Art History*, ed. Thomas Hess and Elizabeth C. Baker (New York: Macmillan, 1971; reprinted 1973). A shortened version of Nochlin's essay was published in *Woman in Sexist Society: Studies in Power and Powerlessness*, ed. Vivian Gornick and Barbara K. Moran (New York: Basic Books: 1971). An extract is also reprinted in this volume, 204–5.

73 Thalia Gouma-Peterson and Patricia Matthews, 'The Feminist Critique of Art History', *The Art Bulletin*, 69: 3 (September 1987) 326–57. This is the most even-handed and detailed analysis of the history of the field I've seen. It took until 1987, however, for *The Art Bulletin* to include feminist art history in their annual 'state of the field' reviews. Griselda Pollock takes issue with this summary of the field in the introduction to her *Generations and Geographies in the Visual Arts: Feminist Readings* (London and New York: Routledge, 1996).

74 For Nochlin's own version of the history of this essay and her subsequent readings of it see her essay 'Starting from Scratch', in *The Power of Feminist Art, op cit.*, 130–39.

75 Mary Ann Caws, *Women of Bloomsbury: Virginia, Vanessa and Carrington* (New York and London: Routledge, 1990).

76 Carol Duncan, 'When Greatness Is a Box of Wheaties', *Artforum* (October 1975) 60–64. Reprinted in Duncan, *The Aesthetics of Power: Essays in Critical Art History* (New York and Cambridge: Cambridge University Press, 1993) 121–34.

77 Eleanor Tufts, *Our Hidden Heritage: Five Centuries of Women Artists* (New York: 1974); Hugo Münsterberg, *A History of Women Artists* (1975) and Petersen and Wilson, *Women Artists: Recognition and Reappraisal from the Early Middle Ages to the Twentieth Century* (New York: 1976).

78 Nochlin understands that she, unlike 'them', does have such access. To her great credit, Nochlin spent the next three decades working from within the academy to revise traditional accounts of male artists ranging from Courbet to Warhol, and inspiring generations of younger art historians to pursue feminist inquiries.

79 See Thalia Gouma-Peterson, *Miriam Schapiro: Shaping the Fragments of Art and Life* (New York: Harry N. Abrams, Inc; Lakeland, Florida: Polk Museum of Art, 1999), for an excellent analysis of Schapiro's work, with a welcome emphasis on its relationship to feminist theory.

80 Felman, *op. cit.*, 96.

81 Chicago, *Through the Flower: My Struggle as a Woman Artist* (New York: Anchor Books, 1982) 55.

82 *Ibid.*

83 Judy Chicago and Miriam Schapiro, 'Female Imagery', *Womanspace Journal*, 1 (Summer 1973) 26.

84 *Ibid.*

85 Lippard's essay is reprinted in this volume, 197–198.

86 Linda Nochlin, 'Introduction', Ann Sutherland Harris and Linda Nochlin, ed., *Women Artists: 1550–1960* (New York: Alfred A. Knopf; Los Angeles: Los Angeles County Museum of Art, 1977) 67.

87 Barbara Buhler Lynes, 'Georgia O'Keeffe and Feminism: A Problem of Position', in Norma Broude and Mary Garrard, ed. *The Expanding Discourse: Feminism and Art History, op. cit.*, 437–50.

88 See Alice Walker, 'One Child of One's Own', *Ms* (July 1979); reprinted in *In Search of Our Mother's Gardens* (San Diego and New York: Harcourt, Brace, Jovanovitch, 1983) 383–84.

89 The best treatment of *The Dinner Party* is Amelia Jones, ed., *Sexual Politics: Judy Chicago's Dinner Party in Feminist Art History* (Los Angeles: UCLA at the Armand Hammer Museum of Art, 1996). See especially Amelia Jones' essay, 'The Sexual Politics of *The Dinner Party*: A Critical Context', for a careful discussion of all of the issues concerning the Chicago conundrum. On the popularity of the installation see Annette Kubitza, 'Re-reading the Readings of *The Dinner Party* in Europe', 148–76.

90 Parker and Pollock, *Old Mistresses: Women Artists and Ideology* (London: Routledge and Kegan Paul, 1981): 130.

91 Judith Barry and Sandra Flitterman-Lewis, 'Textual Strategies: The Politics of Art-making', *Screen*, 21: 2 (1980) 35–48.

92 *Ibid.*

93 Amelia Jones, ed., *Sexual Politics: Judy Chicago's Dinner Party in Feminist Art History, op.cit.*, Viki Wylder, *Judy Chicago: Trials and Tribulations* (Florida State University Museum of Fine Arts, 1999); Broude

and Garrard, *The Power of Feminist Art*, op. cit.

94 Amelia Jones, *Body Art/Performing the Subject* (Minneapolis: University of Minnesota Press, 1998).

95 Louise Bourgeois, *Destruction of the Father, Reconstruction of the Father: Writings and Interviews: 1923–1997*, edited and with texts by Marie-Laure Bernadac and Hans-Ulrich Obrist (Cambridge, Massachusetts: MIT Press, 1998).

96 Andrej Warminski, *Readings in Interpretation: Holderlin, Hegel, Heidegger* (Minneapolis: University of Minnesota Press, 1987) liii–liv.

97 See Griselda Pollock, 'Screening the Seventies: Sexuality and Representation in Feminist Practice – a Brechtian perspective', *Vision and Difference: Femininity, Feminism and Histories of Art* (New York and London: Routledge, 1988) 155–199. See also Margaret Iverson, Douglas Crimp, Homi K. Bhabha, *Mary Kelly* (London: Phaidon Press, 1997). Kelly's own writings also usefully illuminate her art. See especially her *Imaging Desire* (Cambridge, Massachusetts: MIT Press, 1996).

98 See Caroline Jones, *Machine in the Studio: Constructing the Post-war American Artist* (Chicago and London: The University of Chicago Press, 1996). See the works by Amelia Jones cited above.

99 Sonia Lins, *Artes* (Belgca: Sroeck Ducaju, 1996). In Portuguese with English translation.

100 Goldin dedicated the catalogue *I'll Be Your Mirror*, compiled for the 1996–97 retrospective of her work at The Whitney Museum of American Art, to her sister, Barbara Holly Goldin.

101 Mira Schor, *Wet: On Painting Feminism and Art Culture* (Durham, North Carolina: Duke University Press, 1997).

102 Walter Benjamin's crucial 1936 essay, 'The Work of Art in the Age of Mechanical Reproduction', is reprinted in his *Illuminations*, ed. Hannah Arendt, trans. Harry Zohn, (New York: Schocken Books, 1968): 217–25. Frederic Jameson's important essay 'The Cultural Logic of Late Capitalism' originally appeared in *New Left Review* (July–August 1984), but has been reprinted in his influential study *Postmodernism, or, The Cultural Logic of Late Capitalism* (Durham, North Carolina: Duke University Press, 1991) 1–54.

103 Laura Cottingham, 'The Feminist Continuum: Art after 1970', in *The Power of Feminist Art, op cit.*, 278.

104 See Orlan, 'Intervention' and Tanya Augsburg, 'Orlan's Performative Transformations of Surgery', both in *The Ends of Performance*, ed. Peggy Phelan and Jill Lane (New York and London: New York University Press, 1998) 285–327.

105 See especially Kobena Mercer, ed., *Black Film, British Cinema* (London: Institute of Contemporary Arts, 1988); David Morley and Kuan-Hsing Chen, eds., *Stuart Hall: Critical Dialogues in Cultural Studies* (London and New York: Routledge, 1996). Jean Fisher is former editor of the journal *Third Text* and editor of *Global Visions: Towards a New Internationalism in the Visual Arts* (London: Kala Press, 1994). In the US context see Valerie Smith, ed., *Representing Blackness: Issues in Film and Video* (New Brunswick, New Jersey: Rutgers University Press, 1997).

106 Rosalind Krauss, 'Antivision', *October*, 36 (Spring 1986) 147–54.

107 Luce Irigaray, 'This Sex Which Is Not One', first translated by Claudia Reeder in *The New French Feminisms*, ed. Elaine Marks and Isabelle de Courtivron (New York: Schocken Books, 1981) 101. See also Irigaray's book of the same name, trans. by Catherine Porter with Caroline Burke (Ithaca: Cornell University Press, 1985), originally published as *Ce Sexe que n'en est pas un* (Paris: Editions de Minuit, 1977).

108 Kaja Silverman, 'Dis-embodying the Female Voice', in *Re-Vision: Essays in Feminist Film Criticism* (Los Angeles: The American Film Institute, 1984) 131–49.

109 'Up to and Including Our Limits' is a reference to the title of Carolee Schneemann's retrospective at the New Museum of Contemporary Art, New York, 1996: 'Up to and Including Her Limits'.

110 Judith Butler, *Bodies That Matter: On the Discursive Limits of 'Sex'* (New York and London: Routledge, 1993).

111 Jane Gallop, *Thinking through the Body* (New York: Columbia University Press, 1988); Diana Fuss, *Essentially Speaking: Feminism, Nature and Difference* (New York and London: Routledge 1989); Naomi Schor's essay 'The Essentialism Which Is Not One' originally appeared in the journal *differences*. It has been reprinted in *Engaging with Irigaray: Feminist Philosophy and Modern European Thought*, ed. Schor, Carolyn Burke and Margaret Whitford (New York: Columbia University Press, 1994).

112 Originally published in *October*, Nixon's essay is reprinted in this volume, 275–6.

113 Marcia Tucker, *Bad Girls: Grasp Cord and Pull from Wrapper* (New York: New Museum of Contemporary Art; Cambridge, Massachusetts: MIT Press, 1994).

114 *Inside the Visible*, op. cit.

115 *Stopping the Process? Contemporary Views on Art and Exhibitions*, Mika Hannula, ed. (Helsinki: Nordic Institute for Contemporary Art, 1998).

116 Lisa Bloom, ed., *With Other Eyes: Looking at Race and Gender in Visual Culture* (Minneapolis: University of Minnesota Press, 1999).

117 Some of the discussion is reprinted in this volume, 273–5.

118 Judith Lewis Herman, *Trauma and Recovery* (New York: Basic Books, 1992); Shoshana Felman and Dori Laub, *Testimony: Crises of Witnessing in Literature, Psychoanalysis and History* (New York and London: Routledge, 1992); Cathy Caruth, ed., *Trauma: Explorations in Memory* (Baltimore: The Johns Hopkins University Press, 1995).

119 Gina Pane, *Partitions: Opere Multimedia 1984–85* (Milan: Mazzotta; Padiglione d'Arte Contemporanea, 1985) 50.

120 John Cage's influence is strong here. Cage's scores for performances are sets of rules that frame the activities and sounds that the musician orchestrates. Performance artists were inspired by these scores to create similar scores for their own pieces.

121 See Barbara Rose, *Magdalena Abakonowicz* (New York: Harry N. Abrams, Inc., 1994).

122 Elaine Scarry, *The Body in Pain: The Making and Unmaking of the World* (New York and Oxford: Oxford University Press, 1986).

123 See my *Mourning Sex: Performing Public Memories* (New York and London: Routledge, 1997) for a fuller discussion of the implications of this for those of us who still believe language can describe pain and must be employed to keep alive ethical and affective responses to it.

124 For a fuller discussion see my 'Joyce Kozloff's Crimes of Passion', *Artforum* (May 1990) 173–77.

125 See the exhibition catalogue *Cecilia Edefalk* (Bern: Kunsthalle; Stockholm: Moderna Museet, 1999).

126 Parveen Adams has written the best account I've read of the risks and rewards of Della Grace's photography. See 'The Three (Dis)Graces' and 'The Bald Truth', both in her *The Emptiness of the Image: Psychoanalysis and Sexual Differences* (London and New York: Routledge, 1996 132–40, 141–59.

127 'On Being a Jenny Saville Painting', from the exhibition catalogue *Jenny Saville: Terrains* (New York: Gagosian Gallery, 1999) 24.

128 Johanna Burton, 'The Primal Seen: Jenny Saville and the Matrix of Materiality', unpublished paper.

129 Linda Nochlin, 'Courbet's *l'origine du monde*: The Origin without an Original', *October*, 37 (Summer 1986) 77–86.

WORK-S

MAGDALENA ABAKANOWICZ
MARINA ABRAMOVIC & ULAY
EIJA-LIISA AHTILA
CHANTAL AKERMAN
LAURIE ANDERSON
ELEANOR ANTIN
JANINE ANTONI
IDA APPLEBROOG
ALICE AYCOCK
ALEX BAG
JUDY BAMBER
JUDITH BARRY
UTE META BAUER
VANESSA BEECROFT
LYNDA BENGLIS
SADIE BENNING
DARA BIRNBAUM
LEE BONTECOU
PAULINE BOTY
LOUISE BOURGEOIS
SONIA BOYCE
GENEVIÈVE CADIEUX
SOPHIE CALLE
HELEN CHADWICK
SARAH CHARLESWORTH
JUDY CHICAGO
ABIGAIL CHILD
LYGIA CLARK
BETSY DAMON
LINDA DEMENT
MARLENE DUMAS
JEANNE DUNNING
CHERYL DUNYE

MARY BETH EDELSON
NICOLE EISENMAN
DIAMELA ELTIT
CATHERINE ELWES
TRACEY EMIN
VALIE EXPORT
KAREN FINLEY
ROSE FINN-KELCEY
ANDREA FRASER
SUSAN FRAZIER, VICKIE
HODGETTS & ROBIN WELTSCH
COCO FUSCO
ANYA GALLACCIO
ROSE GARRARD
NAN GOLDIN
ILONA GRANET
RENÉE GREEN
GUERRILLA GIRLS
LUCY GUNNING
ANN HAMILTON
BARBARA HAMMER
HARMONY HAMMOND
MARGARET HARRISON
MONA HATOUM
LYNN HERSHMAN
EVA HESSE
SUSAN HILLER
LUBAINA HIMID
CHRISTINE & IRENE
HOHENBÜCHLER
JENNY HOLZER
REBECCA HORN
KAY HUNT

JOAN JONAS
TINA KEANE
MARY KELLY
KAREN KNORR
ALISON KNOWLES
SILVIA KOLBOWSKI
JOYCE KOZLOFF
BARBARA KRUGER
SHIGEKO KUBOTA
YAYOI KUSAMA
LESLIE LABOWITZ
SUZANNE LACY
KETTY LA ROCCA
BRENDA LAUREL
LOUISE LAWLER
ZOE LEONARD
SHERRIE LEVINE
MAYA LIN
YVE LOMAX
SARAH LUCAS
ANA MENDIETA
ANNETTE MESSAGER
KATE MILLETT
TRINH T. MINH-HA
MARY MISS
LINDA MONTANO
LAURA MULVEY & PETER
WOLLEN
ALICE NEEL
SHIRIN NESHAT
YOKO ONO
CATHERINE OPIE
ORLAN

THÉRÈSE OULTON
GINA PANE
HOWARDENA PINDELL
ADRIAN PIPER
RONA PONDICK
YVONNE RAINER
AIMEE RANKIN
PAULA REGO
ELAINE REICHEK
CATHERINE RICHARDS
SU RICHARDSON
PIPILOTTI RIST
ULRIKE ROSENBACH
MARTHA ROSLER
BETYE SAAR
NIKI DE SAINT-PHALLE
DORIS SALCEDO
JENNY SAVILLE
MIRIAM SCHAPIRO
CAROLEE SCHNEEMANN
MIRA SCHOR
COLLIER SCHORR
JOAN SEMMEL
CINDY SHERMAN
KATHARINA SIEVERDING
SHAHZIA SIKANDER
LAURIE SIMMONS
LORNA SIMPSON
MONICA SJÖÖ
SYLVIA SLEIGH
JAUNE QUICK-TO-SEE SMITH
KIKI SMITH
JO SPENCE

NANCY SPERO
ANNIE SPRINKLE
JANA STERBAK
RACHEL STRICKLAND
MITRA TABRIZIAN
ROSEMARIE TROCKEL
COSEY FANNI TUTTI & GENESIS
P. ORRIDGE
MIERLE LADERMAN UKELES
VERUSCHKA (VERA LEHNDORFF
& HOLGER TRULZSCH)
VNS MATRIX
KARA WALKER
KATE WALKER
GILLIAN WEARING
CARRIE MAE WEEMS
RACHEL WHITEREAD
FAITH WILDING
HANNAH WILKE
SUE WILLIAMS
MARTHA WILSON
FRANCESCA WOODMAN
MARIE YATES

TOO MUCH

Although largely unrecognized, women artists played a significant role in the new art forms that emerged in the early 1960s. Happenings, Fluxus and performance sought a discursive, interactive relationship between artist and spectator; new conceptual frameworks emerged, informed by gender awareness. Critic and curator Lucy R. Lippard identified an emerging style infused with bodily connotations, in the work of Eva Hesse among others, that she termed 'Eccentric Abstraction'. Women artists began to intervene directly in male-defined social and political spheres, articulating frustration at the injustices of domination. As avant-garde performance artist Carolee Schneemann wrote: 'Our best development grows from works which initially strike us as "too much" … Because my sex and work were harmoniously experienced I could have the audacity, or courage, to show the body as a source of varying emotive power.'

Alice NEEL
Pregnant Maria
1964
Oil on canvas
81.5 × 119.5 cm [32 × 47 in]

Pregnant Maria is one of several portraits Neel produced of pregnant women she knew in New York. Neel's painting draws attention towards unresolved tensions in her subject matter through the creation of a disjuncture in viewers' expectations: the subject is framed within a set of references which are unfamiliar in this context. Here the portrayal of pregnancy is formally and stylistically conflated with the confrontational re-working of an erotic pose frequently found in mass media photography and which can be traced back through the history of Western painting to models such as the female nudes of Titian and Goya.

Born in 1900, Alice Neel had made accomplished figurative work since the 1930s but it was not until ten years after this painting was completed that she had her first museum retrospective at the age of seventy-four.

Lee BONTECOU
Untitled
1961
Welded steel, canvas, wire
204 × 226 × 88 cm [80.25 × 89 × 34.75 in]
Collection, The Museum of Modern Art, New York

Bontecou's sculptural constructions, exhibited from 1960 onwards, were influential precedents for the development of what critic Lucy R. Lippard would later refer to as 'Eccentric Abstraction'. Made of worn-out conveyer belts, aeroplane parts and saws, encased in wire frameworks supporting stretched canvas fragments in sombre shades of rust and grey, Bontecou's reliefs combined seduction and repulsion. Projecting uncomfortably into the viewer's space, the surfaces are punctured with holes, some of which are seductive, suggesting what feminist artists such as Judy Chicago would later describe as 'central core' imagery. Others are barred from view with jagged teeth, suggesting *vagina dentata*. Despite these overtly vaginal allusions and the prominent use of stitching, Bontecou's constructions were described by the majority of contemporary male critics as icons of industrialism, mechanical power, thrust and propulsion.

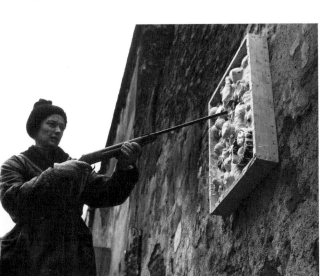

Niki de SAINT-PHALLE
Tir à Volonté (Fire at Will)
1961
Paris

Tir à Volonté (*Fire at Will*) was a series of works de Saint-Phalle made in the early 1960s. She attached bags of liquid pigment onto white relief surfaces. These burst when they were fired at with a .22 calibre rifle by herself or others (including artists Jasper Johns and Robert Rauschenberg). The works were first exhibited at Galerie J, Paris, in 1961.

'The smoke gave the impression of war. The painting was the victim. Who was the painting? Daddy? All men? Small men? Tall men? Big men? Fat men? Men? My brother John? Or was the painting me? … The new bloodbath of red, yellow and blue splattered over the pure white relief metamorphosed the painting into a tabernacle for death and resurrection. I was shooting at myself, society with its injustices. I was shooting at my own violence and the violence of the times. By shooting at my own violence, I no longer had to carry it inside of me like a burden.'
– Niki de Saint-Phalle, Artist's statement, 1961

Nancy SPERO
Female Bomb
1966
Gouache and ink on paper
86.5 × 68.5 cm [34 × 27 in]

Enraged by the Vietnam war, Spero made a series of ink and gouache drawings between 1966 and 1969 which attempted to express war's obscenity. Drawings such as *Female Bomb* and *Sperm Bomb* (made in the same year) highlighted the sexual and scatological metaphors behind the language of modern warfare. In all of these works the machines of war are personified, gendered and sexualized.
'I thought the terminology and slogans like "pacification" were really an obscene use of language. They would firebomb whole villages and then the peasants would be relocated into refugee camps. This was called "Pacification and Re-education". So in [another painting in the series, *S.U.P.E.R.P.A.C.I.F.I.C.A.T.I.O.N.* (1968)] the helicopter has breasts hanging down and people are hanging on with their teeth … '
 Despite the strongly gendered nature of Spero's protest, not until the early 1970s did she identify her work explicitly with feminism.
– Nancy Spero, 'Jo Anna Isaak in conversation with Nancy Spero', 1996

left

Pauline <u>BOTY</u>

It's a Man's World I

1963

Oil on canvas, collage

122 × 91 cm [48 × 34 in]

bottom left

Pauline <u>BOTY</u>

It's a Man's World II

1963-65

Oil on canvas

122 × 122 cm [48 × 48 in]

Between 1961 and her premature death at the age of twenty-eight in 1966, Boty constructed an alternative narrative within the male-dominated British Pop art scene. Her works address issues of identification and pleasure which would occupy feminists in the following decades. The first of these two paintings, which constitute a diptych, is composed of figures – from Lenin to Einstein to Elvis – and artefacts drawn from spheres symbolically associated with male power: aviation; classical and neoclassical sculpture and architecture; sport; pop music; literature; politics; science. In these images derived from either high art or mass media photography Jackie Kennedy is the only female presence, the 'exceptional female', portrayed turning to her husband at the fateful Dallas motorcade. These assembled icons of patriarchal culture are juxtaposed with the second painting that presents images which could signify liberated female eroticism. However, their similarity to photos from men's pornographic magazines, their vertical, 'phallic' compositional arrangement, and their superimposition onto an eighteenth-century landscape park, seem to confirm that the women's bodies are regulated by the normative culture of masculine privilege and authority represented in the first painting. The 'permissiveness' of the swinging 1960s scene, in which Boty was a fashionable figure, offered the promise that bodily pleasure could be liberating. These paintings are a critical portrayal of the spaces of male power which continued to ensure that this promise was denied.

Niki de SAINT-PHALLE (with Jean TINGUELY and Per-Olof ULTVEDT)
Hon
1966
Wood, papier mâché, paint, found and fabricated objects
600 × 2350 × 1000 cm [236 × 925 × 394 in]

Hon, meaning 'She' in Swedish, was constructed as a temporary monument at the Moderna Museet, Stockholm, 1966, in collaboration with Jean Tinguely and Per-Olof Ultvedt. Visitors entered the gigantic, vividly multicoloured female figure through the space between her legs, finding themselves inside a warm, dark 'body' that contained among other features a bar, a love nest, a planetarium, a gallery of 'suspect' artworks, a cinema and an aquarium. *Hon*, which evolved from the artist's earlier small-scale figurines called *Nanas*, playfully paid homage to ancient and modern mythical archetypes of woman as nurturer, while simultaneously demytho-logizing notions of the female body as a place of dark, unknowable mysteries.

Paula REGO
The Punishment Room
1969
Acrylic and mixed media on canvas
120 × 120 cm [47.5 × 47.5 in]

The Punishment Room traces memories of Rego's Catholic childhood in Portugal. Fragmented, brightly coloured images suggesting innocent girlish pleasures are juxtaposed with large, foreboding male figures. This early work by the British-based figurative painter was influenced by *art brut*. Using quick drying, vividly coloured acrylics, the work is executed in a style reminiscent of childrens' doodling and comic-book illustration. Rego viewed the constraints of the fine art tradition as a kind of 'punishment room'. Her discovery from 1959 onwards of the work of Dubuffet and his contemporaries freed her from these strictures, enabling her to challenge the taboos associated with non 'high art' material and representation.

Monica SJÖÖ
God Giving Birth
1968
Oil on hardboard
183 × 122 cm [72 × 48 in]
Collection, Museum Anna Nordlander, Skelleftea, Sweden

A self-taught artist and activist in the British Women's Liberation Movement, Swedish-born Sjöö rejected abstraction for figuration after the experience of giving birth to her first child. She researched matriarchal cultures and ancient woman-centred religions founded upon worship of goddess figures and mysteries based on the lunar cycles. Paintings such as *God Giving Birth* were intended as empowering images for women, which challenged the oppressively patriarchal nature of Christian and secular Western iconography. In 1973 the work was shown in London in the group exhibition organized by Sjöö, Ann Berg, Beverley Skinner and Liz Moore, "Five Women Artists: Images of Womanpower'. It aroused such controversy that public complaints led to a police report being sent to the Director of Public Prosecutions; Sjöö was threatened with legal action on charges of blasphemy and obscenity.

Judy CHICAGO
Pasadena Lifesavers, Yellow No. 4
1969-70
Acrylic lacquer on acrylic sheet,
Plexiglas
152.5 × 152.5 cm [60 × 60 in]

'*Pasadena Lifesavers* ... embodied all of the work I had been doing in the past year, reflecting the range of my own sexuality and identity, as symbolized through form and colour, albeit in a neutralized format. There were fifteen paintings, sprayed on the back of clear acrylic sheets, then framed with a sheet of white Plexiglas behind the clear sheet. The series consisted of five images, painted in three different colour series ... I had internalized parts of society's dictum that women should not be aggressive, and when I expressed that aspect of myself through forms that were quite assertive, I became frightened and thought there was "something wrong with my paintings" ... As I recovered from my feelings of shame for having revealed something that was so different from the prevailing concepts of "femininity". I gradually accepted the paintings, and in doing so, also accepted myself more fully ... '
– Judy Chicago, *Through the Flower: My Struggles as a Woman Artist*, 1975

Miriam SCHAPIRO
Sixteen Windows
1965
Acrylic on canvas
183 × 203 cm [72 × 80 in]

Sixteen Windows is a transitional work that led Schapiro towards feminism. In the late 1950s she began her career as a painter of hard-edge, geometric compositions which referenced architectural forms. In the mid 1960s Schapiro began to recognize that although these compositions reflected a specific 'masculine' tradition, they were also strongly connected with women's experience of domestic architectural environments. In 1967 Schapiro took up a teaching post at the University of California, San Diego, encountering Judy Chicago, with whom she would initiate the Feminist Art Program at California Institute of the Arts in 1971. *Womanhouse* (Institute of the Arts, Valencia, California, 1972), initiated by Schapiro and Chicago in collaboration with other artists, was a house transformed into a series of installations and sites for shared experiences and exchanges. *Dollhouse* (1972), a miniature installation, further explored domestic architectural space as a site of political transformation.

Black Garment
1969
Sisal
300 × 180 × 60 cm [118 × 71
× 23.5 in]
Collection, Stedelijk Museum,
Amsterdam

Born in Poland in 1930, Abakanowicz
began working as an artist in Warsaw
in the late 1950s. In the aftermath of
Poland's wartime devastation and
transformation, she decided that her
own art had to represent a total break
with the recent past. This included
abandoning the materials from which
this recent past was fabricated.
Abakanowicz thereby attempted to
re-connect human experience with
conditions that existed before the
alienation and brutality of the industrial
age. By the mid 1960s, she had begun
to work exclusively with natural fibres,
such as sisal. She began to make woven
room-sized structures which a Polish
critic in 1965 referred to as *Abakans*, a
name the artist adopted for these works
from then onwards. In contrast to the
often industrially fabricated and
immediately manifest works of
Minimalism, the *Abakans* revealed
themselves slowly, inviting touch and
exploration, presenting visual and tactile
contrasts to be reconciled in the mind of
the viewer. 'The fibre which I use in my
works derives from plants and is similar
to that from which we ourselves are
composed … Our heart is surrounded by
the coronary plexus, the most vital of
threads … Handling fibre we handle
mystery. A dry leaf has a network
reminiscent of a mummy … When the
biology of our body breaks down, the
skin has to be cut so as to give access to
the inside. Later it has to be sewn on like
fabric. Fabric is our covering and our
attire. Made with our hands, it is a record
of our thoughts.'
– Magdalena Abakanowicz quoted by
Barbara Rose, *Magdalena Abakanowicz*,
1994

Eva HESSE

Contingent

1969

Cheesecloth, latex, fibreglass

8 units, dimensions variable

Collection, National Gallery of Australia, Canberra

Contingent comprises eight sheets of rubberized cheesecloth and fibreglass which vary in proportion and texture. These undulating, light-catching surfaces are hung from threads attached to hooks in the ceiling and reach down to the floor. Markedly different yet still related to the grids and rectangles of Minimalism, such works set up a form of interference, highlighting both the formalism of Minimal art's ordering structures and its arbitrary, obsessive undercurrents. *Contingent* avoids the evocation of specific bodily connotations, yet as critic Lucy R. Lippard observed, Hesse's works convey a sense of identification between the maker's or viewer's body and abstract or figurative forms.

Louise <u>BOURGEOIS</u>
Femme Couteau
1969-70
Pink marble
9 × 67 × 12.5 cm [3.5 × 26 × 5 in]

In the late 1960s Bourgeois moved away from predominantly vertical, totemic figures in wood, patinated bronze or plaster, to the horizontal. Using new materials such as marble to create smooth, sensuous forms reminiscent of Surrealist objects, she explored formal and symbolic relationships of tension and mutability between the poles of 'masculine' and 'feminine' imagery.

Louise <u>BOURGEOIS</u>
Cumul I
1969
White marble
57 × 127 × 122 cm [22.5 × 50 × 48 in]
Collection, Centre Georges Pompidou, Paris

During a flight over the Sahara desert Bourgeois had seen small dwellings clustered around the scarce sources of water. This experience is one of the sources of imagery for the *Cumul* series. These works combine the suggestion of water-bearing cumulus clouds, in their overall white, nebulous forms, with emerging protrusions which suggest simultaneously phallus and breast associations.

Alison KNOWLES
Bean Rolls: A Canned Book
1963
Metal can, beans, paper rolls, text
Dimensions variable

'Using the Alison Knowles *Bean Rolls* and six to eight performers, unroll the rolls over the audience and start reading aloud. Have the audience join in. A single performer goes among the other performers with scissors, cutting out large sections of the rolls. This performer determines the length of the performance.'
– Alison Knowles, 'Simultaneous Bean Reading', 1964

Alison Knowles was closely involved in the Fluxus movement in New York from its inception, introducing a female perspective into the movement's aims of blurring of the boundaries between art and everyday action.

'Alison Knowles is quite aware at this point that only a woman would have made a public salad in 1962, and that only a woman would be so identified with another food – beans, of all kinds, which have figured in so much of her work … [George] Brecht and Robert Watts … had organized a Fluxus-type event called the Yam Festival … I only remember being served a salad, the product of a performance called *Proposition*, with its instruction "Make a salad", by Alison Knowles … On stage she had huge quantities of salad materials, which she mixed in a big pickle barrel and served on paper plates … Knowles has also made a number of word scores involving shoes … a tall woman with outsized feet [she] says her obsession with shoes dated from a remark from a shoe salesman when she was fifteen. He said, "After size nine, a woman buying shoes in our society can't afford to be fussy."'
– Jill Johnston,' Flux Acts', *Art in America*, 1994

Yoko ONO
Cut Piece
1964
Yamaichi Concert Hall, Kyoto

In this performance Ono sat on the stage and invited the audience to approach her and cut away her clothing, so that it gradually fell away from her body. Challenging the neutrality of the relationship between viewer and art object, Ono presented a situation in which the viewer was implicated in the potentially aggressive act of unveiling the female body, which had served historically as one such 'neutral' and anonymous subject for art. Emphasizing the reciprocal way in which viewers and subjects become objects for each other, *Cut Piece* also demonstrated how viewing without responsibility has the potential to harm or even destroy the object of perception. 'People went on cutting the parts they do not like of me. Finally there was only the stone remained of me that was in me but they were still not satisfied and wanted to know what it's like in the stone.'
– Yoko Ono, Artist's statement, 1971

Cut Piece was also performed at the 'Destruction in Art' Symposium at the Institute of Contemporary Arts, London, in 1966

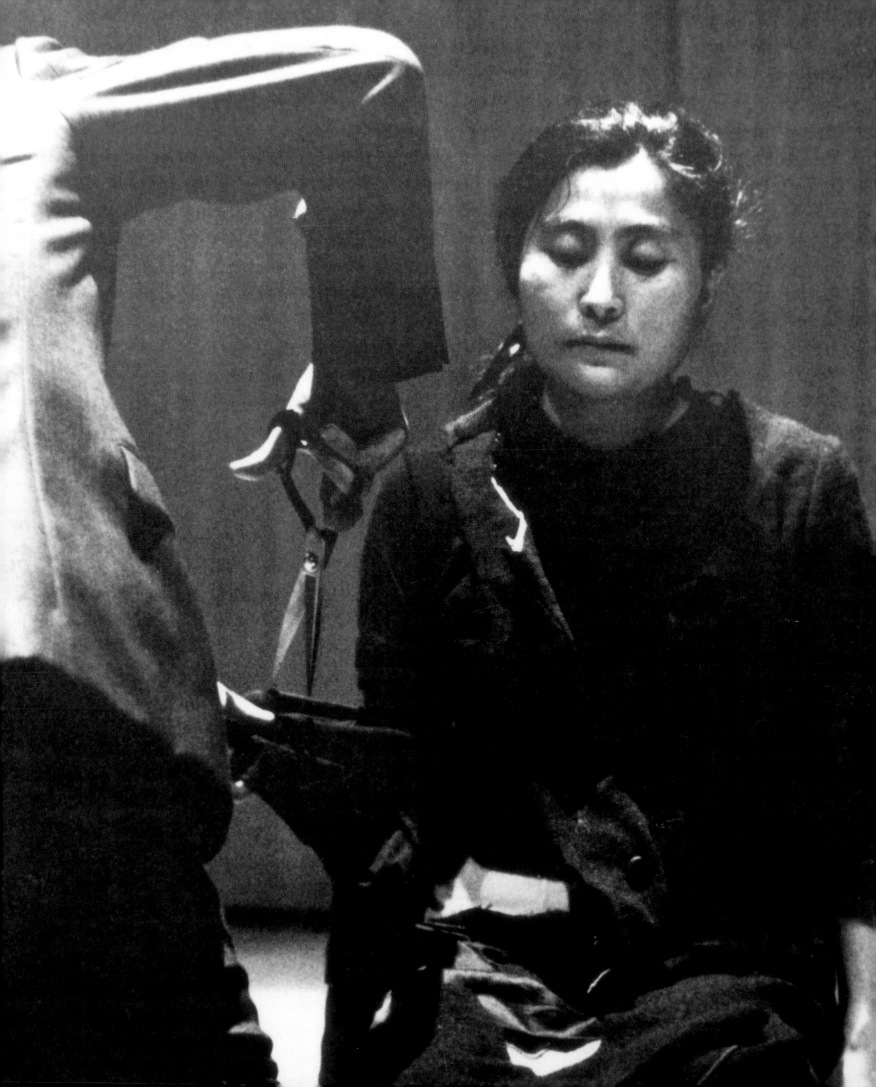

Carolee SCHNEEMANN
Eye Body: 36 Transformative Actions
1963
New York

'In 1962 I began a loft environment built of large panels interlocked by rhythmic
colour units, broken mirrors and glass, lights, moving umbrellas and motorized parts.
I worked with my whole body – the scale of the panels incorporating my own physical
scale. I then decided I wanted my actual body to be combined with the work as an
integral material …'

Schneemann's self-transformations within this environment were recorded by her
friend, the Finnish artist Erró.

'Covered in paint, grease, chalk, ropes, plastic, I establish my body as visual territory.
Not only am I an image-maker, but I explore the image values of flesh as material
I choose to work with. The body may remain erotic, sexual, desired, desiring, but it is
as well votive: marked, written over in a text of stroke and gesture discovered by my
female creative will. I write "my female creative will" because for years my most
audacious works were viewed as if someone else inhabiting me had created them –
they were considered "masculine" when seen as aggressive, bold. As if I were
inhabited by a stray male principle; which would be an interesting possibility – except
in the early 1960s this notion was used to blot out, denigrate, deflect the coherence,
necessity and personal integrity of what I made and how it was made.'
– Carolee Schneemann, *More Than Meat Joy*, 1979

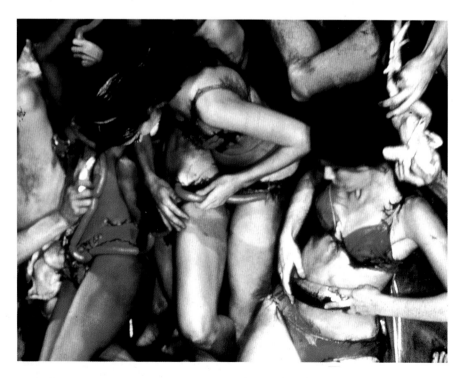

Carolee SCHNEEMANN
Meat Joy
1964
Paris

'*Meat Joy* has the character of an erotic rite: excessive, indulgent, a celebration of
flesh as material: raw fish, chickens, sausages, wet paint, transparent plastic, rope,
brushes, paper scrap. Its propulsion is toward the ecstatic – shifting and turning
between tenderness, wildness, precision, abandon: qualities which could at any
moment be sensual, comic, joyous, repellent. Physical equivalences are enacted as
a psychic and imagistic stream in which the layered elements mesh and gain intensity
by the energy complement of the audience.'
– Carolee Schneemann, *More Than Meat Joy*, 1979

Meat Joy was an orgiastic Happening in which male and female performers grappled
with one another and a variety of fleshy, messy materials in close proximity to the
audience. It was first performed in Paris in an event called 'Expression' organized by
the artist and critic Jean-Jacques Lebel and subsequently presented in London and
New York. The Happening was a series of improvised gestures and relationships
which had been loosely planned and rehearsed. The participants were expected to
develop these ideas during the performance. Schneemann composed a soundtrack
of Paris street sounds – traffic noise and the cries of food vendors – superimposed on
Motown tunes. Light and sound technicians were also expected to improvise to a large
extent, following the energy shifts of the performers and the audience.

Valie EXPORT (with Peter WEIBEL)
Tapp und Tastkino (Touch Cinema)
1968
Vienna

In 1968, Export collaborated with Actionist Peter Weibel on a series of guerrilla street actions. *Tapp und Tastkino (Touch Cinema)* documents Export's street appearance wearing a miniature stage set constructed around her naked but concealed breasts. Using a megaphone, Weibel encouraged members of the public to step up, reach through the stage curtain and touch her breasts.

'In that I, in the language of film, allowed my "body screen", my chest, to be touched by everybody, I broke through the confines of socially legitimate social communication. My chest was withdrawn from the "society of spectacle" which had drawn the woman into "objectification" with it. Moreover, the breast is no longer the property of one single man; rather, the woman attempts through the free availability of her body to determine her identity independently: the first step from object to subject.'
— Valie Export quoted in Peter Nesweda, 'In Her Own Image: Valie Export, Artist and Feminist', *Arts Magazine*, 1991

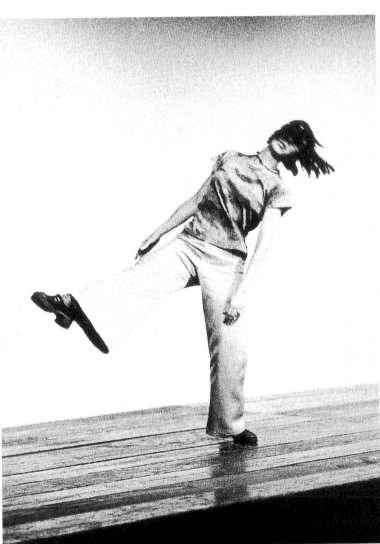

Yvonne RAINER
Trio A
1966
Portland Center for the Visual Arts, 1973

Rainer's most celebrated piece of choreography, *Trio A* was first performed in 1966 as part of a larger work entitled *The Mind Is a Muscle, Part 1*, a collaboration with other experimental dancers and choreographers such as Steve Paxton. The first version was performed at Judson Church in Greenwich Village, the New York theatre space central to the development of new practices in 'movement theatre', where artists such as Carolee Schneemann and Robert Morris also performed. In *Trio A*, Rainer designed a series of movements which were not based on formally delineated phrases and which disrupted the rhythms between climax and rest. Conceived with the intention that it could be performed by someone with no previous dance training, the piece extended the boundaries of previous improvised dance derived from ballet, and focused on everyday movements, often related to the performance of tasks. The piece also attempted to undermine what Rainer perceived as the polarized narcissism and voyeurism central to the spectacle of dance: 'the "problem" of performance was dealt with by never permitting the performers to confront the audience. Either the gaze was averted or the head was engaged in movement.'
— Yvonne Rainer, 'The Mind Is a Muscle', 1999

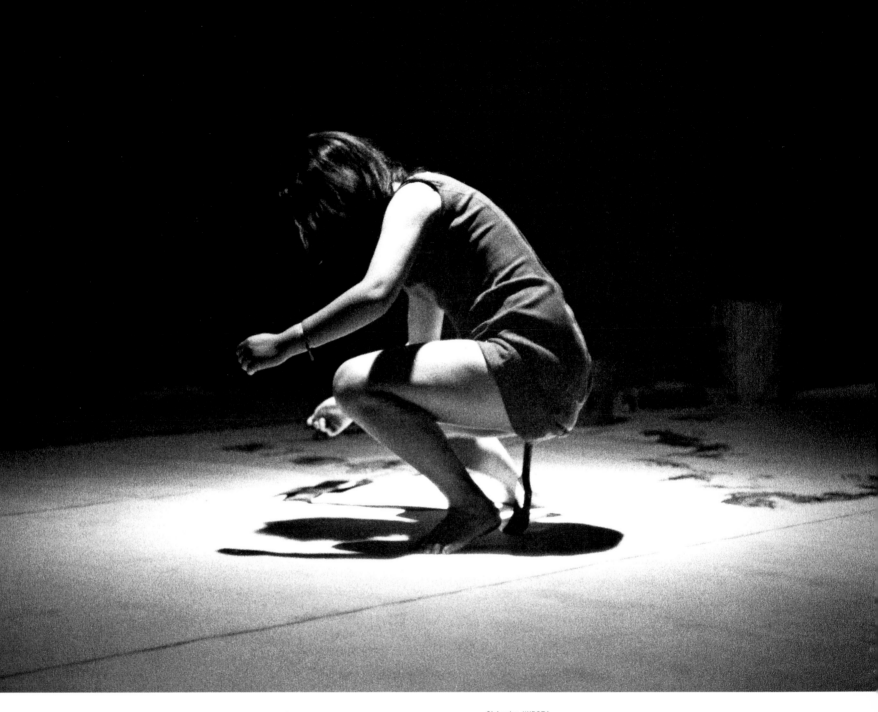

Shigeko <u>KUBOTA</u>
Vagina Painting
1965
'Perpetual Fluxfest', New York

At the 'Perpetual Fluxfest', a Fluxus movement public festival in New York in 1965,
Kubota made an 'action' painting, disliked at the time by many of her male fellow
artists, which referred to and subverted Jackson Pollock's method of making drip
paintings on the floor of his studio. Kubota laid a large sheet of paper on the floor
and proceeded to paint red strokes on it with a brush attached to the crotch of her
underwear. This created a deliberately 'feminine' process of gestural painting, flowing
from the creative core of the female body, in contrast to the 'ejaculation' of thrown,
dripped and scattered paint. Kubota was also parodying Yves Klein's use of naked
women as 'human paintbrushes' in his Happenings of the late 1950s and early 1960s.
Using her vagina as a source of inscription, Kubota questioned the Western cultural
designation of female genitalia, interpreted by Freud as a site of 'lack' (of the phallus),
and the notion that this 'lack' denies access to valid expression through language,
visual signs and gestures.

Yayoi KUSAMA
Kusama's Peep Show or Endless Love Show
1966
Mirrors, coloured lights
210 × 240 × 205 cm [83 × 94.5 × 81 in]
Installation, Castellane Gallery, New York

This and other installation environments Kusama created from 1963 onwards combined her obsessive drive to gain control over her hallucinations of infinitely repeating patterns with an astute critical awareness of developments in current art movements. This work in particular represented a new departure; accompanied by a pop music soundtrack, it fused the aesthetics of Pop, experimental and kinetic art with the gaudy flashing lights and mirrors of a peep show or disco floor. The work was also participatory. Invited to peer through a peep hole on the outside of the plain hexagonal box structure, suddenly the viewer would be immersed within a startling, incandescent environment, seemingly repeated into infinity, thus sharing in the artist's own visionary perception. From this date onwards Kusama began to organize participatory performance events. Often involving naked body painting sessions, these actions included protests against the war in Vietnam and in favour of freedom of bodily and sexual expression. An art practice that had originally arisen for personal therapeutic reasons was transformed by the artist into public, politicized gestures of revolution.

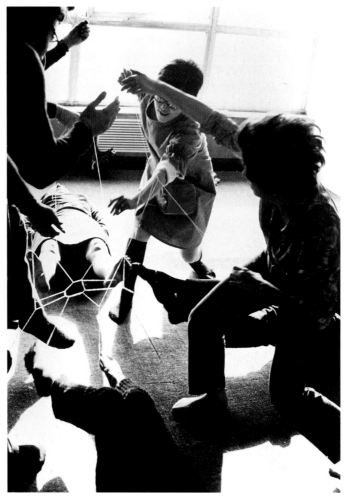

Lygia CLARK
Estruturas Vivas (Living
Structures)
1969
Paris

A web of elastic bands was connected at its ends to one of the feet of four people lying down, and to the hands of four people standing. The disposition of the people in space followed the design of the web. The ordering of the group's movements formed a structure experienced through its component gestures. In the 1960s Clark, a leading member of the Brazilian Neo-Concrete movement, began to explore the possibilities of art that was invitational and participatory. In 1966 she abandoned metal constructivist forms and began to use both natural and domestic 'relational objects', in works that invited 'sensorial' experiences of relation to the world through the body. From 1969 to 1976 Clark lived and taught in Paris, conducting experiments in gestural communication with groups of up to sixty students. On her return to Rio de Janeiro in 1976, precipitated by illness, she evolved a form of therapy for individuals based on her experimental art practice which continued until her death in 1988.

PERSONALIZING THE POLITICAL

By the early 1970s feminism had engendered a recognized art movement. Throughout Europe and the United States feminists came together to organize women-only exhibitions and formed groups dedicated to consciousness-raising, activism and research. The first Women's Liberation Movement group exhibition was held in London; The Ad Hoc Women Artists' Committee was established in New York; Judy Chicago led women-only studio classes at Fresno State University and with Miriam Schapiro instigated the Feminist Art Program at the California Institute for the Arts; Faith Ringgold and Michele Wallace initiated the activist group Women, Students and Artists for Black Art Liberation. Womanhouse, a collective project that emerged from the Feminist Art Program, became a catalyst for the creation of radical, women-only communities where personal histories could be shared and social change engendered. Private, everyday actions and objects, including artists' own bodies, became both the subject and often the medium itself of women's art. Artists depicted men in poses stereotyped as 'feminine', or traced suppressed elements in culture through investigation of matriarchal archetypes, the unconscious and the prelingual.

Margaret HARRISON
The Little Woman at Home
1971
Graphite and watercolour on paper
63.5 × 52 cm [25 × 20.5 in]

Harrison participated in the first Women's Liberation Movement group exhibition at the Woodstock Gallery, London, in 1971. In the same year her show of drawings at Motif Editions Gallery was London's first overtly feminist solo exhibition. In these works, stereotypical imagery of women was depicted with ironic humour, and sometimes transposed onto male subjects. The exhibition was closed by police after only one day due to complaints about defamatory material, in particular a depiction of *Playboy* magazine's founder and editor, Hugh Heffner, as a male 'bunny girl', complete with a 'bunny penis'. The title *The Little Woman at Home* highlights lack of support in the art world for artists such as Harrison, whose work engaged directly with social issues. These satirical drawings freed her from the constraints of prevalent styles which were deemed suitable for feminist subject matter. Harrison viewed the growing feminist hostility to painting as a new form of conservatism, denying the possibility of subject matter opening up form.

Joan <u>SEMMEL</u>
Intimacy-Autonomy
1974
Oil on canvas
127 × 249 cm [50 × 98 in]

'A few years ago, several of us got together to "split" a model, only in this case, there were two models, a man and a woman who were involved with each other, so they posed like lovers. That got me into dealing with the subject in an open way. Then other things began to enter, including my identification with feminism. Women have never allowed themselves to admit their sexual fantasies. They have been encouraged to create themselves in terms of male fantasy. I wanted to make imagery that would respond to female feelings. My paintings deal with communication, how a hand touches a body, rather than male or female domination. Women are conditioned to play a masochistic role. But I want to show sensuality with the power factor eliminated. The images are handled in an objective, cool way, with non-realistic space, with a sense of being removed from the world. But there is feeling in the gestures, passion in the colour. Ultimately, the play and relationship of colour is what my painting is about. I'm using sex to hang my art on.'
– Joan Semmel, 'Sex to Hang Art On', 1974

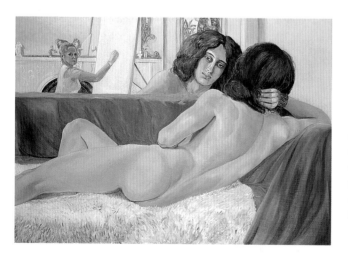

Sylvia <u>SLEIGH</u>
Philip Golub Reclining
1971
Oil on canvas
107 × 152.5 cm [42 × 60 in]

In this and other paintings of the same period Sleigh attempted to reverse the historical pictorial hierarchy of male artist and female model in Western art. In doing so she drew attention to some of the problems involved in this reversal. The subject's langorous pose, long hair, fine features and apparent narcissism appear conventionally 'feminine': like the female subject of the traditional male gaze, he appears to present himself as an object of vision. However, Sleigh introduces a deliberate awkwardness into the style and composition of the work, highlighting the forced, uncomfortable nature of a relationship that is still in transition.

Nancy SPERO

Codex Artaud I (detail)

1971

Typescript, gouache and collage on paper

56 × 218 cm [22 × 86 in]

At the end of the 1960s Spero painted a series of gouaches dedicated to the French writer associated with Surrealism, Antonin Artaud. In the *Codex Artaud* series that followed these paintings, Spero worked with collage on non-uniform panels and friezes, using whatever kind of paper was immediately available. This marked a further departure in her work from the heroic, monumental associations of scale and material that prevailed in US art at the time. Typescript sections of texts by or referring to Artaud were placed in relation to images of fragmented human and animal figures, words and letter forms from different cultures. The work explores the extremes and limitations of language, alongside the dissolving and re-combining of cultural and corporeal connections. Artaud's mental disturbance, and his incarceration in a mental institution, were closely linked with his attempts to be liberated from both linguistic and bodily constraints, which he saw as intimately connected. His writing has been discussed by theorist Julia Kristeva in relation to feminist discourse, as expressing the pain and rage of those who are marginalized, outside of the dominant forms of language. Amidst the ambiguous fusion of representational symbols in *Codex Artaud*, women's tongues appear to swell into phallic forms, evoking the patriarchal basis of the symbolic order of language, and the continuing alterity of women's voices.

BRAZIL

The methods of torture include the pau de
arara (parrot's perch), setting fire to
parts of the body which have been dampened
with alcohol, injection of ether under the
skin, strong electric s hocks combined with
near-drowning, forcing objects up the rectum
and the vigina of women, and the 'Christ's
crown' (a steel ring, applied on the head,
which is gradually tightened): (0

Nancy SPERO
Torture of Women (detail, panel 7)
1976
Typescript, gouache, handprinting and collage on paper
14 panels, 51 × 3810 cm [20 × 1500 in] overall
Collection, National Gallery of Art, Ottawa

'In 1972 I had had enough of Artaud. I thought there is real pain and torture going on …
His pain is real, but it is the expression of an internal state … I decided to address the
issues I was directly involved in – women's issues. I wanted to investigate the more
palpable realities of torture and pain.'
– Nancy Spero, Artist's statement, 1996

 Torture of Women, which occupied Spero for the next three years, was her first
explicitly feminist work and followed her active involvement in groups such as WAR
(Women Artists in Revolution) and the founding of AIR (Artists-in-Residence), the first
women's gallery in New York, in 1972. Handprinted enlarged text fragments as well as
typewritten reports from Amnesty International on the torture of women in totalitarian
regimes were collaged alongside imaginary and mythological figures, which Spero
had begun to handprint from 1974. Images based on ancient Egyptian goddess
figures, among other sources, were juxtaposed with those of contemporary women
freedom fighters and anonymous victims of violence.

Betye SAAR
Black Girl's Window
1969
Found objects, wood, paint
91 × 46 × 4 cm [36 × 18 × 1.5 in]

'I knew it was autobiographical ... there's a black figure pressing its face against the glass, like a shadow. And two hands that represent my own fate. On the top are nine little boxes in rows of three marked by the crescent, the star and the sun. But look what's at the centre, a skeleton. Death is in the centre. Everything revolves around death. In the bottom is a tintype of a woman. It's no one I know, just something I found. But she's white. My mother's mother was white, Irish, and very beautiful. I have a photograph of her in a hat covered with roses. And there's the same mix on my father's side. I feel that duality, the black and the white.'
– Betye Saar, Artist's statement, 1984

Saar first explored autobiography in *Black Girl's Window*. In this work Saar adds a further dimension to her previous use of assemblage; it becomes a ritual process. Symbols derived from occult sources suggest that the trapped figure needs to connect with the spiritual in order to escape from her confines.

Saar began making assemblage works in the late 1960s. She used assemblage not only because it challenged fine art categories in its use of found and recycled materials but because it enabled her to work with concentrated layers of symbolism.

Betye SAAR
Record for Hattie
1974
Found objects, wood, paint
34 × 55.5 × 5 cm [13.5 × 22
× 2 in]

Record for Hattie was made as a
memorial to Saar's aunt; assembling
her personal posessions, the work
evokes reveries and reflections upon
her womanhood. Saar began
incorporating her assemblage works in
boxes in the 1970s, influenced in part by
Joseph Cornell, whose work she had
first encountered in Pasadena in 1968.
Modernist movements such as
Surrealism, which forms the
background to Cornell's work, were
strongly influenced by African art and
aesthetics, but mainly in terms of their
European notion of 'the primitive' as an
anti-rational, reverse mirror of Western
values. The objects collected together
in Saar's works, while familiar, also
appear enigmatic and suggestive of
ritual and spirituality. However, rather
than exoticizing cultural artefacts,
Saar presents them, from her African-
American perspective, as a repository
of memories, evidence of the collective
social and spiritual values of people of
African descent.

left, Joyce <u>KOZLOFF</u>
Zenmour
1975
Acrylic on canvas
198 × 122 cm [78 × 48 in]

In the early 1970s Kozloff, along with Miriam Schapiro and students at California Institute for the Arts, began researching vernacular traditions of art making by women across a wide range of cultures, as appropriate forms to adopt in the creation of new feminist art. Collectively, this tendency became known as the Pattern and Decoration Movement. Its first exhibition, 'Ten Approaches to the Decorative', was held in New York in 1976. The artists' formalized use of patterns derived from ceramic, weaving and other traditional arts and crafts critiqued the 'purity' of geometric abstraction, and the pejorative, often gender-based use of the term 'decorative'. Kozloff researched and travelled extensively to locate the source material for her paintings, such as *Zenmour*, that shift the specific historical and cultural meanings of the original forms through re-situating them as painting in a contemporary context. In many of Kozloff's works, two different decorative systems are set in opposition; the superimposition of colours and patterns leads to shifts in the sense of pictorial space. Her work is both celebratory and refutational:

'*Negating the Negative*

anti-pure, anti-purist, anti-puritanical, anti-minimalist, anti-post-minimalist, anti-reductivist, anti-formalist … anti-universal, anti-internationalist, anti-imperialist, anti-bauhausist, anti-dominant, anti-authoritarian … anti-logic, anti-conceptual, anti-male-dominated, anti-virile, anti-tough, anti-cool, anti-cruel … anti-controlled, anti-controlling, anti-arrogant, anti-sublime, anti-grandiose, anti-pedantic, anti-patriarchal, anti-heroic, anti-genius, anti-master

On Affirmation

fussy, funny, funky, perverse, mannerist, tribal, rococo, tactile, self-referring, sumptuous, sensuous, salacious, eclectic, exotic, messy, monstrous, complex, ornamented … '
– Joyce Kozloff, 'Negating the Negative', 1976

opposite, Miriam <u>SCHAPIRO</u>
Connection
1976
Collage, acrylic on canvas
183 × 183 cm [72 × 72 in]

Schapiro combined acrylic painting with patchwork-like fabric collage to construct large-scale works such as *Connection*. She and her fellow collaborators, who included students at California Institute of the Arts, defined these as *femmage*: 'We feel that several criteria determine whether a work can be called *femmage*. Not all of them appear in a single object. However, the presence of at least half of them should allow the work to be appreciated as *femmage*. 1. It is a work by a woman. 2. The activities of saving and collecting are important ingredients. 3. Scraps are essential to the process and are recycled in the work. 4. The theme has a woman-life context. 5. The work has elements of covert imagery. 6. The theme of the work addresses itself to an audience of intimates. 7. It celebrates a private or a public event. 8. A diarist's point of view is reflected in the work. 9. There is drawing and/or handwriting sewn in the work. 10. It contains silhouetted images which are fixed on other material. 11. Recognizable images appear in narrative sequence. 12. Abstract forms create a pattern. 13. The work contains photographs or other printed matter. 14. The work has a functional as well as an aesthetic life.

'These criteria are based on visual observation of many works made by women in the past … this art has been excluded from the mainstream, but why is that so? What is mainstream? How may such an ommission be corrected? … the culture of women will remain unrecognized until women themselves regard their own past with fresh insight. To correct this situation, must we try to insert women's traditional art into the mainstream? How will the authorities be convinced that what they consider low art is worth representing in history? The answer does not lie in mainstream art at all, but in sharing women's information with women.'
– Melissa Meyer and Miriam Schapiro, '*femmage*', 1978

Louise BOURGEOIS

The Destruction of the Father

1974

Latex

238 × 364 × 249 cm [94 × 143.5 × 98 in]

This work was first exhibited as part of the installation 'Le repas du soir' at 112
Greene Street Gallery, New York, in 1974. In a dramatically lit space, it formed part
of a larger, cave-like environment. Bourgeois recounts the childhood fantasy that
generated *The Destruction of the Father*:

'At the dinner table my father would go on and on, showing off, aggrandizing himself.
And the more he showed off, the smaller we felt. Suddenly there was a terrific
tension, and we grabbed him – my brother, my sister, my mother – the three of us
grabbed him and pulled him on to the table and pulled his legs and arms apart ...
And we were so successful in beating him up that we ate him up.'

– Louise Bourgeois, *Destruction of the Father/ Reconstruction of the Father: Writings
and Interviews 1923–1997,* 1998

The basis of this work is a 'table' which is encrusted and overhung with sprouting,
ambiguous bodily derived forms, suggestive of a nurturing motherhood that
overwhelms the patriarchal place of the father. Among the sources of imagery the
work recalls are ancient Greek statues of Artemis, whose rituals involved the
castration of bulls and the sacrifice of males; these have clusters of similar rounded
forms protruding from their torsos, which could represent castrated testicles as
much as breast forms.

Alice AYCOCK
A Simple Network of Underground Wells and Tunnels
1975
Earth, concrete, timber
Wall, 30 × 900 × 1500 cm [12 × 354 × 590 in]
Underground excavation, 600 × 1200 cm [236 × 472.5 in]
Merriewold West, Far Hills, New Jersey

A series of six concrete block wells, connected by tunnels, was built in an excavated area. Three of the wells could be entered and three functioned as vertical 'relieving' wells, which were closed and completely surrounded with earth. The open-entry wells were indicated above ground by wooden covers. Inside the wells were ladders to enable participants to climb down and crawl through tunnels which connected the open wells to each other. The dark underground tunnels were designed to produce unease and disorientation, heightening psychic awareness of the body's relationship to this spatial environment. Aycock's use of the maze form drew experimentally upon cultural associations of female identity with the earth and natural cycles. She referred to her archaeological-architectural structures as 'psycho-architecture'. In conceiving this work Aycock drew on experiences from her past, combining architectural history with personal memories and dreams.

Mary MISS
Perimeters/Pavilions/Decoys
1977-78
Wood, steel, earth
Tallest tower, 5.5 m [18 ft]
Underground excavation, 12 × 12 m [40 × 40 ft]
Pit opening, 5 × 5 m [16 × 16 ft]

Three tower-like structures, two earth mounds and an underground courtyard were built on a 10 hectare (4 acre) site. The work must be walked through in order to be experienced in its entirety; there are changes of scale in the towers and innaccessible spaces in the underground structure. Boundaries and perceptions of distance are brought into question, as are the limits of illusion and reality. The viewer is aware of both the passage of time and of the changing relationships of the body in space. 'You feel the work is disappearing before your eyes or that, while experiencing it, you are passing through a mirror into another reality … Despite her good craftsmanship and her love of materials, she denies you the possibility of being seduced by their surface appearances. (All of her outdoor pieces have succumbed to the elements or have been destroyed, except the wood-lattice in an open air pit piece she did at Oberlin which has been remade in metal.) Her attitude is reticent and respectful towards her materials, in the manner of Japanese temple architecture and symbolic garden landscaping … '
– April Kingsley, 'Six Women at Work in the Landscape', 1978

Susan HILLER
Sisters of Menon
1972-79
Blue pencil, typewriting, gouache, labels on paper
8 panels, 193 × 183 cm [76 × 72 in] overall
top, installation of panels
bottom, detail of typescript panel

'I had been working on a project called *Draw Together*, a group investigation into "the origins of images and ideas". One evening … I picked up a pencil and began to make random marks on a blank sheet of drawing paper. At first the marks formed what looked like childish letters I could not decipher. Then coherent words began to appear. The pencil seemed to have a mind of its own and wrote page after page of text in an unfamiliar style … Here my spontaneous scribbling ended up as writing. In later examples, writing dissolved into marks that look like crypto-linguistic, calligraphic signs … Perhaps the last word [one] in the *Sisters of Menon* scripts provides a clue, for the ancient Greeks (I'm told) had only one term for writing and drawing.'
– Susan Hiller, *Sisters of Menon*, 1983

'… the *Sisters of Menon* script reformulates the encounter between the Sphinx and Oedipus. The Sisters text revolves around a new perspective on the question, Who am I? The Sisters ask, "Who is this one?" and they answer themselves, "I am this one. You are this one. Menon is this one. We are this one." It's a new starting point. Identity is a collaboration, the self is multiple. "I" am a location, a focus.'
– Susan Hiller, 'Looking at New Work: an interview with Rozsika Parker', 1983

Susan <u>HILLER</u>
Fragments (detail)
1977-78
Potsherds, gouache drawings,
charts, texts
Dimensions variable

A hundred small broken pieces of Pueblo pottery were placed on 100 sheets of sketchbook paper laid on the floor in a grid formation. Each sheet also contained a gouache painting of a pottery fragment, different from the actual one resting on the paper. There were further fragments, in archaeological specimen bags, on the walls as well as a photograph and texts.

Inspired by women pioneers in the field, Hiller had studied and taught anthropology in the mid 1960s. However, she became disillusioned, aware that passionate involvement with the values of peoples encountered had been replaced by theoretically detached appropriation of cultural data for its use value. After fieldwork in Central America she left the US in 1970 and settled in Britain. Determined to find a way of becoming a full participant in shared cultural experience, she became an artist. *Fragments* juxtaposed indigenous (Pueblo) systems of taxonomy with those of anthropologists. The work included statements by Pueblo artists emphasizing that their design ideas were simultaneously traditional (based on fragments from the past) and innovative, original (inspired, for example, by dreams). Their practice was thus located as an art form rather than relegated to 'craft'. Texts shown alongside the shards juxtaposed typescripts from fieldwork by archaeologists and anthropologists such as Ruth Bunzel, one of the pioneers Hiller admired, with handwritten records of statements by the Pueblo women. Visual representations and diagrams by the artist suggested parallels between the activities of the field worker and the artist. Hiller's material was not appropriated; its parallel existence was maintained as an acknowledgment of the culture that had affected her subjectively in forming the work.

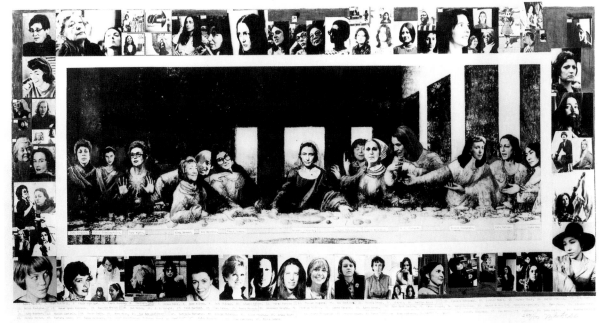

SOME LIVING AMERICAN **WOMEN** ARTISTS

Mary Beth <u>EDELSON</u>
Some Living American Women
Artists/Last Supper
1972
Offset poster
66 × 132 cm [26 × 52 in]

Edelson's collage depicts over eighty living women artists. Those seated at the table include Georgia O'Keeffe (centre), Lee Krasner, Helen Frankenthaler, Lynda Benglis and Yoko Ono. Produced as a poster, the work 'was widely reproduced in early feminist publications … Organized religion's penchant for cutting women out of positions of authority is challenged in this poster, as well as the widespread assumption that women do not have access to the sacred. But here we are instated in this famous religious icon for all the world to see.'
– Mary Beth Edelson, Artist's statement, 2000

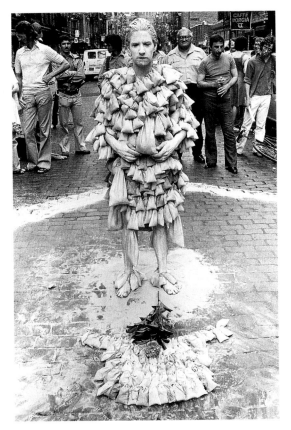

Betsy <u>DAMON</u>
7,000 Year-old Woman
1977
Prince Street, New York

'She found me in Los Angeles in Spring 1975. I began imagining myself covered with small bags filled with flour. For the next two years I constantly saw the image with one change. She became a clown and I decided to paint my face and body white. Only after completing the first Sacred Grove did I identify her as a 7,000 year-old woman. While I was more and more in awe of her and did not know much about her, naming her was the first step towards performing her.'

This piece was performed on two occasions, first in an intimate gallery space, and secondly, in collaboration with artist filmmaker Su Friedrich, in the broader public arena of a New York street. Damon recalls the first performance:

'Hanging from and covering my body were 420 small bags filled with 60 lbs of flour that I had coloured a full range of reds from dark earth red to pink and yellow. To begin the piece I squatted in the centre of the gallery while another woman drew a spiral out from me which connected to a large circle delineated by women who created a space with sonic meditation. Very slowly I stood and walked the spiral, puncturing and cutting the bags with a pair of scissors … By the end of the performance the bags on my body were transformed into a floor sculpture. I invited the audience to take the bags home and perform their own rites … During the performance I was a bird; a clown; a bagged woman; an ancient fertility goddess; heavy-light; a striptease artist; sensuous and beautiful. After the performance I was certain that at some time in history women were so connected to their strength that the ideas of mother, wife, lesbian, witch, as we know them, did not exist.'
– Betsy Damon, Artist's statement, 1977

Mary Beth <u>EDELSON</u>
Goddess Head
1975
Photo collage
Approx. 20 × 25 cm [8 × 10 in]

Exploring mythical connections of the feminine with the ocean's maternal source
of life, Edelson collaged a fossilized spiral shell in the place of her head, creating
an enigmatic 'goddess' figure. Thus transformed, the artist presents an image of the
modern female body connected with ancient and monolithic sources of energy. In her
collages of the 1970s Edelson looked to the symbols and myths of women's 'lost'
history in order to recuperate a sense of female heritage and to bind contemporary
woman to a collective feminine community.

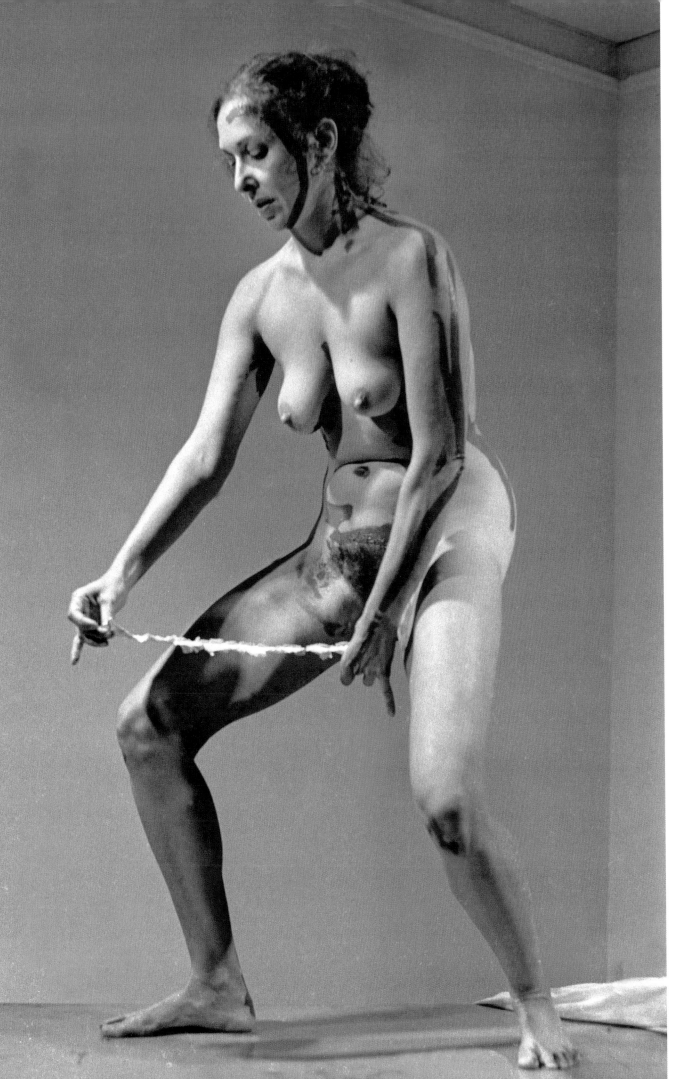

Carolee <u>SCHNEEMANN</u>
Interior Scroll
1975
East Hampton, Long Island

Wearing only a sheet, Schneemann told her audience she would read from her book, *Cézanne, She Was a Great Painter*. She then unwrapped the covering sheet and painted large strokes of mud on the contours of her body and face. She climbed onto a long table and read the text while assuming a series of life-model poses, balancing the book in one hand. Dropping the book, she slowly extracted a scroll from her vagina and read the inscriptions on it, which were taken from feminist texts she had written for a previous work. One of these, originally written for her film *Kitch's Last Meal* (1973–77), describes her encounter with a male structuralist filmmaker who complains that her work is full of 'personal clutter … persistence of feelings … diaristic indulgence' and so on:

'He said you can do as I do
take one clear process
follow its strictest
implications intellectually
establish a system of
permutations establish
their visual set …
he protested
you are unable to appreciate
the system of the grid
the numerical rational
procedures –
the Pythagorean cues …
he said we can be friends
equally though we are not artists
equally I said we cannot
be friends equally and we
cannot be artists equally …

'he told me he had lived with
a "sculptress" I asked does
that make me a "film-makeress"?

'Oh No he said we think of you
as a dancer'

First performed for an exhibition of paintings and series of performance works for a largely female audience, entitled 'Women Here and Now', *Interior Scroll* resulted from Schneemann's research into 'vulvic space' and its connection with serpent forms as Goddess attributes in ancient cults.

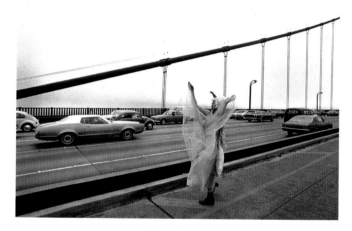

Linda <u>MONTANO</u>
Chicken Dance
1972
Golden Gate Bridge, San Francisco

In 1969, while a graduate student at the University of Wisconsin, Montano became frustrated with conventional art practice. She decided to blur the boundaries between art and everyday life in order to explore unconscious subject matter, fears, fantasies and healing processes. She experimented with different personae, the first being Chicken Woman, an alter ego that enabled her to experience a range of identities including that of 'nun, saint, martyr, plaster statue, angel, absurd snow white dream character'. For the next seven years Chicken Woman presided over various art events, was spied sitting on sidewalks in New York or performing the Chicken Dance on San Francisco's Golden Gate Bridge, as an act of healing for past suicides. From the mid 1970s onwards Montano developed other personae including Dr Jane Gooding, neurosurgeon and shaman; Sister Rose Augustine; Kay Rogers, Blues singer; and Hilda Mahler, Olympic swimmer and karate black belt.

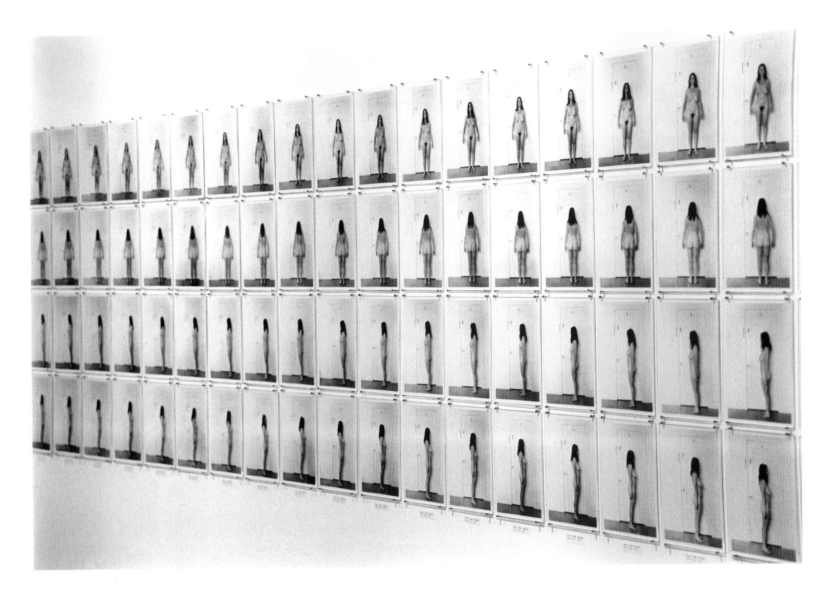

Lynda <u>BENGLIS</u>
Bounce I
1969
Poured pigmented latex
Dimensions variable

Bounce I was a hybrid of painting, sculpture and performance, and one of the first instances when Benglis explicitly commented on the gendered aspects of gestural forms. She dripped fluorescently pigmented liquid latex rubber in 'formless' configurations onto the floor of the Bykert Gallery, New York. The piece critiqued formalist art criticism's classification of the gestural actions of male Abstract Expressionist painters as 'masterly'. Although these artists had been a major influence on her own earlier work, Benglis was concerned to open up questions about designations of the 'feminine' through a continual questioning of expressive forms and the deployment of new or unorthodox materials.

Eleanor <u>ANTIN</u>
Carving: A Traditional Sculpture
1973
Black and white photographs, text
144 photographs, 18 × 12.5 cm [7 × 5 in] each
Collection, Art Institute of Chicago

'This work was carved during the period between 15 July 1972 and 21 August 1972. The material (the artist's body) was photographed every morning in four positions – front, back, right and left profile – to depict the process of "carving" down during a strict dieting regimen.' Parodying the method of traditional Greek sculpture in which the sculptor worked his way round a figure, repeatedly carving a thin layer from all sides in order to 'keep the whole in view', Antin presented her body as the object of her own sculpting activity, through a process that, unlike carving, worked from the inside out. Like the Greek sculptor she could choose when to stop. 'When the image was finally refined to the point of aesthetic satisfaction the work was completed.' There was a proviso that the final result would be determined by '(1) the ideal image towards which the artist aspires, and (2) the limitations of the material'. Antin concludes with a paraphrase of a quote from Michelangelo, 'not even the greatest sculptor can make anything that isn't already inside the marble', and ironically points to the primacy of the material internal to her 'sculpted' body, which is precisely what enables her to control that body.
– all quotes from Eleanor Antin, Artist's writings, 1973

Joan <u>JONAS</u>
Vertical Roll
1972
Video
19 mins., black and white, sound

Influenced by the movement theatre of the Judson Dance Group, Jonas mixed sound, movement and image, seeking to break down boundaries between traditional artforms and the new media of video and performance art. This unedited video tape utilizes one of the primary technical features of video, the vertical roll across the screen that results from two out-of-sync frequencies: the frequency signal sent to the monitor and the signal by which it is interpreted. When both signals are the same, the image is stable. In the first sequence Jonas bangs a spoon against a mirror, creating the impression of a relationship between the sound and the image disturbance. She is then seen jumping up and down, sometimes in sync with the vertical roll as it hits the bottom of the monitor, sometimes appearing to jump over the roll. Her hands then appear, making similar movements; the vertical roll creates the illusion that they are clapping. In the final image Jonas' head fills the frame; the vertical roll appears to push her head out of the picture.

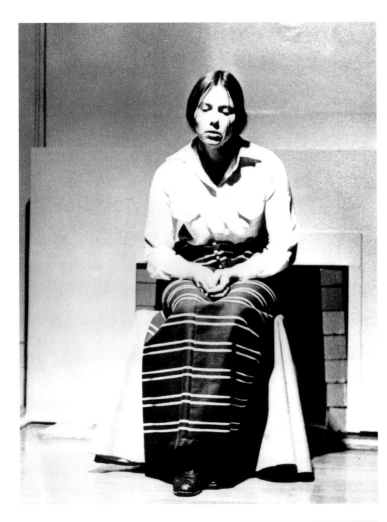

Faith <u>WILDING</u>
Waiting
1971
Womanhouse, Los Angeles, 1972

Wilding performed *Waiting* as part of the group consciousness-raising activities of the Womanhouse project in Los Angeles. Sitting passively with her hands in her lap she rocked back and forth as she listed the endless waiting of a woman's life. 'Waiting … waiting … waiting/Waiting for someone to come in/Waiting for someone to pick me up/Waiting for someone to hold me/Waiting for someone to feed me/Waiting for someone to change my diaper … Waiting/… Waiting to be a big girl/ … Waiting to wear a bra/Waiting to menstruate/Waiting to read forbidden books/ … /Waiting to have a boyfriend/Waiting to go to a party, to be asked to dance, to dance close/Waiting to be beautiful/Waiting for the secret/Waiting for life to begin … Waiting …
' … Waiting to be somebody/ … Waiting for my pimples to go away/Waiting to wear lipstick, to wear high heels and stockings/Waiting to get dressed up, to shave my legs/Waiting to be pretty … Waiting …/Waiting for him to notice me, to call me/Waiting for him to ask me out … /Waiting for him to fall in love with me …
'Waiting to get married/ … Waiting for my wedding night/… Waiting for him to come home, to fill my time … /Waiting for my baby to come/Waiting for my belly to swell/Waiting for my breasts to fill with milk/Waiting to feel my baby move/Waiting for my legs to stop swelling/Waiting for the first contractions/Waiting for the contractions to end/Waiting for the head to emerge/Waiting for the first scream, the afterbirth/ … Waiting for my baby to suck my milk/Waiting for my baby to stop crying …
Waiting for him to tell me something interesting, to ask me how I feel/Waiting for him to stop being crabby, to reach for my hand, to kiss me good morning/Waiting for fulfilment …
'Waiting for my body to break down, to get ugly/Waiting for my flesh to sag/ … Waiting for a visit from my children, for letters/Waiting for my friends to die … /Waiting for the pain to go away/Waiting for the struggle to end … /Waiting … '
– Faith Wilding, *Waiting*, 1971

Susan <u>FRAZIER</u>, Vickie <u>HODGETTS</u> and Robin <u>WELTSCH</u>
Nurturant Kitchen
1972
Found and fabricated objects, paint
Dimensions variable
Womanhouse, Los Angeles

'Out of our consciousness-raising techniques came the motif for the kitchen. As we expressed our real underlying feelings about the room, it became obvious that the kitchen was a battleground where women fought with their mothers for their appropriate state of comfort and love. It was an arena where ostensibly the horn of plenty overflowed, but where in actuality the mother was acting out her bitterness over being imprisoned in a situation from which she could not bring herself to escape and from which society would not encourage such an escape. Three women collaborated on the kitchen. They painted everything a store-bought pink – refrigerator, stove, canned goods, toaster, sink, walls, floor, ceiling. Drawers were papered with collages of far away places. On the ceiling and walls were attached fried eggs, which transformed themselves into breasts as they travelled down the walls. Five moulds were made from clay showing this transformation, and they were created in a spongy material and painted realistically. The reality of the woman's condition that was epitomized by this kitchen, coupled with a consistently high level of quality art making, made the experience of walking into our nurturing centre breathtaking … '
– Miriam Schapiro, 'The Education of Women as Artists: Project Womanhouse', 1973
 Nurturant Kitchen was one of the site-specific collaborations created over a six-week period at Womanhouse (Valencia, California, 1972), initiated by Judy Chicago and Miriam Schapiro with fellow artists and students at the California Institute for the Arts. In an abandoned residential building on the outskirts of Los Angeles, seventeen room installations were created; regular debates and consciousness-raising sessions were held, which led to performances that articulated female experience.

Martha <u>ROSLER</u>
Semiotics of the Kitchen
1975
Video
6 mins., black and white, sound

Rosler stands, as in a TV cookery lesson, in front of a kitchen table piled with various cooking utensils. She recites the alphabet, holding up an item to the camera to illustrate each letter, so that A stands for apron, B for bowl, C for chopper and so on. However Rosler's gastronomic lexicon becomes muffled as she aggressively brandishes each object. She swishes and stabs the air with a kitchen knife, or stirs and then suddenly aims a throw at an imaginary victim with the soup ladle. Repressed rage at domestic servitude simmers and overflows the containing signifiers of language. From the outset, Rosler's practice has been equally engaged with both art and theory. This is one of the earliest video works which evidences her commitment to the idea that the purpose of theory (in this case the prevailing structuralism of the 1970s) is not merely to transform theory but also to transform the inequity of social and political conditions.

Martha <u>ROSLER</u>
Vital Statistics of a Citizen, Simply Obtained
1977
Video
40 mins., colour, sound

Rosler is seen, clothed and unclothed, being systematically measured by two male 'researchers' who record her measurements on a chart and compare them with a set of 'normal' measurements. Rosler's acting out of this submissive status is contrasted with her directorial, voice-over statements:

'Her mind learns to think of her body as something different from her "self" ... I needn't remind you about scrutiny, about the scientific study of human beings. Visions of the self, about the excruciating look at the self from the outside as if it were a thing divorced from the inner self. How one learns to manufacture oneself as a product. How one learns to see oneself as a being in a state of culture as opposed to a being in a state of nature. How to measure oneself by the degree of artifice: the re-manufacture of the look of the external self to simulate the idealized version of the natural. How anxiety is built into these looks. How ambiguity, ambivalence, uncertainty are meant to accompany every attempt to see ourselves, to see herself as others see her. This is a work about how to think about yourself ... '
– Martha Rosler, *Vital Statistics of a Citizen, Simply Obtained*, 1977

Chantal AKERMAN
Jeanne Dielman, 23 Quai du commerce, 1080 Bruxelles
1975
210 mins., colour, sound

Three days in the life of a widowed Belgian mother are documented with great precision, in a film of over three hours duration in its original version. Much of the action is filmed in real time. Jeanne Dielman's rigid household routines include visits from different male clients each day whose fees for her sexual services support herself and her son. Maintaining a relentlessly even distance from the action throughout, the film refuses to set up privileged points of view on the action by close-ups, cut ins and other narrative techniques of classic cinema. The camera position corresponds to Akerman's own height, constructing a 'woman's eye' view. These cinematic elements establish the order of Dielman's household tasks, which exert control over her life. The smallest digressions from this ordered routine assume enormous proportions but are also perceived as no more or less important than her final 'slip', the murder of her third client. As in structural film, to which Akerman's 'hyperrealist' work is related, the viewer is forced to keep a distance, taking an active part in deciphering both narrative and image.

Laura MULVEY, Peter WOLLEN
Riddles of the Sphinx
1976
95 mins., colour, sound

Mulvey's film theory and practice arose from participation in the London Women's Film Group, set up in 1971, which linked Marxist and structuralist theory with Freudian theories of the unconscious to analyse the production of woman as a sign within the patriarchal order. This collaboration with Wollen retells the Oedipus myth from the perspective of the Sphinx – the silent, half-female creature situated outside the city gates. The central section of the film is composed of thirteen slow 360 degree pans. The riddles become contemporary dilemmas confronted by a young mother whose feminist consciousness gradually comes into voice: 'Question after question arose, revolving in her mind without coming to any conclusion. They led both out into society and back into her own memory. Future and past seemed locked together. She felt a gathering of strength but no certainty of success.'
– Laura Mulvey, Peter Wollen, *Riddles of the Sphinx*, script, 1976

 Mulvey and Wollen were closely associated with Mary Kelly during this period; their films resemble Kelly's structural schema for sections of her work *Post-Partum Document* (1973–79). Images from Kelly's work were incorporated within *Riddles of the Sphinx*.

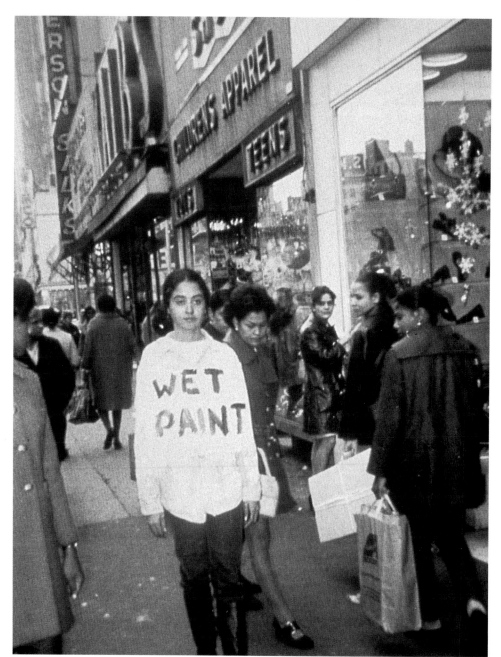

top
Adrian <u>PIPER</u>
Catalysis III
1970-71
New York
bottom
Adrian <u>PIPER</u>
The Mythic Being: Cruising White
Women
1975
Cambridge, Massachusetts

Piper's performances, which took place
in the street, on the subway, in museums,
bookshops and other public places,
demonstrate a desire to question and
disrupt general social attitudes towards
difference, and how this is read through
a person's appearance and gestures.
In her *Catalysis* series her presence, or
'quirky personal activities', were genuinely
disruptive. For example, she would
appear on the subway in stinking clothes
during rush hour or with balloons attached
to her ears, nose, hair and teeth. She
would go shopping in a smart department
store in clothing with sticky paint letters
reading 'WET PAINT' or to a library
carrying a concealed tape recording
of loud belches. In this way she forced
a direct confrontation with the public.
In the *Mythic Being* series Piper
disguised herself as an androgynous,
racially indeterminate young man,
wearing a black t-shirt, flared jeans, big
sunglasses, an afro wig and Zapata-style
moustache. The *Mythic Being* series also
included drawings, photographs and
collages that developed in conjunction
with the performances.

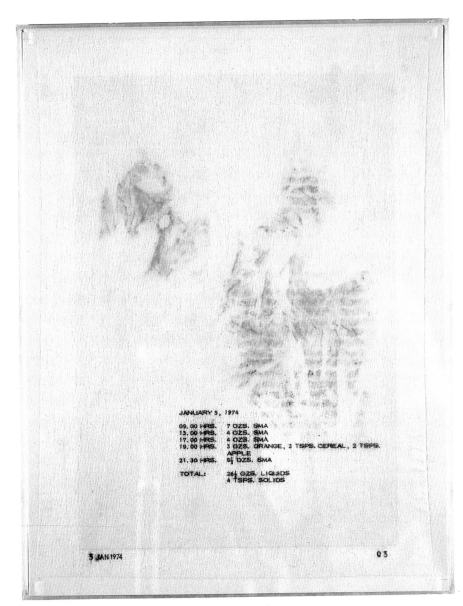

JANUARY 5, 1974

09.00 HRS.	7 OZS. SMA
13.00 HRS.	4 OZS. SMA
17.00 HRS.	4 OZS. SMA
19.00 HRS.	3 OZS. ORANGE, 3 TSPS. CEREAL, 2 TSPS. APPLE
21.30 HRS.	8½ OZS. SMA
TOTAL:	26½ OZS. LIQUIDS
	4 TSPS. SOLIDS

5 JAN 1974 03

left

Mary <u>KELLY</u>

Post-Partum Document: Documentation I, Analysed Faecal Stains and Feeding Charts (prototype)

1974

Perspex units, white card, diaper lining, plastic sheeting, paper, ink

1 of 7 units, 28 × 35.5 cm [11 × 14 in] each

Collection, E.A. Generali Foundation, Vienna

opposite

Mary <u>KELLY</u>

Post-Partum Document: Documentation VI, Pre-writing Alphabet, Exergue and Diary (detail)

1978

Perspex units, white card, resin, slate

1 of 15 units, 20 × 25.5 cm [8 × 10 in] each

Collection, Arts Council of England

In 1973 *Post-Partum Document* 'was conceived as an ongoing process of analysis and visualization of the mother/child relationship. It was born as an installation in six consecutive sections, comprising in all 135 small units. It grew up as an exhibition, adapted to a variety of genres (some realizing my desire for it to be what I wanted it to be, others resisting, transgressing) and finally reproduced itself in the form of a book.'

– Mary Kelly, 'Preface', *Post-Partum Document*, 1983

The project analysed the artist's lived experience of motherhood; it inserted the voice of feminine subjectivity into the language of Conceptual art, while also explicitly refuting naturalization of the discourse of women's practice. Furthermore her investigation led Kelly to depart from psychoanalytic orthodoxy to posit a concept of maternal fetishism. Kelly suggests that if a baby fulfils in fantasy the plenitude denied by 'lack' of the phallus (according to Freudian Oedipal theory), the growing distance and thus 'loss' of the maturing child represents a castration threat, in response to which the mother's memorabilia – shoes, locks of hair, photographs – both commemorate the loss and defend against it. Kelly represents the 'transitional objects' of the mother as well as the child, not as surrogates but as emblems of desire, drawing attention to the fetishistic nature of representation itself.

(age 3.6) e IS FOR ELEPHANT. He calls it the "curvy one" and pronounces it—"eeh". He often forgets it and sometimes writes it upside-down "ə". When he sees an e a present or a breast, he says, "What's that?" Something at once lost, forgotten, remembered and hoped for "ə" as in "me." E IS FOR ALLIGATORS ENTERTAINING ELEPHANTS. E IS FOR AN EAGLE ON AN ELEPHANT IN AN EGG AND SPOON RACE. GOOD NIGHT EDWARD ELMER ELEPHANT. GOOD NIGHT LITTLE E.

February 22, 1977: I noticed the general conditions more than the children this time, like the rubbish outside the building and the dust inside. When I washed the cups the rag looked so grey I couldn't bring myself to use it. But I suppose they do the best they can, it isn't their own space, its only rented during the day from a Boys club. There's no playground and the children have to stay indoors. All but about 20 mins of the 2 hrs. is 'unstructured' and seems to get out of hand, I'm afraid they'll get hurt. I can't stand the bad grammar after about an hour of it - I can't believe I could be so uptight and pretentious. I feel inadequate myself because I can't offer Kelly more. I wish he could go to a good school, but it's hopeless in this area. I went to the Social Services Dept. and self-righteously demanded the names and addresses of proper nursery schools. They just smiled and refused, saying it would be of no use since all of them had at least a 2 yr. waiting list.

3.603e

Mierle Laderman UKELES
Hartford Wash: Washing, Tracks, Maintenance: Outside
1973
Hartford, Connecticut

In a series of seventeen performances between 1973 and 1976, Ukeles carried out
'maintenance' activities in public spaces, during public hours, cleaning streets and
museum floors as well as performing all the duties of the guards in a museum. Her
maintenance actions provoked the viewer to question the importance of such actions
as cultural activities, and to celebrate the people who traditionally carry them out.
'I am an artist. I am a woman. I am a wife.

'I am a mother. (Random order)

'I do a hell of a lot of washing, cleaning, cooking, renewing, supporting, preserving,
etc. Also, (up to now separately) I "do" art.

'Now, I will simply do these maintenance everyday things, and flush them up to
consciousness, exhibit them, as Art. I will live in the museum as I customarily do at
home with my husband and my baby, for the duration of the exhibition (Right? or if you
don't want me around at night I would come in every day), and do all these things as
public Art activities: I will sweep and wax the floors, dust everything, wash the walls
(i.e., "floor paintings, dust works, soap-sculpture, wall-paintings"), cook, invite people
to eat, make agglomerations and dispositions of all functional refuse.

'The exhibition area might look "empty" of art, but it will be maintained in full public
view.

'MY WORKING WILL BE THE WORK … '
– Mierle Laderman Ukeles, *II. The Maintenance Art Exhibition: 'Care'. A. Part One:
Personal*, from *Manifesto for Maintenance Art, 1969. Proposal for an Exhibition:
'Care'*., 1969

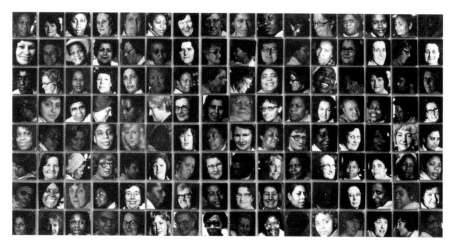

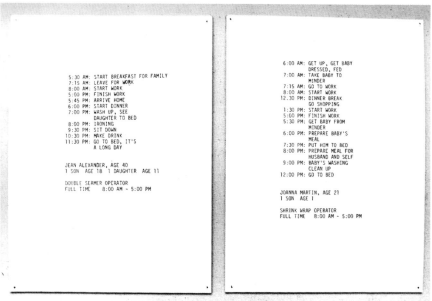

Margaret HARRISON, Kay HUNT, Mary KELLY
Women & Work: A Document on the Division of Labour in Industry
1973-75
Black and white photographs, charts, tables, photocopied documents,
film loops, audiotapes
Dimensions variable
South London Art Gallery, London, 1975

Between 1970 and 1975, two collective projects in London examined women's
working conditions in unprecedented ways. The Berwick Street Film Collective made
the documentary *Nightcleaners* (1970–75), which focused on the complexities and
minute details of its subjects' real-time experience. *Women & Work* was a
documentary installation on the implementation of the Equal Pay Act in a metal box
factory. In 1972 the Collective, which included Mary Kelly, came to a meeting during
'Strike', an exhibition about a strike by women workers, by the artist Conrad Atkinson,
with whom Harrison worked, held at the Institute of Contemporary Arts, London.
Harrison and Kelly discussed working on a project together, which became *Women
& Work* when they were joined by artist and activist Kay Hunt, who initiated the project
at a South London factory similar to one where her female relatives had worked.
Like Atkinson's work the project was rooted in working-class experience and used
all available forms of information and display to convey the interwoven complexities
and iniquities of the system. However, it built on this work by foregrounding the role of
gender in working-class situations. The project questioned the authoritative position
of the artist outside the field of investigation and highlighted the necessity of allowing
space for incorporating subjective material from the participants. The female workers
not only discussed their factory work and conditions but their unpaid labour in the
home and their feelings about their roles. This reinforced a perception that the division
of labour was psychologically and gender based as well as socially determined by the
capitalist class system. Harrison went on to develop these investigations in important
subsequent projects such as the controversial work *Rape* (1977) and *Homeworkers*
(1978) on the conditions of mainly women with young children who do piece work at
home, working longer hours than full-time office or factory workers, but earning less
than a quarter of an average weekly salary. Kay Hunt went on to make pacifist work
based on extensive research into the conditions of women who worked in munitions
factories during World War II.

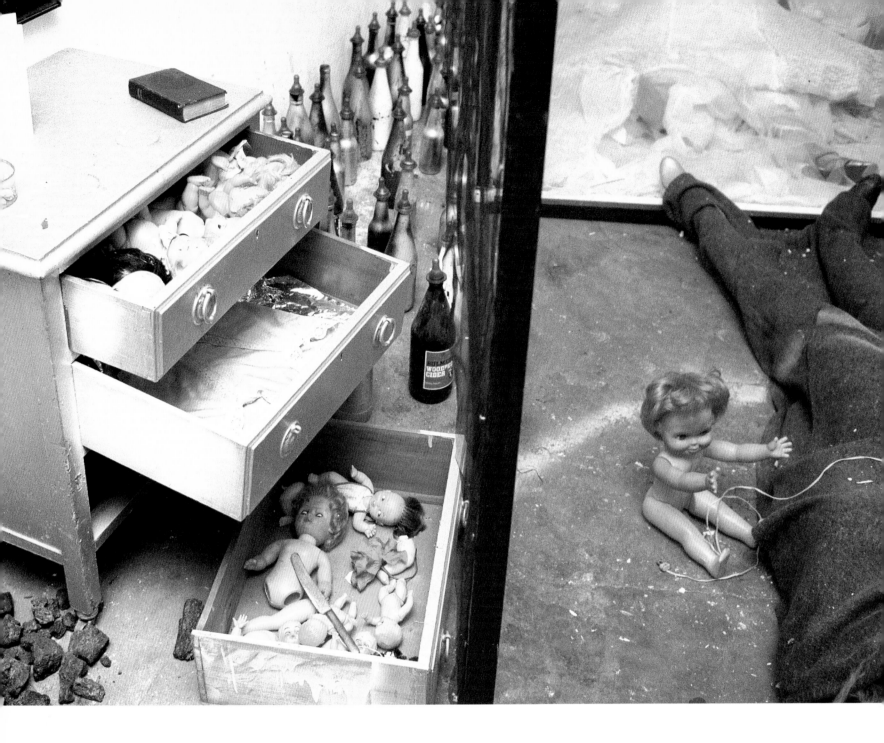

Kate WALKER

Death of the Housewife (detail)

1974

Found objects, assemblage

Dimensions variable

Women's Centre, Radnor Terrace, London

Inspired by the Womanhouse project in California, Walker set up Woman's Place
in the South London Women's Centre, a dilapidated house in Radnor Terrace, south
east London. Six women – Phil Goodall, Patricia (Chick) Hull, Catherine Nicholson,
Su Richardson, Monica Ross and Suzy Varty – took part in constructing different
environments in each room. Walker's installation occupied three rooms and was
themed around domesticity, marriage and death. Walker and others worked with
discarded everyday objects out of economic as well as emotional necessity; it was
also a means of creating art quickly within the limited amount of time available to
them outside domestic obligations.

PERSONALIZING THE POLITICAL

Tina KEANE
Collapsed Dream
1974
Mirrorboard, bamboo, string
274.5 × 213.5 × 122 cm [108 × 84 × 48 in]
Women's Workshop/Artists Union exhibition, Arts Meeting Place, London
'image/dream/illusion
image/language/illumine …
The mirrorboard the illusion of water,
the bamboo poles elegance,
the string a tangled web'
— Tina Keane, Artist's statement, 1974

The Women's Workshop collective was formed in 1972, as a support structure to counteract women artists' isolation. Its exhibitions were non-selective, in counter-distinction to the male-dominated art world's hierarchies and in recognition of the fact that unless they joined together to take over a space, women practitioners of many different aesthetic and political perspectives were all equally marginalized.

Kate MILLETT
The Trial of Sylvia Likens (detail)
1965-78
Found objects, wood, paint, photocopies, tape recordings
Dimensions variable

'On October twenty-sixth, 1965, in Indianapolis, Indiana, the starved body of a sixteen-year-old girl named Sylvia Likens was found in a back bedroom of Gertrude Baniszewski's house on New York Street, the corpse covered with bruises and with the words 'I am a prostitute and proud of it' carved upon the abdomen. Sylvia's parents had boarded her and her younger sister, Jenny Likens, with Gertrude in July. The beatings and abuse Sylvia suffered over the summer had increased so, by September, that the last weeks of her life were spent as a captive in the basement of the house … '
— Kate Millett, *The Trial of Sylvia Likens*, 1978

Best known as a writer, Millett also produced sculpture over a fifteen year period. Utilizing a New York basement space for the work's first presentation in 1978, Millett attempted to create a visual metaphor for the various types of imprisonment the tragedy represented. Tableaux recreating the events were juxtaposed with large photocopied images, detailed written documentation and tape-recorded readings by the artist, creating a nauseatingly claustrophobic, oppressive environment.

Su RICHARDSON
Burnt Breakfast, from Feministo
1975-77
Crocheted wool
ø approx. 23 cm [9 in]

Burnt Breakfast was made for 'Feministo: Portrait of the Artist as a Housewife', a project set up in 1975 by Sally Gollop, Kate Walker and others in response to domestic isolation and exclusion from the art system. Women ranging in age from nineteen to sixty years old participated in the project which involved exchanging small artworks through the mail. These were shown in an exhibition of the same name at the Institute of Contemporary Arts, London, in 1977. The pieces were exhibited within a series of tableaux based on domestic environments. Three hundred works were included in the exhibition, which toured regional cities in Britain as well as Germany and Austria. Among the many women who participated in this project, Birmingham-based Phil Goodall emerged as a central figure. In 1977 she devised, with Tricia Davis, the multimedia collaborative project 'Mother's Pride: Mother's Ruin.'

Laurie <u>ANDERSON</u>
Fully Automated Nikon
(Object/Objection/Objectivity)
(detail)
1973
Black and white photographs, text
Dimensions variable

'I decided to shoot pictures of men who made comments to me on the street. I had always hated this invasion of my privacy and now I had the means of my revenge. As I walked along Houston Street with my fully automated Nikon, I felt armed, ready. I passed a man who muttered 'Wanna fuck?' This was standard technique: the female passes and the male strikes at the last possible moment forcing the woman to backtrack if she should dare to object. I wheeled around, furious. 'Did you say that?' He looked around surprised, then defiant. 'Yeah, so what the fuck if I did?' I raised my Nikon, took aim, began to focus. His eyes darted back and forth, an undercover cop? CLICK.'
– Laurie Anderson, Artist's statement, 1994

Suzanne <u>LACY</u>
Rape Is
1972
Artist's Book

This book work was made by Lacy as a project of the Women's Design Program, set up by Sheila Levrant de Breitteville in 1971 as an extension of the Feminist Art Program at California Institute of the Arts. The book describes a range of behaviours which constitute rape, in a neutral, non judgemental form. The reader is required to 'violate' the book's red seal in order to open it. Each section opens with the statement 'Rape Is', on the left. On the right are descriptions of situations in which women find themselves on a regular basis, ranging from psychological to emotional and physical harassment:
'Rape Is/When your boyfriend hears your best friend was raped and he asks, "What was she wearing?"'

Valie EXPORT
Genital Panic
1969
Munich

In 1969, dressed in a black shirt, jeans with the crotch removed, and with a machine gun slung over her shoulder, Export entered a sex cinema in Munich. Addressing the audience, she announced that real female genitals were available and they could do whatever they wished.

'I moved down each row slowly, facing people. I did not move in an erotic way. I walked down each row, the gun I carried pointed at the heads of the people in the row behind. I was afraid and had no idea what people would do. As I moved from row to row, each row of people silently got up and left the theatre. Out of film context, it was a totally different way for them to connect with the particular erotic symbol.'
– Valie Export, 'Interview with Ruth Askey', 1981

Judy CHICAGO
Red Flag
1971
Photo lithograph
51 × 61 cm [20 × 24 in]

'"Offensiveness" played a potent part in destroying femininity and female beauty … for Judy Chicago, in her notorious *Red Flag*, a photo lithograph of herself from the waist down pulling out a bloody tampon. [Germaine] Greer suggested that to overcome disgust for one's menstrual blood, a woman should taste it. In order to overturn femininity, feminist artists necessarily flouted good taste and feminine respectability by pointedly showing women's desire for sexual and cultural power, manifested … by breaking the taboo of ladylike purity. *Red Flag* takes a female bodily process out of obscurity; it is interesting to note that some viewers saw the tampon as an image of castration, which shows how much the eye has been socially and culturally educated to *not* see the reality of women's bodies.'
– Joanna Frueh, 'The Body Through Women's Eyes', 1994

Ana MENDIETA
Rape Scene
1973
Moffit Street, Iowa City, Iowa

Mendieta performed several actions around the subject of rape following an incident on the Iowa University campus where a fellow student had been raped and murdered. In one version of this work she invited friends and fellow students to visit her at her own apartment in Moffit Street, Iowa City. Finding the apartment door slightly open, the visitors entered a darkened room in which a single light illuminated the artist stripped from the waist down, smeared with blood and stretched over and bound to the table. Broken plates and blood lay on the floor beside her. Mendieta later recalled in an interview how the incident had moved and frightened her.

 Mendieta also performed this piece outside, away from the domestic environment, in 'untamed' nature. Her violated female body, half hidden by leaves and twigs, was linked more to primal forces in this location, but the emotional impact was just as powerful. Her direct identification with a specific victim meant that she could not be seen as an anonymous object in a theatrical tableau. Her performances presented the specificity of rape, through which she hoped to break the code of silence that renders it anonymous and general, denying the particular and the personal.

Ana MENDIETA
Untitled (Snow Silueta)
1977
Iowa

Mendieta's earth actions stage a death or a dissolution that implicates a rebirth through reintegration with the maternal body of the earth.
'My art is grounded in the belief in one Universal Energy which runs through everything from insect to man, from man to spectre, from spectre to plant, from plant to galaxy.

 'My works are the irrigation veins of the Universal fluid. Through them ascend the ancestral sap, the original beliefs, the primordial accumulations, the unconscious thoughts that animate the world.

 'There is no original past to redeem; there is the void, the orphanhood, the unbaptized earth of the beginning, the time that from within the earth looks upon us. There is above all the search for origin.'
– Ana Mendieta, Artist's statement, 1988

Rhythm 0
1974
Studio Morra, Naples

In an evening performance exploring the dynamics of passive aggression, Abramovic
stood by a table and offered herself to spectators, who could do what they liked with
a range of objects and her body. A text on the wall read, 'There are seventy-two objects
on the table that can be used on me as desired. I am the object.' The objects included a
gun, a bullet, a saw, an axe, a fork, a comb, a whip, lipstick, a bottle of perfume, paint,
knives, matches, a feather, a rose, a candle, water, chains, nails, needles, scissors,
honey, grapes, plasters, sulphur and olive oil. By the end of the performance all her
clothes had been sliced off her body with razor blades, she had been cut, painted,
cleaned, decorated, crowned with thorns and had had the loaded gun pressed against
her head. After six hours the performance was halted by concerned spectators.
Abramovic described this piece as the conclusion of her research on the body.

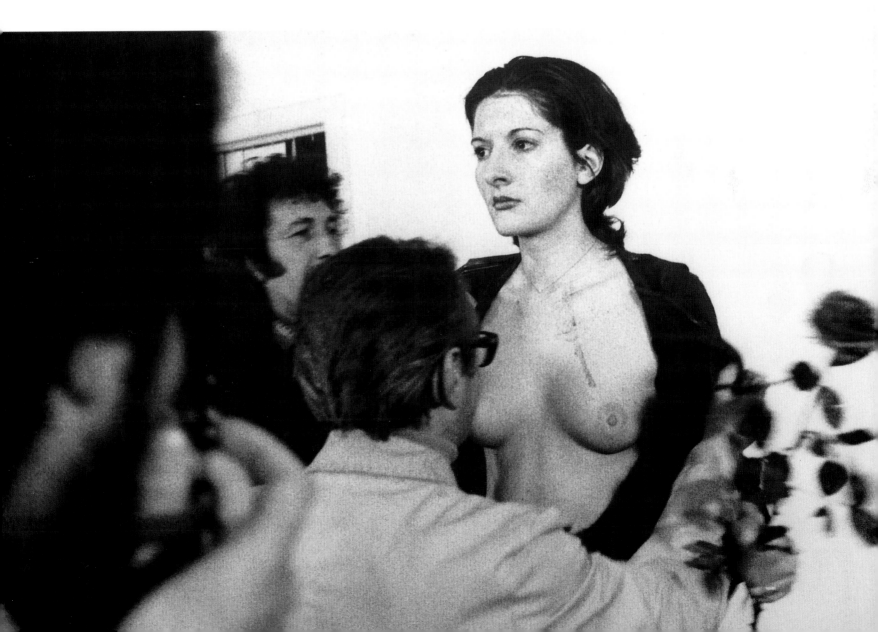

Gina PANE
Autoportrait(s)
1973
Galerie Stadler, Paris

During the first part of this action the artist lay suspended like an inert object above burning candles for half an hour. In the second part she stood facing a wall onto which slides of women painting their fingernails were projected. With her back to the audience, Pane made small incisions in the skin around her own fingernails with a razor blade. Photographic documentation of the work was later exhibited within a photomontage. Between 1968 and 1978 Pane placed her own body at the centre of her art practice, often creating self-inflicted wounds in front of an audience who became direct participants in the ethical and existential issues raised by the work. 'With these actions, I wanted to indicate radically the "sign" of the body, and the wound was the real sign of "this" body, of "this" flesh. It was impossible for me to reconstruct an image of the body without the flesh being present, without it being placed frontally, without veils and mediations.' To Pane, the body was 'the irreducible core of the human being, its most fragile part. This is how it has always been, under all social systems, at any moment in history. And the wound is the memory of the body; it memorializes its fragility, its pain, thus its "real" existence ... '
– Gina Pane, 'Interview with Ezio Quarantelli', 1988

Ulrike ROSENBACH
Don't Believe I Am an Amazon
1975
Kunstmuseum, Dusseldorf

Rosenbach covered a target with a large black and white reproduction of Shephan Lochner's Renaissance painting *Madonna of the Rose Bower* (c. 1435–40), at which she shot fifteen arrows. From a square hole cut into the centre of the target, a video camera recorded Rosenbach shooting the arrows. The performance subsequently appeared as a video in which the recording made by the camera in the target was superimposed on the image of the Madonna, thus reversing the direction of the shooting arrows so that the artist's own face is superimposed on the Madonna's face as she shoots. The artist thus appears as both victim and torturer, which would seem to point to the multiple nature of feminine roles within society.

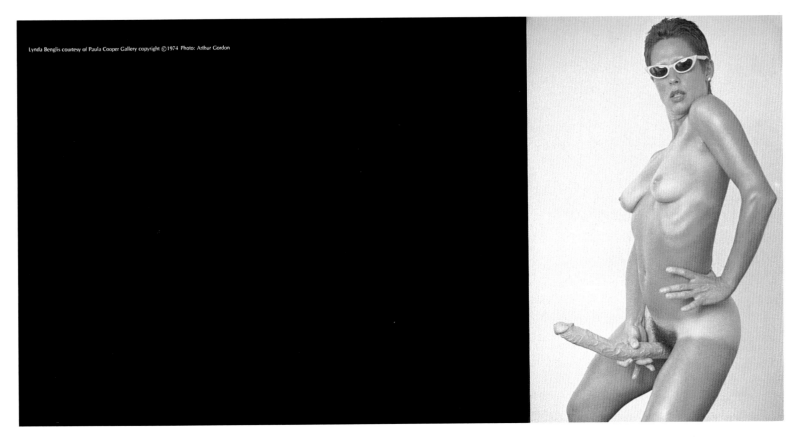

Lynda Benglis courtesy of Paula Cooper Gallery copyright ©1974 Photo: Arthur Gordon

Lynda BENGLIS
Untitled
1974
Colour photograph
26.5 × 26.5 cm [10.5 × 10.5 in]

For her exhibition invitations Benglis used photographs of herself staged in various gender roles, ranging from 'macho male' to 'submissive female'. This image was published in the advertisement placed in *Artforum* shown above. It was initally intended to be one of the magazine's artist projects. The image should have appeared as a centrefold artist's statement, but this was not permitted by the magazine. Benglis declined the magazine's offer to reproduce the image provided it was accompanied by an article on her work. Instead she paid for advertising space under her gallery's name, claiming that 'placing the gallery's name on the work strengthened the statement, thereby mocking the commercial aspect of the ad, the art-star system and the way artists use themselves, their persona, to sell the work. It was mocking sexuality, masochism and feminism.'
– Lynda Benglis quoted by Susan Keane, 'Dual Natures', 1991

Lynda BENGLIS (with Marilyn LENKOWSKY)
Female Sensibility
1973
Video
13 mins., colour, sound

Titled after the question often repeated by feminists at the time as to whether there was such a thing as 'female sensibility', this video features Benglis and Marilyn Lenkowsky slowly caressing and kissing each other. The colour is exaggerated to highlight the blue-green lipstick on Benglis and the red-black on Lenkowsky. Radio talk shows and musical refrains play in the background, including 'When a man needs a woman … ' *Female Sensibility* is one of several videos made by Benglis in which the viewer's voyeuristic position is playfully subverted.

Cosey Fanni TUTTI
Untitled (detail)
1976
Black and white photograph exhibited as part of magazine page
'Prostitution', Institute of Contemporary Arts, London

Tutti worked for two years on the 'Prostitution' project devised by COUM
Transmissions, of which she and Genesis P. Orridge were founder members.
Tutti had approached producers of sex magazines and films, presenting herself as
a model, without discussing her own project with the makers. The resulting material,
such as the photograph reproduced here, was shown as part of 'Prostitution' at the
Institute of Contemporary Arts, London, in 1976. The colour and black and white
photographs of Tutti posing alone, or with other women and men, for the sex industry
were intended to be hung on the gallery walls in their original magazine format.
Due to censorship restrictions imposed on the exhibition organizers these images
were only allowed to be viewed one at a time, in a print rack. The project also involved
performance and discussion events on issues of sex and prostitution, inviting women
who worked in the sex industry, artists and members of the public to enter into
dialogue. Materials exhibited included the artist's used tampons. Together with the
incorporation of used diapers by Mary Kelly in *Post-Partum Document*, the preceding
exhibition in the same space, this perceived transgression of aesthetic boundaries
aroused hysterical reactions from the British media and art establishment, unable
to address the political implications of the work.

As part of a description of the project which Tutti published in the ICA bulletin, she
reflected on the complex politics and psychology of production and consumption that
her investigation had revealed: 'The people who produce it think that they are "using"
the public. The producers are using the public, but in a way they either do not know
or never think or admit that they know. It is basically all a means by which they can
explore their own sexual fantasies, "using" the models, and presuming the models
don't have the intelligence to see what they are doing. I project myself into the role
of "model" knowing fully what is happening and what to expect. The only thing that
invisibly sets me apart is my perception of things. As yet I have met no one who has
seen the commercial sex world as I have, or who would care to admit it. They seem
so busy keeping their games to their related roles that they are blind to the truly
strange, complicated, ironic situation they are in.

'My projects are presented unaltered in a very clinical way, as any other COUM
project would be. The only difference is that my projects involve the very emotional
ritual of making love. To make an action I must feel that the action is me and no one
else, not a projected character for people's entertainment.'
– Cosey Fanni Tutti, Artist's statement, 1976

Barbara HAMMER
Multiple Orgasm
1976
16mm film
6.5 mins., colour, silent

The image of a cave's interior is superimposed upon the artist's filmic view of herself
during masturbation. 'Woman, with her two genital lips, is already two according to
[Luce] Irigaray; two who stimulate and embrace continually and who are not divisible
into ones. This idea, so poetically expressed, reinforced my desire to express myself
in multiple images either through superimpositions, bi-packing of two or more
images in the optical printer, or passing the film through the printer various times.'
– Barbara Hammer, Artist's statement, 1990

Hammer's experimental film juxtaposes images that refuse easy assimilation,
inviting viewers actively to confront their emotional reactions. An eco-feminist,
Hammer draws connections between natural phenomena and female sexuality.

Ketty LA ROCCA
La Vittoria di Samotracia (The Victory of Samothrace)
1974
Photograph, ink on paper
25.5 × 78.5 cm [10 × 31 in]

La Vittoria di Samotracia uses a sequential format and a graphic inscription of the word 'you' overlaid on a reproduction of a work of art. Using this found imagery from printed media as its visual source, the work progressively dissolves the original referent of the image so that it is transformed into a form that suggests the pre-symbolic. La Rocca's collages of newspaper images and words emerged in the 1960s from the context of the visual poetry and performance work of the avant-garde in Florence. In these works she subtly undermined the subliminal messages within advertising and investigated processes of translation and transcription. Her work of the 1970s evolved from a series of photographic images of hands, which explored the relationship between language and the body. Writing, reduced to the word 'you', overlays these images, questioning the distinctions between author and viewer, self and other. The use of graphic outlines first appeared in the third version of her key work *Le mia parole e tu?* (*My Words and You?*). Images of hands which make gestures like sign language are arranged in a sequence: first a photograph, then its outlines appearing as written lines of text, then a graphic diagram of the photograph. In the first panel La Rocca conceals her face with her hand, suggesting the invisibility of the self and of the female artist.

Rebecca HORN
Einhorn (Unicorn)
1970-72
Fabric and wood
Dimensions variable

A semi-naked performer wandered through a field of wheat and a forest, wrapped in an armature of bandages, connected together to form a body support for a wooden pole balanced on the head, evoking the horn of the unicorn, a medieval symbol of purity. The performance was documented in the eponymous film of 1970, and again in the film *Performances 11* (1973). In Horn's early works performers wear strange prostheses and garments, experiencing the state of constriction as a precondition for a new experience of the self.

'When I saw her first on the street, walking by – (me, dreaming my own "unicornian" dreams) – her strange rhythm, one step in front of the next …

'All was like an echo-shock of my own imagination. Her movements, a flexibility: (knowing how to use the legs entirely), but the rest of her: frozen in ice, from head to hips, and back again …

'Next weeks, finding right proportions, body weights and object heights, distances and balances …

'The performance took place in early morning – still damp, intensely bright – the sun more challenging than any audience …

'Her consciousness electrically impassioned; nothing could stop her trancelike journey … '
– Rebecca Horn, *Einhorn (Unicorn)*, 1971

Martha WILSON
Breast Forms Permutated
1972
Black and white photograph
71 × 81 cm [28 × 32 in]

This image is accompanied by the following text inscribed underneath in pencil: 'Beginning with the flat-chested example in the upper left-hand corner, breast forms can occur as either conical (down), spherical (diagonal), or pendulous (across). The intermediate forms (small-conical, small-pendulous, conical-full, pendulous-full) complete the diagram. Theoretically, the "perfect set" is located in the centre.'

Wilson's work of this period sets up a critical counterpoint between the idealized systems, permutations and grids of 1970s Minimal and Conceptual art, as well as commercial design and advertising, and the infinite variance and integrity of individual women's bodies.

Annette MESSAGER
Les tortures volontaires
(Voluntary Tortures)
1972
86 gelatin silver prints, 1 album
Dimensions variable

In this installation, presented in various combinations in different locations, Messager exhibited a selection of photographs derived from images produced by the beauty industry to promote its products and services. Although the work draws attention to the implicit violence evoked in imaging and conforming with stereotypes of beauty, the message of these fragmentary images is ambiguous: some of the 'tortures' involve cosmetic surgery, but most are depictions of mundane cosmetic treatments and procedures, which appear both banal and absurd in Messager's recontextualization.

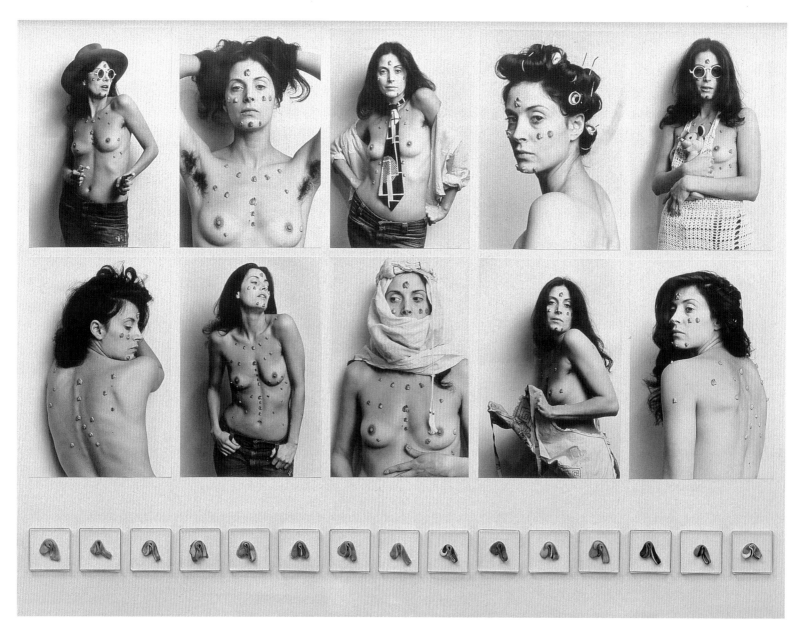

Hannah <u>WILKE</u>

S.O.S. Starification Object Series

1974–79

28 black and white photographs

15 × 10 cm [6 × 4 in] each

This photographic series arose from live performances where Wilke, topless, flirted with her audience as they chewed pieces of gum, which she then collected and arranged on the surface of her skin. These were modelled into labial shapes, derived from her exploration of vulvar sculptural forms from the late 1950s onwards. Marking her body as 'feminine' they also suggested historical scars.

'To also remember that as a Jew, during the war, I would have been branded and buried had I not been born in America. Starification-Scarification … Jew, Black, Christian, Muslim … Labelling people instead of listening to them … Judging according to primitive prejudices. Marxism and Art. Fascistic feelings, internal wounds, made from external situations.'

– Hannah Wilke, Artist's statement, 1977

'Visual prejudice has caused world wars, mutilation, hostility and alienation generated by fear of "the other". Self-hatred is an economic necessity, a capitalistic, totalitarian, religious invention used to control the masses through the denial of the importance of a body language … The pride, power and pleasure of one's own sexual being threatens cultural achievement, unless it can be made into a commodity that has economic and social utility.'

– Hannah Wilke, Artist's statement, 1980

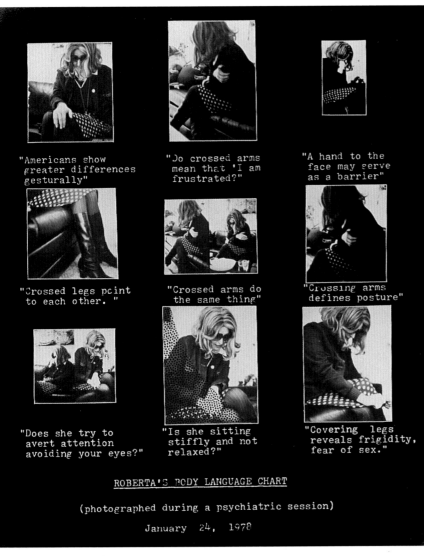

"Americans show greater differences gesturally"

"Do crossed arms mean that 'I am frustrated?"

"A hand to the face may serve as a barrier"

"Crossed legs point to each other. "

"Crossed arms do the same thing"

"Crossing arms defines posture"

"Does she try to avert attention avoiding your eyes?"

"Is she sitting stiffly and not relaxed?"

"Covering legs reveals frigidity, fear of sex."

ROBERTA'S BODY LANGUAGE CHART

(photographed during a psychiatric session)

January 24, 1978

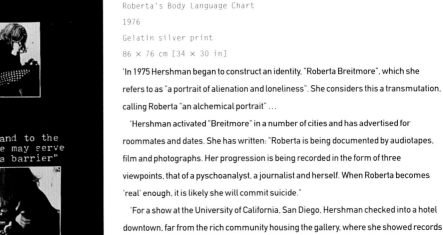

Lynn HERSHMAN
Roberta's Body Language Chart
1976
Gelatin silver print
86 × 76 cm [34 × 30 in]

'In 1975 Hershman began to construct an identity, "Roberta Breitmore", which she refers to as "a portrait of alienation and loneliness". She considers this a transmutation, calling Roberta "an alchemical portrait" …

'Hershman activated "Breitmore" in a number of cities and has advertised for roommates and dates. She has written: "Roberta is being documented by audiotapes, film and photographs. Her progression is being recorded in the form of three viewpoints, that of a pyschoanalyst, a journalist and herself. When Roberta becomes 'real' enough, it is likely she will commit suicide."

'For a show at the University of California, San Diego, Hershman checked into a hotel downtown, far from the rich community housing the gallery, where she showed records of "Roberta": stolen images of herself with her "contacts", a psychiatric work-up, a vita. She showed holograms of herself making up as Breitmore and photos of her face marked with names of the make-up used.'

– Martha Rosler, 'The Private and the Public: Feminist Art in California', 1977

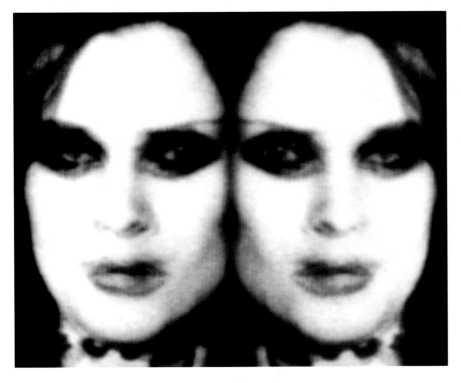

Katharina SIEVERDING
Transformer 1 A/B
1973
Digital analogue, acrylic, Perspex
2 parts, 190 × 125 cm [75 × 49 in] each

This series of works included images of performance artists Jürgen Klauke and Urs Lüthi with Sieverding, placed alongside those of androgynous rock musicians David Bowie, Brian Eno and Lou Reed. Sieverding also created photographic montages with her partner Klaus Mettig, in which their male and female faces became almost indistinguishable. Blurred boundaries and arbitrary distinctions emphasize lack of difference between self and other. For Sieverding 'the conquest of another gender takes place in oneself'. While many women artists working with images of identity were concerned with emphasizing their difference from the masculine, Sieverding explored the zones of similarity as a way to communicate 'roles, repressions … and self-extension' common to the psychology of both genders.

– all quotes from Lucy R. Lippard, 'The Pains and Pleasures of Rebirth', 1976

Francesca WOODMAN
Untitled (New York)
1979
Black and white photograph
20 × 25.5 cm [8 × 10 in]

This series of works shows the artist posed in various relationships with details of interiors; in this image the patterns on her clothing and the form of the fish bone set up a series of mediations between the artist's body and the features of the wall behind. This series of images relates to an earlier series Woodman made in 1975–76 at Providence, Rhode Island, in which her body is not distinguished from its background, as it is in later works, but seems to disappear into the fabric of a dilapidated house. Frequently blurred by movement, her body merges into the building's fragmenting structure. Abandoning overt objecthood to present herself as an 'in-between' presence, Woodman at once repels and invites the voyeurism conventionally invoked by depictions of the female body.

DIFFERENCES

In the late 1970s psychoanalytical concepts of sexual difference became influential in feminist circles. Informed by the work of post-Freudian theorists, most notably Jacques Lacan, feminist artists examined the construction of difference in visual representation. 'Difference: On Representation and Sexuality' (New Museum of Contemporary Art, New York, 1984) presented both female and male artists from the United States and Britain whose work specifically addressed the intersection of gender, cultural identity and representation. Visual artists began to focus on issues of spectatorship and voyeurism in relation to the 'Other'. Performance and installation works increasingly articulated feminist perspectives of difference across a wide range of political issues. Appropriation was explored by artists who sought no longer to make 'positive images of women' but to work critically with the existing order, exposing latent cultural meanings as well as the paternal authority inherent in notions of artistic originality.

Maya LIN
Vietnam Veterans Memorial
1982
Black granite
1. 150 m [493 ft]

Lin designed a memorial which departs radically from historical notions of the monumental. In contrast to the vertical obelisk of the nearby Washington Memorial, Lin's monument is a horizontal black granite wall that descends 10 feet (3 metres) below grade level at its vertex. The wall is inscribed with the names of the more than 58,000 United States citizens recorded killed or untraced during the Vietnam war. Viewers are reflected in the surface as they read the names. The wall reaches its deepest point at the date at which the highest casualties were recorded; its incision then decreases up to the date of the US withdrawal.

'The Vietnam Veterans Memorial is not an object inserted into the earth but a work formed from the act of cutting open the earth and polishing the earth's surface – dematerializing the stone to pure surface, creating an interface between the world of the light and the quieter world beyond the names. I saw it as part of the earth – like a geode.'
– Maya Lin, Artist's statement, 1995

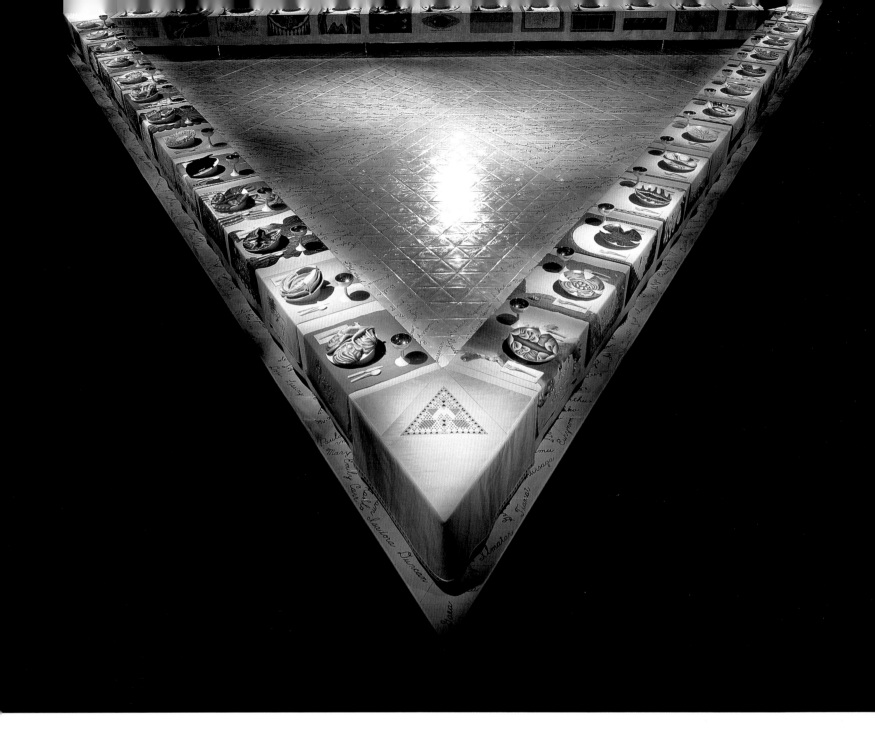

Judy <u>CHICAGO</u>
The Dinner Party
1974-79
Wood, ceramic, fabric, needlework, metal, paint
1463 × 1280 × 91.5 cm [576 × 504 × 36 in]

Over a hundred women collaborated on this monumental project. Thirty-nine place settings, each commemorating a female historical or mythological figure, are placed around an equilateral triangle formed from three tables. Each of the thirty-nine women is represented on a hand-painted plate by an abstract form based on 'central core' vulvic imagery; an embroidery and a chalice. On the base tiles are inscribed a further 999 names. The work's chronological sequence traces the social origins and decline of matriarchy, its replacement by patriarchy, the institutionalization of male oppression and women's response to it. The work toured internationally and attracted among the largest crowds ever to view a museum exhibit.

opposite

Harmony HAMMOND

Kudzu

1981

Cloth, wire, wood, celastic, acrylic, glitter, rhoplex, gesso, wax, charcoal powder

228.5 × 228.5 × 106.5 cm [90 × 90 × 42 in]

Collection, Wadsworth Atheneum, Hartford, Connecticut

'When I was driving into North Carolina in the early 1980s as a visiting artist, I saw this huge vine that seemed to grow everywhere, engulfing houses and whole stands of trees on the hillside. When I asked what it was called, I was told "Kudzu". "Kudzu" was brought into the south east over a century ago to control soil erosion but because it grows so quickly is now out of control. It seemed like the perfect metaphor for racism, homophobia and xenophobia, or people's fears of that which is "different".'
– Harmony Hammond, Artist's statement, 2000

Hammond's work often combines painting and sculpture in an attempt to acknowledge and develop the political dimensions of abstraction. Her identitification with lesbianism, and the possibility of articulating this through abstract works, emerged during her participation in the AIR (Artists-in-Residence) gallery project in New York in the early 1970s. The in-between, transitional state of Hammond's objects and narrative-like juxtapositions suggests metaphors for change. Hammond's work shows us a different view of the agricultural landscape, a terrain marked not by beauty but by hardship and struggle, exploitation and grief.

Jaune Quick-to-See SMITH

Site: Canyon de Chelly

c. 1985

Oil on canvas

142 × 107 cm [56 × 42 in]

Smith's consistent point of reference is her childhood experience on the lands of the Salish and Kootenai peoples of Montana, followed by a long period of formal European-American education. Among the most noted Native American artists, curators and environmental activists of her generation, Smith was initially discouraged from pursuing art because she was a woman. Forging alliances with the women's movement in the 1970s, she developed a feminist approach to the incorporation of materials, patterns and techniques traditionally associated with women's labour. In paintings and collages she combines these with references to the Modernist abstraction of artists such as de Kooning and Rauschenberg, to create an intercultural dialogue. In 1985 she curated, with Harmony Hammond, 'Women of Sweetgrass, Cedar and Sage', an exhibition of paintings, drawings and objects made by Native American women, at the American Indian Community House, New York. 'Like New York artists incorporating and reacting to western art history, we respond to our visual history while crossing into new territories. But in this case we are bridging two cultures and two histories of art forms.' Smith's later work, particularly her use of collage, is not without humour in its critique of the Western canon: 'Humour has been a panacea for what ails. The women tend to express their humour in a more subtle way than the men ... Humour is considered to have a role alongside the art forms, the landscape, storytelling and religion. Humour is a mainstay of Indian life.'
– all quotes from Jaune Quick-to-See Smith, 'Women of Sweetgrass, Cedar and Sage', 1985

Untitled (Film Still) No. 3

1977

Black and white photograph

20.5 × 25.5 or 76 × 101.5 cm [8 × 10 or 30 × 40 in]

In 1973, while still at college, Sherman had produced a series of photographs in which
she altered her face with make-up and hats, taking on different personae (*Untitled
A–E*). This fascination with self-transformation led her to dress up in different
costumes when attending gallery openings and events in her home town of Buffalo,
New York State. When she moved to New York City she began a series of photographs
documenting her role-playing in the series *Film Stills*, in which she posed as a variety
of familiar but unidentifiable film heroines. Sherman leaves the viewer free to con-
struct a narrative for each character, thus implicating the spectator in the voyeuristic
nature of these images. At the same time, by offering so many different characters
within the series, Sherman undermines any attempt to fix identities.

In many images Sherman appears as a seductress, caught in a moment of
pensive contemplation, looking in the mirror, lying on her bed – traditionally
'feminine' reflective activities. Speaking of these images Sherman said, 'to pick
a character like that was about my own ambivalence about sexuality – growing
up with the women role-models that I had, and a lot of them in films, that were like
that character, and yet you were supposed to be a good girl'.
– Cindy Sherman, 'Interview with George Howell', 1995

Cindy SHERMAN
Untitled No. 87
1981
Colour photograph
61 × 122 cm [24 × 48 in]

Following her untitled black and white film stills in the early 1980s, Sherman made
a group of horizontal colour images. These less obviously stereotypical images of
women in unidentifiable spaces were often photographed from above. The horizon-
tality of these photographs, the facial expressions of the women, the viewing position
and dramatic lighting used, were interpreted in different ways. Film theorist Laura
Mulvey saw these images as a further development of mechanisms of masquerade.
In her 1993 essay 'Cindy Sherman: Untitled', art historian Rosalind Krauss discussed
these works in terms of the new signifiers developed in them (backscreen projection,
colour and point of view) rather than in terms of character and role. She writes of both
high art's and the mass media's insistent use of the vertical and suggests Sherman's
transition from the vertical to the horizontal in these photographs indicates her
interest in desublimation. This is further developed in the intense lighting contrast
that complicates the relationship between the three- dimensional form of the figure
and the background.

Sherrie <u>LEVINE</u>
Untitled (After Walker Evans No. 3, 1936)
1981
Gelatin silver print
25.5 × 20.5 cm [10 × 8 in]
Collection, Metropolitan Museum of Art, New York

In presenting an identical photograph of the famous original, Sherrie Levine appropriates, literally takes, Walker Evans' image of an impoverished woman during the 1930s depression. The images by male photographers and artists which Levine appropriates invariably have as their subjects images of the 'Other' – women, nature, the poor. Levine's action not only highlights the paternal authority invested in the original image but reveals how the original in turn represents an act of appropriation in relation to its subjects.

Karen <u>KNORR</u>
Connoisseurs (detail)
1986
Colour photograph, brass plaque
103 × 103 cm [40.5 × 40.5 in]

A brass plaque placed beneath this image when it is exhibited, states 'The Genius of the Place'. Knorr often produces her work in series, specifically to contest the value system signified by the single work. The sequences of images in a series, each with a caption-like text either printed onto the photographic paper as an integral part of the work or on a separate plaque beneath, can be read as fragmented narratives with no fixed beginning or closure. Knorr's works from this period, which include 'gentlemen's clubs' among their subjects, appropriate the high society genres of group portraiture and photography of interiors, transforming the material into what the artist describes as non-portraiture – a commentary on the social mores of privileged patriarchal groups.

Louise LAWLER

Living Room Corner, Arranged by Mr and Mrs Burton Tremaine, New York
City
1984
Cibachrome
71 × 99 cm [28 × 39 in]

The artworks in this photograph are presented as two objects among other decorative
commodities within the domestic environment of the collectors' home. Lawler's
photographs showing artworks as they are privately, commercially or institutionally
displayed draw attention to the conditions surrounding the reading of art; they
investigate the social role of placement or position in the production of meaning.
Lawler's focus suggests that meaning derives not from the internal order of an
artwork but from its context. It is variable rather than fixed and depends on its cultural
and historical surroundings.

Marie YATES
Image-Woman-Text (detail)
1980
Colour photographs, photocopies, text
2 panels, 107.5 × 107.5 cm [48 × 48 in] each

Two composite panels display photographs of women's faces. In the first panel the photographs exist as photocopies which have been overpainted in a gestural style. In the second panel the same photographs are reproduced with a high gloss finish. Texts are either overprinted onto the image or appear on the white paper backing of corners of the photographs which are folded over. Interrupting the images the texts reproduce unanchored statements from various non-specific perspectives alternating between first, second and third person voices: 'In a dream'; 'I thought something was wrong'; 'The sight made her gloomy'. The images appear de-individualized, reduced to anonymous formats and styles of representation. In the process of attempting to decipher the work the viewer encounters ways in which the imaging of women is connected to the projection of fantasies.

Silvia KOLBOWSKI
Model Pleasure I, Reposition
1984
Cibachrome
41 × 51 cm [16 × 20 in]

The *Model Pleasure* series, begun in 1982, consists of ten works, each composed of a grouping of images taken from fashion and advertising plates which are rephotographed and reassembled. In reframing these images and drawing attention to their construction, Kolbowski accentuates the double meanings which the advertising industry employs in its uses of images of women. Her work seeks to understand how idealized images are projected in the context of consumerist industries, exploring the masculine attempt to fix woman within a system of spectacle, as object of the controlling gaze. *Model Pleasure I* (1982), which includes four spotlit found photographs, is rephotographed and reduced in size within the frame of the resulting work, *Model Pleasure I, Reposition*. Here the 'void' surrounding the image inset within it is itself subjected to scrutiny. It disrupts the conventional trajectory of vision associated with male positions of control over visual spectacle.

Yve LOMAX
Open Rings and Partial Lines
(detail)
1983-84
15 black and white and colour
photographs
58.5 × 81 cm [23 × 32 in] each

This photographic series is suggestive
of filmic narrative; however, the
fragmentary sequence of the images
renders such a reading elusive.

'I have attempted to bring into play the
basic assumptions of the classical model
of communication, i.e. subject/object,
sender/message/receiver. In short, to
open up these communications and not
to take them for granted. So … in the
work I have attempted to produce an
assemblage where a "middle" or "third"
term neither unifies nor fragments
nor divides.'
— Yve Lomax, Artist's statement, 1983

VERUSCHKA (Vera Lehndorff
& Holger Trulzsch)
Black door to the garden, Peterskirchen
1975
Dye transfer on paper
30.5 × 29.5 cm [12 × 11.75 in]

A celebrated fashion model of the 1960s, Veruschka (Vera Lehndorff) began to make
artworks in the 1970s. In collaboration with the photographer Holger Trulzsch, she
staged her body, camouflaged with water-based theatrical paint, to effect its partial
or complete merger with urban or natural environments. This reversal of the conven-
tional codes of representation dominant in nude photography allowed Veruschka
to transform and control her relation to the camera as a naked female subject.
' … There is something far more aesthetically engaging and philosophically astute
than a thing's appearance, and that is a thing's disappearance … In Zen meditation
the meditator is absorbed into the perceived object, becoming 'the same thing'.
The goal of the images … is the merger of the body with the found environment,
but the body never disappears completely. The extent of its absorption into the
background is the psychic charge of the image.'
— Gary Indiana, 'Ex-Model Found in Wall', 1985

Laurie <u>SIMMONS</u>
First Bathroom (Woman Standing)
1978
Colour photograph
15 × 23 cm [6 × 9 in]

A number of artists have used staged photographs to create fantastic or surreal environments. Simmons' scenarios, although seductive and humorously kitsch, ultimately focus on the banality and constriction of women's everyday lived experience. The tiny 1950s style plastic women concentrate on domestic tasks or occasionally go on outings; whatever they are doing, they appear to be 'programmed', their dream house environments becoming prisons of depersonalization.

Dara <u>BIRNBAUM</u>
Technology/Transformation: Wonder Woman
1978-79
Video
6 mins., colour, sound

Footage from the 1970s TV series *Wonder Woman*, in which an ordinary woman is transformed into a superhero, is spliced together so that the heroine is repetitively spinning, running and fighting. The repetition of these special effects is juxtaposed with the original soundtrack, which has been subjected to the same formal procedures as the images. The second part of the video includes the lyrics of the pop song 'Wonder Woman', reproduced in white letters on a blue background, drawing attention to its sexist and politically reactionary ideology. Through a complex series of manipulations Birnbaum's work draws attention to and transforms the ideological messages which underlie technologically mediated mass cultural forms.

Laurie <u>ANDERSON</u>
United States
1979-83
Multimedia performance and recording

Anderson's seven-hour opus is divided into four sections – *Transportation, Politics, Money, Love*. Broadening her focus from the personal, autobiographical tone of her earlier solo performances, *United States* is a multimedia examination of the social codes, linguistic and sign systems by which information is transmitted and received in urban society, and of their ideological implications. Fast-changing projections of a wide range of urban imagery create a sense of geographical and temporal dislocation, compounded further by Anderson's multivocal narratives and her fusion of human and synthetic, technocratic messages and sounds. Further undermining the stability of her identity as performer through parody and quotation, Anderson assumes an almost shamanistic role, both orchestrating and mediating the messages of a technocratic society.

Sarah CHARLESWORTH
Red Mask (from Objects of Desire)
(detail)
1983
Laminated cibachrome print,
lacquered wood frame
102 × 76 cm [40 × 30 in]

Objects of Desire is a series of
photographs which examine the
seductive powers of photography.
Exterior trappings of identity, the forms
and postures of seduction – a scarf,
a mask, a shock of blonde hair –
are presented within the high sheen
of laminated surfaces, emphasizing the
fetishistic nature of their significance
and allure. Since the late 1960s when she
came into association with Conceptual
artists Douglas Huebler and Joseph
Kosuth, Charlesworth has made
conceptual photographic work which
re-uses pre-existing imagery to explore
cultural values.

Jenny HOLZER
Truisms
1977-82
Spectacolor sign
Project, 'Messages to the Public', Times Square, New York, 1982

Holzer began to make *Truisms* after she moved from Rhode Island to Manhattan
in 1977 to join the Whitney Museum of American Art's Independent Study Program.
Adapting the language-based practice of her male Conceptual art predecessors for
an interventionist, more directly politicized use, Holzer extensively researched social
statements such as truisms from a wide range of sources. She adapted this material
to construct texts that mimic the authoritative voices of capitalism and mass culture.
By making the statements gender neutral, and presenting them as if they were
familiar and accepted, Holzer highlighted the subliminal influences of social
conditioning on the unconscious. Originally printed in black type on white paper and
pasted, anonymously, onto walls around Manhattan, the *Truisms*, and other related
series, were later presented in a range of media which included printed T-shirts,
billboards and electronic signs.

Barbara **KRUGER**

Untitled (You are not yourself)
1982
Black and white photograph
183 × 122 cm [72 × 48 in]

Barbara Kruger's work of the early 1980s registers her generation's turn away from the immediately preceding strategies of feminism. Female solidarity had been explored and celebrated but it was now perceived that there had been a failure to challenge the fundamental ideological structures from which discrimination emanates. In 1982, alongside making her work, Kruger began to write criticism which addressed latent ideologies in cinema, a prevailing subject of feminist theory in which gender and sexuality came increasingly to be perceived as constructions produced through the signs of representation. Kruger, who had formerly worked as a commercial graphic artist, directed her focus to the media's strategies of producing normalized subjects, who conform to its ideological, social and economic orders. Like Holzer, she observed that coercion was effected through the way we receive verbal or visual messages, as we consume the codes circulated by anonymous sources of power. Kruger sought to intercept this process and reverse its logic. When she deploys the personal pronouns 'I', 'me', 'we' and 'you', known in linguistics as 'shifters', instead of being invested with the coercive authority of advertising, they begin to reveal ways in which the place of the viewer in language is indefinite, refusing alignment with gender. Rather than 'masculine' or 'feminine' positions, there emerges an interplay between 'active' and 'passive' relations.

Heart-shaped Bruise, New York City, 1980 (from The Ballad of Sexual
Dependency)
1980
Colour photograph
Dimensions variable

Since the early 1970s Nan Goldin has documented every aspect of the lives of herself
and her intimate friends. 'The Ballad of Sexual Dependency is the diary I let people
read … There is a popular notion that the photographer is by nature a voyeur, the last
one invited to the party. But I'm not crashing; this is my party. This is my family, my
history … I don't ever want to be susceptible to anyone else's version of my history.'
– Nan Goldin, The Ballad of Sexual Dependency, 1986

The work was first shown at the Mudd Club, New York, in 1979, as a slide show
accompanied by recordings of contemporary rhythm and blues and rock ballads.
An ongoing project, it has been shown in many venues and formats around the world,
ranging from nightclubs to art centres. In 1986 one definitive selection of images
from the series was published in a book of the same title. Goldin's own experiences,
transformations and relationships are seen as interdependent with those of the
friends who shape her sense of a recreated family and whose trust establishes
the basis of her representational frame.

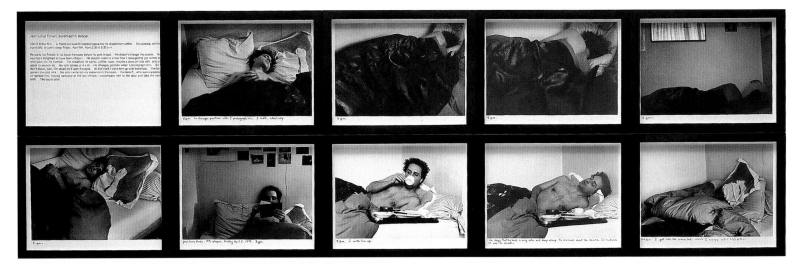

Sophie CALLE
The Sleepers (Jean-Loup Forain) (detail)
1979
Black and white photographs, text
Dimensions variable

When Calle returned to her home city of Paris after a period of seven years travelling, she felt compelled to begin a series of projects to reacquaint herself with the city, its people and herself. At this stage, she did not view her activities as art which could be exhibited, but as private social experiments which were of personal significance. She entered a series of real life roles, including that of a striptease artist, which she fulfilled for a limited time and documented. In this work she invited strangers to come into her apartment and sleep in her bed when she was not using it. She documented their presence there, and her conversations with them, as they explained why they had responded to the invitation and described their lives and their patterns of work and rest.

Sophie CALLE
Suite vénitienne
1980
Black and white photographs, text
Dimensions variable

Suite vénitienne documents Calle's journey to Venice in pursuit of a man whom she had seen briefly at a party in Paris. He did not know that he was being followed. She located the hotel in Venice where he was staying and photographed her subject at every opportunity, recording the places he visited and what he himself photographed. Over a two-week period, disguised by a blonde wig, Calle learned his plans by questioning people in the shops and bars he had visited. He eventually discovered that he was being followed and confronted her. She took a different train from him back to Paris in order to wait for his arrival and take her last picture. The photographs are presented in sequence with a text below describing the course of events. In 1988 the French theorist Jean Baudrillard wrote an essay describing this project in terms of a reciprocal loss of will on the part of both the pursued and the pursuer. This was published alongside the artist's work in a book of the same title.

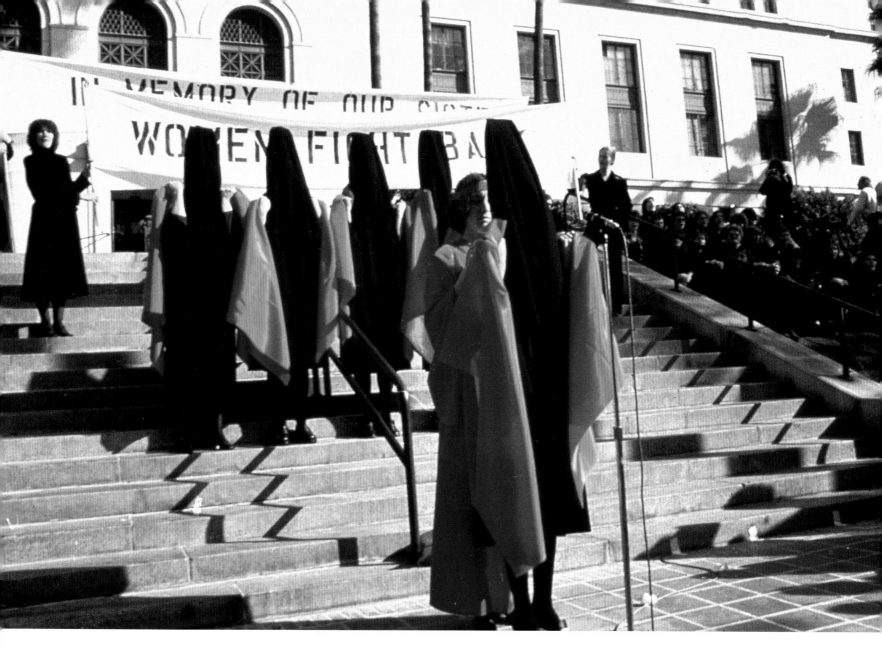

Suzanne LACY and Leslie LABOWITZ
In Mourning and in Rage
1977
Performance
Los Angeles City Hall

This action, Lacy's first collaboration with Labowitz, formed a powerful and succesful protest against the local media's sensationalized coverage of a series of rape-related murders of women in Los Angeles. Media reports had exploited women's fears and vulnerability for commercial gain, offering no access to support lines, participatory debate, or other means of empowerment. The artists and their collaborators co-ordinated the support of local council officials and others in their actions, which effected a swift turnaround in the attitudes of the newspaper journalists and TV broadcasters. For *In Mourning and in Rage*, both a memorial and a public address, black garments worn by the women participants symbolized mourning; the costumes created an artificial sense of height, transforming the women into seven-foot high, powerful presences; red shawls evoked both pain and anger. This action was one of the major events in a city-wide Los Angeles project centred on abuse of women, *Three Weeks in May*, organized by Ariadne: A Social Network. Founded by Lacy and Labowitz, Ariadne evolved into a nationwide organization for women.

Hannah <u>WILKE</u>

What Does This Represent? What Do You Represent? (Reinhardt)

1978-84

Black and white photograph

152.5 × 101.5 cm [60 × 40 in]

In 1945 the New York school painter Ad Reinhardt drew a cartoon of a man pointing to an abstract painting, jeering, 'What does this represent?' Below, the painting reconfigures itself into an angry face, sprouting legs and a pointing arm, shouting at the bewildered man, 'What do you represent?' In Hannah Wilke's work the artist, naked except for make-up and stiletto heels, wearing an ambiguously victimized and defiant expression, sits with legs spread so that her genitals are placed at the centre of the image. Reinhardt's text is printed over the area of the floor, on which are scattered 'boy's toys', including model pistols and machine guns. The piece redirects Reinhardt's ironic word play specifically towards the balance of power in gender representation. This work is part of Wilke's *So Help Me Hannah* series of self-portrait performances, recorded on video between 1979 and 1985. Each image is overprinted with quotations from male artists and philosophers.

Marina <u>ABRAMOVIC</u> and <u>ULAY</u>

Relation in Time

1977

Studio G7, Bologna

Marina Abramovic and Ulay sat for sixteen hours, back to back, tied together by their hair, without any movement, isolated from the audience. When this time had elapsed, viewers could enter. The artists held their pose for a further hour. The gaze of the artists outwards rather than towards each other rendered both vulnerable to the audience's direct gaze. However, direct engagement by the audience was denied by inviting them to enter the room towards the end of the performance, leading to a sense of intrusion. The physical and emotional bond between the artists forged by the action heightened both their mutual closeness and their distance from the audience. When Abramovic and Ulay began to collaborate in 1976 they spoke of themselves collectively as an androgynous being. The series of relation works they performed in the mid 1970s moved between socially defined poles of masculinity and femininity, engaging spectators in their own exploration of the boundaries of relationship.

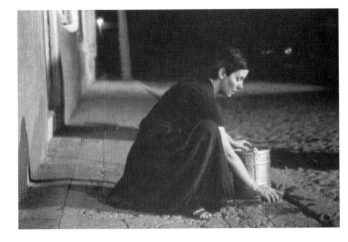

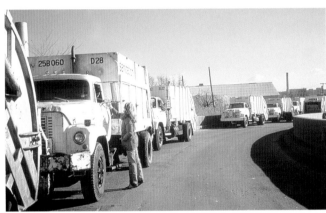

Diamela ELTIT
Maipu
1980
Santiago, Chile

Eltit inflicted cuts and burns on her arms and legs before going to a brothel where she read aloud part of a novel she had written. She then washed the pavement in front of the brothel. 'The self-mortification of her body testifies to a refusal to accept the model of beauty which makes a fetish of the woman ... In all of Eltit's work the woman is mainly portrayed in situations which locate her on the edge of the social system, or on the verge of always being excluded from its symbolic contract. These situations exacerbate her sense of alienation in a world ruled by masculine representations; borderline situations where she has to make the most of her relationship to language and its codes of representation and reality.'
– Nelly Richard, 'The Rhetoric of the Body', 1986

Mierle Laderman UKELES
Touch Sanitation
1979-80
New York

This project was begun on 24 July 1979 and continued until 26 June 1980, the time it took Ukeles to travel with and work alongside every single one of New York's 8,500 sanitation workers. The project required her to shake hands with every one of these workers in order to represent a 'healing vision' and 'share' in the housekeeping of the city, a 'maintenance ritual act celebrating daily survival'. Ukeles drew attention to the maintenance activities of daily life, those chores that women regularly assume and without which society would fall apart. She sought to highlight the fact that the enacting of these chores is generally taken for granted, and those who maintain our cities receive no acclaim.

Adrian PIPER
Funk Lessons
1982-84
University of California at Berkeley

Piper enacted a series of collaborative performances with both large and small audiences. Funk has its origins in African tribal music and dance, where the concern is with participation as a collectively shared experience of pleasure and unity. Piper began by introducing some of the basic dance movements to the white participants, discussing their cultural and historical meanings and their roles within black culture. The participants would then rehearse, internalize and improvise on these movements. Piper concentrated on the structural features, major themes and subject matter that define funk music and its relation to disco, rap, rock, punk and new wave. Her performances attempted to overcome cultural and racial barriers and divisions between high and low culture in order to politically activate these spaces.

Howardena PINDELL
Free, White and 21
1980
Video
12 mins., colour, sound

This piece is a video self-portrait that recounts several of Pindell's experiences as an African-American woman growing up in the United States. It recounts her childhood experience of being cared for by a white babysitter; her experiences in kindergarten; as a student in high school; in university; receiving a job rejection; and finally being treated badly at a wedding, as the only black woman present. During these accounts a white woman interjects with: "you don't exist until we validate you"; "and you know, if you don't want to do what we tell you to do then we will find other tokens"; and finally: "and you really must be paranoid. I have never had experiences like that. But, of course, I am free, white and twenty-one" The work directly criticizes white feminists and the racism prevalent within the art world. Pindell worked with the Heresies collective and other feminist groups. This video was first shown in the exhibition 'Dialectics of Isolation: An Exhibition of Third World Women Artists in the United States' in September 1980 at AIR Gallery, New York, curated by the artist Ana Mendieta.

Rose <u>FINN-KELCEY</u>

Mind the Gap

1980

'About Time: Video, Performance and Installation by 21 Women Artists', Institute of Contemporary Arts, London, and Franklin Furnace, New York

'Two parallel running tracks were marked out on the floor, heading in opposite directions, each into a dead end. Facing each other across the tracks were a large block of ice and a treadmill/moving carpet … A small flickering tongue of electric light on a stand, a Marconi radio facing a microphone, rows of chairs for the audience, these completed the scene. We took our seats and were soon enveloped in the sound of numbing musical platitudes, supermarket muzak, absurdly contrasting with the formal beauty of the installation … Rose's recorded voice periodically overlaid the music. Each insertion described a working idea, generally discarded, occasionally carried out. "The steam from six kettles against the energy produced by her running on the treadmill. Could she outlast the evaporating water?" … Was the artist ever going to appear? Her recorded voice had claimed that she would not … As I was concluding that she would not appear, Rose emerged from the darkness … She was carrying two weightlifter's dumb bells linked by a fine wire. With great care, she hung them over the block of ice and left them to rotate gently … A man's voice on the tape read a passage from Mary Kelly's Frankenstein in which the inventor faces his own creation. Here we can identify the artist exhausted as her creation comes to life and she can see that it has inherited all the imperfections of its creator's intentions. The treadmill at last came into lumbering life. Rose climbed onto the machine … she broke into a slow jog … Rose became a ghostly figure, headless and handless, as the ultra-violet light picked out only her clothes. The white figure then disappeared. The tape ended with the shattering sound of an earth rift and the all clear siren …

'I sense the danger of continually focusing on the hardships and contradictions facing the woman artist, but in this image of the runner, Rose Finn-Kelcey has been able to produce a positive, powerful work which sacrifices nothing to truth but, in the use of ambiguity, irony and sharp observation, has been able to transcend what can so easily become a self-defeating pessimism.'

– Catherine Elwes, 'Rose Finn-Kelcey, *Mind the Gap*', 1980

Catherine <u>ELWES</u>

Menstruation

1979

A three-day performance at the Slade School of Art, London, to coincide with the duration of a menstrual period, this work was also presented in 1980 in the 'About Time' exhibition at the Institute of Contemporary Arts, London. Dressed in white, against which the menstrual blood was visible, Elwes inhabited a glass-fronted white box-like room. She was asked questions by the audience to which she responded by writing on the walls and the glass. The work was intended to reconstitute menstruation as a metaphorical framework by giving it the authority of cultural form and placing it within an art context.

'My work currently involves my presence as a live element interacting with pre-recorded dialogues or monologues. I try to set up a network of shifting identities that draw the viewer/listener in at various levels. In this way I allow her/him a freedom within the work to make a series of identifications or deductions that enable her/him to complete the "story". Time past, present and future is the medium through which memories, fantasies and projections emerge as a sequence of fluctuating images. The work reflects the social and psychological position I share with many women of my generation. I inherited a set of values that were challenged in the 1970s by a growing awareness of the women's movement. I saw the possibility of freeing myself from an old order that restricted my development as an individual and as an artist … I base my work on a continued analysis of that past in order to build an understanding of present conflicts as a bridge to a possible future.'

– Catherine Elwes, 'Each Fine Strand', 1980

Rose <u>GARRARD</u>
Beyond Still Life
1980
'About Time: Video, Performance and Installation by 21 Women Artists',
Institute of Contemporary Arts, London, and Franklin Furnace, New York

From a revisited childhood incident Garrard developed a performance exploring
relationships between representation and female subjectivity within a perspective
of layered time. Seeing her older brother kill a sparrow had overwhelmed her capacity
to express her feelings, afraid that her expression of outrage would be perceived as
weakness. She had quietly retrieved the dead bird and placed it next to a book and
vase she was painting at the time, in an attempt to create a 'still life'. In Garrard's
performance, a book recreating this scene lay open at the myth of Pandora, from
which extracts were read by a recorded male voice. 'Recalling this small but traumatic
event to which I remained a passive observer, led me to examine my detached "still
life" roles – the artist as observer, the passivity of the female model – and the role of
active performer seen usually as a scene of masculine power … the prejudiced roles
of these familiar stereotypes are questioned as the artist alternates between being
performer, subject and spectator in relation to the objects.'
– Rose Garrard, Artist's statement, 1980

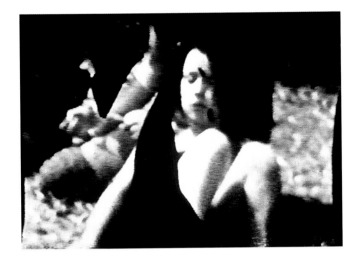

Tina KEANE
In Our Hands, Greenham
1984
12 video monitors, coloured spotlights, scaffolding
Dimensions variable

Set within a blockade-like structure, twelve video monitors show women peace campaigners at Greenham Common, England, a major site of United States nuclear missile installations during the 1980s. The women join hands around the base's perimeter fence, into which they weave strands of wool, decorating it with family photographs and personal memorabilia. These images are juxtaposed with film of a spider spinning its web: the imagery is framed by the outline of a woman's hands. 'The symbol most closely associated with the women's peace movement is the weaving of webs. Each link in a web is fragile, but woven together creates a strong and coherent whole.'
– Alice Cook, Gwyn Kirk, *Greenham Common Everywhere*, 1984

Margaret HARRISON
Common Land/Greenham (detail)
1989
Installation of found objects, painting, wire fence
Dimensions variable

Harrison's installation, exhibited in Britain and the United States, connected the political issues and symbolism of the women's peace movement with debates about feminist painting and the representation of landscape. Since 1981, when the peace camp was first established at Greenham Common, the women had been charged with trespass. In their defence they argued their historic rights to occupy common land. At Greenham, issues of power, property, ecology and gender converged. Harrison's installation recreated the women's action of festooning perimeter fences with clothes and other symbolic objects and included quotations from both protestors and their military adversaries. The landscape paintings incorporated in the work challenged the ahistoricism of romanticism, portraying landscape as a genre of historical and political transformation.

Mona HATOUM
Under Siege
1982
Aspex Gallery, Plymouth

In this performance the naked artist struggled to remain standing in a transparent plastic cubicle filled with wet clay, repeatedly slipping and falling. Three different soundtracks of revolutionary songs, news reports and statements in English, French and Arabic created a sound collage that filled the space. This work functioned as a statement about the persistent struggle endured by marginalized groups in a state of constant seige, an experience Hatoum had encountered as a Palestinian woman in European society, unable to return to Beirut because of the war. One week after this performance Lebanon was invaded and Beirut was under siege.

IDENTITY CRISES

A number of feminist artists had become internationally successful by the close of the 1980s. Theoretically engaged work was widely debated in art journals such as *Artforum* and *October*. Artists explored the subversive possibilities of female spectatorship. A new generation of African-American and black British feminist artists explored the intersection of racial and sexual identities and the legacies of colonialism, and drew attention towards the dominance of white women within feminism. Female performance artists questioned distinctions between art, popular culture and lived experience, and explored bodily taboos. These artists were especially vulnerable in the United States 'culture wars' of the late 1980s. Conservative politicians attacked public arts funding for work which gave voice to the 'transgressive' expression of communities marginalized through gender, racial and sexual exclusion. Graphic activists responded, addressing the political dimensions of rape, abortion, AIDS, and the continuing marginalization of women in the art world's institutions.

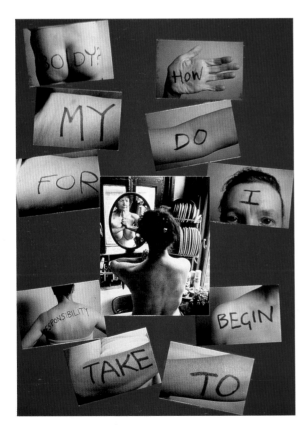

Jo SPENCE
How Do I Begin to Take Responsibility for My Body?
1985
Colour photomontage
70 × 50 cm [27.5 × 19.5 in]

In 1979 Spence was diagnosed with breast cancer. Rejecting conventional treatment, she explored holistic therapy, and the personal and feminist political dimensions of living with cancer. Spence used the term 'photo-therapy' to define her collaboration with the photographer Rosy Martin. In this image, the central photograph by Maggie Murray of Spence performing breast-strengthening exercises before a mirror is surrounded by 'images of my fragmented body which had been written on and staged for the camera in a photo therapy session with Rosy Martin. My aim is to try and form a bridge between work done on health struggles, usually dealt with through documentary photography, and work done on body as image. An understanding of how these spheres relate seems to me essential to being healthy and well balanced.'
– Jo Spence, *Putting Myself in the Picture: A Political and Photographic Autobiography*, 1985

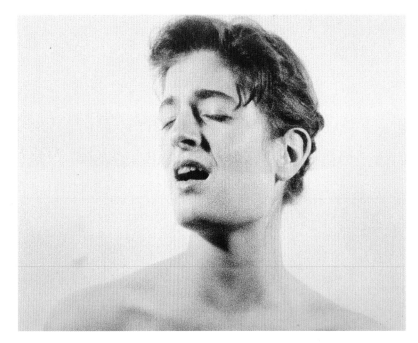

Geneviève CADIEUX
Hear Me with Your Eyes
1989
Black and white resin coated
prints and chromogenic print
mounted on wood screen
Triptych, 249 × 310 cm [98 × 122
in] each

Cadieux's huge photographic panels portraying close-up images of the human face or body evoke conflicting emotions in tension – fear and euphoria, desire and repression, articulation and silence. They raise questions about the relationships between the body, desire and gesture in the face of contemporary crises of subjectivity. Their large-scale format imposes a claustrophobic response, refusing the viewer the reassurance of distance. At the same time, however, they also suggest an oceanic sense of emotional and expressive release. One of the work's relationships to other media is the use of the visual lexicon and limitations of cinematic frames for the representation of pain or desire. Cadieux addresses the idea of the sublime, freezing moments that seem to have the potential to disrupt or transcend the limits of signification.

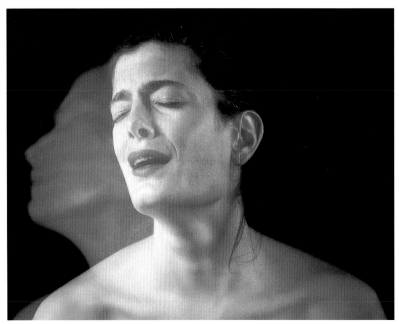

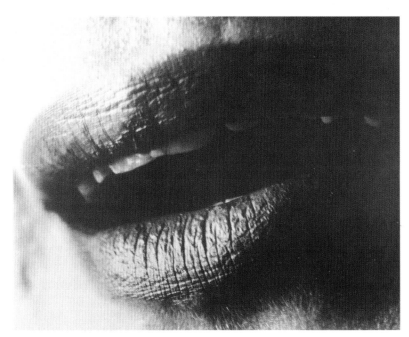

LOOKING INTO THE MIRROR, THE BLACK WOMAN ASKED, "MIRROR, MIRROR ON THE WALL, WHO'S THE FINEST OF THEM ALL?" THE MIRROR SAYS, "SNOW WHITE, YOU BLACK BITCH, AND DON'T YOU FORGET IT!!!"

Carrie Mae <u>WEEMS</u>
Mirror, Mirror
1987-88
Gelatin silver print
51 × 41 cm [20 × 16 in]

Weems has worked since the mid 1980s with visual and verbal narratives that
address African-American experience of racial and gender stereotyping and
oppression. She offers possible strategies for black women's self-recovery, through
the engagement of various levels of reading of African-American cultural forms such
as folklore, as well as representations from white culture. Weems combines and
subverts the cultural expectations of viewers approaching the work from various
perspectives, using tableaux, narratives, ironic and sardonically humourous images
and texts. Prejudice based on skin colour is addressed directly in *Mirror, Mirror*,
part of the *Ain't Jokin* series. The work ironically rebounds upon and thus renders
impotent the genre of the racist joke. At the same time, *Mirror, Mirror* communicates
dilemmas of identification for both black and white women who encounter the work,
inviting each to question the notions of beauty in which they situate themselves.

Carrie Mae <u>WEEMS</u>
Untitled (Kitchen Table Series) (detail)
1990
Gelatin silver print
68.5 × 68.5 cm [27 × 27 in] each

In this series of photographs Weems stages a domestic scene in which gestures
and everyday objects convey unspoken messages about African-American identities
and their representation, using herself as one of the subjects in the images.
'When I was constructing the *Kitchen Table* series, Laura Mulvey's article "Visual
and Other Pleasures" came out, and everybody and their mama was using it, talking
about the politics of the gaze, and I kept thinking about the gaps in her text … All the
pieces in the *Kitchen Table* series highlight "the Gaze" … using that as the beginning
and the turning point … to start creating a space in which black women are looking
back … and challenging all those assumptions about the gaze, and also questioning
who is in fact looking. How much are white women looking? How much are black
men looking?

'The work is very class based. It is working-class based; I think that reality shapes
the pictures – the way the images are constructed. I'm very interested in ideas about
blues and jazz, that expressive musical culture. That's where I function … But how
do you again use that, how do you … begin to construct a visual world that this music
is played in, that's generated by the culture that the music creates. So in doing the
Kitchen Table piece, it was always about how you construct it. How do you make
a blues piece? What does that look like?'
– Carrie Mae Weems, quoted in bell hooks, *Art On My Mind: Visual Politics*, 1995

eyes in

the back of

your head

Dear Friend,
 I am black.
 I am sure you did not realize this when you made/laughed at/agreed with that racist remark. In the past, I have attempted to alert white people to my racial identity in advance. Unfortunately, this invariably causes them to react to me as pushy, manipulative, or socially inappropriate. Therefore, my policy is to assume that white people do not make these remarks, even when they believe there are no black people present, and to distribute this card when they do.
 I regret any discomfort my presence is causing you, just as I am sure you regret the discomfort your racism is causing me.
 Sincerely yours,
 Adrian Margaret Smith Piper

Adrian PIPER
My Calling Card 1
1986-90
Guerrilla performance with calling card
Card, 5 × 9 cm [2 × 3.5 in]

Piper frequently found herself at a dinner or cocktail party where the guests were almost exclusively white. The guests, not aware of Piper's African-American identity (she is of mixed race parentage), would freely engage in racist conversation. As one of a range of options Piper established to deal with such situations, she presented this 'calling card' to each person who had acted in this way. Piper describes this and other similar actions as reactive guerrilla performances.

Lorna SIMPSON
Back
1991
2 colour Polaroids, 3 plastic plaques
63.5 × 105.5 cm [25 × 41.5 in]

This is one of a series in which Simpson has assembled fragmented Polaroid images of a female model whom she has regularly collaborated with; at other times, in a work such as *Guarded Conditions* (1989) Simpson has used images of her own body. In both cases, the body is fragmented and viewed from behind. The back of the model's head is sensed as being in a state of guardedness towards possible hostility she can anticipate as a result of the combination of her gender and the colour of her skin. In this image the complex historical and symbolic associations of African-American hairstyles are also brought into play. The message of the text and the formal treatment of the image reinforce a sense of vulnerability. The fragmentation and serialization of bodily images disrupts and denies the body's wholeness and individuality. In attempting to read the work the viewer is provoked into confronting recent histories of Western appropriation and consumption of the black female body.

Mitra TABRIZIAN (with Andy Golding)
The Blues (detail)
1986-87
Colour photographs, text
3 triptychs, 130 × 180 cm [51 × 71 in] each

This series of three triptych works uses as a unifying motif the African-American musical form of the blues, which offers an attempt to achieve meaning in a situation fraught with contradictions. The blue colour is also an integral part of the *mise en scène* of crime films, and the photographs use the codes of film posters to present untold stories, critical moments in black subjects' confrontations with the status of whiteness. No matter what position he is placed in, under police interrogation, in prison, in a low-paid job, the black male subject of the work questions the centrality of white male identity. The work begins with a confrontation between men, derived from the artist's reading of Frantz Fanon's study of the traumatic effects of colonialism, *Black Skin White Masks* (1952). It ends with the encounter between a black man and a black woman, as Tabrizian extends and reinterprets Fanon's political analysis of binary oppositions and constructions of difference, addressing their wider implications for relations between women and men.

Mary KELLY

Interim Part I: Corpus (detail)

1984-85

Laminated photo positive, silkscreen, acrylic on Plexiglas

2 of 30 panels, 122.5 × 90 cm [48 × 35.5 in] each

Corpus is a component of the *Interim* project, an installation comprising thirty panels of silkscreened and laminated photographs on Plexiglas. It invokes the body (corpus) through photographs of folded, twisted and knotted articles of clothing placed alongside panels of hand-written first-person accounts of the experiences of ageing. These images take the place of imagery of women's faces or bodies (which was considered by Kelly at that time to be problematic) in order to explore the notion of femininity and the social order that names and describes it. Kelly's work makes reference to the photographic records of 'female hysteria' made by the nineteenth-century French neurologist J.-M. Charcot. The clothing is arranged in similar exaggerated poses to those of the women in his photographs and labelled with the terminology he gave to the so-called 'passionate attitudes' which accompanied hysterical attacks. *Interim* challenges the notion of the condition of 'femininity' as biological and re-situates it within the order of discourse and language, as a cultural construct.

Rosemarie <u>TROCKEL</u>
Untitled
1985
Wool
2 panels, 40 × 50 cm [16 × 19.5 in] each

Trockel's knitted works of the 1980s can be seen as comments on female art production as well as on Pop and Minimal art. They also question the function and meaning of symbols. The artist talks explicitly of the 'depreciation' she intends to inflict upon the visual elements she has selected, which lose their ideological significance as they become 'purified' into a geometrical motif. Trockel focuses on what has been 'removed' from the realm of art by reintroducing a discussion of the categories of creativity; in so doing she aims at positing a re-definition of historical, feminine creativity. Decorative motifs, presented as autonomous and formal, occupy a realm of ambiguity between figuration and abstraction, shedding their original meaning and assuming a new, uncertain identity.

2 panels, 40 × 50 cm [16 × 19.5 in] each

Helen CHADWICK
Of Mutability
1986
left
Carcass
Organic and vegetable matter, glass
228.5 × 61 × 61 cm [90 × 24 × 24 in]
below and opposite
Oval Court
Colour photocopies, wood, paint, mirrors
Dimensions variable
'Helen Chadwick: Of Mutability', Institute of Contemporary Arts,
London
Collection, Victoria & Albert Museum, London

For the installation *Of Mutability*, Chadwick made photocopied images from her body alongside images of dead and decaying flora and fauna, presenting them in a raised, pool-like, cyclical installation. The body's poses mimic famous displays of the female subject, such as Bernini's *Ecstasy of Saint Theresa*. Five golden spheres were placed on top of the pool. On the surrounding walls were *trompe l'oeil* colonades on paper scrolls and vanitas mirrors depicting the artist's face. Presenting her own body in poses of allegorical excess, Chadwick invited the viewer to interpret it metaphorically. The sadomasochistic qualities of the iconography – the noose around her neck, the hood over her head, the axe in her groin – are a reminder of the destructiveness inherent in consumption. Through the plurality of her image – her body appears twelve times – the artist herself disappears into the impersonal realm of the flesh and the senses. *Carcass* was installed in the space adjoining *Oval Court*. It comprised a glass container in which remnants of material used to make the cornucopia images for *Oval Court* were packed, together with household refuse, and left to decay. This was intended as a *memento mori* of the work's construction. 'The boundaries have dissolved, between self and other, the living and the corpse. This is the threshold of representation ... '
– Helen Chadwick, *Enfleshings*, 1989

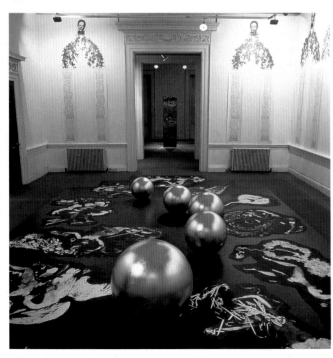

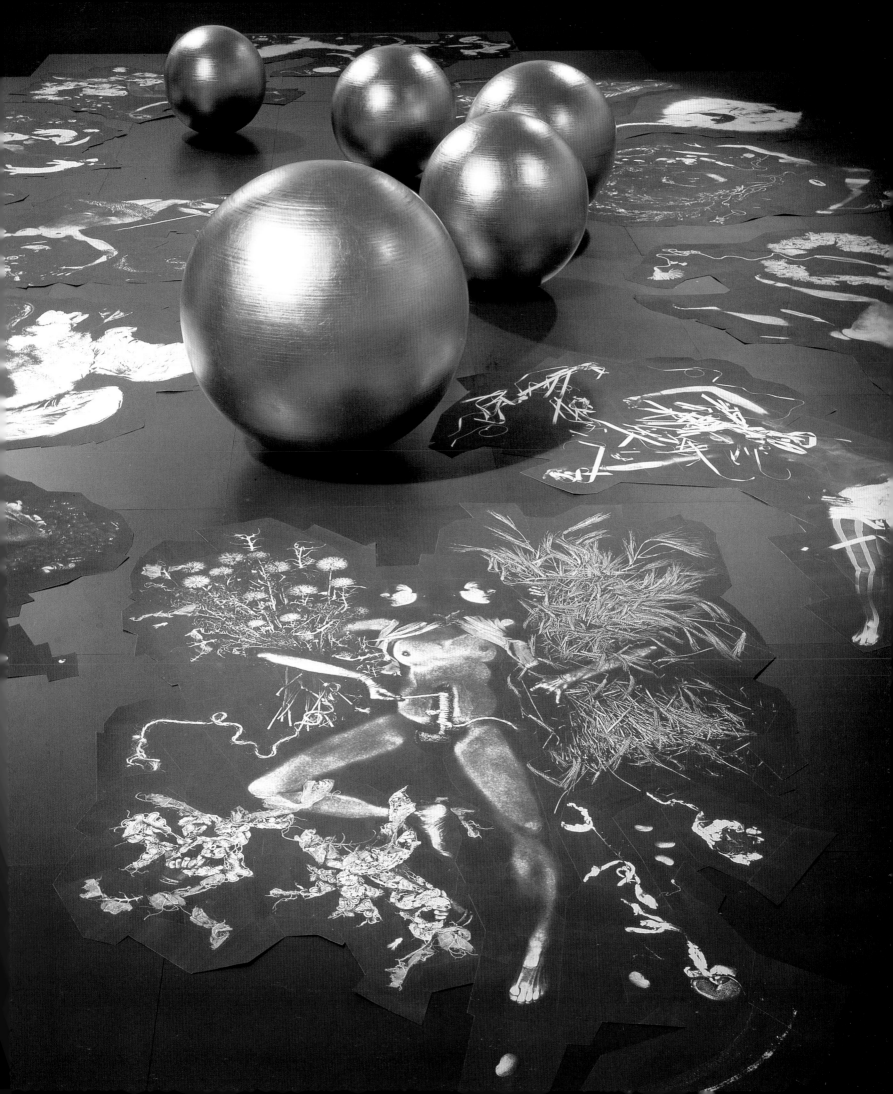

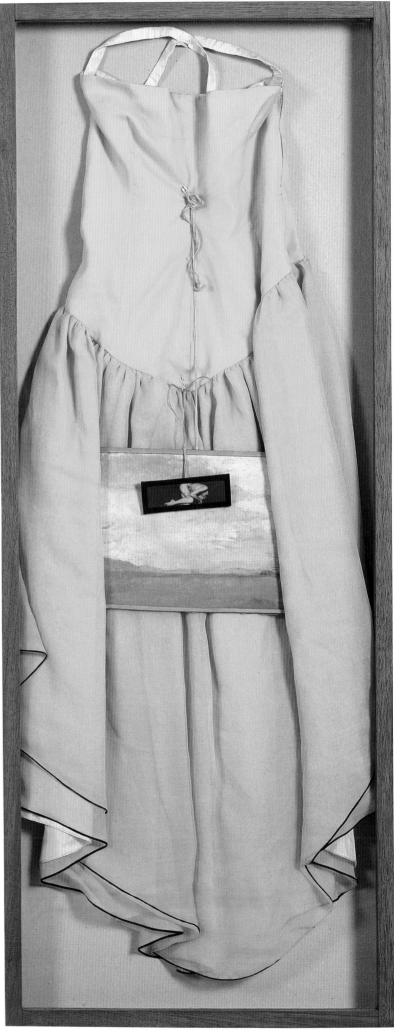

Annette <u>MESSAGER</u>
Histoire des robes (Story of
Dresses)
1990
Dresses, pastel drawing, black
and white photographs, string,
pins, wood, glass
376 × 353 × 18 cm [148 × 139
× 7 in]

Encased in shallow glass vitrines, small paintings, framed photographs and texts are attached to dresses in a manner reminiscent of religious shrines. In this work Messager has refined her longstanding investigation of the subjugation of the female body to the point at which images of the body are no longer directly conspicuous but are replaced by the metaphorical presence of clothing, which she here views as a 'second skin', embodying all the secrets and hopes of everyday existence.

Jana <u>STERBAK</u>
Remote Control
1989
Steel frame, electronic controls
h. 127 cm [50 in]
Collection, Museu d'Art Contemporàni, Barcelona

Sterbak created two, larger than human scale, mechanized structures based on the historical form of the crinoline dress. Once lowered into one of the crinolines, the performer, who is suspended above the ground, can mobilize herself using a radio-operated remote control mechanism, enabling her to glide around the room. However, even though the remote control is in the performer's hands, her movements are determined by those of the mechanical apparatus. The work interactively critiques the complex, culturally inscribed performance of 'femininity'.

Lubaina <u>HIMID</u>
We Will Be
1983
Wood, paint, drawing pins, wool, collage, silver paper
183 × 91.5 cm [72 × 36 in]

British artist Himid was born in 1954 on the African island of Zanzibar, then still a British colony, now part of the independent republic of Tanzania. Himid's work excavates repressed and forgotten histories of the experiences and culture of people of African descent. She brings these histories into contemporary contexts where white social and historical hierarchies are questioned and challenged. Her figures often evoke the Nubian physiognomies and cultural forms of the Egyptians whose civilization was absorbed into classical Greek culture – an African influence that was gradually denied and written out of European history from the early period of the European slave trade until the late twentieth century. Important to her work is painting's intersection with decoration and adornment in the everyday life of cultures which have been marginalized. Himid also draws on the tradition of history painting, depicting moments where black women are visible in history and are active in determining its course.

Mona HATOUM
Measures of Distance
1988
Video
15 mins., colour, sound

Arabic script, taken from letters Hatoum's mother wrote to her in London from Beirut, rolls over the screen like a veil, covering the still photographs of her naked mother in the shower. The images were taken by Hatoum on a visit to her home in Beirut. Her voice-over translates the text which speaks of her mother's sorrow at the distance which separates her from her daughter. The complexity of the piece is an interplay of the closeness and distance which political circumstances have forced upon this close bond between mother and daughter, the centrality of language, and their trespass on patriarchal law ('don't mention a thing about it to your father'). These issues of identity and alienation recur throughout Hatoum's work as an exiled woman living in London.

Susan HILLER
Belshazzar's Feast
1983-84
Video installation
Collection, Tate Gallery, London
Campfire version, Institute of Contemporary Arts, London, 1986

Hiller's investigation of the 'unconscious' aspects of her society's culture extended in the 1980s to video installation.

'Nowadays we watch television, fall asleep, and dream in front of the set as people used to do by their firesides. In this video piece I'm considering the TV set as a substitute for the ancient hearth and the TV screen as a potential vehicle of reverie replacing the flames. Some modern television reveries are collective. Some are experienced as intrusions, disturbances, messages, even warnings, just as in an old tale like *Belshazzar's Feast*, which tells how a society's transgression of divine law was punished, advance warning of this came in the form of mysterious signs appearing on the wall. My version quotes newspaper reports of "ghost" images appearing on televisions, reports that invariably locate the source of such images outside the subjects who experience them. These projections thus become 'transmissions', messages that might appear on TV in your own living rooms.'
– Susan Hiller, Artist's statement, 1985

Aimee RANKIN
Ecstasy Series
1987
Wood, digital media, mirrors, lighting, sound
Dimensions variable

A series of coloured wall-mounted boxes have peepholes, deliberately made small so that it is difficult to see inside. Peering in, the viewer can make out a dazzling, rectangular space which is filled with lights – the optical illusion of an 'infinity tunnel' created using mirrors. This seemingly infinite, receding space is also conceived as symbolizing the 'bed' at the centre of an imaginary 'bedroom'. The work 'reveals the underside of an extremely complex technological system, in the seething impulses of entropy always gnawing at the edges of this order ... I was working with the issue of seduction, which in visual terms is the play with what is not revealed ... I wanted that frustration to reveal something about the workings of desire.'
– Aimee Rankin, Artist's statement, 1987

Judith BARRY
Echo (detail)
1986
Mixed media video installation
Dimensions variable

In this installation a free-hanging double-sided screen reflects images that are interrupted by the spectators' silhouettes as they pass between screen and projector. On either side of the screen, two alternating projections containing two film-loop inserts reproduce an endless cycle of multiple scenes, repeating, yet never the same, one side depicting 'nature' and the other side an evening view of the 1937 World's Fair globe and AT & T's 'Chippendale' building. The piece reinterprets the entropy of the mythical figures Echo and Narcissus, in terms of the seductive and destructive power of spectacle generated by corporate technology. Barry's installations examine the impact of information and computer media on the design and use of public space and address the paradox of technological systems which both aid and inform while exercising powers of surveillance and control.

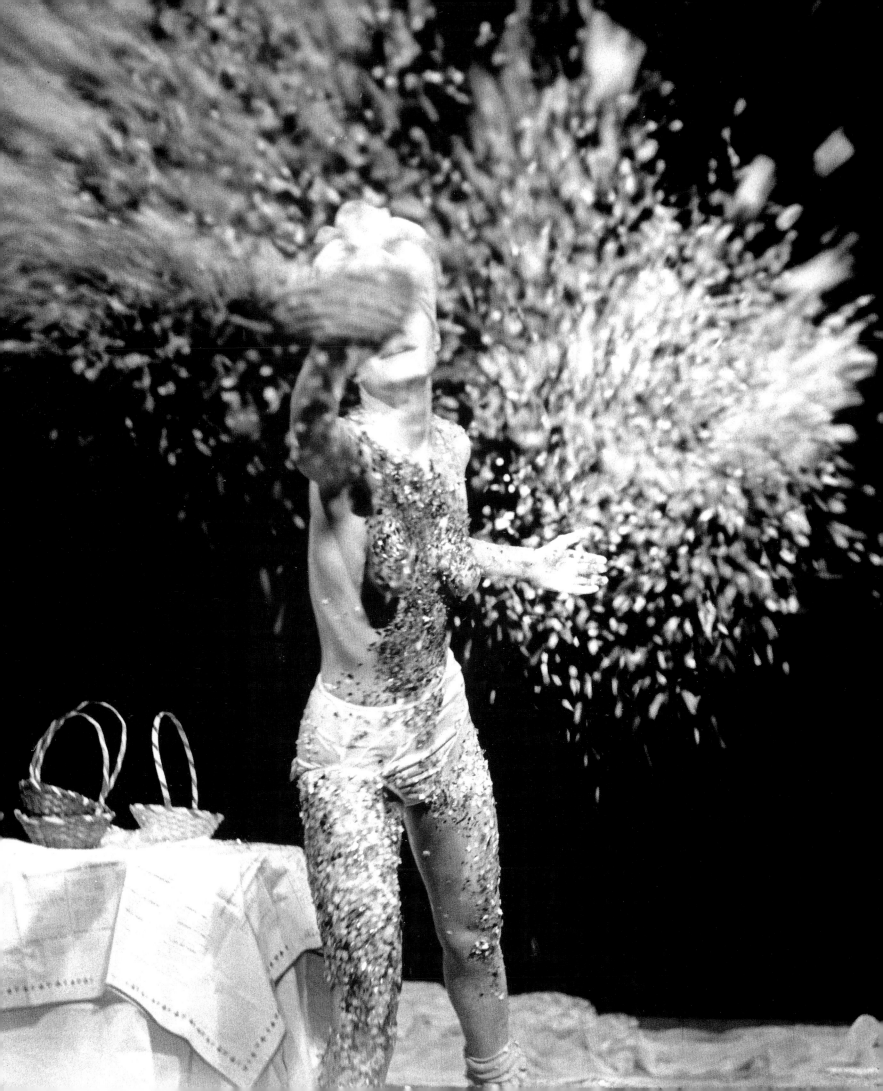

Karen FINLEY
The Constant State of Desire
1986
The Kitchen, New York

In 1985 Finley toured the US with the solo performance *I'm An Ass Man*, which dealt with the themes of sexual abuse and misogynist attitudes which affect the lives of women from infancy until death. In December 1986, The Kitchen performance space in New York hosted Finley's next major work, *The Constant State of Desire*, which dealt with the desire to control others. It received much critical acclaim and toured throughout the US and Europe. Finley has made performances using her body as a visual field on which fear, desire and violence are projected in order to challenge prevailing attitudes towards women, sex and art. More recently her work has questioned notions of censorship and the rights of artists to speak out about issues of abuse and the commodification of desire in Western capitalist societies.

Annie SPRINKLE
Post-Porn Modernist Show
1992
New York

Self-styled 'feminist porn activist', Sprinkle makes performances informed by her work in the sex industry, where she transformed herself from a sex object into a figure empowered by her sexuality. In this performance she narrated and demonstrated her career achievements. After douching she inserted a speculum and invited the audience to see her cervix, inverting the power relations between subject and object.

Cindy SHERMAN
Untitled No. 222
1990
Colour photograph
152.5 × 112 cm [60 × 44 in]

Sherman's series of thirty-five *History Portraits* (1989–90) arose from a commission where she collaborated with the Limoges factory in France to produce porcelain from original eighteenth-century moulds, decorated with images of the artist dressed in period costumes. The following year Sherman produced a series of photographs based on characters from the French Revolution for the bicentennial in Paris, and these were followed by further works which, with the exception of several based on actual paintings, depict types from the genre. 'The pictures, with their almost sculptural but artificial "deep space", propose subjects that point to the fact that we are never coherent in ourselves but always take meaning from the others whose significance we in turn project. (A dynamic, not incidentally, that could be said to describe the hidden mechanics of art history as a discipline.)'
– Amelia Jones, *Cindy Sherman*, 1997

far left

Ida <u>APPLEBROOG</u>

Untitled

1986

Oil on canvas

112 × 41 cm [44 × 16 in]

left

Ida <u>APPLEBROOG</u>

Don't Call Me Mama

1987

Oil on canvas

112 × 41 cm [44 × 16 in]

Applebroog's multi-partite paintings of the 1980s focus on apparently trivial scenes and actions, often using cartoon-like repetition to present sequences that suggest fragmented stories. In the mid 1970s Applebroog made a transition from abstract sculpture to figurative painting and book works as a result of her encounter with feminism. She made small books which presented disjunctive narratives and questioned ideologies of representation, mailing these to friends and figures in the art world. These were followed by her sequential paintings which address feminist issues of victimization and marginalization with a fine balance of empathy and irony. In deciphering and interpreting these works, the viewer is invited to engage an active ethical response.

Sonia BOYCE
She Ain't Holding Them Up,
She's Holding On
1986
Acrylic on canvas
227 × 113 cm [89.5 × 44.5 in]
Collection, Middlesbrough Museum
and Art Gallery, England

The title reinforces the problematic
position of the woman in the bottom
half of the painting. She is identified
with a sense of Englishness by the rose
patterns that adorn her dress, while
above and around her other, richer
patterns proliferate. These reflect both
the influence of her mother's West
Indian sense of decoration, and Boyce's
contention at the time that her work,
despite resembling painting, was
drawing, a means of expression which
should be appreciated on its own merits.
'In one sense I am celebrating the
strength of black women; however
I try not to glorify that strength because
I'm constantly reminded of why black
women have to be strong. As we know
there is a barrage of institutionalized
representations of black people.
There are enough insulting and negative
images. The question becomes then,
how does one confront these distortions
and initiate change? … When you
start to discuss the issues that affect
a community, transposing positives
for negatives is insufficient in dealing
with the complexities of human
experiences … '
– Sonia Boyce, 'In Conversation with
John Roberts', 1987

Your body is a battleground

March on Washington
Sunday, April 9, 1989

Support Legal Abortion
Birth Control
and Women's Rights

On April 26 the Supreme Court will hear a case which the Bush Administration hopes will overturn the Roe vs. Wade decision, which established basic abortion rights. Join thousands of women and men in Washington D.C. on April 9. We will show that the majority of Americans support a woman's right to choose. In Washington: Assemble at the Ellipse between the Washington Monument and the White House at 10 am; Rally at the Capitol at 1:30 pm

Barbara KRUGER
Untitled (Your body is a battleground)
1989
Photographic silkscreen on vinyl
61 × 61 cm [112 × 112 in]

In the embattled late 1980s, during the censorious 'culture wars' in the US provoked by right-wing politicians in alliance with religious fundamentalists; the worsening AIDS crisis; and retrogressive legislation on women's rights, Kruger showed her solidarity with a number of graphic activist groups, such as Gran Fury, by producing posters and other artefacts for direct action use. This work was used as the rallying poster for the 1989 pro-choice march on Washington and was subsequently adapted for the promotion of women's rights in other countries.

Ilona GRANET
No Cat Calls
1985-88
Silkscreen on metal
61 × 61 cm [24 × 24 in]

From 1985 to 1988 New York art activist Ilona Granet created and erected street signs
in lower Manhattan, New York. Collectively she titled them the *Emily Post* series,
named after a well known United States authority on etiquette. The signs were
a protest against male street behaviour towards women, such as cat-calls, whistles
and suggestive comments, and made their point with humour. Many of them were
reworkings of standardized images taken from sign-painters' dictionaries. The signs
were displayed in the street as 'regulations' for etiquette, suggesting that sexual
harassment is as dangerous as the traffic accidents that their sign prototypes were
designed to prevent.

GUERRILLA GIRLS
Do women have to be naked to get into the Met. Museum?
1989
Poster

The Guerrilla Girls, an anonymous group of women artists who have staged protests
against institutionalized sexism and racism, were most active in the late 1980s and
early 1990s. Their campaigns used posters, cards, flyers and other graphic material
to present revealing statistics and uncompromising political messages. For public
appearances members have protected their anonymity with gorilla masks, assuming
the names of women artists in history such as Georgia O'Keeffe. Originally intended
for a billboard, this poster was rejected by the Public Art fund in New York and was
subsequently self-funded and displayed on the buses and streets of New York.

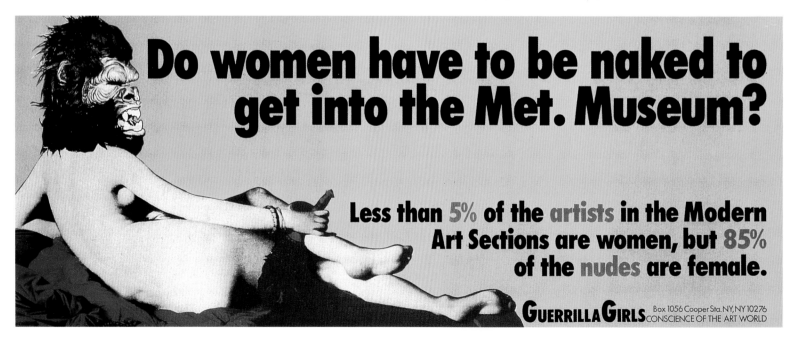

Trinh T. MINH-HA
Surname Viet, Given Name Nam
1989
16mm film
108 mins., colour, sound

This formally complex film explores the historical and cultural experience of Vietnamese women in traditional and post-war societies of North and South Vietnam and in the United States, and the ways in which they intersect. 'It is illusory to think that women can remain outside of the patriarchal system of language. The question is … how to engage poetic language without simply turning it into an aestheticized, subjectivist product … Language is at the same time a site for empowerment and a site for enslavement. And it is particularly enslaving when its workings remain invisible. How one brings that out in a film is precisely what I have tried to do in *Surname Viet, Given Name Nam* … what is important is not only what the women say but what site of language they occupy (or do not occupy) in their struggle.'
– Trinh T. Minh-ha, 'Speaking Nearby', 1994

Yvonne RAINER
The Man Who Envied Women
1985
16mm film
125 mins., colour, sound

In *The Man Who Envied Women* Rainer takes the critical work of feminist filmmaker and theorist Laura Mulvey to its logical conclusion. Mulvey's analysis demonstrated that the male gaze is an integral part of cinematic structure, inscribed by everything from camera position to narrative form. Rainer decided to test what happens when the usual object of the male gaze, the heroine, is denied a visual presence within the film. This strategy was prefigured in Rainer's earlier choreographic work: one of the important innovations of *Trio A* was the refusal of the female dancer to engage with the gaze of the viewer throughout the performance. In *The Man Who Envied Women* the protagonist, played by the dancer and choreographer Trisha Brown, never appears in view throughout the film's duration. Further problematizing the way that audiences would identify and engage visually with the narrative, Rainer's two male protagonists play the same role, so that they become interchangeable. The film employs a wide array of spatial arrangements as an integral part of its narrative method, as Rainer investigates the cinematic devices that keep characters inside and spectators outside of the frame.

Abigail CHILD
Mayhem
1987
16mm film
20 mins., colour and black and white, sound

Perils, *Mayhem* and *Mercy* belong to the series *Is This What You Were Born For?*
(1986–89) in which Child investigates power and gender relations through a homage
to past cinematic genres such as *film noir*. Through rapid collages of image fragments
from early cinema, Child assembles experimental narratives, drawing attention to the
minutiae of conventional techniques of cinema such as gesture and camera frame,
which establish not only narrative continuity and pace, but the construction of gender
and sexual identities. Child destabilizes these artifices, focusing on moments of
rupture and excess where subliminal apprehensions of alternative readings
become apparent.

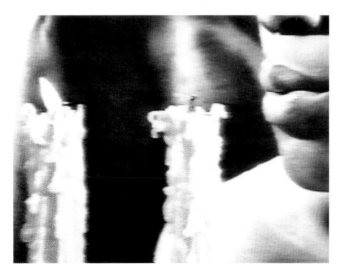

Cheryl DUNYE
Janine
1990
Video
9 mins., black and white, sound

Janine was the first of Dunye's video works to gain international acclaim. Her
work uncovers the hidden histories of black lesbian identities, and works towards
cinematic representations of black women that refute racial, gender and sexual
stereotypes. Dunye creates a new level of subjectivity through her self-referential
role as both director and actor in her works, as well as the often humorous blurring
of distinctions between fiction and documentary. These find their most ambitious
expression in her first feature film, *The Watermelon Woman* (1996), a mock-
documentary centred on an aspiring filmmaker, played by Dunye, obsessed with
a 1930s African-American actress whom she suspects was the lover of a white female
director. The controversial cultural historian Camille Paglia appears as herself within
the film's narrative, giving voice to critical analysis within the fictional frame.

Sadie BENNING
It Wasn't Love
1992
Video
20 mins., black and white, sound

Benning began at fifteen to weave her diary entries into experimental narratives.
The videos were usually made in the confines of her own bedroom and suggest
the intimacy of a confessional. In this work, she sits perched before the camera,
disclosing intimate details about falling in love, feeling as if she is a freak, quitting
school, discovering she is a lesbian. Her early works were made using a hand-held
Fisher-Price PXL2000 'Pixelvision' video camera, designed for use by children but
soon adopted by experimental filmmakers for its low-resolution pixelated effects.
Benning experimented from the outset with masks and drawings in relation to her
personae. In a later work such as *The Judy Spots* (1998), broadcast on MTV, the angst
she explores is portrayed by a papier mâché doll .

CORPOREALITY

The 1990s saw a renewed interest in the gendered body as an artistic source – no longer as the fetishized object of the male gaze but as something to be explored in all of its diversity. The 1990s body was infused with consciousness of polymorphous perversity and cyborg futures. Many women artists returned to the traditional media of painting and sculpture, in contrast to the predominance of photography and language-based work of the previous decade. Feminists working with new technologies often introduced a visceral component. There was a return to objects, rather than words; 'lightness' instead of the weight of theory. This is seen in a number of artists' embrace of humour, sentimentality and the naive. Others appropriated macho attitudes and nonchalant poses. The generation profiled in several exhibitions of the mid 1990s coincidentally titled 'Bad Girls' also depicted the abject body, a concern that was central to the work of established women artists who explored ageing, illness and loss. Other female artists explored neglected and in-between spaces and ephemeral materials, and critiqued the institutional exclusion of women.

Andrea FRASER
Welcome to the Wadsworth: A Museum Tour
1991
Wadsworth Atheneum, Hartford, Connecticut

In a series of works of the late 1980s and early 1990s Fraser invented an alter ego based on one of the 'docents' who, usually on a voluntary basis, conduct guided tours of museums. At the commencement of each tour, provided for visitors who were usually unaware of her subversive position, Fraser would mirror the conventional speech of the docent, only gradually introducing a series of strategic departures from the normal narrative as the tour progressed. Unexpectedly referring, for example, to directional signs, the gift shop or the security system and describing them as if they were works of art on exhibit, she gradually and subtly introduced political and feminist critique of the institution, speaking from an indeterminate position, between institutional insider and the 'ideal visitor' from whom the ranks of many museum volunteers are drawn.

Ute Meta BAUER (with Tine
Geissler and Sandra
Hastenteufel)
Informations Dienst (Information
Service)
1992-95
Archival documentation, filing
and presentational materials
Dimensions variable

This archive documenting artworks by contemporary women artists was first exhibited in 1992 at Martin Schmitz Galerie in Kassel, concurrently with Documenta IX, in protest at Documenta's under-representation of women. The archive was subsequently exhibited at other locations where the institutionalized absence of women was noted. In each case the hosts of the archive agreed to a basic set of formal presentation conditions established by the organizers. Each new site had the opportunity to recontextualize the exhibition of the archive through varying curatorial decisions.

Renée GREEN
Import/Export Funk Office
1992
Installation with audio, video
and reading materials
Dimensions variable
Collection, The Museum of
Contemporary Art, Los Angeles

Green's installation juxtaposes materials which range across the histories of African-American and white American and European literature and film. In such a context a 1930s film of 'exploration' that describes a journey into 'deepest, darkest Africa' becomes a tool in its own deconstruction. Placed alongside the works of writers such as Hawthorne and Melville are key African-American texts such as Harriet Jacobs' autobiographical *Incidents in the Life of a Slave Girl*, as well as a 'lexicon of funk'. Presenting as simultaneous these diverse accounts of history, culture and community, the archive enables visitors to reconstruct culturally diverse readings within an institutional space. Green's work addresses the diasporic histories of African-American experience, often in relation to indexes, genealogies and taxonomies. Her work highlights and questions received ideas about unitary black identities and communities and traces alternative readings of history.

Thérèse OULTON
Correspondence I
1990
Oil on canvas
233.5 × 213.5 cm [92 × 84 in]

In Oulton's paintings the problematic historical relationship of women's art with the 'old masters' is addressed, not through appropriation or irony, but through gestures of refusal. Conventional ways of interpreting and appreciating painterly technique are refused through a subversive use of high art conventions. Chiaroscuro is employed, for example, to imply modelling, yet no discernable object of representation can be observed to justify the use of this technique. Gestural marks and techniques are denuded of their habitual representational meanings, yet their affective associations are retained. Oulton seeks thus to transform the 'debased' inherited language of painting from within, so that the possibility of renewal might emerge organically through her engagement with the medium.

Mira SCHOR
Area of Denial (detail)
1991
Oil on linen
16 panels, 40.5 × 51 cm [16 × 20 in] each

This series of sixteen paintings refers to a military term used in the Gulf war to describe a type of bomb designed to explode above ground and 'deny' oxygen to enemy soldiers below. Schor often works with fragments of language that are charged with the political resonances of current events. A complex relationship is set up between the source of the phrase and the political dimensions of the act of painting, in which the military terminology of the modernist avant-garde is one point of reference. Through a re-exploration of the possibilities of relationship between figure and ground, Schor refutes those postmodernist critics who have proclaimed the death of painting. 'In French, *terrains vagues* describes undeveloped patches of ground abutting urban areas, grey, weedy lots at the edge of the architectural construct of the city. *Terrains vagues*, spaces of waves, the sea of liquidity, where the eye flows idly and unconstructed, uninstructed. These spaces are vague, not vacant (*terrains vides*). In such interstices painting lives, allowing entry at just these points of "imperfection", of neglect between figure/ground. Between figure/ground there is imperfection, there is air, not the overdetermined structure of perspectival space or the rigid dichotomy of positive and negative space, not the vacuumed vacant space of painting's end ... ' – Mira Schor, 'Figure/Ground', 1997

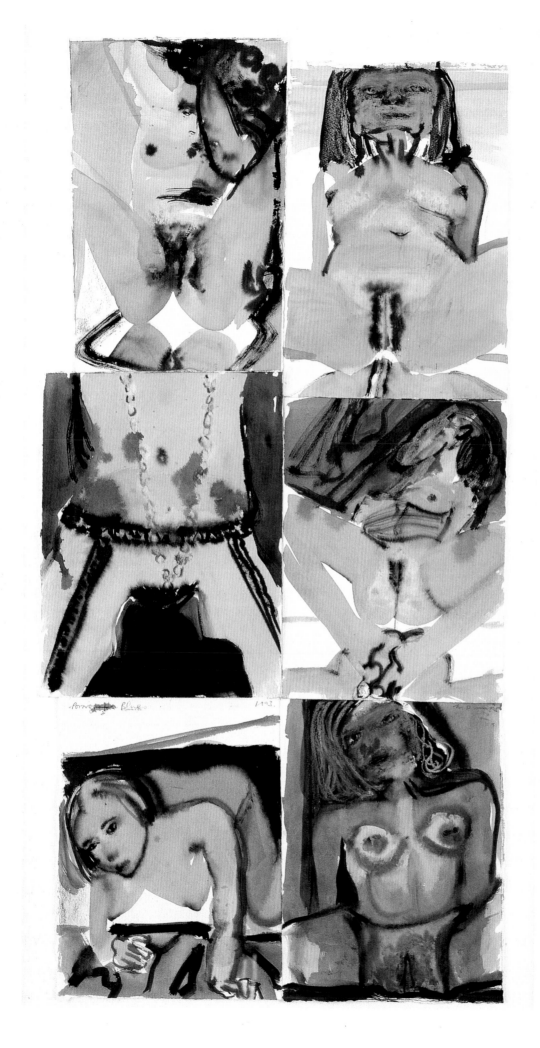

Porno Blues
1993
Ink wash, watercolour on paper
6 drawings, 30.5 × 22.5 cm
[12 × 9 in] each

In two series of drawings both made in
1993, *Porno Blues* and *Porno as Collage*,
Dumas used pages from sex magazines
as her source material, investigating the
interplay between pornography's
photographic revelations and the veilings
and concealments of art, which are
widely held to be the distinguishing
features of eroticism. Marlene Dumas
has been placed in the tradition of
Expressionism and compared with
Edvard Munch and Emil Nolde.
Due to her ironic view of painting's
production and reception she has also
been considered a neo-conceptualist.
A further dimension in her work of the
1990s has been a distinctive exploration
of eroticism. Although Dumas' imagery
of predominantly female subjects is
often derived from mass media photo-
graphic sources, she is not interested in
strategies of refusal, or the construction
of 'anti-images' as a way of subverting
stereotypical representations. Rather,
through exploring the sensuous
properties of her medium, she aims to
expand the possibilities in painting for
representation of the workings of desire.

Nicole EISENMAN
The Minotaur Hunt (detail)
1992
Acrylic mural, no longer extant
3 × 4.5 m [10 × 15 ft]
Trial Balloon Gallery, New York

Eisenman's radical re-evaluation of historical and contemporary mythologies led her to make a series of works in the early 1990s which featured plural manifestations of the legendary Minotaur. Several of these took the form of large scale temporary murals in a mock history painting style. One version was exhibited at Trial Balloon Gallery, New York, in 1992; another was shown at the 'Bad Girls' exhibition (Institute of Contemporary Arts, London, 1993–94).

'A tribe of strapping amazons hunt minotaurs.

'In Picasso's private mythology, these women, Olga, Dora, Françoise, are muses. Refashioned, these muses become the huntresses, symbols of strength and vengeance.

'The tribunal of women gives way to the central conflict. The bound minotaur is stabbed. The bounty of this hunt is the blood of the beast that Paloma [Picasso] has introduced onto the world market this fall: the cologne for men *Minotaur*. The story is of Paloma's endangered integrity, self defence through aggressive capitalism and patricide by cannibalism.

'The murals to me always seem unfinished, sections are incomplete. The life of the mural is short – like that of a drunken teenager smashing his car into an oncoming train; there is no chance of failure, to die with potential, to live in memory, heroic.'
– Nicole Eisenman, Artist's statement, 1993

Sue WILLIAMS
A Funny Thing Happened
1992
Acrylic on canvas
122 × 107 cm [48 × 42 in]

Sue Williams' graffiti-like series of paintings refer in unexpectedly disturbing ways to the kind of humour addressed, for example, by the artist Richard Prince in his series of paintings and collages based on jokes. Williams goes a stage further than the ironic ambiguity of Prince's appropriations, of which she is critical. Not only do the dilemmas she presents appear to be as unresolved as the paintings themselves, but there appears to be no escape from the tortuous emotions they evoke.

'Do victims feel the kick as pain or pleasure? "Fuck off." When the object of my love and affection gives me the boot as hard as he can it hurts quite a bit. Also, a deep feeling of humiliation and rejection (harder please). Yet there is something horny about the feeling: dear old Dad. Of course I go back for more (home). This is a riot for everyone with their shit together. Well no alternatives came to mind at the time. What can I say? And all these bruises about the face and misshapen lip touching the nose (a turn-off) so everyone knows what you've been up to. Oh, the embarrassment, the shameful feeling of worminess. "Look, an untogether woman" Even from Dad! "How could she let that happen?" No gun. "How could she do that to herself?" How did I kick myself in the head? I am a worm, hear me whimper mumble mumble. Fuck you all. Fifteen years of therapy, groups, twelve-step-programmes. I'll never do it again. Then I am attacked and raped by a total stranger (I swear! O can't he see that I am centred and working on boundary issues? That I have my shit together: Hell – I OWN my OWN SHIT. What gives? Why wasn't I training in combat? Should I go outside again? Well, no alternatives came to mind at the time.'
– Sue Williams, Artist's statement, 1993

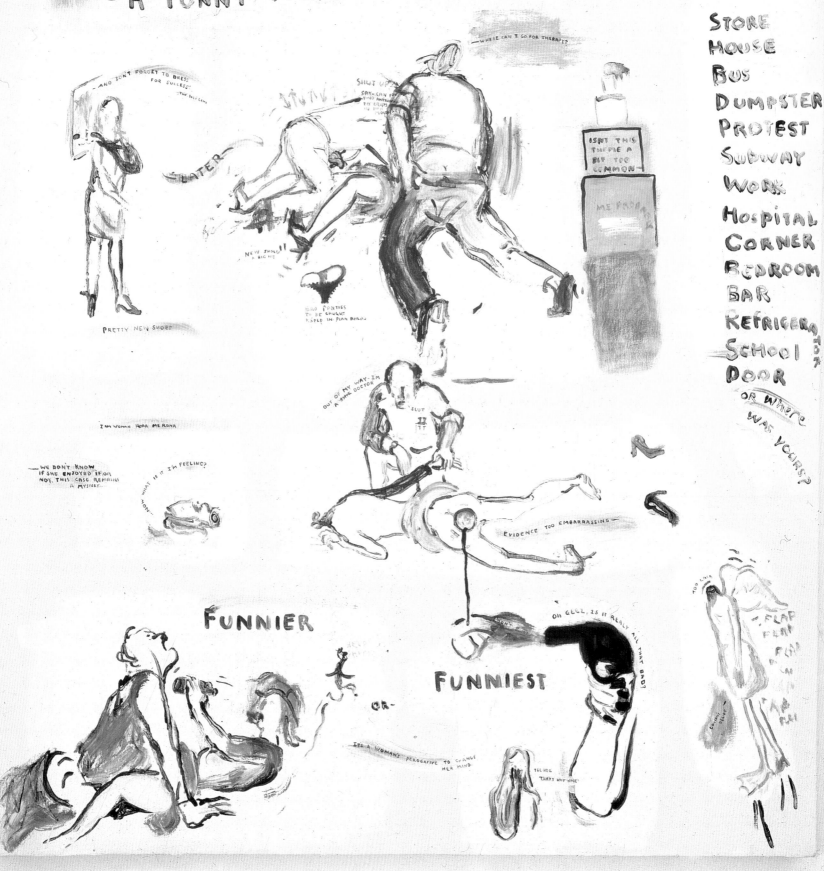

Kiki <u>SMITH</u>
Tale
1992
Wax, pigment, papier mâché
58.5 × 58.5 × 406 cm [23 × 23 × 160 in]

A female figure crawls abjectly along the floor, trailing an indeterminate stream of blood or excrement. In her sculptures Smith works through problems that persist in the representation of the female body figuratively as a universal referent. *Tale* addresses the dilemma of being unable to control readings of the female body. 'Your hair holds on you, the shit and the pee and the chafed skin, the milk and the cum and the placenta, you can feel your hair in the second person not feeling it in the first. Tender threads. Haunting ways to remain staining.'
– Kiki Smith, quoted by Jo Anna Isaak, *Feminism and Contemporary Art: The Revolutionary Power of Women's Laughter*, 1996

Helen <u>CHADWICK</u> (with David Notarius)
Piss Flowers (detail)
1991-92
Bronze, cellulose, enamel
Dimensions variable
Collection, Banff Centre for the Arts, Canada

During a four-week residency at the Banff Centre for the Arts in Canada, Chadwick, together with her partner David Notarius, created a series of sculptures cast from the shapes which emerged as they urinated into deep snow. The indented shapes which formed as the snow was displaced were immediately filled with plaster, then cast in bronze and covered in enamel paint. When transformed from negative to positive forms in space, the artist's female urine pattern resembled a phallic stem and her male partner's resembled the petals of an open flower, reversing the symbolism conventionally associated with their gendered creative positions.

Janine ANTONI
Gnaw (detail)
1992
600 lbs (270 kg) of chocolate gnawed by the artist
54 × 54 × 54 cm [21 × 21 × 21 in]

Over several weeks, Antoni performed the action of repeatedly biting into two large cubes, one consisting of lard, the other of chocolate. The mouthfuls of the two substances which she spat out were collected and fashioned into commodities such as lipstick and chocolate sweets. These were exhibited in glass cases alongside photographic documentation of the gnawed cubes. Drawing attention to feminist associations of the comforting and aphrodisiac properties of chocolate and the abject quality of lard, this work also engaged with Antoni's ongoing art historical critique. The minimalist cube was devoured and its substance converted, in an oral-sadistic gesture which was both destructive and imbued with pathos, into products stereotypically associated with femininity.

For some commentators, who had been engaged in psychoanalytically based feminism during the previous decades, this work signified a regression in women's art practice from the linguistic to the oral, the theoretical to the pre-verbal. Others welcomed Gnaw and other key works by Antoni, such as Loving Care (1993), for their articulation of women artists' ambivalent relationship to patriarchal art history.

Rona PONDICK
Treats
1992
Plastic and rubber
300 parts, approx. 5 × 5 × 5 cm [2 × 2 × 2 in] each

Like Antoni's Gnaw, Pondick's installations of the early 1990s also evoked infantile oral-sadistic fantasies. Works such as Mouth (1992–93) and Treats are composed of teeming, randomly strewn balls which resemble disembodied, greedy, savage mouths with rows of grinning, bared teeth, or devouring breast-like forms. Rather than marking a regression from more theoretical, discursive practice, Pondick's works, as well as Antoni's, were widely discussed by some feminists as opening up a space for the articulation of an assertive female subjectivity.

Anya <u>GALLACCIO</u>
Prestige
1990
24 kettles, air compression unit
Dimensions variable

This installation in the central chimney of the defunct Wapping pumping station, London, consisted of twenty-four kettles linked to an air compressor so that their whistles could be heard continuously. The viewer's encounter was channelled through the sound, audible for some distance around the building, before the installation was seen. Through being massed together, domestic kettles 'take over' the monumental space of male industrial power with their different reverberation of sound. Gallaccio's installation works respond to the charged identity of their sites through the placement within them of ephemeral and transient materials and phenomena, such as flowers, chocolate, salt or ice.

Rachel <u>WHITEREAD</u>
House
1993
Concrete
h. approx. 7.5 m [25 ft]

In 1993 Whiteread completed a cast in concrete of a nineteenth-century house in the East End of London. Bordering a park, it was the last in its row to be evacuated prior to its intended demolition. Via the public arts organization Artangel, permission was secured from local authorities to make the work, which involved infilling the interior space of the entire structure, then carefully demolishing its shell so that the concrete cast of negative space remained as a monument to the house's existence and the life which it had sustained. The work, which was temporary, provoked strong but unresolved responses across all constituencies. 'House was both a closed architectural form and an open memorial; at one and the same time hermetic and implacable, but also able to absorb into its body all those individual thoughts, feelings and memories projected onto it.'
– James Lingwood, *Rachel Whiteread: House*, 1995

Doris <u>SALCEDO</u>
Unland: the orphan's tunic
1997
Wood, cloth, hair
80 × 245 × 98 cm [31.5 × 96.5 × 38.5 in]

As the viewer approaches an old, worn table, spliced together from two broken sections, a white sheen is perceived to be a fine covering of silk. At the join of the two parts, human hair is also seen to be woven into the table's surface. In *Unland*, a series of three works made between 1995 and 1998, Salcedo referred in her titles to writing by the exiled German Jewish poet Paul Celan (1920–70). A survivor of the Holocaust, Celan reflected in his poetry a despair in the possibility of recovering coherent meaning and of overcoming loss. In his fragmented verse the negative prefix 'un' appears frequently, as do references to blindness and constraints against sight. Salcedo's sculptures using found women's shoes, clothing and domestic furniture are similarly fragmented, dislocated objects that evoke the personal tragedies of loss in her native Colombia, provoking meditation on their universal significance.

Ann <u>HAMILTON</u>
indigo blue
1991
Site specific installation and performance, Spoleto Festival,
Charleston, South Carolina
'Located in an old garage in Charleston, South Carolina ... this piece was informed by
the experience of living for six weeks in Charleston and more than a year of readings
in American labour history. In the centre, a steel platform was piled with 14,000 lbs of
company-owned recycled work clothing ... Obscured by the pile from the front, at the
back of the space a figure sat erasing slim blue books, seated at a table borrowed
from the central market that once housed one of Charleston's pre-Civil War slave
markets. With a Pink Pearl eraser and saliva, the books were erased back to front,
with the eraser waste left to accumulate over the duration of the piece. Although the
space was entered at ground level, a window in the small upstairs office of the garage
gave another view of the pile and of the activity at the table. One wall of the office was
hung with udder-sized net bags of soya beans, which sprouted and later rotted in the
leakage of summer rains. With the humid weather, the space was filled with the
musty smell of the damp clothes and the organic decomposition of the soya beans.'
– Ann Hamilton, Artist's statement, 1991

Ann <u>HAMILTON</u>
indigo blue
1991
Site specific installation and performance, Spoleto Festival,
Charleston, South Carolina
'Located in an old garage in Charleston, South Carolina ... this piece was informed by
the experience of living for six weeks in Charleston and more than a year of readings

Zoe LEONARD

Untitled

1992

Black and white photographs

19 photographs, dimensions variable

Neue Galerie, Documenta IX, Kassel, Germany

In the Neue Galerie, a public collection of historical German art, Leonard made a site-specific intervention in one entire wing, a suite of seven rooms. The first and last rooms were left unchanged. The five rooms in between were each altered in the following way: eighteenth- and nineteenth-century portraits of men and landscape paintings were removed while paintings in which women were the primary subject remained. Nineteen black and white close-up photographs of women's genital area were inserted in the space left by the removed paintings.

'Documenta IX in 1992 was a break for me. I was finally able to inject funny, sexy, powerful images directly into a stymied and claustrophobic atmosphere.'

– Zoe Leonard, *Art in America*, 1994

Sarah LUCAS
Bitch
1995
Table, melons, T-shirt, vacuum-packed smoked fish
approx. 80 × 100 × 50 cm [31.5 × 39.5 × 19.5 in]

A T-shirt hanging over the end of an old kitchen table is pulled out of shape by two large melons protruding underneath. At the other end a smoked fish in a bag makes its presence known. The allusion to a sexist, derogatory portrayal of a woman on all fours is evident. However, far from being one-liners, Lucas' sculptures, assemblages and collages continue to resonate after the initial affect of their Rabelaisian wit has subsided. The work invites and sustains a range of unresolved, intersecting responses from both women and men, opening up the body as a site of discussion, rather than adopting a clearly delineated oppositional stance.

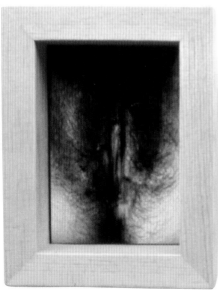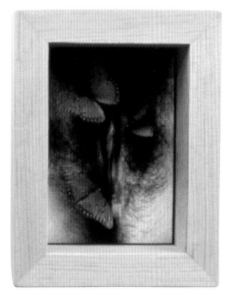

Judy BAMBER
My Little Fly, My Little Butterfly
1992
Wood, found objects, paint
2 parts, 24 × 19 cm [9.5 × 7.5 in] each

Two small hyperrealist paintings of female genitals are hung at the eye level of a woman of average height. One image is covered with flies, the other with butterflies, fixed to the surface with pins. The first image both repels the male gaze and underlines feelings of abjection confronted by women impelled, through conformity to social norms, to suppress the visceral presence of their bodies. The second image transforms the scene through symbolic associations of butterflies with metamorphosis, beauty and freedom. Bamber's work engages with pornographic codes of representation, reversing and transforming their fetishization of the feminine subject.

Jeanne <u>DUNNING</u>
Untitled with Tongue
1990
Cibachrome and frame
57 × 46 cm [22.5 × 18 in]

In 1990 Dunning continued her investigation of female portraiture begun in 1988 when she had made a series of portraits of women in which the addition of facial hair disrupted viewers' expectations. The 1990 series was made up of three images: a woman with an 'unshaven', soiled appearance; a woman with a mysterious bulge in her cheek; a woman displaying a disturbingly oversized, bright red tongue. These images were exhibited alongside other photographs of ambiguous close-up subjects, suggestive of body parts or of fruit and vegetable matter. Dunning uses traditional strategies of photography such as still life and portraiture, disrupting them so that they mutate, unsettling the authority of the tradition. The viewer is unable to grasp the 'correct' meaning, due to the addition of unexpected details. Simultaneously seductive and repellent, the works engage with the viewer's desire to gain access to the subject through symbolization. The failure to do so which they provoke forces a realization of the violence implicit in this process.

Catherine <u>OPIE</u>

Chicken (from Being and Having)

1991

Chromogenic print

43 × 56 cm [17 × 22 in]

'Opie created a set of framed portraits of mustachioed or bearded faces … In each shot, the camera moves up close to the model's face … The close-up articulates what feels like an intimacy between the model and the artist, an intimacy, moreover, not available to the viewer. The person looking at the photograph is positioned simultaneously as voyeur, as mirror image and as participant, but ultimately it is the spectator who feels caught between looks, between being and having.

'Very often the camera comes close enough to the model's face to reveal the theatricality of the facial hair; in other portraits the facial hair appears to be real, and this sets up a visual trap in which the viewer might attempt to determine whether she or he is looking at a male or female face. This is a trap because Opie's images are often quite beyond the boundaries of gender … '

– Judith Halberstam, *Female Masculinity*, 1998

VNS MATRIX
All New Gen
1992
Wall-mounted and back-lit digital images, online video game
Dimensions variable

All New Gen is an interactive work created by a group of artists based in Adelaide, Australia, which humorously mimics a 'boy's own' adventure world of computer games in order to hijack cowboy toys and re-map cyberspace. The work comprises a series of back-lit, wall-mounted computerized images, large laminated hoardings and an online computer game. Through this the 'spectator' can follow the adventures of All New Gen, an anarcho-cyber terrorist, agent of the new world disorder, who with her band of renegade DNA sluts Patina de Panties, Dentata and the Princess of Slime (fem-warriors), refuse to take any prisoners in their wars against Big Daddy Mainframe. The game offers the player the option of unscrewing a chrome penis and turning it into a portable phone. The DNA sluts seductively suggest through the headphones that the player should visit the three-dimensional Alpha Bar and the Bonding Booth, in which various bisexual punishment rituals are played out on video.

Brenda LAUREL, Rachel STRICKLAND
Placeholder
1993
Interactive video game

Laurel and Strickland disrupt the masculine world of video game production to create virtual reality simulations in which body boundaries become ambiguous. *Placeholder* creates an interactive environment centred on three locales: a group of vertical rock formations known as 'hoodoos', a natural cave and a mountain waterfall. The simulated environments are then animated and the user can interact by choosing one of four game-playing identities: spider, crow, snake or fish. A goddess figure also appears, making suggestions or commands. The piece can accommodate two users, who can interact simultaneously to create their own narratives.

Linda DEMENT
Cyberflesh Girlmonster
1995
Interactive video animation

The user of this interactive computer work can click onto abject, monstrous, biomorphic-appearing, visceral forms or onto disembodied grinning mouths or seductive lips. When thus activated these whisper 'press here' and 'touch me', or another monstrous shape may appear, or a digital video, a story or medical information about the state described in the story may appear. There is no menu system or clear, controllable interface, so that the player engages in the game in a relatively blind state. The hybrid imagery and speech is derived from selected body parts and statements recorded and scanned by over thirty women volunteers during the Artists' Week of the Adelaide Festival, Australia, in 1994. Conglomerate bodies were made from the information donated. The work is a macabre, comic representation of monstrous femininity from a feminist perspective that encompasses revenge, desire and violence.

Catherine <u>RICHARDS</u>

The Virtual Body
1993
Electronics, computer, wood, glass, mirror, brass, liquid crystal
Mylar, monitor, transparencies
122 × 61 × 61 cm [48 × 24 × 24 in]
Installation in Rococo room, Antwerp 93 Festival

A wooden cabinet stood in the centre of a Rococo room in Antwerp. As spectators entered they could see a miniature glass room on top of the cabinet. Through its semi-transparent and illuminated walls the image of the room it was situated in could be dimly perceived. Peering through a brass peephole in the ceiling of the miniature room, spectators momentarily saw a reflected image of the Rococo room's ceiling, but just as it appeared it was replaced by an image of the floor, which in turn was overtaken by the ceiling as the space in the miniature room destabilized. At one side of the cabinet was a space through which the viewer could place a hand. This triggered a third state: the glass walls became opaque and the viewer could see the floor image scrolling beneath his or her hand, gradually creating an illusion of motion as the hand appeared to be travelling infinitely further away from the body. The installation reinterpreted notions of space in Baroque and Rococo architecture and painting, in the context of the digital age. In this scenario the sense of the body as a unitary whole dissolved to the point where it could no longer be distinguished from the surrounding digital information environment.

ORLAN
Omnipresence
1993
Sandra Gering Gallery, New York

Orlan's work of the 1990s has continued her longstanding concern with historical stereotypes of female beauty, through plastic surgery operations upon her own face. At each operation, one of the artist's features is transformed to resemble that of a famous art historical precedent, for example, Leonardo da Vinci's Mona Lisa. Cumulatively, these transformations form a composite 'ideal' physiognomy combining features from many works of art. *Omnipresence*, Orlan's seventh 'performance-operation', was broadcast live by satellite from New York to fifteen sites worldwide, including the Centre Georges Pompidou, Paris. Spectators around the world could ask the artist questions both before and during parts of the operation, performed by a feminist surgeon. Elaborately staging the event with drapery and costumes created by fashion designers, Orlan transformed the operating theatre (set up inside a New York gallery) into her studio, while her operation provided the material for the production of film, video, photographs and objects to be exhibited later. Over the forty-day period directly after the operation, Orlan juxtaposed photographs of her bruised, healing face with computer-morphed images of goddesses from Greek mythology. This emphasized the physical deformity and pain she was undergoing in order to attain a culturally idealized beauty.

Hannah WILKE (with Donald Goddard)
Intra-Venus Series II (details)
1993
Chromogenic supergloss photographs
121 × 182 cm [48 × 72 in] each

Wilke made *Intra-Venus* while she was dying of lymphoma. A series of life-sized colour photographs of her swollen and bruised body displays the deforming effects of cancer treatment. Self-portrait watercolours, medical object-sculptures and collages made with the hair she lost during chemotherapy are also part of the work. Prior to *Intra-Venus* Wilke had been known (and often criticized by other feminists) for work using her own glamorous, model-like face and body as a central element in her performance works. Transformed by her illness, Wilke continued to make work using her body, no longer young and beautiful, no longer conforming to an idealized feminine image. *Intra-Venus* was exhibited posthumously at the Ronald Feldman Gallery, New York, in 1994.

Alex BAG
Untitled (Fall 95)
1995
Video
28 mins., colour, sound

In *Untitled (Fall 95)* Bag appears in the persona of an art student who goes through a variety of transformations, delivering often hilarious monologues accompanying the various phases her assumed identities pass through. Bag's works use low-tech, vox-pop style video and an array of self-mutations to redirect television's ubiquitous presence, turning it into a tool that can be 'curated' by individuals for their own needs and pleasures rather than those of the broadcasting corporations. Blending street awareness with social experimentation, Bag creates a chameleon presence, mixing and matching, slipping and sliding between TV culture and personal agendas.

Tracey EMIN
Why I Never Became a Dancer
1995
Video
6 mins., 30 secs., colour, sound

Emin recounts a talent contest for dancing when she was heckled by boys in the audience. The camera retraces the scenes of her youth in Margate.
' I'd slept with quite a few of them … I was fourteen and they were between nineteen and twenty-four. You could say that they should have known better than to sleep with a fourteen-year-old girl … They shouldn't have publicly humiliated me. But this story is very edited. Even when I walked down the High Street they used to shout "Slag!" or "Slut!" I never did anything wrong to them; all I did was have sex with them … '
– Tracey Emin, 'The Story of I: Interview with Stuart Morgan', 1997
Emin's recollections of the past, often anguished, scenes of her life, function as an exorcism of the emotional trauma. In this respect her work reactivates a function of art that had been present in early feminist art activities such as the consciousness-raising groups of Womanhouse (Valencia, California, 1972), and had continued in live art practice, but had been largely excluded from the arena of visual art until the 1990s. Emin's sharing of her personal experiences is the conceptual material of her work, which she expresses through a variety of forms, from performance and video to installations such as a tent embroidered with the names of all the people she has shared a bed with, *Everyone I Have Ever Slept With 1963–1995* (1995).

Collier SCHORR
Bundeswehr
1998
C-print
30 × 40 cm [12 × 16 in]

During the 1990s, Schorr, a New York-based artist, frequently used Germany as a location for studying the intersection of personal, group and national identities. In images of young models, often posed in military uniforms, that are at first glance reminiscent of recent German photography by artists such as Thomas Ruff and Candida Hofer, Schorr observes the existential isolation of her subjects. Gesture, pose, attitude, the ways that movement is performed for the moment of the photograph, are key to Schorr's investigation of the ideological play between binary oppositions of identity: '*Bundeswehr* … is about skirting heroism. The subject strikes a pose to suggest the starry high associated with fictional soldiers. The text skirts the model's chest, highlighting the possibility of breasts … '
– Collier Schorr, Artist's statement, 2000

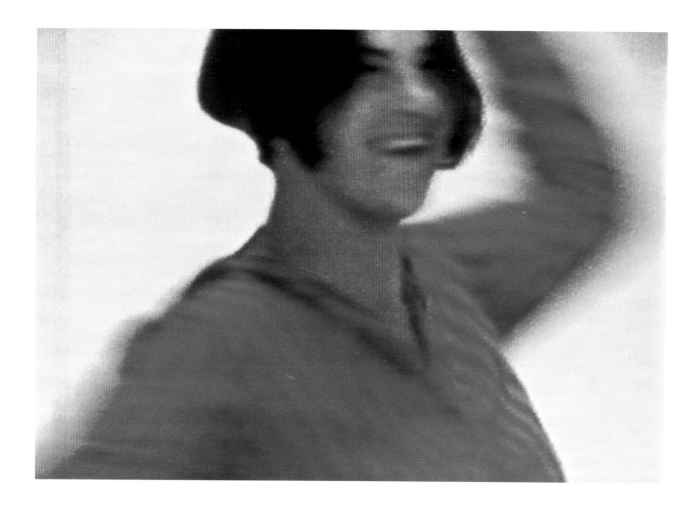

Lucy <u>GUNNING</u>
Climbing around My Room
1993
Video
7 mins., 30 secs., colour, sound

A video camera trails the movements of the protagonist as, with the quiet concentration of a rock climber, she uses every available surface except the floor (door knob, clothes hook, window ledge, bookshelf …) to edge her way around the perimeter of a room. Barefoot, clad in a red dress, she demonstrates great skill in preventing her climb from lapsing into the 'unladylike'. Like the subjects in Gunning's other works, whether mimicking horse sounds (*The Horse Impressionists*, 1994) or performing inaudibly (*Opera Singer*, 1996), this woman has a complex relationship with 'normal' language and expression. Gunning's subjects seem aware that they could be accused of not complying with the composure expected of womanhood, that various forms of assertive action are still classed as bordering on hysteria when performed by women. At the same time, their resolute performance alters and modifies that perception.

FEMMES DE SIÈCLE

The work of many women artists at the end of the 1990s showed evidence of millennial reflection, exploring collective memories, associations and traumas to re-open questions of history and the memorial. Pushing the limits and definitions of gender, some artists have explored gender identification in states of transition. Others have, sometimes controversially, reappropriated stereotypical imagery to address social and historical issues. In contrast to these challenging strategies, a number of artists have pursued the unsensational re-evaluation of the everyday, addressing banal situations, liminal spaces and chance encounters.

Coco FUSCO
Better Yet When Dead
1997
YYZ Artspace, Toronto;
International Arts Festival
of Medellin, Colombia

'Despite ... an exceptional array of cults dedicated to virgins and female saints, Latin America is still a terrain where women do not exercise control over their own bodies ... Latin women gain power over the collective cultural investment in their bodies when they die spectacular deaths, particularly if they die young. I sought to perform this ultimate expression of female will by feigning death – as other women.' Seeking to 'activate the psychodynamics of cross-cultural attraction', a central concern of her work, Fusco performed this action for several hours a day over several days, first in Canada, then in Colombia. Among the artists who inspired the work, referred to in accompanying texts, were Frida Kahlo, Ana Mendieta and performer Evita Perón.
– all quotes from Coco Fusco, 'Better Yet When Dead', 2000

Christine and Irene HOHENBÜCHLER
Zwei Rechts, Zwei Links Stricken
(To Knit 2, Purl 2)
1994
Cotton rope
Dimensions variable
Kunstverein, Munich, 1996

Born and based in Vienna, the Hohenbüchlers focus in much of their work on the traditionally 'female' skills of sewing, knitting and weaving – the only area of accomplishment which Freud notoriously allowed as women's original contribution to Western civilization. The Hohenbüchlers extend their own sibling collaboration to include the participation of groups with learning difficulties or from psychiatric and penal institutions, whose texts and artefacts are often interwoven with those of the artists. Rather than functioning as therapists, the Hohenbüchlers describe their strategy in terms of multiple authorship. Offering a collaborative framework, they hope to challenge viewers' expectations of work which blurs the boundaries between art and handicraft and which gives voice to those excluded by social institutionalization.

Shahzia <u>SIKANDER</u>
Ready to Leave
1994-97
Vegetable colour, dry pigment,
watercolour, tea on hand-prepared
'wasli' paper
25 × 19 cm [10 × 7.5 in]

Sikander studied traditional Mughal styles of miniature painting in Lahore, Pakistan. She applies these techniques in her small-scale works. Although some of her work directly represents contemporary political figures and issues, more often she creates a fantasy world, where traditional religious and allegorical imagery provides a starting point for modern, hybrid figures and scenes. Small, floating female figures are encircled by loops and cascades of white ribbons. A recurring principal figure often wears a white veil and has ribbons instead of feet. Often she is depicted with multiple arms brandishing a range of weapons. She is conceived as a symbol of female empowerment, rather than aggression, and floats to show that she is not grounded in anything other than herself. The figure is unnamed and changes form and meaning at will, a characteristic which the artist, raised as a Muslim and now resident in the US, adapts from the openness of Hindu mythology and applies to the diversity of her own shifting sense of identity.

Kara <u>WALKER</u>
Camptown Ladies
1998
Cut paper and adhesive on wall
274 × 2042 cm [108 × 804 in]
overall

Walker uses black-paper silhouette cut-outs to construct imagery that mingles 'the most deeply disturbed fantasies of Southern whites with the hitherto unimaginable visions of a contemporary young African-American woman … these scenes, at first glance the offspring of countless moonlight-and-magnolias illustrations, invariably turned out on closer inspection to involve blatantly coarse seductions or horrifically perverse scenarios.'
– Jerry Cullum, 'Landscape, Borders and Boundaries', 1995

The work sparked controversy, going beyond a clearly positioned critique of historically racist imagery to explore a seductive fascination with repressed and forbidden layers of interpretation.

Elaine <u>REICHEK</u>
Sampler (World Wide Web)
1998
Embroidery on linen
28.5 × 36 cm [11 × 14 in]

Reichek has focused on needlework sampler traditions to explore developments in artistic and cultural history through the perspective of a historically devalued craft medium. Re-presenting diverse material, from works by male artists, authors and filmmakers to those of Jenny Holzer and Barbara Kruger, Reichek links these and even the World Wide Web with an alternative history of fabrication and conceptualization.

Shirin NESHAT
Speechless
1996
Black and white photograph
101.5 × 152.5 cm [40 × 60 in]

Neshat's photograph shows an Islamic woman wearing a veil (*chador*) which is lifted
to reveal her face. What at first glance might be fleetingly misread as an earring is
seen to be the foreshortened barrel of a gun pointing towards the viewer; it is discon-
nected yet embedded in the image of the female subject. The image is overlaid with
Arabic text. To the non Arabic-literate viewer the text remains a mute, decorative form
whose meaning is inaccessible. This double effect of inscription and concealment is
echoed by the black *chador*, which for a Western audience is a symbol of oppression
and suffering, while in the Islamic world the *chador* makes female entrance into the
public sphere possible through its obliteration of the private, individual realm of the
visible female body. The gun embodies similar double-edged interpretations.
Neshat constructs images of Iranian identity that challenge assumptions about the
meaning and status of visual representation associated with the Islamic world.
For those who understand the texts, these also maintain positions of ambiguity
and struggle. They are authored by Iranian women, some of whom, like the feminist
Forough Farokhzad, complain of being trapped in Iranian culture; others, such as
the poet Tahereh Saffarzadeh, express passion for the Islamic revolution and the
liberation of the *chador*.

overleaf
Jenny HOLZER (with Tibor Kalman)
Lustmord
1993-94
Photographs of handwriting in ink on skin
32 × 22 cm [12.5 × 8.5 in] each

The English equivalent of the German word 'lustmord' is 'rape-slaying'. This was the
title of several works Holzer made in the aftermath of war in the former Yugoslavia.
The project was first presented in *Südeutsches Zeitung Magazin* in Germany.
Texts were written on the skin of women volunteers, and presented as cropped
photographs on the magazine pages. There is no way of knowing whether the skin
surfaces belong to a victim, perpetrator or observer. The texts similarly alternate
between the three viewpoints. The magazine cover reproduced one of the texts in red
ink mixed with blood provided by women involved in the project. The writing on the
skin opens up the incongruity between the rape as a traumatic act and its symbolic
inscription. The inscriptions remain detached from the body; they are messages that
can never convey the trauma of the act itself.

I TRY TO
EXCITE MYSELF
SO I
STAY CRAZY

I WANT TO
FUCK HER
WHERE SHE
HAS TOO
MUCH HAIR

I WANT TO BRUSH
HER HAIR BUT
THE SMELL OF HER
MAKES ME CROSS
THE ROOM. I HELD
MY BREATH AS
LONG AS I COULD.
I KNOW I DISAPPOINT HER.

MY BREASTS
ARE SO
SWOLLEN
THAT I
BITE THEM

I KNOW WHO
YOU ARE AND
IT DOES ME
NO GOOD
AT ALL

SHE ACTS
LIKE AN ANIMAL
LEFT FOR COOKING

SHE FELL ON THE FLOOR
IN MY ROOM.
SHE TRIED TO BE
CLEAN WHEN SHE DIED
BUT SHE WAS NOT.
I SEE HER TRAIL

SHE HAS NO
TASTE LEFT
TO HER AND
THIS MAKES IT
EASIER FOR ME

SHE STARTED RUNNING
WHEN EVERYTHING
BEGAN POURING FROM
HER BECAUSE
SHE DID NOT WANT
TO BE SEEN.

THE BIRD TURNS
ITS HEAD AND
LOOKS WITH
ONE EYE WHEN
YOU ENTER

THE COLOR OF
HER WHERE SHE
IS INSIDE OUT
IS ENOUGH TO
MAKE ME
KILL HER

WITH YOU
INSIDE ME
COMES THE
KNOWLEDGE OF
MY DEATH

YOU CONFUSE ME
WITH SOMETHING
THAT IS IN YOU
I WILL NOT
PREDICT HOW
YOU WANT TO
USE ME

YOU HAVE SKIN
IN YOUR MOUTH
YOU LICK ME
STUPIDLY

HER GORE IS IN
A BALL OF CLEANING
RAGS. I CARRY OUT THE
DAMPNESS LEFT FROM
MY MOTHER. I RETURN
TO HIDE HER JEWELRY

THE BLACK SPECKS
INSIDE MY EYES
FLOAT ON HER BODY
I WATCH THEM WHILE
I THINK ABOUT HER

YOUR AWFUL
LANGUAGE
IS IN
THE AIR
BY MY HEAD

I TAKE HER
FACE WITH ITS
FINE HAIRS.
I POSITION
HER MOUTH

Susan HILLER
From the Freud Museum
1991-97
Vitrine installation, 50 archival boxes individually titled and dated,
containing artefacts, notes, images, 1 video programme on lcd monitor
Boxes 25.5 × 33.5 × 6.5 cm [10 × 13 × 2.5 in] each
Collection, Tate Gallery, London

This installation's title refers to Sigmund Freud's last home, now the London Freud
Museum, where this work was first installed near to Freud's own remarkable collection
of antiquities and ethnographic objects. The title is also intended to suggest that we all
inhabit particular historically formed archives, which, in the case of Western Europeans,
might well be named 'the Freud museum'. The key to the work is the explicit evocation of
memory and its corollary, forgetting – waters from the streams of Lethe and Mnemosyne
have a central place in Hiller's suggestive collection of relics, samples, fragments and
rubbish. The process of interpreting the contents of each box in relation to its title and
its accompanying text, diagram or picture provides space where viewers can experience
their own roles as active participants – collaborators, interpreters, analysts or detectives.

Mona HATOUM
Present Tense
1996
Soap and glass beads
4.5 × 299 × 241 cm [2 × 118 × 95 in]

In 1996 Hatoum, whose Palestinian parents came from Haifa but had not been able
to return there since 1948, visited Jerusalem for the first time. *Present Tense* is one
of a series of installations and small works she made during her month there. 'On my
first day in Jerusalem I came across a map divided into a lot of little areas circled in
red, like little islands with no continuity or connection between them. It was the map
showing the territorial divisions arrived at under the Oslo Agreement, and it
represented the first phase of returning land to the Palestinian authorities. But really
it was a map about dividing and controlling the area.' A week later, Hatoum decided
to make a work with the pure olive oil soap made traditionally by hand in factories in
a Palestinian area; a transient substance which she also became aware of as a shared
symbol of continuity and resistance. She decided at that point to draw the outline of the
map on the surface of the soap, at first using nails but rejecting their aggressive form,
using instead glass beads pressed into the soap's surface. Responses to the work
revealed the very different backgrounds of the two cultures trying to co-exist. While
some Israeli visitors to the exhibition saw the soap as referring to the atrocities of the
concentration camps – a reference not intended by the artist – Palestinian visitors
immediately recognized the smell and associations of the soap. One visitor asked,
'Did you draw the map on soap because when it dissolves we won't have any of these
stupid borders?'
– all quotes from Mona Hatoum, *Mona Hatoum*, 1997

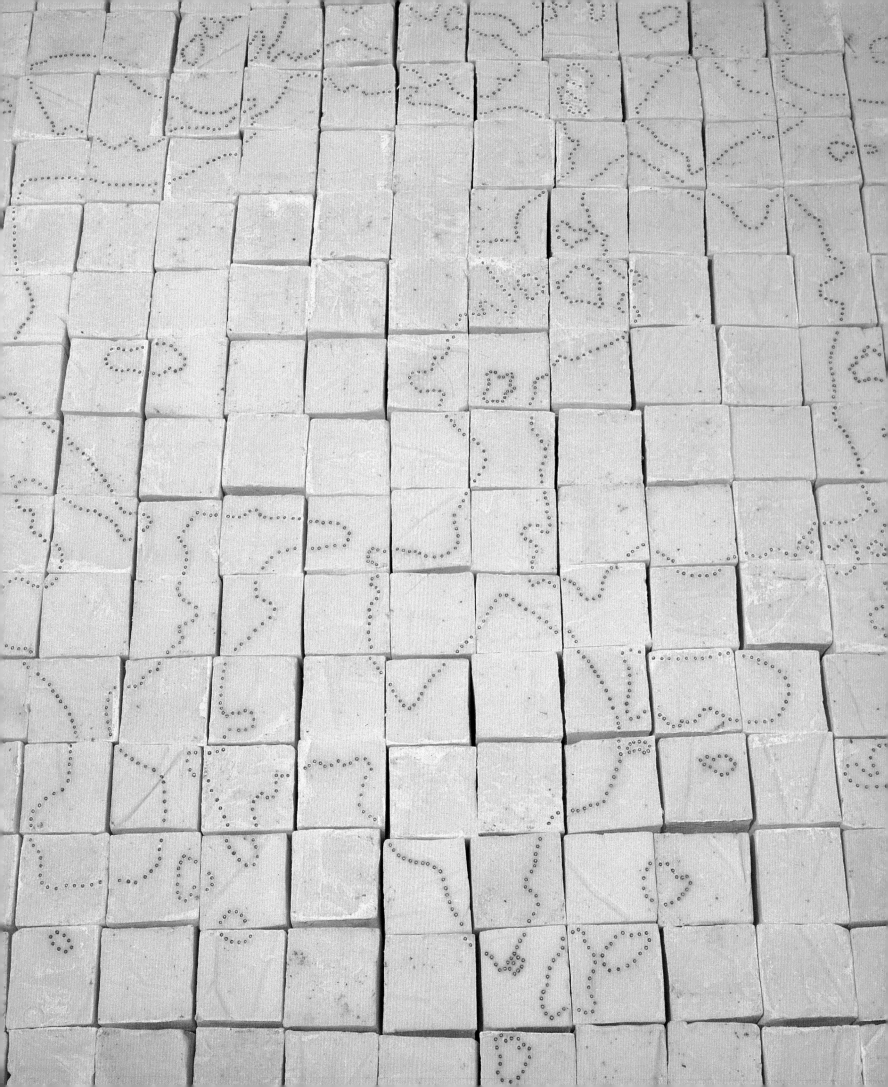

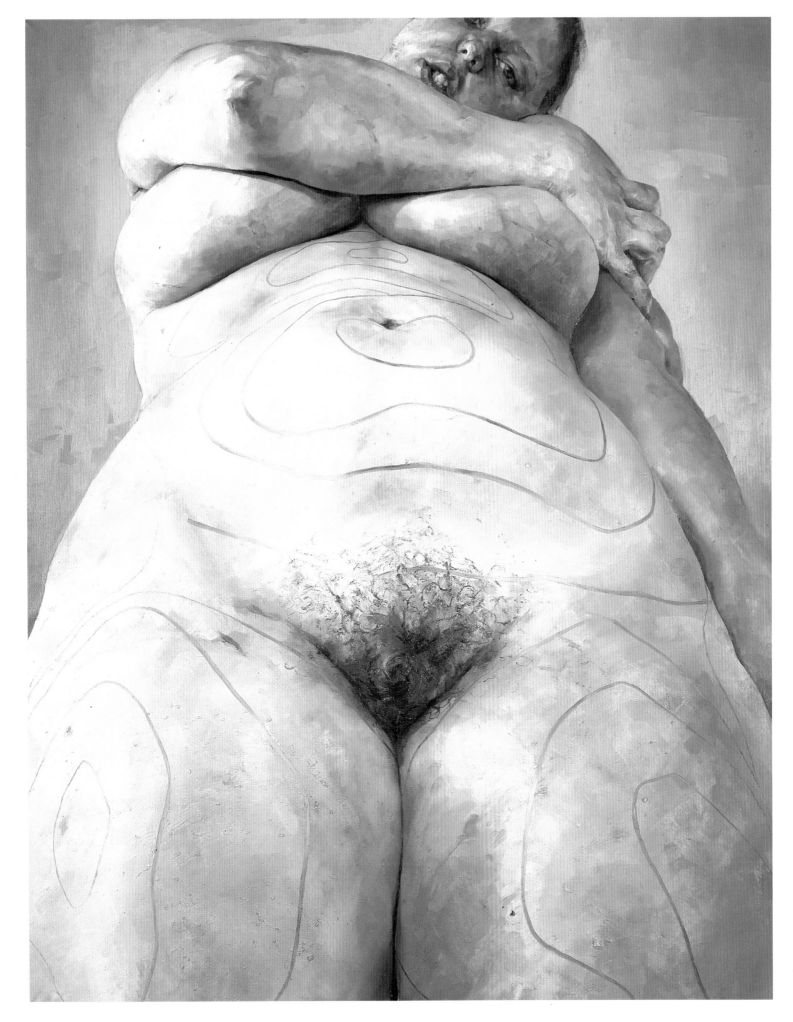

Jenny <u>SAVILLE</u>
Plan
1993
Oil on canvas
274.5 × 213.5 cm [108 × 84 in]

In this painting Saville combines the image of a female subject's body with the suggestion of landscape. The lines painted on the body's surface resemble contour markings on maps, while also suggesting areas of the body's topography indicated for liposuction, the surgical removal of unwanted fat. In this mapping of the body as an area of problematic terrain a relationship is set up between perceptions of the natural and the planned. The question of who is exercising control over this 'plan' remains troubling and implicates the viewer of the image.

Saville originally began making her large-scale paintings of female nudes by using photographs of parts of her own body to explore the role of model and artist at the same time. Both seductive and disturbing, Saville's images present the female nude pushing out towards the viewer, rather than being safely contained within a frame.

Vanessa <u>BEECROFT</u>
vb.dw.337.c
1994
Graphite and watercolour on paper
26 × 18 cm [11.5 × 8 in]

This is one of a series of works, originally conceived as part of a diary-like document chronicling a subject's struggle with anorexia nervosa. It takes the form of small pencil and watercolour sketches on paper. These are often fragmented and sometimes brightly coloured or covered in black marks. Beecroft's drawings are integrally related to her live performance and video works with young female participants. These explore the contrast between the individuality of the models and the stereotypes from the world of fashion and the media which they are required to mimic during the performances.

Eija-Liisa AHTILA
If 6 Was 9
1995
Split-screen video installation, colour, sound, each tape 10 mins.
The dialogues of three different groups of teenagers are projected simultaneously across a three-part split screen. They speak in Finnish with English subtitles. The dialogues are fictitious but are based on the Finnish artist's conversational research with teenagers on their attitudes towards sex and womanhood. What results is an indefinite combination of private memories, real and fictive events. Ahtila experiments with narrative techniques and temporal perspective to subvert traditional feature and TV film techniques in favour of mulilayered narratives with many possible readings. The form and context of the work are similarly intentionally adaptable, so that most of the artist's works can be presented in varied exhibition contexts, as cinema screenings or as TV broadcasts.

Gillian WEARING
Take Your Top Off (detail)
1993
3 C-type prints mounted on aluminium
73.5 × 99.5 cm [29 × 39 in] each
'I phoned people without meeting them first, and then went to their places and got into bed. I wouldn't go through a rehearsal beforehand. I just wanted to know what would happen, so it was all done on the same day … When I first showed it I didn't tell anyone that the people in the work were transsexuals … I didn't want to make that point … I wanted them just to be seen as people who looked like women.'
– Gillian Wearing, 'In conversation with Donna De Salvo', 1999
The artist sits in bed alongside her subjects, three people at different stages of transsexual transformation. With her own top off, she appears as a friendly participant yet strangely over-involved, occupying a troubling, ambiguous position. Often placing herself in vulnerable, unpredictable situations with strangers, Wearing acts out and implicitly questions notions of the artist as social anthropologist.

Pipilotti RIST
Sip My Ocean
1996
Video projection
3.5 mins., colour
Collections, Louisiana Museum of Modern Art, Humblebaek, Denmark; Museum of Contemporary Art, Chicago; Solomon R. Guggenheim Museum, New York
Continuously projected as two mirrored video images in the corner of a room, *Sip My Ocean* evokes a dream-like world of the unconscious. Images composed almost entirely of underwater scenes present kaleidoscopic impressions that become related, through the accompanying vocal soundtrack, to the experience of falling in love and surviving it. Rist sings a version of Chris Isaac's song 'Wicked Game', moving from the whispered adolescent longing of 'I never thought I'd fall in love with someone like you', to the emotional devastation of the adult recognition 'I never thought I'd lose someone like you'. The mirroring effect of the projection suggests the dualities at play in emotional desire. The seductiveness of desire and fulfilment is counterposed by suggestions of perilous undercurrents when everyday objects of domestic security – a toaster, a plate, a cup – are seen floating like abandoned toys to the bottom of the sea.

DOCU-
MENTS

PARVEEN ADAMS	GERMAINE GREER	ANNETTE MICHELSON	NANCY SPECTOR
CHANTAL AKERMAN	SUSAN GUBAR	KATE MILLETT	JO SPENCE
LAWRENCE ALLOWAY	BARBARA HAMMER	TRINH T. MINH-HA	LISA TICKNER
EMILY APTER	HARMONY HAMMOND	LAURA MULVEY	MARCIA TUCKER
BILL ARNING	DONNA J. HARAWAY	EILEEN MYLES	MIERLE LADERMAN
JAN AVGIKOS	N. KATHERINE HAYLES	SHIRIN NESHAT	UKELES
JEAN BAUDRILLARD	EVA HESSE	MIGNON NIXON	CAROLE S. VANCE
TESSA BOFFIN	SUSAN HILLER	LINDA NOCHLIN	KATE WALKER
SONIA BOYCE	LUCE IRIGARAY	YOKO ONO	MARINA WARNER
JUDITH BUTLER	JO ANNA ISAAK	GLORIA FEMAN	GILLIAN WEARING
SOPHIE CALLE	JILL JOHNSTON	ORENSTEIN	GILDA WILLIAMS
C. CARR	AMELIA JONES	ORLAN	
HELEN CHADWICK	KELLIE JONES	CRAIG OWENS	
JUDY CHICAGO	MARY KELLY	ROZSIKA PARKER	
HÉLÈNE CIXOUS	DIANA KETCHAM	ADRIAN PIPER	
LYGIA CLARK	APRIL KINGSLEY	SADIE PLANT	
EVA COCKCROFT	ANNE KOEDT	GRISELDA POLLOCK	
LAURA COTTINGHAM	JUTTA KOETHER	RADICALESBIANS	
ROSALIND COWARD	SILVIA KOLBOWSKI	YVONNE RAINER	
ELIZABETH COWIE	LIZ KOTZ	AIMEE RANKIN	
SIMONE DE BEAUVOIR	MAX KOZLOFF	REDSTOCKINGS	
ROSALIND DELMAR	ROSALIND KRAUSS	ADRIENNE RICH	
DIANE DI PRIMA	JULIA KRISTEVA	SU RICHARDSON	
VALIE EXPORT	BARBARA KRUGER	FAITH RINGGOLD	
JEAN FISHER	LESLIE LABOWITZ	SARAH J. ROGERS	
JEAN FRASER	SUZANNE LACY	MONICA ROSS	
BETTY FRIEDAN	ROSA LEE	ANNE-MARIE	
JOANNA FRUEH	MAYA LIN	SAUZEAU BOETTI	
COCO FUSCO	ULF LINDE	MIRIAM SCHAPIRO	
ANYA GALLACCIO	KATE LINKER	MIRA SCHOR	
SANDRA M. GILBERT	LUCY R. LIPPARD	COLLIER SCHORR	
NAN GOLDIN	AUDRE LORDE	JOAN SIMON	
RENÉE GREEN	JOSEPH MASHECK	VALERIE SOLANAS	

1. [see page 197]
Meret OPPENHEIM
Object (Le Dejeuner en
fourrure)
1936
Fur-covered cup, saucer
and spoon
h. 7 cm [2.5 in] overall

2. [see page 200]
Lygia CLARK
Pedra e ar (Stone and
air)
1966
Air, plastic bag,
elastic band, stone

3. [see page 204]
Angelica KAUFFMANN
Ceiling painting,
central hall, Royal
Academy of Arts, London
1778
Oil on canvas
132 × 150 cm
[52 × 59 in]

4. [see page 205]
Sophie TÄUBER-ARP
Untitled
1927
Watercolour on paper
28 × 39 cm
[11 × 15.5 in]

5. [see page 211]
Judy CHICAGO
Boxing Ring
1970
Advertisement
27 × 27 cm
[10 × 10 in]

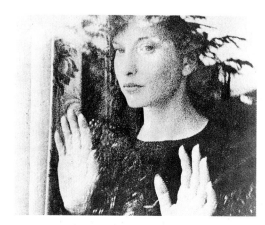

6. [see page 213]
Maya DEREN (with
Alexander Hammid)
Meshes of the Afternoon
1943
14 mins., black and
white

7. [see page 218]
MUJERES MURALISTAS
Latinoámerica
1974
Acrylic mural
6 × 23 m
[20 × 75 ft]
San Francisco

8. [see page 230]
Hannah O'SHEA
A Visual Time Span (A
Visual Diary)
1964-76
'About Time', Institute
of Contemporary Arts,
London, 1980

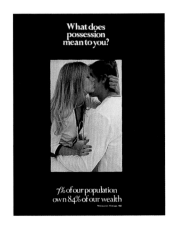

9. [see page 238]

Victor <u>BURGIN</u>

Possession

1976

Offset poster

109 × 84 cm

[43 × 33 in]

10. [see page 259]

David <u>SALLE</u>

The Burning Bush

1982

Oil and acrylic on canvas

234 × 300 cm

[92 × 118 in]

11. [see page 259]

Elizabeth <u>MURRAY</u>

Can You Hear Me

1984

Oil on canvas relief

269 × 404 × 30 cm

[106 × 159 × 12 in]

12. [see page 263]

Tessa <u>BOFFIN</u>

Angelic Rebels (detail)

1989

Black and white photograph

5 parts, 25.5 × 20 cm

[10 × 8 in] each

13. [see page 266]

Liubov <u>POPOVA</u>

Painterly Architectonics

1918

Watercolour and gouache on paper

29 × 23.5 cm

[11.5 × 9 in]

14. [see page 267]

Hannah <u>WILKE</u>

So Help Me Hannah Series: Portrait of the Artist with Her Mother, Selma Butter (1978-81) (detail)

1989

Black and white photograph

5 parts, 25.5 × 20 cm

[10 × 8 in] each

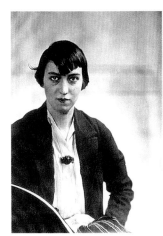

15. [see page 282]

Berenice <u>ABBOTT</u>

Auto-portrait

1925

Gelatin silver print

25.5 × 20 cm

[10 × 8 in]

16. [see page 287]

Frida <u>KAHLO</u>

Self-portrait with Cropped Hair

1940

Oil on canvas

40 × 28 cm

[15.5 × 11 in]

TOO MUCH

Frustration with the sexual status quo informs many of these texts, such as Betty Friedan's study, *The Feminine Mystique* (1963) – a 'wake-up call' for middle-class American women – and Valerie Solanas' uncompromising *SCUM Manifesto* (1968). Women struggled to voice their experiences of male-dominated society and for recognition in all social arenas. Their articulation provided a basis for the analysis of their shared plight. Art critics Lucy R. Lippard and Jill Johnston contributed to a growing awareness of women artists. Lippard only later identified with feminism, yet in the essay for her exhibition 'Eccentric Abstraction' (1966) her discussion of sensuous impulses in the work of contemporary female artists influenced feminist art and its interpretation. Jill Johnston championed the work of many emerging female artists as well as the experimental movement theatre of the Judson Dance Group. A provocative, outspoken lesbian, participating flamboyantly in the art scene she documented, Johnston would become a central figure in the Women's Liberation Movement.

Simone DE BEAUVOIR
The Second Sex [1949]

THE INDEPENDENT WOMAN

[...] What woman essentially lacks today for doing great things is forgetfulness of herself; but to forget oneself it is first of all necessary to be firmly assured that now and for the future one has found oneself. Newly come into the world of men, poorly seconded by them, woman is still too busily occupied to search for herself.

There is one category of women to whom these remarks do not apply because their careers, far from hindering the affirmation of their femininity, reinforce it. These are women who seek through artistic expression to transcend their given characteristics; they are the actresses, dancers and singers. For three centuries they have been almost the only women to maintain a concrete independence in the midst of society, and at the present time they still occupy a privileged place in it. Formerly actresses were anathema to the Church, and the very excessiveness of that severity has always authorized a great freedom of behaviour on their part. They often skirt the sphere of gallantry and, like courtesans, they spend a great deal of their time in the company of men; but making

their own living and finding the meaning of their lives in their work, they escape the yoke of men. Their great advantage is that their professional successes – like those of men – contribute to their sexual valuation; in their self-realization, their validation of themselves as human beings, they find self-fulfillment as women: they are not torn between contradictory aspirations. On the contrary, they find in their occupations a justification of their narcissism; dress, beauty care, charm, form a part of their professional duties [...]

Woman is still astonished and flattered at being admitted to the world of thought, of art – a masculine world. She is on her best behaviour; she is afraid to disarrange, to investigate, to explode; she feels she should seek pardon for her literary pretensions through her modesty and good taste. She stakes on the reliable values of conformity; she gives literature precisely that personal tone which is expected of her, reminding us that she is a woman by a few well-chosen graces, affectations and preciosities. All this helps her excel in the production of best-sellers; but we must not look to her for adventuring along strange ways [...]

Much more interesting are the insurgent females who have challenged this unjust society; a literature of protest can engender sincere and powerful works; out of the well

of her revolt George Eliot drew a vision of Victorian England that was at once detailed and dramatic; still, as Virginia Woolf has made us see, Jane Austen, the Brontë sisters, George Eliot, have had to expend so much energy negatively in order to free themselves from outward restraints that they arrive somewhat out of breath at the stage from which masculine writers of great scope take their departure; they do not have enough strength left to profit by their victory and break all the ropes that hold them back [...]

The fact is that the traditional woman is a bamboozled conscious being and a practitioner of bamboozlement; she attempts to disguise her dependence from herself, which is a way of consenting to it. To expose this dependence is in itself a liberation; a clear-sighted cynicism is a defence against humiliations and shame: it is the preliminary sketch of an assumption. By aspiring to clear-sightedness, women writers are doing the cause of women a great service; but – usually without realizing it – they are still too concerned with serving this cause to assume the disinterested attitude towards the universe that opens the widest horizons. When they have removed the veils of illusion and deception they think they have done enough; but this negative audacity leaves us still faced by an enigma, for the truth itself is ambiguity, abyss, mystery: once stated, it

must be thoughtfully reconsidered, re-created. It is all very well not to be duped, but at that point all else begins. Woman exhausts her courage dissipating mirages and she stops in terror at the threshold of reality [...]

How could van Gogh have been born a woman? A woman would not have been sent on a mission to the Belgian coal mines in Borinage, she would not have felt the misery of the miners as her own crime, she would not have sought a redemption; she would therefore have never painted van Gogh's sunflowers. Not to mention that the mode of life of the painter – his solitude at Arles, his frequentation of cafés and brothels, all that nourished van Gogh's art in nourishing his sensitivity – would have been forbidden her [...] There is hardly any woman other than St. Theresa who in total abandonment has herself lived out the situation of humanity: we have seen why. Taking her stand beyond the earthly hierarchies, she felt, like St. John of the Cross, no reassuring ceiling over her head. There were for both the same darkness, the same flashes of light, in the self the same nothingness, in God the same plenitude. When at last it will be possible for every human being thus to set his pride beyond the sexual differentiation, in the laborious glory of free existence, then only will woman be able to identify her personal history, her problems, her doubts, her hopes, with those of humanity; then only will she be able to seek in her life and her works to reveal the whole of reality and not merely her personal self. As long as she still has to struggle to become a human being, she cannot become a creator [...]

The free woman is just being born; when she has won possession of herself perhaps Arthur Rimbaud's prophecy will be fulfilled:
'*There shall be poets! When woman's unmeasured bondage shall be broken, when she shall live for and through herself, man – hitherto detestable – having let her go, she, too, will be poet! Woman will find the unknown! Will her ideational worlds be different from ours? She will come upon strange, unfathomable, repellent, delightful things; we shall take them, we shall comprehend them*'.'
It is not sure that her 'ideational worlds' will be different from those of men, since it will be through attaining the same situation as theirs that she will find emancipation; to say in what degree she will remain different, in what degree these differences will retain their importance – this would be to hazard bold predictions indeed. What is certain is that hitherto woman's possibilities have been suppressed and lost to humanity, and that it is high time she be permitted to take her chances in her own interest and in the interest of all.

1 In a letter to Pierre Demeny, May 15, 1871.
Simone de Beauvoir, *The Second Sex*, trans. H.M. Parshley (New York: Alfred A. Knopf, 1971) xiii-xxx; Originally published as *Le Deuxième Sexe* (Paris: Librairie Gallimard, 1949).

Diane DI PRIMA
The Quarrel [1961]

You know I said to Mark that I'm furious at you.

No he said are you bugged. He was drawing Brad who was asleep on the bed.

Yes I said I'm pretty god damned bugged. I sat down by the fire and stuck my feet out to warm them up.

Jesus I thought you think it's so easy. There you sit innocence personified. I didn't say anything else to him.

You know I thought I've got work to do too sometimes. In fact I probably have just as fucking much work to do as you do. A piece of wood fell out of the fire and I poked it back in with my toe.

I am sick I said to the woodpile of doing dishes. I am just as lazy as you. Maybe lazier. The toe of my shoe was scorched from the fire and I rubbed it where the suede was gone.

Just because I happen to be a chick I thought.

Mark finished one drawing and looked at it. Then he put it down and started another one.

It's damned arrogant of you I thought to assume that only you have things to do. Especially tonight.

And what a god damned concession it was for me to bother to tell you that I was bugged at all I said to the back of his neck. I didn't say it out loud.

I got up and went into the kitchen to do the dishes. And shit I thought I probably won't bother again. But I'll get bugged and not bother to tell you and after a while everything will be awful and I'll never say anything because it's so fucking uncool to talk about it. And that I thought will be that and what a shame.

Hey hon Mark yelled at me from the living room. It says here Picasso produces fourteen hours a day.

Diane Di Prima, 'The Quarrel' (1961), published in *A Different Beat: Writings by Women of the Beat Generation*, ed. Richard Peabody (London: Serpent's Tail, 1997) 46.

Betty FRIEDAN
The Problem That Has No Name [1963]

The problem lay buried, unspoken, for many years in the minds of American women. It was a strange stirring, a sense of dissatisfaction, a yearning that women suffered in the middle of the twentieth century in the US. Each suburban wife struggled with it alone. As she made the beds, shopped for groceries, matched slipcover material, ate peanut butter sandwiches with her children, chauffeured Cub Scouts and Brownies, lay beside her husband at night, she was afraid to ask even of herself the silent question, 'Is this all?'

For over fifteen years there was no word of this yearning in the millions of words written about women, for women, in all the columns, books and articles by experts telling women their role was to seek fulfilment as wives and mothers. Over and over women heard in voices of tradition and of Freudian sophistication that they could desire no greater destiny than to glory in their own femininity. Experts told them how to catch a man and keep him, how to breastfeed children and handle their toilet training, how to cope with sibling rivalry and adolescent rebellion; how to buy a dishwasher, bake bread, cook gourmet snails and build a swimming pool with their own hands; how to dress, look and act more feminine and make marriage more exciting; how to keep their husbands from dying young and their sons from growing into delinquents. They were taught to pity the neurotic, unfeminine, unhappy women who wanted to be poets or physicists or presidents. They learned that truly feminine women do not want careers, higher education, political rights – the independence and the opportunities that the old-fashioned feminists fought for. Some women, in their forties and fifties, still remembered painfully giving up those dreams, but most of the younger women no longer even thought about them. A thousand expert voices applauded their femininity, their adjustment, their new maturity. All they had to do was devote their lives from earliest girlhood to finding a husband and bearing children.

By the end of the 1950s the average marriage age of women in America dropped to twenty, and was still dropping, into the teens. Fourteen million girls were engaged by seventeen. The proportion of women attending college in comparison with men dropped from 47 per cent in 1920 to 35 per cent in 1958. A century earlier, women had fought for higher education; now girls went to college to get a husband. By the mid 1950s 60 per cent dropped out of college to marry, or because they were afraid too much education would be a marriage bar. Colleges built dormitories for 'married students', but the students were almost always the husbands. A new degree was instituted for the wives – 'PhT' (Putting Husband Through).

Then American girls began getting married in high school. And the women's magazines, deploring the unhappy statistics about these young marriages, urged that courses on marriage, and marriage counsellors, be installed in the high schools. Girls started going steady at twelve and thirteen, in junior high. Manufacturers put out brassieres with false bosoms of foam rubber for little girls of ten. And an advertisement for a child's dress, sizes 3–6x, in the *New York Times* in the autumn of 1960, said: 'She Too Can Join the Man-Trap Set'.

By the end of the 1950s the US birthrate was overtaking India's. The birth-control movement, renamed Planned Parenthood, was asked to find a method whereby women

who had been advised that a third or fourth baby would be born dead or defective might have it anyhow. Statisticians were especially astounded at the fantastic increase in the number of babies among college women. Where once they had two children, now they had four, five, six. Women who had once wanted careers were now making careers out of having babies. So rejoiced *Life* magazine in a 1956 paean to the movement of American women back to the home [...]

For over fifteen years, the words written for women and the words women used when they talked to each other, while their husbands sat on the other side of the room and talked shop or politics or septic tanks, were about problems with their children, or how to keep their husbands happy, or improve their children's school, or cook chicken or make slipcovers. Nobody argued whether women were inferior or superior to men; they were simply different. Words like 'emancipation' and 'career' sounded strange and embarrassing; no one had used them for years. When a Frenchwoman named Simone de Beauvoir wrote a book called *The Second Sex*, an American critic commented that she obviously 'didn't know what life was all about', and besides, she was talking about French women. The 'woman problem' in America no longer exists.

If a woman had a problem in the 1950s and 1960s, she knew that something must be wrong with her marriage or with herself. Other women were satisfied with their lives, she thought. What kind of a woman was she if she did not feel this mysterious fulfillment waxing the kitchen floor? [...]

But on an April morning in 1959 I heard a mother of four, having coffee with four other mothers in a suburban development fifteen miles from New York, say in a tone of quiet desperation, 'the problem'. And the others knew, without words, that she was not talking about a problem with her husband or her children or her home. Suddenly they realized they all shared the same problem, the problem that has no name. They began, hesitantly, to talk about it. Later, after they had picked up their children at nursery school and taken them home to nap, two of the women cried, in sheer relief, just to know they were not alone.

Gradually I came to realize that the problem that has no name was shared by countless women in America [...]

Just what was this problem that has no name? What were the words women used when they tried to express it? Sometimes a woman would say, 'I feel empty somehow ... incomplete'. Or she would say, 'I feel as if I don't exist'. Sometimes she thought the problem was with her husband, or her children, or that what she really needed was to redecorate her house or move to a better neighbourhood or have an affair or another baby. Sometimes she went to a doctor with symptoms she could hardly describe: 'A tired feeling ... I get so angry with the children it scares me ... I feel like crying without any reason'. (A Cleveland doctor called it 'the housewife's syndrome'.) A number of women told me about great bleeding blisters that break out on their hands and arms. 'I call it the housewife's blight', said a family doctor in Pennsylvania. 'I see it so often lately in these young women with four, five and six children who bury themselves in their dishpans.

But it isn't caused by detergent and it isn't cured by cortisone.'

Sometimes a woman would tell me that the feeling gets so strong she runs out of the house and walks through the streets. Or she stays inside her house and cries. Or her children tell her a joke, and she doesn't laugh because she doesn't hear it. I talked to women who had spent years on the analyst's couch, working out their 'adjustment to the feminine role', their blocks to 'fulfillment as a wife and mother'. But the desperate tone in these women's voices, and the look in their eyes, was the same as the tone and the look of other women, who were sure they had no problem, even though they did have a strange feeling of desperation [...]

In 1960 the problem that has no name burst like a boil through the image of the happy American housewife. In the television commercials the pretty housewives still beamed over their foaming dishpans and *Time*'s cover story on 'The Suburban Wife, an American Phenomenon' protested: 'Having too good a time ... to believe that they should be unhappy.' But the actual unhappiness of the American housewife was suddenly being reported – from the *New York Times* and *Newsweek* to *Good Housekeeping* and CBS Television ('The Trapped Housewife'), although almost everybody who talked about it found some super-ficial reason to dismiss it. It was attributed to incompetent appliance repairmen (*New York Times*) or the distances children must be chauffeured in the suburbs (*Time*) or too much PTA (*Redbook*). Some said it was the old problem – education: more and more women had education, which naturally made them unhappy in their role as housewives [...]

It is no longer possible to ignore that voice, to dismiss the desperation of so many American women. This is not what being a woman means, no matter what the experts say. For human suffering there is a reason; perhaps the reason has not been found because the right questions have not been asked or pressed far enough. I do not accept the answer that there is no problem because American women have luxuries that women in other times and lands never dreamed of; part of the strange newness of the problem is that it cannot be understood in terms of the age-old material problems of man: poverty, sickness, hunger, cold. The women who suffer this problem have a hunger that food cannot fill. It persists in women whose husbands are struggling interns and law clerks or prosperous doctors and lawyers; in wives of workers and executives who make $5,000 a year or $50,000. It is not caused by lack of material advantages; it may not even be felt by women preoccupied with desperate problems of hunger, poverty or illness. And women who think it will be solved by more money, a bigger house, a second car, moving to a better suburb, often discover it gets worse.

It is no possible today to blame the problem on loss of femininity: to say that education and independence and equality with men have made American women unfeminine. I have heard so many women try to deny this dissatisfied voice within themselves because it does not fit the pretty picture of femininity the experts have given them. I think, in fact, that this is the first clue to the

mystery: the problem cannot be understood in the generally accepted terms by which scientists have studied women, doctors have treated them, counsellors have advised them and writers have written about them. Women who suffer this problem, in whom this voice is stirring, have lived their whole lives in the pursuit of feminine fulfillment. They are not career women (although career women may have other problems); they are women whose greatest ambition has been marriage and children [...]

If I am right, the problem that has no name stirring in the minds of so many American women today is not a matter of loss of femininity or too much education or the demands of domesticity. It is far more important than anyone recognizes. It is the key to these other new and old problems which have been torturing women and their husbands and children and puzzling their doctors and educators for years. It may well be the key to our future as a nation and a culture. We can no longer ignore that voice within women that says: 'I want something more than my husband and my children and my home.'

Betty Friedan, 'The Problem That Has No Name', *The Feminine Mystique* (New York and London: W.W. Norton and Co., 1963) 15-32.

Valerie SOLANAS
SCUM[1] Manifesto [1967]

Life in this society being, at best, an utter bore and no aspect of society being at all relevant to women, there remains to civic-minded, responsible, thrill-seeking females only to overthrow the government, eliminate the money system, institute complete automation and destroy the male sex.

It is now technically possible to reproduce without the aid of males (or, for that matter, females) and to produce only females. We must begin immediately to do so. Retaining the male has not even the dubious purpose of reproduction. The male is a biological accident: the y (male) gene is an incomplete x (female) gene, that is, has an incomplete set of chromosomes. In other words, the male is an incomplete female, a walking abortion, aborted at the gene stage. To be male is to be deficient, emotionally limited; maleness is a deficiency disease and males are emotional cripples.

The male is completely egocentric, trapped inside himself, incapable of empathizing or identifying with others, of love, friendship, affection or tenderness. He is a completely isolated unit, incapable of rapport with anyone. His responses are entirely visceral, not cerebral; his intelligence is a mere tool in the service of his drives and needs; he is incapable of mental passion, mental interaction; he can't relate to anything other than his own physical sensations. He is a half dead, unresponsive lump, incapable of giving or receiving pleasure or happiness; consequently, he is at best an utter bore, an inoffensive blob, since only those capable of absorption in others can be charming. He is trapped in a twilight zone halfway between humans and apes, and is far worse off than the

apes because, unlike the apes, he is capable of a large array of negative feelings – hate, jealousy, contempt, disgust, guilt, shame, doubt – and, moreover, he is *aware* of what he is and isn't.

Although completely physical, the male is unfit even for stud service. Even assuming mechanical proficiency, which few men have, he is, first of all, incapable of zestfully, lustfully, tearing off a piece, but is instead eaten up with guilt, shame, fear and insecurity, feelings rooted in male nature, which the most enlightened training can only minimize; second, the physical feeling he attains is next to nothing; and, third, he is not empathizing with his partner, but is obsessed with how he's doing, turning in an A performance, doing a good plumbing job. To call a man an animal is to flatter him; he's a machine, a walking dildo. It's often said that men use women. Use them for what? Surely not pleasure.

Eaten up with guilt, shame, fears and insecurities and obtaining, if he's lucky, a barely perceptible physical feeling, the male is, none the less, obsessed with screwing; he'll swim a river of snot, wade nostril-deep through a mile of vomit, if he thinks there'll be a friendly pussy awaiting him [...]

Completely egocentric, unable to relate, empathize or identify, and filled with a vast, pervasive, diffuse sexuality, the male is psychically passive. He hates his passivity, so he projects it onto women, defines the male as active, then sets out to prove that he is ('prove he's a Man'). His main means of attempting to prove it is screwing (Big Man with a Big Dick tearing off a Big Piece) [...]

Women, in other words, don't have penis envy; men have pussy envy [...]

In actual fact the female function is to explore, discover, invent, solve problems, crack jokes, make music – all with love. In other words, create a magic world [...]

1 Society for Cutting Up Men.

Valerie Solanas, *SCUM Manifesto* (Paris: Olympia Press, 1968); reprinted by the Matriarchy Study Group, London (1993) 3–27. The text was written and self-published in 1967 by Solanas as a photocopied text she distributed by hand in New York.

Jill JOHNSTON

Dance: Yvonne Rainer I and II

[1963]

I. On 28 and 29 April Yvonne Rainer presented a new work for six dancers at Judson Memorial Church. 'Terrain', a long dance in five sections, is a brilliant culmination of a style and method that Miss Rainer has been exploring in short pieces over the past year or so. After the concert on the 29th a friend of the choreographer exuberantly congratulated me for having said a while back that Miss Rainer will be the next Martha Graham. I didn't, in fact, say that at all, so after I reminded the friend of what I actually wrote, he went on to say that at the time he thought it was unfair to place a 'burden' on a young artist with grand prophecies (my words), but that he now agreed with me

and thought Miss Rainer was equal to any ... challenge, I think he said.

THE NEXT RAINER

Actually, in that review of the last Judson Church concerts I made a statement and not a prophecy. If I had to say Miss Rainer would be the next anything, I'd say she would be the next Yvonne Rainer. However, by indulging in a historical reference, I realize that I was dabbling in a notorious occupational absurdity of critics. In the case of Miss Rainer, now that I think of it, the absurdity is based on a simple rationale. As spokesman I believe I was expressing the enthusiasm of a number of people who, like myself, have been pleasurably involved in the progress and doings of a certain group of dancers and who recognized in Miss Rainer, participating in that group from the beginning, an unusual personality of fertile imagination, with the drive and intelligence to project in objective terms an individual style, derived from the immediate past, with original modifications and advances [...]

It is interesting to note how Miss Rainer has here developed an original scheme based on the complex, refined chance methodology of Merce Cunningham (who is as responsible as anybody for the recent breakthrough of exciting dance business). Cunningham's procedure, which he has not used exclusively, is to set all the components of the dance – the movements and their situation in space and time – by the use of charts representing a large number of possibilities of those components, and tossing coins to determine, at each step, which possibility should occur. Miss Rainer, on the other hand, makes certain choices to begin with and transposes the chance operation into the actual performance of the dance. Chance here becomes improvisatory. The total method is a combination of set material with directives for the free, spontaneous use of that material, limited by rules which further enhance or restrict the freedom of the performer [...]

II. GAME OF *LOVE*

I don't know if I was moved or not by the game of *Love*, the duet, performed by Miss Rainer and William Davis, which emerges from the group *Play* and is directly followed by *Bach*, the finale of set movements collected from previous sections. For some old-fashioned reason, the moment I know my blood rushed was the moment at the end, just as they untangle and Miss Rainer sits slowly on Mr Davis' lap (both in a semi-standing position) and the Bach chorale suddenly floods the church.

If I wasn't moved by the duet, I was pleasurably shocked. Thirteen years of watching dance duets that amount to pretty flirtations or static idealizations and euphemism does not exactly prepare you for live love-making. This is a dance, however. The imagination of lovers around the world may vary considerably, but no pair of lovers would conceive it like this. The duet is a long, sustained gesture, for one thing. And it progresses by slipping in and out of 'actual' gestures and stylized gestures, adroitly handled to make the real physical contact a believable involvement even while you know it's a dance. You know it's a dance because the situation

is stylized by subtle deviations from the natural and by the total absence, in the quality of performance, of that emotion which might normally accompany that motion. The dance is further flattened by the bland vocal reiteration of universally familiar phrases of love – both positive and negative, which completes the abstraction: 'I love you', 'I don't love you', 'I really do love you', 'I've always loved you', 'I don't love you', 'I love you very much', etc.

HOW CLOSE?

I think I was moved by the dance. I was and I wasn't. The ambivalence becomes clearer. How close are you permitted to get to an art object? Could this dance be performed with more explicit emotion and bring you closer without driving you away? If so, I'd like to see it and get involved in it. Meanwhile, I'm very happy that someone finally thought of a dance in which two people touch each other factually, the way things are when desire flows into action [...]

The poise and control were perfect, always maintaining that difficult balance on a tightwire over life on the one side and art on the other.

AUTHENTIC STYLE

This was true of all the performers in the concert. I could have said it at the beginning, because it was so important to the success of the dance. They all looked as authentic as Miss Rainer in her style of movement. I mean that they looked like themselves even while rendering the material accurately. They're exceptionally trained dancers, and they have the extra qualities to handle improvisatory situations with a satisfying mixture of assertion and response, without strain, having a good time. Trisha Brown, Judith Dunn, William Davis, Steve Paxton and Albert Reid.

Jill Johnston, 'Dance: Yvonne Rainer I and II', *Village Voice* (23 May/6 June 1963).

Yoko ONO

Film No. 5 (Rape, or Chase)

[1964]

Rape with camera. One and a half hours, colour, synchronized sound.

A cameraman will chase a girl on a street with a camera persistently until he corners her in an alley, and, if possible, until she is in a falling position.

The cameraman will be taking a risk of offending the girl as the girl is somebody he picks up arbitrarily on the street, but there is a way to get around this.

Depending on the budget, the chase should be made with girls of different age, etc. May chase boys and men as well.

As the film progresses, and as it goes towards the end, the chase and the running should become slower and slower like in a dream, using a high-speed camera.

I have a cameraman who's prepared to do this successfully.

Yoko Ono, 'Film No. 5 (Rape, or Chase)', *Grapefruit* (Tokyo:

Wunternaum Press, 1964). Sixteen other scripts were first published in *Film Quarterly*, 43: 1 (Autumn 1989) 16–21.

Ulf LINDE
A Giant Among Women [1966]

She – 'a cathedral built by Niki de Saint-Phalle, Jean Tinguely and Per-Olof Ultvedt' – takes up the greater part of Room 1 at the Moderna Museet, Stockholm.

This three-storey building contains a bar, a planetarium, a lookout tower, an aquarium, a slide, a cinema, a tunnel of love, several magnificent pieces of art – plus a gallery of highly suspect *oeuvres* – a number of entirely ineffective machines, automatic vendors for various kinds of goods, service personnel, a small plant for the production of broken glass, a public telephone – plus other attractions ...

She is also a gigantic female figure – about 30 yds [27.5 m] long. Three large cupolas make the woman's belly and breasts. *She*'s body is lying on its back. Her skin glitters in splendid colour. And the gateway that leads into this rumbling, moaning, humming organism is – quite simply – the 'gate of life'.

She is reminiscent of both the Sophia mosque and the Willendorf Venus; she is a dilated hatcher – who herself resembles an egg. (Perhaps because Niki de Saint-Phalle has painted her in the same way as children paint Easter eggs.) *She*'s posture is that of generation. *She* is the ancient Great Mother with thighs widely parted – we see the waiting of dry land for rain and lightning or the facing expectancy of a female mammal, not just a woman. If we like, we can find also quite clear allusions to pre-Christian fertility cults. The fish-pond, for instance – we meet it immediately on entering the colossal body – existed in the goddess Astarte's temple courts in Babylon. And Tinguely's placing of a planetarium in one of *She*'s breasts becomes perhaps more meaningful if we know that the stars were once thought to be the drops of milk squeezed from a great divine udder by the longing ones on Earth.

The eroticism that prevails in this building is in other words mythical and poetic; the three artists have scrupulously avoided all naturalistic 'improprieties'.

But to approach *She* with a knowledge of classical fertility symbols is naturally not enough. A more necessary key is the world of now; the bar in the 'cathedral' is as dark and pokey as hundreds of thousands the world over – rooms for the lonely, desiring to be desired. The confined cinema auditorium is built in the same spirit. It is reminiscent also of a cheap charter aircraft – the emergency exit is in fact an aircraft door. The Tunnel of Love in Fun House style is another example; around us everywhere we feel the stage-property world of urbanized lust – Unreal City!

And furthest in, nearest the chancel or head, Ultvedt has made an ominously scraping construction in black and white; its forms derive clearly enough from dry bones – death too is with us.

Another poetical effect is achieved by allusion to the organs of the human body. The bar is in the belly, and waste is disposed of down a chute into Tinguely's formidable glass-breaking machine below – the whole thing is felt to allude to the digestive process. That the goldfish pond occupies the site of the womb requires no commentary. And Ultvedt's heart is not simply a flapping, rocking, pumping shape; we find there also the man in *She*'s heart – a figure sitting and watching a television screen, which transmits an excited, tossed sea, while numerous hands caress him [...]

But *She* is rich also in its plastic form; the great female is beautifully disposed over the ground – her posture, with the arms close into the body, is static, ritual. And we suddenly notice how refreshing it seems – what an effective departure Niki de Saint-Phalle has made from all the sterile, contrived gestures of Pop art. *She* resembles more a hill of Tuscan vineyards than a playmate of the month [...]

Ulf Linde, 'A Giant Among Women' (Stockholm: 1966); reprinted, trans. Patrick Hort, in *Niki de Saint Phalle* (Munich: Kunsthalle and Prestel Verlag, 1987) 140.

Lucy R. LIPPARD
Eccentric Abstraction [1966]

'Only the ugly is attractive.'
– Champfleury

The rigours of structural art would seem to preclude entirely any aberrations towards the exotic. Yet in the last three years, an extensive group of artists on both east and west coasts, largely unknown to each other, have evolved a non-sculptural style that has a good deal in common with the primary structure as well as, surprisingly, with aspects of Surrealism. The makers of what I am calling, for semantic convenience, eccentric abstraction,' refuse to eschew imagination and the extension of sensuous experience while they also refuse to sacrifice the solid formal basis demanded of the best in current non-objective art [...]

If government-sponsored academic sculpture is rooted in a heroic and funereal representation left over from the nineteenth century, the primary structurists have introduced a new kind of funeral monument – funereal not in the derogatory sense, but because their self-sufficient unitary or repeated forms are intentionally inactive. Eccentric abstraction offers an improbable combination of this death premise with a wholly sensuous, life-giving element. And it introduces humour into the structural idiom, where angels fear to tread. Incongruity, on which all humour is founded, and on which Surrealism depends so heavily, is a prime factor in eccentric abstraction, but the contrasts that it thrives upon are handled impassively, emphasizing neither one element nor the other, nor the encounter between the two. Opposites are used as complementaries rather than contradictions; the result is a formal neutralization or paralysis that achieves a unique sort of wholeness. Surrealism was based on the 'reconciliation of distant realities'; eccentric abstraction is based on the reconciliation of different forms or formal effects, a cancellation of the form-content dichotomy.

For instance, in her latest work, a labyrinth of white threads connecting three equally spaced grey panels, Eva Hesse has adopted a modular principle native to the structural idiom. She limits her palette to black, white and grey, but the finality of this choice is belied by an intensely personal mood. Omitting excessive detail and emotive colour, but retaining a tentative, vulnerable quality in the simplest forms, she accomplishes an idiosyncratic, unfixed space that is carried over from earlier paintings and drawings. A certain tension is transmitted by the tight-bound, paradoxically bulbous shapes of the smaller works, and by the linear accents of the larger ones. Energy is repressed, or rather imprisoned in a timeless vacuum tinged with anticipation and braced by tension.

There are a good many precedents for the sensuous objects, one of the first being Meret Oppenheim's notorious fur-lined teacup, saucer and spoon. Salvador Dali's extension of the idea, a fur-lined bathtub made for a Bonwit Teller display window in 1941, was a more potent vehicle for sensuous identification. The viewer was invited figuratively to immerse himself in a great fur womb, as he was twenty-five years later invited by Claes Oldenburg's gleaming, flexible blue and white vinyl bathtub. Yves Tanguy's 1936 object, *From the Other Side of the Bridge*, was another early example – a stuffed hand-like form choked suggestively off in two places by a tight rubber band extending from a panel marked 'caresses, fear, anger, oblivion, impatience, fluff'. Around 1960 Yayoi Kusama developed similar ideas in her phallus-studded furniture which, though unquestionably fecund, remained Surrealist in spirit. Lee Bontecou's gaping reliefs were a departure in the way they firmly subjugated the evocative element to unexpected formal ends, and in H.C. Westermann's *The Plush* (1964), fusion of the sensuous element with deadpan abstract form was completely resolved.[2] Ay-O's 'womb box' and blind or tactile peep-shows, Lucas Samaras' sadistic pin and needle objects and yarn-patterned boxes, Lindsey Decker's plastic extrusions which are both physically attractive and evocatively disturbing, even repellent, achieve similar effects without relinquishing the format of previous object art – mainly the box, plaque or vitrine motif.

Since the late 1940s, Louise Bourgeois has been working in manners relatable to eccentric abstraction – not so much non-sculptural as far out of the sculptural mainstreams. Her exhibition at the Stable Gallery in 1964 included several small, earth or flesh-coloured latex moulds which, in their single flexible form, indirectly erotic or scatological allusions and emphasis on the unbeautiful side of art, prefigured the work of younger artists today. Often labially slit, or turned so that the smooth, yellow-pink-brown lining of the mould as well as the highly tactile outer shell is visible, her mounds, eruptions, concave-convex reliefs and knot-like accretions are internally directed, with a suggestion of voyeurism. They imply the location rather than the act of metamorphosis, and are detached, but less aggressive than the immensely scaled work of her younger colleagues. In usual sculptural terms, these small, flattish, fluid moulds are decidedly

1. Meret Oppenheim

unprepossessing, ignoring decorative silhouette, mass, almost everything conventionally expected of sculpture. On the other hand, they have an uneasy aura of reality and provide a curiously *surrounded* intimacy despite their small size. They provoke that part of the brain which, activated by the eye, experiences the strongest physical sensations.

Such mindless, near-visceral identification with form, for which the psychological term 'body ego' seems perfectly adaptable, is characteristic of eccentric abstraction. It is difficult to explain why certain forms and treatments of form should elicit more sensuous response than others. Sometimes it is determined by the artist's own approach to his materials and forms; at others by the viewer's indirect sensations of identification, reflecting both his personal and vicarious knowledge of sensorial experience in general. Body ego can be experienced two ways: first through appeal, the desire to caress, to be caught up in the feel and rhythms of a work; second, through repulsion, the immediate reaction against certain forms and surfaces which take longer to comprehend. The first is more likely to be wholly sensuous while the second is based on education and taste, the often unnatural distinctions between beauty and ugliness, right and wrong subject matter […]

1 This article provided the basis for lectures at the University of California in Berkeley and the Los Angeles County Museum, in the summer of 1966, and for an exhibition by the same title at the Fischbach Gallery in New York, autumn 1966.

2 *The Plush* is a geometric semaphore that might have been conceived by David Smith, but it is covered with kinky green and lavender carpeting. Other Westermanns approach this concept, but he is essentially a figurative artist.

Lucy R. Lippard, 'Eccentric Abstraction', *Art International*, 10: 9 (20 November 1966) 28; 34-40.

Eva HESSE

Artist's statement [1969]

Hanging.
Rubberized, loose, open cloth.
Fibreglass – reinforced plastic.

Began somewhere in November–December 1968.
Worked.
Collapsed 6 April 1969. I have been very ill.
Statement.
Resuming work on piece,
have one complete from back then.
Statement, 15 October 1969, out of hospital,
short stay this time,
third time.
Same day, students and Douglas Johns began work.
MORATORIUM DAY
Piece is in many parts.
Each in itself is a complete statement,
together am not certain how it will be.

A fact, I cannot be certain yet.
Can be from illness, can be from honesty.
irregular, edges, six to seven feet long,
textures coarse, rough, changing.
see through, non see through, consistent, inconsistent,
enclosed tightly by glass like encasement just hanging there,
then more, others, will they hang there in the same way?
try a continuous flowing one,
try some random closely spaced,
try some distant far spaced.
they are tight and formal but very ethereal, sensitive, fragile,
see through mostly,
not painting, not sculpture, it's there though.
I remember I wanted to get to non art, non connotive,
non anthropomorphic, non geometric, non, nothing,
everything, but of another kind, vision, sort.
from a total other reference point. is it possible?
I have learned anything is possible. I know that,
that vision or concept will come through total risk,
freedom, discipline.
I will do it.

today, another step, on two sheets we put on the glass,
did the two differently.
one was cast – poured over hard, irregular, thick plastic;
one with screening, crumpled, they will all be different,
both the rubber sheets and the fibreglass,
lengths and widths.
question how and why in putting it together?
can it be different each time? why not?
how to achieve by not achieving? how to make by not making?
it's all in that,
it's not the new, it is what is yet not known,
thought, seen, touched but really what is not.
and that is.

The above text has been reproduced with the author's original use of capitalization. Eva Hesse, 'Artist's statement', *Art in Process IV* (New York: Finch College, 1969); reprinted in Lucy R. Lippard, *Eva Hesse* (New York: New York University Press, 1976) 165.

Mierle Laderman UKELES

Manifesto for Maintenance Art, 1969. Proposal for an exhibition: 'CARE' [1969]

I IDEAS

A The Death Instinct and The Life Instinct:
 The Death Instinct: separation; individuality; Avant-Garde par excellence; to follow one's own path to death – do your own thing; dynamic change.
 The Life Instinct: unification; the eternal return; the perpetuation and MAINTENANCE of the species; survival systems and operations; equilibrium.

B Two basic systems: Development and Maintenance.
 The sourball of every revolution: after the revolution who's going to pick up the garbage on Monday morning?
 Development: pure individual creation; the new; change; progress; advance; excitement; flight or fleeing.
 Maintenance: Keep the dust off the pure individual creation; preserve the new; sustain the change; protect progress; defend and prolong the advance; renew the excitement; repeat the flight:
show your work – show it again
keep the contemporaryartmuseum groovy
keep the home fires burning
 Development systems are partial feedback systems with major room for change.
 Maintenance systems are direct feedback systems with little room for alteration.

C Maintenance is a drag; it takes all the fucking time (lit.)
The mind boggles and chafes at the boredom.
The culture confers lousy status on the maintenance jobs
= minimum wages, housewives = no pay.
 Clean your desk, wash the dishes, clean the floor, wash your clothes, wash your toes, change the baby's diaper, finish the report, correct the typos, mend the fence, keep the customer happy, throw out the stinking garbage, watch out don't put things in your nose, what shall I wear, I have no sox, pay your bills, don't litter, save string, wash your hair, change the sheets, go to the store, I'm out of perfume, say it again – he doesn't understand, seal it again – it leaks, go to work, this art is dusty, clear the table, call him again, flush the toilet, stay young.

D Art:
 Everything I say is Art is Art. Everything I do is Art is Art. 'We have no Art, we try to do everything well.' (Balinese saying.)
 Avant-garde art, which claims utter development, is infected by strains of maintenance ideas, maintenance activities, and maintenance materials.
 Conceptual & Process art, especially, claim pure development and change, yet employ almost purely maintenance processes.

E The exhibition of Maintenance Art, '*CARE*', would zero in on pure maintenance, exhibit it, and yield, by utter opposition, clarity of issues […]

The above extract has been reproduced with the author's original use of capitalization.
Mierle Laderman Ukeles, *Manifesto for Maintenance Art, 1969. Proposal for an exhibition: 'CARE'. I. IDEAS*; reprinted in Kristine Stiles and Peter Selz (eds.), *Theories and Documents of Contemporary Art: A Sourcebook of Artists' Writings* (Berkeley and London: University of California Press, 1996) 220-21. This extract is from the first part of the manifesto (*I. IDEAS*). An extract from the first section (*A. Part One: Personal*) of the second part of the manifesto (*II. THE MAINTENANCE ART EXHIBITION: 'CARE'*) is reprinted in the caption on page 94 of this volume. The second part has two further sections: *B. Part Two: General* and *C. Part Three: Earth Maintenance*. In its entirety, the manifesto constitutes an artwork.

CLEAN YOUR DESK
WASH THE DISHES
CLEAN THE FLOOR
WASH YOUR CLOTHES
WASH YOUR TOES
CHANGE THE BABY'S DIAPER
FINISH THE REPORT
CORRECT THE TYPOS
MEND THE FENCE
KEEP THE CUSTOMER HAPPY
THROW OUT THE STINKING GARBAGE
WATCH OUT DON'T PUT THINGS IN YOUR NOSE
WHAT SHALL I WEAR
I HAVE NO SOX
PAY YOUR BILLS
DON'T LITTER
SAVE STRING
WASH YOUR HAIR
CHANGE THE SHEETS
GO TO THE STORE
I'M OUT OF PERFUME
SAY IT AGAIN – HE DOESN'T UNDERSTAND
SEAL IT AGAIN – IT LEAKS
GO TO WORK
THIS ART IS DUSTY
CLEAR THE TABLE
CALL HIM AGAIN
FLUSH THE TOILET
STAY YOUNG

Mierle Laderman Ukeles, 'Manifesto for Maintenance Art, 1969. Proposal for an exhibition, "CARE"'. 1969

Lygia CLARK
To Rediscover the Meaning of Our Routine Gestures
[1973]

I assembled a large number of worthless materials which, when grasped, rediscovered by the touch, induced a stimulating trauma.

The first of those experiments began thus: I had fractured my wrist in a car accident. It was coated in a kind of paste that had to be kept hot: my hand was imprisoned in a plastic bag kept in place by an elastic band, forming a sort of watertight sheath. One day I tore off the plastic bag, blew it up and sealed it with the elastic band; taking a small stone, I tried to hold it in place by pressing the bag with both hands on one of the points of the air pocket; then I let it be engulfed, thus mimicking an extremely disturbing birth. I was bowled over by the experience, which also marked the end of my crisis. I started to make a huge number of quite different new propositions: sensorial masks (smell, sound, tactile sensations), clothes that condition movement, forcing us to rediscover the meaning of our routine gestures, a *livro sensorial* or sensorial book (water, shells, pebbles, aluminium, wool) and an infinite number of other experiments which are difficult to describe. One of them, with the help of a rubber tube of the kind used for breathing by deep sea divers, made a strong impression on me. When you pinch the junction of the two joined ends of the tube, which is thus transformed into a ring, and stretch it, it emits a disturbing sound of asphyxiated breathing. So the first time I heard that breath (the proposition is called *Respire comigo* [*Breathe with me*]), my awareness of my own breathing obsessed me for several suffocating hours, whilst an unknown energy seemed to be born within me.

It was at that time that the political and social nature of my work became evident to me. Since it was a liberation for man, the release of a repressed desire, since the participant rediscovered a sensory energy deliberately numbed by our social habits, those experiments had a revolutionary impact and were also received as such. Indeed there were extremely violent reactions when they were presented at the Venice Biennale, in Germany and in Paris. All my current experiments on my body prove me right, even if they have nothing to do with my ideas [...]

Lygia Clark, 'To Rediscover the Meaning of Our Routine Gestures', published in 'L'art c'est le corps', *Preuves*, 13 (1973) 140-43.

Redstockings Manifesto
[1969]

I. After centuries of individual and preliminary political struggle, women are uniting to achieve their final liberation from male supremacy. Redstockings is dedicated to building this unity and winning our freedom.

II. Women are an oppressed class. Our oppression is total, affecting every facet of our lives. We are exploited as sex objects, breeders, domestic servants and cheap labour. We are considered inferior beings, whose only purpose is to enhance men's lives. Our humanity is denied. Our prescribed behaviour is enforced by the threat of physical violence.

Because we have lived so intimately with our oppressors, in isolation from each other, we have been kept from seeing our personal suffering as a political condition. This creates the illusion that a woman's relationship with her man is a matter of interplay between two unique personalities, and can be worked out individually. In reality, every such relationship is a *class* relationship, and the conflicts between individual men and women are *political* conflicts that can only be solved collectively.

III. We identify the agents of our oppression as men. Male supremacy is the oldest, most basic form of domination. All other forms of exploitation and oppression (racism, capitalism, imperialism, etc.) are extensions of male supremacy; men dominate women, a few men dominate the rest. All power structures throughout history have been male-dominated and male-oriented. Men have controlled all political, economic and cultural institutions and backed up this control with physical force. They have used their power to keep women in an inferior position. *All men* receive economic, sexual and psychological benefits from male supremacy. *All men* have oppressed women.

IV. Attempts have been made to shift the burden of responsibility from men to institutions or to women themselves. We condemn these arguments as evasions. Institutions alone do not oppress; they are merely tools of the oppressor. To blame institutions implies that men and women are equally victimized, obscures the fact that men benefit from the subordination of women and gives men the excuse that they are forced to be oppressors. On the contrary, any man is free to renounce his superior position provided that he is willing to be treated like a woman by other men.

We also reject the idea that women consent to or are to blame for their own oppression. Women's submission is not the result of brainwashing, stupidity or mental illness but of continual, daily pressure from men. We do not need to change ourselves, but to change men.

The most slanderous evasion of all is that women can oppress men. The basis for this illusion is the isolation of individual relationships from their political context and the tendency of men to see any legitimate challenge to their privileges as persecution.

V. We regard our personal experience and our feelings about that experience as the basis for an analysis of our common situation. We cannot rely on existing ideologies as they are all products of male supremacist culture. We question every generalization and accept none that are not confirmed by our experience.

Our chief task at present is to develop female class consciousness through sharing experience and publicly exposing the sexist foundation of all our institutions. Consciousness-raising is not 'therapy', which implies the existence of individual solutions and falsely assumes that the male-female relationship is purely personal, but the only method by which we can ensure that our programme for liberation is based on the concrete realities of our lives.

The first requirement for raising class consciousness is honesty, in private and in public, with ourselves and other women.

VI. We identify with all women. We define our best interest as that of the poorest, most brutally exploited woman.

We repudiate all economic, racial, educational or status privileges that divide us from other women. We are determined to recognize and eliminate any prejudices we may hold against other women.

We are committed to achieving internal democracy. We will do whatever is necessary to ensure that every woman in our movement has an equal chance to participate, assume responsibility and develop her political potential.

VII. We call on all our sisters to unite with us in struggle. We call on all men to give up their male privileges and support women's liberation in the interest of our humanity and their own.

In fighting for our liberation, we will always take the side of women against their oppressors. We will not ask what is 'revolutionary' or 'reformist', only what is good for women.

The time for individual skirmishes has passed. This time we are going all the way. Redstockings, 7 July, 1969. P.O. Box 744, Stuyvesant Station, New York, NY 10009.

Redstockings [anonymous collective], 'Redstockings Manifesto' (New York: Redstockings, 1969); reprinted in *The Vintage Book of Feminism: The Essential Writings of the Contemporary Women's Movement*, ed. Miriam Schneir (London: Vintage, 1995) 125-29. The manifesto was originally designed as a flyer for distribution at women's liberation events; a facsimile is available from Redstockings Women's Liberation Archives for Action Distribution Project at http://www.afn.org/~redstock/

PERSONALIZING THE POLITICAL

Attempts to define the nature of 'the feminine' in art dominate the period, from Judy Chicago and Miriam Schapiro's efforts to locate authentic sources of female imagery, to Anne-Marie Sauzeau Boetti's feminist interpretation of 'negative capability'. Linda Nochlin's essay 'Why Have There Been No Great Women Artists?' (1971) cautioned against the search for essentially feminine art, recommending instead analysis of social structures that have inhibited women artists. English translations appeared of continental feminists such as Hélène Cixous, Luce Irigaray and Julia Kristeva, stimulating ideas on relationships between female bodies, identity and creativity. British feminists explored the political implications of psychoanalysis; Laura Mulvey's 'Visual and Other Pleasures', published in 1975, analysing filmic representations of women, was widely influential. Periodicals emerged, including *Chrysalis*, *Feminist Art Journal*, *Feminist Art News*, *Heresies*, *Spare Rib*, *Womanspace* and *Women's Art News*. Within their pages the submerged histories of female creativity were explored.

Kate MILLETT
Postscript [1969]

Jean Genet's homosexual analysis of sexual politics was chosen, not only for the insights it affords into the arbitrary status-content of sexual role, but because it was against the taboo of homosexuality that Norman Mailer's counter-revolutionary ardour has hurled its last force. Yet there is evidence in the last few years that the reactionary sexual ethic we have traced, beginning with D.H. Lawrence's cunning sabotage of the feminist argument and Henry Miller's flamboyant contempt for it, has nearly spent itself.

Other progressive forces have recently asserted themselves, notably the revolt of youth against the masculine tradition of war and virility. Of course the most pertinent recent development is the emergence of a new feminist movement. Here again, it is difficult to explain just why such a development occurred when it did.' The enormous social change involved in a sexual revolution is basically a matter of altered consciousness, the exposure and elimination of social and psychological realities underlining political and cultural structures. We are speaking, then, of a cultural revolution, which, while it must necessarily involve the political and economic reorganization traditionally implied by the term revolution, must go far beyond this as well. And here it would seem the most profound changes implied are ones accomplished by human growth and true re-education, rather than those arrived at through the theatrics of armed struggle – even should the latter become inevitable. There is much reason to believe that the possession of numbers, dedication and creative intelligence could even render unnecessary the usual self-destructive resort to violent tactics. Yet no lengthy evolutionary process need be implied here, rather the deliberate speed fostered by modern communication, in an age when groups such as students, for example, can become organized in a great number of countries in a matter of some two years.

When one surveys the spontaneous mass movements taking place all over the world, one is led to hope that human understanding itself has grown ripe for change. In America one may expect the new women's movement to ally itself on an equal basis with blacks and students in a growing radical coalition. It is also possible that women now represent a very crucial element capable of swinging the national mood, poised at this moment between the alternatives of progress or political repression, towards meaningful change. As the largest alienated element in our society, and because of their numbers, passion and length of oppression, its largest revolutionary base, women might come to play a leadership part in social revolution, quite unknown before in history. The changes in fundamental values such a coalition of expropriated groups – blacks, youth, women, the poor – would seek are especially pertinent to realizing not only sexual revolution but a gathering impetus towards freedom from rank or prescriptive role, sexual or otherwise. For to actually change the quality of life is to transform personality, and this cannot be done without freeing humanity from the tyranny of sexual-social category and conformity to sexual stereotype – as well as abolishing racial caste and economic class.

It may be that a second wave of the sexual revolution might at last accomplish its aim of freeing half the race from its immemorial subordination – and in the process bring us all a great deal closer to humanity. It may be that we shall even be able to retire sex from the harsh realities

of politics, but not until we have created a world we can bear out of the desert we inhabit.

1 Civil Rights was undoubtedly a force, for second-
generation feminists were, like their predecessors,
inspired by the example of black protest. The
disenchantment of women in the New Left with the sexist
character of that movement provided considerable
impetus as well.

Kate Millett, 'Postscript' (1969) *Theory of Sexual Politics*
(Garden City, New York: Doubleday & Co., 1970; reprinted New
York: Simon & Schuster, Touchstone Editions, 1990).

Anne KOEDT
The Myth of the Vaginal Orgasm [1970]

Whenever female orgasm and frigidity are discussed, a false distinction has generally been defined by men as the failure of women to have vaginal orgasms. Actually the vagina is not a highly sensitive area and is not constructed to achieve orgasm. It is the clitoris which is the centre of sexual sensitivity and which is the female equivalent of the penis.

I think this explains a great many things: first of all, the fact that the so-called frigidity rate among women is phenomenally high. Rather than tracing female frigidity to the false assumptions about female anatomy, our 'experts' have declared frigidity a psychological problem of women. Those women who complained about it were recommended psychiatrists, so that they might discover their 'problem' – diagnosed generally as a failure to adjust to their role as women.

The facts of female anatomy and sexual response tell a different story. Although there are many areas for sexual arousal, there is only one area for sexual climax; that area is the clitoris. All orgasms are extensions of sensation from this area. Since the clitoris is not necessarily stimulated sufficiently in the conventional sexual positions, we are left 'frigid'.

Aside from physical stimulation, which is the common cause of orgasm for most people, there is also stimulation through primarily mental processes. Some women, for example, may achieve orgasm through sexual fantasies, or through fetishes. However, while the stimulation may be psychological, the *effect* is still physical, and the orgasm necessarily takes place in the sexual organ equipped for sexual climax – the clitoris. The orgasm experience may also differ in degree of intensity – some more localized, and some more diffuse and sensitive. But they are all clitoral orgasms.

All this leads to some interesting questions about conventional sex and our role in it. Men have orgasms essentially by friction with the vagina, not the clitoral area, which is external and not able to cause friction the way penetration does. Women have thus been defined sexually in terms of what pleases men; our own biology has not been properly analyzed. Instead, we are fed the myth of the liberated woman and her vaginal orgasm – an orgasm which in fact does not exist.

What we must do is redefine our sexuality. We must discard the 'normal' concepts of sex and create new guidelines which take into account mutual sexual enjoyment. While the idea of mutual enjoyment is liberally applauded in marriage manuals, it is not followed to its logical conclusion. We must begin to demand that if certain sexual positions now defined as 'standard' are not mutually conducive to orgasm, they no longer be defined as standard. New techniques must be used or devised which transform this particular aspect of our current sexual exploitation [...]

WHY MEN MAINTAIN THE MYTH

1. *The Penis as Epitome of Masculinity*. Men define their lives primarily in terms of masculinity. It is a universal form of ego-boosting. That is, in every society, however homogeneous (i.e., with the absence of racial, ethnic, or major economic differences) there is always a group, women, to oppress [...]

Since the clitoris is almost identical to the penis, one finds a great deal of evidence of men in various societies trying to either ignore the clitoris and emphasize the vagina (as did Freud), or, as in some places in the Middle East, actually performing clitoridectomy. Freud saw this ancient and still practiced custom as a way of further 'feminizing' the female by removing this cardinal vestige of her masculinity. It should be noted also that a big clitoris is considered ugly and masculine. Some cultures engage in the practice of pouring a chemical on the clitoris to make it shrivel up into a 'proper' size.

It seems clear to me that men in fact fear the clitoris as a threat to masculinity.

2. *Sexually Expendable Male*. Men fear that they will become sexually expendable if the clitoris is substituted for the vagina as the centre of pleasure for women. Actually this has a great deal of validity if one considers *only* the anatomy. The position of the penis inside the vagina, while perfect for reproduction, does not necessarily stimulate an orgasm in women because the clitoris is located externally and higher up. Women must rely upon indirect stimulation in the 'normal' position.

Lesbian sexuality could make an excellent case, based upon anatomical data, for the irrelevancy of the male organ. Albert Ellis says something to the effect that a man without a penis can make a woman an excellent lover [...]

3. *Lesbianism and Bisexuality*. Aside from the strictly anatomical reasons why women might equally seek other women as lovers, there is a fear on men's part that women will seek the company of other women on a full human basis. The recognition of clitoral orgasm would threaten the heterosexual *institution*. For it would indicate that sexual pleasure was obtainable from either men *or* women, thus making heterosexuality not an absolute, but an option. It would thus open up the whole question of *human* sexual relationships beyond the confines of the present male-female role system.

This text developed from a paper presented at the First
National Women's Liberation Conference, Chicago (1968).
Anne Koedt, 'The Myth of the Vaginal Orgasm', *Notes From the
Second Year* (Chicago: 1970); reprinted in *Radical Feminism*,
ed. Anne Koedt, Ellen Levine, Anita Rapone (New York:
Quadrangle, 1973) 198-207.

Germaine GREER
Sex [1970]

Women's sexual organs are shrouded in mystery.

It is assumed that most of them are internal and hidden, but even the ones that are external are relatively shady. When little girls begin to ask questions their mothers provide them, if they are lucky, with crude diagrams of the sexual apparatus, in which the organs of pleasure feature much less prominently than the intricacies of tubes and ovaries. I myself did not realize that the tissues of my vagina were quite normal until I saw a meticulously engraved dissection in an eighteenth-century anatomy textbook.' The little girl is not encouraged to explore her own genitals or to identify the tissues of which they are composed, or to understand the mechanism of lubrication and erection. The very idea is distasteful. Because of this strange modesty, which a young woman will find extends even into the doctor's surgery, where the doctor is loath to examine her, and loath to expatiate on what he finds, female orgasm has become more and more of a mystery, at the same time as it has been exalted as a duty. Its actual nature has become a matter for metaphysical speculation. All kinds of false ideas are still in circulation about women, although they were disproved years ago: many men refuse to relinquish the notion of female ejaculation, which although it has a long and prestigious history is utterly fanciful.

Part of the modesty about the female genitalia stems from actual distaste. The worst name anyone can be called is *cunt*. The best thing a cunt can be is small and unobtrusive: the anxiety about the bigness of the penis is only equalled by anxiety about the smallness of the cunt. No woman wants to find out that she has a twat like a horse-collar: she hopes she is not sloppy or smelly, and obligingly obliterates all signs of her menstruation in the cause of public decency. Women were not always so reticent: in ballad literature we can find lovely examples of women vaunting their genitals, like the lusty wench who admonished a timid tailor in round terms because he did not dare measure her fringed purse with his yard:
'*You'l find the Purse so deep,*
You'l hardly come to the treasure.'[2]
Another praised her shameful part in these terms:
'*I have a gallant Pin-box,*
the like you ne'er did see,
It is where never was the Pox
something above my knee ...
O 'tis a gallant Pin-box
you never saw the peer;
Then Ile not leave my Pin-box
for fifty pound a year.'[3]
Early gynaecology was entirely in the hands of men, some of whom, like Samuel Collins, described the vagina so lovingly that any woman who read his words would have been greatly cheered. Of course such books were not

meant to be seen by women at all. He speaks of the vagina as the Temple of Venus and the *mons veneris* as Venus' cushion, but he abandons euphemism to describe the wonders of the female erection:

' ... *the Nymphs ... being extended to compress the Penis and speak a delight in the act of Coition ... The use of the blood-vessels is to impart Vital Liquor into the substance of the Clitoris, and of the Nerves to impregnate it with a choyce Juyce inspired with animal Spirits (full of Elastick Particles making it Vigorous and Tense) ... The Glands of the Vagina ... being heated in Coition, do throw off the rarified fermented serous Liquor, through many Meatus into the Cavity of the Vagina, and thereby rendereth its passage very moist and slippery, which is pleasant in Coition ... The Hypogastrick Arteries do sport themselves in numerous Ramulets about the sides and other parts of the Vagina, which are so many inlets of blood to make it warm and turgid in the Act of Coition.*'[4]

Collins' description is an active one: the vagina *speaks*, *throws*, is *tense* and *vigorous*. He and his contemporaries assumed that young women were even more eager for intercourse than young men. Some of the terms they used to describe the tissues of the female genitalia in action are very informative and exact, although unscientific. The vagina is said to be lined 'with tunicles like the petals of a full-blown rose', with 'Wrinckle on wrinckle' which 'do give delight in Copulations'. The vagina was classified as 'sensitive enough' which is an exact description. They were aware of the special role of the clitoris, in causing the 'sweetness of love' and the 'fury of venery'.

The notion that healthy and well-adjusted women would have orgasms originating in the vagina was a metaphysical interpolation in the empirical observations of these pioneers. Collins took the clitoris for granted, as a dear part of a beloved organ; he did not underemphasize the role of the vagina in creating pleasure, as we have seen. Unhappily we have accepted, along with the reinstatement of the clitoris after its proscription by the Freudians, a notion of the utter passivity and even irrelevance of the vagina. Love-making has become another male skill, of which women are the judges. The skills that the Wife of Bath used to make her husbands swink, the athletic sphincters of the Tahitian girls who can keep their men inside them all night, are alike unknown to us. All the vulgar linguistic emphasis is placed upon the *poking* element; *fucking*, *screwing*, *rooting*, *shagging* are all acts performed upon the passive female: the names for the penis are all *tool* names. The only genuine intersexual words we have for sex are the obsolete *swive*, and the ambiguous *ball*. Propagandists like Theodore Faithfull (and me) are trying to alter the emphasis of the current imagery [...] Women will have to accept part of the responsibility for their own and their partners' enjoyment, and this involves a measure of control and conscious co-operation. Part of the battle will be won if they can change their attitude towards sex, and embrace and stimulate the penis instead of *taking* it. Enlightened women have long sung the praises of the female superior position, because they are not weighed down by the heavier male body, and can respond more spontaneously. It is after all a question of communication, and communication is not advanced by the *he talk*, *me listen* formula.

The banishment of the fantasy of the vaginal orgasm is ultimately a service, but the substitution of the clitoral spasm for genuine gratification may turn out to be a disaster for sexuality [...]

1 e.g. Samuel Collins, *Systema Anatomicum* (London, 1685), p. 566, and Palfijn's *Surgical Anatomy* (London, 1726), plates facing pages 226 and 227, also his *Description Anatomique des Parties de la Femme* (Paris, 1708, the plates are not numbered) and Spigelius, *De humani corporis Fabrica* (1627), Tab. XVII, Lib. VIII, and *Les Portraits Anatomiques* of Vesalius (1569), and the *Tabulae Anatomicae* of Eustachius (1714).

2 *A Pleasant new Ballade Being a merry Discourse between a Country Lass and a young Taylor*, c.1670.

3 *The High-prized Pin-Box. Tune of, Let every Man with Cap in's Hand* etc., c.1665.

4 Samuel Collins (*op. cit.*), pp. 564-5.

Germaine Greer, 'Sex', *The Female Eunuch* (London: MacGibbon & Kee Ltd., 1970) 48-57.

RADICALESBIANS
The Woman-Identified Woman [1972]

At the Second Congress to Unite Women, convened in New York City in May 1970, an unscheduled event interrupted the first evening's programme. As some four hundred feminist activists listened to the final moments of a presentation by the drama group Burning City, the auditorium suddenly went dark. When the lights came up again, twenty women wearing T-shirts imprinted 'Lavender Menace' stood at the front of the room.

Lavender Menace was a recently formed collective of lesbian feminists. Its name derived from a remark attributed to Betty Friedan – that lesbians in the women's movement were a 'lavender menace' that could ultimately hurt the cause.' Actually, lesbians had been involved in the women's movement from its inception, most often without identifying themselves as homosexual. But since the birth of the gay liberation movement in 1969, many lesbians had wished to end what seemed to them a demeaning charade. A few had revealed their sexual orientation – only to encounter antagonism where they least expected it: in the feminist family.

The Lavender Menace, arrayed at the front of the auditorium, spoke to those attending the congress about discrimination against lesbians in the women's movement. When they called for sympathetic members of the audience to come forward, about thirty women responded. The next day, conference participants crowded into impromptu workshops on lesbianism conducted by the Menaces. Similar events occurred at a congress on the West Coast. The issue of gays in the women's movement – long hidden in the shadows – had emerged into the light.

One of the first projects of Lavender Menace, who renamed themselves Radicalesbians, was to produce a position paper titled 'The Woman-Identified Woman'.

Lesbians began to pressure NOW [National Organization for Women] to publicly support their struggle for basic human rights, and many bitter feuds erupted. By 1971, however, NOW passed a resolution affirming a woman's right 'to define and express her own sexuality' and stating that 'NOW acknowledges the oppression of lesbians as a legitimate concern of feminism'. Two years later NOW incorporated lesbian rights into its legislative agenda.

But this was by no means the end of the matter. The lesbian issue continued to generate personal and ideological splits among feminists – including among radical feminists – that sisterhood could not always surmount. Lesbians and straights both played a part in this unfortunate turn of events: Some straight feminists were afraid of being labelled dykes and wished to dissociate both the movement and themselves from lesbianism, while some lesbians claimed that lesbianism was an example of feminism in action and preached that the only true feminists were those who renounced relations with the opposite sex entirely. Such proselytizing apparently influenced a number of feminists to become lesbians by choice; but others, like longtime activist Anne Koedt, found the claims 'outrageous'. Koedt wrote, 'It seems to me to show a disrespect for another woman to presume that it is any group's (or individual's) prerogative to pass revolutionary judgment on the progress of her life ... Feminism is an offering, not a directive.'[2]

Women in the movement have in most cases gone to great lengths to avoid discussion and confrontation with the issue of lesbianism. It puts people up-tight. They are hostile, evasive, or try to incorporate it into some 'broader issue'. They would rather not talk about it. If they have to, they try to dismiss it as a 'lavender herring'. But it is no side issue. It is absolutely essential to the success and fulfillment of the women's liberation movement that this issue be dealt with. As long as the label 'dyke' can be used to frighten a woman into a less militant stand, keep her separate from her sisters, keep her from giving primacy to anything other than men and family – then to that extent she is controlled by the male culture. Until women see in each other the possibility of a primal commitment which includes sexual love, they will be denying themselves the love and value they readily accord to men, thus affirming their second-class status. As long as male acceptability is primary – both to individual women and to the movement as a whole – the term 'lesbian' will be used effectively against women. In so far as women want only more privileges within the system, they do not want to antagonize male power. They instead seek acceptability for women's liberation, and the most crucial aspect of the acceptability is to deny lesbianism – i.e., deny any fundamental challenge to the basis of the female role.

It should also be said that some younger, more radical women have honestly begun to discuss lesbianism, but so far it has been primarily as a sexual 'alternative' to men. This, however, is still giving primacy to men, both because the idea of relating more completely to women occurs as a *negative reaction to men*, and because the lesbian relationship is being characterized simply by sex, which is divisive and sexist. On one level, which is both personal and political, women may withdraw emotional and sexual

energies from men, and work out various alternatives for those energies in their own lives. On a different political/psychological level, it must be understood that what is crucial is that women begin disengaging from male-defined response patterns. In the privacy of our own psyches, we must cut those chords to the core. For irrespective of where our love and sexual energies flow, if we are male-identified in our heads, we cannot realize our autonomy as human beings.

But why is it that women have related to and through men? By virtue of having been brought up in a male society, we have internalized the male culture's definition of ourselves. That definition views us as relative beings who exist not for ourselves, but for the servicing, maintenance and comfort of men. That definition consigns us to sexual and family functions, and excludes us from defining and shaping the terms of our lives. In exchange for our psychic servicing and for performing society's non-profit-making functions, the man confers on us just one thing: the slave status which makes us legitimate in the eyes of the society in which we live. This is called 'femininity' or 'being a real woman' in our cultural lingo. We are authentic, legitimate, real to the extent that we are the property of some man whose name we bear. To be a woman who belongs to no man is to be invisible, pathetic, inauthentic, unreal. He confirms his image of us – of what we have to be in order to be acceptable by him – but not our real selves; he confirms our womanhood – as he defines it, in relation to him – but cannot confirm our personhood, our own selves as absolutes. As long as we are dependent on the male culture for this definition, for this approval, we cannot be free.

The consequence of internalizing this role is an enormous reservoir of self-hate. This is not to say the self-hate is recognized or accepted as such; indeed most women would deny it. It may be experienced as discomfort with her role, as feeling empty, as numbness, as restlessness, a paralyzing anxiety at the centre. Alternatively, it may be expressed in shrill defensiveness of the glory and destiny of her role. But it does exist, often beneath the edge of her consciousness, poisoning her existence, keeping her alienated from herself, her own needs, and rendering her a stranger to other women. They try to escape by identifying with the oppressor, living through him, gaining status and identity from his ego, his power, his accomplishments. And by not identifying with other 'empty vessels' like themselves. Women resist relating on all levels to other women who will reflect their own oppression, their own secondary status, their own self-hate. For to confront another woman is finally to confront one's self – the self we have gone to such lengths to avoid. And in that mirror we know we cannot really respect and love that which we have been made to become.

As the source of self-hate and the lack of real self are rooted in our male-given identity, we must create a new sense of self. As long as we cling to the idea of 'being a woman', we will sense some conflict with that incipient self, that sense of I, that sense of a whole person. It is very difficult to realize and accept that being 'feminine' and being a whole person are irreconcilable. Only women can

give each other a new sense of self. That identity we have to develop with reference to ourselves, and not in relation to men. This consciousness is the revolutionary force from which all else will follow, for ours is an organic revolution. For this we must be available and supportive to one another, give our commitment and our love, give the emotional support necessary to sustain this movement. Our energies must flow toward our sisters, not backwards toward our oppressors. As long as women's liberation tries to free women without facing the basic heterosexual structure that binds us in one-to-one relationship with our own oppressors, tremendous energies will continue to flow into trying to straighten up each particular relationship with a man, how to get better sex, how to turn his head around – into trying to make the 'new man' out of him, in the delusion that this will allow us to be the 'new woman'. This obviously splits our energies and commitments, leaving us unable to be committed to the construction of the new patterns which will liberate us.

It is the primacy of women relating to women, of women creating a new consciousness of and with each other which is at the heart of women's liberation, and the basis for the cultural revolution. Together we must find, reinforce and validate our authentic selves. As we do this, we confirm in each other that struggling, incipient sense of pride and strength, the divisive barriers begin to melt, we feel this growing solidarity with our sisters. We see ourselves as prime, find our centres inside of ourselves. We find receding the sense of alienation, of being cut off, of being behind a locked window, of being unable to get out what we know is inside. We feel a realness, feel at last we are coinciding with ourselves. With that real self, with that consciousness, we begin a revolution to end the imposition of all coercive identifications, and to achieve maximum autonomy in human expression.

1 In some versions of the anecdote, Friedan is said to have
 called the charge of lesbianism in the movement a
 'lavender herring' - a play on 'red herring', a term from
 the 1950s.
2 Anne Koedt, 'Lesbianism and Feminism', in *Radical
 Feminism*, ed. Anne Koedt, Ellen Levine, and Anita Rapone
 (New York: Quadrangle, 1973), pp. 255-256. Reprinted
 from *Notes from the Third Year* (1971).
 Radicalesbians [March Hoffman (Artemis March), Ellen Bedoz,
 Cynthia Funk, Rita Mae Brown, Lois Hart and 'Barbara XX',
 with other anonymous members of the group], 'The Woman-
 Identified Woman', (New York: Gay Flames, 1972).

Linda NOCHLIN
Why Have There Been No Great Women Artists? [1971]

Why have there been no great women artists? The question is crucial, not merely to women, and not only for social or ethical reasons, but for purely intellectual ones as well. If, as John Stuart Mill so rightly suggested, we tend to accept whatever *is* as 'natural'[1], this is just as true in the realm of academic investigation as it is in our social

arrangements: the white Western male viewpoint, unconsciously accepted as *the* viewpoint of the art historian, is proving to be inadequate. At a moment when all disciplines are becoming more self-conscious – more aware of the nature of their presuppositions as exhibited in their own languages and structures – the current uncritical acceptance of 'what is' as 'natural' may be intellectually fatal. Just as Mill saw male domination as one of many social injustices that had to be overcome if a truly just social order were to be created, so we may see the unconscious domination of a white male subjectivity as one among many intellectual distortions which must be corrected in order to achieve a more adequate and accurate view of history.

A feminist critique of the discipline of art history is needed which can pierce cultural-ideological limitations, to reveal biases and inadequacies *not merely in regard to the question of women artists, but in the formulation of the crucial questions of the discipline as a whole*. Thus the so-called woman question, far from being a peripheral sub-issue, can become a catalyst, a potent intellectual instrument, probing the most basic and 'natural' assumptions, providing a paradigm for other kinds of internal questioning, and providing links with paradigms established by radical approaches in other fields. A simple question like 'Why have there been no great women artists?' can, if answered adequately, create a chain reaction, expanding to encompass every accepted assumption of the field, and then outward to embrace history and the social sciences or even psychology and literature, and thereby, from the very outset, to challenge traditional divisions of intellectual inquiry.

The assumptions lying behind the question 'Why have there been no great women artists?' are varied in range and sophistication. They run from 'scientifically' proven demonstrations of the inability of human beings with wombs rather than penises to create anything significant, to relatively open-minded wonderment that women, despite so many years of near equality, have still not achieved anything of major significance in the visual arts.

The feminist's first reaction is to swallow the bait and attempt to answer the question as it is put: to dig up examples of insufficiently appreciated women artists throughout history; to rehabilitate modest, if interesting and productive, careers; to 'rediscover' forgotten flower-painters or David-followers and make a case for them; to demonstrate that Berthe Morisot was really less dependent upon Manet than one had been led to think – in other words, to engage in activity not too different from that of the average scholar, man or woman, making a case for the importance of his own neglected or minor master. Such attempts, whether undertaken from a feminist point of view, like the ambitious article on women artists which appeared in the 1858 *Westminster Review*,[2] or more recent scholarly re-evaluation of individual women artists, like Angelica Kauffmann or Artemisia Gentileschi,[3] are certainly well worth the effort, adding to our knowledge of women's achievement and of art history generally. A great deal still remains to be done in this area, but unfortunately, such attempts do not really confront the question 'Why have there been no great women artists?'; on the contrary,

3. Angelica Kauffmann

by attempting to answer it, and by doing so inadequately, they merely reinforce its negative implications.

There is another approach to the question. Many contemporary feminists assert that there is actually a different kind of greatness for women's art than for men's. They propose the existence of a distinctive and recognizable feminine style, differing in both formal and expressive qualities from that of men artists and posited on the unique character of women's situation and experience.

This might seem reasonable enough: in general, women's experience and situation in society, and hence as artists, is different from men's, and certainly an art produced by a group of consciously united and purposely articulate women intent on bodying forth a group consciousness of feminine experience might indeed be stylistically identifiable as feminist, if not feminine, art. This remains within the realm of possibility; so far, it has not occurred.

No subtle essence of femininity would seem to link the work of Artemisia Gentileschi, Mme Vigée-Lebrun, Angelica Kauffmann, Rosa Bonheur, Berthe Morisot, Suzanne Valadon, Käthe Kollwitz, Barbara Hepworth, Georgia O'Keeffe, Sophie Täuber-Arp, Helen Frankenthaler, Bridget Riley, Lee Bontecou and Louise Nevelson, any more than that of Sappho, Marie de France, Jane Austen, Emily Brontë, George Sand, George Eliot, Virginia Woolf, Gertrude Stein, Anaïs Nin, Emily Dickinson, Sylvia Plath and Susan Sontag. In every instance, women artists and writers would seem to be closer to other artists and writers of their own period and outlook than they are to each other.

It may be asserted that women artists are more inward-looking, more delicate and nuanced in their treatment of their medium. But which of the women artists cited above is more inward-turning than Redon, more subtle and nuanced in the handling of pigment than Corot at his best? Is Fragonard more or less feminine than Mme Vigée-Lebrun? Is it not more a question of the whole rococo style of eighteenth-century France being 'feminine', if judged in terms of a two-valued scale of 'masculinity' versus 'femininity'? Certainly if daintiness, delicacy and preciousness are to be counted as earmarks of a feminine style, there is nothing fragile about Rosa Bonheur's *Horse Fair*, c. 1851. If women have at times turned to scenes of domestic life or children, so did the Dutch Little Masters, Chardin and the Impressionists – Renoir and Monet – as well as Berthe Morisot and Mary Cassatt. In any case, the mere choice of a certain realm of subject matter, or the restriction to certain subjects, is not to be equated with a style, much less with some sort of quintessentially *feminine* style.

The problem lies not so much with the feminists' concept of what femininity in art is, but rather with a misconception of what art is: with the naive idea that art is the direct, personal expression of individual emotional experience – a translation of personal life into visual terms. Yet art is almost never that; great art certainly never. The making of art involves a self-consistent language of form, more or less dependent upon, or free from, given temporally-defined conventions, schemata or systems of

notation, which have to be learned or worked out, through study, apprenticeship or a long period of individual experimentation.

The fact is that there have been no great women artists, so far as we know, although there have been many interesting and good ones who have not been sufficiently investigated or appreciated – nor have there been any great Lithuanian jazz pianists or Eskimo tennis players. That this should be the case is regrettable, but no amount of manipulating the historical or critical evidence will alter the situation. There *are* no women equivalents for Michelangelo or Rembrandt, Delacroix or Cézanne, Picasso or Matisse, or even, in very recent times, for Willem de Kooning or Andy Warhol, any more than there are black American equivalents for the same. If there actually were large numbers of 'hidden' great women artists, or if there really should be different standards for women's art as opposed to men's – and, logically, one can't have it both ways – then what are feminists fighting for? If women have in fact achieved the same status as men in the arts, then the status quo is fine.

But in actuality, as we know, in the arts as in a hundred other areas, things remain stultifying, oppressive and discouraging to all those – women included – who did not have the good fortune to be born white, preferably middle class and, above all, male. The fault lies not in our stars, our hormones, our menstrual cycles or our empty internal spaces, but in our institutions and our education – education understood to include everything that happens to us from the moment we enter, head first, into this world of meaningful symbols, signs and signals. The miracle is, in fact, that given the overwhelming odds against women, or blacks, so many of both have managed to achieve so much excellence – if not towering grandeur – in those bailiwicks of white masculine prerogative like science, politics or the arts […]

What is important is that women face up to the reality of their history and of their present situation. Disadvantage may indeed be an excuse; it is not, however, an intellectual position. Rather, using their situation as underdogs and outsiders as a vantage point, women can reveal institutional and intellectual weakness in general and, at the same time that they destroy false consciousness, take part in the creation of institutions in which clear thought and true greatness are challenges open to anyone – man or woman – courageous enough to take the necessary risk, the leap into the unknown.

1 John Stuart Mill, 'The Subjection of Women' (1869) in *Three Essays by John Stuart Mill* (London: World's Classics Series, 1966) 441.

2 Ernst Guhl, 'Women Artists', a review of *Die Frauen in die Kunstgeschichte* in *The Westminster Review* (American edition) 70 (July 1858) 91-104. I am grateful to Elaine Showalter for having brought this review to my attention.

3 See, for example, Peter S. Walch's excellent studies of Angelica Kauffmann or his doctoral dissertation, 'Angelica Kauffmann', Princeton University (1967). For Artemisia Gentileschi, see R. Ward Bissell, 'Artemisia Gentileschi - A New Documented Chronology', *Art Bulletin*, 50 (June 1968) 153-68.

Linda Nochlin, 'Why Have There Been No Great Women Artists?', *ARTnews*, 69: 9 (1971); reprinted in *Art and Sexual Politics: Women's Liberation, Women Artists and Art History*, ed. Thomas B. Hess and Elizabeth C. Baker (New York: Collier Books, Collier Macmillan Publishing Co., 1973) 1-37.

Hélène CIXOUS
The Laugh of the Medusa
[1971]

[…] I write this as a woman, towards women. When I say 'woman', I'm speaking of woman in her inevitable struggle against conventional man; and of a universal woman subject who must bring women to their senses and to their meaning in history. But first it must be said that in spite of the enormity of the repression that has kept them in the 'dark' – that dark which people have been trying to make them accept as their attribute – there is, at this time, no general woman, no one typical woman. What they have *in common* I will say. But what strikes me is the infinite richness of their individual constitutions: you can't talk about *a* female sexuality, uniform, homogeneous, classifiable into codes – any more than you can talk about one unconscious resembling another. Women's imaginary is inexhaustible, like music, painting, writing: their stream of phantasms is incredible.

I have been amazed more than once by a description a woman gave me of a world all her own which she had been secretly haunting since early childhood. A world of searching, the elaboration of a knowledge, on the basis of a systematic experimentation with the bodily functions, a passionate and precise interrogation of her erotogeneity. This practice, extraordinarily rich and inventive, in particular as concerns masturbation, is prolonged or accompanied by a production of forms, a veritable aesthetic activity, each stage of rapture inscribing a resonant vision, a composition, something beautiful. Beauty will no longer be forbidden.

I wished that that woman would write and proclaim this unique empire so that other women, other unacknowledged sovereigns, might exclaim: I, too, overflow; my desires have invented new desires, my body knows unheard-of songs. Time and again I, too, have felt so full of luminous torrents that I could burst – burst with forms much more beautiful than those which are put up in frames and sold for a stinking fortune. And I, too, said nothing, showed nothing; I didn't open my mouth, I didn't repaint my half of the world. I was ashamed. I was afraid, and I swallowed my shame and my fear. I said to myself: You are mad! What's the meaning of these waves, these floods, these outbursts? Where is the ebullient, infinite woman who, immersed as she was in her *naiveté*, kept in the dark about herself, led into self-disdain by the great arm of parental-conjugal phallocentrism, hasn't been ashamed of her strength? Who, surprised and horrified by the fantastic tumult of her drives (for she was made to believe that a well-adjusted normal woman has a … divine

composure), hasn't accused herself of being a monster? Who, feeling a funny desire stirring inside her (to sing, to write, to dare to speak, in short, to bring out something new), hasn't thought she was sick? Well, her shameful sickness is that she resists death, that she makes trouble.

And why don't you write! Write! Writing is for you, you are for you; your body is yours, take it. I know why you haven't written. (And why I didn't write before the age of twenty-seven.) Because writing is at once too high, too great for you, it's reserved for the great – that is for 'great men'; and it's 'silly'. Besides, you've written a little, but in secret. And it wasn't good, because it was in secret, and because you punished yourself for writing, because you didn't go all the way, or because you wrote, irresistibly, as when we would masturbate in secret, not to go further, but to attenuate the tension a bit, just enough to take the edge off. And then as soon as we come, we go and make ourselves feel guilty – so as to be forgiven; or to forget, to bury it until the next time [...]

The Dark Continent is neither dark nor unexplorable. It is still unexplored only because we've been made to believe that it was too dark to be explorable. And because they want to make us believe that what interests us is the white continent, with its monuments to Lack. And we believed. They riveted us between two horrifying myths: between the Medusa and the abyss. That would be enough to set half the world laughing, except that it's still going on. For the phallogocentric sublation' is with us, and it's militant, regenerating the old patterns, anchored in the dogma of castration. They haven't changed a thing: they've theorized their desire for reality! Let the priests tremble, we're going to show them our sexts!

Too bad for them if they fall apart upon discovering that women aren't men, or that the mother doesn't have one. But isn't this fear convenient for them? Wouldn't the worst be, isn't the worst, in truth, that women aren't castrated, that they have only to stop listening to the Sirens (for the Sirens were men) for history to change its meaning? You only have to look at the Medusa straight on to see her. And she's not deadly. She's beautiful and she's laughing [...]

We've been turned away from our bodies, shamefully taught to ignore them, to strike them with that stupid sexual modesty; we've been made victims of the old fool's game: each one will love the other sex. I'll give you your body and you'll give me mine. But who are the men who give women the body that women blindly yield to them? Why so few texts? Because so few women have as yet won back their body. Women must write through their bodies, they must invent the impregnable language that will wreck partitions, classes and rhetorics, regulations and codes, they must submerge, cut through, get beyond the ultimate reserve-discourse, including the one that laughs at the very idea of pronouncing the word 'silence', the one that, aiming for the impossible, stops short before the word 'impossible' and writes it as 'the end'.

Such is the strength of women that, sweeping away syntax, breaking that famous thread (just a tiny little thread, they say) which acts for men as a surrogate umbilical cord, assuring them – otherwise they couldn't come – that the old lady is always right behind them, watching them make phallus, women will go right up to the impossible [...]

1 Standard English term for the Hegelian *Aufhebung*, the French *la relève*.

Hélène Cixous, 'Le rire de la méduse', *L'arc* (1971) 39-54; reprinted as 'The Laugh of the Medusa', trans. Keith Cohen and Paula Cohen, *Signs*, 1:4 (Summer 1976) 875-93; *New French Feminisms*, ed. Elaine Marks and Isabelle de Courtivron (Amherst: The University of Massachusetts Press, 1980) 245-64.

Valie EXPORT
Women's Art: A Manifesto
[1972]

THE POSITION OF ART IN THE WOMEN'S LIBERATION MOVEMENT IS THE POSITION OF WOMAN IN THE ART'S MOVEMENT.
THE HISTORY OF WOMAN IS THE HISTORY OF MAN. because man has defined the image of woman for both man and woman, men create and control the social and communication media such as science and art, word and image, fashion and architecture, social transportation and division of labour. men have projected their image of woman onto these media, and in accordance with these medial patterns they gave shape to woman. if reality is a social construction and men its engineers, we are dealing with a male reality. women have not yet come to themselves, because they have not had a chance to speak in so far as they had no access to the media.

let women speak so that they can find themselves, this is what I ask for in order to achieve a self-defined image of ourselves and thus a different view of the social function of women. we women must participate in the construction of reality via the building stone of media communication.

this will not happen spontaneously or without resistance, therefore we must fight! if we shall carry through our goals such as social equal rights, self-determination, a new female consciousness, we must try to express them within the whole realm of life. this fight will bring about far reaching consequences and changes in the whole range of life not only for ourselves but for men, children, family, church ... in short for the state.

women must make use of all media as a means of social struggle and social progress in order to free culture of male values. in the same fashion she will do this in the arts knowing that men for thousands of years were able to express herein their ideas of eroticism, sex, beauty including their mythology of vigour, energy and austerity in sculpture, paintings, novels, films, drama, drawings, etc., and thereby influencing our consciousness. it will be time.
AND IT IS THE RIGHT TIME

that women use art as a means of expression so as to influence the consciousness of all of us, let our ideas flow into the social construction of reality to create a human reality. so far the arts have been created to a large extent solely by men. they dealt with the subjects of life, with the problems of emotional life adding only their own accounts, answers and solutions. now we must make our own assertions. we must destroy all these notions of love, faith, family, motherhood, companionship, which were not created by us and thus replace them with new ones in accordance with our sensibility, with our wishes.

to change the arts that man forced upon us means to destroy the features of woman created by man. the new values that we add to the arts will bring about new values for women in the course of the civilizing process. the arts can be of importance to the women's liberation in so far as we derive significance – our significance – from it: this spark can ignite the process of our self-determination. the question, what women can give to the arts and what the arts can give to the women, can be answered as follows: the transference of the specific situation of woman to the artistic context sets up signs and signals which provide new artistic expressions and messages on one hand, and change retrospectively the situation of women on the other.

the arts can be understood as a medium of our self-definition adding new values to the arts. these values, transmitted via the cultural sign-process, will alter reality towards an accommodation of female needs.
THE FUTURE OF WOMEN WILL BE THE HISTORY OF WOMAN.

The above text has been reproduced with the author's original use of capitalization.

Valie Export, 'Women's Art: A Manifesto', exhibition statement for *MAGNA*, *Feminism: Art and Creativity* (March 1972). First published in *Neues Forum*, 228 (January 1973) 47; reprinted, trans. Resigna Haslinger, in *Theories and Documents in Contemporary Art: A Sourcebook of Artists' Writings*, ed. Kristine Stiles and Peter Selz (Berkeley: University of California Press, 1996) 755-56.

Marcia TUCKER
Bypassing the Gallery System [1973]

On opening day, the ground floor of 97 Wooster Street in lower Manhattan's SoHo section was packed. People spilled out onto the sidewalk, talking, laughing, discussing plans, arguing. Inside, a photographer was trying to get twenty-two women together for a single photograph – lots of friendly jostling, joking, linked arms, warmth, confusion, excitement. It would have been like any other Saturday art opening in SoHo, except for a sense of amazed disbelief on the part of some, and a vicarious sense of achievement for others.

Three months before, the clean, bright, beautifully organized gallery space had been a dark, dirty storefront – plaster peeling, floors warped, wiring exposed, the ceiling torn and the fixtures dangling. A year before that, it had been 'an idea buzzing around in my head', said Barbara Zucker, one of the twenty-two founders of Artists-in-Residence (AIR).

The opening of AIR, the first independent women's gallery, was a milestone. A co-operative consisting of twenty artists, a gallery co-ordinator and a video

programme director, it is funded partly by its members, partly by a grant from the New York State Council of the Arts, and partly by donations from people who believe in its potential. Perhaps most unusual, it is non-profit. Whereas New York art galleries take a commission of anywhere from 30 to 60 per cent, all the money for a work sold by AIR goes to the artist.

One of AIR's most unusual features is its Monday Program. On a day when commercial galleries are closed, AIR is open, and its members offer their skills and knowledge to others. They also plan to visit schools and colleges, conducting symposiums and teaching women the basic techniques for making stretchers for their paintings, making frames, and designing posters and mailers. They will also attempt to show women how to organize their time, find day care, obtain legal and business guidance and develop their own galleries and exhibitions.

AIR's exhibition programme provides a show for each of the twenty artists in the gallery; two women a month. Kasha Linville serves as the 'gallery co-ordinator', not the director. As she says, 'I don't have power over other people'.

Through the Video Program, approximately thirty videotapes are made of members and non-members at work and discussing their art in their studios. Hermine Fried, who is in charge of this programme, feels that it is 'a way of making the artist more real to the public', of extending communication by recording more intimate, natural situations and making them available to a wider range of people, including high school and college women.

How did the women of AIR organize such a complex project? Barbara Zucker, a sculptor who has been living and working in New York since 1962, told me: 'My fantasy has always been to have a one-woman show, a show on my own terms'. But for years she did what most artists in the city are forced to do to get their work shown – make endless calls to dealers, try to set up studio visits, take slides around to galleries – only to experience the humiliation of haranguing, the disappointment of commitments made and withdrawn, the frustration of spending precious time doing business instead of making art.

Last January Barbara Zucker and Susan Williams, another sculptor and a close friend, began to explore ways of creating a situation for themselves and others that could provide an alternative to the difficulties they faced, both as artists and as women. They visited studios and asked those whose work they respected to join them. These earliest members formed a kind of search committee, visiting as many studios as possible. They looked through the Women's Slide Registry, presently housed at 55 Mercer Street in New York City. The registry contains slides of the paintings and sculptures of hundreds of artists in the metropolitan area. They located fourteen others, many of whose work had been previously unknown to them. Finally, all the prospective members met to see slides of one another's work and to make final decisions about joining the gallery. Two decided against it, and two more were chosen by the entire group. Each woman initially contributed a small amount of money and

agreed to a minimal monthly payment for maintenance.

They then divided into four groups: a legal committee that found two women lawyers willing to exchange their services for art; a grants committee that researched and obtained financial support and further developed the specific functions of the gallery; a publicity committee that developed a mailing list, a flyer and sent out press releases; and a building committee that had perhaps the most difficult job of all – organizing the renovation of the space [...]

The success of their venture had to do with the fact that the artists were not chosen on the basis of friendship, art-world politics or the need for exposure, but on the basis of their work, thus providing what one woman called a kind of 'internal quality control'. It is an alternative structure in terms of art rather than politics, although it's political in its formation. 'It's about what women can do, about higher goals. We want it to be a prototype.'

The attitudes of artists not involved in the gallery vary, but almost all agree that it is indeed a prototype. One male painter at the opening acknowledged that AIR was 'the wave of the future. There's no middleman here, so it gets the art off the merchandising level. It's really healthy. The capitalist-gallery structure is breaking down because of its past record of manipulation, and this is a way of solving the problem' [...]

Whether AIR will include men at some future date is still an open question, but, at present, all agree it's necessary to exclude them. It is an established fact that women artists have had, and continue to have, a more difficult time getting their work shown and sold. A survey of the ten leading New York art galleries indicates that 96.4 per cent of their artists are male. The percentage of one-woman exhibitions in museums is also notoriously low. The Guggenheim Museum has not yet had a major one-woman show, nor has the Metropolitan Museum of Art. The Museum of Modern Art had only four such shows between 1942 and 1969. Demonstrations by artists' groups such as the Ad Hoc Women's Committee, WAR (Women Artists in Revolution) and Women in the Arts have been somewhat effective in changing the situation, but reforms are slow in coming. AIR is all-female because, says Nancy Spero, 'We need it more than men do. For centuries they've done just fine, now it's our turn' [...]

Like other collectives, AIR has found communal decision-making sometimes difficult and frustrating. 'It's so hard to get in touch with twenty-two different people to get twenty-two different opinions', said one artist. 'We get everyone's opinion on every issue. There's lots of irritation with one another, but everyone gets a fair hearing. It's more non-elitist than most situations, though, because we try to take the most complete poll possible, and the meetings are generally held in consciousness-raising style. The decisions as to who would show when were done by drawing lots.' But the difficulties are gradually resolving as personal tensions disappear. 'It's such a hopeful situation. It's important to work at it, and we have more interest in being supportive than not', one woman pointed out.

Regardless of the internal challenges and the external judgments, the twenty-two women of AIR believe in their

gallery as a genuine option. For those of us in the art world who are not affiliated with AIR, it also provides options. Rather than griping about weaknesses and exclusivity of the existing system, we can look to AIR as an alternative model that can function successfully [...]

Marcia Tucker, 'Bypassing the Gallery System', Ms., 1: 8 (February 1973) 33-35.

April KINGSLEY
Women Choose Women
[1973]

'Women Choose Women' at The New York Cultural Center is a pioneering enterprise with repercussions for the entire art-institutional structure. It is the first example of a large-scale exhibition held in a major art museum and organized entirely by the members of a minority group within the art community. We have often heard in the past few years, since women artists have been forming politically active groups, that hundreds of talented women artists are working without recognition. This is our first opportunity to see what a large body of their work is like, and its quality more than justifies the rhetoric we have heard.

It is significant, too, that our first opportunity to judge for ourselves about women's art came about in a do-it-yourself show. As Lucy R. Lippard points out in her catalogue introduction, museums are 'discriminatory, usually under the guise of being discriminating'. Galleries are similar offenders. As a result women have had to band together and organize their own shows to gain more than occasional and token exposure in the art world. 'Thirteen Women Artists', a collective effort on Prince Street last spring, made important inroads into the gallery situation and sparked a renewal of interest in the idea of the co-op as a democratic outlet for artists who aren't, or who don't wish to be, part of the commercial gallery system. The two largest exhibitions of women's art to date have been: 1) the 'Gedok American Woman Artist Show' in the Hamburg Kunsthaus last spring, and 2) the 'Unmanly Art' exhibition at The Suffolk Museum, Stony Brook, this autumn; each included over fifty artists. However, the Stony Brook show was in three successive sections, which unavoidably reduced its impact and the opportunity for comparison. There have been a smattering of smaller shows – 'Ten Artists* (*Who also happen to be women)' at Lockport and Fredonia, New York, '9 × 9' at Fordham University in Manhattan, various group and solo shows at the AIR Gallery and a series of one-woman exhibitions at Rutgers University in New Jersey. But until another major New York museum takes up the challenge made by Women in the Arts (WIA) last April to mount large shows of women's art, this one at the Cultural Center will have to function as the model for its kind [...]

The extent to which the organizers are effective at producing a truly representative exhibition, is the extent to which the critic's problems in discussing it are increased. To make matters worse, the entire question of the existence of a discernible feminine style is raised by this

show. Every woman artist I've spoken to hates the whole concept of feminine art, possibly because, as Lucy R. Lippard suggests, women's conditioning has been to the effect that 'women's art has been, and is, by definition, *inferior* art'. No one wants to be confined within limits, and that is what most discussions of the femininity of women's art tend to do. Fully aware of the problem, I am none the less forced to address myself to it, since this is the first opportunity we've had for a comprehensive view of the subject.

There are two major and a few minor themes that run through most of the discussion of 'women's imagery'. One major thesis is that the biological realities of a woman's body – her round organs, bilateral symmetry and centrally located uterus – condition her work as an artist. Judy Chicago and her California Institute of Arts Feminist Program group feel that these factors tend to produce centrally focused paintings or sculpture and a preponderance of circular, ovoid or box shapes in overlapping flowerlike concentric structures. I am afraid, however, that despite the logical neatness of this theory, precious little work can be found, in this show at least, that conforms to it [...]

The other major thesis concerning female imagery is that it is frequently derived from women's societal conditioning. This is a vague notion that women's activities – cooking, sewing, coping with daily realities – colour their imagery and their technical methods [...]

A few of the minor themes in the general talk about feminine imagery don't seem to hold up any better than the ones I've just outlined when they are examined on this scale. Lawrence Alloway pointed out in his introduction to the 'New York Women Artists' show at the Art Gallery in the State University of New York at Albany that 'there is a marked concern with synonymity of form ... which reveals itself in the use of grids or in the accretion of small forms'. I have leaned towards this idea myself lately considering the work of Agnes Martin and Eva Hesse in particular. But, again, the sample here provided few examples to support the theory [...]

Other theories I tested on the show included Lucy R. Lippard's notion of the prevalence of sky-blue-pink pastel colouration in women's painting for which I could find only a few more than a dozen examples; her 'ubiquitous linear "bag" or parabolic form that turns in on itself' to which I could locate only a few conformees; and her layering or stratified imagery theory was confirmed by only a couple of instances, Joyce Kozloff's *Underground Landscape* being the clearest. Some of Lippard's vaguer feelings about women's art, like the impression that it is loosely handled, textural and sensuous, were impossible to decide about one way or the other. I came away with the general feeling that all one can say about women's art to differentiate it from men's art is that women artists seem to have a tendency towards curvilinearity (though not towards any specific shape of curve) and that they seem to like all the parts of their work to show, in some way, the traces of their hands' passage over it. That is to say, there is an absence of empty or nonchalant passages. One or both of these tendencies were visible in almost every work on view.

On the whole what the show did prove was that women make art in a variety of distinctly idiosyncratic, underivative ways and that they make art that is as strong, both conceptually and perceptually, as men's art [...]

Although any contention that women have a natural leaning towards the depiction of realistic imagery would be refuted in this show by the fact that less than a third of the works belonged in that category, I believe that the two Realist shows overlapping it on the other floors were partly responsible for the smallish representation. Sylvia Sleigh's token portrait of Philip Golub, for instance, could not make the same impression as one of her large paintings would have made. As it was, Alice Neel's frightening study of a nude *Pregnant Woman* and Janet Kogan's *Interiorized Self-Portrait*, which seemed reminiscent of both Rousseau and Magritte, made the strongest cases for the power of the womanly figuration to express deep levels of femininity not available to men artists [...]

'Women Choose Women' is a good show (one that I'd be proud to be in if I were an artist) comparable to any major museum exhibition of like scale and intention. Since only ten of the women in this show are in the Whitney Biennial, it functions as a sort of Salon des Refusés for that institution's female contingent. Its success not only promises women a large and permanent share of the art world action, but it also opens the way for a new approach to institutional responses to pressure groups within the art community [...]

April Kingsley, 'Women Choose Women', *Artforum*, 11: 7 (March 1973).

Miriam SCHAPIRO
The Education of Women as Artists: Project Womanhouse [1973]

The Feminist Art Program at the California Institute of the Arts was joyous and exhausting work. Judy Chicago and I embarked on a team teaching experiment and found our collaboration in such an intensive teaching situation inspiring and liberating. Ideas and energy cascaded from one teacher to another, and the feeling that one did not have to carry the entire responsibility for the programme freed us.

METHODS OF TEACHING: GROUP OPERATION
Twenty-one young women artists elected to join this exclusively female class. We did not teach by fixed authoritarian rules. Traditionally the flow of power has moved from teacher to student unilaterally. Our ways were more circular, more womblike; our primary concern was with providing a nourishing environment for growth.

Classes began by sitting in a circle; a topic for discussion was selected. We moved around the room; each person assumed responsibility for addressing herself to the topic on her highest level of self-perception. In the classical women's liberation technique, the personal

became the political. Privately held feelings imagined to be personally held 'hang-ups' turned out to be everyone's feelings [...] In our group we made rules based on mutual aesthetic consent to encourage and support the most profound artistic needs of the group.

Sometimes the struggle for subject matter assumed a different cast. We were able to find material to make art from, but we sensed that the material was inappropriate. There are some interesting unwritten laws about what is considered appropriate subject matter for art making: dolls, pillows, toys, underwear, children's toys, washbasins, toasters, frying pans, refrigerator door handles, shower caps, quilts and satin bedspreads.

CONCEPTION OF WOMANHOUSE
Womanhouse began as a topic for discussion in one of our class meetings. We asked ourselves what it would be like to work out of our closest associative memories – the home. Our home, which we as a culture of women have been identified with for centuries, has always been the area where we nourished and were nourished. It has been the base of operations out of which we fought and struggled with ourselves to please others. What would happen, we asked, if we created a home in which we pleased no one but ourselves? What if each woman were to develop her own dreams and fantasies in one room of that home? The idea seemed like a good one [...]

CREATION OF WOMANHOUSE
[...] Out of our consciousness-raising techniques came the motif for the kitchen. As we expressed our real underlying feelings about the room, it became obvious that the kitchen was a battleground where women fought with their mothers for their appropriate state of comfort and love. It was an arena where ostensibly the horn of plenty overflowed, but where in actuality the mother was acting out her bitterness over being imprisoned in a situation from which she could not bring herself to escape and from which society would not encourage such an escape. Three women collaborated on the kitchen. They painted everything a store-bought pink – refrigerator, stove, canned goods, toaster, sink, walls, floor, ceiling. Drawers were papered with collages of far away places. On the ceiling and walls were attached fried eggs, which transformed themselves into breasts as they travelled down the walls. Five moulds were made from clay showing this transformation, and they were created in a spongy material and painted realistically. The reality of the woman's condition that was epitomized by this kitchen, coupled with a consistently high level of quality art making, made the experience of walking into our nurturing centre breathtaking [...]

EVALUATION
[...] For Judy Chicago and myself, our experiences as feminists had provided us with a context for a meaningful teaching experiment. We re-evaluated our own experiences as young art students and made the transition into teaching young women art students. We permitted them to be themselves on all levels, to express their womanly art as they saw fit. We did not legislate what

might be fit subject matter for them. We waited to see what it turned out to be, urging them on at every step of the way to do whatever it was they did best. And the breakdown of role playing that occurred inspired the women to assume greater responsibility. Urging young women artists to make extraordinary demands on themselves is hazardous. Societal expectations for young women are not demanding. They are expected to fulfil their biological roles as wives and mothers and not much more. We dealt with our young women students as artists. It required work for them and for us; we were reminded again and again that it is indeed the responsibility of all older women, 'established' women artists, to serve as role models to their young women students, models as productive, integrated artists as well as women.

Our students set goals for themselves, and they came through. It wasn't always easy. They had to cope first of all with being part of a group; but they retained their individuality and provided warmth, comfort and support for each other. They tasted the professional life by creating a large, complex work of art. They put it on exhibition and found themselves exposed and in a position of having to cope with feedback from the public. This was more difficult. The situation plunged them into reality and away from their 'safe', childlike, art student fantasies of how they wished their world, their art and their lives to appear to other people. They made the first step from student to professional. At times they cried; but in the end they transcended their illusions and learned the art of coping with 'the way things really are'.

When the house went on exhibition, extensive media exposure brought all segments of the public to the opening. Ordinarily the public comes to an exhibit self-consciously wondering what to think about the art. Without a programme they are lost. At Womanhouse, women, particularly, walked in to what was essentially their home ground, knowing instinctively how to react ... the aesthetic distance provided by the controlled environment at Womanhouse allowed them to respond with fullness to the honour, joy and beauty of the house which, in the end, was really theirs.

Miriam Schapiro, 'The Education of Women as Artists: Project Womanhouse', *Art Journal*, 32: 4 (Summer 1973); reprinted in *Feminist Collage: Educating Women in the Visual Arts*, ed. Judy Loeb (New York and London: Teachers College Press, 1979) 247-53.

Laura MULVEY
Visual Pleasure and
Narrative Cinema [1973]

A POLITICAL USE OF PSYCHOANALYSIS
This paper intends to use psychoanalysis to discover where and how the fascination of film is reinforced by pre-existing patterns of fascination already at work within the individual subject and the social formations that have moulded him. It takes as its starting-point the way film reflects, reveals and even plays on the straight, socially established interpretation of sexual difference which controls images, erotic ways of looking and spectacle. It is helpful to understand what the cinema has been, how its magic has worked in the past, while attempting a theory and a practice which will challenge this cinema of the past. Psychoanalytic theory is thus appropriated here as a political weapon, demonstrating the way the unconscious of patriarchal society has structured film form.

The paradox of phallocentrism in all its manifestations is that it depends on the image of the castrated woman to give order and meaning to its world. An idea of woman stands as linchpin to the system: it is her lack that produces the phallus as a symbolic presence, it is her desire to make good the lack that the phallus signifies. Recent writing in *Screen* about psychoanalysis and the cinema has not sufficiently brought out the importance of the representation of the female form in a symbolic order in which, in the last resort, it speaks of castration and nothing else. To summarize briefly: the function of woman in forming the patriarchal unconscious is twofold: she firstly symbolizes the castration threat by her real lack of a penis and secondly thereby raises her child into the symbolic. Once this has been achieved, her meaning in the process is at an end. It does not last into the world of law and language except as a memory, which oscillates between memory of material plenitude and memory of lack. Both are posited on nature (or on anatomy in Freud's famous phrase). Woman's desire is subjugated to her image as bearer of the bleeding wound; she can exist only in relation to castration and cannot transcend it. She turns her child into the signifier of her own desire to possess a penis (the condition, she imagines, of entry into the symbolic). Either she must gracefully give way to the word, the name of the father and the law, or else struggle to keep her child down with her in the half-light of the imaginary. Woman then stands in patriarchal culture as a signifier for the male other, bound by a symbolic order in which man can live out his fantasies and obsessions through linguistic command by imposing them on the silent image of woman still tied to her place as bearer, not maker, of meaning.

There is an obvious interest in this analysis for feminists, a beauty in its exact rendering of the frustration experienced under the phallocentric order. It gets us nearer to the roots of our oppression, it brings closer an articulation of the problem, it faces us with the ultimate challenge: how to fight the unconscious structured like a language (formed critically at the moment of arrival of language) while still caught within the language of the patriarchy? There is no way in which we can produce an alternative out of the blue, but we can begin to make a break by examining patriarchy with the tools it provides, of which psychoanalysis is not the only but an important one. We are still separated by a great gap from important issues for the female unconscious which are scarcely relevant to phallocentric theory: the sexing of the female infant and her relationship to the symbolic, the sexually mature woman as non-mother, maternity outside the signification of the phallus, the vagina. But, at this point, psychoanalytic theory as it now stands can at least advance our understanding of the status quo, of the patriarchal order in which we are caught.

DESTRUCTION OF PLEASURE AS A RADICAL WEAPON
As an advanced representation system, the cinema poses questions about the ways the unconscious (formed by the dominant order) structures ways of seeing and pleasure in looking. Cinema has changed over the last few decades. It is no longer the monolithic system based on large capital investment exemplified at its best by Hollywood in the 1930s, 1940s and 1950s. Technological advances (16mm and so on) have changed the economic conditions of cinematic production, which can now be artisanal as well as capitalist. Thus it has been possible for an alternative cinema to develop. However self-conscious and ironic Hollywood managed to be, it always restricted itself to a formal *mise en scène* reflecting the dominant ideological concept of the cinema. The alternative cinema provides a space for the birth of a cinema which is radical in both a political and an aesthetic sense and challenges the basic assumptions of the mainstream film. This is not to reject the latter moralistically, but to highlight the ways in which its formal preoccupations reflect the psychical obsessions of the society which produced it and, further, to stress that the alternative cinema must start specifically by reacting against these obsessions and assumptions. A politically and aesthetically avant-garde cinema is now possible, but it can still only exist as a counterpoint.

The magic of the Hollywood style at its best (and of all the cinema which fell within its sphere of influence) arose, not exclusively, but in one important aspect, from its skilled and satisfying manipulation of visual pleasure. Unchallenged, mainstream film coded the erotic into the language of the dominant patriarchal order. In the highly developed Hollywood cinema it was only through these codes that the alienated subject, torn in his imaginary memory by a sense of loss, by the terror of potential lack in fantasy, came near to finding a glimpse of satisfaction: through its formal beauty and its play on his own formative obsessions. This article will discuss the interweaving of that erotic pleasure in film, its meaning and, in particular, the central place of the image of woman. It is said that analyzing pleasure or beauty, destroys it. That is the intention of this article. The satisfaction and reinforcement of the ego that represent the high point of film history hitherto must be attacked. Not in favour of a reconstructed new pleasure, which cannot exist in the abstract, nor of intellectualized unpleasure, but to make way for a total negation of the ease and plenitude of the narrative fiction film. The alternative is the thrill that comes from leaving the past behind without simply rejecting it, transcending outworn or oppressive forms, and daring to break with normal pleasurable expectations in order to conceive a new language of desire [...]

Laura Mulvey, 'Visual Pleasure and Narrative Cinema' (1973) [Introduction], first published in *Screen*, 16: 3 (Autumn 1975); reprinted in *Visual and Other Pleasures* (London: Macmillan, 1989).

Lawrence ALLOWAY, Max KOZLOFF, Rosalind KRAUSS, Joseph MASHECK, Annette MICHELSON
Letter to the Editor [1974]

To the Editor:

For the first time in the thirteen years of *Artforum*'s existence, a group of associate editors feel compelled to dissociate themselves publicly from a portion of the magazine's content, specifically the copyrighted advertisement of Lynda Benglis photographed by Arthur Gordon and printed by courtesy of the Paula Cooper Gallery in the November 1974 issue of the magazine. The history of the copyright mark and the 'courtesy', so anomalous among the advertisements, needs to be told. Ms Benglis, knowing that the issue was to carry an essay on her work, had submitted her photograph in colour for inclusion in the editorial matter of the magazine, proposing it as a 'centrefold' and offering to pay for the expenses of that inclusion. John Coplans, the editor, correctly refused this solicitation on the grounds that *Artforum* does not sell its editorial space. Its final inclusion in the magazine was therefore as a paid advertisement by some arrangement between the artist and her gallery. The copyright and the caption linger as vestiges of the artist's original intention.

We want to make clear the reasons why we object to its appearance within *Artforum*'s covers:

1. In the specific context of this journal it exists as an object of extreme vulgarity. Although we realize that it is by no means the first instance of vulgarity to appear in the magazine, it represents a qualitative leap in that genre, brutalizing ourselves and, we think, our readers.

2. *Artforum* has, over the past few years, made conscious efforts to support the movement for women's liberation, and it is therefore doubly shocking to encounter in its pages this gesture that reads as a shabby mockery of the aims of that movement.

3. Ms Benglis' advertisement insinuates two interconnected definitions of art-world roles that are seriously open to question. One is that the artist is free to be exploitative in his or her relation to a general public and to that community of writers and readers who make *Artforum*. The other is that *Artforum* should be a natural accomplice to that exploitation, for the advertisement has pictured the journal's role as devoted to the self-promotion of artists in the most debased sense of that term. We are aware of the economic interdependencies which govern the entire chain of artistic production and distribution. None the less, the credibility of our work demands that we be always on guard against such complicity, implied by the publication of this advertisement. To our great regret, we find ourselves compromised in this manner and that we owe our readers an acknowledgment of that compromise.

This incident is deeply symptomatic of conditions that call for critical analysis. As long as they infect the reality around us, these conditions shall have to be treated in our future work as writers and as editors.

Lawrence Alloway, Max Kozloff, Rosalind Krauss, Joseph Masheck, Annette Michelson, 'Letter to the Editor', *Artforum*, 13: 4 (December 1974).

Judy CHICAGO
Back to Painting / Getting Married / The Women's Movement [1975]

The domes led me back to painting. I began working on a series of images on small sheets of clear acrylic, spraying them with an air brush and using them as models for the colour layouts in the domes. Then I became interested in two-dimensional forms independent from the domes. I felt I could use a flat format better than a sculptural one for the issues I was dealing with. One thing two-dimension afforded was a body identification between myself and the painted forms. This was hard to achieve in sculpture, which seemed to exist outside of oneself so much more. At first, the forms – three round shapes, one above the other two – were blobby, undefined, as if to say that my own self-image was still undefined. Then I did some drawings in which the centres of the forms were dark. I felt the darkness in my stomach as a sense of wrongness, as if there were something wrong with *me*, and I knew that I was going into the place inside me that had been made to feel wrong by my experiences in the male-dominated world. I opened the forms and let them stand for my body experience instead of my internalized shame. The closed forms transmuted into doughnuts, stars, revolving mounds, which represented cunts. (I use that word deliberately, as it is that word that most embodies society's contempt for women. In turning the word around, I hope to turn society's definition of the female around and make it positive, instead of negative, at least in my work.) I chose that format because I wanted to express what it was like to be organized around a central core, my vagina, that which made me a woman. I was interested in a dissolving sensation, like one experiences in orgasm. It seemed to me that my experience as a woman had a dual nature. On the one hand, it was through my cunt that I made contact with Lloyd, who affirmed me and gave me great pleasure, especially at the moment of orgasm, when I was totally vulnerable and exposed and loved for being in that state. At the same time, because I had a cunt, I was despised by society. By making an image of the sensation of orgasm, I was trying to affirm the fact of being female and thus implicitly challenge male superiority.

I made shapes where the central holes contracted and expanded, clicked around in a circle, twisted, turned, dissolved, thrust forward and became soft, both consecutively and simultaneously. I repeated the forms in an effort to establish a continuum of sensation. As I went along, the paintings became increasingly difficult technically. But that difficulty seemed to be a parallel to the emotional risk they represented for me. The colour systems I had been developing allowed me to establish a method of representing emotional states through colour – thus assertiveness could be represented by harsh colours, receptiveness through softer, swirling colour, the state of orgasm through colour that dissolved. I began to combine these various colour systems with the forms I was evolving in order to try to convey the multiple aspects of my own personality and thus assert the fullness of the female self as I experienced it. Again, I was working within a male-oriented form language, which inherently limited the degree to which all this information could be seen, but I did not appreciate this at the time.

In 1969 I began a series of paintings entitled *Pasadena Lifesavers*. They embodied all of the work I had been doing in the past year, reflecting the range of my own sexuality and identity, as symbolized through form and colour, albeit in a neutralized format. There were fifteen paintings, 152.5 × 152.5 cm [5 × 5 ft], sprayed on the back of clear acrylic sheets, then framed with a sheet of white Plexiglas behind the clear sheet. The series consisted of five images, painted in three different colour series. The first series was hinged on red/green opposition, a combination that caused the forms to grey out. I was frightened by the images, by their strength, their aggressiveness. I had internalized parts of society's dictum that women should not be aggressive, and when I expressed that aspect of myself through forms that were quite assertive, I became frightened and thought there was 'something wrong with my paintings'. Lloyd helped me then, as he had so many times, making me see there was nothing wrong with my aggressiveness. As I recovered from my feelings of shame for having revealed something that was so different from the prevailing concepts of 'femininity', I gradually accepted the paintings, and in doing so, also accepted myself more fully.

The next group was softer; the paintings were based on what I called spectral colour – that is, starting with one colour and moving on to one close to that colour in the spectrum until I arrived back at the beginning colour. The images and ground interplayed as I carried over the segments of colour into the background, which I had not done in the first group. The third series was blue-green-purple in colour and bleached out when looked at for any length of time. As I think of the *Pasadena Lifesavers* now, I can see the three groups as representing my 'masculine' aggressive side, my 'feminine' receptive side and the hiding of myself that I was still doing at the time. But the paintings function on many levels and, as well as possessing layers of symbolic meanings, which can be read if one knows how to read abstract form, they are also visually engaging. They were a first step in my struggle to bring together my point of view as a woman with a visual form language that allows for transformation and multiple connotations [...]

The first material from the slowly developing women's movement reached the West Coast. When I read it, I

couldn't believe it. Here were women saying the things I had been feeling, saying them out loud. I trembled when I read them, remembering the put-downs I encountered whenever I had tried to express the facts of my life as a woman artist. I had so internalized the taboo about mentioning it that I shuddered with terror reading Valerie Solanas' book and some of the early journals of the women's movement. Even though I thought Solanas extreme, I recognized the truth of many of her observations, and I identified with all the material in those early tracts as I had never identified with anything in my whole life.

As I read, I slowly allowed the information to seep into my pores, realizing that at last there was an alternative to the isolation, the silence, the repressed anger, the rejection, the depreciation and the denial I had been facing. If these women could say how they felt, so could I. Coincidentally, I had been invited by several colleges in the area to speak about my work. I decided to use the opportunities to express my real feelings, to reveal what I had been going through as a woman and an artist. I was so scared. My voice shook, I could hardly talk. I spoke about the isolation and the rejection, the put-downs and the distortions. I spoke about my anger towards men because they had used me sexually. Everyone was shocked; there were angry reactions from the men. I drove home and trembled in terror at the fantasies that told me that something terrible was going to happen because I was saying the unsayable. I was telling the truth about my experiences as a woman, and I felt sure that I would be punished for it, that someone would break into my studio and destroy all my paintings or would shoot me or beat me up [...]

By the end of 1969 I felt that I was in a new place in my life and work. Painting *Pasadena Lifesavers*, resolving and stabilizing my relationship with Lloyd, expressing my real experiences as a woman in lectures, all conjoined to make me feel that I had more permission to be myself. I had not shown my work in Los Angeles for some time, and I decided that it was important to try to establish my range as an artist. I felt that I was not seen in the art world in a way that was commensurate with my achievements, and I still hoped that I could change that. I had been creating coherent bodies of work for some time, had worked across various media, including painting, sculpture and process art, was dealing with the subject matter of my own identity as a woman, and had developed technical procedures in spraying and in fireworks that no one had done before. I wanted to share what I had done with my community, and arranged to have a show of the domes, the atmospheres in photo and film form, and the entire *Pasadena Lifesavers* series. I also wanted my being a woman to be visible in the work and had thus decided to change my name from Judy Gerowitz to Judy Chicago as an act of identifying myself as an independent woman.

The show, held at California State College at Fullerton, directed by Dextra Frankel, was beautiful, and Dextra's installation was fantastic. My name change was on the wall directly across from the entrance. It said:
'*Judy Gerowitz* hereby divests herself of all names imposed upon her through male social dominance and freely chooses her own name *Judy Chicago*.'

But, even though my position was so visibly stated, male reviewers refused to accept that my work was intimately connected to my femaleness. Rather, they denied that my statement had anything at all to do with my art. Many people interpreted the work in the same way they interpreted my earlier, more neutralized work, as if I were working with only formal issues. At that time, there was no acknowledgement in the art community that a woman might have a different point of view than a man, or if difference was acknowledged, that difference meant inferiority.

As I look back on this, I realize that many issues were involved in the situation. I had come out of a formalist background and had learned how to neutralize my subject matter. In order to be considered a 'serious' artist, I had *had* to suppress my femaleness. In fact, making a place as an artist had depended on my ability to move away from the direct expression of my womanliness. Although I was trying to make my images clearer, I was still working in a frame of reference that people had learned to perceive in a particular, non-content-oriented way. But what other frame of reference existed then for abstract art? I was expecting the art community to actually 'see' my work differently, to look at it in new terms, to respond to it on an emotional level. I realize that most people didn't know how to 'read form' as I did. When Miriam Schapiro, the well-known painter from the East Coast who had recently moved to LA, brought her class to the show, it was obvious that she could 'read' my work, identify with it and affirm it. On the other hand, a male artist friend of mine had told me: 'Judy, I could look at these paintings for twenty years and it would never occur to me that they were cunts'. The idea that my forms were cunts was an oversimplification, obviously, but at that time, even a greatly simplified perception seemed better than no perception at all of the relationship between my femaleness and my art [...]

Judy Chicago, 'Back to Painting/ Getting Married/The Women's Movement', *Through the Flower: My Struggles as a Woman Artist* (Garden City, New York: Doubleday & Co, 1975).

Rozsika PARKER

Housework [1975]

'*Bless my little kitchen, lord,*
I love its every nook,
And bless me as I do my work,
Wash pots and pans and cook.'
– Rhyme printed on souvenir plate

This verse was on a souvenir ceramic plate tacked onto the wall of the kitchen at 14 Radnor Terrace, Lambeth – a kitchen knee high in garbage, old newspapers, half drunk coffees, milk rotting in bottles, fag ends and grubby plastic cartons. The kitchen was part of a project undertaken by six women. For two weeks they worked together on the South London Women's Centre, painting it, renovating it and finally creating rooms which exposed the hidden side of the domestic dreams.

'Rooms as images of mental states from unconscious basements to hot tin rooftops.'
– Kate Walker
'A room as a chrysalis – using my appearance and the room as a projection of myself – positive and negative.'
– Sue Madden

The house was on view during April and May. An orange front door opened onto a hall carpeted with artificial grass where a black staircase, covered in chalked poems and quotations, led to Kate Walker's kitchen – a nightmare kitchen, oppressive and cluttered. Footsteps on the floor marked an endless, persistent circle from fridge to basin to stove and back again. Out of the stove floated an enormous wedding cake complete with silver bells, lace and blossoms, while below it, half submerged in a heap of garbage, lay a woman's body. Scattered on the floor nearby were traces of a female childhood – dolls and the story of Cinderella written out in coloured crayons. In contrast to the general sordid chaos, the cupboards were obsessively tidy with packets of food carefully balanced on top of each other and towels precisely piled and neatly folded.

SILVER BEER BOTTLES
If the basement represents the instinctual, nurturing aspect of the home in its darkest form, the ground floor rooms dealt with the social and emotional expectations bound up with marriage. On one side of two adjoining rooms there was a bride swathed in white gauze who stretched out her arms to welcome an unseen groom. She was placed in an all white environment with chocolate box landscapes and collages of Princess Anne's wedding decorating the walls. On the mantelpiece, along with a copy of the *Common Prayer Book* and Charles Dicken's *Great Expectations*, was a long line of silver beer bottles capped by baby-bottle teats. The other room was all black and contained a corpse wrapped in a grey blanket. Dust surrounded the body, a pair of scuffed slippers lay nearby and a man's carefully folded grey shirt was placed in the grate. On the mantelpiece a black piece of paper read, 'died ... believed ... had failed ... half embalmed ... road of love and unselfishness'. And the room was presided over by a big, black leather chair. Kate Walker says that she purposely used the most trite, stale images associated with women in an effort to bring over their true implications. She stopped painting and began to create environments because she wanted to find a more immediate way of working; a method which brings quick results and reactions. She couldn't integrate painting, for her a slow, intense, isolated process, into the rest of life with her children. 'I can't bear the idea of a one sided existence totally dedicated to my art', she says. 'I'd rather think of myself as a housewife than an artist.' Looking back at the Radnor Terrace project she regrets that she stopped work while the house was on view – her rooms evolve as she works on them and by presenting them as a finished product she thought the 'human, tatty immediacy was a bit lost'.

FILMING CLEANSING RITUALS
Upstairs was an all white, shaded, claustrophobic

5. Judy Chicago

bedroom. Sue Madden called the room Chrysalis because she intended to use the room as a projection or a space in which 'to grow and transform'. She wanted to externalize and examine this process in a film using both the room and her appearance as an extension or reflection of her changing states of mind. She says that the following quotations were her starting points:

'*A woman must continually watch herself ... From earliest childhood she has been taught and persuaded to survey herself continually. And so she comes to consider the surveyed and the surveyor within her as the two constituents yet always distinct elements of her identity as a woman.*'
– John Berger

'*Each sister wearing masks of Revlon, Clairol, Playtex, to survive. Each sister faking orgasm under the systems' very concrete bulk at night, to survive.*'
– Robin Morgan

With these ideas in mind, Sue was going to start by filming removing rituals; plucking eyebrows, shaving armpits and legs, cutting toe nails, applying face packs, astringents, etc. Working consciously through these activities 'which wipe away women's identity', and moving on from them, she hoped to bring together the surveyed and surveyor within herself. Yet when it came to filming herself she couldn't do it:

'*As I started to wonder how I might explore these negative images I began to feel that performing these rituals yet again would be sacrificial and masochistic. For example, I recently stopped shaving my legs after ten years, and it was a genuinely significant experience – in a way it made me begin to experience my body as an integrated whole.*'
As a solution she made a 'second skin' on which to perform the rituals; a model of her body complete even to embroidered moles, hairs and appendix scar. Making the model helped her to come to terms with her 'first skin' but the film was never made. 'The nature of my film', she says, 'was to communicate to women how I was feeling about myself, but this would have meant them being involved in the same kind of activity. I think for women to build up any significant working situation they must first commit themselves to developing close contact and communication between themselves' [...]

BREAKING FREE
[Radnor Terrace] was criticized for being too depressing and too propagandist. Yet patriarchal society has always used art to propagandize particular limited and limiting images of women; mother, muse and sex object. Both Radnor Terrace and Womanhouse in Los Angeles are necessary steps towards breaking free of the stereotypes.
Rozsika Parker, 'Housework', *Spare Rib*, 26 (1975) 38.

Rosalind DELMAR
Women and Work [1975]

A visit to an art gallery can produce a variety of different experiences. You can discover a particular picture, which remains in your imagination; you can work through a whole series of related paintings or sculptures, the product of one artist or school. Often, for me, in representational art the most striking aspect of the artist's practice is the use of colour – all else can fade, but that remains. And, of course, the use of colour relates to the object of the artist's preoccupation.

If you start off from this point of view, a visit to 'Women and Work' can be somewhat disconcerting, for the first impression is that it is colour-less. That turns out to be not altogether the case, however. In a darkened section of the gallery, an enclosed space, you find two colour films simultaneously projected, showing side by side the jobs done by women and by men in the Metal Box factory which is the location for the study on show. Accompanying the films are the sounds of the factory, the whirring, booming and clanging of the machines which are being tended. It is this segment of the exhibition which suggests, through the use of film camera and amplified sound, the flesh and blood of the process which the rest of the work attempts to analyze.

'Women and Work' is a show devised by three women artists, Kay Hunt, Mary Kelly and Margaret Harrison. It was on exhibition during May at the South London Art Gallery, and will be shown elsewhere throughout the country. The work on display is the result of two years' collaboration between women who share a common commitment to the women's liberation movement. Their project was to combine research on the sexual division of labour in industry with the techniques of informational art.

The film material is, of course, one of the results of their study. For the rest, there are blown-up reproductions of charts and tables showing the different jobs performed by men and women and their different wages, a section showing the results of the job evaluation exercise carried out in the factory as a way of dealing with the Equal Pay Act, photographs of the hourly-paid women workers, a map indicating the location of the factory and where the workers live.

The theme of the sexual division of labour in production is played out in various ways. What comes across very clearly is the different demands made on the workers' physique. The male jobs tend to be mobile (often involving the movement of the whole body); the women's jobs tend to be static, fiddly and repetitive. This point is underlined in the section of photographs illustrating job description – they all require the camera to concentrate its attention on women's hands.

The final section of the exhibition comprises books, documents and tape-recordings, including one of older women reminiscing about changes in the allocation of jobs into male and female. To meet the needs of this material one corner of the room is converted into a small reference section. Indeed, for the purposes of the show, the gallery is transformed into a mixture of sites – library, viewing theatre, display centre. And the mounting of the exhibition shows great resourcefulness in the use of available space. But what raises most questions is the artistic position adopted.

It is obvious that aesthetic considerations are central from the careful positioning of the material. There is a formality and insistence in the almost geometrical placing of black, white and grey visuals against bare white walls. Its aura is one of a deliberate under-statement, an invitation to discovery, rather than an overt declaration of findings. This low-key presentation led one group of leftist artists to dub the show a manifestation of a new offshoot of bourgeois ideology – 'aridism'. To the management of the factory, on the other hand, 'Women and Work' didn't appear at all arid. Their reaction was to ban the women artists from visiting the factory again. It doesn't seem too fanciful to assume that they had in part recognized that the women had demonstrated the extent to which the job and wage differentials between male and female takes its place as a particular aspect of a general system of class exploitation.

All the same, it is the case that the artists have taken up a somewhat polemical position against other conceptions of avant-garde art. In 'Women and Work' material from one situation – the point of production – is transferred firmly into the gallery, in a gesture which runs directly counter to those who argue that the purpose of revolutionary artists is to liberate art from the galleries – a sort of 'out of the galleries, on to the streets' position.

Moreover, it is the fact that the photographs, interviews, tables and charts are contained in a particular mode within the gallery which makes them into 'art'. The exhibits could be described variously as the tools in trade of the historian, the sociologist, the trades union militant or the women's liberation activist. It is in meeting the needs of the gallery and highlighting the aspect of visual perception that they are transposed into instruments of artistic production.

In that process too, the artists reveal the sort of demands which they make on themselves and on their audience. Some artists want the visitor to take an active part in freely arranging what they have produced. By contrast, Mary Kelly, Margaret Harrison and Kay Hunt demand intellectual involvement and submission to the guidance and direction of the exhibitors.

If the format and the thinking behind the show have any ideal objective it is that a learning process should be set up. This in itself puts extra demands on the artists – in particular the demand that the show be not just informative but also explanatory. Although 'Women and Work' does stand out for its clarity and lucidity of exposition, there is still the sense that its informational style is insufficiently backed by explanational guidance – the material, unfortunately doesn't 'speak for itself'. What could, and doesn't, do the job of offering either additional explanation or some interpretation of the findings, is the catalogue.

That said, there is no doubt in my mind that 'Women and Work' is a stimulating and thought-provoking experiment. As a form of alternative propaganda it raises questions about the nature of agitational art. As research it comes out of the need for a greater understanding of the issues involved in the struggle to liberate women from a narrow confinement to tedious labour.
Rosalind Delmar, 'Women and Work', *Spare Rib* (October 1975) 32.

Barbara HAMMER
Artist's Statement [1991]

6. Maya Deren

[...] It wasn't until 1972 when I was enrolled in film history class and saw *Meshes of the Afternoon* (1943) by Maya Deren that I knew there was room for a woman's vision on the screen. I believe I recognized gender construction and projection in that film, although I didn't have the language more than 'woman's imagery' at that time. My first 16mm film, *I Was I Am*, pays direct homage to Deren. Not only am I the protagonist, I go through a transformation from a princess to a dyke, and after discarding my tiara take a key from my mouth to start the engine on my motorcycle; but also, many of the films of the 1970s, especially *The Psychosynthesis Trilogy* (*I Was I Am*, 1973; *X*, 1974; and *Psychosynthesis*, 1975), are replete with charged imagery that represents for me emotional meanings.

Deren as a theorist was also important. *Film Culture*, No. 39, Winter 1965, included many of her writings. Especially important to me was her description of 'vertical cinema' as opposed to a horizontal, linear, often narrative cinema. The sense of image relation building on image relation in a deep, impacted manner of possibilities and ambiguities made cinema a wealthy field for me. The 'brick-building' theory of cinema of accumulation in a narrow and straight line never appealed to me, as life seemed so much more complex, my emotions so multiple, and mystery more important than 'scientific understanding'.

So it was no wonder when *New French Feminism*, edited by Elaine Marks and Isabelle de Courtivron, published 'This Sex Which Is Not One' by Luce Irigaray in 1981 that I was captivated by her creative and wondrous writing of the multiplicity of woman's sexuality. Woman with her two genital lips is already two according to Irigaray, two who stimulate and embrace continually and who are not divisible into ones. This idea, so poetically expressed, reinforced my desire to express myself in multiple images either through superimpositions, bi-packing of two or more images in the optical printer, or passing the film through the printer various times. Never was I trying to 'veil' a meaning, but rather to enlarge upon a feeling/tone I was creating [...]

Although I didn't have the theory or the words to form it, I worked throughout the 1970s to make films of my lesbian experience. These stand outside the heterosexual discourse on gender and its representation. I was propelled in numerous films to 'represent one lesbian identity/experience' by making images that were unique to my re-naming myself as lesbian. I believed that in making films that re-presented at least one lesbian's experience (my own as I knew no other), I could contribute to abolishing lesbian invisibility [...]

Barbara Hammer, 'Interview with Julia Hodges, Jamie Ramoneda, Kathy Sizeler', *ArtPapers*, 15:5 (1991).

Anne-Marie SAUZEAU BOETTI
Negative Capability as Practice in Women's Art [1976]

In Italy, like anywhere else, many women artists still deny the idea of a female art. They feel either offended or frightened by a hypothesis which seems to imply a deliberate fall back into the gynaeceum. If the word 'feminine' frightens these artists it is because they are not confident about the possibility of filling it with a reality which is different from the metaphorical womanhood invented by men. They say, and they are convinced, that art is good or bad, but has no sex. It is a fact that their artistic research is often so perfectly in line with the cognitive order of male culture, that their work (at its best and its worst) has no substantially different connotation from man's art. If we assume that culture is an asexual absolute, it means that women have just one problem, historical backwardness, which will be overcome with time, with the general social evolution and the demonstrative anticipation of an emancipated female elite. Between this theory and women's traditional docile reverence, there is no opposition but a great deal of agreement: male humanism remains the yardstick of value and strength [...]

Other artists tackle the difficult task of the most rarefied cognitive and creative processes in male art, the least existential and for that reason particularly demanding for women (emancipation as a third nature?). I am alluding to the activities that require the greatest mobilization of the abstracting and sublimating faculties (abstract art in the 1950s, programmed and optical art in the 1960s, Conceptual art starting in the late 1960s). Now, when the woman artist lives profoundly as a woman in her profession and strongly enough in her mastery of the means she is managing, it is my belief that a gradual differentiation from this 'father' art occurs. It does so in the daily dialectic between intuition and cognitive mobilization, between desire and intellectualism, between the female and male polarities existing in her as a human being. Her relationship with the technique and artistic field she deals with, her very language, changes when she reaches the point of exercising her ability to symbolize areas of life which have been historically unexpressed (and sheltered) for so long. In this case she enters the double space of *INCONGRUENCE*, by which I mean that she can still be read and appreciated through the cultural criteria of the avant-garde, formal quality and so on, BUT also through another criterion, as a landmark of an *ALIEN* culture, with reference to other values and mind schemes (a Fourth World, Susan Sontag would say). This represents an indirect and difficult path through the territory of art (with the risk of getting lost), a certain appropriation/negation of languages and expressive media.

Some young artists and feminist supporters think that feminist art can exist as a new artistic language. I remember a small show in Trieste last spring called 'Feminists'. In the presentation, such art was praised as 'accusatory, violent, hard, crude' (in contrast to the gentle conciliating tradition of women). Indeed, a woman is liable to feel violent and crude (if not alien and lost) when she 'seizes the word', since the daily abuse of her existence has been violent and crude. It is also true that her redeemed creativity cannot exist in a pure state, outside history, all shadow-cultures or exiled cultures being related to the revolution which prepares their return home. Nevertheless, ideological and pamphletarian matter as such cannot build up a creative expression. The explicit figurations or references to feminist themes (anger, body expropriation, body rediscovery, etc) are by themselves no guarantee of a diverse relation with the instruments of expression. What is more (and worse for art), ideology is reassuring: as a political project it supplies a goal and gives a positive validity to accusation; when applied to artistic expression it is usually anti-revolutionary whenever it does not succeed in being IMPLIED in the very language, since it directs expressive research into the didactic and illustrative processes we all know (all the party and state forms of art). So, when women's art explicitly accuses and vindicates, it re-enters the LEGIBLE cultural space as militancy; and in order to be antagonistic (a type of dialogue), it has to recompose itself artificially (for instance through a 'provocative' use of Pop technique), which means betraying the basic disunity, 'negativity' and *OTHERNESS* of woman's experience. I do acknowledge feminist group expression as a rich militant instrument, in the way Chilean and Portuguese 'murales' are a renewed political praxis; but I don't believe in 'feminist art' since art is a mysterious filtering process which requires the labyrinths of a single mind, the privacy of alchemy, the possibility of exception and unorthodoxy rather than rule.

Woman's exclusion is historical, not natural. She has been absent from history because she has never given MEANINGS OF HER OWN through a LANGUAGE OF HER OWN to culture (and to herself as part of it). Instead, she has assumed those established by man (for instance she has complied with his metaphorical vision of her real self). The new meanings cannot be conveyed through an 'old' language (for instance the explicit and coherent reference to these meanings – the bad joke of filling a smelly pot with fresh water). But what is of greater importance is that these new meanings CANNOT BE AFFIRMED AT ALL through any alternative positive management of the artistic language, because these meanings refer to a scattered reality, to a subject in the negative who wants to go through all the resources of 'NEGATIVE CAPABILITY' (Keats and Duchamp let their own feminine identity bloom quite freely). The actual creative project of woman as a subject involves *BETRAYING* the expressive mechanisms of culture in order to express herself through the break, within the gaps between the systematic spaces of artistic language. This is not a matter of accusation or vindication, but of *TRANSGRESSION* (closer to madness than to reason).

The cuts and waves in the braided transparent material (Carla Accardi), the waiting needles around the curled void knitting (Marisa Merz), the absent and broken body reflected back from the other side of life (Iole de Freitas), the quivering hands that 'embroider' their own shape with calligraphy and attempt to save themselves from metaphor and unreality (Ketty La Rocca), are examples, among many others, of such languages in the 'negative'. This kind of project offers the only means of objectivizing feminine existence: not a positive avant-garde subversion but a process of differentiation. Not the project of fixing meanings but of breaking them up and multiplying them.

Anne-Marie Sauzeau Boetti, 'Negative Capability as Practice in Women's Art', *Studio International*, 191: 979 (January-February 1976) 24-26.

Lucy R. LIPPARD
The Pains and Pleasures of Rebirth: Women's Body Art
[1976]

[...] As Lea Vergine has pointed out in her book *Il Corpo come Linguaggio*,[1] Body art originated in Europe, though not with the expressionist Happenings of the sadomasochistic Viennese school in 1962, as she states, but with Yves Klein's use of nude women as 'living brushes'.[2] In the US, something like body art was an aspect of many Happenings from the late 1950s on, but body works as entities in themselves only emerged in the late 1960s as an offshoot of Minimalism, Conceptualism, film, video and performance art. Virtually no women made Body art in New York during the late 1960s, although it has been an important element in the oeuvres of Carolee Schneemann, Yayoi Kusama, Charlotte Moorman, Yvonne Rainer, Joan Jonas and others. In the early days of the new feminism, the first art by women to be taken seriously and accepted into the gallery and museum structure rarely differed from the prevailing, primarily abstract styles initiated by men. If it did reflect a different sensibility beneath an acceptable facade, this was hardly noticed by either men or women.

Body works by women, and art dealing with specifically female or feminist issues, materials, images and experience, whatever style they were couched in, became publicly visible with more difficulty than mainstream art and have therefore acquired a 'radical' image in some circles. Although such 'women's work' eventually suffered a brief vogue, it was initially considered clever or pretty, but not important, and was often relegated to the category of naive art or craft. This despite the fact that the autobiographical and narrative modes now fashionable were in part inspired by women's activities, especially consciousness-raising. Indeed, since much women's work came out of isolation or feminist enclaves rather than from the general 'scene', and since it attempted to establish a new iconography, it was justifiably perceived as coming from an 'other' point of view, and it was frequently labelled

retrograde for its lack of compliance with the 'evolutionary' mainstream.

In a parallel development, the concept of 'female imagery' arose on the West Coast through the ideas and programmes of Judy Chicago and Miriam Schapiro [...] If the results on the East and West Coasts were somewhat different, the motivations were the same. Now, six years later, Body art with a feminist consciousness is still considered to be more subversive than neutral art by women that ignores the sexual identity of its maker and/or its audience.

In Europe, on the other hand, an opposite situation seems to have developed. 'Neutral' art made by women still has little chance of making it into the market mainstream, while the male establishment, unsympathetic to women's participation in the art world as equal competitors, has approved (if rather patronizingly and perhaps lasciviously) of women working with their own, preferably attractive, bodies and faces. Of the handful of women artists who currently appear at all in vanguard European magazines and exhibitions, the large majority deal with their own faces and figures. This was borne out by last autumn's 'Biennale des Jeunes' in Paris. I have been told that both the male editor of an Italian art tabloid and a male French neo-Duchampian artist have discouraged women from working in other ways by publicly and powerfully applauding women's art which limits itself to these areas. Perhaps as a result, female critics like Catherine Francblin have had negative reactions to women's Body art. In an interesting article in *Art Press*, she sees it as a return to infantilism and an inability to separate one's own identity from that of the mother, or subject from object. She blames these artists for '*reactivation of primitive autoerotic pleasures. For what most women expose in the field of art ... is just the opposite of a denial of the woman as object in so much as the object of desire is precisely the woman's own body.*'[3]

The way I see it – obviously controversially – is that, due to their legitimate and necessary desire to affirm both their female experience and themselves as artists, many European women have been forced into the position of voluntarily doing what the male establishment wants them to do: stay out of the 'real world' of sales and seriousness. To extricate themselves, they have the tragic choice of rejecting the only outlets for their work (the magazines and museums) or of rejecting their feminist consciousness and its effect on their work and, by implication, rejecting themselves. This does not affect the quality of the art being made, but it does crucially affect how it is perceived and interpreted by the general audience.

The alternative, of course, might be the foundation of art outlets based on solid political feminism, but this too is difficult in a culture where 'Marxism' has successfully overrun or disdained feminist issues, to the point where the apolitical artist has no place to turn, and the political artist has only one place to turn. One does not call oneself a feminist in polite art-society in Europe unless one wants to be ridiculed or ignored [...]

[...] A woman artist's approach to herself is necessarily

complicated by social stereotypes. I must admit to a personal lack of sympathy with women who have themselves photographed in black stockings, garter belts, boots, with bare breasts, bananas and coy, come-hither glances. Parody it may be (as in Dutch artist Marja Samsom's 'humorous glamour pictures' featuring her alter ego 'Miss Kerr', or in Polish artist Natalia LL's red-lipped, tongue-and-sucking 'Consumption art'), but the artist rarely seems to get the last laugh. A woman using her own face and body has a right to do what she will with them, but it is a subtle abyss that separates men's use of women for sexual titillation from women's use of women to expose that insult.

It was not just shyness, I suspect, that kept many women from making their own Body art from 1967 to 1971 when Bruce Nauman was 'Thighing', Vito Acconci was masturbating, Dennis Oppenheim was sunbathing and burning himself and Barry Le Va was slamming into walls. It seemed like another very male pursuit, a manipulation of the audience's voyeurist impulses, not likely to appeal to vulnerable women artists just emerging from isolation. Articles and books on Body art include frequent pictures of nude females, but few women artists.[4] Men can use beautiful, sexy women as neutral objects or surfaces,[5] but when women use their own faces and bodies they are immediately accused of narcissism. There is an element of exhibitionism in all body art, perhaps a legitimate result of the choice between exploiting oneself or someone else. Yet the degree to which narcissism informs and affects the work varies immensely. Because women are considered sex objects, it is taken for granted that any woman who presents her nude body in public is doing so because she thinks she is beautiful. She is a narcissist, and Vito Acconci, with his less romantic image and pimply back, is an artist.

Yet Vergine has noted that, 'generally speaking, it is the women, like Joan Jonas, who are the least afraid to know their own body, who don't censor it. They make attempts at discovery beyond acculturation.'[6] I must say I admire the courage of the women with less than beautiful bodies who defy convention and become particularly vulnerable to cruel criticism, although those women who *do* happen to be physically well endowed probably come in for more punishment in the long run. Hans Peter Feldmann can use a series of ridiculous porno-pinups as his art,[7] but Hannah Wilke, a glamour girl in her own right who sees her art as 'seduction', is considered a little too good to be true when she flaunts her body in parody of the role she actually plays in real life. She has been making erotic art with vaginal imagery for over a decade, and since the women's movement, has begun to do performances in conjunction with her sculpture, but her own confusion of her roles as beautiful woman and artist, as flirt and feminist, has resulted at times in politically ambiguous manifestations which have exposed her to criticism on a personal as well as on an artistic level.

Another case in point is Carolee Schneemann, known in the early 1960s as a 'body beautiful' because she appeared nude in Happenings – her own as well as those of Claes Oldenburg and others, though for years she was labelled more comfortably 'dancer' than 'artist' – 'an

image, but not an Image-Maker, creating my own self-image' (1968). Schneemann's work has always been concerned with sexual (and personal) freedom, a theme still often considered unacceptable from a woman: she intends to prove that the life of the body is more *variously* expressive than a sex-negative society can admit. '*I didn't stand naked in front of 300 people because I wanted to be fucked, but because my sex and work were harmoniously experienced. I could have the audacity, or courage, to show the body as a source of varying emotive power.*' (1968) '*I use my nude body in* Up To and Including Her Limits *as the stripped-down, undecorated human object*'. (1975) '*In some sense I made a gift of my body to other women: giving our bodies back to ourselves. The haunting images of the Cretan bull dancer – joyful, free, bare-breasted, skilled women leaping precisely from danger to ascendancy, guided my imagination.*' (1968)[8]

A similarly defiant narcissism or 'vulgarity' resulted when Lynda Benglis confronted the double standard head-on in some advertisements for herself, which provided the liveliest controversy the art world has had for years. A respected sculptor (whose imagery is, incidentally, as abstract as it is sexual[9]) and video artist (here the imagery is autobiographical and autoerotic), Benglis has published a series of photographic ads for her exhibitions that included: herself in a Greek boy's skirt; herself leaning butchly on a car; herself as a pin-up in a famous Betty Grable pose, but with her jeans dropped around her ankles; and finally – the *coup de grâce* – herself as a greased nude in sunglasses, belligerently sporting a gigantic dildo. The uproar that this last image created proved conclusively that there are still things women may not do. The notion of sexual transformation has, after all, been around for some time. No such clamour arose in 1970 when Vito Acconci burned hair from his chest, 'pulling at it, making it supple, flexible – an attempt to develop a female breast', then tucked his penis between his legs to 'extend the sex change' and 'acquired a female form' by having a woman kneel behind him with his penis 'disappearing' in her mouth.[10] Nor was there any hullabaloo when Scott Burton promenaded Fourteenth Street in drag for a 1969 Street Work, or when he flaunted a giant black phallus in a static performance in 1973, when William Wegman made his amusing *trompe-l'oeil* 'breast' piece (on video, with his elbows) or when Lucas Samaras played with himself in front of his Polaroid camera.

It has often been remarked that body art reflects the 'role crisis' in contemporary life. The urge to androgyny, in fact, has been frequently expressed by artists of both sexes, though more often by men than by women (oddly, given the advantage of being male in this society). Urs Lüthi, [the Swiss artist] who makes campy transvestite photodramas starring himself, says that ambivalence is the most significant aspect of his work, and that he sees himself as a stranger. Katharina Sieverding, in Dusseldorf, has made photoworks on 'Aspects of Transvestism' which she sees not as a pathological phenomenon but as 'communications material', exposing roles, repression, ambiguity, possibility and self-extension: 'The conquest of another gender takes place in oneself'.[11] Such a positive approach has more in common with the traditional

(Platonic, Gnostic, etc.) myth of the androgyne as two in one, 'the outside as the inside and the male with the female neither male nor female',[12] than with contemporary art's emphasis on separation instead of union of the two sexes. A woman working with androgyny these days would not be 'accused' of being a lesbian, because gay women no longer want to be men, but see themselves as the last word in woman-identified women.

In 1972, in Halifax, Martha Wilson made a 'drag' piece in which she transformed herself first into a man and then into a man dressed as a woman. Suzy Lake, in Montreal, transforms herself into her friends, both male and female, in two ways – with cosmetics and through photo-retouching. In *Suzy Lake as Gary Smith*, the documentation is organized 'with reference to a binary logic: the first row = female, augmentation, transformation done on the actual subject; the second row = male, diminution, transformation done at a distance on the photo image'.[13] In Annette Messager's *Collector* albums of found photographic images of women's lives, she has created *femmes-hommes* and *hommes-femmes* whose disguises are lightly laid over their dominant characteristics; men are still men (although with long lashes and red lips) and women are still women (although with beards and moustaches). Jacki Apple's *Identity Exchanges*, *Transfers* and *Redefinitions* also involve impersonation of both sexes and 'the relationship between the many views of a single person and the varying positions of the viewers to the object'.[14] Eleanor Antin's several art personae include one man – a seventeenth-century king in whose beard, boots, cape and sword she visits her subjects on the streets of Solana Beach, California. Adrian Piper too has a male ego – the 'Mythic Being' with Afro, shades and moustache, who also walks the streets in a continuation of Piper's several years of exploration of the boundaries of her personality. 'The fact that I'm a woman I'm sure has a great deal to do with it … at times I was "violating my body"; I was making it public. I was exposing it; I was turning me into an object …'[15] Dressed as the Mythic Being, she re-enacts events from her own life but re-experiences them as a man. One of the many things the Mythic Being is to his creator is 'a therapeutic device for freeing me of the burden of my past, which haunts me, determines all my actions …'[16]

For the most part, however, women are more concerned with female than with male roles and role models.[17] Ulrike Rosenbach, in Germany, has made a series of videotapes of herself dressed in the high hat, or *Haube*, worn in the fourteenth century by married women and made a symbol of self-confidence and equality in the Renaissance; she uses it 'to transcend the conventional erotic context of contemporary women'. In a 1974 performance called *Isolation Is Transparent*, dressed in a black net leotard, she combined erotic 'coquetry with the female body' and 'man's work with hammer and nails', weaving a rope skirt around herself from the corners of the space until she became 'the centre of the earth'.[18] Also in performance, Yugoslavian artist Marina Abramović recorded her reactions after swallowing pills intended to cure schizophrenia. Two cameras, one pointed at the artist and the other at the audience, emphasized the

subject/object relationship and the perfectly natural desire to see yourself as others see you. Camera and video monitor have multiplied the mirrors into which for centuries women have peered anxiously before going out to confront the world. Cosmetics pieces were common in the early 1970s, when consciousness-raising began to bring those mirrors out before public scrutiny. One of the early instances was *Léah's Room* in Womanhouse (1972), where a lovely young woman made herself up, wiped off the cosmetics, made herself up again, and took them off again, dissatisfied, and so on.

To 'make yourself up' is literally to create or re-create yourself. In two colour photographs of herself, *Perfection* and *Deformation* (1974), Martha Wilson explored her dual self-image, and did so again in a fat and thin variation in a 1975 videotape. Mary Beth Edelson has transformed her own photograph into those of two admired role models, Georgia O'Keeffe and Louise Nevelson. Nancy Kitchel has also made 'disguise' pieces and has studied the physiological results of psychological stress on her own face in several 'exorcism' pieces involving her family and love affairs. Athena Tacha has dealt with her family and heredity, and in an ongoing piece called *The Process of Ageing* is cataloguing in detail the effects of time on her body. Annette Messager has drawn the ravaging lines of jealousy on a photograph of a woman's face, while other women, among them Marisol, Yoko Ono, Joan Jonas and Faith Ringgold, have used masks in the place of cosmetics.

Psychological emphasis and the need for a profound level of transformation of the self and of others are subtly reflected in the work of two Italian women. Diana Rabito deals with 'Retinal Cannibalism' – 'talking with the eyes' – comparing in one piece the signs of hypertension produced in a woman's face to the *craquelure* of antique Chinese porcelains. Ketty La Rocca, unable to break into the male art world with her art or her writings, made a highly expressive book in 1971 using photographs of her hands to illustrate proverbs. Until her recent death, she worked in a complex matrix of word and abstracted autobiography; her *You You* series shows her hands juxtaposed against X-ray images, presenting, for instance, a skull as a mask, face as 'pantomime made by language', a skull as a foetal image with the hand – the language symbol – about to burst out of it, the whole image outlined by the handwritten word 'you' repeated around its edge.

Transformation is also the motive for cooler variations in which body is subordinated to art, exemplified by Martha Wilson's anti-prurient *Breast Forms Permutated* (1972), in which nine pairs of breasts stare out of a grid, wondrous and humorous in their variety; by Rita Myers' laconic *Body Halves* of 1971, where her nude photo is split vertically down the middle and reversed, revealing the minute discrepancies between the two halves; by Antin's *Carving* (1973), a series of clinically naked self-portrait photos documenting her weight loss. [Austrian] artist Friederike Pezold's videotapes use her body abstractly, but the most 'ordinary' (i.e., not erogenous) zones, such as elbows, feet, knees and shoulders, evoke extraordinary images of sensuality – more erotic in their disguise than the parts simulated would be in reality. Lauren Ewing, in a videotape, also uses ambiguously defined body parts in a

suggestive manner; fingers slowly erase the words 'She was forced to consider the Message after it was over' from an apparently erotic zone […]

Much of the work discussed above clearly rises from a neurotic dissatisfaction with the self. There are exceptions on both sides, but whereas female unease is usually dealt with hopefully, in terms of gentle self-exploration, self-criticism or transformation, anxiety about the masculine role tends to take a violent, even self-destructive form. Acconci and Oppenheim burned, scarred, irritated their own bodies around 1970; Burden has taken the lead since then by having himself shot in the arm, locking himself in a baggage locker for five days, nearly electrocuting himself, nearly immolating himself, nearly being run over and so forth. Though lacking the horror-show theatricality of the Viennese S & M school, the deadpan masochism of American male body artists has a decidedly chilling effect.

Almost the only woman who engages in such practices is Gina Pane, in Paris, who has cut herself with razor blades, eaten until she got sick and subjected herself to other tortures. Her self-mutilation is no less repellent than the men's, but it does exist within a framework which is curiously feminine. Take, for instance, her *Sentimental Action* (1973), a performance she describes as the 'projection of an "intra" space' activated by the sentiments of 'the magic mother/child relationship, symbolized by death … a symbiotic relationship by which one discovers different emotional solutions'. Using her body as a 'conductor', she takes apart 'the prime image – the red rose, mystic flower, erotic flower, transformed into a vagina by reconstitution into its most present state: the painful one'.[19] Photo-documentation shows the artist dressed in white with her face hidden in a bunch of roses and her bleeding arm, pierced by a line of tacks, stretched out before her.

If few women artists inflict pain on their own bodies, the fear of pain, cruelty and violence surfaces frequently in their work. Hannah Wilke's *S.O.S. (Starification Object Series)* (1974) includes a performance in which, shirtless, she flirts with the audience while they chew bubblegum, which she then forms into tiny loops resembling vaginas and sticks in patterns on her nude torso. She calls these 'stars', in a play on the celebrity game, but they are also scars, relating on the positive side to African rituals through which women gain beauty and status, and on the negative side to the anguish of the artist's real 'internal scarification'. In German artist Rebecca Horn's strange, mechanically erotic films, her body is always protected by bizarre contraptions resembling medieval torture apparatuses; she makes contact with objects or people but only at a remove; in her elongated, stiff-fingered gloves, tickling feathered headdresses, cages and harnesses, she achieves a curiously moving combination of potential sadism and tenderness.

Iole de Freitas, a Brazilian living in Italy, combats the archetypal female fear of the knife by wielding it herself in cryptically beautiful photo pieces, sometimes combined with fragments of her body seen in a framelike mirror on the floor, as though in the process of examining and reconstructing her own image. One recalls Maya Deren's image of the knife between the sheets here, as well as in the film *Sentimental Journey* by Italian artist Valentina

Berardinone, which concerns 'the anthropomorphism of the rose … transformation … intense persecutory anguish … and tunnels; its dominant theme is murder'. In Iowa City, Ana Mendieta has made brutal rape pieces where the unwarned audience enters her room (or a wooded area) to discover her bloody, half-naked body. She has also used herself as a symbol of regeneration in a series of slide pieces. In one she is nude in an ancient stone grave in Mexico, covered by tiny white flowers which seem to be growing from her body; in another she lies nude over a real skeleton to 'give it life'; and in another she makes herself into the 'white cock', a Cuban voodoo fetish, covered with blood and feathers. She has traced her skeleton on her nude body to become 'Visible Woman' and ritually outlined her silhouette in flowers, flames, earth and candles.

A good deal of this current work by women, from the psychological makeup pieces to the more violent images, is not so much masochistic as it is concerned with exorcism, with dispelling taboos, with exposing and thereby defusing the painful aspects of women's history. The prototypes may have been several works by Judy Chicago – her *Menstruation Bathroom* at Womanhouse (1972),[20] her notorious photo-lithograph *Red Flag* (1971), a self-portrait from the waist down showing the removal of a bloody Tampax (often read by male viewers as a damaged penis) and her 'rejection drawings', which demand: 'How Does It Feel to Be Rejected? It's Like Having Your Flower Split Open'. In a recent two-woman exhibition at the College of St. Catherine in Saint Paul, Betsy Damon and Carole Fisher showed respectively, drawings, collages and reliefs titled *Mutilation Images: A Garden* and *Self Images: Terrible Mother of the Blood River*. Many of these took, however, the hopeful shape of the butterfly – female transformation *par excellence* – also introduced into feminist iconography by Judy Chicago. The visual resemblance of a butterfly to the Great Goddess' double-edged ax is not coincidental, for Chicago has made a series of painted-china plaques that deal with the 'butterfly vagina' and its history as passage, portal, Venus of Willendorf and so forth. Edelson, in photographs of herself as a symbol of 'Woman Rising' from the earth, from the sea, her body painted with ancient ritual signs, adopts these images to a new feminist mythology. She also incorporates into her work stories written by the audience of her shows; mother stories, heroine stories, menstruation and birth stories, all of them part of her search for ancient woman's natural, shameless relationship to her body.

One curious aspect of all of this woman's work, pointed out by Joan Simon, is the fact that no women dealing with their own bodies and biographies have introduced pregnancy or childbirth as a major image […] The destruction of derogatory myths surrounding female experience and physiology appears to be one of the major motives for the recent surge in body art by feminist artists. Perhaps procreativity is the next taboo to be tackled, one that might make clearer the elusive factors that divide body art by women from that by men.

1 Lea Vergine, *Il Corpo come Linguaggio* (Milan: Prearo, 1974).

2 The Gutai group in Japan also made similar events in the late 1950s, and Carolee Schneemann's *Eye-Body (Nude in Environment)* dates from 1963.

3 Catherine Francblin, 'Corps-object, femme-object', *Art Press*, 20 (September-October 1975).

4 This continues. Max Kozloff's 'Pygmalion Revisited' in *Artforum* (November 1975) is the latest example. A few women body artists are mentioned and no women are reproduced in twelve illustrations. He also seems unaware of the existence of a large selection of such art by women and complains that there are 'very few artists exploiting dress, ornament and headgear …'

5 In the course of my research in European art magazines I found: a woman with her blouse open, a woman's body signed as art, a woman with a gallery announcement written on her two large bare breasts, a provocative 1940s pinup captioned 'Subscribe to me - I'm Extra' to advertise an 'artists' magazine' of that name.

6 Lea Vergine, *Data* (Summer 1974).

7 Hans Peter Feldmann, *Extra*, 5.

8 The 1968 quotations are taken from Schneemann's book *Cézanne She Was a Great Painter* (1975); the 1975 quotation was from another self-published book, *Up To and Including Her Limits* (1975).

9 Benglis' wax totems are acknowledged labial imagery; her sparkle-covered knot pieces are named after strippers and all the knot pieces have sexual connotations.

10 *Avalanche*, special edition (Autumn 1972). Susan Mogul, in Los Angeles, has made a delightful feminist parody of Acconci's masturbatory activities in her vibrator video piece.

11 Katharina Sieverding, *Heute Kunst* (April-May 1974).

12 This is a quotation from Gnostic mysticism in 'The Myth of the Androgyne' by Robert Knott, *Artforum* (November 1975). The subject is also treated in the same issue by Whitney Chadwick, who notes that throughout the nineteenth century 'the myth of "the man/woman" … emblemized the perfect *man* of the future' (my italics), thus absorbing the female altogether, which seems to be the point of most male androgynous art.

13 See Paul Heyer in *Camerart* (Montreal: Galerie Optica, 1974).

14 Jacki Apple, *c7500* (unpublished artist's statement, 1973).

15 Adrian Piper, *The Drama Review* (March 1972).

16 Adrian Piper, 'Notes on the Mythic Being, I' (March 1974).

17 I have written on costume, autobiographical and role-playing art by women in 'Transformation Art', *Ms.* (October 1975).

18 Ulrike Rosenbach in *Avalanche* (May 1974).

19 Pane quoted in Vergine, *op. cit.*

20 Leslie Labowitz and Friederike Pezold in Germany have also made menstruation pieces, as have Judith Stein, Jacki Apple in a terrifying autobiographical text, and Carolee Schneemann in her important orgiastic Happening, *Meat Joy* (1964).

Lucy R. Lippard, 'The Pains and Pleasures of Rebirth: Women's Body Art', *Art in America*, 3 (May-June 1976) 73-81; reprinted in *The Pink Glass Swan: Selected Feminist Essays on Art* (New York: The New Press, 1995).

Chantal AKERMAN

On *Jeanne Dielman* [1976]

[...] I *do* think [*Jeanne Dielman, 23 Quai du commerce, 1080 Bruxelles]* is a feminist film because I give space to things which were never, almost never, shown in that way, like the daily gestures of a woman. They are the lowest in the hierarchy of film images. A kiss or a car crash come higher, and I don't think that's an accident. It's because these are women's gestures that they count for so little. That's one reason I think it's a feminist film.

But more than the content, it's because of the style. If you choose to show a woman's gestures so precisely, it's because you love them. In some way you recognize those gestures that have always been denied and ignored. I think that the real problem with women's films usually has nothing to do with the content. It's that hardly any women really have confidence enough to carry through on their feelings. Instead the content is the most simple and obvious thing. They deal with that and forget to look for formal ways to express what they are and what they want, their own rhythms, their own way of looking at things. A lot of women have unconscious contempt for their feelings. But I don't think I do. I have enough confidence in myself. So that's the other reason why I think it's a feminist film – not just what it says but *what* is shown and *how* it's shown.

I didn't have any doubts about any of the shots. I was very sure of where to put the camera and when and why. It's the first time I had that feeling so strongly.

You *know* who is looking; you always know what the point of view is, all the time. It's always the same. But still, I was looking with a great deal of attention and the attention wasn't distanced. It was not a neutral look – that doesn't exist anyhow. For me, the way I looked at what was going on was a look of love and respect. Maybe that's difficult to understand but I really think that's it. I *let* her live her life in the middle of the frame. I didn't go in too close, but I was not *very* far away. I let her be in her space. It's not uncontrolled. But the camera was not voyeuristic in the commercial way because you always knew where I was. You know, it wasn't shot through the keyhole.

It was the only way to shoot that scene and to shoot that film – to avoid cutting the woman into a hundred pieces, to avoid cutting the action in a hundred places, to look carefully and to be respectful. The framing was meant to respect the space, her and her gestures within it.

We didn't have a lot of choice about where to put the camera because I didn't want angle shots. I wanted them all to be straight, as much as possible.

Delphine said, 'Why do you use such a low angle?' I said, 'That's my size.' She said, 'It's better from a little higher up.' And I said, 'No, I don't want to do that. That's not how I see the world.' It was never shot from the point of view of the son or anyone else. It's always me. Because the other way is manipulation. The son is not the camera; the son is her son. If the son looks at his mother, it's because you asked him to do it. So you should look at the son looking at the mother, and not have the camera in place of the son looking at the mother [...]

In movies the most important images, the most effective and powerful ones, are crimes, car chases, etc. Not a woman shown from the back doing dishes. But that that is shown on the same level as the murder ... In fact I think it's much more dramatic. I really think that when she bangs the glass on the table and you think the milk might spill, that's as dramatic as the murder.

But the murder was the logical thing to have happen there. To me, she had only two solutions: either to kill herself or kill someone else. Of course there is some part of me in the film and I would have killed someone else. Certain people hate this murder and say, 'You have to be more pure. If you show a woman doing the dishes, you shouldn't show a murder.' But I don't think that's true. The strength of the thing is to show them both in the same film. And it didn't end with the murder. There are seven really very strong minutes after that.

A lot of people said that it was a pity to have that murder because the film would have been so much more novel without it. I don't think so at all. If there had not been that murder, there would have been a sentimentality about the end. And that's what I didn't want. When you write something where the end is the same as the beginning it's really boring. That's very clichéd, to have no ending. And I also think that, in reference to the hierarchy of images, you can match images that are supposed to be very low in the hierarchy with images that are high in it.

It's really a hard problem to try to say what differentiates a woman's rhythm in film because a man can use these same forms of expression. I don't know if we have the words, if they exist yet. I don't think we know enough about women's films even to ... I can talk about myself but I can't speak in a general, theoretical way at all. I just think that I've finally reached the right point, meaning that I agree with what I do. It's not like I feel one way and my work expresses something else. But I can't define it any more theoretically. We speak of 'women's rhythm', but it isn't necessarily the same for all women. I also think that Hollywood doesn't express a man's rhythm either, but the rhythm of capitalism or fascism. Men are cheated by it too.

But you know, some theorists say it is because we experience pleasure in another way than men do. Sexual pleasure. I really think that in movies it's right there. When I saw *Hotel Monterey* again this morning, I really thought it was an erotic film. I felt that way – *la jouissance du voir.*

Chantal Ackerman, excerpts from an interview with *Camera Obscura* (November, 1976) in Janet Bergstrom, 'Jeanne Dielman, 23 Quai du commerce, 1080 Bruxelles', *Camera Obscura*, 2 (Berkeley: Committee on Publications of the University of California, 1977) 118-121.

Luce IRIGARAY

This Sex Which Is Not One

[1977]

Female sexuality has always been conceptualized on the basis of masculine parameters. Thus the opposition between 'masculine' clitoral activity and 'feminine' vaginal passivity, an opposition which Freud – and many others – saw as stages, or alternatives, in the development of a sexually 'normal' woman, seems rather too clearly required by the practice of male sexuality. For the clitoris is conceived as a little penis pleasant to masturbate so long as castration anxiety does not exist (for the boy child), and the vagina is valued for the 'lodging' it offers the male organ when the forbidden hand has to find a replacement for pleasure-giving. In these terms, women's erogenous zones never amount to anything but a clitoris – sex that is not comparable to the noble phallic organ, or a hole-envelope that serves to sheathe and massage the penis in intercourse: a non-sex, or a masculine organ turned back upon itself, self-embracing [...]

About woman and her pleasure, this view of the sexual relation has nothing to say. Her lot is that of 'lack', 'atrophy' (of the sexual organ) and 'penis envy', the penis being the only sexual organ of recognized value. Thus she attempts by every means available to appropriate that organ for herself: through her somewhat servile love of the father-husband capable of giving her one, through her desire for a child-penis, preferably a boy, through access to the cultural values still reserved by right to males alone and therefore always masculine, and so on. Woman lives her own desire only as the expectation that she may at last come to possess an equivalent of the male organ.

Yet all this appears quite foreign to her own pleasure, unless it remains within the dominant phallic economy. Thus, for example, woman's autoeroticism is very different from man's. In order to touch himself, man needs an instrument: his hand, a woman's body, language ... And this self-caressing requires at least a minimum of activity. As for woman, she touches herself in and of herself without any need for mediation, and before there is any way to distinguish activity from passivity. Woman 'touches herself' all the time, and moreover no one can forbid her to do so, for her genitals are formed of two lips in continuous contact. Thus, within herself, she is already two – but not divisible into one(s) – that caress each other.

This autoeroticism is disrupted by a violent break-in: the brutal separation of the two lips by a violating penis, an intrusion that distracts and deflects the woman from this 'self-caressing' she needs if she is not to incur the disappearance of her own pleasure in sexual relations. If the vagina is to serve *also*, but *not only*, to take over for the little boy's hand in order to assure an articulation between autoeroticism and heteroeroticism in intercourse (the encounter with the totally other always signifying death), how, in the classic representation of sexuality, can the perpetuation of autoeroticism for woman be managed? Will woman not be left with the impossible alternative between a defensive virginity, fiercely turned in upon itself, and a body open to penetration that no longer knows, in this 'hole' that constitutes its sex, the pleasure of its own touch [...]

Within this logic, the predominance of the visual, and of the discrimination and individualization of form, is particularly foreign to female eroticism. Woman takes pleasure more from touching than from looking, and her entry into a dominant scopic economy signifies, again, her

consignment to passivity: she is to be the beautiful object of contemplation. While her body finds itself thus eroticized, and called to a double movement of exhibition and of chaste retreat in order to stimulate the drives of the 'subject', her sexual organ represents *the horror of nothing to see*. A defect in this systematics of representation and desire. A 'hole' in its scopophilic lens. It is already evident in Greek statuary that this nothing-to-see has to be excluded, rejected, from such a scene of representation. Woman's genitals are simply absent, masked, sewn back up inside their 'crack'.

This organ which has nothing to show for itself also lacks a form of its own. And if woman takes pleasure precisely from this incompleteness of form which allows her organ to touch itself over and over again, indefinitely, by itself, that pleasure is denied by a civilization that privileges phallomorphism. The value so granted to the only definable form excludes the one that is in play in female autoeroticism. The *one* of form, of the individual, of the (male) sexual organ, of the proper name, of the proper meaning ... supplants, while separating and dividing, that contact of *at least two* (lips) which keeps woman in touch with herself, but without any possibility of distinguishing what is touching from what is touched [...]

Luce Irigaray, 'Ce sexe qui n'en est pas un', *Cahiers du Grif*, 5 (1977); reprinted in *Ce Sexe qui n'en est pas un* (Paris: Editions de Minuit, 1977); published in English as 'This Sex Which is Not One', trans. Claudia Reeder, *New French Feminisms*, ed. Elaine Marks and Isabelle de Courtivron (1981) 99-106; reprinted in *This Sex Which Is Not One*, trans. Catherine Porter and Carolyn Burke (Ithaca: Cornell University Press, 1985) 23-26.

Susan HILLER
Women, Language and Truth
[1977]

Each of us is simultaneously the beneficiary of our cultural heritage and the victim of it. I wish to speak of a 'paraconceptual' notion of culture derived from my experience of my ambiguous placement within this culture. This placement has been painful to recognize and difficult to express.

From my awareness of my situation has come an acceptance that for me there is no possibility of adopting a theoretical stance (on any issue such as 'women's practice in art') based on the language of an(y) other. It is always a question of following a thought, first incoherent, later more expressible, through its process of emergence out of and during the inconsistencies of experience, into language.

And this means I cannot claim to represent a 'position' which has already been defined in available terms, political, sociological or art-historical. I am being far from modest in taking up this position, for it seems to me to be the essential issue facing us. And the area in which this 'language' I am speaking about, verbal or visual, makes

itself possible, is limited. But within these limits there is great freedom.

Although I can certainly be located within any grid system that the viewpoints of politics, sociology or art history lay upon the world of experience in innumerable permutations and in varying degrees of subtlety; and although I am exposed every day to the common generality of attitudes whose limited range indicates the basic ideological 'set' involved – describing me as a woman, artist, foreigner, etc; and although in addition I myself have inevitably absorbed and incorporated all of these attitudes and many of these viewpoints; and although 'I' must be in some sense co-determinate with this culture, and my expression, *to be comprehensible to any degree*, merely an aspect of it, yet I can find myself ONLY in refusing to speak in ready-made terms as an example, representative or instance.

Those of you who are first and foremost involved in the women's movement or in pursuing a political programme as artists will perhaps feel an uneasiness, or hear this as a negation of more obviously 'committed' perspectives. That would be unfair. So let me add a particularly paradoxical note: my terms of expression and my painful and tenuous grasp of my – really our – situation, means that I am fully capable of actions that imply that my being is incorporated within any one of these categories. Thus from time to time I have participated in effective political actions based on a tentative analysis or an incomplete theoretical stance; I can describe my own experiences within the modes of the modern feminist confessional tradition; and I can discuss art in terms of issues, and 'who and when' ...

In proportion to the strength I gain and the illusion of consistency I give as a conscious user of these conventional languages of the culture, I lose my sense of reality. But in proportion to my non-use of these conventional languages comes a loss of certainty and public effectiveness and the appearance of inconsistency. This is a true dilemma, and now I will exhibit the inconsistency I have mentioned, for I must speak of it from the point of view of the categories 'woman' and 'artist' which we know to be in collision. The results of this collision can't yet be seen, but I envisage an eventual explosion, ending in mutation of all personal, political and cultural themes ...

To sum up would be premature, obviously. But I can end with the following: (1) all my ideas begin as part of the necessity for truth-telling in art practice; (2) not being entirely at home in the ordinary, dominant languages makes this less than simple. At the same time, it gives me a wide range of options; and (3) the greatest self-betrayal for an artist is not indulging in anarchic or careless opposition to rational politics, but in fashioning acceptable SEMBLANCES of truth.

Hiller's contribution to a panel discussion on 'Women's practice in art', organized by the Women's Free Art Alliance at the AIR Gallery, London, 20 February, 1977; reprinted in Susan Hiller, *Thinking About Art: Conversations with Susan Hiller*, ed. Barbara Einzig (Manchester: Manchester University Press, 1996) 43-44.

Eva COCKCROFT
Women in the Community Mural Movement [1977]

Women's role in the community mural movement is much greater than is generally recognized. Major city-sponsored mural programmes in Boston (Adele Seronde and Summerthing), New York (Susan Shapiro-Kiok and Cityarts) and Los Angeles (Judy Baca and Citywide) have been initiated and directed by women artists, who have given these programmes much of their character and philosophy. Women have led school mural projects, mural collectives and mural-work with street youth. Whether working as individual muralists, members of coalitions or in collectives, women have increasingly dominated the mural movement as a force for non-elitism, collectivity and the practice of social philosophies ranging from humanism to Marxism.

Murals on urban walls reflecting the aspirations of neighbourhood residents began as part of the more general social upheaval of the 1960s. Artists found themselves dragged into the social arena and forced to consider questions beyond those of pure form. By the late 1960s they could no longer avoid confronting questions concerning the relevance, audience and uses of their art. A number of movements arose that tried to enlarge the audience and scope of contemporary art. Minority-group and politically active artists felt both a demand and an opportunity to create an art responsive to their special heritage and relevant to their own ethnic group, community or movement. Mainstream artists attempted to bring art out of the museums and into the cities in the form of urban super-graphics, environmental sculptures, street-works and Happenings. Out of the coincidence of these social and artistic forces the community mural movement began in 1967–68 [...]

Within the Latin culture, *machismo* often reaches rather extreme forms, yet this is countered by a strong communal tradition. It is not surprising therefore that in 1974 a group of Latin American women muralists – Mujeres Muralistas – was formed in San Francisco. Most of the women were students or recent graduates of the San Francisco Art Institute and connected with the Galeria de La Raza, the centre for Chicano artists in the Mission district. Their philosophy was simple and very positive: '*Our cultures, our images are strong. It is important that the atmosphere of the world be plagued with colour and life. Throughout History there have been very few women who have figured in art. What you see is proof that women, too, can work at this level. That we can put together scaffolding and climb it. We offer you the colours that we make.*' Their two best-known walls, *Latinoámerica* and the Paco's Tacos Stand mural were both done in the spring and summer of 1974. They celebrate the beauty and richness of the Latin tradition. For *Latinoámerica*, the four women comprising the original core of Mujeres Muralistas – Patricia Rodriguez, Consuelo Mendez Castillo, Irene Perez and Graciela Carrillo de Lopez – worked together to create

7. Mujeres Muralistas

the design. Different parts of the mural are painted by each artist in her individual style; yet the mural succeeds as a unified work because of the clear organization, and the distinctively bright, clear colour that is characteristic of the group. In the Paco's Tacos mural the unity is more tenuous. The wall divides into two distinctly different halves reflecting the different artistic styles of Consuelo Mendez Castillo and Graciela Carrillo de Lopez. In many ways Mujeres Muralistas was never really a 'collective', but rather a group of women who came together to work on a particular wall mural. An almost instant fame forced them into a prematurely formalized existence as a 'collective group', while leaving them little time to resolve differences in political consciousness between members of the group, or cultural differences between Chicana and Latin American women. The problem of individualism was never really tackled, although there was an attempt to make decisions by a consensus of the group. Internal differences caused the group to dissolve formally early in 1976. The women who comprised Mujeres Muralistas are now working as individual muralists [...]

Eva Cockcroft, 'Women in the Community Mural Movement', *Heresies*, 1 (January 1977) 14-22.

Su RICHARDSON, Monica ROSS, Kate WALKER

Flying in the Face of Male Artocracy [1978]

FENIX¹ is a travelling exhibition, made by Monica Ross, Su Richardson and Kate Walker. Ross, Richardson and Walker met at the Women Artists/Historians Conference of 1974.² They have worked together subsequently, organizing, writing and exhibiting within the context of the Women's Art Movement, at the point of its recent intervention in the Gallery System. 'FEMINISTO POSTAL EVENT' 1976–77³ was one example of this phase.

The concept of collective artwork is related, in FENIX, to the process called Consciousness Raising within feminist small groups⁴ and also to the progress of the Women's Art Movement in Britain.

The development of the WAM has been slower here than in some parts of Europe, and very fragile compared with its strong proliferation in the US. It has been forced to develop a theoretical basis, partly because the exclusion of women from our institutions has been firmer in Britain.⁵ In many cases the developments of women's art abroad have been easily assimilated into the main body of the culture, and sunk into the elitist category: 'avant garde'. A few of these co-opted phenomena exist within the British art world,⁶ but the slowness of this process has given us the opportunity to explore alternatives and to sharpen strategy to a finer point. An outline of the practice in FENIX indicates this point of attack.

FENIX is made in situ at each gallery. The artists work

publicly, improvizing the installation for one week, at each site, after which it is kept for a further period. It then travels to the next exhibition space where it continues to grow, building upon previous work. This type of working procedure as a feminist strategy is best described from a dialogue (recorded Birmingham May 1978) between Ross, Richardson and Walker.

THE GENERATION WHICH THIS TRIO REPRESENTS IS THE FIRST IN WHICH WORKING CLASS WOMEN HAVE HAD ACCESS TO ART EDUCATION. SOME OF THESE WOMEN ARE MAKING A CONSCIOUS COLLECTIVE ATTEMPT TO COMBINE MOTHERHOOD WITH A PROFESSIONAL CAREER.⁷ INDIVIDUAL CAREERIST 'SOLUTIONS', SUCH AS WE HAVE SEEN THROUGHOUT ART HISTORY DO NOT WORK IN THEIR INTEREST.

FENIX ARISES FROM A PARADOXICAL BACKGROUND: the education of women of working class origins in a pursuit which has been the prerogative of the leisured classes, i.e. what is called 'FINE ART' — mainly white, European, male and middle class.

1 I am indebted to Margaret Harrison for the use of this term - a slogan used in a women artists' demonstration 1976, which protested against the inequality of opportunity in the gallery system.

2 See *Studio International*, Women's Issue, 1977.

3 A series of nine exhibitions in Britain and abroad of work sent by post between women artists (started in 1974 by Kate Walker).

4 See Mary Michaels, *Learning to Be There* (California: Sea Cow) for an account of how consciousness raising relates to feminist art. Also Judy Chicago, *Through the Flower: My Life as a Woman Artist* (New York: Doubleday, 1977) 70, 'Fresno Women's Programme'.

5 Although women have had access to art education in equal numbers to men, since the beginning of this century, the proportion of women artists represented in the gallery, art education and arts administration systems rests at less than 4 per cent.

6 Paris Biennale (London: Arts Council of Great Britain, 1979), for example, or Hayward Annual (London: Arts Council of Great Britian, 1978).

7 Monica Sjöö, *Women Are the New Left* (Manchester: Matri/Amaron Publications, 1979).

Su Richardson, Monica Ross and Kate Walker, *Flying in the Face of Male Artocracy*, pamphlet, n.p. (London: 1978).

Gloria Feman ORENSTEIN

The Re-emergence of the Archetype of the Great Goddess in Art by Contemporary Women [1978]

As the archetype of the Great Goddess re-emerges into

consciousness today, women artists, through trans-personal visionary experiences, are bringing to light energic psychic forces, symbols, images, artifacts and rituals whose configurations constitute the basic paradigm of a new feminist myth for our time.

'When a psychological need arises it seems inevitably the deeper layers of the collective unconscious are activated and sooner or later the memory of a myth of an event or an earlier psychic state emerges into consciousness.'¹

Evoking the memory of an earlier psychic state, one in which divinity was seen to reside in matter and the energies of the earth were revered as sacred, the Goddess has become that which activates those forces within woman identified with holiness and with creative power. If the artist is the avatar of the new age, the alchemist whose great Art is the transformation of consciousness and being, then contemporary women artists such as Mary Beth Edelson, Carolee Schneemann, Mimi Lobell, Buffie Johnson, Judy Chicago, Donna Byars, Donna Henes, Miriam Sharon, Ana Mendieta, Betsy Damon, Betye Saar, Monica Sjöö and Hannah Kay, by summoning up the powers associated with the Goddess archetype, are energizing a new form of Goddess consciousness, which, in its most recent manifestation, is exorcizing the patriarchal creation myth through a repossession of the female visionary faculties [...]

Becoming conscious of the presence of Goddess imagery in one's work is a long arduous process of visual re-education. Carolee Schneemann, who in childhood saw the radiant face of the Great Mother in the moon and believed that the world was permeated by invisible energies, unconsciously made her first Goddess image in 1963 when she was working on her theatre piece *Chromolodeon*. In her desire for a companion figure for the piece, she made the head of a horned bull and mounted it on a clothed dressmaker's dummy. Seven years later she was to discover that the bull was the sacred beast of the Great Goddess. In the 1960s Schneemann did not yet understand the real significance of the bull iconography in her work. In her series of body pieces, such as *Meat Joy* of 1964, she began to put the materials from the static works onto herself, and in *Eye Body* (1963) she used two snakes on her body in a set of transformative actions. Later, reviewing her artistic evolution through the 1970s, Schneemann came to understand that the serpents in her earlier works were related to the Minoan Snake Goddess through a series of iconographical similarities and personal connections.

The figure of the Minoan Snake Goddess, arms upright, is currently featured in much Goddess-culture art. This merging of the self with that of the Goddess functions as a mirror reflection in which women see themselves as the Goddess and the Goddess in themselves.

The process of the evolution of Goddess consciousness itself became the theme of *Homerunmuse* (performed at the Brooklyn Museum during the 'Women Artists 1550–1950' show, Autumn 1977). In a meditation upon the female and the muse, whose presence is indicated in the word 'museum', but whose usual absence from the institution was made obvious by the fact of the women artists' show, Schneemann rejects 'the abstracted

token Muse as fragmentation'. Through a collage of texts Schneemann reiterates the theme of woman remaking herself into the image of the Goddess [...]

Ana Mendieta, who came to the US from Cuba in 1961, thinks of the earth as the Goddess. She recalls a mountain in Cuba, La Mazapan de Matanza, that is in the shape of a reclining woman. Her transformational rituals explore the boundaries between spirit and matter. In a piece she did in a labyrinth, *Silueta de Laberinto* (1974), she worked with the metamorphosis of the self that occurs in sorcery and trance. In this piece someone traced her silhouette on the ground. When Mendieta left the labyrinth, her image was imprinted upon the earth, suggesting that through a merging with the Goddess spirits are evoked that infuse the body and cause such occurrences as out-of-body journeys or astral travel. In Earth Sorcery, of which all her works are examples, the Earth Goddess is the shaman and the spell is invoked through a magical rite in which unification with the Earth Mother transpires. Mendieta is concerned with rebirth and her grave and burial mound pieces suggest that material death does not imply spiritual death.

In some of her works, Mendieta wraps herself in black cloth, imposing her mummified form upon the ground which is then dug out around her. A series of these imprints are eventually lit with gunpowder, leaving silhouetted after-images embedded in the earth as a testimony to the magical site of transformation, the dwelling of the Goddess, where the human and the divine had come to mingle as preparation for a new destiny. Her art concretizes that process of Earth Alchemy, using prime matter itself as the alchemistic vessel through which spirit will be made to re-enter matter and transform woman into the vital incarnation of the Earth Goddess once more [...]

Mary Beth Edelson's work has long been intimately involved in the explorations of the Goddess. In 1961 her painting of Madonna and Child entitled *Godhead* introduced concentric circles as sources of energy from the Madonna's head. In these early paintings[2] her women were frequently depicted with their arms uplifted, reminiscent of the posture of many early Goddess figures. The primal image of the outstretched arms of the Goddess, whose power must be reclaimed by women for themselves today, is seen by Edelson not only as a spiritual signifier, but as a contemporary symbol of our political activism.

In 1969 she began to evolve a more defined and specific area of archetypal imagery, out of which emerged the exhibition *Woman Rising*, revolutionary in the way it brought to consciousness psychic material about the Great Goddess. Her most innovative images for today have been the body images she has created through performing private body rituals where the body itself is the house of wisdom. In these, the artist calls upon Goddess energy, using her own body as a stand-in for the Goddess and as a symbol for Everywoman, whose expanded states of body-consciousness and multiple transformations are evoked through contact with powerful natural energies.

On 1 March 1977, Edelson performed a mourning ritual ceremony for her exhibition 'Your 5,000 Years Are Up', entitled *Mourning Our Lost Herstory*, at the Mandeville

Gallery, University of California at La Jolla. Ten women sat in a circle in the centre of a fire ring, the only source of light, chanting and wailing while seven silent 244-cm [8-ft-high] black-draped figures, which had previously seemed to be an uninhabitated formal sculptural installation on the back wall, came alive and began to move around the cavernous gallery. More recently, she performed a mourning-reclamation ritual at AIR Gallery, New York City, entitled *Proposals For: Memorials to the 9,000,000 Women burned as Witches in the Christian Era*. This ritual, based on research about witch burning in relation to women who were Goddess worshippers, evoked the spirits of individual women who were tortured during the Inquisition. Edelson is not content, however, to exorcise the past; her art is about mythic recreation of holy spaces for women's culture today [...]

Betye Saar's work, through its mystical, visionary imagery, probes the collective unconscious for those images of female power specific to black women. By delving deeply into the religious practices of Africa and Haiti, Saar resurrects images of the Black Goddess, the Voodoo Priestess and the Queen of the Witches, collecting the amulets and artifacts of these cultures and placing them in her boxes in order to create potent talismanic collections of magically charged objects and icons. For Saar, contemporary black women are all incarnations of the Black Goddess, and in reclaiming black power, women are instinctively venerating an ancient female force still worshipped in other cultures today. *Voo Doo Lady W/3 Dice* (1977) is a mixed-media collage on fabric that identifies black woman in her image of oppression with the mystical Black Goddess, implying through its iconography that women should worship the deity within themselves, and that a familiarity with occult and mythological traditions will reveal the true face of the Goddess to all women.

In her piece *7,000 Year-old Woman*,[3] performed publicly 21 May 1977, Betsy Damon covered herself with small bags of coloured flour which she punctured in a ritual ceremony. As each small bag of flour emptied, like a miniature sandtimer, it was as if the artist and her assistant, through intense concentration and meditation, had incorporated a bit of lost time into the aura of their consciousnesses. This piece demonstrates how contemporary Goddess-culture art seeks to transform the body and the consciousness of modern woman by infusing it with a sense of herstory, reclaimed and reintegrated into the present sense of the self.

Damon has been performing rituals in nature for several years, working collectively with women, creating rites of anger, rebirth and transformation, such as the *Birth Ritual*, in which each woman gives birth to another, chanting, 'I am a woman. I can give birth to you.' In the *Naming Ritual*, performed in Ithaca, women chanted, 'I am a woman. I give you my hand. We are women. Our circle is powerful.' After the chanting they intoned the names of all the women in the ritual. It was during her performance of *Changes*, in Ithaca, that she dreamed of the *Maypole Ritual*. This fertility rite was held in that same city and participants brought corn, food, poetry and other offerings to the celebration. They painted their bodies,

danced and wove maypoles out of colourfully dyed gauze [...]

Judy Chicago has made a major contribution to this tradition by conceptualizing and creating a travelling multi-media exhibition, *The Dinner Party Project*, an environmental recasting of the history on Western civilization in feminist terms.[4] Accompanying the *Dinner Party Project*'s exhibition is a book in the form of an illuminated manuscript of five sections, some of which include a re-writing of Genesis as an alternate creation myth in which the Goddess is the supreme Creatrix. It also contains a section of myths, legends and tales of the women, a vision of the Apocalypse which is a vision of the world made whole by the infusion of feminist values, and the Calling of the Disciplines, a list of the women represented in the table relating who they were and what they did.

Chicago's work has long been making links between female iconography and a feminist reinterpretation of the Creation Myth. In her series of porcelain plates entitled *The Butterfly Vagina as the Venus of Willendorf*, *The Butterfly Vagina as the Great Round*, etc. sexuality is expressly connected to spiritual transformation. For Chicago, the butterfly symbolizes both liberty and metamorphosis. The new specimens in *The Butterfly Goddess* series represent a new breed of women: these are women yet to be born to a world in which the Goddess is recognized as the original deity; women whose sexual energy is accepted as a legitimate form of creative power.

Her *Womantree* series suggests the principle of a female Tree of Life out of which these 'Ancient New Beings' will emerge, possessing all the secrets of the matriarchal past transmitted over time through the sacred matrilineage women now reclaim. Chicago's flower forms, seed shapes and pod forms relate to the principles of feminist alchemy and suggest the final transmutation into 'The Ancient New Being' of which the butterfly is her prime symbol.

Chicago's dream has always been to bring art out of the world and back into the culture so that it will affect the people as it once did in the Middle Ages.

Monica Sjöö's synthesizing of artistic, political and mythological material has served as a catalyst of Goddess-consciousness in England. Her underground pamphlet, *The Ancient Religion of the Great Cosmic Mother of All*, which will be published by *Womanspirit* in the coming year, is a poetic attempt to cull all information that can be obtained through a feminist occult reading of history, symbolism, myth, art and literature, and bring it into a powerful re-evaluation of many of the philosophical underpinnings of contemporary thought. Her artworks create Goddess emblems which narrate the story of the real crucifixion, that of women who have been sacrificed upon the cross of patriarchal culture. They speak of female rebirth into a new ethos through the revolutionary force of women as workers and visionaries [...]

1 June Singer, *Androgeny: Towards a New Theory of Sexuality* (New York: Anchor, 1976) 71.

2 See 'Mary Beth Edelson's Great Goddess', *Arts Magazine* (November 1975).

3 Betsy Damon, 'The 7,000 Year Old Woman', *Heresies*, 3

(Autumn 1977) 9–13.

4 Arlene Raven and Susan Rennie, 'Interview with Judy
 Chicago', *Chrysalis*, 4, 89–101.
Gloria Feman Orenstein, 'The Re-emergence of the Archetype
of the Great Goddess in Art by Contemporary Women',
Heresies, 5 (Spring 1978) 74–84.

April KINGSLEY
Six Women at Work in the Landscape [1978]

The pioneering days of making artworks in the landscape are over. The scouts who survived are back, and the settling-in phase has begun. Just as women shouldered half of the backbreaking workload of civilizing the wilderness in those early days of our country, so do they now share equally with male artists in this new wave of creative, intellectual domination over nature. In fact, women seem to be making most of the truly innovative moves in this art form at the moment […]

Alice Aycock's work presents the clearest model for these concepts. It is highly formalized yet wholly participatory; it's clean and fully exposed yet rife with implications. Experiencing one of her sculptures, one relives childhood scares and wonders. Her interior works are like rough stage sets in which to act out a private theatre of the absurd with their blind, narrowing passageways, stairs to the ceiling and high, slender perches over empty space. Outdoors she digs into the earth making fire pits, walled trenches, wells, buried chambers and tunnels. She has constructed many major works out of doors. Three of them, located on her family's land in Pennsylvania, were built between 1972 and 1974 – a low, stone-sided, sod-roofed building sited and structured to give the impression as you enter it (on hands and knees) that you're crawling into the side of a hill; a walled trench around a platform of walled earth, containing a central pit, which you must leap across a too-wide space to reach; and a 9.75-m [32-ft] -diameter timber maze of concentric dodecagonal rings 1.8 m [6 ft] in height.

All of these pieces involve making hard decisions concerning one's safety, but the series of choices created by the maze's nineteen entrance points and seventeen barriers results in a total loss of orientation. So youthful fears – of getting lost, of crawling headfirst into a space too narrow to turn around in, of failing to leap a chasm successfully – are all incorporated in these pieces. The structures themselves recall ancient Egyptian mastabas, Minoan labyrinthine palaces and primitive plains dwellings, but the purposes or uses have been changed. Aycock taps into modern people's collective unconscious by predetermining their physical interaction with the piece.

Alice Aycock is a compulsively hard worker. For each project she draws up detailed plans with the accuracy of an architect which contain information so complete that any construction worker could execute the piece. She either builds the structures herself (or in one case with her mother) or she supervises their construction closely. She's already built more major pieces than most artists do in a lifetime, all in the past five years since she matured as an artist. She documents them exhaustively and supports potential readings of their context with a staggering number of references which only Duchamp would have fully appreciated. As an example, she cited the following specific sources for her *Wooden Posts Surrounded by Fire Pits* which she executed on the grounds of the Nassau County Museum last autumn: a Haitian voodoo ceremony, a Tunuquanan Indian village surrounded by a circular palisade of wooden posts, a drawing of a sixteenth-century Indian dance in Virginia, Zulu soldiers in military formation and their circular distribution of homes and corrals, the Mayan labyrinth at Oxkintok, Yucatan, the Court of a Thousand Columns at Chichen Itza, an Egyptian hypostyle hall and the Hall of Mysteries at Eleusius.

In addition, she fleshed out her associations with this configuration with stories from Turkish military history about heads being displayed on posts, about vampires, witches, Lilith, Aztec sacrifices, her own travels in the Yucatan and childhood memories of lighting fires in secret to cook crayfish she'd caught, plus a dozen or so others. She leaves one little to add, but one needn't know any of that information to sense its weight behind the piece, supporting it. You can't avoid feeling the air charged with energy from the crackle and scent of logs burning in the fire pits as you pass through them up to and into the concentric rings of upright, pitch-soaked logs. You are drawn by some ineluctable force towards the centre of the structure, but find yourself blocked and detoured by the increasing proximity of one post to the next as the centre nears and by unexpected barriers in the walk spaces between the rings. Confusion results. Only a child or an animal could possibly penetrate to the centre's hollow core. You squeeze between the logs as far as you can, and then suddenly you realize you aren't certain you can locate the particular space you navigated to get where you are in order to get back out again. Then the smoke from the surrounding fire pits begins to seem ominous and you panic to escape […]

She says, 'Because the archaeological sites I have visited are like empty theatres for past events, I try to fabricate dramas for my buildings, to fill them with events that never happened'. She sets the scenarios for those dramas from her dreams and from dreamlike passages in the writings of Gabriel García Marquez, Jorge Luis Borges, H. Rider Haggard, Edgar Allan Poe and in a host of ancient myths and fables. No other artist I know of, even her one-time teacher Robert Morris, so consciously incorporates literary, historical and psychological references in her work as obsessively and consistently as Aycock does […]

Mary Miss always seems to generate the sense of an interior space, on the other hand, even though she doesn't roof-over or completely enclose her structures. The illusion of insideness is created in part by her habit of exteriorizing the expected interior structure of a given object. She usually works in wood – boards, 5 × 10 cm [2 × 4 in] planks, lattice, fencing, etc. – occasionally with sheet metal, and rarely with other semi-structural materials such as chicken wire and cardboard. Wooden structures are commonly rigid right angles with some material or other so that the wood construction is hidden inside shell or facing walls, not expressed outwardly. Mary Miss not only shows the wood structure but turns it inside out.

Sunken Pool, executed on the grounds of the Greenwich County Day School in 1974, has a smooth sheet-steel interior supported by a latticed brace of 5 × 10 cm [2 × 4 in] beams on the outside of its 6-m [20-ft] circumference. She has here, as she frequently does, extended the verticals of the supporting members far beyond the confines of the material it embraces. The result is a look of incompleteness that implies potential extension. Once having stepped down into the water inside the steel cylinder which extends down 91.5 cm [3 ft] below ground, through one of the T-shaped entrances on axis in its walls, one finds oneself 'outside' while actually inside. Space is contained while paradoxically intangible. There is a sensation of floating free in empty, unbounded space despite the absoluteness of the enclosure.

Needless to say, the courage it takes to step down into the dark water, unsure of the bottom, and to move into the 'tank' is great. Also similar in some respects to the experience of an Alice Aycock work are the protected fort-clubhouse-secret hiding place-initiation ceremony site intimations given off by the structure. Like a Cecile Abish in some respects is the openness to the ground, its potential for being swallowed up by surrounding growth. But its sound is unique. It's the sound of one hand clapping or a tree falling in a forest with no one to hear it fall. Mary Miss has a curious quality of absence, of negation in her style. Her formal vocabulary – O's, X's, V's and H's – belong to tic-tac-toe, a pointless game. She builds barriers to your passage, floorless buildings and seried ranks of rings or notches that telescope your lines of sight in reverse until the sighted space disappears into the earth like the setting sun it imitates. She marks time and measures distance with these objects, but they lead nowhere. Like the indoor wall or floor pieces she makes that seem all inside out, or the pool where you feel outside when you're inside, you feel the work is disappearing before your eyes or that, while experiencing it, you are passing through a mirror into another reality, like a character in 'Children of Paradise' […]

April Kingsley, 'Six Women at Work in the Landscape', *Arts Magazine*, 52: 8 (April 1978).

DIFFERENCES

With the growth of academic women's studies, feminist theory proliferated. The notion that sexual identity is culturally constructed rather than biologically determined became influential. Post-Freudian theories of sexual difference, initially debated in literary and film studies, were applied to the visual arts. Mary Kelly, Kate Linker and Craig Owens among others discussed strategies for analysing the construction of difference in representation, confronting the mastery of the male gaze, and deconstructing myths of artistic originality. Two important analyses of women artists' position in Western culture were published: *The Mad Woman in the Attic* (1979) by Sandra M. Gilbert and Susan Gubar, and *Old Mistresses* (1981) by Rozsika Parker and Griselda Pollock. Differences between women and within feminism were debated. Jo Spence's work highlighted difference created by class and illness. Contesting academic feminism's limitations, Audre Lorde called for the recognition of 'those of us who have been forged in the crucibles of difference – those of us who are poor, who are lesbians, who are black, who are older', for whom '*survival is not an academic skill*'.

Parveen ADAMS, Rosalind COWARD, Elizabeth COWIE

m/f Editorial [1978]

m/f sees its work as a contribution to the development of political and theoretical debate within what is loosely called the Women's Movement. Any political and theoretical argument that places itself within the Women's Movement commits itself to a concern with what is specific to women. But some theoretical formulations of women as a specific social group entail positions with which we must disagree. One such formulation is in terms of essential femininity. This can take two forms; either the idea of transhistorical oppression of women at all times, or the idea of an 'original' femininity that is repressed or suppressed. Another approach is to assume that women are a social group, but one whose history has been suppressed. The reinstatement of this history is then assumed to be a sufficient political practice.

In other words, the concern with what is specific to women both provides moments of political unity and at the same time operates to obscure very real political issues. The unity of the Women's Movement lies in the belief that the sexual division of labour between men and women, as it is constituted at present, has profound and adverse effects on the social position of women. But attempts to consider sexual division from within existing political and theoretical frameworks cannot provide the analysis that is needed.

The 'Marxist-Feminist' position constitutes a recognition of this inadequacy. Traditionally, in this country, Marxist politics have stressed not only the organization of capitalist society in terms of class division, but also the primacy of the class division as the determinant of political action. It has also been argued that the transformation of this division will necessarily bring about significant changes for women. But the problem of women cuts across class division. Given this traditional definition of society in terms of class and politics, the problem of women is always secondary to the problem of the class organization of society. This placing of a politics of women has left some of us in difficult political straits, since we have no desire to dissociate ourselves from a politics that aims to erase the class basis of society. But neither can we accept the empty promise that the transition to socialism will in itself bring about a change in the relations between the sexes [...]

We are interested in how women are produced as a category; it is *this* that determines the subordinate position of women. Some feminists have taken up psychoanalysis as providing an account of the process of the construction of the sexed subject in society. This is seen as important because it is with the construction of sexual difference and its inscription in the social that feminism is concerned. But psychoanalysis has had little to say on the relationship of this construction to particular historical moments, or the effect that considering the historical moment might have on psychoanalytic theory itself. Thus psychoanalysis is not a sufficient theory for understanding the construction of women as a category.

The particular historical moment, the institutions and practices within which and through which the category of

woman is produced, must be addressed. This is not a problem of origins but of the continual production of the sexual division within those institutions and practices.

The problem of the production of sexual division has been addressed in this issue in a number of ways: through an examination of how psychoanalysis constructs the category of woman, how Marxism conceptualizes the sexual division of labour, and how discursive practices such as film produce the category of women.

We hope that *m/f* will be open to questions that will advance theoretical and political considerations of women today. *m/f* places itself as a predominantly theoretical journal, and we believe that at this moment this work is of major importance for feminism. But we also believe that a politics cannot be 'read off' from theory and that theory can never be a substitute for politics. One of our foremost aims therefore will be the development of a theoretical debate on women's politics; a debate that must take place in relation to existing socialist and feminist politics.

Parveen Adams, Rosalind Coward, Elizabeth Cowie, 'Editorial', *m/f*, 1 (1978).

Audre LORDE
The Master's Tools Will Never Dismantle the Master's House [1979]

I agreed to take part in a New York University Institute for the Humanities conference a year ago, with the understanding that I would be commenting upon papers dealing with the role of difference within the lives of American women: difference of race, sexuality, class and age. The absence of these considerations weakens any feminist discussion of the personal and the political.

It is a particular academic arrogance to assume any discussion of feminist theory without examining our many differences, and without a significant input from poor women, black and Third World women, and lesbians. And yet, I stand here as a black lesbian feminist, having been invited to comment within the only panel at this conference where the input of black feminists and lesbians is represented. What this says about the vision of this conference is sad, in a country where racism, sexism and homophobia are inseparable. To read this programme is to assume that lesbian and black women have nothing to say about existentialism, the erotic, women's culture and silence, developing feminist theory, or heterosexuality and power. And what does it mean in personal and political terms when even the two black women who did present here were literally found at the last hour? What does it mean when the tools of a racist patriarchy are used to examine the fruits of that same patriarchy? It means that only the most narrow perimeters of change are possible and allowable.

The absence of any consideration of lesbian consciousness or the consciousness of Third World women leaves a serious gap within this conference and within the papers presented here. For example, in a paper on material relationships between women, I was conscious of an either/or model of nurturing which totally dismissed my knowledge as a black lesbian. In this paper there was no examination of mutuality between women, no systems of shared support, no interdependence as exists between lesbians and women-identified women. Yet it is only in the patriarchal model of nurturance that women 'who attempt to emancipate themselves pay perhaps too high a price for the results', as this paper states.

For women, the need and desire to nurture each other is not pathological but redemptive, and it is within that knowledge that our real power is rediscovered. It is this real connection which is so feared by a patriarchal world. Only within a patriarchal structure is maternity the only social power open to women.

Interdependency between women is the way to a freedom which allows the *I* to *be*, not in order to be used, but in order to be creative. This is a difference between the passive *be* and the active *being*.

Advocating the mere tolerance of difference between women is the grossest reformism. It is a total denial of the creative function of difference in our lives. Difference must be not merely tolerated, but seen as a fund of necessary polarities between which our creativity can spark like a dialectic. Only then does the necessity for interdependency become unthreatening. Only within that interdependency of different strengths, acknowledged and equal, can the power to seek new ways of being in the world generate, as well as the courage and sustenance to act where there are no charters.

Within the interdependence of mutual (non-dominant) differences lies that security which enables us to descend into the chaos of knowledge and return with true visions of our future, along with the concomitant power to effect those changes which can bring that future into being. Difference is that raw and powerful connection from which our personal power is forged.

As women, we have been taught either to ignore our differences, or to view them as causes for separation and suspicion rather than as forces for change. Without community there is no liberation, only the most vulnerable and temporary armistice between an individual and her oppression. But community must not mean a shedding of our differences, nor the pathetic pretense that these differences do not exist.

Those of us who stand outside the circle of this society's definition of acceptable women; those of us who have been forged in the crucibles of difference – those of us who are poor, who are lesbians, who are black, who are older – know that *survival is not an academic skill*. It is learning how to stand alone, unpopular and sometimes reviled, and how to make common cause with those others identified as outside the structures in order to define and seek a world in which we can all flourish. It is learning how to take our differences and make them strengths. *For the master's tools will never dismantle the master's house.* They may allow us temporarily to beat him at his own game, but they will never enable us to bring about genuine change. And this fact is only threatening to those women who still define the master's house as their only source of support.

Poor women and women of colour know there is a difference between the daily manifestations of marital slavery and prostitution because it is our daughters who line 42nd Street. If white American feminist theory need not deal with the differences between us, and the resulting difference in our oppressions, then how do you deal with the fact that the women who clean your houses and tend your children while you attend conferences on feminist theory are, for the most part, poor women and women of colour? What is the theory behind racist feminism?

In a world of possibility for us all, our personal visions help lay the groundwork for political action. The failure of academic feminists to recognize difference as a crucial strength is a failure to reach beyond the first patriarchal lesson. In our world, divide and conquer must become define and empower.

Why weren't other women of colour found to participate in this conference? Why were two phone calls to me considered a consultation? Am I the only possible source of names of black feminists? And although the black panelist's paper ends on an important and powerful connection of love between women, what about inter-racial co-operation between feminists who don't love each other?

In academic feminist circles, the answer to these questions is often, 'We did not know who to ask'. But that is the same evasion of responsibility, the same cop-out, that keeps black women's art out of women's exhibitions, black women's work out of most feminist publications except for the occasional 'Special Third World Women's Issue', and black women's texts off your reading lists. But as Adrienne Rich pointed out in a recent talk, white feminists have educated themselves about such an enormous amount over the past ten years, how come you haven't also educated yourselves about black women and the differences between us – white and black – when it is key to our survival as a movement?

Women of today are still being called upon to stretch across the gap of male ignorance and to educate men as to our existence and our needs. This is an old and primary tool of all oppressors to keep the oppressed occupied with the master's concerns. Now we hear that it is the task of women of colour to educate white women – in the face of tremendous resistance – as to our existence, our differences, our relative roles in our joint survival. This is a diversion of energies and a tragic repetition of racist patriarchal thought.

Simone de Beauvoir once said: 'It is in the knowledge of the genuine conditions of our lives that we must draw our strength to live and our reasons for acting.'

Racism and homophobia are real conditions of all our lives in this place and time. *I urge each one of us here to reach down into that deep place of knowledge inside herself and touch that terror and loathing of any difference that lives there. See whose face it wears.* Then the personal as the political can begin to illuminate all our choices.

Originally delivered as comments at 'The Personal and the Political Panel', *Second Sex Conference*, New York (29 September 1979). Audre Lorde, 'The Master's Tools Will Never

Dismantle the Master's House', *Sister Outsider* (Freedom, California: The Crossing Press, 1984); reprinted in *The Audrey Lorde Compendium* (London: Pandora, 1996).

Adrienne RICH
Compulsory Heterosexuality and Lesbian Existence [1978]

I want to say a little about the way 'Compulsory Heterosexuality' was originally conceived and the context in which we are now living. It was written in part to challenge the erasure of lesbian existence from so much of scholarly feminist literature, an erasure which I felt (and feel) to be not just anti-lesbian, but anti-feminist in its consequences, and to distort the experience of heterosexual women as well. It was not written to widen divisions but to encourage heterosexual feminists to examine heterosexuality as a political institution which disempowers women – and to change it. I also hoped that other lesbians would feel the depth and breadth of woman identification and woman bonding that has run like a continuous though stifled theme through the heterosexual experience, and that this would become increasingly a politically activating impulse, not simply a validation of personal lives. I wanted the essay to suggest new kinds of criticism, to incite new questions in classrooms and academic journals, and to sketch, at least, some bridge over the gap between *lesbian* and *feminist*. I wanted, at the very least, for feminists to find it less possible to read, write or teach from a perspective of unexamined heterocentricity [...]

I have chosen to use the terms *lesbian existence* and *lesbian continuum* because the word *lesbianism* has a clinical and limiting ring. *Lesbian existence* suggests both the fact of the historical presence of lesbians and our continuing creation of the meaning of that existence. I mean the term *lesbian continuum* to include a range – through each woman's life and throughout history – of woman-identified experience, not simply the fact that a woman has had or consciously desired genital sexual experience with another woman. If we expand it to embrace many more forms of primary intensity between and among women, including the sharing of a rich inner life, the bonding against male tyranny, the giving and receiving of practical and political support, if we can also hear it in such associations as *marriage resistance* and the 'haggard' behaviour identified by Mary Daly (obsolete meanings: 'intractable', 'wilful', 'wanton' and 'unchaste', 'a woman reluctant to yield to wooing'),' we begin to grasp breadths of female history and psychology which have lain out of reach as a consequence of limited, mostly clinical, definitions of *lesbianism* [...]

1 Mary Daly, *Gyn/Ecology: The Metaethics of Radical Feminism* (Boston: Beacon, 1978) 15.

Adrienne Rich, 'Compulsory Heterosexuality and Lesbian Existence' (1978), *Signs* (1980); edited and reprinted as series of pamphlets (Denver, Colorado: Antelope Publications, 1982); reprinted in *Adrienne Rich's Poetry*

and Prose*, ed. Barbara Charlesworth Gelpi and Albert Gelpi (New York and London: W.W. Norton and Co., 1993) 203-24.

Sandra M. GILBERT, Susan GUBAR
The Madwoman in the Attic [1979]

[...] Unlike her male counterpart, then, the female artist must first struggle against the effects of a socialization which makes conflict with the will of her (male) precursors seem inexpressibly absurd, futile or even – as in the case of the Queen in 'Little Snow White' – self-annihilating. And just as the male artist's struggle against his precursor takes the form of what Harold Bloom calls revisionary swerves, flights, misreadings, so the female writer's battle for self-creation involves her in a revisionary process. Her battle, however, is not against her (male) precursor's reading of the world but against his reading of *her*. In order to define herself as an author she must redefine the terms of her socialization. Her revisionary struggle, therefore, often becomes a struggle for what Adrienne Rich has called 'Revision – the act of looking back, of seeing with fresh eyes, of entering an old text from a new critical direction ... an act of survival'. Frequently, moreover, she can begin such a struggle only by actively seeking a *female* precursor who, far from representing a threatening force to be denied or killed, proves by example that a revolt against patriarchal literary authority is possible.

For this reason, as well as for the sound psychoanalytic reasons Juliet Mitchell and others give, it would be foolish to lock the woman artist into an Electra pattern matching the Oedipal structure Bloom proposes for male writers. The woman writer – and we shall see women doing this over and over again – searches for a female model not because she wants dutifully to comply with male definitions of her 'femininity' but because she must legitimize her own rebellious endeavours. At the same time, like most women in patriarchal society, the woman writer does experience her gender as a painful obstacle, or even a debilitating inadequacy; like most patriarchally conditioned women, in other words, she is victimized by what Mitchell calls 'the inferiorized and "alternative" (second sex) psychology of women under patriarchy'. Thus the loneliness of the female artist, her feelings of alienation from male predecessors coupled with her need for sisterly precursors and successors, her urgent sense of her need for a female audience together with her fear of the antagonism of male readers, her culturally conditioned timidity about self-dramatization, her dread of the patriarchal authority of art, her anxiety about the impropriety of female invention – all these phenomena of 'inferiorization' mark the woman writer's struggle for artistic self-definition and differentiate her efforts at self-creation from those of her male counterpart.

As we shall see, such sociosexual differentiation means that, as Elaine Showalter has suggested, women writers participate in a quite different literary subculture from that inhabited by male writers, a subculture which has its own distinctive literary traditions, even though it defines itself *in relation to* the 'main', male-dominated, literary culture – a distinctive history. At best, the separateness of this female subculture has been exhilarating for women. In recent years, for instance, while male writers seem increasingly to have felt exhausted by the need for revisionism which Bloom's theory of the 'anxiety of influence' accurately describes, women writers have seen themselves as pioneers in a creativity so intense that their male counterparts have probably not experienced its analogue since the Renaissance, or at least since the Romantic era. The son of many fathers, today's male writer feels hopelessly belated; the daughter of too few mothers, today's female writer feels that she is helping to create a viable tradition which is at last definitively emerging.

There is a darker side of this female literary subculture, however, especially when women's struggles for literary self-creation are seen in the psychosexual context described by Bloom's Freudian theories of patrilineal literary inheritance. As we noted above, for an 'anxiety of influence' the woman writer substitutes what we have called an 'anxiety of authorship', an anxiety built from complex and often only barely conscious fears of that authority which seems to the female artist to be by definition inappropriate to her sex. Because it is based on the woman's socially determined sense of her own biology, this anxiety of authorship is quite distinct from the anxiety about creativity that could be traced in such male writers as Nathaniel Hawthorne or Fyodor Dostoevsky. Indeed, to the extent that it forms one of the unique bonds that link women in what we might call the secret sisterhood of their literary subculture, such anxiety in itself constitutes a crucial mark of that subculture [...]

Sandra M. Gilbert and Susan Gubar, *The Madwoman in the Attic* (New Haven, Connecticut, and London: Yale University Press, 1979) 45-51.

Harmony HAMMOND
Feminist Abstract Art: A Political Viewpoint [1977]

There are many articles written on feminist art which try to pinpoint and define a feminist sensibility. Few of these articles go beyond the recognition that feminist art is based on the personal experiences of women by beginning to question its larger political implications and the role it plays in feminist revolution. Most articles originating from the art world tend to be formal descriptive attempts at documenting what women are doing, and do not attempt a feminist analysis of function and meaning.

In a reactionary escape from formalist criticism, most movement writing on feminist art deals with political issues, but lacks any real understanding of the creative process, how it functions for the artist and how it affects form and content. Without such an understanding it is

impossible to evaluate the work as art. While feminist poets and writers comment on each other's work and write of their own processes, we visual artists tend to remain silent and let others do the writing for us. Our silence contributes to a lack of dialogue between artist and audience, to the lack of criticism from a feminist perspective, and ultimately to the misinterpretation of our work [...]

Because of [its] history [...] it is difficult to determine abstract painting's relationship to feminist ideology. There are radical feminists who are making abstract art. Radical feminism operates from the belief that women as a class are oppressed, and that a mass political women's movement is necessary to overthrow male supremacy.' Therefore, we might ask, how are the visions of radical feminists analyzed and portrayed in this art?

It is necessary to break down the myths and fears surrounding abstract art and make it understandable. Women – artists and non-artists – need to talk about art, and talking about abstract art need not be more difficult than discussing portraits, nudes, vaginas or whatever. Every work of art is understandable on many different levels. It is by talking about our work and work processes that we will not only begin to develop a new language for interpreting abstract art, but also to integrate this work with society. This language, which I see evolving from consciousness-raising techniques, will be able to be shared with any woman, regardless of class background. For artists, such a dialogue with the audience is essential, as it offers valuable feedback for the development of our art.

I want to reclaim abstract art for women and transform it on our own terms [...]

As we examine some contemporary abstract art by women, it is important to develop a sense of identity and connection with our own past creativity rather than that of the oppressor who has claimed 'fine art' and 'abstract art' for himself. In fact, the patriarchal putdown of 'decorative' traditional art and 'craft' has outright racist, classist and sexist overtones [...]

The way many women *talk* about their work is revealing, in that it often denies formal art rhetoric. Women tend to talk first about their personal associations with the piece, and then about how these are implemented through visual means; in other words, how successful the piece is in its *own* terms. This approach to art and to discussing art has developed from the consciousness-raising experience. It deals primarily with the work itself, what it says and how it says it – rather than with an imposed set of aesthetic beliefs [...]

Art in transition is political, for it both *is* our development and *describes* our development. In a sense we are coming out through our art, and the work itself is a record of the ongoing process of developing a feminist aesthetic ideology.

The fact that innovative form is so feared by the male establishment shows that like content it has a power of its own. If our lives and our art are connected, and if 'the personal is political' in the radical sense, then we cannot

separate the content of our work from the form it takes. As abstract artists, we need to develop new abstract forms for revolutionary art [...]

Art in transition is political for it both *is* our development and *describes* our development. In a sense we are coming out through our art, and the work itself is a record of the ongoing process of developing a feminist aesthetic ideology.

1 Brooke, 'The Retreat to Cultural Feminism', ed.
 Redstockings, *Feminist Revolution* (New York: 1975).
Harmony Hammond, 'Feminist Abstract Art: A Political
Viewpoint', *Heresies*, 1 (January 1977).

Suzanne LACY, Leslie LABOWITZ
Evolution of a Feminist Art
[1978]

'*The truth is that no place is safe. It seems clear to say that women should not hitchhike: seventeen of the eighty-six [raped during* Three Weeks in May*] were raped while accepting or offering a ride to a stranger or acquaintance. But twenty-one were raped at night in their own homes. Should we not stay home either? We all know not to walk late at night: thirteen of the eighty-six were raped while doing so – and twenty-three were raped on the streets in broad daylight! One woman was raped by her bus driver when she fell asleep before the end of the route, another at five o'clock in the afternoon as she sat in her office. Women are offered help when their cars break down and are raped instead. Women are offered medicine when they are sick and are raped instead. Women go to parties with men they think are friends and end up gang-raped instead. It's clear from the facts of the map, it's clear from the reality of women who speak out, that there is no privileged or protected group of women ... '*
– Statement to the press during *Three Weeks in May*

'*We are here because we want you to know that these ten women are not isolated cases of random unexplainable violence. That this violence wreaked upon them is not different, except perhaps in degree and detail, from all of the daily real-life reports which reach the news media, from those fictionalized mutilations shown by our entertainment industries, and from the countless unreported cases of brutalization of our relatives, friends and loved ones who are women ... '*
– Statement to the press during *In Mourning and in Rage*

It is predictable in this time of acknowledged backlash against feminism that violence towards women is increasing. As feminists realize the importance of this issue, we find ourselves knocking at the very threshold of an authoritarian patriarchy. Violence is the critical point around which the position of women revolves: it is the final expression of a system that feels its power threatened. We have seen into the institutionalized

violence of gynaecology, forced marriage and motherhood, psychiatry and incarceration. Now we are becoming aware of the role of so-called random and individual acts of violence in the systematic terrorization of women. We are more than the scapegoats for frustration within the social system. Our bodies are manipulated by the patriarchy as a battlefield for the diversion of attention away from economic systems which are themselves predicated on and preserved by violence.

Through the sobering confrontation with the politics of violence, women are educating themselves to the strategies necessary for revolutionary change. Collective action and pooling resources are important pre-strategic acts for those of us whose first concern is saving the physical bodies of women. As artists we work with the issue of violence as source material, using feminist ideology to shape forms necessary for changing culture. These forms involve the collective action of many women artists and non-artists, working to 'break the silence' and create solutions to violence.

Last year we introduced a course in feminist social art to a group of women at the Feminist Studio Workshop and discovered that before the formal concerns and political ideology that structured our work could be comprehended, these women had to go through a developmental process that would link them personally with a broad public artform. The 'expanding self' became a metaphor for the process of moving the boundaries of one's identity outwards to encompass other women, groups of women and eventually all people. Powerful feminist political art comes from such personal and spiritual connection to the world. Our approach in this article, as well as in our educational activities, is to make manifest the process by which we personally arrived at a public statement of our feminism through art. First we will describe how our different individual developments brought us to similar aesthetic and political conclusions. These ideas were shared and refined during our work of the past year: *Three Weeks in May, Record Companies Drag Their Feet* and *In Mourning and in Rage* ...

Three Weeks in May was a process image documenting the repeated sexual assaults against women in Los Angeles from reports gathered daily from the Los Angeles Police Department. The decision to place the maps in a public site was critical to the subsequent structure of the piece, as it brought the question of responsibility to the audience into the aesthetic design. The rape map itself was an effective consciousness-raiser for those who watched its ominous progress, but to allow it to stand as the sole image of the piece would be to portray only the continuing victimization of women. A second map focused on what was being done by listing phone numbers of rape prevention and intervention agencies. These maps were the central image around which the performance structure of three weeks of activities was created.

Going into the public sphere added to the piece the awareness of multiple communities and their possible roles in social art. Members of the 'community' of government employees and officials were instrumental in installing the maps as well as publicizing the piece [...]

AT THE MOMENT A VIEWER GLIMPSES A VULVA ON A PLATE SHE CAN SHIFT HER EYES TO A PATCH OF NEEDLEWORK AND THINK JUST LIKE GRANDMA USED TO DO

Diana Ketcham, 'On the Table: Joyous Celebration', 1979

During the fall of 1977 in Los Angeles a particularly horrible series of rape killings had been grouped together as 'The Hillside Strangler Case'. The media was reporting in detail each of the ten victims' personal histories, photographic accounts of each death, and speculations about the identity and personality of the murderers. Quotations from frightened neighbours and stories on the ineffectual means women were using to protect themselves served only to further terrorize women. Far from providing useful incentive towards self-protective measures, the media's dissection of the cases served as a focus for the unspoken fears of constant potential assault. Women were living in more fear, feeling isolated and helpless. It is characteristic of such highly sensationalized reporting to avoid a political or comprehensive statement, to focus instead on individual motivation for random acts of violence.

We formulated the strategy for a memorial event which would introduce a feminist perspective into the media's handling of the case. We created a public ritual for women to share their rage and grief, to transform the individual struggle to comprehend these assaults into a collective statement.

We were aware of the multiple distortions possible in the interpretation of the event as it was distilled by media communications. In particular they would want to make the event an individual reaction of grief against the ten specific victims of the strangler. We knew the media would focus on this particular statement in the hopes of finding an explanation for the entire performance. A concise and dramatically delivered statement was planned to capture media attention and present a radical feminist perspective on violence.

The ten women on the steps, the chorus and their banner served as a visual backdrop against which the remainder of the piece unfolded. We provided a framework for the participation of women's organizations and governmental representatives to share in the collective statement of the event. By incorporating elected representatives we would increase our power base and allow them to participate in radical feminist thinking and politics. During the construction of the event we had contacted the Rape Hotline Alliance, and with them formulated demands for mandatory self-defense in grade schools, telephone emergency listing of rape hotline numbers, and increased funding for neighbourhood protection programmes. The second part of the piece was designed to manifest these demands and to build a collaborative relationship between participating groups.

The event received local and national television coverage and some international press. The Los Angeles media itself was very affected by the event. Part of our strategy was to motivate the reporters to participate in the concern about violence and to question their manner of reporting crimes. One news reporter took her cameras to the phone company the day of the performance, and under this pressure the representative stated that the emergency listing of the rape hotline numbers was assured of receiving company approval. The event also instigated a series of television appearances dealing with a critique of the media handling this case.

The success of the piece in generating such response had to do not only with the power of the issue and our organizational activities, but with the impact of the images themselves which were chosen to show powerful women. Women began to move to make that power a reality.

Suzanne Lacy, Leslie Labowitz, 'Evolution of a Feminist Art: Public Forms and Social Issues', *Heresies*, 6 (Winter, 1978).

Diana KETCHAM
On the Table: Joyous Celebration [1979]

[…] An undertaking so ambitious and flagrantly political is difficult to place, at least within any category of mainstream art of the last decade. Art world people who like it explain that it's an attack on Minimalism, since it has concept, or that it is an example of the new eclecticism, since it uses traditional crafts. Others say it falls in the tradition of nineteenth-century public art – frequently didactic murals and statuary – and descends directly from Mary Cassatt's mural for the Women's Building at the Chicago exposition of 1893. But many enthusiasts are hard-pressed to define *The Dinner Party*. They ask: is it art? Is it politics? Is it fine art or crafts? Is it the work of a single artist or a collective, accumulative work like the medieval cathedrals? Is it erotic? Is it pornographic? Does it celebrate women? Does it denigrate women? Is it a Judy Chicago ego trip? Few of them are asking: is it a success? […]

The key to *The Dinner Party*'s broad appeal is its use of traditional crafts. Chicago was shrewd enough to realize that for many American women, the most accessible arts are domestic ones like needlework. If a woman doesn't do needlework herself, she has a mother or grandmother who did. California is the scene of a fibre-arts movement, including a stitchery revival. But *The Dinner Party* is mining a cultural vein that goes deeper than fashions in crafts, or even a phenomenon as widespread as the interest in quilts. Many of the women in the new audience respond to *The Dinner Party* because they feel competent to understand at least some of the techniques it uses. (Besides, needlework can lend itself to the merely quantitative appreciation often given to labour-intensive crafts. 'So many hours, so many tiny stitches.')

The Dinner Party also has the familiarity of a religious work. Entering the exhibition hall, darkened except for the light reflected off linen and glazes, is like walking into a church. The crowd is hushed, its attitude reverent. The table, draped in embroidered linens, is an altar. The place settings are shrines to individual saints, the whole table a pantheon […]

The familiarity of so many aspects of *The Dinner Party* neutralizes what could disturb the same audience, namely, the sexual connotations of the images on the plates. Art-wise and feminist viewers take these images for the convention they have become; there are the usual mutters of approval about demystifying female sexuality, about women knowing their own bodies. The new audience,

however, says things like, 'Is that what I think it is?' When asked about their reaction later, they told me, 'Oh, yes, I thought it was a vagina, but it didn't bother me'. The refrain is 'it didn't bother me'. What they seem to be saying is that it should have bothered them or would have bothered them, but by some miracle that they don't understand, it did not. The miracle is Chicago's balance of media and styles. At the moment a viewer glimpses a vulva on a plate, she can shift her eyes to a patch of needlework and think: 'Just like grandma used to do'.

Whether genital imagery is appropriate for portraits of great women of history is the question most often asked. Chicago sidesteps this issue when she insists that the image does not have to be taken as genital but as a butterfly, a flower and so on. Her most useful answer is that it does not have to be taken as *literal*. She calls it 'form transformed beyond its physiological inspiration', and adds, 'When a male artist makes a sculpture with a great thrusting member we don't see a phallus, we see thrust.' She wants to do the same with female imagery. As far as *The Dinner Party* audience is concerned, she has.

This achievement is itself surprising. 'I'm amazed the museum hasn't had fifty letters objecting to the piece as pornographic', says one critic. Chicago has used women's history and women's crafts to soften the impact of images people objected to when they were all alone on her canvases. She put vulvas on plates and served them up to a staid museum audience. They didn't even know what they were eating.

Although *The Dinner Party* works as art packaging, the response to it raises some disturbing issues. The women in the new audience are moved by the piece because it 'is so big' and 'took so many years to make'. They admire Chicago because she 'organized all those people' and 'finished something'. This kind of appreciation is a reminder of how low women's expectations of each other are. It is the old story of Dr Johnson praising a woman who could preach, as he would a dog who could walk on his hind legs, not because it was done well but because it was done at all.

Also, in trying to rehabilitate women's traditional crafts, Chicago runs up against the contradiction implicit in all efforts to give social minorities pride in their past. It is difficult to insist that women artists have a glorious tradition at the same time you insist that women artists have been oppressed. How do you celebrate crafts like china painting and needlework if you want to acknowledge that these crafts have not given women's talents full scope? On the one hand, Chicago is delighted that American women have kept the china-painting tradition alive; on the other, she is horrified that women have 'wasted their talents putting roses on plates'. Chicago the feminist wants to give the china painters their historic due. Chicago the artist is offended by the aesthetic of what they have done.

The same tension exists at the heart of the dinner party idea. By making a table setting into a monumental art object, is Chicago saying, 'This is the culmination of what women have done with their creativity, let us be proud of that'? Or is she saying, 'This is *all* that the male culture has

allowed women to do with their creativity. To hell with you, male culture'? There is an edge of exaggeration to the piece that suggests the latter. Its scale is not just grand, it is grandiose. The plates are slightly too large, the colours slightly too bright. Men feel the irony of the piece. It makes them think Chicago is making fun of something and they're afraid they may be it. By using a woman's tradition as her form, is Chicago trying to have it both ways on this issue? If people find the dinner party motif appropriately celebratory, she can take credit for it. If they say it is a cliché, or demeaning to women, or symbolic of their oppression, she can blame it on the men.

Another question is what *The Dinner Party* says about the future of feminist art. Craftspeople in California are talking about the boost the piece will give the stitchery revival, but Chicago says she's not trying to encourage women artists to take up needlework. She makes a rigid distinction between fine arts and crafts, and places her own career on the fine arts side of the fence. One young artist told me, 'It's wonderful for women who are not artists to learn to re-evaluate their grandmother's embroidery, but where is the lesson for us?' Her reaction clarifies who *The Dinner Party* is for. Despite the originality of its concept, the piece is not a step forward for the women's movement but a backward glance. It sums up the basic feminist lesson that the first step in coming to consciousness is for women to know what other women have done. It is a simple lesson. But then, when has public art ever taught anything else? Besides, the popularity of *The Dinner Party* shows that there are thousands of women in America eager to learn it.

Diana Ketcham, 'On the Table: Joyous Celebration', *Village Voice* (11 June 1979).

Nan GOLDIN
The Ballad of Sexual
Dependency [1979]

The Ballad of Sexual Dependency is the diary I let people read. My written diaries are private; they form a closed document of my world and allow me the distance to analyze it. My visual diary is public; it expands from its subjective basis with the input of other people. These pictures may be an invitation to my world, but they were taken so that I could see the people in them. I sometimes don't know how I feel about someone until I take his or her picture. I don't select people in order to photograph them; I photograph directly from my life. These pictures come out of relationships, not observation.

People in the pictures say my camera is as much a part of being with me as any other aspect of knowing me. It's as if my hand were a camera. If it were possible, I'd want no mechanism between me and the moment of photographing. The camera is as much a part of my everyday life as talking or eating or sex. The instant of photographing, instead of creating distance, is a moment of clarity and emotional connection for me. There is a popular notion that the photographer is by nature a

voyeur, the last one invited to the party. But I'm not crashing; this is my party. This is my family, my history.

My desire is to preserve the sense of people's lives, to endow them with the strength and beauty I see in them. I want the people in my pictures to stare back. I want to show exactly what my world looks like, without glamourization, without glorification. This is not a bleak world but one in which there is an awareness of pain, a quality of introspection.

We all tell stories which are versions of history – memorized, encapsulated, repeatable and safe. Real memory, which these pictures trigger, is an invocation of the colour, smell, sound and physical presence, the density and flavour of life. Memory allows an endless flow of connections. Stories can be rewritten, memory can't. If each picture is a story, then the accumulation of these pictures comes closer to the experience of memory, a story without end.

I want to be able to experience fully, without restraint. People who are obsessed with remembering their experiences usually impose strict self-disciplines. I want to be uncontrolled and controlled at the same time. The diary is my form of control over my life. It allows me to obsessively record every detail. It enables me to remember.

This is the history of a re-created family, without the traditional roles. My favourite book, as a child, was Richard Hughes' *A High Wind in Jamaica*, in which a group of children are separated from their parents and taken away by pirates. The parents are constantly worrying about the children, wondering how much the children are missing them. The children, in fact, hardly think about the parents. They adapt immediately to their new reality and are caught up in the adventure of their own experiences.

In my family of friends, there is a desire for the intimacy of the blood family, but also a desire for something more open-ended. Roles aren't so defined. These are long-term relationships. People leave, people come back, but these separations are without the breach of intimacy. We are bonded not by blood or place, but by a similar morality, the need to live fully and for the moment, a disbelief in the future, a similar respect for honesty, a need to push limits, and a common history. We live life without consideration, but with consideration. There is among us an ability to listen and to empathize that surpasses the normal definition of friendship.

The people and locales in my pictures are particular, specific, but I feel the concerns I'm dealing with are universal. Many people try to deflect this by saying, 'We don't look like the subjects of these pictures; they're not about us.' But the premise can be applied to everyone; it's about the nature of relationships.

I often fear that men and women are irrevocably strangers to each other, irreconcilably unsuited, almost as if they were from different planets. But there is an intense need for coupling in spite of it all. Even if relationships are destructive, people cling together. It's a biochemical reaction, it stimulates that part of your brain that is only satisfied by love, heroin or chocolate; love can be an addiction. I have a strong desire to be independent, but at

the same time a craving for the intensity that comes from interdependency [...]

I was eleven when my sister committed suicide. This was in 1965, when teenage suicide was a taboo subject. I was very close to my sister and aware of some of the forces that led her to choose suicide. I saw the role that her sexuality and its repression played in her destruction. Because of the times, the early 1960s, women who were angry and sexual were frightening, outside the range of acceptable behaviour, beyond control. By the time she was eighteen, she saw that her only way to get out was to lie down on the tracks of the commuter train outside of Washington, DC. It was an act of immense will.

In the week of mourning that followed, I was seduced by an older man. During this period of greatest pain and loss, I was simultaneously awakened to intense sexual excitement. In spite of the guilt I suffered, I was obsessed by my desire.

My awareness of the power of sexuality was defined by these two events. Exploring and understanding the permutations of this power motivates my life and my work.

I realized that in many ways, I was like my sister. I saw history repeating itself. Her psychiatrist predicted that I would end up like her. I lived in fear that I would die at eighteen. I knew it was necessary for me to leave home, so at fourteen I ran away. Leaving enabled me to transform, to recreate myself without losing myself.

When I was eighteen I started to photograph. I became social and started drinking and wanted to remember the details of what happened. For years, I thought I was obsessed with the record-keeping of my day-to-day life. But recently, I've realized my motivation has deeper roots: I don't really remember my sister. In the process of leaving my family, in recreating myself, I lost the real memory of my sister. I remember my version of her, of the things she said, of the things she meant to me. But I don't remember the tangible sense of who she was, her presence, what her eyes looked like, what her voice sounded like.

I don't ever want to be susceptible to anyone else's version of my history.

I don't ever want to lose the real memory of anyone again.'

1 This book is dedicated to the real memory of my sister, Barbara Holly Goldin.

First presented as a performance at the Mudd Club, New York (1979). Nan Goldin, *The Ballad of Sexual Dependency*, ed. Marvin Heiferman, Mark Holborn and Suzanne Fletcher (New York: Aperture Foundation, 1986).

Rozsika PARKER
Feminist art practices in
'About Time' and 'Issue' [1980]

In 1974 no public gallery in London would accept an exhibition of twenty-six women Conceptual artists, 'C.7,500',' selected by Lucy Lippard. In 1980 the ICA housed three major feminist exhibitions ['Women's Images of Men', 'About Time', 'Issue'], a women's film

season, a series of panel discussions and a weekend conference. 'Questions on Women's Art' involving artists from all these shows as well as those from the related venture 'Eight Artists: Women: 1980' at the Acme Gallery.

Why the shift? It cannot be viewed as a token gesture, a way of accommodating feminist demands before the door is closed behind us again. The time span, the broad spectrum of events – too insistent and varied in form and content to be organized in one kind of exhibition – counteracted that danger.

A complex set of factors determined the events at the ICA. At one level they signified the great change of consciousness brought about by the women's liberation movement in the early 1970s. For example, though public critical response to the shows continued to negate and contain feminist art practices, no one outrightly dismissed the shows with the levels of abuse aimed at 'C.7,500' ('It stinks of the ghetto'). But most importantly the shows were the result of diverse strategies by feminist artists. Since 1974 they have continued to campaign for equal access to art world structures, while simultaneously organizing alternative exhibition spaces and producing small magazines. And women working within the system – in art schools, galleries, universities, art centres and regional art associations – have purposefully supported women's endeavours, while independent networks of women artists' groups have developed throughout the country. Panel discussions, feminist conferences and workshops have repeatedly addressed the issue, 'What is feminist art?'

The answer produced by the ICA shows was, 'It doesn't exist'. Instead we were presented with a multiplicity of feminist art practices, deliberately intervening in the main currents and institutions of contemporary art practice – or equally deliberately raising questions about them. The achievement of feminists over the last decade has been not only to break the silence on women's specific experience, but to question the basic assumptions about art and the artist that have worked to establish the dominance of white, male, middle-class art […]

The reception of the exhibition ['Women's Images of Men'] indicates why some feminists consider that introducing a novel content is in itself insufficient. For example, somewhat bitter experiences have shown feminists that so-called 'positive images of women', though an important means of consciousness-raising among women, have not been able to challenge radically the narrow meanings and connotations of 'woman' in art. Because meanings depend on how the art is seen, from what ideological position it is received, the most decisively feminist image of a woman can be recuperated as body, as nature, as object for male possession. Therefore some feminist artists turned to radical art practices other than the traditional fine arts of painting, sculpture and photography. Some are exploring performance art and video to investigate novel ways of presenting women's experience. They are not attempting the impossible – the creation of a new language untouched by existing expectations – but rather to show how representations of women are reproduced in our culture. 'To unlock the power of imagery, to decode its mystery, to make the

impossibly evocative also a moment of dissection and comprehension'. That is the aim of feminist performance art, wrote Sally Potter in the catalogue for 'About Time: Video, Performance and Installation by 21 women artists'.

The selectors requested work which 'indicated the artist's awareness of a woman's particular experience within patriarchy'. So this too was a theme show, but less tightly defined, and interesting because of its stress on particular media. New media is not essential for feminist art practice but it does offer possibilities for working directly with the artist-audience relationship, and exposing multiple, complex, overlapping meanings within the same piece – useful for feminists determined to challenge the certainties of our society.

Most work went beyond presenting women's experience within patriarchy to show how that experience is constructed: through the mass media, the family, education, advertising, consumerism, fashion, domestic labour and styles of art. Within installations, mixed media was juxtaposed to powerful effect. The artist's intention or personal experience was conveyed on tape, in a text or in person and juxtaposed to photographs, slides, objects, drawings, or video which interacted with her words, sometimes revealing the power of media to transform meanings, or indicating contradictions and conflicts between a woman's subjective experience and the cultural expectations and definitions within which she works.

It is dangerous, though, to generalize about the diverse work contained in 'About Time' and even more dubious to attempt to sum up the different approaches contained within the performances. Feminist performance today is, I think, determined by two developments within the recent history of feminism. Firstly, a growing understanding of the role of audiences in producing meanings makes performance art appealing in that it can allow an artist to engage directly with her audience: secondly, feminists have always placed importance on collective work. Initially feminist performances invariably involved several performance artists – a device for questioning the notion of artist as isolated, purely self-expressive, exceptional being. Today, however, the emphasis is more on collaboration between individual artists and audience, not in the sense of direct audience participation, but in that audiences are rarely allowed to simply 'appreciate' the work. Offered elliptical fragments of sounds and images, we had to draw out connections and form meanings, within a framework nevertheless carefully determined by the artist, calculated to raise issues about women in a patriarchal society.

One of the problems facing feminist performance artists is the tradition of female performers as spectacle for an audience. How, asked Sally Potter in the catalogue, can women avoid appearing simply as an object on display positioned always in relation to male desire: 'Women performance artists who use their own bodies as the instrument of their work, constantly hover on the knife edge of the possibility of joining the spectacle of women'. A variety of methods were employed to focus the audiences' attention from the artist as object to the subject of her work. The artist herself was distanced through video, lighting and recorded voice. She rarely, if ever,

engaged directly with the audience, she worked with her back to the audience, sometimes altogether 'off stage', leaving the audience with a curious assemblage of objects – the traces of her presence.

The drawback to all performance art – the number of people who can manage to see the work – is particularly acute for women who are fighting institutional discrimination. Installations relating to the performances were on show in the gallery, but the problem was exacerbated by the brevity of the exhibition. It lasted only ten days and there was a different performance every evening […]

The next show 'Issue', unlike the others which were selected by participants, was put together by the American critic Lucy Lippard. She has played an important and useful role in Britain. She was responsible for 'C.7,500' mentioned above, she introduced the catalogue for the 1978 Hayward Annual selected by women, and now she has brought 'Issue' over here. The exhibition was conceived of from an overtly political perspective and it demonstrates 'the contributions of feminist art to the full panorama of social-change art'.

All three shows were placed in the gallery – not, as some have suggested, to gain acceptance from the establishment, but to change it. 'Women's Images of Men' with the publicity it received outside the usual reviewing channels brought a wider public to the gallery. Artists in 'About Time' claimed that their working methods criticized conventional use of a gallery as a 'clean white space', while 'Issue' brought evidence of art-making in very different contexts straight to the heart of the system.

All of the artists in 'Issue' challenged the idea that art is very simply a visual experience. They raised questions about how art can be used to produce knowledge of structures of power. The practices and media they employed were those most appropriate to each artist's objectives and her intended audience. There was no pure painting, sculpture or photography.

Lucy Lippard described the feminist art practices in 'Issue' as 'moving out' into the world, placing so-called women's issues in a broader perspective and/or utilizing mass production techniques to convey its messages about global traumas such as racism, imperialism, nuclear war, starvation and inflation to a broader audience.

She uses the term 'moving out'. In one sense this means going beyond the stage of feminist art practice characterized as 'looking for shared images' in women's art – to consider those issues loosely defined as socialist feminist. But the term can be profoundly misleading if it is taken to mean that feminists are just identifying with other struggles. On the contrary, once feminists realize that as women they are positioned in the world by social and political forces all the institutions of society become subjects for scrutiny. The most powerful works in the show revealed the chain of connections from the artist's personal recognition of oppression to 'global traumas'. The issues examined in 'Issue' were shown not simply to be either the result of capitalism or of patriarchy but of their intersection. After an exhibition like 'Issue', overtly political art which excludes a critique of patriarchy will, I think, appear incomplete.

The work could roughly be divided into two categories. Some artists directly addressed the gallery context. They presented their ideas in such a way that it fulfilled the audience's expectations of visual pleasure – yet challenged complacency with intellectually demanding or emotionally distressing content. Those who cynically characterize such work as 'gallery socialism' would perhaps prefer feminists not to disturb the easy tenor of gallery life. Other artists exhibited records of art practice in other sites. They revealed how they had worked with a chosen audience developing appropriate means of communications from bus cards to postcards, utilizing the mass media in such a way as to avoid their ideas being distorted in the process. They were accused by critics of simply providing documentation. That is exactly what they were doing; showing one public their work with another. How else were we to see it?

The co-existence of the two types of work in one show, and the varied approaches in the other exhibition, underline the point I made initially – there is no feminist art, but a multiplicity of practices, ever developing, and undoubtedly pushed forward by the events at the ICA.

1 'C.7,500' was finally exhibited at The Artists' Meeting
 Place, Earlham Street, London.
'About Time', Institute of Contemporary Arts, London,
included the work of Hannah O'Shea, Catherine Elwes, Rose
Finn-Kelcey, Sonia Knox and Rose Garrard. 'Issue' included
Suzanne Lacy and Leslie Labowitz, Nicole Croiset and Nil
Yalter, FENIX (Su Richardson, Monica Ross, Kate Walker),
Margaret Harrison, Candace Hill-Montgomery, Jenny Holzer,
Alexis Hunter, Maria Karras, Mary Kelly, Margia Kramer,
Loraine Leeson, Beverley Naldus, Adrian Piper, Martha
Rosler, Miriam Sharon, Bonnie Sherk (The Farm), Nancy Spero,
May Stevens, Mierle Laderman Ukeles, Marie Yates.
Rozsika Parker, 'Feminist art practices in "Women's Images
of Men", "About Time" and "Issue"', reprinted in Rozsika
Parker and Griselda Pollock, ed., *Framing Feminism: Art and
the Women's Movement 1970-85* (London and New York:
Routledge, 1986).

Laura MULVEY

Afterthoughts on Visual Pleasure and Narrative Cinema [1981]

So many times over the years since my 'Visual Pleasure and Narrative Cinema' article was published in *Screen*, I have been asked why I only used the *male* third person singular to stand in for the spectator. At the time, I was interested in the relationship between the image of woman on the screen and the 'masculinization' of the spectator position, regardless of the actual sex (or possible deviance) of any real live movie-goer. In-built patterns of pleasure and identification impose masculinity as 'point of view'; a point of view which is also manifest in the general use of the masculine third person. However, the persistent question 'what about the women in the audience?' and my

own love of Hollywood melodrama (equally shelved as an issue in 'Visual Pleasure') combined to convince me that, however ironically it had been intended originally, the male third person closed off avenues of inquiry that should be followed up. Finally, *Duel in the Sun* and its heroine's crisis of sexual identity brought both areas together.

I still stand by my 'Visual Pleasure' argument, but would now like to pursue the other two lines of thought. First (the 'women in the audience' issue), whether the female spectator is carried along, as it were by the scruff of the text, or whether her pleasure can be more deep-rooted and complex. Second (the 'melodrama' issue), how the text and its attendant identifications are affected by a *female* character occupying the centre of the narrative arena. So far as the first issue is concerned, it is always possible that the female spectator may find herself so out of key with the pleasure on offer, with its 'masculinization', that the spell of fascination is broken. On the other hand, she may not. She may find herself secretly, unconsciously almost, enjoying the freedom of action and control over the diegetic world that identification with a hero provides. It is *this* female spectator that I want to consider here. So far as the second issue is concerned, I want to limit the area under consideration in a similar manner. Rather than discussing melodrama in general, I am concentrating on films in which a woman central protagonist is shown to be unable to achieve a stable sexual identity, torn between the deep blue sea of passive femininity and the devil of regressive masculinity.

There is an overlap between the two areas, between the unacknowledged dilemma faced in the auditorium and the dramatic double bind up there on the screen. Generally it is dangerous to elide these two separate worlds. In this case, the emotions of those women accepting 'masculinization' while watching action movies with a male hero are illuminated by the emotions of a heroine of a melodrama whose resistance to a 'correct' feminine position is the critical issue at stake. Her oscillation, her inability to achieve stable sexual identity, is echoed by the woman spectator's masculine 'point of view'. Both create a sense of the difficulty of sexual difference in cinema that is missing in the undifferentiated spectator of 'Visual Pleasure'.

Laura Mulvey, 'Afterthoughts on "Visual Pleasure and
Narrative Cinema" inspired by King Vidor's *Duel in the Sun*
(1946)', paper presented at conference 'Cinema and
Psychoanalysis' (Buffalo, New York: Center for Media
Studies, SUNY, 1981); first published in *Framework* (city:
pub., 1981); reprinted in *Visual and Other Pleasures*
(London: Macmillan, 1989).

Rozsika PARKER, Griselda POLLOCK

Critical Stereotypes: The Essential Feminine or How Essential is Femininity [1981]

[...] Even a cursory glance at the substantial literature of art history makes us distrust the objectivity with which the past is represented. Closer reading alerts us to the existence of powerful myths about the artist, and the frequent blindness to economic and social factors in the way art is produced, artists are taught and works of art are received. In the literature of art from the sixteenth century to the present two striking things emerge. The existence of women artists was fully acknowledged until the nineteenth century, but it has only been virtually denied by modern writers. Related to this inconsistent pattern of recognition is the construction and constant reiteration of a fixed categorization – a 'stereotype' – for all that women artists have done [...]

Curiously the works on women artists dwindle away precisely at the moment when women's social emancipation and increasing education should, in theory, have prompted a greater awareness of women's participation in all walks of life. With the twentieth century there has been a virtual silence on the subject of the artistic activities of women in the past, broken only by a few works which repeated the findings of the nineteenth century. A glance at the index of any standard contemporary art history text book gives the fallacious impression that women have always been absent from the cultural scene.

Twentieth-century art historians have sources enough to show that women artists have always existed, yet they ignore them. The silence is absolute in such popular works surveying the history of western art as E.H. Gombrich's *Story of Art* (1961) or H.W. Janson's *History of Art* (1962). Neither mentions women artists at all. The organizers of a 1972 exhibition of the work of women painters, *Old Mistresses: Women Artists of the Past*, revealed the full implications of that silence:
'*The title of this exhibition alludes to the unspoken assumption in our language that art is created by men. The reverential term "Old Master" has no meaningful equiva-lent; when cast in its feminine form, "Old Mistress", the connotation is altogether different, to say the least.*' [...]
Most consistent, however, is the pejorative attribution of a certain notion of femininity to all women artists. James Laver wrote on women artists of the seventeenth century:
'*Some women artists tried to emulate Frans Hals but the vigorous brush strokes of the master were beyond their capability; one has only to look at the works of a painter like Judith Leyster (1609–61) to detect the weakness of the feminine hand.*'[2]
But if the 'weakness of femininity' is so clear in contrast to the 'masculine' vigour of Frans Hals, why were so many works by Judith Leyster attributed to Frans Hals in the past? (Leyster's existence was rediscovered in 1892 when a painting thought to be by Hals was found to have Judith Leyster's signature.)[3]

This 'feminine' stereotype is a 'catch-all' for a wide range of ideas, and it has a long history. As Mary Ellmann showed in her study of phallic criticism and sexual analogy in literary criticism, *Thinking About Women* (1968), the stereotype is a product of a patriarchal culture which constructs male dominance through the significance it attaches to sexual difference. Women and all their

<div style="writing-mode: vertical-rl">8. Hannah O'Shea</div>

activities are characterized as the antithesis of cultural creativity, making the notion of a woman artist a contradiction in terms. A nineteenth-century writer stated it clearly: 'So long as a woman refrains from *unsexing* herself by acquiring genius let her dabble in anything. The woman of genius does not exist but when she does she is a man.'[4]

Often the only way critics can praise a woman artist is to say that 'she paints like a man', as Charles Baudelaire commented on Eugénie Gautier in 1846.

None the less, writers have been forced to confront the fact that women have consistently painted and sculpted, but their use of a feminine stereotype for all that women have done serves to separate women's art from Art (male) and to accommodate the internal contradiction between the reality of women's activities and the myths of male cultural creativity. One example of this is Vasari's chapter on Properzia de' Rossi (c.1490–1530), who started as a carver of curios but turned professional sculptor, producing bas-relief carvings such as *Joseph and Potiphar's Wife* (c. 1520). Vasari tells us, in this order, that she was accomplished in household management, beautiful in body, a better singer than any woman in her city and, finally, a skilled carver. All he could see in her work was subtlety, smoothness and a delicate manner. *Joseph and Potiphar's Wife* is praised for being 'A lovely picture, sculptured with womanly grace and more than admirable.' His readers are reassured that Properzia de' Rossi conformed to the social expectations and duties of a noblewoman of the era.

Almost a hundred years later Count Bernsdorff reviewed the works of Angelica Kauffman (1741–1807), a founder member of the Royal Academy, praising her for propriety and conformity to social norms:
'*Her figures have the quiet dignity of Greek models ... Her women are most womanly and modest. She conveys with much art the proper relations between the sexes; the dependence of the weaker on the stronger which so much appeals to her male critics.*'
The heyday of this special characterization of women's art as biologically determined or as an extension of their domestic and refining role in society, quintessentially feminine, graceful, delicate and decorative, is without doubt the nineteenth century. Bourgeois ideology attributed an important but ancillary role to women.[5] They were the defenders of civilization, guardians of the home and social order. John Ruskin's book *Sesame and Lilies* (1867) is a clear statement of Victorian ideals and the rigid division of roles for men and women; men work in the outside world and women adorn the home, where they protect traditional, moral and spiritual values in a new industrial society. As his title of the section on women's roles, 'Of Queen's Gardens', implies, women are to fulfil themselves in a kind of aristocratic, untainted Garden of Eden, and he finally declares:
'*Now their separate characters are these. The man's power is active, progressive and defensive. He is eminently the doer, the creator, the discoverer. His intellect is for invention and speculation, but the woman's intellect is not for invention or creation but sweet ordering, arrangement and decision. Her great function is praise*'[6] [...]

But the most important feature of Victorian writing on women was that it attributed natural explanations to what were in fact the result of ideological attitudes. It prescribed social roles and social behaviour while pretending to describe natural characteristics. Thus John Jackson Jarves analysed the same group of sculptors in the following terms:
'*Few women as yet are predisposed to intellectual pursuits which demand wearisome years of preparation and deferred hopes. Naturally they turn to those fields of art which seem to yield the quickest returns for the least expenditure of mental capital. Having in general a nice feeling for form, quick perceptions and a mobile fancy with not infrequently a lively imagination it is not strange that modelling in clay is tempting to their fair fingers ... Women by nature are likewise prompted in the treatment of sculpture to motives of fancy and sentiment rather than realistic portraiture or absolute creative imagination.*'[7]
Such language endlessly reinforces the notion of the 'fair' femininity of women's art and its supposed source in their gender, although we can locate the reasons for women's concentration on certain subjects and their more limited achievements in the sphere of nude sculpture or public commissions of heroic portraits, in the social structure of education, training, public policy and Victorian propriety.

At least one Victorian writer, Elizabeth Eliet, fully recognized that social, not biological factors account for women's choice of art forms:
'*The kind of painting in which the object is prominent has been most practised by female artists. Portraits, landscapes and flowers, and pictures of animals are in favour among them. Historical or allegorical subjects they have comparatively neglected; and perhaps, a significant reason for this has been that they could not demand the years of study necessary for the attainment of eminence in these. More have been engaged in engraving on copper than in any other branch of art, and many have been miniature painters.*

'*Such occupation might be pursued in the strict seclusion of the home to which custom and public sentiment consigned the fair student. Nor were they inharmonious with the ties of friendship and love, to which her tender nature clung. In most instances women have been led to the cultivation of art through the choice of parents or brothers. While nothing has been more common than to see young men embrace the profession against the wishes of their families and in the face of difficulties, the example of a woman thus deciding for herself is extremely rare.*'[8]
Victorian writers found a way of recognizing women's art compatible with their bourgeois patriarchal ideology. They contained women's activities, imposing their own limiting definitions and notions of a separate sphere. Yet it was actually these rigid prescriptions which insidiously prepared the ground for twentieth-century dismissal and devaluation of all women artists. It was the Victorians' insistence on essentially different spheres for men and women that precipitated women artists into historical oblivion once Victorian chivalrous sentimentality gave way to a more disguised but potent sexism.

The contradictory character of Victorian attitudes to women's art can best be illustrated by two quotations. The positive value they attributed to women as refined spirits is expressed in an article in the *Art Journal* of 1874, a review of an exhibition of the Society of Lady Painters[9] founded in 1857:
'*Nevertheless the refinement which characterizes the painting of Lady Artists cannot be passed over without remark. We cannot say that English art does not stand in need of its influence and there is good reason to believe that Englishmen might take a lesson from Englishwomen in this ... There is scarcely a trace of vulgarity and we may even go so far as to say that the pictures here collected suggest a more cultured spirit than can be claimed for the average art product.*'
This piece of criticism, coloured by Victorian attitudes, nonetheless attributes some significance to the specificity of women's art. His comments are addressed to the state of English painting in 1874. However, a more extended essay on the place of women in art by a French critic, Léon Legrange, declaims universal absolutes, in themselves conditioned by nineteenth-century ideology, which concern both the quality of women's art and the specialization, flower painting for example, or graphic art, within which women artists were confined by the social structure:
'*Male genius has nothing to fear from female taste. Let men of genius conceive of great architectural projects, monumental sculpture and elevated forms of painting. In a word, let men busy themselves with all that has to do with great art. Let women occupy themselves with those types of art they have always preferred, such as pastels, portraits or miniatures. Or the painting of flowers, those prodigies of grace and freshness which alone can compete with the grace and freshness of women themselves. To women above all falls the practice of the graphic art, those painstaking arts which correspond so well to the role of abnegation and devotion which the honest woman happily fills here on earth, and which is her religion.*'[10]
In a few brief lines Legrange illustrates all the destructive stereotyping we have discussed. Men are the true artists, they have genius; women have only taste. Men are busy with serious works of the imagination on a grand scale but women are occupied in minor, delicate, personal pastimes. The flower analogy places both women and their work in the sphere of nature. Woman's socially appointed 'duty' becomes divinely ordained and her historical restriction to certain practices an inevitable result of Nature and God.

The legacy of the Victorians' views on women and art has been the collapse of history into nature and sociology into biology. They prepared the way for current beliefs about women's innate lack of talent and 'natural' predisposition for 'feminine' subjects. On the other hand, some late Victorian 'compilers of short memoirs' on women artists, for instance, Elizabeth Eliet, showed more historical sense. Clayton (1876), Clement (1904) and Sparrow (1905) record the consistent presence of women in the fine arts, recognizing difficulties they had as women to negotiate in the form of both institutional and social factors. Such texts enable us to see that women in art *do* have a history, but a different one from the accepted norm,

because of their particular relation to official structures and male-dominated modes of art production. For women artists have not acted outside cultural history, as many commentators seem to believe, but rather have been compelled to act within it from a place other than that occupied by men [...]

1 A. Gabhart and E. Broun, *Walters Art Gallery Bulletin*, 24:7 (1972).

2 James Laver, 'Women Painters', *Saturday Book* (1964) 19.

3 For a full discussion of Leyster and the attribution of her work see Juliane Harms, 'Judith Leyster, 1hr Leben und 1hr Werk', *Oud Holland*, XLIV (1927); and T. Ness, 'Great Women Artists', *Art and Sexual Politics* (1973) 4-48.

4 Cited in Octave Uzanne, *The Modern Parisienne*, 1912 (our italics).

5 L. Davidoff, *The Best Circles* (1973).

6 *Works of John Ruskin*, Library Edition, XVIII (1905) 122.

7 John Jackson Jarves, 'Progress of American Sculpture in Europe', *Art Journal*, X (1871) 7.

8 Elizabeth Eliet, *Women Artists in All Ages and Countries* (1859) 3.

9 The Society of Lady Painters was first known as the Society of Female Artists, but later it acquired its more genteel title. It represents another aspect of the notion of separate spheres resulting from the structure of Victorian society. Since women were excluded from the most important institutions of art education, they founded their own schools and institutions, thus perpetuating one of the main forces in their exclusion from an accepted place in the official history of art. The history of women's institutions is a further example of the structural factors in the neglect of women artists.

10 Léon Legrange, 'Du rang des femmes dans l'art', *Gazette des Beaux-Arts* (1860).

Rozsika Parker and Griselda Pollock, 'Critical Stereotypes: The Essential Feminine or How Essential Is Femininity', *Old Mistresses: Women, Art and Ideology* (New York: Pantheon Books, 1981) 1-14.

Faith RINGGOLD
The Wild Art Show [1982]

[...] What would it be like to curate a show in which other artists could express their rage [...]

Wild art is a personal revelation of your most personal concerns ... You may have never told anyone about it. Or you may have told everyone, and they are all bored to death of the subject. Own up to it, and you will have a perfect proposal for wild art.

Wild art is hot, not cool. It is exceptional, not conceptional. Though data, interesting and contrived programmes, systems, media and materials are a part of wild art they are not the subject – You are. Wild art is private ... It is our secret selves we are communicating in wild art ... what we are ... when we are alone, unhampered by cultural taboos and other devices that reduce our feelings to terms others can ignore.

Wild art is a secret ... so please do not blast it to a room full of people. Cover your piece at its most revealing point. Make the covering (box, drape, sliding door) a work of art, so that the viewer is drawn to it. Put an explanation on your cover, and directions for viewing, or at least a provocative statement.

Be neat with your wildness ... Please create all parts of your piece in sturdy construction ready for installation.

Wild art should overwhelm us with its form, content and feeling, not its size. No piece should be larger than a human form – a child's.

Do not make easily pocketed items ... if you ... make books or other collectibles ... think of a way to secure them.

Wild art can take any form ... mixed media, multimedia, drawing, painting, sculpture, prints, anything visual [...]

However much we speculate, 'The Wild Art Show' speaks for itself in the women's own statements. They are about power, guilt, family, femininity, vanity, secrets, old age, life, death, artistic and sexual freedom, make-up, fashion, youth, style, winning grants, favours, stardom, being kept, fear of surgery, contempt, envy, fear of exposure, fear of freedom, fear of success, freedom, oppression, repression, identity, abuse, rape, rejection, fear of exclusion, violence, fantasies, inspiration, dreams, illusions, spirituality, peace, eroticism, sex, beauty, incest, lovers, husbands, cultural oppression, political beliefs, children, love, romance, fertility, impotence, orgasm, religion, menstrual blood, anger, hate, Aunt Jemima and Barbie dolls, vaginas, penises, men, women, shoplifting, lesbianism and finally some things that are, in one artist's own words – 'too personal' [...]

Faith Ringgold, 'The Wild Art Show', *Woman's Art Journal*, 3: 1 (Spring-Summer 1982) 18-19.

Barbara KRUGER
Incorrect [1982]

Photography has saturated us as spectators from its inception amidst a mingling of laboratorial pursuits and magic acts to its current status as propagator of convention, cultural commodity, and global hobby. Images are made palpable, ironed flat by technology and, in turn, dictate the seemingly real through the representative. And it is this representative, through its appearance and cultural circulation, that detonates issues and raises questions. Is it possible to construct a way of looking which welcomes the presence of pleasure and escapes the deceptions of desire? How do we, as women and as artists, navigate through the marketplace that constructs and contains us? I see my work as a series of attempts to ruin certain representations and to welcome a female spectator into the audience of men. If this work is considered 'incorrect', all the better, for my attempts aim to undermine that singular pontificating male voiceover which 'correctly' instructs our pleasures and histories or lack of them. I am wary of the seriousness and confidence of knowledge. I am concerned with who speaks and who is silent: with what is seen and what is not. I think about inclusions and multiplicities, not oppositions, binary indictments, and warfare. I'm not concerned with pitting morality against immorality, as 'morality' can be seen as a compendium of allowances inscribed within patriarchy, within its repertoire of postures and legalities. But then, of course, there's really no 'within' patriarchy because there's certainly no 'without' patriarchy. I am interested in works that address these material conditions of our lives: that recognize the uses and abuses of power on both an intimate and global level. I want to speak, show, see, and hear outrageously astute questions and comments. I want to be on the sides of pleasure and laughter and to disrupt the dour certainties of pictures, property, and power.

Barbara Kruger, 'Incorrect' (1982), *Remote Control: Power, Cultures and the World of Appearances* (Cambridge, Massachusetts: MIT Press, 1993).

Julia KRISTEVA
Stabat Mater [1983]

THE PARADOX: MOTHER OR PRIMARY NARCISSISM

If it is not possible to say of a *woman* what she *is* (without running the risk of abolishing her difference), would it perhaps be different concerning the *mother*, since that is the only function of the 'other sex' to which we can definitely attribute existence? And yet, there too, we are caught in a paradox. First, we live in a civilization where the *consecrated* (religious or secular) representation of femininity is absorbed by motherhood. If, however, one looks at it more closely, this motherhood is the *fantasy* that is nurtured by the adult, man or woman, of a lost territory; what is more, it involves less an idealized archaic mother than the idealization of the *relationship* that binds us to her, one that cannot be localized – an idealization of primary narcissism. Now, when feminism demands a new representation of femininity, it seems to identify motherhood with that idealized misconception and, because it rejects the image and its misuse, feminism circumvents the real experience that fantasy overshadows. The result? – a negation or rejection of motherhood by some avant-garde feminist groups. Or else an acceptance – conscious or not – of its traditional representations by the great mass of people, women and men.

Christianity is doubtless the most refined symbolic construct in which femininity, to the extent that it transpires through it – and it does so incessantly – is focused on *Maternality*.' Let us call 'maternal' the ambivalent principle that is bound to the species, on the one hand, and on the other stems from an identity catastrophe that causes the Name to topple over into the unnameable that one imagines as femininity, nonlanguage or body. Thus Christ, the Son of man, when all is said and done, is 'human' only through his mother – as if Christly or Christian humanism could only be a

IS IT POSSIBLE TO CONSTRUCT A WAY OF LOOKING
WHICH WELCOMES THE PRESENCE OF
PLEASURE
AND ESCAPES THE DECEPTIONS OF
DESIRE?

Barbara Kruger, 'Incorrect', *Remote Control: Power, Cultures and the World of Appearances*, 1993

maternalism (this is, besides, what some secularizing trends within its orbit do not cease claiming in their esotericism). And yet, the humanity of the Virgin mother is not always obvious, and we shall see how, in her being cleared of sin, for instance, Mary distinguishes herself from mankind. But at the same time the most intense revelation of God, which occurs in mysticism, is given only to a person who assumes himself as 'maternal'. Augustine, Bernard of Clairvaux, Meister Eckhart, to mention but a few, played the part of the Father's virgin spouses, or even, like Bernard, received drops of virginal milk directly on their lips. Freedom with respect to the maternal territory then becomes the pedestal upon which love of God is erected. As a consequence, mystics, those 'happy Schrebers' (Sollers) throw a bizarre light on the psychotic sore of modernity: it appears as the incapability of contemporary codes to tame the maternal, that is, primary narcissism. Uncommon and 'literary', their present-day counterparts are always somewhat oriental, if not tragical – Henry Miller, who says he is pregnant; Artaud, who sees himself as 'his daughters' or 'his mother' ... It is the orthodox constituent of Christianity, through John Chrysostom's golden mouth, among others, that sanctioned the transitional function of the Maternal by calling the Virgin a 'bond', a 'medium' or an 'interval', thus opening the door to more or less heretical identifications with the Holy Ghost.

This reabsorption of femininity within the Maternal is specific to many civilizations, but Christianity, in its own fashion, brings it to its peak. Could it be that such a reduction represents no more than a masculine appropriation of the Maternal, which, in line with our hypothesis, is only a fantasy masking primary narcissism? Or else, might one detect in it, in other respects, the workings of enigmatic sublimation? These are perhaps the workings of masculine sublimation, a sublimation just the same, if it be true that for Freud picturing Da Vinci, and even for Da Vinci himself, the taming of that economy (of the Maternal or of primary narcissism) is a requirement for artistic, literary or painterly accomplishment?

Within that perspective, however, there are two questions, among others, that remain unanswered. What is there, in the portrayal of the Maternal in general and particularly in its Christian, virginal, one, that reduces social anguish and gratifies a male being; what is there that also satisfies a woman so that a commonality of the sexes is set up, beyond and in spite of their glaring incompatibility and permanent warfare? Moreover, is there something in that Maternal notion that ignores what a woman might say or want – as a result, when women speak out today it is in matters of conception and mother-hood that their annoyance is basically centred. Beyond social and political demands, this takes the well-known 'discontents' of our civilization to a level where Freud would not follow – the discontents of the species [...]

1 Between the lines of this section one should be able to detect the presence of Marina Warner, *Alone of All Her Sex: The Myth and Cult of the Virgin Mary* (New York: Knopf, 1976); and Ilse Barande, *Le Maternel singulier* (Paris: Aubier-Montaigne, 1977), which underlay my reflections.

Julia Kristeva, 'Stabat Mater', *Histoires d'amour* (Paris: Éditions Donoël, 1983), published in English in *Tales of Love*, trans. Leon S. Roudiez (New York: Columbia University Press, 1987) 234-36.

Jo Anna ISAAK
The Revolutionary Power of Women's Laughter[1] [1983]

[...] It is the potential of this *jouissance*, th[e] play of the signifiers themselves that the exhibition 'The Revolutionary Power of Women's Laughter' intends to explore. It is not then a study in the comic, nor of laughter as invective, but an investigation into the function of language and the discourse that attempts to account for it – the logic of those systems and relations that create an identity for a sentence, a sign, an individual. The analysis of how meaning is produced and organized undermines the structures of domination in this form of society (call it the paternal, the phallic, the symbolic), and shatters its belief in a transparent text, an 'innocent' uncoded experience of a 'real' world, in the notion that language or any other form of symbolic production simply expresses 'things as they are'. The aim is both to dismantle the presumption of the 'innocence' of the signifying system and to explore the only signifying strategy which allows the speaking subject to shift the limits of its enclosure – through play, *jouissance*, laughter. 'A code cannot be destroyed, only played off' (Barthes).

The exhibition constitutes a reading of the text which is no longer consumption, but play. The works do not postu-late a new set of meanings or values, rather they function as visual or verbal puns, eruptions in the production of meaning and what is the same thing, the idea of value. The exhibition also points to the more radical potential of this play, suggested, although not developed, in Saussure's theories, since the signifier can have an active function in creating and determining the signified [...]

1 'The Revolutionary Power of Women's Laughter' was an exhibition curated by Isaak which opened in New York, touring the US and Canada for two years. The exhibition, by changing 'the focus from women artists' marginalization to the underlying meaning of images themselves and the ways in which that meaning can be reconstituted provided a very different vantage point for feminists; it eliminated much of the "male-hating" stereotype previously used to denigrate feminists and substituted a broader and more sophisticated theoretical approach that reverberated in the prevalent cultural and political discourse of postmodernism.' Marcia Tucker, 'Women Artists Today: Revolution or Regression?' *Making Their Mark: Women Artists Move into the Mainstream, 1970-85*, ed. Randy Rosen and Catherine C. Brawer (New York: Abbeville Press, 1986) 199.
Jo Anna Isaak, 'The Revolutionary Power of Women's Laughter' (New York: Protetch McNeil Gallery, 1983); a revised version of this essay is reprinted in Jo Anna Isaak, *Feminism and Contemporary Art: The Revolutionary Power of Women's Laughter* (London and New York: Routledge, 1996).

Craig OWENS
The Discourse of Others: Feminists and Postmodernism [1983]

[...] Several years ago I began the second of two essays devoted to an allegorical impulse in contemporary art – an impulse that I identified as Postmodernist – with a discussion of Laurie Anderson's multi-media performance *Americans on the Move*.' Addressed to transportation as a metaphor for communication – the transfer of meaning from one place to another – *Americans on the Move* proceeded primarily as verbal commentary on visual images projected on a screen behind the performers. Near the beginning Anderson introduced the schematic image of a nude man and woman, the former's right arm raised in greeting, that had been emblazoned on the Pioneer spacecraft. Here is what she had to say about this picture; significantly, it was spoken by a distinctly male voice (Anderson's own processed through a harmonizer, which dropped it an octave – a kind of electronic vocal transvestisism):

'*In our country, we send pictures of our sign language into outer space. They are speaking our sign language in these pictures. Do you think they will think his hand is permanently attached that way? Or do you think they will read our signs? In our country, goodbye looks just like hello.*'

Here is my commentary on the passage:
'*Two alternatives: either the extraterrestrial recipient of this message will assume that it is simply a picture, that is, an analogical likeness of the human figure, in which case he might logically conclude that male inhabitants of Earth walk around with their right arms permanently raised. Or he will somehow divine that this gesture is addressed to him and attempt to read it, in which case he will be stymied, since a single gesture signifies both greeting and farewell, and any reading of it must oscillate between these two extremes. The same gesture could also mean "Halt!" or represent the taking of an oath, but if Anderson's text does not consider these two alternatives that is because it is not concerned with ambiguity, with multiple meanings engendered by a single sign; rather, two clearly defined but mutually incompatible readings are engaged in blind confrontation in such a way that it is impossible to choose between them.*'

This analysis strikes me as a case of gross critical negligence. For in my eagerness to rewrite Anderson's text in terms of the debate over determinate versus indeterminate meaning, I had overlooked something – something that is so obvious, so 'natural' that it may at the time have seemed unworthy of comment. It does not seem that way to me today. For this is, of course, an image of sexual difference or, rather, of sexual differentiation according to the distribution of the phallus – as it is marked and then re-marked by the man's right arm, which appears less to have been raised than erected in greeting. I

was, however, close to the 'truth' of the image when I suggested that men on Earth might walk around with something permanently raised – close, perhaps, but no cigar. (Would my reading have been different – or less indifferent – had I known then that, earlier in her career, Anderson had executed a work which consisted of photographs of men who had accosted her in the street?)[2] Like all representations of sexual difference that our culture produces, this is an image not simply of anatomical difference, but of the values assigned to it. Here, the phallus is a signifier (that is, it represents the subject for another signifier); it is, in fact, the privileged signifier, the signifier of privilege, of the power and prestige that accrue to the male in our society. As such, it designates the effects of signification in general. For in this (Lacanian) image, chosen to represent the inhabitants of Earth for the extraterrestrial Other, it is the man who speaks, who represents mankind. The woman is only represented; she is (as always) already spoken for.

If I return to this passage here, it is not simply to correct my own remarkable oversight, but more importantly to indicate a blind spot in our discussions of Postmodernism in general; our failure to address the issue of sexual difference – not only in the objects we discuss, but in our own enunciation as well.[3] However restricted its field of inquiry may be, every discourse on Postmodernism – at least in so far as it seeks to account for certain recent mutations within that field – aspires to the status of a general theory of contemporary culture. Among the most significant developments of the past decade – it may well turn out to have been the most significant – has been the emergence, in nearly every area of cultural activity, of a specifically feminist practice [...]

Still, if one of the most salient aspects of our postmodern culture is the presence of an insistent feminist voice (and I use the terms presence and voice advisedly), theories of Postmodernism have tended either to neglect or to repress that voice. The absence of discussions of sexual difference in writings about Postmodernism, as well as the fact that few women have engaged in the Modernism/Postmodernism debate, suggest that Postmodernism may be another masculine invention engineered to exclude women. I would like to propose, however, that women's insistence on difference and incommensurability may not only be compatible with, but also an instance of postmodern thought. Postmodern thought is no longer binary thought (as Lyotard observes when he writes, 'Thinking by means of oppositions does not correspond to the liveliest modes of postmodern knowledge [le savoir postmoderne]').[4] The critique of binarism is sometimes dismissed as intellectual fashion; it is, however, an intellectual imperative, since the hierarchical opposition of marked and unmarked terms (the decisive/divisive presence/absence of the phallus) is the dominant form both of representing difference and justifying its subordination in our society. What we must learn, then, is how to conceive difference without opposition [...]

Because of the tremendous effort of reconceptualization necessary to prevent a phallologic relapse in their own discourse, many feminist artists have,

in fact, forged a new (or renewed) alliance with theory – most profitably, perhaps, with the writing of women influenced by Lacanian psychoanalysis (Luce Irigaray, Hélène Cixous, Montrelay ...). Many of these artists have themselves made major theoretical contributions: filmmaker Laura Mulvey's 1975 essay on 'Visual Pleasure and Narrative Cinema', for example, has generated a great deal of critical discussion on the masculinity of the cinematic gaze.[5] Whether influenced by psychoanalysis or not, feminist artists often regard critical or theoretical writing as an important arena of strategic intervention: Martha Rosler's critical texts on the documentary tradition in photography – among the best in the field – are a crucial part of her activity as an artist. Many Modernist artists, of course, produced texts about their own production, but writing was almost always considered supplementary to their primary work as painters, sculptors, photographers, etc.,[6] whereas the kind of simultaneous activity on multiple fronts that characterizes many feminist practices is a Postmodern phenomenon. And one of the things it challenges is Modernism's rigid opposition of artistic practice and theory.

At the same time, Postmodern feminist practice may question theory – and not only aesthetic theory. Consider Mary Kelly's Post-Partum Document (1973–79), a six-part, 165-piece artwork (plus footnotes) that utilizes multiple representational modes (literary, scientific, psychoanalytic, linguistic, archeological and so forth) to chronicle the first six years of her son's life. Part archive, part exhibition, part case history, the Post-Partum Document is also a contribution to as well as a critique of Lacanian theory. Beginning as it does with a series of diagrams taken from Ecrits which Kelly presents as pictures, the work might be (mis)read as a straightforward application or illustration of psychoanalysis. It is, rather, a mother's interrogation of Lacan, an interrogation that ultimately reveals a remarkable oversight within the Lacanian narrative of the child's relation to the mother – the construction of the mother's fantasies vis-à-vis the child. Thus, the Post-Partum Document has proven to be a controversial work, for it appears to offer evidence of female fetishism (the various substitutes the mother invests in order to disavow separation from the child); Kelly thereby exposes a lack within the theory of fetishism, a perversion heretofore reserved for the male. Kelly's work is not anti-theory; rather, as her use of multiple representational systems testifies, it demonstrates that no one narrative can possibly account for all aspects of human experience. Or as the artist herself has said, 'There's no single theoretical discourse which is going to offer an explanation for all forms of social relations or for every mode of political practice'.[7]

Symptoms of our recent loss of mastery are everywhere apparent in cultural activity today – nowhere more so than in the visual arts. The modernist project of joining forces with science and technology for the transformation of the environment after rational principles of function and utility (Productivism, the Bauhaus) has long since been abandoned; what we witness in its place is a desperate, often hysterical attempt to recover some sense of mastery via the resurrection of heroic large-scale

easel painting and monumental cast-bronze sculpture – mediums themselves identified with the cultural hegemony of Western Europe. Yet contemporary artists are able at best to simulate mastery, to manipulate its signs; since in the modern period mastery was invariably associated with human labour, aesthetic production has degenerated today into a massive deployment of the signs of artistic labour – violent, 'impassioned' brushwork, for example. Such simulacra of mastery testify, however, only to its loss; in fact, contemporary artists seem engaged in a collective act of disavowal – and disavowal always pertains to a loss ... of virility, masculinity, potency.[8]

This contingent of artists is accompanied by another which refuses the simulation of mastery in favour of melancholic contemplation of its loss. One such artist speaks of 'the impossibility of passion in a culture that has institutionalized self-expression'; another of 'the aesthetic as something which is really about longing and loss rather than completion'. A painter unearths the discarded genre of landscape painting only to borrow for his own canvases, through an implicit equation between their ravaged surfaces and the barren fields he depicts, something of the exhaustion of the earth itself (which is thereby glamourized); another dramatizes his anxieties through the most conventional figure men have conceived for the threat of castration – Woman ... aloof, remote, unapproachable. Whether they disavow or advertise their own powerlessness, pose as heroes or as victims, these artists have, needless to say, been warmly received by a society unwilling to admit that it has been driven from its position of centrality; theirs is an 'official' art which, like the culture that produced it, has yet to come to terms with its own impoverishment.

Postmodernist artists speak of impoverishment – but in a very different way. Sometimes the Postmodernist work testifies to a deliberate refusal of mastery, for example, Martha Rosler's The Bowery in Two Inadequate Descriptive Systems (1974–75), in which photographs of Bowery storefronts alternate with clusters of typewritten words signifying inebriety. Although her photographs are intentionally flat-footed, Rosler's refusal of mastery in this work is more than technical. On the one hand, she denies the caption/text its conventional function of supplying the image with something it lacks; instead, her juxtaposition of two representational systems, visual and verbal, is calculated (as the title suggests) to 'undermine' rather than 'underline' the truth of each.[9] More importantly, Rosler has refused to photograph the inhabitants of Skid Row, to speak on their behalf, to illuminate them from a safe distance (photography as social work in the tradition of Jacob Riis). For 'concerned' or what Rosler calls 'victim' photography overlooks the constitutive role of its own activity, which is held to be merely representative (the 'myth' of photographic transparency and objectivity). Despite his or her benevolence in representing those who have been denied access to the means of representation, the photographer inevitably functions as an agent of the system of power that silenced these people in the first place. Thus, they are twice victimized: first by society, and then by the photographer who presumes the right to speak on their behalf. In fact, in such photography it is the

photographer rather than the 'subject' who poses – as the subject's consciousness, indeed, as conscience itself. Although Rosler may not, in this work, have initiated a counter-discourse of drunkenness – which would consist of the drunks' own theories about their conditions of existence – she has nevertheless pointed negatively to the crucial issue of a politically motivated art practice today: 'the indignity of speaking for others'.[10]

Rosler's position poses a challenge to criticism as well, specifically, to the critic's substitution of his own discourse for the work of art. At this point in my text, then, my own voice must yield to the artist's; in the essay 'in, around and afterthoughts (on documentary photography)' which accompanies *The Bowery … * Rosler writes:

'*If impoverishment is a subject here, it is more certainly the impoverishment of representational strategies tottering about alone than that of a mode of surviving. The photographs are powerless to deal with the reality that is yet totally comprehended-in-advance by ideology, and they are as diversionary as the word formations – which at least are closer to being located within the culture of drunkenness rather than being framed on it from without.*'[11]

THE VISIBLE AND THE INVISIBLE

A work like *The Bowery in Two Inadequate Descriptive Systems* not only exposes the 'myths' of photographic objectivity and transparency; it also upsets the (modern) belief in vision as a privileged means of access to certainty and truth ('Seeing is believing') […]

That the priority our culture grants to vision is a sensory impoverishment is hardly a new perception; the feminist critique, however, links the privileging of vision with sexual privilege. Freud identified the transition from a matriarchal to a patriarchal society with the simultaneous devaluation of an olfactory sexuality and promotion of a more mediated, sublimated visual sexuality.[12] What is more, in the Freudian scenario it is by looking that the child discovers sexual difference, the presence or absence of the phallus according to which the child's sexual identity will be assumed […]

In recent years there has emerged a visual arts practice informed by feminist theory and addressed, more or less explicitly, to the issue of representation and sexuality – both masculine and feminine. Male artists have tended to investigate the social construction of masculinity (Mike Glier, Eric Bogosian, the early work of Richard Prince); women have begun the long-overdue process of deconstructing femininity. Few have produced new, 'positive' images of a revised femininity; to do so would simply supply and thereby prolong the life of the existing representational apparatus. Some refuse to represent women at all, believing that no representation of the female body in our culture can be free from phallic prejudice. Most of these artists, however, work with the existing repertory of cultural imagery – not because they either lack originality or criticize it – but because their subject, feminine sexuality, is always constituted in and as representation, a representation of difference. It must be emphasized that these artists are not primarily interested in what representations say about women; rather, they investigate what representation *does* to women (for example, the way it invariably positions them as objects of the male gaze). For, as Lacan wrote:

'*Images and symbols* for *the woman cannot be isolated from images and symbols* of *the woman … It is representation, the representation of feminine sexuality whether repressed or not, which conditions how it comes into play.*'[13]

Critical discussions of this work have, however, assiduously avoided – skirted – the issue of gender. Because of its generally deconstructive ambition, this practice is sometimes assimilated to the Modernist tradition of demystification. (Thus, the critique of representation in this work is collapsed into ideological critique.) In an essay devoted (again) to allegorical procedures in contemporary art, Benjamin Buchloh discusses the work of six women artists – Dara Birnbaum, Jenny Holzer, Barbara Kruger, Louise Lawler, Sherrie Levine, Martha Rosler – claiming them for the model of 'secondary mythification' elaborated in Roland Barthes's 1957 *Mythologies*. Buchloh does not acknowledge the fact that Barthes later repudiated this methodology – a repudiation that must be seen as part of his increasing refusal of mastery from *The Pleasure of the Text* on.[14] Nor does Buchloh grant any particular significance to the fact that all these artists are women; instead, he provides them with a distinctly male genealogy in the Dada tradition of collage and montage. Thus, all six artists are said to manipulate the languages of popular culture – television, advertising, photography – in such a way that 'their ideological functions and effects become *transparent*'; or again, in their work, 'the minute and seemingly inextricable interaction of behaviour and ideology' supposedly becomes an '*observable* pattern'.[15]

But what does it mean to claim that these artists render the invisible visible, especially in a culture in which visibility is always on the side of the male, invisibility on the side of the female? And what is the critic really saying when he states that these artists reveal, expose, 'unveil' (this last word is used throughout Buchloh's text) hidden ideological agendas in mass-cultural imagery? Consider, for the moment, Buchloh's discussion of the work of Dara Birnbaum, a video artist who re-edits footage taped directly from broadcast television. Of Birnbaum's *Technology/Transformation: Wonder Woman* (1978–79), based on the popular television series of the same name, Buchloh writes that it 'unveils the puberty fantasy of Wonder Woman'. Yet, like all of Birnbaum's work, this tape is dealing not simply with mass-cultural imagery, but with mass-cultural *images of women*. Are not the activities of unveiling, stripping, laying bare in relation to a female body unmistakably male prerogatives?[16] Moreover, the women Birnbaum re-presents are usually athletes and performers absorbed in the display of their own physical perfection. They are without defect, without lack, and therefore with neither history nor desire. (Wonder Woman is the perfect embodiment of the phallic mother.) What we recognize in her work is the Freudian trope of the narcissistic woman, or the Lacanian 'theme' of femininity as contained spectacle, which exists only as a representation of masculine desire.[17]

The deconstructive impulse that animates this work has also suggested affinities with Poststructuralist textual strategies, and much of the critical writing about these artists – including my own – has tended simply to translate their work into French. Certainly, Foucault's discussion of the West's strategies of marginalization and exclusion, Derrida's charges of 'phallocentrism', Deleuze and Guattari's 'body without organs' would all seem to be congenial to a feminist perspective. (As Irigaray has observed, is not the 'body without organs' the historical condition of woman?)[18] Still, the affinities between poststructuralist theories and Postmodernist practice can blind a critic to the fact that, when women are concerned, similar techniques have very different meanings. Thus, when Sherrie Levine appropriates – literally takes – Walker Evans' photographs of the rural poor or, perhaps more pertinently, Edward Weston's photographs of his son Neil posed as a classical Greek torso, is she simply dramatizing the diminished possibilities for creativity in an image-saturated culture, as is often repeated? Or is her refusal of authorship not in fact a refusal of the role of creator as 'father' of his work, of the paternal rights assigned to the author by law?[19] (This reading of Levine's strategies is supported by the fact that the images she appropriates are invariably images of the Other: women, nature, children, the poor, the insane …)[20] Levine's disrespect for paternal authority suggests that her activity is less one of appropriation – a laying hold and grasping – and more one of expropriation: she expropriates the appropriators.

Sometimes Levine collaborates with Louise Lawler under the collective title 'A Picture is No Substitute for Anything' – an unequivocal critique of representations as traditionally defined. (E.H. Gombrich: 'All art is image-making, and all image-making is the creation of substitutes.') Does not their collaboration move us to ask what the picture is supposedly a substitute for, what it replaces, what absence it conceals? And when Lawler shows 'A Movie Without the Picture', as she did in 1979 in Los Angeles and again in 1983 in New York, is she simply soliciting the spectator as a collaborator in the production of the image? Or is she not also denying the viewer the kind of visual pleasure which cinema customarily provides – a pleasure that has been linked with the masculine perversions voyeurism and scopophilia?[21] It seems fitting, then, that in Los Angeles she screened (or didn't screen) *The Misfits* – Marilyn Monroe's last completed film. So that what Lawler withdrew was not simply a picture, but the archetypal image of feminine desirability.

When Cindy Sherman, in her untitled black-and-white studies for film stills (made in the late 1970s and early 1980s), first costumed herself to resemble heroines of grade-B Hollywood films of the late 1950s and 1960s and then photographed herself in situations suggesting some immanent danger lurking just beyond the frame, was she simply attacking the rhetoric of 'auteurism by equating the known artifice of the actress in front of the camera with the supposed authenticity of the director behind it'?[22] Or was her play-acting not also an acting out of the psychoanalytic notion of femininity as masquerade, that is, as a representation of male desire? As Hélène Cixous has written, 'One is always in representation, and when a

woman is asked to take place in this representation, she is, of course, asked to represent man's desire.'[23] Indeed, Sherman's photographs themselves function as mirror-masks that reflect back at the viewer his own desire (and the spectator posited by this work is invariably male) — specifically, the masculine desire to fix the woman in a stable and stabilizing identity. But this is precisely what Sherman's work denies: for while her photographs are not always self-portraits, in them the artist never appears to be the same, indeed, not even the same mode; while we can presume to recognize the same person, we are forced at the same time to recognize a trembling around the edges of that identity.[24] In a subsequent series of works, Sherman abandoned the film-still format for that of the magazine centrefold, opening herself to charges that she was an accomplice in her own objectification, reinforcing the image of the woman bound by the frame.[25] This may be true; but while Sherman may pose as a pin-up, she still cannot be pinned down.

Finally, when Barbara Kruger collages the words, 'Your gaze hits the side of my face' over an image culled from a 1950s photo-annual of a female bust, is she simply 'making an equation ... between aesthetic reflection and the alienation of the gaze: both reify'?[26] Or is she not speaking instead of the *masculinity* of the look, the ways in which it objectifies and masters? Or when the words 'You invest in the divinity of the masterpiece' appear over a blown-up detail of the creation scene from the Sistine ceiling, is she simply parodying our reverence for works of art, or is this not a commentary on artistic production as a contract between fathers and sons? The address of Kruger's work is always gender-specific; her point, however, is not that masculinity and femininity are fixed positions assigned in advance by the representational apparatus. Rather, Kruger uses a term with no fixed content, the linguistic shifter ('I/You'), in order to demonstrate that masculine and feminine themselves are not stable identities, but subject to ex-change.

There is irony in the fact that all these practices, as well as the theoretical work that sustains them, have emerged in a historical situation supposedly characterized by its complete indifference. In the visual arts we have witnessed the gradual dissolution of once fundamental distinctions — original/copy, authentic/inauthentic, function/ornament. Each term now seems to contain its opposite, and this indeterminacy brings with it an impossibility of choice or, rather, the absolute equivalence and hence interchangeability of choices. Or so it is said.[27] The existence of feminism, with its insistence on difference, forces us to reconsider. For in our country goodbye may look just like hello, but only from a masculine position. Women have learned — perhaps they have always known — how to recognize the difference.

1 See my 'The Allegorical Impulse: Towards a Theory of Postmodernism' (part 2), *October*, 13 (Summer 1980) 59-80. *Americans on the Move* was first performed at The Kitchen Center for Video, Music, and Dance in New York City in April 1979; it has since been revised and incorporated into Anderson's two-evening work *United States, Parts I-IV*, first seen in its entirety in February 1983 at the Brooklyn Academy of Music.

2 This project was brought to my attention by Rosalyn Deutsche.

3 As Stephen Heath writes, 'Any discourse which fails to take account of the problem of sexual difference in its own enunciation and address will be, within a patriarchal order, precisely indifferent, a reflection of male domination'. Stephen Heath, 'Difference', *Screen*, 19: 4 (Winter 1978-79) 53.

4 Editions de Jean-Francois Lyotard, *La condition postmoderne* (Paris: Minuit, 1979) 29.

5 Published in *Screen*, 16: 3 (Autumn 1975).

6 See my 'Earthwords', *October*, 10 (Autumn 1979) 120-32.

7 'No Essential Femininity: A Conversation Between Mary Kelly and Paul Smith', *Parachute*, 26 (Spring 1982) 33.

8 For more on this group of painters, see my 'Honor, Power and the Love of Women', *Art in America*, 71: 1 (January 1983) 7-13.

9 Martha Rosler interviewed by Martha Gever in *Afterimage* (October 1981) 15. *The Bowery in Two Inadequate Descriptive Systems* has been published in Rosler's book *3 Works* (Halifax: The Press of The Nova Scotia College of Art and Design, 1981).

10 'Intellectuals and Power: A Conversation Between Michel Foucault and Gilles Deleuze', *Language, counter-memory, practice* (Ithaca: Cornell University Press, 1977) 209. Deleuze to Foucault: 'In my opinion, you were the first - in your books and in the practical sphere - to teach us something absolutely fundamental: the indignity of speaking for others.'
The idea of a counter-discourse also derives from this conversation, specifically from Foucault's work with the 'Groupe d'information de prisons'. Thus, Foucault: 'When the prisoners began to speak, they possessed an individual theory of prisons, the penal system and justice. It is this form of discourse which ultimately matters, a discourse against power, the counter-discourse of prisoners and those we call delinquents - and not a theory *about* delinquency.'

11 Martha Rosler, 'in, around, and afterthoughts (on documentary photography)', *3 Works, op. cit.*, 79.

12 Sigmund Freud, *Civilization and Its Discontents*, trans. J. Strachey (New York and London: W.W. Norton and Co., 1962) 46-47.

13 Jacques Lacan, 'Guiding Remarks for a Congress on Feminine Sexuality', in *Feminine Sexuality*, ed. J. Mitchell and J. Rose (New York and London: W.W. Norton and Co., Pantheon, 1982) 90.

14 On Barthes' refusal of mastery, see Paul Smith, 'We Always Fail - Barthes' Last Writings', *SubStance*, 36 (1982) 34-39. Smith is one of the few male critics to have directly engaged the feminist critique of patriarchy without attempting to rewrite it.

15 Benjamin Buchloh, 'Allegorical Procedures: Appropriation and Montage in Contemporary Art', *Artforum*, 21: 1 (September 1982) 43-56.

16 Lacan's suggestion that 'the phallus can play its role only when veiled' suggests a different inflection of the term 'unveil' - one that is not, however, Buchloh's.

17 On Birnbaum's work, see my 'Phantasmagoria of the Media', *Art in America*, 70: 5 (May 1982) 98-100.

18 See Alice A. Jardine, 'Theories of the Feminine: Kristeva', *enclitic*, 4: 2 (Autumn 1980) 5-15.

19 'The author is reputed the father and owner of his work: literary science therefore teaches *respect* for the manuscript and the author's declared intentions, while society asserts the legality of the relation of author to work (the "*droit d'auteur*" or "copyright", in fact of recent date since it was only really legalized at the time of the French Revolution). As for the Text, it reads without the inscription of the Father.' Roland Barthes, 'From Work to Text', *Image/Music/Text*, trans. S. Heath (New York: Hill and Wang, 1977) 160-61.

20 Levine's first appropriations were images of maternity (women in their natural role) from ladies' magazines. She then took landscape photographs by Eliot Porter and Andreas Feininger, then Weston's portraits of Neil, then Walker Evans' FSA photographs. Her recent work is concerned with Expressionist painting, but the involvement with images of alterity remains: she has exhibited reproductions of Franz Marc's pastoral depictions of animals and Egon Schiele's self-portraits (madness). On the thematic consistency of Levine's 'work', see my review, 'Sherrie Levine at A&M Artworks', *Art in America*, 70: 6 (Summer 1982) 148.

21 See Christian Metz, *The Imaginary Signifier*, trans. Britton, Williams, Brewster and Guzzetti (Bloomington: Indiana University Press, c.1982).

22 Douglas Crimp, 'Appropriating Appropriation', in *Image Scavengers: Photography*, ed. Paula Marincola (Philadelphia: Institute of Contemporary Art, 1982) 34.

23 Hélène Cixous, 'Entretien avec Francoise van Rossum-Guyon', quoted in Heath, *op. cit.*, 96.

24 Sherman's shifting identity is reminiscent of the authorial strategies of Eugenie Lemoine-Luccioni as discussed by Jane Gallop; see *Feminism and Psychoanalysis: The Daughter's Seduction* (Ithaca: Cornell University Press, 1982) 105: 'Like children, the various productions of an author date from different moments, and cannot strictly be considered to have the same origin, the same author. At least we must avoid the fiction that a person is the same, unchanging throughout time. Lemoine-Luccioni makes the difficulty patent by signing each text with a different name, all of which are "hers".'

25 See, for example, Martha Rosler's criticisms in 'Notes on Quotes', *Wedge*, 2 (Autumn 1982) 69.

26 Hal Foster, 'Subversive Signs', *Art in America*, 70: 10 (November 1982) 88.

27 For a statement of this position in relation to contemporary artistic production, see Mario Pemiola, 'Time and Time Again', *Artforum*, 21: 8 (April 1983) 54-55. Pemiola is indebted to Baudrillard; but are we not back with Ricoeur in 1962 - that is, at precisely the point at which we started?

Craig Owens, 'The Discourse of Others: Feminists and Postmodernism', *The Anti-Aesthetic: Essays on Postmodern Culture*, ed. Hal Foster (Seattle: Bay Press, 1983) 57-82.

Mary KELLY

Beyond the Purloined Image

[1983]¹

9. Victor Burgin

Roland Barthes has said that those who fail to re-read are obliged to read the same story everywhere. Perhaps by a similar default, we are obliged to see the same exhibition time and time again.

Considering that, when I was asked to curate yet another 'women's show', I saw it instead as an opportunity to go beyond, exactly to 're-read' the biological canon of feminist commitment and situate the question of gender within a wider network of social and aesthetic debates. Specifically, I wanted to show how recent developments in photographic practice, initiated by artists in London, had gone beyond the more reductive quotational tactics of their New York equivalents, precisely by extending a feminist theory of 'the subject' to a critique of artistic authorship.

I am not, however, exploring 'the truth' of my intentions here, in order to create a unitary 'author' for the exhibition/text. Beyond its title, there is no explanation; there is, rather, a set of intentions, a group of diverse statements, a practice of selection and collaboration that could be called a *discursive event*. In as much as a fragment of this event concerns the 'naming' of it, I should say that my thematic emphasis is an attempt, not simply to purloin, but to re-work and extend the notion of 'appropriation'. It is one that has been used, predominantly by New York critics, to describe the work of artists who take their images from the so-called mass media and re-present them 'in visual quotation marks'.² Their aim in doing this (the part that interests me) is to contest the ownership of the image, and dispel the aura of genius, madness, originality and maleness that surround the *artist-auter*.

Like their American counterparts in a show such as 'The Stolen Image and its Uses', the artists in 'Beyond the Purloined Image' refuse to retreat into the esoteric realms of pre- or Postmodernism.³ They are passionately, but critically, committed to the contemporary world; yet they are not content merely to pilfer its cultural estate. Instead, they are exploring its boundaries, de-constructing its centre, proposing the de-colonisation of its visual codes and of language itself. They are adopting what I would call a strategy of *depropriation*.⁴ Point of view and frame, use of caption and narrative sequence; all are subject to investigation as Peter Wollen has emphasized in 'Photography and Aesthetics': 'This is not simply a "de-construction", but rather a process of "re-production" which involves a disorientation and re-orientation of the spectator in which new signifieds are superimposed disturbingly on the memories/anticipations of old presuppositions.'⁵

Mitra Tabrizian for instance takes the concept of 'documentary' and turns it inside out by exposing the fabricated 'reality' of the subjects she photographs – designers, photographers, agents, executives. In

Governmentality, she unmasks not only the codes of the magazine image, but also the function of advertising as an institution. In contrast Karen Knorr appropriates the lush genre of traditional portraiture and transforms it into what she calls 'non-portraiture', that is, an acid commentary on the manners, gestures and social values of a particular class; in this case, those who frequent *Gentlemen's Clubs*. For both artists the problem of 'politics' is posed rather than prescribed, as Victor Burgin advocates – 'new forms of politicization' within the institutions of art (and) photography must begin with the recognition that meaning is perpetually displaced from the image to the discursive formations which cross and contain it'⁶ […]

Judith Crowle's re-visions of the past are startling and direct. She confiscates stereotyped pictures of men and women from the Photography Annuals of the 1930s and then subjects these historicized images to another distortion by using a mirror. Crowle is not "making strange" as an end in itself, but as a means of effectively shattering our traditional view of sexual roles. Ray Barrie embarks on a parallel enterprise, but uses radically diverse sources such as graffiti, advertisements, holiday snaps and popular literature to map out the still uncharted terrain of male sexuality. His aim is not to locate a fixed site on that route, but rather to observe the constantly shifting landscape of fantasy and reminiscence that shapes our sexual identities, the implicit reference is Freud: '… but we shall, of course, willingly agree that the majority of men are also far behind the masculine ideal and that all human individuals, as a result of their bi-sexual disposition and of cross-inheritance, combine in themselves both masculine and feminine characteristics, so that pure masculinity and femininity remain theoretical constructions of uncertain content'.⁷

In a piece entitled *Screen Memories*, we trace the man's desire for status, for property; his fear of punishment, his fantasized revenge and finally the absurdity of this vicious phallocentric cycle. Barrie makes a pointed comment, 'Men are obsessed with femininity. Consequently, they have seen feminist theory merely as a means of unravelling that "enigma". Feminism also offers clues to understanding how masculinity is formed; but this has generally been resisted since it would require us to deal instead, with the absurdity of the phallus. (Men never tire of looking up the proverbial "ladies skirt", but they don't like being caught with their pants down.)'

Marie Yates also pursues 'the subject' of sexual difference, but in the occupied territory of language. She deploys a complex juxtaposition of jewel-like images or icons, symbols and indexical signs to engage us in a multilayered reading of her *Dream of Personal Life*. Visually, the work is unified by the technique of montage, but then fragmented into a series of objects. Similarly, there is the unifying pull of the narrative towards some resolution; but this is again refused, revealed to be 'fictitious', in order to open rather than close the text. Seeing her work reminds me of Jane Gallop's provocative metaphor, 'The notions of integrity and closure in a text (or image) are like that of virginity in a body. They assume that if one does not respect the boundaries between inside and outside, one is "breaking and entering", violating a

property.' In a sense, Yates is 'asking for it', that is, a reading which re-positions, even deletes the author herself.

The re-positioning of spectator and author alike is a persistent undertaking in the work of Yve Lomax and Susan Trangmar as well. Lomax borrows the rhetoric of *film noir* to manufacture a 'plot' between a mysterious fragment of media melodrama and another equally ambiguous personal interlude. Her tactics resemble Cindy Sherman's in so far as they urge us to search for hidden relations, explanations or 'meanings', but there is a crucial difference – she breaks the story line, opens the ring of identification and pushes a 'third term' onto the stage in the guise of 'lack', that is, a space between the two images which queries the photograph's assumed finitude, rather than solving the enigma of the subject's identity. Describing the work, aptly titled *Open Rings and Partial Lines*, she says 'I have attempted to bring into play the basic assumptions of the classical model of communication i.e. subject/object, sender/message/receiver. In short: to open up these assumptions and not to take them for granted. So … in the work I have attempted to produce an assemblage where a "middle" or "third" term neither unifies nor fragments or divides which in turn calls into question the position of the two sides as two sides. It is this play of neither/nor which excites me' […]

In summary, but certainly not in conclusion, it is evident that the artists who are engaged in a depropriative practice take their cue from Brecht and Godard, rather than the Situationists. They are concerned with the image but not consumed by the spectacle; critical, but not moralistic; obsessed with pleasure, but with the kind to which Barthes referred when he wrote 'knowledge is delicious'. Moreover, and crucially, *depropriationists* are not afraid to pose the question of subjectivity and of sexuality together with, across or even against the 'allegorical' imperatives of a politically correct art. The depropriative text is heterogeneous, disruptive, open, pleasurable *and* political. Finally, it also goes (almost) without saying, that the artists' intentions reach far beyond the curatorial confiscation of their imaged effects. So let us 'proceed analytically', as Brecht suggested and 'transform finished works into unfinished works'. In this way, we will make *meaning* possible and our pleasure in it unpurloined.

1 Title of an exhibition of photographic work by Ray Barrie, Judith Crowle, Karen Knorr, Yve Lomax, Olivier Richon, Mitra Tabrizian, Susan Trangmar and Marie Yates, which I curated for *Riverside Studios*, London, 3-29 August, 1983. This article is an extended version of the catalogue introduction.

2 See for instance Douglas Crimp, 'The Photographic Activity for Post-Modernism', *October*, 15 (1980); also Benjamin H.D. Buchloh, 'Allegorical Procedures: Appropriation and Montage in Contemporary Art', *Artforum* (September 1982); and Kate Linker, 'On Richard Prince's Photographs', *Arts Magazine* (November 1982).

3 'The Stolen Image and its Uses' included work by Bikky Alexander, Silvia Kolbowski, Barbara Kruger, Sherrie Levine and Richard Prince. It was curated by Abigail

Solomon-Godeau for Light Work/Community Darkrooms,
Syracuse, New York, 16 March–15 April 1983.

4 Stephen Heath uses the term *depropriation* to describe
 the film practice of Straub, Oshima and Godard in
 'Lessons from Brecht', *Screen* (Summer 1974).

5 Peter Wollen, 'Photography and Aesthetics', *Readings
 and Writings* (London and New York: Verso, 1982).

6 Victor Burgin, 'Photography, Phantasy, Function',
 Thinking Photography (London: Macmillan, 1982).

7 Sigmund Freud, 'Some Psychological Consequences of the
 Anatomical Distinction between the Sexes', 1925,
 Collected Papers, vol. 5.

Mary Kelly, 'Beyond the Purloined Image', *Block*, 9 (1983);
reprinted in Mary Kelly, *Imaging Desire* (Cambridge,
Massachusetts: MIT Press, 1996) 107–114.

Kate LINKER
Eluding Definition [1984]

Among the tortuous texts of Jacques Lacan, several speak
with unusual lucidity and pertinence about the constraints
surrounding the very idea of women. In 'Encore', an essay
from the early 1970s approaching the *terra incognita* of
feminine desire, Lacan speaks 'of all those beings who
take on the status of the woman'.¹ Lacan exposes the
problem as one of authority, for 'status' is a juridical term,
denoting a condition or position with regard to the law.
Woman's supposed 'nature', he implies, is highly
unnatural; it is not inherent but assumed (or imposed)
from outside. But in another text Lacan goes further, as if
to answer our inevitable question about sexual formation:
*'Images and symbols for the woman cannot be isolated
from images and symbols of the woman. It is
representation ... the representation of feminine sexuality
... which conditions how it comes into play.'*
In a manner radical for feminism, Lacan discloses
sexuality as a problem of language.

If this privileging of language is crucial, it is because it
calls attention to the way feminism participates in a larger
and more encompassing direction, the investigation of
cultural constraints. Lacan's insights coincide with
deconstructive theory, which views reality as the effect of
systems of representation, as a product of codes
authorized and empowered by the Western social
apparatus. What is traced in his work is the distance
travelled by the decentred subject, subjected to and
through language, from the model of the previous period
which was defined as unified, autonomous and self-
possessing 'master' of its universe. Feminism is seen to
exemplify the Postmodernist concern with the production
of the subject rather than the Modernist preoccupation
with the subject of production. Similarly, as part of a
recognition of difference, of previously marginal or
excluded discourses, feminism joins Postmodernism in
exposing the legitimizing apparatus of Western
representation, as it converges on the patriarchal white
male.² As Lacan implies, the problem involves both the
assumption of, and assumptions of status. Or as Mary
Ann Doane has remarked, it concerns the delineation of a
'place' assigned by culture to women in a network of
relations of power³ [...]

Many women artists have insisted that the female body
be placed, as Doane comments, 'within quotation marks'
– that it need not be celebrated, but contextually
described.⁴ They have protested a liberal perspective that
in no way accounts for the ideological structures of which
discrimination is but a symptom, which leaves untouched
the integrated value system through which feminine
oppression is enacted. It is with the aim of understanding
the construction of sexed subjectivity in language that
artists have turned to the theoretical priming of
psychoanalysis [...]

Drawing on the figures of dominant discourse and
their attendant power relations, many artists have
attempted to erode this 'place' assigned by culture to
women; notable here are Barbara Kruger's dislocations of
the 'mastering' position, as inscribed in mass media texts.
Kruger's deployment of the deictic terms 'I', 'me', 'we' and
'you' show that the place of the viewer in language is
unsettled, shifting, indefinite, refusing alignment with
gender.

Kruger's terms tally with those of Freud, who resisted
the notions of the 'masculine' and 'feminine' ('among the
most confused that occur in science'), arguing instead for
'active' and 'passive' relations, and connecting sexuality to
the situation of the subject. In Dorit Cypis' work, which
employs photomontages, superimposed image
projections and often sound, the conventional
relationship between viewer and viewed is inverted; the
spectator is encouraged to intervene and actively
construct the narrative, and elude masculine and feminine
roles. Others have investigated positioning from a more
analytic view, showing its immanence to the
representational structure laid down by patriarchy. Silvia
Kolbowski's use of media images (specifically, images
taken from fashion magazines) indicates their address to
the viewer in terms of coded body representations, but
these representations are only aftereffects, echoes, ghosts
of an earlier system. Much of her project depends on a
double directive, exploring the masculine attempt to fix
woman within a spectacular system (as object of the
controlling gaze) and as object of fantasy (the
paradoxically idealized and subjected Other). The sexual
direction of visual pleasure which Freud located in the
scopic drive is associated, here, with a phallic economy, as
it is installed in difference and repeated in its figures
(Nature/Culture, Other/One); woman's visual
subordination, like her mystical elevation, is seen as a
male project aimed at healing the division inherent in
subjectivity.

Throughout Kolbowski's work the ways in which
woman is looked at, imaged, mystified and objectified
indicate her exclusion from representation; denied access
to language, she cannot 'speak' but is, rather, 'spoken'.
Several projects, like *Model Pleasure III* (1982), articulate
the position of the hysteric who, by refusing fixed
divisions, oscillates between masculine and feminine,
threatening phallocentric order. Hysteria's political
dimension as a resistance to the symbolic has been
emphasized in recent theory; it opposes universalizing
reduction and the legitimizing function it implies. Hysteria
also embodies Lacan's injunction to 'dephallicize', to
assume the phallus critically (and with it, a theoretical
position denied to women in Western society), so as to
expose the arbitrary privilege on which it stands.

Such re-presentations of representation examine and
question their binding constraints; other practices have
investigated how these constraints are executed in and
through specific apparatuses of representation. In recent
years a significant body of theory has addressed the
mastering role of the photographic apparatus, exploring
how the camera's falsifying monocular perspective
constructs the viewed scene as subject to the central
masculine position.⁵ A sense of controlling individuality, of
mastery through technological, legal and social means,
informs the capitalist conquest of nature and, after it,
humanity, so it is not surprising to find this perspective
inscribed within those reproductive apparatuses –
photography, cinema and television – that coincide with
and support the ideology of capitalism. Sherrie Levine, for
example, has addressed this photographic theme; much
of her work features images of Otherness – nature,
women, the poor, the insane⁶ – as they are sighted through
the lens of desire and fixed by the masculine 'camera eye'.
Even when Levine rephotographs a painting by Ernst
Ludwig Kirchner, she chooses an image whose emphatic
triangular geometry focuses the position of the woman,
accentuating her domination within, and through, the
visual field.

Attention has also turned to the psychic effects of the
photograph's visual allures – to the shimmering surfaces
that recall the mirror stage, as recounted by Lacan,
echoing our first mis-recognition of unity. Lacan calls such
instances of false unity the Imaginary, and locates in them
the sites of identifications by which subjectivity is
constructed. The illusory coherence it offers has made the
Imaginary ideology's aid, and its inherence in images has
primed awareness to photography's role in social
normalization. Thus when Sarah Charlesworth examines
the seductive powers of photographed images in a recent
series, *Objects of Desire* (1983–84), the practice extends
her exploration of the visual modalities inherent in the
photograph. Glistening laminated surfaces bound by
lacquered frames contrive a specular brilliance, creating
images of images, exaggerations of the *effects* we attribute
to photographs. Within them, a scarf, a mask, a
bombshell-blond shock of hair present ' ... the forms and
postures of seduction – the shapes, forms or gestures', as
the artist remarks, 'that are the exterior trappings of
identity'.⁷ Such partial objects function as fetishes,
elements to which desire attaches to fulfil a fantasy of
wholeness. Furthermore, as Charlesworth adds, they are
'embodiments in a social "attitude"' – the configurations
of desire accounting for the (always historical)
perpetuation of norms. But desire is not caused by objects,
but in the unconscious; it can only be known through its
displacements, through the substitutions it endures.
Consequently, fetishism in its various forms only serves to
repeat and reactivate the one, and primary, fantasy. What
is at stake in our fascination with photographs, the artist
seems to imply, may be their ability to restage (replay? re-

present?) a fundamental striving for unity.

This inquiry into the system of sexuality is not confined by medium, as feminist work on literary narrative suggests. 'In high school sex was a war, a conventional war about the conventions', writes Lynne Tillman in *Haunted Houses*, a novel-in-progress devoted (like her other work) to exploring the construction of sexual experience. When Tillman collaborates with Sheila McLaughlin, she joins a host of women filmmakers (Sally Potter, Bette Gordon and Candace Reckinger among them) in challenging cinema's implication of image and code. Video as well contains a significant roster, including Dara Birnbaum and Judith Barry. Birnbaum's *Wonder Woman* and Barry's *Casual Shopper*[8], for example, are figures of narcissism, the one 'the phallic mother' of television spectacle, the other the ideologized consumer seeking personal completeness and libidinal pleasure through the purchase of material objects.

In its psychic and economic parallels, Barry's project suggests the existence of a total economy like that described by Hélène Cixous: 'an ideological theatre where the multiplication of representations, images, reflections, myths, identifications'[9] points to the phallus' sovereign power. Current practice has attended to this 'insinuation' of politics into the 'tissue of reality', where it comprises a network traversing the social body.[10] Significant, here, is Kolbowski's recent work, which explores the displacement of difference into advertising logos, illuminating the sexual investment of lines, forms and supposed voids in (male) space. We find this approach, as well, in the links exposed by Kruger between women and money (Woman as Capitalized, as object of exchange) as sublimations of masculine interests. Most importantly, the approach argues, as Kristeva remarks, the impossibility of socio-political transformation without a change in subjectivity, in our relations to constraints, to pleasure and to language and representation themselves [...]

Lawler's 'arrangements of arrangements' – photographs showing artworks as they are privately, commercially or institutionally displayed – point to the conditions surrounding the reading of art; they inquire into the role of placement or position in meaning's production, into the specific social inscription of the work. Meaning, Lawler implies, comes not from within, but from without. Nor is it fixed (natural? true?) but variable, cultural, a historical formation. And in this questioning of meaning's autonomy we recognize a dagger directed at a tenet of Western aesthetics: that artworks are unified structures, enduring objects, expressions of the creative subject.

Considered within contextualist practice in general, Lawler's art suggests the implications of a perspective based on historical constructions and definitions; contesting the authority of categories, its premises collide and coincide with current feminism, which would find in it an analogue to woman's construction in relation to a complex of social texts. In a recent installation Lawler extended her approach, considering the multiple factors that determine art's reading within an interdiscursive network. Not only institutional and architectural context are questioned in these works, but also titles, labels,

descriptions of materials – the shards of language that impose meaning, anchoring the inherent plurality of the text. Lacan might call it attention 'to the letter' – to the material products of language rather than to their essentialized 'spirit'. Within these surroundings, determined by culture, the question of origin recedes, as in retreat, towards a vanishing point established by ideology's eye.

1 Jacques Lacan, 'Encore', Seminar XX as cited in Jacqueline Rose, 'Introduction - II', in eds. Juliet Mitchell and Jacqueline Rose, *Feminine Sexuality: Jacques Lacan and the école freudienne* (New York and London: W.W. Norton and Co., Pantheon, 1982) 27. All other quotes from Lacan, including the following from 'Guiding Remarks for a Congress on Feminine Sexuality' (1958) are derived from this source.

2 For a discussion see Craig Owens, 'The Discourse of Others: Feminists and Postmodernism', *The Anti-Aesthetic: Essays on Postmodern Culture*, ed. Hal Foster (Seattle: Bay Press, 1983) 57-82. For a treatment of questions of representation in general see my 'Representation and Sexuality', *Parachute*, 32 (Autumn 1983), 12-23.

3 Mary Ann Doane, 'Film and the Masquerade: Theorizing the Female Spectator', *Screen*, 23: 3-4 (September-October 1982) 87.

4 Mary Ann Doane, 'Woman's State: Filming the Female Body', *October*, 17 (Summer 1981) 24.

5 For discussion of this photographic construction of subjectivity see Victor Burgin, 'Photography, Fantasy, Fiction', in *Thinking Photography* (London: Macmillan, 1982).

6 Owens, *op. cit.*, 81n.

7 Sarah Charlesworth, 'Interview with David Deitcher', *Afterimage*, 12:1/2 (Summer 1984) 17.

8 As presented in Birnbaum's *Technology/Transformation: Wonder Woman* (1978-79), and Barry's *Casual Shopper* (1981).

9 Hélène Cixous, 'Sorties', in eds. Elaine Marks and Isabelle de Courtivron, *New French Feminisms* (New York: Schocken, 1987) 96.

10 Michel Foucault, *Discipline and Punish* (New York: Vintage Books, 1979) 25-26.

Kate Linker, 'Eluding Definition', *Artforum*, 23:4 (December 1984), 61-68.

Sophie **CALLE**
Suite vénitienne [1983]

For months I followed strangers on the street, for the pleasure of following them, not because they particularly interested me. I photographed them without their knowledge, took notes of their movements, then finally lost sight of them and forgot them. At the end of January 1980, on the streets of Paris, I followed a man whom I lost sight of a few minutes later in the crowd. That very evening, quite by chance, he was introduced to me at an opening. During the course of our conversation, he told me he was planning an imminent trip to Venice. I decided to shadow him.

Sophie Calle, 'Suite vénitienne', *Suite vénitienne/Sophie Calle. Please Follow Me/Jean Baudrillard* (Paris: Editions de l'Etoile, 1983); reprinted in English as *Suite vénitienne/Sophie Calle. Please Follow Me/Jean Baudrillard*, trans. Dany Barash and Danny Hatfield (Seattle: Bay Press, 1988) 2.

Jean **BAUDRILLARD**
Suite vénitienne [1983]

A strange arrogance compels us not only to possess the other, but also to penetrate his secret, not only to be desired by him, but to be fatal to him, too. The sensuality of behind-the-scenes power: the art of making the other disappear. That requires an entire ritual.

First, following people at random on the street for one hour, two hours, in brief, unordered sequences – the idea that people's lives are haphazard paths that have no meaning and lead nowhere and which, for that very reason, are 'curious' (fascinating, but undoubtedly curious to you as well).

The other's tracks are used in such a way as to distance you from yourself. You exist only in the trace of the other, but without his being aware of it; in fact, you follow your own tracks almost without knowing it yourself. Therefore, it is not to discover something about the other or where he's heading – nor is it 'drifting' in search of the random path: all of this, which corresponds to various contemporary ideologies, is not particularly seductive. And yet this experience is entirely a process of seduction.

You seduce yourself by being absent, by being no more than a mirror for the other who is unaware – as with Kierkegaard's mirror, hanging on the opposite wall: the young girl doesn't think of it, but the mirror does. You seduce yourself into the other's destiny, the double of his path, which, for him, has meaning, but when repeated, does not. *It's as if someone behind him knew that he was going nowhere* – it is in some way robbing him of his objective: seducing him. The cunning demon of seduction slips between him and himself, between you and him. This is so powerful that people can often sense they are being followed, through some sort of intuition that something has penetrated their space, altering its curvature – a feeling of being reflected without knowing it.

One day Sophie decides to add another dimension to this 'experience'. She learns that someone she barely knows is travelling to Venice. She decides to follow him throughout his trip. Arriving in Venice, she telephones a hundred hotels and ends up locating the one where he is staying. She convinces the owner of the house across the street to let her use a window, so she can watch this man's comings and goings (he is there on vacation). She has a camera, and at every opportunity, she photographs him, the places he has been and the places he has photographed. She expects nothing of him; she does not want to know him. She does not consider him to be particularly attractive.

It is carnival time in Venice. As he might recognize her,

she dons a blonde wig to cover her dark hair. She puts on make-up; she disguises herself. But carnival pleasures do not interest her; following him is her only concern. At great effort she spends fourteen days on his trail. She learns his plans by questioning people in shops he has visited. She even discovers the departure time of his train back to Paris so that, having taken a different train, she's able to wait for him and take a last picture of him as he disembarks [...]

Everything is at the vanishing point. Everything happens as the result of an unwarranted predestination; why him, why Venice, why follow him? The very blindness with which this plan is carried out (which is the equivalent of an order received from elsewhere: you shall follow me for fourteen days – but this order was not given by anyone) already corresponds to that blinding effect and disappearance of will characteristic of the vanishing point. And starting there, everything converges into the same effect: the shadowing, Venice, the photography, all this is being played out beyond the vanishing point. The shadowing makes the other vanish into the consciousness of the one who follows him, into the traces that he unknowingly leaves behind – Venice is a vanished city, where all history has already disappeared and where one enters alive into the disappearance – and photography is itself an art of disappearance, which captures the other vanished in front of the lens, which preserves him vanished on film, which, unlike a gaze, saves nothing of the other but his vanished presence (according to Barthes, it's not so much the death that one reads there, but rather the vanishing. Death is the source of moral fright, vanishing is alone the source of a 'seductive' aesthetic of disappearance).

It is not by chance, either, that 'The Big Sleep' gathers together sleep – in itself a vanishing of consciousness – photography, and a succession of people who sleep and cross paths in the apartment: at once appearing then disappearing, one into another. One must add to this the vanishing of defences, of resistance, that sort of hypnosis under which the people acquiesce to the plan for its very improbability.

Imagine a swooning woman: nothing is more beautiful, since swooning is at once the experience of overwhelming pleasure and the escape from pleasure, a seduction and an escape from seduction.

Please follow me.

Sophie Calle, 'Suite vénitienne', *Suite vénitienne/Sophie Calle. Please Follow Me/Jean Baudrillard* (Paris: Editions de l'Etoile, 1983); reprinted in English as *Suite vénitienne/Sophie Calle. Please Follow Me/Jean Baudrillard*, trans. Dany Barash and Danny Hatfield (Seattle: Bay Press, 1988) 76-86.

Susan HILLER
Looking at New Work: Interview with Rozsika Parker [1983]

Rozsika Parker Looking at your new work, the first thing that strikes me is that your automatic writing works – the scripts – have changed considerably since you produced *Sisters of Menon* in 1972.

Susan Hiller Yes, now I'm producing without any sense of amazement and a great deal of pleasure a rather refined calligraphic series – a set of marks that simply flow. The marks are the record of my hand passing, and though they're certainly patterned, regular, formalized, and in their own terms, articulate – they don't represent anything, in a literal sense.

Parker Are you saying the new work doesn't mean anything? *Sisters of Menon* seemed to me to have been insisting that we decipher the script and understand the meaning of the text.

Hiller Among the other things it's doing, the *Sisters of Menon* script reformulates the encounter between the Sphinx and Oedipus. The *Sisters* text revolves around a new perspective on the question, Who am I? The Sisters ask, 'Who is this one?' and they answer themselves, 'I am this one. You are this one. Menon is this one. We are this one'. It's a new starting-point. Identity is a collaboration, the self is a multiple. 'I' am a location, a focus. It seems to me my newer scripts are clearly rooted in this understanding. This 'writing' is a way for me to speak my desire for utterance. I used to describe the signs themselves as crypto-linguistic, that is, representing language referring to language, or pretending to be language – now I'm practically at the point of claiming that my newer automatic works are a new language, or are making one. (*Laughter*.) One that is, at the same time, in terms of our individual personal histories.

Parker Are you now deliberately changing the 'feminine' associations of automatic writing?

Hiller That's complicated. First of all, the timing seems right to give this work a more central place in my own practice, since there's now a context in recent linguistic theory and feminist thinking. When I began to work in this way, ten years ago or so, theory hadn't yet begun to link up – well, let's say it couldn't link up the 'analytic' and the 'ecstatic'. So I very gradually begin to exhibit small automatic works alongside other projects, and this seems to have worked. What I hope for now is that these works should not just be seen in purely pictorial terms, or as decorated surfaces, but taken seriously as a form of patterned utterance [...]

Parker I can see how automatism relates to your concern to widen the notion of what we define as art and to question conventional ideas of the artist, but how does it connect to your ideas on women's relationship to language?

Hiller Well – although for years I recognized the gap between our 'fruitful incoherence' and the use of so-called rational discourse, which by definition means white, middle-class, male language in our society, to articulate ideas – yet it still took time for me to fully understand my own dual programming. I'm now more at ease with the fact that when something really new is coming into being in my work, I lose my grasp of it in intellectual terms. This leads to commitment – this makes me realize that to put the new into old language is to destroy its ability to intervene and change the system of ideas we live under.

Parker I remember in our interview in 1978' you said to me that it's when we try to deal with the contradictions arising from our experience within accepted frameworks and categories that we have no language. You went on to say that the lived experience of a person is cut off by a kind of verbal formulation of that experience. So I see your present work with automatic writing as a validation of what you call 'fruitful incoherence'. How does this relate to another important strand in your work – your concern with art in its popular dimension? How accessible are the automatic works?

Hiller Well, as you know, on one level I'm a populist, so of course I worry about being too esoteric. But strangely, it's a non-problem, since a good part of my visibility as an artist has come about not through academic support or investors' interest or establishment backing, but through a kind of on-going rapport with an audience. This particular area of my work has found terrific support from all kinds of people, including many who've had little or nothing to do with the art world or recent debates on language. Among others, young women who are struggling with their own incoherence tell me they identify with this aspect of my work. They feel they recognize these signs – what can I call them –? These ineffable signs – because don't forget that on one level the world is constantly presenting us with signs that we as women have to deny or translate. My scripts are signs with a slightly exotic, hieratic feel to them. They don't accuse us the way signs in the world do.

Parker You mean they are not placing us – forming us –

Hiller Right, because they go on and on in a rhythm like breathing or walking. They relate to internal rhythms which are not aestheticized or distanced from us physically. Listening to other people describe their reactions to them, and to my voice improvisations on *Élan*, I've been pleased to discover there is a direct, perhaps unconscious response to communication from the unconscious – or something like that.

Parker In our last interview, we talked a bit about Surrealism. How do you now relate to Surrealism?

Hiller I don't like what's called Surrealist painting; I feel the Surrealists have been badly misunderstood. I'm determined to insert my work with automatism within and against the tradition of the gestural in modern art – *against* the reactionary, self-aggrandizing gesturalism that has re-emerged recently, and *within* the socially-motivated investigation of mark-making initiated by the Surrealist group.

Looking back on their experiments with automatism, and then tracing the fate of automatism within painting, has given me insight into how what was intended to be subversive turned into an acceptable look or style. Breton's writings on automatism were part of his

endeavour to reconcile Marxism and psychoanalysis. He felt that a grasp of the implications of automatism would eventually erode all notions of personal property rights and individual authorship of works. (I've been working on that point for years, but you know being a woman artist and giving up one's property claim to one's discoveries is not quite the same thing as it is for a man, since one is never acknowledged to have had a right in the first place.)

The early automatic pieces produced by the Surrealists were collective and anonymous. An involvement with spontaneous gesture and utterance erodes notions of personal authorship because everyone can do it – no minimal standards. So why put your name to it? Particularly since it's unpredictable and seems to be outside any kind of individual control.

I've looked into what happened to this approach historically. Jackson Pollock began working very much in the tradition of Surrealist automatic drawing, and his drawings turned away from recognizable figurative shapes into records of physical gestures. Numerous other artists liked the look of this and began to replicate it endlessly. No one ever went back to investigate the root of it – what it meant, and its implications for definitions of the self, creativity, inspiration, the nature and function of art, etc ...

Parker You've worked with unconscious communications in the form of dreams for years now. How has the work developed and changed?

Hiller The early pieces I did with dreams were collective, collaborative projects. *Dream Mapping,* for example, attempted to discover whether or not there are shared structures that underlie individual dreams. In these recent wall pieces we're looking at, I'm trying to erode the supposed boundary between dream life and waking life. The work is clearly positioned in the waking world, since the pieces start off with photomat portraiture, but it uses the disconnected and fragmented images produced automatically by these machines as analogies for the kind of dream images we all know, for instance suddenly catching a glimpse of oneself from the back. It doesn't seem accidental that the machines produce this kind of image, because, as I've been saying for years about popular, disposable imagery, there's something there beyond the obvious, which is why it's worth using in art. Maybe it's the way this kind of photobooth image emphasizes the frame, the way the image is quite constrained by the frame or the way the frame cuts it out of its context.

I think it was James Hillman who said something about the fact that we worry all day about what our dream self gets up to – people talk about this in analysis and so forth – but what if our dream self is deeply, deeply disturbed about what we get up to during the day? (*Laughter.*) So much of the truth about the situation of women that has been discovered through the hard intellectual work of the women's movement is about retrieving repressed, suppressed, unknown, rendered invisible, erased, negative meanings – so it makes sense to locate this work from the other side looking back.

Parker Your work has always confronted the opposition our culture maintains between the rational and irrational, between empiricism and intuitive ways of apprehending

the world, between dream life and waking life. And within the dichotomies you have validated and reconsidered the 'sides of life' associated with women. I mean, dreams and night are so often dismissed as mystical, unreal, unreliable, quintessentially feminine. It seems to me, though, that you face a problem here. How can you work with supposedly feminine areas without being identified with the material by your audience to the point of being seen one-sidedly as purely irrational, etc?

Hiller I suppose you're referring to the works that have a romantic look and no texts, such as *Towards an Autobiography of Night*? In this series I'm simply saying, 'this is my territory'; if anyone has the right to claim it, it's me, asserting that I'm the one who is speaking, rather than being spoken about. Working with liquid gold leaf, I've pointed out the illuminated aspects within these night-time images – lights in houses, pools of moonlight on the rocks, birds that in traditional symbolism stand for the illumination of the spirit, and of course, the full moon in all the pictures. So there's a kind of pun: gold paint equals 'illumination' as in old manuscripts, and I'm also using the gold for light in darkness. This is meant to be about my own illumination – you know, the way they convey sudden insight in cartoons with a light bulb and the word 'thinks'. I want to show how one can claim a position of speaking from the side of night, the side of the unknown, while not reducing oneself to darkness and the unknowable.

Obviously, I'm not unaware of the danger of associating myself with nature – colluding in my being assigned, as a female, to 'the natural'. That's why in each scene I include a human handprint, mine. That's the first sign on cave walls of the human self. It's a symbol as well as a representation, and simultaneously evokes the cultural and the natural – and it's androgynous. I certainly hope that my work isn't a demonstration of the problems of being a woman and an artist, but of some possible solutions. Probably everything worth doing in art is risky and dangerous, personally and professionally, and the danger of possible misinterpretation you mention is only one of many dangers [...]

1 'Dedicated to the Unknown Artists: an interview with Rozsika Parker', *Thinking about Art: Conversations with Susan Hiller*, ed. Barbara Einzig (Manchester: Manchester University Press, 1996); abridged from an interview originally published in *Spare Rib*, 72, London, July 1978, 28–30.
'Looking at New Work: an interview with Rozsika Parker', *Thinking about Art: Conversations with Susan Hiller* , ed. Barbara Einzig (Manchester: Manchester University Press, 1996) 51–59; originally published in *Susan Hiller 1978-83: The Muse My Sister* (Derry: Orchard Gallery, 1984).

Maya LIN
An Interview with Elizabeth Hess [1983]

Elizabeth Hess Certain people are outraged by your memorial. They read it as a statement against the

Vietnam war.

Maya Lin [...] The monument may lack an American flag, but you're surrounded by America, by the Washington Monument and the Lincoln Memorial. I don't design pure objects like those. I work with the landscape, and I hope that the object and the land are equal players [...]

Hess Why do you think veterans like Tom Carhart dislike your memorial?

Lin I haven't gotten one negative letter from a veteran. Most of them are not as conservative as Carhart. It's the administration that would like to remember Vietnam the same way it remembers other wars – through the heroes. Well, one of the things that made this war different is the fact that the veterans were hurt by the politics. They came back and their country called them 'murderers'. Nothing can make up for that. You can't pretend that this war was the same as others.

Hess What do you think about the decision to add Hart's piece?

Lin It was a coup [...] It had nothing to do with how many veterans liked or disliked my piece. Ross Perot has powerful friends who managed to get a compromise through. Even Jan Scruggs said, 'We've been ambushed.' The vice president of the Fund called what happened a 'rape' of my decision. I didn't even find out that they had made a 'few modifications' until I saw it announced on TV. Perot flew in fifty people who hated the design from all over the country and they spread rumours in the White House that the designer was a leftist, that the jurors were all communists, and people believed it.

Hess How has the memorial fund treated you?

Lin The fund has always seen me as female – as a child, I went in there when I first won and their attitude was – OK, you did a good job, but now we're going to hire professionals (men) to take care of it. I said no! I wanted to help put together a team that knew about landscape, granite. Their basic attitude was I gave them the design and they could do what they wanted with it. They expected me to take the money ($20,000) say thank you and let them take it over [...]

Hess What do you think of Hart's sculpture?

Lin Three men standing there before the world – it's trite. It's a generalization, a simplification. Hart gives you an image – he's illustrating a book.

Hess But do you think the veterans will have an easier time relating to Hart's work?

Lin No! I don't think the veterans are as unintelligent as some people would like to judge them.

Hess Why did you choose black for the colour of the stone?

Lin [...] Black for me is a lot more peaceful and gentle than white. White marble may be very beautiful, but you can't read anything on it. I wanted something that would be soft on the eyes, and turn into a mirror if you polished it. The point is to see yourself reflected in the names. Also the mirror image doubles and triples the space. I though black was a beautiful colour and appropriate for the design.

Hess Has this situation radicalized you in anyway?

Lin There were certain things I was aware of intellectually

that I had never seen before. In the academic world where I grew up, my femaleness, the fact that I was Asian, was never important. You didn't see prejudice. People treated you first as a human being. When I first came to Washington my biggest shock was that no one listened to me. I didn't know if it was because of my youth, my gender, or my ethnicity.

Hess Do you think the memorial has a female sensibility?

Lin I didn't set out to conquer the earth, or overpower it, the way Western man usually does. I don't think I've made a passive piece, but neither is it a memorial to the idea of war.

Elizabeth Hess, 'An Interview with Maya Lin', *Art in America*, 71:4 (April 1983) 120.

Adrian PIPER

Notes on Funk [1983–85]

NOTES ON FUNK I

From 1982 to 1984 I staged collaborative performances with large or small groups of people, entitled *Funk Lessons*. The first word in the title refers to a certain branch of black popular music and dance known as 'funk' (in contrast, for example, to 'punk', 'rap' or 'rock'). Its recent ancestor is called 'rhythm and blues' or 'soul', and it has been developing as a distinctive cultural idiom within black culture since the early 1970s. Funk constitutes a language of interpersonal communication and collective self-expression that has its origins in African tribal music and dance and is the result of the increasing interest of contemporary black musicians and the populace in those sources elicited by the civil rights movement of the 1960s and early 1970s (African tribal drumming by slaves was banned in the US during the nineteenth century, so it makes sense to describe this increasing interest as a 'rediscovery').

This medium of expression has been largely inaccessible to white culture, in part because of the different roles of social dance in white as opposed to black culture. For example, whereas social dance in white culture is often viewed in terms of achievement, social grace or competence, or spectator-oriented entertainment, it is a collective and participatory means of self-transcendence and social union in black culture along many dimensions, and so is often much more fully integrated into daily life. Thus it is based on a system of symbols, cultural meanings, attitudes and patterns of movement that one must directly experience in order to understand fully. This is particularly true in funk, where the concern is not how spectacular anyone looks but rather how completely everyone participates in a collectively shared, enjoyable experience.

My immediate aim in staging the large-scale performance (preferably with sixty people or more) was to enable everyone present to

GET DOWN AND PARTY. TOGETHER.

This helps explain the second word in the title, that is, 'Lessons'. I began by introducing some of the basic dance movements to the audience, and discussing their cultural and historical background, meanings and the roles they play in black culture. This first part of the performance included demonstrating some basic moves and then, with the audience, rehearsing, internalizing, rerehearsing and improvising on them. The aim was to transmit and share a physical language that everyone was then empowered to use. By breaking down the basic movements into their essentials, these apparently difficult or complex patterns became easily accessible to everyone. Needless to say, no prior training in or acquaintance with dance was necessary. Because both repetition and individual self-expression are both important aspects of this kind of dance, it was only a matter of a relatively short time before these patterns became second nature. However, sometimes this worked more successfully than others, depending on the environment and the number and composition of the audience-participants. (See my videotape, *Funk Lessons with Adrian Piper*, produced by Sam Samore and distributed by The Kitchen, for a record of one of the more successful performances.) Also, the large-scale performance compressed a series of lessons that might normally extend over a period of weeks or months.

As we explored the experience of the dance more fully, I would gradually introduce and discuss the music (which had, up to this point, functioned primarily as a rhythmic background) and the relation between the dance and the music: because of the participatory and collective aspects of this medium, it is often much easier to discern the rhythmic and melodic complexities of the music if one is physically equipped to respond to it by dancing. Thus the first part of the performance prepared the audience for the second. Here I concentrated on the structural features that define funk music, and on some of its major themes and subject matter, using representative examples. I would discuss the relation of funk to disco, rap, rock, punk and new wave, and illustrate my points with different selections of each. During this segment, except for brief pauses for questions, dialogue and my (short) commentaries, everyone was refining their individual techniques, that is, they were LISTENING by DANCING. We were all engaged in the pleasurable process of self-transcendence and creative expression within a highly structured and controlled cultural idiom, in a way that attempted to overcome cultural and racial barriers. I hoped that it also overcame some of our culturally and racially influenced biases about what 'High Culture' is or ought to be. Again, this didn't always work out.

The 'Lessons' format during this process became ever more clearly a kind of didactic foil for collaboration: dialogue quickly replaced pseudoacademic lecture/demonstration, and social union replaced the audience-performer separation. What I purported to 'teach' my audience was revealed to be a kind of fundamental sensory 'knowledge' that everyone has and can use.

The small-scale, usually unannounced and unidentified spontaneous performances consisted in one intensive dialogue or a series of intensive dialogues with anywhere from one to seven other people (more than eight people tend to constitute a party, the interpersonal dynamics of which are very different). I would have people over to dinner or for a drink and, as is standard middle-class behaviour, initially select my background music from the Usual Gang of Idiots (Bach, Mozart, Beethoven, Brahms, etc.). I would then interpose some funk and watch people become puzzled, agitated or annoyed, and then I would attempt to initiate systematic discussion of the source of their dismay (in fact these reactions to my unreflective introduction of the music into this social context were what initially alerted me to the need to confront the issues systematically and collaboratively in the performance context). This usually included listening to samples of funk music and analyzing their structures, content and personal connotations for each listener, in a sympathetic and supportive atmosphere. Occasionally, it also included dance lessons of the kind described previously, though this usually worked better with party-size or larger groups.

The intimate scale of the dialogue permitted a more extensive exploration of individual reactions to funk music and dance, which are usually fairly intense and complex. For example, it sometimes elicited anxiety, anger or contempt from middle-class, college-educated whites: anxiety, because its association with black, working-class culture engenders unresolved racist feelings that are then repressed or denied rather than examined; anger, because it is both sexually threatening and culturally intrusive to individuals schooled exclusively in the idiom of the European-descended tradition of classical, folk and/or popular music; contempt, because it sounds 'mindless' or 'monotonous' to individuals who, through lack of exposure or musicological training, are unable to discern its rhythmic, melodic and topical complexity.

Alternately, funk sometimes elicited condescension or embarrassment from middle-class, college-educated blacks: condescension, because it is perceived as black *popular* culture, that is, relatively unsophisticated or undeveloped by comparison with jazz as black high culture; embarrassment, because funk's explicit and aggressive sexuality and use of Gospel-derived vocal techniques sometimes seem excessive by comparison with the more restrained, subdued, white- or European-influenced middle-class lifestyle. Often this music is also associated with adolescent popularity traumas concerning dancing, dating or sexual competence. These negative associations linger into adulthood and inhibit one's ability even to listen to this genre of music without painful personal feelings.

These and other intense responses were sympathetically confronted, articulated and sometimes exorcized in the course of discussing and listening to the music. The result was often cathartic, therapeutic and intellectually stimulating: to engage consciously with these and related issues can liberate one to listen to and understand this art form of black, working-class culture without fear or shame, and so to gain a deeper understanding of the cultural and political dimensions of one's social identity […]

Adrian Piper, 'Notes on Funk I–IV', first performed in 1982-84, transcribed in 1983-85. Published in Adrian Piper, *Out of Order, Out of Sight, Vol. I: Selected Writings in Meta-Art, 1968-1992* (Cambridge, Massachussets: MIT Press, 1996).

IDENTITY CRISES
The conservative politics that emerged both in Britain and the US in the late 1980s initially fostered a sense of political defeat among feminists and artists. The AIDS crisis exacerbated this despondency, while also stimulating new activist energies and alliances between feminists and people living with HIV. Theories proliferated about possible strategies for challenging the sexual, racial and economic status quo. Many proposed feminist subversion as a more effective strategy than outright confrontation. Questions of identity and identification, of who one is and where one speaks from, were key.

Jo SPENCE
The Picture of Health? 1982 Onwards [1983]

Four years ago I was diagnosed as having breast cancer. Like so many women before me I submitted myself to the medical machine, going along with the treatment so far as to have a lumpectomy performed. The feelings generated in the circumstances surrounding this were so totally negative that I felt, come what may, that I had to get off the medical orthodoxy's production line. The article 'Confronting Cancer' shows how I felt at the time.

CONFRONTING CANCER

When I was a young woman, living still in the parental home, I became aware that I was Waiting for Something to Happen. Years later, when it had apparently already happened without my even noticing, I regretted the loss of this feeling of expectation. Even later, I realized what it had been — the desire that comes with wanting to fall in love, wanting to be told you are loved, by that special Other. Recently, I realized that the feeling had come back. Not (sadly) in relation to love, but to illness and hatred.

This preamble is by way of approaching a difficult subject. Last Christmas, having recently completed three years' study as a mature student, having earned my first-class degree with honours, now utterly exhausted and wondering what the hell it had all been about, I had to go into hospital. Suddenly.

Dutifully, so as not to waste time, I took with me several books on theories of representation, a thin volume on health and a historical novel. One morning, whilst reading, I was confronted by the awesome reality of a young white-coated doctor, with student retinue, standing by my bedside. As he referred to his notes, without introduction, he bent over me and began to ink a cross onto the area of flesh above my left breast.

As he did so a whole chaotic series of images flashed through my head. Rather like drowning. I heard this doctor, whom I had never met before, this potential daylight mugger, tell me that my left breast would have to be removed. Equally I heard myself answer, 'No'. Incredulously; rebelliously; suddenly; angrily; attackingly; pathetically; alone; in total ignorance. I, who had spent three years (and more) immersed in a study of ideology and visual representation, now suddenly needed another type of knowledge; what has come to be called 'really useful social knowledge'. Not only the knowledge of how to rebel against this invader, but also of what to do beyond merely reacting negatively. I realized with horror that my body was not made of photographic paper, nor was it an image or an idea or a psychic structure ... it was made of blood, bones and tissue. Some of them now appeared to be cancerous. And I didn't even know where my liver was located.

This peculiar disjunction in my knowledge of the physical world caused such total crisis in my thinking and activity that it is only now, some six months later, that I am beginning to realize what has happened to me. So began a research project on the politics of cancer, with a fervent desire to understand how I could begin to have a different approach to health in which there would be less consumerism, more medical accountability, more social responsibility, more self responsibility.

Ever since I can remember I have tackled extreme forms of adversity by becoming ill. Usually after the event, I have manifested asthma, hay fever, eczema, colds, flu, bronchitis, depression, lumps and tumours ... whatever. I am now convinced that these came about because, within the class I belonged to, I had been socialized to neglect myself, materially, environmentally, economically, psychically, even (dare I say it) spiritually. Now I am taking the toll as I approach my fifties of having tried so hard for years to give too much, to perform too much, to be too involved in too much ... often for the wrong reasons and with the wrong people.

I was aware in my hospital bed, as I took the first step towards defiance of the medical orthodoxy, that it would be a long and lonely confrontation. It took an immense amount of courage initially to say no, that I didn't want to be mutilated (beyond the three vivid slashes that now adorn my breast), or to be radiated or drugged (what in warfare are called 'hack and burn' methods). The recollection that, at twenty-eight, I had had an ovarian tumour removed because of the side effects of early steroid treatment for my asthma, and that, now, I could lose first one then another breast, terrified me beyond all reason, beyond anything that had ever happened to me before. The realization that I also had months of waiting whilst I was screened to find out if I was now clear of active cancer equally terrified me.

I took the coward's way out and became a vegan. I tackled my diet first. In five months (following the integrated regime of the Bristol Cancer Help Centre) I have lost four stone in weight merely by eating healthily. I sought out therapists in order to find out how to help make my life more balanced without giving up struggling. I took up co-counselling and learnt how to be assertive rather than aggressive. I regularly visit 'my' psychiatric social worker who has steadily worked through endless problems with me, patiently unravelling my closed off system of logic, my repressed desires. And I found myself a delightfully bolshy socialist feminist naturopath. Now I can begin to hear myself ticking over again. No miracles, no racing motor, no rejuvenated going off into the sunset ... it's just that I can begin to hear my inner voices speaking to me in ways I didn't realize were possible.

Beyond that, I can still call upon the social knowledge of all the theoretical and political work I have encountered across the latter years of my life. I can again begin to feel solidarity in political struggles, in spite of the total loneliness of defying the medical orthodoxy. No longer am I engulfed with guilt about not working hard enough, not putting on a good enough performance, whether I occupy the correct political position or not, whether this or that

latest theory can be lived without. I have had to face the fact that I am totally vulnerable, able to die, to feel terror, to be terrorized … but able to fight back with the help of others. Thank you. I learned a lot […]

Jo Spence, 'The Picture of Health? 1982 Onwards', *City Limits* (22 July 1983); reprinted in *Putting Myself in the Picture: A Political, Personal and Photographic Autobiography* (London: Camden Press, 1986) 151-163.

Donna J. HARAWAY
A Cyborg Manifesto: Science, Technology, and Socialist-Feminism in the Late Twentieth Century [1985]

CYBORGS: A MYTH OF POLITICAL IDENTITY

[…] Monsters have always defined the limits of community in Western imaginations. The Centaurs and Amazons of ancient Greece established the limits of the centred polis of the Greek male human by their disruption of marriage and boundary pollutions of the warrior with animality and woman. Unseparated twins and hermaphrodites were the confused human material in early modern France who grounded discourse on the natural and supernatural, medical and legal, portents and diseases – all crucial to establishing modern identity. The evolutionary and behavioural sciences of monkeys and apes have marked the multiple boundaries of late twentieth-century industrial identities. Cyborg monsters in feminist science fiction define quite different political possibilities and limits from those proposed by the mundane fiction of Man and Woman.

There are several consequences to taking seriously the imagery of cyborgs as other than our enemies. Our bodies, ourselves; bodies are maps of power and identity. Cyborgs are no exception. A cyborg body is not innocent; it was not born in a garden; it does not seek unitary identity and so generate antagonistic dualisms without end (or until the world ends); it takes irony for granted. One is too few, and two is only one possibility. Intense pleasure in skill, machine skill, ceases to be a sin, but an aspect of embodiment. The machine is not an *it* to be animated, worshipped and dominated. The machine is us, our processes, an aspect of our embodiment. We can be responsible for machines; *they* do not dominate or threaten us. We are responsible for boundaries; we are they. Up till now (once upon a time), female embodiment seemed to be given, organic, necessary; and female embodiment seemed to mean skill in mothering and its metaphoric extensions. Only by being out of place could we take intense pleasure in machines, and then with excuses that this was organic activity after all, appropriate to females. Cyborgs might consider more seriously the partial, fluid, sometimes aspect of sex and sexual embodiment. Gender might not be global identity after all, even if it has profound historical breadth and depth.

The ideologically charged question of what counts as daily activity, as experience, can be approached by exploiting the cyborg image. Feminists have recently claimed that women are given to dailiness, that women more than men somehow sustain daily life, and so have a privileged epistemological position potentially. There is a compelling aspect to this claim, one that makes visible unvalued female activity and names it as the ground of life. But *the* ground of life? What about all the ignorance of women, all the exclusions and failures of knowledge and skill? What about men's access to daily competence, to knowing how to build things, to take them apart, to play? What about other embodiments? Cyborg gender is a local possibility taking a global vengeance. Race, gender and capital require a cyborg theory of wholes and parts. There is no drive in cyborgs to produce total theory, but there is an intimate experience of boundaries, their construction and deconstruction. There is a myth system waiting to become a political language to ground one way of looking at science and technology and challenging the informatics of domination – in order to act potently.

One last image: organisms and organismic, holistic politics depend on metaphors of rebirth and invariably call on the resources of reproductive sex. I would suggest that cyborgs have more to do with regeneration and are suspicious of the reproductive matrix and of most birthing. For salamanders, regeneration after injury, such as the loss of a limb, involves regrowth of structure and restoration of function with the constant possibility of twinning or other odd topographical productions at the site of former injury. The regrown limb can be monstrous, duplicated, potent. We have all been injured, profoundly. We require regeneration, not rebirth, and the possibilities for our reconstruction include the utopian dream of the hope for a monstrous world without gender.

Cyborg imagery can help express two crucial arguments in this essay: first, the production of universal, totalizing theory is a major mistake that misses most of reality, probably always, but certainly now; and second, taking responsibility for the social relations of science and technology means refusing an anti-science metaphysics, a demonology of technology, and so means embracing the skilful task of reconstructing the boundaries of daily life, in partial connection with others, in communication with all of our parts. It is not just that science and technology are possible means of great human satisfaction, as well as a matrix of complex dominations. Cyborg imagery can suggest a way out of the maze of dualisms in which we have explained our bodies and our tools to ourselves. This is a dream not of a common language, but of a powerful infidel heteroglossia. It is an imagination of a feminist speaking in tongues to strike fear into the circuits of the supersavers of the new right. It means both building and destroying machines, identities, categories, relationships, space stories. Though both are bound in the spiral dance, I would rather be a cyborg than a goddess.

Donna J. Haraway, 'A Cyborg Manifesto: Science, Technology, and Socialist-Feminism in the Late Twentieth Century', *Simians, Cyborgs, and Women: The Reinvention of Nature* (London: 1991) 149-81. Originally published as 'Manifesto for cyborgs: science, technology and socialist-feminism in

the 1980s', *Socialist Review*, 80 (1985) 65-108.

Trinh T. MINH-HA
Questions of Images and Politics [1986]

[…] I have often been asked about what some viewers call the 'lack of conflicts' in my films. Psychological conflicts are often equated with substance and depth. Conflicts in Western contexts often serve to define identities. My suggestion to this so-called lack is: let difference replace conflict. Difference as understood in many feminist and non-Western contexts, difference as foregrounded in my film work, is not opposed to sameness, nor synonymous with separateness. Difference, in other words, does not necessarily give rise to separatism. There are differences as well as similarities within the concept of difference. One can further say that difference is not what makes conflicts. It is beyond and alongside conflict. This is where confusion often arises and where the challenge can be issued. Many of us still hold on to the concept of difference *not* as a tool of creativity – to question multiple forms of repression and dominance – but as a tool of segregation – to exert power on the basis of racial and sexual essences. The apartheid-type of difference.

Let me point to a few examples of practices of such a notion of difference.

The positioning of voices in film. In documentary practice, for example, we are used to hearing either a *unified* voice-over, or a string of *opposing, clashing* views from witnesses which are organized so as to bring out objectively the so-called two sides of an event or problem. So, either in unification or in opposition. In one of my films, *Naked Spaces*, I use three different voices to bring out three modes of informing. The voices are *different*, but *not opposed* to each other, and this is precisely where a number of viewers have reading problems. Some of us tend to consume the three as one because we are trained not to hear how voices are positioned and not to have to deal with difference otherwise than as opposition.

The use of silence. On the one hand, we face the danger of inscribing femininity as absence, as lapse and blank in rejecting the importance of the act of enunciation. On the other hand, we understand the necessity to place women on the side of negativity (Kristeva) and to work in 'undertones' (Irigaray) in our attempts at undermining patriarchal systems of values. Silence is so commonly set in opposition with speech. Silence as a will not to say or a will to unsay, a language of its own, has barely been explored.

The Veil. If the act of unveiling has a liberating potential, so does the act of veiling. It all depends on the context in which such an act is carried out, or more precisely, on how and where women see dominance. Difference should neither be defined by the dominant sex nor by the dominant culture. So that when women decide to lift the veil, one can say that they do so in defiance of their men's oppressive right to their bodies; but when they

decide to keep or to put back on the veil they once took off, they may do so to reappropriate their space or to claim anew difference, in defiance of genderless hegemonic standardization. (One can easily apply the metaphor of the veil here to filmmaking.)

Making films from a different stance supposes 1) a re-structuring of experience and a possible rupture with patriarchal filmic codes and conventions; 2) a difference in naming – the use of familiar words and images, and of familiar techniques in contexts whose effect is to displace, expand or change their preconceived, hegemonically accepted meanings; 3) a difference in conceiving 'depth', 'development' or even 'process' (processes within processes are, for example, not quite the same as a process or several linear processes); 4) a difference in understanding rhythms and repetitions – repetitions that never reproduce nor lead to the same ('an other among others'); 5) a difference in cuts, pauses, pacing, silence; 6) a difference, finally in defining what is 'cinematic' and what is not.

The relationship between images and words should render visible and audible the 'cracks' (which have always been there; nothing new …) of a filmic language that usually works at glueing things together as smoothly as possible, banishing thereby all reflections, supporting an ideology that keeps the workings of its own language as invisible as possible, and thereby mystifying filmmaking, stifling criticism and generating complacency among both makers and viewers.

Working with differences requires that one faces one's own limits so as to avoid indulging in them, taking them for someone else's limits; so as to assume one's capacity and responsibility as a subject working at modifying these limits. The patriarchal conception of difference relies heavily on biological essences. In refusing such a contextualization of difference, we have to remain aware of the necessary dialectics of closure and openness. If in breaking with patriarchal closures feminism leads us to a series of musts and must-nots, then this only leads us to other closures. And these closures will then have to be re-opened again so that we can keep on growing and modifying the limits in which we tend to settle down.

Difference is not otherness. And while otherness has its laws and interdictions, difference always implies the interdependency of these two-sided feminist gestures: that of affirming 'I am like you' while pointing insistently to the difference; and that of reminding 'I am different' while unsettling every definition of otherness arrived at.

Trinh T. Minh-Ha, 'Questions of Images and Politics' (1986) in *When the Moon Waxes Red: Representation, Gender and Cultural Politics* (New York and London: Routledge, 1991) 147-52.

Sonia BOYCE
In Conversation with John Roberts [1987]

Sonia Boyce […] In 1982 I went to the 'Women in Art Education' conference that was held at Battersea Arts Centre, London. Among the 300 or so people there, there were four other black women and two black men. The atmosphere was very peculiar; I got the feeling from some of the white women that not only were they surprised that we should be interested in such a conference, but that we should have been in the canteen serving behind the counter instead! Throughout the two days there was one workshop on black visual art that was taken by a very nice but patronizing English woman who had lived in Africa for several years, and one equally bad workshop on working class women and art. At the plenary there was a discussion on a draft document to be put before the CNAA saying that there should be proportional representation of women in art colleges. I stood up and said that there should be proportional representation full stop. There was a huge argument about this; I was accused of being emotive. Then Trevor Mathison (who is now a member of the Black Audio Film Collective) got up to say something in support, and another woman stood up and said 'I can't deal with him as a black man'. Well, all hell broke loose, Trevor walked out followed by the remaining black women. I stayed to argue it out, which was stupid because they kept me there trying to explain their own view. I thought we were there to campaign for a change in art education – production and consumption – however, it turned out that we were there to further the careers of the middle-class white women there. They failed to see their own racism. For the first time, it occurred to me that there was a chasm between the struggles of the women's movement and the struggles of the black people. Nevertheless, having said that, I don't think we as black artists have resolved as yet where we want to go. In many ways it is easy to be damning about the outcome of some of the initiatives of those involved in the promotion of black visual culture and the motives of those mainstream institutions who have opened up possibilities for black artists. What is required is to distinguish the constructive elements from those areas which maintain a kind of tokenistic, grant related liberal (guilt ridden) inclusionism. Many of these problems came up in relation to the show 'The Thin Black Line' at the Institute of Contemporary Arts in November 1985 selected by Lubaina Himid – who made it quite clear in the title how contemptuous the ICA's offer of the corridor was for the show […]

John Roberts Do you think the GLC's (Greater London Council) promotion of 'positive discrimination' was a hindrance or a help in this area?

Boyce It was a big hindrance, but it was also a help. What the GLC did was give communities the resources to mobilize on a different scale. They made it seem possible that a local government could provide opportunities for black people. Unfortunately the GLC's policy decisions really did confuse and blur the edges of what was tokenistic and what wasn't. The notion of 'positive discrimination' headed us down a complex and, in my view, wrong road.

Roberts Did they expect a certain kind of artist, and a certain kind of work?

Boyce Many artists were asked to produce murals, rather than continue with what they were already doing, which meant they were obliged to fit into the role of accessible/public/'popular' artist. I think the commissioning of black artists to produce murals was an attempt to redress the lack of support for art in public spaces. Public accountability and bureaucratic control are not always sympathetic to the concerns an artist may address in the work. This is a problem I'm sure some community arts projects have had to face. It's a difficult course to take, and not often successful […]

Before I went to college I wasn't aware that any contemporary black artists existed. My school education only went as far as El Greco, Van Gogh, Picasso and a brief glimpse at the Bauhaus, a completely different world and time. What was happening in black music, dance and theatre was a more primary source of inspiration for me.

Roberts This process of development is a very familiar one. The cultural roots and allegiances of black kids tend to be predominantly in music and dance. Do you think this is changing at all?

Boyce Yes it's changing, there are a growing number of black students in art college. That was a result of the struggle of the black community. A whole new generation has grown up in this hostile society and therefore there is a need to create and develop a new visual culture […]

Roberts Your work is part of the recent emergence of a radical black art, but its tone and range of reference is clearly non-agitational […]

Boyce I don't know how to define agitational. Yes, some of the work is celebratory but that is not all. In *Big Women's Talk* (1984), I am discussing many things, not only the bond between women over generations but also the power relations/powerful relationship between mother and child. In the *Missionary Positions* (1985) series I am dealing with how ideology is received at home and school, the influence of religion – in particular Christianity – and its links with the whole ideological/economic/political structure. All this is implicit in the work. I suppose I appear to fall easily into the category of being a woman artist: men take on the world and women deal with the personal. I try to deal with the personal as explicitly political. I became very frightened by the way my work was being discussed as 'domestic', 'sensual' and decorative. I tried to deny that this was a prominent aspect of the work; I was more preoccupied with the issues mentioned earlier. As for the notion of this being a quest for another form of 'truth-telling', my work has not been critical of other practices, rather it has been a question of understanding my own limitations. For three years I argued that drawing was not only there as a preparation for painting but had its own merits as a form of expression. I am now very adamant, despite the fact that my drawings look like paintings, that I am not a painter. It's a way of resisting the idea of painting as all important and drawing as subsidiary.

Roberts However, the drawings do draw on painting conventions. Many of the works, with their patterned surfaces and high colour contrast, point towards a personal negotiation of Western painting conventions. Is this a deliberate strategy?

Boyce My use of pattern owes a lot to my mother's house: your eyes can't stop blinking for all the patterns in my

mother's house. When you go in the living room there are patterns everywhere, on the carpet, on the curtains, on the wallpaper, on the ceiling. They have their own co-ordination. When I started doing drawings about my childhood, I found a book on 1950s design, and I began to use some of the designs as backgrounds. It was at this point that I realized I was including my mother's influence, or rather a West Indian sense of decoration. The patterns, though, aren't simply there to decorate, but are there to give clues to the picture. Many of the images I produce are reminiscent of strip cartoons, snapshots, etc. in that the image focuses, is edited down to the essential information required. Rather than allowing the viewer into a pictorial/mirrored space, the created space is flattened, denying entry, yet often the figures depicted do invite entry. These contradictions between invitation, surface barrier and the sensuality of pastels and crayons is only something I have realized recently.

Roberts How do you view the notion of the 'positive image' in relation to black experience, a category which has had a high critical profile in discussions of black art, particularly photography [...]

Boyce In one sense I am celebrating the strength of black women; however I try not to glorify that strength because I'm constantly reminded of why black women have to be strong. As we know there is a barrage of institutionalized representations of black people. There are enough insulting and negative images. The question becomes then, how does one confront these distortions and initiate change? There was a time when I saw the need, and supported the idea of positive images, of redressing the balance, so to speak, but I have got past that stage. When you start to discuss the issues that affect a community, transposing positives for negatives is insufficient in dealing with the complexities of human experiences and given structures [...]

Sonia Boyce, 'In Conversation with John Roberts', *Third Text*, 1 (Autumn 1987) 55-64.

Aimee RANKIN

Artist's statement [1987]

I haven't heard so much talk about positions since the last time I played 'Twister'. To speak, as we have seen, is to assume a certain position. If we call for 'a number of voices and positions that might question each other', as Barbara [Kruger] and Silvia [Kolbowski] agree to do, we are still left with the sticky question of the position one assumes in asking questions. It all goes to show how easy it is to get lost in the labyrinth of language. If, as has been suggested and as I truly hope, the system of logic which models our thinking process is showing signs of wear, soon we might be able to assume whatever positions we wish in an exuberant orgy of mental gymnastics that would freely encourage a fluid interchange of meaning. Until that time, we operate within our broken logic in the only way we know: by tracing patterns on an axis of similarity and difference and trying to make sense of the mosaic. For me, coming to terms with the artistic practices that inspire me

posed this challenge. To become aware of one's own position one must situate oneself and others in some way. To question positionality can become the most rigid position of all by pointing an accusing finger at the awkwardness of others.

Like everything else, this makes me think of sex. Somebody's got to assume a position sooner or later or nothing will get done. It doesn't matter who's on top as long as it feels good. Sometimes discourse fucks me nicely and I don't begrudge myself this pleasure. Sometime I like to use it to fuck it back – discourse as a sort of strap-on prosthetic dick. I like being able to play in more than one position.

In the end it all boils down to power. How do we fight the dynamic of power since in fighting it we place ourselves within it? Rather than avoiding confrontation, which would eliminate the pleasurable rubbing of one idea against another to see what sparks fly, I would suggest a refusal of the stakes. This is why we should never take this discursive game or our places within it too seriously. Whatever happened to that old 1970s idea, 'the revolutionary power of women's laughter'? Who would want a revolution that didn't allow for dancing in the first place? And what could make the overswollen dick of culture shrivel faster than a woman's well-timed laughter? The sadness of our predicament is so absurd that in the end all one can do is laugh, and encourage the illicit copulations of language to be more and more perverse, more fluid and slick and polymorphous. And then the dancing can begin [...]

Aimee Rankin, Artist's statement in 'Legacies of Critical Practice in the 1980s', *Discussions in Contemporary Culture*, ed. Hal Foster (Seattle: Bay Press, 1987) 117-18.

C. CARR

Karen Finley [1988]

Karen Finley's monologues represent obscenity in its purest form – an attempt to explore feelings for which there are perhaps *no* words, and certainly no polite ones. Whatever the identity she assumes onstage – as gender, persona and narrative slip and slide – she's talking transgression.

At a late-night show she'd ironically labelled her 'Greatest Hits', Finley performed her most (in)famous acts of the last several years. Each piece involved the creation of a distinct persona – in *I'm an Ass Man* (1985), she becomes a man, a rapist, disgusted that his victim is having her period; in *The Neighbour's Cock* (1985), she's the sexually abused girl who's decided to 'tell'. In *The Constant State of Desire* (1986), she's (among other things) a sort of terrorist who coats stockbrokers' balls with shit and sells them as candy. Sometimes she'll punctuate a piece by smearing food on herself – kidney beans, ice cream bars and eggs, respectively, for the three pieces above. These visual aids hint at the violence she's describing, and signal that all boundaries have collapsed here, including inside/outside. Finley mirrors both the victim and the victimizer in all of us.

When the Kipper Kids (whom she considers an influence) smeared food on themselves, it was infantile and funny, and Finley is often quite funny. But a filthy woman signifies something different than a Kipper Kid. Speaking in images of shit and puke and blood, she's a gaping, leaking human body, an uncontrollable and engulfing female energy.

Before Finley gets to this primal stuff in performance, however, she always shows the audience the real Karen Finley – the picture of vulnerability. The point, again, is to hold nothing back. She will customarily and relentlessly expose her own struggle to perform – telling us at the Pyramid Club, for example, that she was afraid, she was having her period, she'd forgotten a costume, etc. The unrehearsed commentary framing each monologue took on more and more weight, till it completely overwhelmed what she described as her Greatest Hit of all – a monologue about sexual abuse and abandoned old people that she 'illustrates' by putting canned yams up her ass (*Yams Up My Granny's Ass* [1985]) [...]

C. Carr, 'Karen Finley: The Pyramid Club', *Artforum*, 27: 3 (November 1988) 148.

Jean FISHER

Reflections on Echo: Sound by Women Artists in Britain [1989]

[...] The inattention to aural experience in the construction of human subjectivity is undoubtedly coincidental with a general emphasis in critical debates on visual representation, an emphasis which is attributed to the priority given to vision in a Western culture dominated by patriarchal principles. Jacques Lacan equates this priority with the visibility of the phallus, rendering it the privileged signifier of potency under which all those constituencies deemed lacking – in terms of race, gender, class, etc. – are subordinated. Certainly vision has a significant place in the classical founding myths of patriarchy. Oedipus' self-blinding is interpreted by Freud as 'castration' (the self's submission to the authority of the Father – symbolic language); but it is worth noting that this shift towards a 'feminine' position of 'lack' simultaneously enables the hero to gain insight – access to an 'other' knowledge beyond perceptual vision. This visionary role is not, however, given equal value in terms of gender. We might contrast the status held by the blind seer Tiresias, or the blind philosopher Sophocles, with that of Cassandra. Like Tiresias she is also a visionary, and yet she is deprived of a legitimate speech: her utterances are dismissed as inconsequential mad ravings.

A similar depreciation of the female voice and a usurpation of its creative potential is to be found in contemporary media representations. I should like to draw attention to Kaja Silverman's analysis of the use of the woman's voice in mainstream cinema since, like the use of her image as visual spectacle, it aims to disavow and

project the male subject's impotence, or 'symbolic castration', onto the body and voice of the feminine.' This female voice is denied its own utterances to become 'the site of a discursive impotence' – his 'acoustic mirror'. As Silverman points out,[2] one rarely encounters a genuine female voice-over in classic film since this position assumes an omniscient or transcendental (traditionally male) author of the narrative. By contrast, the thrust of a good percentage of conventional psychosexual dramas is to make the woman *confess*, to reveal her 'true nature', as it were (and is this not also the demand that Freud as 'father confessor' makes of his 'hysterical' female patients?).[3] The extreme expression of this 'confession' is the extraction of an involuntary cry, confirming for the male subject his equation of the feminine with the body and nature (as distinct from the mind and intellect), and with the infantile (immature or meaningless speech). The female voice is conventionally synchronized with the image track precisely because it is as 'body as lack' that she is constructed in mainstream cinema.[4] Brian de Palma's *Blow-Out* (1981), understands this essential demand of a male-authored cinema. A sound-effects man on a porn film production is sent in search of a female scream to dub onto a Hitchcockian shower scene since the actress' own is not 'authentic' enough. Not surprisingly this is extracted from a female protagonist at the moment of her death, leaving us with the feminine as a disembodied, endlessly repeatable representation – the recorded scream.[5] In so far as it understands that male representation (or art, if you like) is achieved at the price of a loss of the (feminine) real, *Blow-Out* is a Postmodern reworking of the Orpheus and Narcissus myths of male creativity. Where, however, does this place women's creative practice? If Eurydice is rendered mute and Echo deprived of the right to be the subject of an enunciation within the discourses of patriarchy, in what way can women be the producers of meaning and not simply its passive sign? Can 'lack' be turned to positive effect?

What can be said about Echo's prescribed position? According to one version,[6] Echo's story begins with a maternal sentence. Hera is vexed by the nymph Echo's incessant chatter which distracts her from keeping an eye on Zeus' adulterous affairs. As a punishment, Hera prohibits Echo from uttering all but the last phrase of another's speech. As we know, Echo subsequently falls hopelessly in love with the beautiful but self-absorbed Narcissus. Some say he drowned himself in his own reflection; others say he metamorphosed into a lovely flower. In any case, like Orpheus, Narcissus presents a redemptive phantasy of male loss and regeneration: the artist/poet whose creative act springs from a denial and a usurpation of the generative role of the feminine (the 'maternal') in order to secure his own immortality. As for her, she may, through her expiratory breath, be the inspiration but not the producer of meaning. Thus, as Eurydice's body is relegated to the place of a liminal shade, so Echo's body fades away leaving a voice without originary speech that is, according to this patriarchal myth, nowhere in particular. Clearly her utterance is quite other than the authorial voice of being, since there is no being to speak of. But Echo's disembodied voice that

speaks in others' tongues presupposes an additional function: it is also an ear. Echo becomes both audio receiver and transmitter.

I want to pursue the significance of this function by way of what might, at first, appear to be an unlikely literary elaboration of the story of Echo (if only unconsciously on the part of the author) in Bram Stoker's late gothic novel *Dracula*.[7] It is the character of Mina who absorbs our attention, for she is the matrix of the plot to which all things collect and from which they are reproduced.[8] We first meet her as Mina Murray (a name that recalls the old word *murra*, meaning the substance of precious vessels). She is soon transformed by marriage into Mina Harker, a name that now establishes her role as a listener. In contrast to her voluptuous and romantic friend Lucy, Mina is the disembodied, de-eroticized feminine. Indeed, her 'body' only appears in the text after her 'seduction' by Dracula: a seduction that renders this body 'unclean', and therefore subject to 'disfigurement' by the brand of the Holy Wafer (making visible her transgression in the eyes of the Law).

Mina, described by the patriarch Van Helsing as having 'the mind of a man' (but nevertheless possessing those feminine weaknesses against which she herself must be protected),[9] collects and disseminates information: she writes in hieroglyphic shorthand; she reads and transcribes the written and phonographic diaries; she listens to the men's talk and lends an ear to their emotional troubles; and she collates and reproduces everything on her typewriter. Later, in telepathic communication with Dracula, she becomes his ear and recorder as he flees his future assassins. Her role is thus centred on an economy of the ear not of perceptual vision: she is the transcriber and disseminator of 'truth', but also a 'visionary' in so far as she 'sees' and 'hears' what the men do not. In short, she encompasses these roles assigned to women in the capitalist economy or its fringes: typist, stenographer, nurse, psychic medium, psychoanalyst, etc – all ears, and typically connected to the technologies of (tele.)communication.

In retrospect, we should not be surprised to find that, since the late 1960s and the development of non-traditional forms of art, women artists have found a creative space through technological media, ranging from the single-screen use of film and video, slide and sound projection, to multi-media performance and installation [...]

By contrast, time-based media – and installation strategies that insist on the mobility and accumulative experience of the viewer – introduce a temporal component to art production and reception. (Indeed, one of the legacies of 1970s aesthetic debates, not however exclusive to feminism, was a Brechtian insistence on the active and critical participation of the viewer in the production of meaning of the work.) This, in turn, opens the work to models of *transformability*: a potential to interrogate idealist illusions of coherent subjectivity, and to explore the mutability and heterogeneity of human identities. Hence, for those groups previously denied the right to represent their own experience, time-based functions provide the means for re-narrating subjectivity

and transforming a sense of selfhood from the fixed categories of race, gender and class imposed by dominant culture. It is, therefore, a kind of narrativity that interests us here: Echo's oral-aural circuit. However, a cautionary note: I am not imputing an essential feminine to sound or narrativity, for this would distract us from the profound heterogeneity of women's experiences and their expression in culture. While we may all, broadly speaking, share the same language, our experience, and hence use of it, as gendered, class or ethnically defined subjects are by no means identical. The question is, rather, of the way the reproductive value of the female voice has been not simply suppressed but colonized by a language dominated by the privileged subject and positioned in its social discourses. While women have been essential to economic productivity ['labour' in both senses of the word], this role is rendered marginal in society's master narratives of productivity and creativity.[10] It is also, therefore, a question of working through the stereotypes of a feminine 'passivity' to which, at first glance, Echo's repetition appears to conform. Given this non-place assigned to Echo, does her repetition always return language to a putative (male) place of origin and its pretensions to transcendental meaning, or can it shift the ground of the socio-sexual text [...]

I should like now to shift the location of this narrative to Greenham Common outside London where, in 1981, thousands of women, from different social classes,[11] gathered to form a peace camp in protest against the installation of the 501st USAF nuclear missile base. The base was perceived as symbolic of a malignant military policy endangering the future of life itself. I should like to discuss two pieces of work that refer to this scenario: Tina Keane's single-screen video version of *In Our Hands, Greenham* (1984) and Alanna O'Kelly's sound work *Chant Down Greenham* (1988).[12]

In the visual component of her piece, Tina Keane takes up a primary metaphor in the peace camp: women's industry (productivity) as it works to form the matrix of community, yet its exclusion from the site of power. Images of a spider spinning her web are juxtaposed with footage of the women's activities – joining hands around and outside the perimeter fence of the base; weaving webs of wool to symbolize strength in unity; decorating the fence with family photographs and personal memorabilia. The soundtrack counterpoints the sounds of the peace camp with a woman's voice-over testimony of how she decided, independently of her husband's opinion, to march for peace, and her witness to the ensuing confrontation with the police. What emerges is the sense of euphoria and comradeship experienced by the women.

In Our Hands, Greenham pursues a recurrent theme in Keane's work – women's collective action and sense of generational continuity – which the artist has explored both through early collaborative work with her daughter Emily and through various forms of oral narration – 'As I have heard it from my mother as she has heard it from her mother' (as the woman narrator says in Keane's film *Shadow of a Journey* [1980]). The mother/daughter dyad in Keane's work does not, however, presuppose Freud's Oedipal relation to the maternal as the only form of

identification with the mother open to the daughter. (If anything, the persistent bond between these two female subjects suggests a transgression of the Oedipal demand for the girl's psychic investment to be redirected from the maternal towards the paternal signifier.) Keane's work addresses the position of the female subject within the social text. Hence the importance of the metaphor of the *journey* in Keane's work, which frequently makes problematic the relationship between female subjectivity and historical linearity.[13] In the sound version of *Demolition/Escape*,[14] the arrival and departure of a train brackets *My Girl's a Corker*, a burlesque song denigrating the female body, and whose male gendered 'author' appears in the sudden drop in pitch of Emily's young singing voice. In the installation version of the work, the constant shunting back and forth of a toy train is juxtaposed with a 'countdown' of neon numerals and the videotaped image of the artist struggling to ascend a rope ladder – metaphors of women's entrapment in, and struggles against, dominant narrative closure. Throughout the body of Keane's earlier work, her own childhood memories are woven with the encounters in language of her growing daughter; but continuity here entails not a repetition of the same but a constant attempt to reinscribe and remake female subjectivity across diverse social narratives.

Alanna O'Kelly's *Chant Down Greenham* is less an overt narrative than a tone poem, composed of uncompromising silences alternating, like Keane's piece, with the sounds of the camp – the women's wordless echolia, their derisive whistling, their chanting and drumming, their laughter, and the noise of circling helicopters which, since the Vietnam War (or, at least, since *Apocalypse Now*!) has come to represent the chilling sound of military aggression. These sounds are orchestrated with a powerful keening (from the Irish *caoine*, or *Caoineadh na Marbh* – keen for the dead, which is traditionally part of women's duties at funeral rites). O'Kelly's menacing sustained expulsion of breath is less a cry of loss, however, than a rallying cry of defiance, to which the women's chanting and laughter become a chorus or echo of solidarity. This cry is therefore a reminder of the materiality of sound as it resonates through and connects bodies, revealing the socially unifying function of communal chanting. And it is through *physicality* that the work exerts its most powerful effect, for it not only hits us in the ear but also in the solar plexus. Hence, sound here is not simply the carrier of a message; it figures the power of the voice and body to act beyond its subjugation to articulated speech and its reduction to physiology. O'Kelly's keening liberates the voice from the specular body and reinvents it as political agency, alluding, among other things, to a refusal of the pacification of Irish identities effected through English colonialism.

In neither of the 'Greenham' works is the notion of the community of women, or communication among women, intended to homogenize differences under some universalizing principle; in both cases singularity or personal witness is juxtaposed with communal experience, and one that is attached to a particular social and historical moment. A collective articulation of women's experiences reminds us that femaleness and female sexuality are historically and politically constituted […]

Interference in articulated speech, with its insistence on the inscription of the speaker in linear historical time, is what Echo brings into play. Echo's repetition interrupts and fragments logical syntax, reducing a given utterance to an oscillation of phonetic signifiers disengaged from a determinable 'originary' meaning. Is this fracturing of symbolic language simply the sign of an incoherent 'madness'? Or is this 'madness' what is produced in women whose own desires remain unnarratable? This is what seems to be suggested in Sharon Morris' soundwork *Everyday* (1988), a litany of the mundane repetitive routines of the house-bound wife, which periodically falls into delirious speech. However, that this fracturing of articulated speech may also provide a ground upon which to construct 'other' meanings is suggested by Morris' *The Moon Is Shining on My Mother* (1988).[15] The piece begins with a woman's voice singing a Welsh language lullaby. Soon the voice doubles, then multiplies, slipping into a harmonic humming. From the repetition of the sound 'hum', formed by a simple resonance of the buccal cavity, two voices echo the childlike syllabic fragment 'ma-ma'. Then through a dialogical syncopation, vowels and consonants combine and recombine into a progression of English and French syllables that form themselves into words: ' … a-ma … mum-ma … mur-mur … mur-der … mer-de … a-mour … ai-mee … me-me … ' From this Babelian play of phonemic differences a web of meaning-effects is spun out that speaks of the interruption of the mother tongue by the language of patriarchy, and hence the child's accession to subjectivity through separation, loss of desire for a maternal imaginative space. But in 'me' there forever lingers the faint murmur of 'ma-ma': 'The Moon Is Shining on My Mother' is the song that fades to a memory […]

The cryptolinguistic sign is central to the work of Susan Hiller. Her use of projected automatic scripts and wordless vocalizations alludes to what has been absented from the socio-political domain yet remains as a persistent trace or 'hallucination' at the borders of social consciousness. Hiller makes visible these seemingly marginal utterances as the very terms upon which dominant narratives are predated.

Belshazzar's Feast/The Writing on Your Wall (1983–84), specifically refers to storytelling; one version presents a cluster of video monitors arranged on the floor to suggest a camp-fire.[16] As we watch images of sparking lights develop into flickering tongues of flame, a woman's voice announces the commencement of an artifice: 'What the fire says, Take 1 … ' Thereafter we become engulfed in a mesmerizing daemonic and indecipherable vocalization whose exotic overtones suggest some other space or time. At intervals, a secretive whispering recounts newspaper reports of images of aliens transmitted on TV after station close-down, and the artist's young son Gabriel hesitantly attempts to describe the story of the cryptic and apocalyptic inscription that the prophet Daniel is invited to 'interpret'. *Belshazzar's Feast* is a reverie on the images of reverie as figurations of repressed unconscious desires. What we perceive as transmitted messages – in the fire, on TV, in the patterns of wallpaper, etc. – are projections of our own imaginings. What appears as the 'inexplicable' or 'illogical' on the border of consciousness also marks the limit of the subject in socialized language – or the limitations of the latter to restrain desire. In *Belshazzar's Feast* vocalization releases the vibrations of the libidinal body, and different stories of 'other' selves become audible.

Narratives proliferate, voices multiply, merge and echo one with another. No longer the stutters and paralyses of an unspeakable 'reminiscence'; no longer, also, the confessions extricated from Freud and Breuer's hysterical patients. Women's claim to an authorial voice, resonant with their own experiences, is a move to re-articulate an imaginary space with symbolic language, a move that transgresses the Oedipal demand that they accept their 'lack' with good grace. For Hélène Cixous this body called female is not to be censored, for to do so is also to censor its breath and speech. 'Write yourself', she exhorts, 'Your body must make itself heard'.[17] For Cixous also the female voice is an embodiment, not of Oedipal lack but of a reactivation of a pre-Oedipal desire for the Mother: *'In feminine speech, as in writing, there never stops reverberating something that, having once passed through us, having imperceptibly and deeply touched us, still has the power to affect us – song, the first music of the voice of love, which every woman keeps alive … The Voice sings from a time before law, before the Symbolic took one's breath away and reappropriated it into language under its authority of separation …'*[18]

If Cixous' Voice of the Mother seems like a fantasy of a pre-Oedipal utopia, it is nevertheless articulated through a post-Oedipal experience. As political agency, perhaps we have to think it as a metaphor, like Hiller's 'automatic writing': something that insists in the interstices of symbolic language, that rises like the vampiric mist to contaminate it with its repressed desires. It is perhaps in this way that women's storytelling reclaims the oral traditions of personal and collective memory as counter-narratives to the homogenizing and depoliticizing histories of dominant discourses.

As she speaks, Echo produces a plural singularity. Her transmission is itinerant. Never identical to its source, her repetition is a constant production of difference. Its 'speaking in tongues', its disruption of syntactical order, signal a refusal to be tied to any fixed subject-position. Hera's sentence, while insisting on a maternal alliance, releases an imaginative and subversive speech.

And what of women's use of *silence*? Is this, too, always to be construed as passive acquiescence to her subordination in language? Perhaps not. The absence of sound in Tina Keane's video installation *Escalator* (1988),[19] is notably rare in the artist's body of work. Its effect is all the more oppressive as we become hypnotized by the flow of images of Underground escalator steps, moving endlessly up to a bright scene of corporate success and down to the twilight zone of poverty and homelessness: a world without human communication.

We have already mentioned the silent pauses in *Chant Down Greenham*. Their duration produces an unease, a suspension of breath. O'Kelly resists the demand that

'she' fill absence with the illusory plenitude of words.

And one final story – *Anne Devlin*, as told by the Irish filmmaker Pat Murphy. Anne agreed to act as 'housekeeper' to a group of United Irishmen lead by Robert Emmet who were plotting an uprising at the beginning of the nineteenth century. She was captured, tortured (almost *hanged*) and kept a prisoner by the British military long after the conspiracy had been crushed because she refused to 'confess'. As Luke Gibbons points out, Murphy re-read Anne's silence, not as passivity or absence of meaning but as a political act of defiance: 'Throughout the film, Anne is pre-eminently a messenger, a vehicle or *medium* of communication between Emmet and his various contacts. Yet Anne is a medium with a difference.'[20] From a position always oblique to the action, Anne sees, she touches, but above all she *listens*. And what she hears is an empty rhetoric that springs from the voices of both Irish romantic idealism and British colonial power. If she refuses to speak it is out of loyalty neither to Emmet nor to the nationalist cause; but because she will not speak in the voice of the other the words he wants to hear. She refuses to be an 'acoustic mirror' to male narratives of redemption, and in this refusal her silence is to be feared.

1 Kaja Silverman, *The Acoustic Mirror: The Female Voice in Psychoanalysis and Cinema* (Bloomington and Indianapolis: Indiana University Press, 1988).

2 *Ibid.*, 165.

3 Sigmund Freud and Josef Breuer, *Studies on Hysteria* (London: The Pelican Freud Library, 1974) 368.

4 An apparent exception is the *voluntary* scream uttered by the Doris Day character in Hitchcock's 1956 version of *The Man Who Knew Too Much*, whose intention is to divert the aim of an assassin. The premise of the scream is turned back on itself in so far as the woman must use an effect of her body not to confirm the other's power but to exert her own.

5 The heroine's body is 'bugged' with a miniature microphone through which she must provide the hero with an incessant narrative of her location. His failure to remain connected to this apparatus leads to her death by garrotting - a severance of body from voice.

6 Ovid's *Metamorphoses*.

7 Bram Stoker, *Dracula* (New York: Bantam Books, 1897/1981).

8 In Jonathan Harker's postscript at the end of the novel, we learn that Mina has become the mother of a son whose 'bundle of names links all our little band of men together'.

9 It is noteworthy that film versions of Stoker's novel - for example, Herzog's *Nosferatu* and Badham's *Dracula* - seem unable to deal with the subversive implications of Mina. She is reassigned under the character and name of Lucy.

10 For a critique of Marxism and women's work see Gayatri Chakravorty Spivak, 'Feminism and Critical Theory' in *In Other Worlds: Essays in Cultural Politics* (New York and London: Methuen, 1987) 77.

11 I have not been able to ascertain whether women from other ethnic constituencies also participated.

12 O'Kelly's piece is part of an anthology of sound works by women artists, *Sound Moves* (1988), compiled by Sharon

Morris and Michelle Baharier, and co-ordinated by Projects UK. The work could be heard on British Telecom from 4 May to 6 September 1988. Unfortunately it is not possible to discuss them all here. The participating artists were Michelle Baharier, Mari Gordon, Jan Kerr, Marysia Lewandowska, Sharon Morris, Alanna O'Kelly, Anna O'Sullivan, Maggie Warwick and Caroline Wilkinson.

13 For a theoretical discussion of women's relation to time see Julia Kristeva, 'Women's Time', in *The Kristeva Reader*, ed. Toril Moi (Oxford: Basil Blackwell Ltd., 1986).

14 'Live to Air', *Audio Arts Magazine*, 5: 3 & 4 (1982).

15 Sharon Morris, *Sound Moves*, *op. cit.*

16 *Belshazzar's Feast/The Writing on Your Wall*, version installed at the ICA, London, 1987.

17 Hélène Cixous, 'Sorties', in Cixous and Catherine Clement, *The Newly Born Woman*, trans. Betsy Wing (Minneapolis: University of Minnesota Press, 1986) 97.

18 *Ibid.*, 93.

19 Installed at the Riverside Studios, London, 1988.

20 Luke Gibbons, 'The Politics of Silence: Anne Devlin, Women and Irish Cinema', *Framework*, 30/31, 11.

First version presented as a paper at the Whitney Museum Students Independent Study Program (New York, 1987). Jean Fisher, 'Reflections on Echo', *Eau de Cologne*, 3 (1989); reprinted in *Signs of the Times*: *A Decade of Video, Film and Slide-Tape Installation in Britain, 1980-1990*, ed. Chrissie Iles (Oxford: Museum of Modern Art, 1990).

Yvonne RAINER
Interview with Mitchell Rosenbaum [1989]

[...] *Mitchell Rosenbaum* Can you talk about what you do with the gaze in *The Man Who Envied Women*? You seem to have taken care of the problem of the male gaze in a twist on Buñuel's dual actresses in *That Obscure Object of Desire*.

Yvonne Rainer In Buñuel's film the female characters become objects insofar as they are interchangeable for the male protagonist, who can't tell them apart. In *The Man Who Envied Women*, the male characters are interchangeable, thus becoming objects for the gaze of the audience but not for an embodied female character. This seemed to me taking quite literally the problematic of the image of the woman as the object of the controlling male gaze as elaborated by feminist film theorists. Here I removed her physical presence totally while having two men play the same role. But it then becomes unclear how the gaze operates. The strategy removes it from filmic narrative convention and there's something going on here that disproves a lot of this gaze stuff. The overheard heroine, because she is unseen, cannot be said to be the object of a controlling gaze internal to the film, but then neither is Jack Deller, though both of them are objects of identification for the audience. This is a case where the traditional axes of gaze, power, identification have been skewed somewhat, allowing the female spectator a less

ambivalent access to the image through the voice of the heroine. The male protagonist is not, however, objectified through a simple reversal of codes. His 'imaging' is constantly tempered by his powerful 'discoursing' and by his monitoring and mastering behaviour, in the metaphor of the headphones, for instance. He becomes an emblem and agent of patriarchal abuse. His case, from a narrative standpoint, remains unresolved. He is never brought 'under control' as his cinematic 'wild-woman' counterpart has traditionally been. That would have been too simplistic.

Rosenbaum Your approach to narrative has changed since you made *Lives of Performers*.

Rainer At that time I was doing a kind of parody of narrative. The performers read self-consciously from a script. There was no sync sound. It was a very distanciated kind of narrative. I set up these tableaux of minimal situations all in that barren space that could be dressed with a chair or a suitcase to refer to a history of melodramatic objects and usage. It was very stagey and artificial. You might say I am moving at a snail's pace toward a more conventional, illusionist use of narrative, with professional actors, *mise-en-scène*, and a semblance of plot.

Rosenbaum One of the most difficult sequences to read in *The Man Who Envied Women* is the lecture sequence. In part because of the sheer length of it and partly because the significance of the space in which the lecture takes place is unclear.

Rainer That scene is only twelve minutes long! I made some strategic errors – or one, anyway. The subtext of the space of the lecture as a prime piece of New York real estate up for sale can only be recognized as such at the end when you see the new kitchen and bathroom. I should have either started in the kitchen, or put in more clues – like a realtor's sign or something – to make you focus in on that space and its particular New York significance. It's especially opaque to a European audience.

Rosenbaum It does elicit the most antagonistic responses from people.

Rainer Yes, people have so much trouble with that lecture that at that point they dismiss him [Jack Deller]. Later they dismiss him when he's talking to his shrink about women, doing that self-pitying, imperial rap. After that they want to beat up on him a bit. So they don't know how to take it when he starts speaking this Foucault stuff. Is this just some more bullshit? Is it being used for bullshit purposes, or what? I can rationalize in terms of the complexity of the character. He's not totally bad, not a total schmuck and he has some progressive social positions that are quite clear (and with which I totally agree). Like when he responds to the cigar ad on the wall and he talks about the exploitation of labour in Central America.

Rosenbaum I must admit I didn't realize you had any sympathy for him at all.

Rainer Yeah, I do. There are women who find him vulnerable and appealing. Men are much harder on him, they see him as reprehensible and ludicrous, so they can't take anything he says seriously. But he says a lot of right-on things. I wanted to make a very complicated situation; I didn't want to make a simple agit-prop sort of film. We see

this all the time in the progressive and leftist documentary. In a way he's right when he says, 'I'm a mass of contradictions, and what else can you expect under capitalism?' We get it right in some areas and in other areas we have these emotional needs and desires for autonomy and power that take various forms, some of which may be injurious to those around us.

Rosenbaum Still, for people who see him as all schmuck, he is simply an agit-prop character.

Rainer I think of him as a pastiche and a construction. His speech is recitation from a collage of different things including real life. I think I made a calculating kind of film in which a spectator can go only so far toward psychological recognition before having to pull back and say, 'Hey, who is this person? How is he made? He's full of conflicting information, politically and performance-wise. What does this mean?' And then you have to deal with the information and not just with the guy who speaks it. Like, must you dismiss everything he says because he's a womanizer? I don't think you can read this kind of film in this way. The fact that so many people do, makes me realize how these habits of reading films die very hard, and it continues to be challenging to make films where these viewing habits are interfered with and questioned […]

Mitchell Rosenbaum, 'Interview with Yvonne Rainer', *The Films of Yvonne Rainer* (Bloomington and Indianapolis: Indiana University Press, 1989) 42–43. (Revised 1999.)

Carole S. VANCE
The War on Culture [1989]

[…] In the past ten years, conservative and fundamentalist groups have deployed and perfected techniques of grass-roots and mass mobilization around social issues, usually centring on sexuality, gender and religion. In these campaigns, symbols figure prominently, both as highly condensed statements of moral concern and as powerful spurs to emotion and action. In moral campaigns, fundamentalists select a negative symbol which is highly arousing to their own constituency and which is difficult or problematic for their opponents to defend. The symbol, often taken literally, out of context and always denying the possibility of irony or multiple interpretations, is waved like a red flag before their constituents. The arousing stimulus could be an 'un-Christian' passage from an evolution textbook, explicit information from a high school sex-education curriculum or 'degrading' pornography said to be available in the local adult bookshop. In the anti-abortion campaign, activists favour images of late-term foetuses or better yet, dead babies, displayed in jars. Primed with names and addresses of relevant elected and appointed officials, fundamentalist troops fire off volleys of letters, which cowed politicians take to be the expression of popular sentiment. Right-wing politicians opportunistically ride the ground swell of outrage, while centrists feel anxious and disempowered to stop it – now a familiar sight in the political landscape. But here, in the NEA controversy, there is something new.

Fundamentalists and conservatives are now directing mass-based symbolic mobilizations against 'high culture'. Previously, their efforts had focused on popular culture – the attack on rock music led by Tipper Gore, the protests against *The Last Temptation of Christ* and the Meese Commission's war against pornography. Conservative and neo-conservative intellectuals have also lamented the allegedly liberal bias of the university and the dilution of the classic literary canon by including 'inferior' works by minority, female and gay authors, but these complaints have been made through institutional and bureaucratic channels – by appointing more conservative members to its governing body, the National Council on the Arts, by selecting a more conservative chair and in some cases by overturning grant decisions made by professional panels. Although antagonism to Eastern elites and upper-class culture has been a thread within fundamentalism, the NEA controversy marks the first time that this emotion has been tapped in mass political action […]

Though we might possibly reject the overly literal connection conservatives like to make between images and action ('When teenagers read sex education, they go out and have sex'), we too know that diversity in images and expression in the public sector nurtures and sustains diversity in private life. When losses are suffered in public arenas, people for whom controversial or minority images are salient and affirming suffer a real defeat. Defending private rights – to behaviour, to images, to information – is difficult without a publicly formed and visible community. People deprived of image become demoralized and isolated, and they become increasingly vulnerable to attacks on their private expressions of nonconformity, which are inevitable once sources of public solidarity and resistance have been eliminated.

For these reasons, the desire to eliminate symbols, images and ideas they do not like from public space is basic to contemporary conservatives' and fundamentalists' politics about sexuality, gender and the family. On the one hand, this behaviour may signal weakness, in that conservatives no longer have the power to directly control, for example, sexual behaviour, and must content themselves with controlling a proxy, images of sexual behaviour […] On the other hand, the attack on images, particularly 'difficult' images in the public domain, may be the most effective point of cultural intervention now – particularly given the evident difficulty liberals have in mounting a strong and unambivalent response and given the way changes in public climate can be translated back to changes in legal rights – as, for example, in the erosion of support for abortion rights, where the image of the foetus has become central in the debate, erasing the image of the woman.

Because symbolic mobilizations and moral panics often leave in their wake residues of law and policy that remain in force long after the hysteria has subsided,[1] the fundamentalist attack on art and images requires a broad and vigorous response that goes beyond appeals to free speech. Free expression is a necessary principle in these debates, because of the steady protection it offers to all images, but it cannot be the only one. To be effective and not defensive, the art community needs to employ its

interpretive skills to unmask the modernized rhetoric conservatives use to justify their traditional agenda, as well as to deconstruct the 'difficult' images fundamentalists choose to set their campaigns in motion […]

The fundamentalist attack on images and the art world must be recognized not as an improbable and silly outburst of Yahoo-ism, but as a systematic part of a right-wing political programme to restore traditional social arrangements and reduce diversity. The right wing is deeply committed to symbolic politics, both in using symbols to mobilize public sentiment and in understanding that, because images do stand in for and motivate social change, the arena of representation is a real ground for struggle. A vigorous defence of art and images begins from this insight.

1 The 19th-century Comstock Law, for example, passed during a frenzied concern about indecent literature, was used to suppress information about abortion and birth control in the United States well into the 20th century. For accounts of moral panics, see Jeffrey Weeks, *Sex, Politics and Society*; Judith Walkowitz, *Prostitution and Victorian Society: Women, Class, and the State* (Cambridge: Cambridge University Press, 1980); and Gayle Rubin, 'Thinking Sex: Notes for a Radical Theory of the Politics of Sexuality', in Carole S. Vance, ed., *Pleasure and Danger: Exploring Female Sexuality* (Boston: Routledge & Kegan Paul, 1984) 267–319.

Carole S. Vance, 'The War on Culture', *Art in America*, 77: 9 (September 1989) 39–43.

Kellie JONES
In Their Own Image [1990]

Somewhere in the interstices between the much maligned mutability of 'pluralism' and the marginalized trajectory of 'difference' is the common ground where most artists work. It is baffling to consider that in most art-historical texts, a handful of practitioners represents the industry and ideas of fifty years, while hundreds go unaccounted for – until such time, of course, as they serve the purposes of the commercial or cultural power structure. History, after all, tends to be written by winners. As Lowery Stokes Sims has pointed out, the fictional 'other' is little more than a cathartic symbol, and 'difference' a detour sign deflecting us from issues of power and control of a narrowly defined, nonrepresentative (art) world.' If today there is a 'reworking of existing cultural frames of reference',[2] it is a movement occasioned by the need to redefine a skewed perspective that has somehow cast more than two-thirds of the world's people – and their culture – as 'minority'.

Taking a look at the recent history of photography and text art, it should not be surprising to find women of colour who are involved with this medium, though most books, articles and general documentation might lead you to believe that only white males have created anything of lasting value.[3] Indeed, it is with individually identifying these black women practitioners rather than abstractly

acknowledging their existence that problems arise, that the record has to be set straight […]

The eight artists discussed here all began combining text with photography during the early to mid 1980s. Most had done documentary work and adopted the photography/text format as a method to both delimit and expand the implicit meanings in standard 'straight' photography. On the one hand, joining words to the photograph could clarify the reception of the single image, grounding ideology and meaning and leaving less chance for misinterpretation. This approach, of course, also mirrors the way photographs usually circulate in the world: in magazines, newspapers and advertising, and on television an image is always accompanied by a verbal cue. On the other hand, adding text can also expand the meaning of the single image. Furthermore, the addition of a textual element changes the traditional relationship between the photographer and the subject, forcing the practitioner in some way to explain her voyeurism. At the same time these works challenge the viewer's customary response. A 'typical' family portrait layered with script is no longer seen as a regular family photograph but must be read in a different way, relative to a specific situation; an image of a woman sitting alone in a bucolic field, for example, becomes not a figure of meditation or contemplation but one signifying isolation and danger as directed by the caption below. Implication expands, creating layers and levels of intent; words do not have to allude to pictures nor pictures to words, but can signify ideas outside this framework. These photographers were also drawn to the intrinsic social, almost didactic, function of the format. Because the act of reading expands the time one actually spends with any given work, photography and text do more to engage the viewer as reader/participant […]

As women of African, Asian or Caribbean descent living or born in the US and Britain, they draw on a variety of world views and ethoses. It is often a fragmented existence, described by W. E. B. DuBois at the turn of the century as one lived behind a veil, a life *in* but not entirely *of* the dominant/modern culture. Yet it is interesting that the Postmodern condition of the decentred (Western) individual *sans* 'master narrative' has much in common with the quandary in which people of colour find themselves in the West. As Stuart Hall has noted, 'Now that, in the Postmodern age, you all feel so dispersed, I become centred. What I've thought of as dispersed and fragmented comes, paradoxically, to be *the* representative modern experience!'[4] The work of these artists thus extends and supplements our understanding of Western culture and cultural practices.

So while the techniques and formal methods used by the photographers here are recognizable, there is something – image, language, reference – by which they make them their own. Self-expression cannot be culled from a 'limitless replication of existing models',[5] à la Cindy Sherman, for few exist. And simply recontextualizing found images (as does Sherrie Levine or Richard Prince) will often not get through to an audience including people of colour, who have a hard time getting past stereotypes and slurs that still sting from habitual (and current) use. As

Angela Davis and Michele Wallace have both pointed out, exposing myth as fabrication does not dispel the myth; the 'revelation' simply takes its place next to the fiction as another version of this fiction[6] […]

Mitra Tabrizian's photographs employ the language and structure of film. Using this familiar and popular visual form she deconstructs 'standard' or 'given' definitions of sexuality and race, calling into question the power relations that structure our identity and existence. In a black and white series of works from 1985–86 entitled 'Correct Distance', Tabrizian focuses on woman as enigma, re-presenting the *femme fatale* of 1940s and 1950s *films noirs*. At once mysterious, charming and seductive, the *femme fatale* was up to no good and spelled trouble for any man captured by her spell. Tabrizian twists this stereotypical reading of the ultra-feminine evil temptress and succeeds in offering an alternate and positive vision of these women who appropriate femininity as power.

The Blues (1986–87), a series of photographs Tabrizian made in collaboration with Andy Golding, uses the scale and poses of movie posters, as well as the inflammatory declarative style of their text. Spare interiors bathed in blue light call attention to the melodramatic action of their subjects. *Her Way*, a detail from one of three triptychs in the series, reveals a bathroom interior with a black woman lying on the floor, dead; the words 'See my blood is the same colour as yours' are scrawled on a mirror that also reflects the face of a white man; overlaid text on the lower right provides additional commentary: 'He was a man who had all the answers until she started asking the questions.' Such staged scenarios declare the 'fabricated nature of the photographic image'[7] and the folly of cultural and social categorization. Installed in a gridlike formation, *The Blues* is also reminiscent of a movie storyboard, and recalls the disjunctive, non-chronological narrative found in John Baldessari's work, although Baldessari's interest in the banality of our lives is almost diametrically opposed to Tabrizian's controversial investigations of racial issues and difference. And race is engaged in this work in subtle and various ways. While the staging of each frame seems to be based on the conventions of contemporary espionage films, almost every image has an interracial case of characters and a text that explores themes of assimilation, acculturation and difference. The exploration of these constructs extends to Tabrizian's appropriation, as a unifying motif, of the African-American musical form of the blues. Her use of this musical metaphor is indeed significant, for as James H. Cone has noted, the blues can offer a 'perspective on the incongruity of life and the attempt to achieve meaning in a situation fraught with contradictions'.[8]

Inherent in Lorna Simpson's work is a critique of the formulas of 'straight' photography, its prescribed voyeurism and the patented responses to social disaster or beauty it expects from viewers. Simpson's pieces begin with gesture. They isolate a movement and analyze the sentiment or attitude that that motion or stance suggests. In the triptych *Necklines* (1989), for example, alternate views of a black woman's neck appear in panels up to 1.5m [5ft] high, overwhelming us with their smooth and

sensuous curves; but in small plastic plaques below the photographs, words implying the sexual (necking, neckline) are interspersed with those alluding to violence (reckless, breakneck) problematizing the reading of the images as simply beautiful.

In Simpson's fragmented photographic processions, generic women are never presented as whole. Instead, the figures insist on their completeness through synechdoche – in which the part becomes a proxy for the total entity. On a formal level these works share similarities with both Eadweard Muybridge's and Vito Acconci's photo pieces recording isolated body movements. But whereas Muybridge's works are purely documents of motion and Acconci's texts read as bland operational instructions, Simpson forcefully inserts the woman's – and particularly the black woman's – voice and experience. In *Five Day Forecast* (1988), a sequence of five torsos with folded arms is accompanied by two tiers of plastic plaques. The plaques positioned above the images designate the days of the work week (Monday, Tuesday, etc.), those below supply an alliterative variety of ways women are misinterpreted in the professional (with inferences to the larger) world. This lower level of text also puns on the honorific for an unmarried woman, 'Miss', so that the five women pictured have alternate identities as 'misconstrue' or 'misinformation', and so on.

Simpson has a wonderful feel for language, and she finds inspiration everywhere, in children's rhymes and the sophisticated innuendo of the blues, as well as in the Conceptual art-language gymnastics of such artists as Joseph Kosuth and Lawrence Weiner. But her work also confronts us over and over again with the black female body as beautiful in itself and worthy of contemplation.[9]

Carrie Mae Weems is also interested in language, not so much in its properties of definition per se but as cultural signifier. Trained as a folklorist as well as an artist, Weems has found the implications and subtlety of folklore more interesting than text used didactically; for her, it's an unmediated form of communication that has the ability to speak more directly to deeper issues. A series from the mid 1980s entitled *Ain't Jokin* employs jokes as a way to explore how such humorous narratives are used to legitimate the negative treatment of designated groups in a society. There are sexual jokes that allow sexist comments to slip by 'in the spirit of fun'; there are ethnic jokes whose protagonists may be easily substituted – Polish, African-American, Jewish – depending on the company you're in; and as the saying goes, 'There is truth in jest'. Weems seems effortlessly to combine the directorial mode of staged photographs with a more documentary/photojournalistic style in her various limited-edition books (produced over the last decade) and multipanel pieces. While earlier photographs focused on an explosive condemnation of race relations and were addressed to changing the minds of whites, newer pieces are concerned with communicating with a black audience.

In her recent book *Then What? Photographs and Folklore*[10] (Buffalo: CEPA Gallery, 1990), Weems looks at traditional beliefs to show the power and beauty of African-American culture and, offering new readings of old folktales, considers the function of folklore as a way

African-Americans have learned to live life in America. For example, one belief has it that if a hat is placed on a bed someone will go to jail. But across Weems' photograph of this scenario runs the text: 'Girl evidently the man plans on staying cause when I got home from work yesterday his hat was on my bed.' On the page facing this image is a stanza from a blues song: 'Some got six months, some got a solid year, but me and my buddy we got lifetime here'. While in this case the blues verse might convey the original meaning of the hat/bed conjunction, it might just as well be a comment on the durability of personal relationships as raised by the photo-text. Through the language of African-American folk wisdom, culture and the blues, Weems attempts to locate her own voice, in a present-day extension and reinterpretation of tradition. Like Baldessari's 'blasted allegories', her texts are '"exploded", pieces and bits of meaning floating in the air, their transient syntax providing new ideas'.[11] By questioning what is remembered, the photographer changes contemporary understanding. [...]

For Zarina Bhimji the movement of her photography into space is a way to connect with the larger reality of life itself by including the viewer's presence as an element of the work's 'performance'. Large, at times grainy, photographs hung from the ceiling position us as children in an adult world. Bhimji activates the floor with spices, rose petals and delicate muslin cloth that has been violated by burning. Many of her texts are abstracted from diaries kept over the years, but the words connect with the broader issues of migration, displacement and identity. (*TOUCHING YOU*) – *Discovering the history of my ancestors makes my blood purr* (1989), takes the form of an unspoken conversation between mother and daughter, divided by generations and differing perceptions of 'self' and 'home'. How does one locate the self as an Asian born in Uganda and living in England for decades? As writer and director Hanif Kureishi has said, '"My Country" isn't a notion that comes easily. It is still difficult to answer the question, where do you come from?'[12] Graphs included in the piece detail patterns of migration for Asians since the 1940s. Vaguely defined objects connected with 'Indian-ness' (e.g., a buddha's head, a doll clothed in traditional dress) float in and out of view. This piece, like many of Bhimji's, is, in the artist's words, 'based on memory, dreams, conversations from East African Indian and English backgrounds. I wanted to use them as metaphors, since I am concerned with not imitating the world, but recreating it'[13] [...]

Michele Wallace has pointed out that women of colour fall outside the constructs of Western binary logic.[14] In a society predicated upon such oppositions as black/white, male/female and 'universal'/'other', women of colour remain excluded from the either/or formula in which the polarities to white male are occupied by black (as in male) and female (as in white). In the schema of Western discourse, then, women of colour inhabit a space of complete invisibility and negation that Wallace refers to as 'the "other" of the "other"'.[15]

Much of the photography and text work discussed in this essay has to do with 'making ourselves visible', redefining the image/position of the woman/person of colour within the larger discourse [...] These objects then become texts of redemption and emancipation. Not simply adaptations of Western codes, they construct and (re)define the record of their maker's own existence, challenged as well meanings and definitions once thought to be fixed.

1 Lowery Stokes Sims, 'The Mirror the Other: The Politics of Aesthetics', *Artforum*, 37: 7 (March 1990) 111-15.
2 Gilane Tawadros, *LUMO '89: The Boundaries of Photography*, (Jyväskylä, Finland: Alvar Aalto Museo, 1989) n.p.
3 Throughout this essay I at times use the phrase 'people/women of colour' interchangeably with 'black people/women'. This is because in Britain 'black' has broader racial implications - encompassing peoples of African, Afro-Caribbean and Asian descent - and is closer in significance to what we mean by 'people of colour' in the US. Currently, however, there is much debate in Britain as to the essentialist (inherent, cultural) connotations of the use of the term versus its importance in signifying a shared political oppression. That discussion, however, falls outside the purview of this essay and will have to be taken up in a later article.
4 Stuart Hall, 'Minimal Selves', *ICA Documents 6: Identity* (London: Institute of Contemporary Arts, 1987) 44.
5 Lisa Phillips, 'Art and Media Culture', *Image World: Art and Media Culture*, (New York: Whitney Museum of American Art, 1989) 67. The two basic acceptable personae for women of colour in the West are the mammy/maid and the prostitute. Betye Saar and Carrie Mae Weems are among the artists who have successfully appropriated these debased models.
6 Angela Y. Davis, 'Underexposed: Photography and Afro-American History', *Women, Culture and Politics* (London: Women's Press, 1990) 224-25; Michele Wallace, 'Variations on Negation and the Heresy of Black Feminist Creativity', *Heresies*, 24 (1989) 69-75.
7 Tawadros, *op. cit.*
8 James H. Cone, *The Spirituals and the Blues: An Interpretation* (New York: Seabury Press, 1972) 116.
9 I would like to thank Lowery Stokes Sims for re-emphasizing how Lorna Simpson's work connects with images of beauty, making a place for the recognition of black beauty on its own terms. See Sims, *op. cit.*, 115.
10 Carrie Mae Weems, *Then What? Photographs and Folklore* (Buffalo: CEPA Gallery, 1990).
11 John Baldessari, quoted in *John Baldessari* (Eindhoven: Van Abbemuseum, 1981) 49.
12 Hanif Kureishi, 'The Rainbow Sign' (extract), in *Fabled Territories: New Asian Photography in Britain* (Leeds: Leeds City Gallery, 1989) 9.
13 Zarina Bhimji, quoted in *Employing Image* (Manchester: Corner House Gallery, 1987) n.p.
14 Michele Wallace, 'Variations on Negation and the Heresy of Black Feminist Creativity', *Heresies*, 24 (1989) 69.
15 *Ibid.*
Kellie Jones, 'In Their Own Image', *Artforum*, 19: 3 (November 1990) 133-38.

Adrian PIPER
The Triple Negation of Coloured Women Artists
[1990]

[...] In virtually every field to which women have gained entry in significant numbers, the status of that field and its perception as providing significant social opportunity has diminished: If a woman can do it, the reasoning goes, then what is there to feel superior about? Therefore the first line of defence is to protest roundly that a woman can't do it. The second, when that doesn't work, is to conclude that it's not worth doing. Thus it is no accident that the advent of Postmodernism coincides with the acceptance of Euroethnic women artists into the inner sanctum of that tradition. Their success forces a choice of inference: Either women are just as capable of intellectual transcendence as men, and just what is needed to bring that progression to its next stage, or else their presence undermines the very possibility of further progression altogether. It is quite clear which inference has been chosen. Not coincidentally, Euroethnic Postmodernism expresses a newly pessimistic, nihilistic and self-defeated view of the social and intellectual status of art at just the moment that women have begun to join its major ranks in significant numbers.

Euroethnic Postmodernism's attitude of mourning assumes our arrival at the end of the art-historical progression, and therefore the impossibility of further innovation indigenous to it. This means that innovations that occur outside of that progression, or by those who are not accepted into it, cannot be acknowledged to exist as innovations at all. Accordingly, the normative category of originality against which art within the Euroethnic tradition was judged is replaced by the purportedly descriptive categories of anomaly, marginality and otherness. These aesthetically noncommittal categories can be deployed to acknowledge the existence of such innovations without having to credit them normatively as innovations at all.

Relative to the commitment of the Euroethnic mainstream to its own self-perpetuation and its rejection of any further innovation indigenous to it, the very different concerns that may find expression in the art of CWAs [coloured women artists]' – identity, autobiography, selfhood, racism, ethnic tradition, gender issues, spirituality, etc. – constitute a triple-barrelled threat. First, this work has no halcyon past to mourn. Instead, it offers an alternative art-historical progression that narrates a history of prejudice, repression and exclusion, and looks, not backwards, but forwards to a more optimistic future. It thereby competes with Euroethnic art history as a candidate for truth. Second, it refutes the disingenuous Euroethnic postmodern claim that there *is* no objective truth of the matter about anything, by presenting objective testimony of the truth of prejudice, repression and exclusion.[2] Third, it belies the Euroethnic postmodern stance that claims the impossibility of innovation, by

presenting artifacts that are, in fact, innovative relative to the Euroethnic tradition – innovative not only in the range and use of media they deploy but also in the sociocultural and aesthetic content they introduce. In all of these ways, the art of CWAs is an innovative threat to the systemic intellectual integrity and homogeneity of the Euroethnic art tradition. And so, because artistic success is defined within that tradition as a zero-sum game, these threats must be eliminated as quickly and completely as possible. Thus are CWAs negated as artists by the Euroethnic art world.

The Euroethnic postmodernist stance of mourning, in combination with its negation of CWAs as artists, provides the surest proof (in case we needed it) that the Euroethnic art world is fuelled primarily by a spirit of entrepreneurship, not one of intellectual curiosity, and that its definition of professional success is skewed accordingly. Only a field that defined professional success in economic rather than intellectual terms could seriously maintain that the art of CWAs had nothing new to teach it. Whereas history, literature, anthropology, sociology, psychology, etc., have been scrambling for almost two decades to adjust or modify their canons so as to accommodate the new insights and information to be culled from the life experience of those previously excluded from them, only the Euroethnic art world is still having trouble acknowledging that those insights and information actually exist. In this field, if they don't exist at auctions or in major collections, they don't exist at all. Critics and curators who collaborate in this ideology sacrifice their intellectual integrity for the perquisites of market power. This is the payoff that the zero-sum game of Euroethnic artistic success ultimately offers all its players.

The Euroethnic contemporary art world is administered primarily by Euroethnic men. As in all walks of life, there are good men and there are bad men. In this arena, the bad ones are blessedly easy to detect. Their behaviour and their pronouncements indicate that they evaluate works of art according to their market value rather than according to their aesthetic value. For example, they may refuse even to acknowledge the aesthetic value of work that is not for sale in a major gallery, or they may select artifacts to exhibit or write about solely from those sources. Or they may defend the aesthetic value of very expensive artifacts at great length but on visibly shaky conceptual grounds. Or they may be more visibly impressed by the aesthetic value of a work as its market value increases. Indeed, lacking any broader historical or sociocultural perspective, they may even believe that aesthetic value is nothing but market value. And, believing that only artifacts produced by other Euroethnic men can safeguard the intellectual integrity and homogeneity of the Euroethnic tradition, they distribute payoffs, in proportion to the exercise of the winning zero-sum game strategies earlier described, primarily to other Euroethnic men.

Some women and coloureds collude in the perpetuation of this game, by playing according to its prescribed rules. Euroethnic women who compete with one another and with coloured women for its payoffs divide themselves from CWAs and ally themselves with the Euroethnic men who distribute those payoffs and who are their primary recipients. They thereby ally themselves with the underlying ideological agenda of perpetuating the tradition of Euroethnic art as an intellectually homogeneous, systemic whole. This is to concur and collaborate with the Renaissance, modernist, and postmodernist agenda of implicitly denying the legitimacy – indeed, the very possibility – of intellectually and spiritually transcendent artifacts produced by women.

Put another way: By accepting payoffs for playing the zero-sum game of artistic success according to its prescribed rules, some Euroethnic women collaborate in the repression of the alternative art history to which the art of women in general, as well as that of CWAs, often gives expression. Thus CWAs are negated as women not only through the more brutal, overt attempts at eradication by some Euroethnic male art-world administrators but *whenever* a Euroethnic woman abnegates her connection as a woman to CWAs, in order to receive the payoffs available for repressing them. It is painfully humiliating to witness a Euroethnic woman simultaneously prostituting herself and betraying us in this way [...]

This has nothing to do with what kind of artifact – abstract or representational, in traditional media or new genres – any such artist produces. An unusually dimwitted defense of the repression of coloured artists has it that African Americans are naturally most adept at expressing themselves creatively in music rather than in the visual arts, and that therefore their attempts in the latter media are invariably derivative, superficial, or disappointing. No one who has studied the artifactual strategies of survival and flourishing of colonized peoples under hegemonic rule anywhere could take such an argument seriously. But then of course no one who would offer such an argument would be capable of the minimal intellectual effort of research necessary to disprove it. The fact of the matter is that, like other colonialized peoples, African Americans must master two cultures, not just one, in order to survive as whole individuals, and master them they do. They contribute fresh styles and idioms to the visual arts just as abundantly as they do – and have always done – to music, literature and film.

The Euroethnic tradition has always needed these extrinsic creative resources in order to flourish, and in the past has simply expropriated and used them without permission or acknowledgement.[3] Had that tradition long since invited their producers into the Euroethnic mainstream, it might have been better armed, with creative strategies of cohesion and survival, for withstanding the censorship attacks that continue to issue from within its own fundamentalist ranks. It is not surprising that blind reviewing is virtually inconceivable in contemporary Euroethnic art, whereas it is the norm in other areas of higher education. As an intellectually integral and homogeneous system, the Euroethnic art tradition could not possibly survive a convention of evaluation that ignored the racist, sexist, and aesthetically irrelevant social and political connections that hold it together. That is why it rewards all of us so richly for following the rules of the zero-sum game.

It is very difficult for any of us not to play this game, as it often seems to be the only game in town. But in fact that is not true. It is not true that Euroethnic payoffs of the zero-sum game are the only measures of artistic success, nor the most important over the long term, or even the most satisfying ones. There is great satisfaction in affecting or transforming the audience to one's work, and in making those personal connections that enable the work to function as a medium of communication. There is great satisfaction in learning to see whatever resources are freely available in one's environment in general in that way. There is satisfaction in giving work away, and in avoiding or refusing the corrupting influences of those payoffs, and in reaping the rewards of authentic interpersonal relationships as a consequence. And there is very great satisfaction in not caring enough for those payoffs to be willing to follow the rules in order to receive them: in not caring enough to tailor one's work accordingly, or offer bribes, or curry favour, or protect one's position by remaining silent in the face of injustice, or by undercutting others.

In fact the very conception of artistic success as the payoff of a zero-sum game is faulty, because the price of playing by those rules is the de facto deterioration, over the long term, of the aesthetic integrity of the artifacts produced in accordance with them.[4] Those who play that game according to the rules and win the perquisites of market power may, indeed, achieve artistic success in the Euroethnic art world. But the price they pay is alienation from their own creative impulses and from their own work as a vehicle of self-expression; addiction to the shallow, transitory material and political reassurances of worth that are recruited to take their place; sycophancy and betrayal from those they temporarily view as allies; and mistrust and rejection from those who might otherwise have been friends. It hardly seems worth it.

Because commitment to that game is so self-defeating and divisive for all who try to play it, I do not believe the triple negation of coloured women artists will come to an end until that game itself is over. It will come to an end, that is, when the Euroethnic art world stops trying to negate them as players, and when women and coloureds and Euroethnics stop trying to negate themselves and one another in order to gain entry to it [...]

1 Let's begin with a word about terminology. I do not
 like the currently fashionable phrase 'people of
 colour' for referring to Americans of African, Asian,
 Native American, or Hispanic descent. It is
 syntactically cumbersome. It also has an excessively
 genteel and euphemistic ring to it, as though there
 were some ugly social fact about a person we needed to
 simultaneously denote and avoid, by performing
 elaborate grammatical circumlocutions. Moreover,
 discarding previous phrases, such as 'Negro', 'black',
 'coloured', or 'Afro-American', as unfashionable or
 derogatory implies that there is some neutral
 politically correct phrase that can succeed in
 denoting the relevant group without taking on the
 derogatory and insulting connotations a racist society
 itself attaches to such groups. There is no such
 phrase. As long as African-Americans are devalued, the
 inherently neutral words coined to denote them will

themselves eventually become terms of devaluation. Finally, the phrase is too inclusive for my purposes in this essay. I want to talk specifically about women artists of African descent, in such a way as to include those Hispanic-Americans, Asian-Americans and Native Americans who publicly acknowledge and identify with their African-American ancestry, and exclude those who do not. The term *coloured* seems both etiologically and metaphorically apt.

2 Coloured proponents of poststructuralist discourse often seem not to grasp the self-negating implications of advocating the view that objective truth doesn't exist and that all discourses are suspect, nor the self-defeating implications of adopting what amounts to an unintelligible private language discourse in order to defend these views. But I believe that most Euroethnic poststructuralists grasp these implications quite clearly. That's why they welcome their coloured cohorts into the academy so enthusiastically.

3 A recent example of this depredation is the treatment of graffiti art by the Euroethnic mainstream. Unlike other media of expression in hip-hop culture, such as rap music, which has received sustained attention and encouragement by the music establishment, graffiti art was off the streets, on the walls of major galleries, in the work of various young Euroethnic painters, and out the art-world door within two seasons. Now that its idioms have been furtively incorporated into the Euroethnic canon, it is once again safe to minimize its significance as an independent movement.

4 See 'Power Relations within Existing Art Institutions' and also 'A Paradox of Conscience', Adrian Piper, *Out of Order, Out of Sight: Collected Writings* (Cambridge, Massachussets: MIT Press, 1996).

Adrian Piper, 'The Triple Negation of Coloured Women Artists', first published in *Next Generation: Southern Black Aesthetic* (Chapel Hill: University of North Carolina, 1990); reprinted in Adrian Piper, *Out of Order, Out of Sight, Vol. II: Selected Writings in Art Criticism, 1967-1992* (Cambridge, Massachussets: MIT Press, 1996) 161-74.

Jan AVGIKOS

All That Heaven Allows Love, Honour and *Koonst* [1993]

Jeff Koons' 'Made in Heaven' premiered in New York in 1991, and garnered more local coverage and attendance than any gallery exhibition within memory – who knows, maybe ever. The explicit imagery of Koons and Ilona Staller, a.k.a. Cicciolina, generated considerable controversy, even though pictures of cunts and cocks and cum juices were being produced and/or exhibited by several other artists at the time – Robert Gober, Cindy Sherman, Marilyn Minter, Nan Goldin and Larry Clark, to mention a few. In theory and practice, sex was on everyone's lips and its representation very hotly debated. In this milieu, *many* were critical of 'Made in Heaven' and

found it offensive. Was Koons exploiting Cicciolina? On one hand, those enmeshed in the hysteria of political correctness worried that a woman's body was being 'objectified' and 'degraded'. (No one seemed to care much that Koons was also objectifying the male body.) On the other hand, to all who knew her performances and films, it seemed that Koons' blatant coup was to make Cicciolina's work his own, and that 'Made in Heaven' was yet another example of disenfranchisement: women do the work, men get the credit. Yes, he had paid her a $15,000 model's fee and, yes, he is an acknowledged strategist of appropriation; but it was apparent that Cicciolina's total *oeuvre*, not just her image, had been commandeered by Koons and that, at best, what was disseminated under his name alone should be identified for what it was – a 'collaborative' effort.

The most compelling aspect of the 'collaboration' issue is not why Koons himself claimed sole credit for 'Made in Heaven' and thus intentionally obscured the extent of Cicciolina's influence, but why the critical community so blindly followed suit.' […]

The extent to which the 'Banality' and 'Made in Heaven' series reflect her influence is, for most, difficult to determine. Koons became aware of Cicciolina's work in 1987, prior to exhibition of the 'Banality' works in 1988.[2] During 1987, Cicciolina's film *The Rise of the Roman Empress* premiered in Europe, and it can be seen as representative of the thematics that had long characterized her cinematic and performance work, which later appear as specific figural motifs in the 'Banality' and 'Made in Heaven' projects. More importantly, however, Koons also incorporates the film's social narrative (again, seen as representative of a position Cicciolina had long maintained in her work) as the basis of his recently elaborated theory of liberatory art for the people, which emerges as the rationale of his sex-based imagery. The storyline of *The … Empress* is quite simple. Cicciolina, who plays herself, has been busted for her performances and sentenced to community service. At her invitation, she performs parts of her act (semi-nude) for her attorney, which include provocative play with a baby doll, to which she sings a song about *amore*, and masturbation with a clear crystal dildo. Her attorney suggests that she do 'social work' with another 'offender', John Holmes, who also plays himself in the film. Together they offer themselves as sex therapists, administering to the 'needs of the people', and by the orgiastic finale, everyone is cured of whatever inhibitions ailed them. Cicciolina, a flower-garlanded child-woman and the personification of innocence, without guilt or contamination, never goes anywhere without her teddy bear. Whether greeting clients or engaged in sex therapy, the cuddly bear is there: a penetration scene with Holmes, the P. O. V. shot, and cut to the bear; group sex in the bathroom and back to the bear; an extended orgy and then the final image of the film – the bear with a big hard-on.

In the 'Banality' exhibition, *Popples*, a cute porcelain bear, and *Amore*, a porcelain baby doll, directly correspond to props which so often appeared in Cicciolina's work.[3] *Little Girl*, a mirror etched with the image of a child who plays with her teddy bear amidst flower garlands,

replicates both Cicciolina's leitmotifs and public persona. *Pink Panther*, a sculpture of a voluptuous blonde woman snuggling the Pink Panther, remarkably resembles Cicciolina, who made public appearances holding a pink stuffed animal. Included in 'Banality' is *Naked*, a pair of child lovers who, by 1991, have grown up and are idealized as none other than Koons and Cicciolina themselves. Throughout 'Made in Heaven' themes of innocence and perfect union are emphasized, and sex and love go hand-in-hand. Although graphically depicted, forever-after wedded bliss with a heterosexual focus is hardly a controversial topic. In the age of AIDS, there is no depiction of partner swapping or group sex; rather, the sensational imagery is inscribed as legal, for their love affair has been consummated in marriage. What is 'legal' and what is 'normal' is contradicted by the fact that when sex is inscribed in any way – the private becomes public, which happens to be the conventional definition of pornography according to the Meese Commission's report. Museums and galleries put 'Made in Heaven' behind a wall (as was done at San Francisco's MoMA) or put up a warning label (as at Sonnabend Gallery), thereby 'protecting' the viewer from that which has the power to contaminate. When a 'curtain' is drawn, either figuratively or literally, the institution is not only dramatizing the boundary that separates public and private spheres and announcing that something very special exists on the other side, but eroticizing it by creating a barrier that must be physically penetrated. The viewer is conditioned, however subliminally, to see the work and their own behaviour in relation to it as risqué.

The question of whether or not 'Made in Heaven' is actually pornographic, as has concerned some scholars[4] (above and beyond the relatively low-level 'pro-porn' and 'anti-porn' debate), is quite relevant if we compare a photo-painting such as *Ilona's Asshole*, from 'Made in Heaven', with a virtually identical image from *The … Empress*. Although visually no different, Koons' image is designated as 'fine art', whereas Cicciolina's is categorized as 'pornography'. This distinction has nothing to do with inherent quality. 'Fine art' is what we see in museums, which in turn, sanction, value and *protect* 'artistic' production and display; 'pornography', because of different systems of distribution and contextualization, is marginalized and receives no such sanction or protection. Even though at face value such images may be completely interchangeable, the discourses which pertain to each are radically different. What if, however, for comparative purposes, we acknowledge the arbitrariness of these distinctions and extend an art historical or critical discourse to Cicciolina's work?

Koons' *Dirty Ejaculation*, which spoofs the 'filth' of porn, and *Exaltation*, play well within the margins of acceptability. Cicciolina, in comparable stills from *The … Empress*, transgresses those margins: two dicks juicing over her; triple penetration; masturbation with a 'transparent' dildo; a *ménage à trois* in which the male is fully inscribed within the stereotypic gaze of two women. These images can be seen to refute the claim that there is no place of power for women in pornography. As both the film's star and producer, Cicciolina challenges

conventional standards of what is considered to be 'normal' feminine sexuality, pleasure and fantasy. With respect to fantasy, Koons makes liberal use of other-worldly settings. In her performance work, Cicciolina also invokes a surreal setting. The point is not 'who did it first' or even 'who gets the credit for it' but what each of these artists does with similar themes. In *Wolfman*, Koons makes a pun on the forbidden and the 'man possessed', who, under the full moon, might at any moment turn into a beast and devour his beautiful virginal victim. He takes that which is taboo-hardcore imagery and repressed (uncontrollable) desire and makes it non-threatening by turning the 'wolfman' into an adolescent Peter Pan and his exploits into a pastel Disneyland adventure. (We could call this 'serving the needs of the people', which he so often suggests is his primary concern.) The allusion that such work transgresses or offends is actually part of its theatricality. Pull back the 'curtain' and there's another one: intentional banality. Koons isn't exploring theories of sexuality and representation; clearly, that is not his interest. Rather, as he always has done, he is pointing to institutionalized boundaries and upholding them.

Cicciolina does not limit the performance of 'boundary violations' to her artistic practice but has long maintained, as has Koons, the overlap of art and life. As representative of the Radical Party in Italy, she referred to herself as 'the honourable and perverse' Cicciolina. The honour of perversity has yet to be thoroughly appreciated in the US – particularly feminine perversity – which may account, in part, for the neglect and, indeed, discrimination in acknowledging the importance of her work as a source for Koons' sculpture and painting. To suggest that 'Made in Heaven' should, by rights, be labelled as 'collaborative' points euphemistically to Koons' extensive borrowing of her iconographies and thematics, and ironically to the 'collaboration' of those who have validated the legitimacy of his work at the expense of that from which it stems. It is no small wonder that Cicciolina's status is demoted to 'wife of Koons', but it is also symptomatic of more than discrimation against unorthodox female behaviour (and its translation into artistic practice). What is ludicrous is that it equally denies a major tenet upon which Koons' practice is founded: the comingling of high and low culture.

It is common knowledge that we colonize low culture (all the while despising it) for the sake of high art and that the great duplicity of this mobility is that what flows up, never flows down. To mention Koons and François Boucher in the same breath nullifies the low source, and replaces it with one of high standing and thus makes it suitable for canonical consideration. Such obfuscation serves to reassure the institution, the collector and the viewer alike, that this work has unique value, and that indeed there is a difference between that which merely 'looks' like porn (for art's sake) and 'real' porn. This distinction is imperative for those who believe that art embodies essential qualities, particularly when 'quality' cannot be visually verified or differentiated from the prurient riff-raff of the street. Koons' own role in suppressing Cicciolina's role – as a paid and adored muse, rather than an artist of equal rank from whom he has

heavily borrowed – is not only suspect; it is transparent as well. However, in asking 'who's protecting whom', our real concern should be with the integrity of critical and historical methodologies – and the lengths to which we are willing to go to ensure that art's pedestal remains firmly in place.

1 See Michael Corris' article, 'Jeff Koons in the Heart of Nowhere', in the May 1993 issue of *Art & Text*, for an excellent analysis on the parallel development of Koons' career and critical reception accorded his work.

2 In a recent conversation with the author, Koons vehemently denied any collaborative aspects of his work concerning Cicciolina, and refused to acknowledge the artistic merit of her work.

3 In actual performance, Cicciolina's 'baby doll' is a male child which pees when squeezed, spurting 'ejaculate' streams over her face and body.

4 See John Caldwell's discussion of why 'Made in Heaven' is not pornography, John Caldwell, 'Jeff Koons: The Way We Live Now', *Jeff Koons* (San Francisco: SF MOMA, 1992) 14.

Jan Avgikos, 'All That Heaven Allows: Love, Honour and *Koonst*', *Flash Art*, 26: 171 (Summer 1993) 80-83.

CORPOREALITY

From explorations of female pleasure in looking, self-display and sensual knowledge, to considerations of the body reconfigured through technology, the nature of embodiment provoked extensive debate in the late 1980s and early 1990s. Judith Butler's discussion of mimicry, in which the excessive repetition of gender norms exposes gender as illusory, dovetailed with contemporaneous work by feminist and queer artists and activists. Her writings helped inspire a wave of cultural projects that took a perverse and playful approach to both high and popular culture. Like Butler, commentators such as Liz Kotz and Collier Schorr were more interested in the shifting processes of identification than in fixed notions of identity. Their work was often read as a simple celebration of gender instability; the underlying attention to melancholia in the face of gender's demands was frequently overlooked. The abject body, the body diseased, depressed and in pain, received attention in texts such as Mignon Nixon's discussion of orality and aggression in women's artwork. Debates on the challenges of post-feminism and the role of 'theory' in the 1990s inform texts such as Amelia Jones' 'Feminism, Incorporated'.

Rosa LEE
Resisting Amnesia:[1]
Feminism, Painting and
Postmodernism [1987]

[...] While Mary Kelly adopts the radical stance of refusing to represent images of women in her work in order to preclude the notion of woman as object and spectacle, Therese Oulton's work has become, as she puts it, 'less figurative, rather than more abstract' – not as a deliberately obscuring device, but in order to prevent the naming or 'fixing' of things. It is an intention which is based on the view that the recognition of an object implies the colonization, the possession of it.

'*Feminist investigations of aesthetic theory necessarily aim at a critique of traditional assumptions ...*'[2] If, as

Jacqueline Morreau and Catherine Elwes have pointed out, feminist deconstructive work of the 1970s ran parallel to formalist, Modernist 'attacks' on visual language, then the current eclecticism of style characteristic of Postmodernism also runs concurrently with attempts by women painters to locate themselves within a tradition from which they have been historically excluded and discriminated against. For painters like Oulton this has involved acknowledging the part played by 'old masters', such as Titian, and the art of the past as a central concern of her own painting practice. In establishing this 'conversation piece with the past',[3] Oulton has arrived at a quite different way of 'interrogating' art history, which has nothing to do with the seemingly arbitrary 'plundering and pirating' nor the nostalgic borrowing of motifs and styles which characterizes the work of some of her (male) contemporaries such as Garouste, Mariani, *et al.* [...]

In terms of the language of art and art history, which many women artists have found alien if not alienating, the taking on of the past and the tradition of painting necessarily involves a questioning of numerous assumptions: about the nature of the 'creative process', about the very methods and means of manipulating and applying paint to canvas, about the organization of 'space' on a two-dimensional surface, about painting's 'traditional' subject matters and its contemporary equivalents. While artists like Rose Garrard are engaged in the project of 'cleaning' this language through deconstructing visual imagery and combatting art history's signal omissions (of women artists) through a literal re-citing of those who have been neglected, Oulton makes the following point:
'*You don't clean a language: you've got a debased form – and if you're a painter, that's the language you've got to work with. You don't clean it up by pretending it's sociology ... You can't produce ideas outside the language, outside the means to express them ... There's no hope in out of the blue creating a new language that's free of all those associations.*'[4] [...]

'*A lot of painters talk of attacking the painting, or even*

use the gentler terms, but it's always as though it were inert – stuff to take on whatever you wish it to. I've been trying to develop a way of painting that gives voice to something that is inanimate.'[5]

This acknowledgement of the relative *autonomy* of the material language – the 'slippery, amorphous medium' of paint substance[6] – in relation to painting practice and the painter is reminiscent of other familiar painterly notions: those, for example, of allowing full play to the unconscious processes, of letting a painting 'happen' rather than *making* it (see, for example, Irving Sandler's account of Pollock's 'all-over drip' method and Helen Frankenthaler's interpretation of this, culminating in her 'gestural' stain paintings of the 1950s).[7] However, this notion still maintains the primacy of the painterly *gesture* at the centre of the proceedings. What Oulton is proposing is a far more rigorous approach:

'*The intimacy is in the touch, they are worked with a very small touch and the vastness grows out of smallness. Each brushmark is visible – nothing is hidden. They're one skin deep. It's very important to me that they spread across the canvas and that one brushmark is never on top of another … I've developed a way of sliding one colour on top of another so that you get an optical mix like a glaze, but it's applied like an alla prima approach in that there's no underpainting and no overpainting. I accept what appears on the canvas … I always tell people that they paint themselves, which doesn't mean some kind of unconscious flow because it's actually a strictly conscious method. I spend hours mixing up paints and getting the right viscosity, liquidity and colour range. What happens then between me and the picture is hopefully where the picture has as much to say as I do.*'[8]

The subversive potential of Oulton's method is explored in her latest series of paintings with the overall title, *Letters to Rose*: as Stuart Morgan confirms in the catalogue introduction, 'a reference to the lost history of women through the ages'. In these paintings, the quest for renewal rests on a series of 'refusals' which result from a critique of painting's traditions. Traditional conventions of 'reading' a painting are thwarted through subversive use of those conventions: chiaroscuro is used, for example, to imply modelling, but simultaneously does not refer to any visible, easily apprehendable object. The paintings categorically refuse any one fixed interpretation. Oulton makes use of a painterly language, stripped bare of its old meanings – that is, of that 'depiction' which could be 'read' as a 'representation of'. Nevertheless, these traditional *associations* are retained (though only as a reference to that classical tradition which is under scrutiny). It is through the subversive juxtaposition of paradoxes that the possibility of creating a new, non-representational artistic language emerges. By the use of what ostensibly was, at its inception, a mode of painting committed to the reproduction of things in the world (in their fullest illusory sense) – from, in Oulton's words, the 'debased' language which we have inherited – the possibility of a critical renewal of painting language becomes apparent […]

1 The title, taken from an essay by Adrienne Rich:
 'Resisting Amnesia: History and Personal Life' (1983),
 dedicated to the American feminist historian Joan Kelly
 who died in 1982, is an acknowledgement of the ways in
 which Rich's poetry has informed and inspired my own
 work and painting. It also refers to Charles Harrison's
 articles in *Artscribe* where, speaking of
 Postmodernism's attitude to Modernist critical theory,
 he writes: 'The invitation to amnesia precedes the
 celebration of cultural expansion … The invitation is
 not easy to resist. Who would not want to close their
 eyes and forget the betrayals of the late 1960s, the
 dreary disappointments of the 1970s?' (1986:45).

2 G. Ecker (ed.), *Feminist Aesthetics* (London: The Women's
 Press, 1985) 21.

3 Conversation with Thérèse Oulton (23 July 1985).

4 *Ibid.*

5 Therese Oulton in Sarah Kent, 'Therese Oulton', *Flash
 Art*, 127 (April 1986) 44.

6 *Ibid.*

7 Irving Sandler, *The New York School* (New York: Harper &
 Row, 1978) 58; also chapter 3, *The Colonization of
 Gesture Painting*, 46-58.

8 Oulton in Kent, *op. cit.*, 41.

Rosa Lee, 'Resisting Amnesia: Feminism, Painting and
Postmodernism', *Feminist Review*, 26 (Summer 1987) 19-24.

Mira SCHOR
Figure/Ground [1989]

Some people live by what they see with their eyes – light, darkness, colour, form. Painters are compelled to express this continuous act of seeing and looking through the application of a liquid or viscous matter on a two-dimensional surface. Despite a barrage of criticism of painting and of representation, even painters who are cognizant of or complicit with this critique continue their preoccupation. I am one of these retinal individuals.

Criticism of the practice of painting emerging from a curious blend of Modernist idealism and Marxism may be found in *October* or *Art After Modernism: Rethinking Representation*. While I am reluctant to give this loosely generalized school of criticism a name, 'aesthetic terrorism' might describe its adherents' 'fundamental commitment to the "primacy" of "objectivity"' and their use of 'exclusion as one of their principal creative means'.[1] In this discourse on art, painting has been described as peripheral, vestigial, an 'atavistic production mode' and a 'dysfunctional plastic category'.[2]

According to this discourse, the linear progression of art history brought painting in the twentieth century to certain 'logical' end points, namely abstraction and monochrome, after which representation is always a regression; new technologies emerging out of late capitalism may be more suited to deal with its ideology; painterliness for its own sake, for the sake of visual pleasure, is narcissistic and self-indulgent.

Meanwhile, painting continues […]

Since painting can be most basically defined as the application of pigmented matter – which minimally can be understood as Figure – on a surface that is Ground, this re-audition takes the form of an examination of the figure/ground binarism and an analysis of the language used to critique, indeed to condemn, painting. However, I am not merely considering figure/ground as the deployment of positive and negative space or the phenomenon of 'push pull'. It seems that the formalist concentration on this limited understanding of figure/ground has drained painting of its vitality, and has particularly affected the teaching of painting in this country. Hearing countless students mumble about 'trying to push the space around', one *wants* to give up painting on the spot.

The history of avant-garde painting has been oriented towards a demystification of figure (narratives of religion and history, finally representation of any kind) and an emphasis and an amplification of ground: the flatness of the picture plane, the gallery space as a ground, finally the gallery space as Figure, a subject in itself. The history of Modern painting – with the possible exception of Surrealism and its progeny – is the privileging of ground […]

The privileging of ground is consistent with the utopian ideal often expressed by Modernist pioneers that painting, liberated from representation and reduced to its formal elements, will transcend its end and evaporate into architecture.

Some contemporary critics are astounded that painters have balked at this conclusion. For example, Benjamin H.D. Buchloh, in his signal essay 'Figures of Authority, Ciphers of Regression', links returns to easel painting and to figuration with authoritarian ideologies, both in post 1915 works by Picasso, Derain, Carrà and other Cubists and Futurists, and in recent painting movements such as German and Italian neo-Expressionism[3] […]

Buchloh's frustration is engendered even by traces of mystifying notions about painting in, if not the works, at least the words of artists whose practice is said to (properly) confront the 'despair of painting'.[4] Excerpts from an interview between Buchloh and the German painter Gerhard Richter serve to recapitulate, in the mode of a Harold Pinter play, what the critic of painting wishes and what the contradictory artist prefers:

'*Benjamin Buchloh* … And that is really one of the great dilemmas of the twentieth century, this seeming conflict, or antagonism between painting's representational function and its self-reflection. These two positions are brought very close together indeed in your work. But aren't they brought together in order to show the inadequacy and bankruptcy of both?

Gerhard Richter Bankruptcy, no; inadequacy, always.

Buchloh The claim for pictorial meaning still exists. Then even your Abstract Paintings should convey a content?

Richter Yes.

Buchloh They're not the negation of content, not simply the facticity of painting, not an ironic paraphrase of contemporary expressionism?

Richter No.

Buchloh Not a perversion of gestural abstraction? Not ironic?

Richter Never! What sorts of things are you asking? When I think about contemporary political painting, I prefer

Barnett Newman. At least he did some magnificent paintings.

Buchloh So it's said. Magnificent in what respect?

Richter I can't describe it now, what moved me there. I believe his paintings are among the most important.

Buchloh Perhaps that too is a mythology which would have to be investigated anew. Precisely because it's so hard to describe, and because belief is inadequate in the confrontation with contemporary paintings.

Richter Belief is inescapable; it's part of us. They [Richter's paintings] have a normal seriousness. I can't put a name on it. I've always seen it as something musical. There's a lot in the construction, in the structure, that reminds me of music. It seems so self-evident to me, but I couldn't possibly explain it.

Buchloh That's one of the oldest clichés around. People always have resorted to music in order to save the foundations of abstract painting ... Why is your only recourse that to the metaphor of nature, like a Romantic?

Richter No, like a painter. The reason I don't argue in 'socio-political terms' is that I want to produce a picture and not an ideology. It's always its facticity and not its ideology that makes a picture good.'[5]

It seems possible that it is precisely its 'facticity', its actuality, that is disturbing to those for whom painting is 'dysfunctional' and 'atavistic'. 'Aesthetic terrorists' mock 'the metaphysics of the human touch'[6] on which defences of painting depend. Buchloh adds an infantile and animalistic dimension to painting by calling for the 'abolition of the painter's *patte*'[7] (French: paw), not just his/her hand but his/her *paw*. The painter's *patte* is an 'atavistic production mode' and atavism is used incorrectly as a synonym of 'dysfunctional' to signify a 'morbid symptom'.[8] But something atavistic is a still vital trait resurging from our deep past. Rubbing two sticks together to make fire when a match is handy may be dysfunctional, but the need for, and the fear of, fire are atavistic tropisms. Human mothers, like many mammals, still clean their children's faces with spit. They don't use their tongues, like lionesses, but they do the job roughly, with their 'pattes', and the gesture has a function beyond the immediate and pragmatic: it marks a bond, it is a process of marking whose strength is precisely its atavistic nature.

The desire for an art from which belief, emotion, spirit and psyche would be vacated, an art that would be pure, architectural, that would dispense with the wetness of figure – Marcel Duchamp calls for 'a completely *dry* drawing, a *dry* conception of art'[9] – may find a source in a deeply rooted fear of liquidity, of viscousness, of goo.

Whose goo is feared may emerge from a reading of *Male Fantasies*, Klaus Theweleit's analysis of members of the German *Freikorps*, mercenary soldiers who put down worker rebellions and fought border disputes in the years between the end of World War I and the advent of the Third Reich, and who were precursors, and often future members, of the Nazis. The 'soldier male' (according to Theweleit's term) has never fully developed a 'secure sense of external boundaries',[10] a pleasurable sense of the membrane of skin. He fears the 'Red floods' – of the masses, blood, dirt, 'morass', 'slime', 'pulp',[11] woman –

which he perceives as constantly threatening to dissolve his external boundaries. He also fears the liquid forces insecurely caged within his own body and interior and unconscious/ the 'soldier male' resolves these conflictual fears by the construction of a militarized, regimented body, by incorporation into a desexualized phalanx of men, and by the reduction, through killing, of all outer threats back to the red pulp he imagines everything to be. 'He escapes by mashing others to the pulp he himself threatens to become.'[12] The 'uncanny' nature of the revolutionary mass, which the *Freikorps* were waging war against, with 'its capacity for metamorphosis, multiformity, transformation from one state to another',[13] is akin to the slithery properties of paint. This capacity for mysterious transformation, appearance and disappearance 'corresponds precisely not only to the men's anxiety images of the multiple forms and faces of the mass/Medusa they aim to subdue, but above all to their fears of uncontrollable, unexpected stirrings in their own "interiors"'.[14] Against the unregimented flow of paint, some critics posit the mechanistic one, of architecture or of language. Buchloh questions the importance of Newman's painting 'because it's so hard to describe'. If words fail, the visually undescribable must be 'investigated anew' or eliminated. Not surprisingly Buchloh favours the insertion of words into pictures, especially through collage, where the binding infrastructure mucilage, the glue, is dried, clear and hidden behind the image. Fear of flow also condemns Richter's analogy of painting to music, which, though invisible, is the quintessential flowing element through the ear, which offers no protection between interior and exterior.

A stated desire to '[purge] colour of its last remnants of mythical transcendental meaning; by making painting completely anonymous through seriality and infinite repeatability',[15] and a preference for photography over painting indicates that the problem for some critics is not with colour but with pigment. Pigment is matter that interferes with the ideal of colour. Its excremental nature makes any individualized manipulation of it distressing, and so it must be bleached out, cleansed, expurgated, photosynthesized onto a lamented sheet of paper on which colour has been dematerialized.

Perhaps it is not surprising that many critics who would stop the amorphous flow of paint have most enthusiastically supported women artists who work in photography and video [...]

The Neo-Expressionist movement, which spurred the particular critique of painting discussed here, may well have participated in a culture-wide conservative reaction. For example, the sexual attitudes displayed by David Salle were consistent with the backlash against feminist activism that has permeated the 1980s. Executed with an aesthetic of nostalgia and cynicism, these works did succesfully represent some aspects of contemporary reality. Conversely, the 'problem' with an artist such as Salle was not that he had soiled his post-studio credentials by selling out via painting, but that he used the format of painting to perpetuate a world view wholly acceptable to a reactionary establishment. Elaborating the same content

in another medium would hardly improve its politics. It is necessary to separate *painting* from the rogue elephants whose practice *is* complicit with regressive ideology [...]

There may be a gendered dimension to the critique of representation, the fear of narrative, since, historically, what must be excluded from art discourse is tainted by femininity. Painting's presumed loss of access to a language of historical and political representation must be considered in its connection to the equally axiomatic 'prohibition that enjoins woman – at least in this history – from ever fancying, representing, symbolizing, etc. (and none of these words is adequate, as all are borrowed from a discourse which aids and abets that prohibition) her own relationship to beginning',[16] as Luce Irigaray writes. For 'woman' one can insert 'painter' as far as critical language is concerned. Further, woman's presumed lack of subjectivity, of access to self-representation, is the *ground* for the narrative of the One who 'must resurface the earth with this floor of the ideal'.[17]

That ground was gendered female was never in doubt. Painting in the high Italian Renaissance increasingly became a system for ordering and subduing nature, laying a grid on chaos (femininity), which in the twentieth century became a process of razing and asphalting. For if the ground began to move and 'if the "object" started to speak? Which also means beginning to "see", etc. What disaggregation of the subject would that entail?'[18] It might entail the death of the end-of-painting scenario, which should have been played only once according to late Modernist critics, and which is to be endlessly resimulated by Postmodernists. The narrative of the death of painting is meant to jam the signals of other narratives, that is to say the narrative of the Other [...]

For a painter there is certainly tremendous pleasure in working out a thought in paint. It is a complete process in terms of brain function: an intellectual activity joining memory, verbal knowledge and retinal information, is given visible existence through a physical act. But the value of painting cannot rest on any individual artist's private pleasure. Painting is a communicative process in which information flows through the eye from one brain, one consciousness, to another, as telemetric data speeds from satellite to computer, without slowing for verbal communication. Incidents of paint linger in the working mind of the painter as continuous thrills, as possibilities, like words you may soon use in a sentence and – in a manner that seems to exist outside of spoken language – as beacons of hope to any human being for whom visuality is the site of questions and answers about existence. The black outline of a rock in a Marsden Hartley landscape, the scumbled white of a shawl in a portrait by Goya, the glaze of a donor's veil in the *Portinari Altarpiece*, the translucent eyelid of Leonardo's *Ginevra di Benci*, the pulsing red underpainting of a slave's toe in a Delacroix, the shift from shiny to matte in a passage of indigo blue by Elizabeth Murray, are only a few of a storehouse of details that are of more than professional interest to me.

In French, *terrains vagues* describes undeveloped patches of ground abutting urban areas, grey, weedy lots at the edge of the architectural construct of the city. *Terrains vagues*, spaces of waves, the sea of liquidity, where the eye

10. David Salle

11. Elizabeth Murray

flows idly and unconstructed, uninstructed. These spaces are vague, not vacant (*terrains vides*). In such interstices painting lives, allowing entry at just these points of 'imperfection', of neglect between figure/ground. Between figure/ground there is imperfection, there is air, not the overdetermined structure of perspectival space or the rigid dichotomy of positive and negative space not the vacuumed vacant space of painting's end, but the 'self-forgetful' 'boredom' of the area that glimmers around paint, sometimes only microscopic interactions with a colour, sometimes the full wonder of the dual life of paint mark and illusionism. Paintings are vague terrains on which paint, filtered through the human eye, mind and hand, flickers in and out of representation, as figure skims ground, transmitting thought.

1 Klaus Theweleit, *Male Fantasies*, Vol. 2, *Male Bodies: Psychoanalyzing the White Terror*, trans. Erica Carter and Chris Turner (Minneapolis: University of Minnesota Press, 1989) 418.

2 Benjamin H.D. Buchloh, 'Figures of Authority, Ciphers of Regression', *October*, 16 (Spring, 1981) 59.

3 *Ibid*.

4 Benjamin H.D. Buchloh, *Gerhard Richter: Abstract Paintings* (Eindhoven: Stedelijk Van Abbemuseum, 1978) 20

5 Benjamin H.D. Buchloh, 'Interview with Gerhard Richter', trans. Stephen P. Duffy, in Roald Nasgaard, *Gerhard Richter Paintings*, ed. Terry A. Neff (London and New York: Thames and Hudson, 1988) 21, 24, 26, 28, 29.

6 Douglas Crimp, 'The End of Painting', *October*, 16 (Spring 1981) 77.

7 Benjamin H. D. Buchloh, 'The Primary Colours for the Second Time', *October*, 37 (Summer 1986) 51.

8 The epigraph to 'Figures of Authority, Ciphers of Regression' is a quote from the *Prison Notebooks* of Antonio Gramsci: 'The crisis consists precisely in the fact that the old is dying and the new cannot be born; in this interregnum a great variety of morbid symptoms appears.'

9 Marcel Duchamp, *The Writings of Marcel Duchamp*, ed. Michael Sanouillet and Elmer Peterson (New York: Da Capo Press, 1989) 130. A republication of *Salt Seller: The Writings of Marcel Duchamp* (Oxford: Oxford University Press, 1973).

10 Theweleit, *Male Fantasies*, Vol. 2, *op. cit.*, 213.

11 Klaus Theweleit, *Male Fantasies*, Vol. 1, *Women, Floods, Bodies, History*, trans. Stephen Conway (Minneapolis: University of Minnesota Press), 385-409.

12 Theweleit, *Male Fantasies*, vol. 2, *op. cit.*, 274.

13 *Ibid.*, 35.

14 *Ibid.*, 37.

15 Buchloh, 'Primary Colours', *op. cit.*, 48.

16 Luce Irigaray, *Speculum of the Other Woman* (Ithaca: Cornell University Press, 1985) 83.

17 *Ibid.*, 140.

18 *Ibid.*, 135.

Mira Schor, 'Figure/Ground', *M/E/A/N/I/N/G* (November 1989) 18-27; reprinted in *Wet: On Painting, Feminism and Art Culture*, ed. Mira Schor (Durham, North Carolina, and London: Duke University Press, 1997) 144-55.

Judith BUTLER
From Parody to Politics [1990]

I began with the speculative question of whether feminist politics could do without a 'subject' in the category of women. At stake is not whether it still makes sense, strategically or transitionally, to refer to women in order to make representational claims in their behalf. The feminist 'we' is always and only a phantasmatic construction, one that has its purposes, but which denies the internal complexity and indeterminacy of the term and constitutes itself only through the exclusion of some part of the constituency that it simultaneously seeks to represent. The tenuous or phantasmatic status of the 'we', however, is not cause for despair or, at least, it is not *only* cause for despair. The radical instability of the category sets into question the *foundational* restrictions on feminist political theorizing and opens up other configurations, not only of genders and bodies, but of politics itself.

The foundationalist reasoning of identity politics tends to assume that an identity must first be in place in order for political interests to be elaborated and, subsequently, political action to be taken. My argument is that there need not be a 'doer behind the deed', but that the 'doer' is variably constructed in and through the deed. This is not a return to an existential theory of the self as constituted through its acts, for the existential theory maintains a prediscursive structure for both the self and its acts. It is precisely the discursively variable construction of each in and through the other that has interested me here [...]

Practices of parody can serve to re-engage and reconsolidate the very distinction between a privileged and naturalized gender configuration and one that appears as derived, phantasmatic and mimetic – a failed copy, as it were. And surely parody has been used to further a politics of despair, one which affirms a seemingly inevitable exclusion of marginal genders from the territory of the natural and the real. And yet this failure to become 'real' and to embody 'the natural' is, I would argue, a constitutive failure of all gender enactments for the very reason that these ontological locales are fundamentally uninhabitable. Hence, there is a subversive laughter in the pastiche-effect of parodic practices in which the original, the authentic and the real are themselves constituted as effects. The loss of gender norms would have the effect of proliferating gender configurations, destabilizing substantive identity and depriving the naturalizing narratives of compulsory heterosexuality of their central protagonists: 'man' and 'woman'. The parodic repetition of gender exposes as well the illusion of gender identity as an intractable depth and inner substance. As the effects of a subtle and politically enforced performativity, gender is an 'act', as it were, that is open to splittings, self-parody, self-criticism and those hyperbolic exhibitions of 'the natural' that, in their very exaggeration, reveal its fundamentally phantasmatic status.

I have tried to suggest that the identity categories often presumed to be foundational to feminist politics, that is, deemed necessary in order to mobilize feminism as an identity politics, simultaneously work to limit and constrain in advance the very cultural possibilities that feminism is supposed to open up. The tacit constraints that produce culturally intelligible 'sex' ought to be understood as generative political structures rather than naturalized foundations. Paradoxically, the reconceptualization of identity as an *effect*, that is, as *produced* or *generated*, opens up possibilities of 'agency' that are insidiously foreclosed by positions that take identity categories as foundational and fixed. For an identity to be an effect means that it is neither fatally determined nor fully artificial and arbitrary. That the *constituted* status of identity is misconstrued along these two conflicting lines suggests the ways in which the feminist discourse on cultural construction remains trapped within the unnecessary binarism of free will and determinism. Construction is not opposed to agency; it is the necessary scene of agency, the very terms in which agency is articulated and becomes culturally intelligible. The critical task for feminism is not to establish a point of view outside of constructed identities; that conceit is the construction of an epistemological model that would disavow its own cultural location and, hence, promote itself as a global subject, a position that deploys precisely the imperialist strategies that feminism ought to criticize. The critical task is, rather, to locate strategies of subversive repetition enabled by those constructions, to affirm the local possibilities of intervention through participating in precisely those practices of repetition that constitute identity and, therefore, present the immanent possibility of contesting them [...]

Judith Butler, 'Conclusion: From Parody to Politics', *Gender Trouble: Feminism and the Subversion of Identity* (New York and London: Routledge, 1990) 143-49.

Amelia JONES
Feminism, Incorporated: Reading 'Post-feminism' in an Anti-Feminist Age [1992]

We live in a particular cultural and historical moment of highly charged sexual politics. Within the last year, supporters of women's rights have seen a number of disturbing public displays of these politics: the ridicule of a well-educated African-American female lawyer by an all-white, male Senate commission for her exposure of sexual harassment by an African American male candidate for the Supreme Court; the media-fed rise of Camille Paglia, whose obscenely self-serving, pseudo-intellectual and anti-feminist pronouncements have established her as the Phyllis Schlafly of gender studies. We have consoled ourselves as women candidates for national and local offices emerge in large numbers; but this increase has been paralleled by spectacles of overt bigotry, sexism and heterosexism such as the 1992 Republican convention. We have seen women professionals, both fictional and actual, become targets for reactionary rhetoric about 'family

values' and the 'cultural elite'. And we have become aware that freedom of choice for women is hanging by a judicial thread that the President's appointed hatchet men on the Supreme Court threaten to sever at any moment [...]

The popular deployment of the term 'post-feminism' ... involves invidiously redefining and recuperating femininity, feminism and even masculinity into revitalized racist, class-bound and patriarchal models of gender and sexual identity. The use of the term post-feminism in discourses on contemporary art appears, in contrast, to involve a significantly different project. In my view, however, the Postmodern version of post-feminism similarly plays itself out through appropriative techniques that ultimately generalize and defuse feminist agendas. While artists such as Mary Kelly and Barbara Kruger who speak and work from a feminist political perspective have sometimes been labelled 'post-feminist' by art historians and critics in order to distinguish their work from earlier, supposedly essentialist feminist art practices (as in Laura Mulvey's essay 'Dialogue with Spectatorship: Barbara Kruger and Victor Burgin'), many critical texts on Postmodernism have developed the concept of post-feminism towards ultimately anti-feminist ends.[1] While more subtle than the popular media's outright rejection of feminism as outmoded or expired, the discourses of Postmodernism tend to address the relationship between feminism and Postmodernism through Modernist and ultimately masculinist models of interpretation – models that work to empower the Postmodern critic through an 'aesthetic terrorism' that hierarchizes art practices on the basis of avant-gardist categories of value, excluding those practices outside the boundaries they have determined for 'radical' practice.[2]

The term post-feminism has been developed primarily within dominant discourses of Postmodernism identified with New York City-based journals, art magazines and institutions.[3] A central strategy within these discourses has been to claim radical value for Postmodernism in the visual arts by arrogating a certain kind of feminist practice and incorporating it into a universalist, 'mainstream' Postmodernism. Feminism is thus generalized as one radical strategy among many available to disrupt Modernism's purities [...]

An instructive example of the subtle negation of the specificity of feminist politics is the sophisticated but still presumptuous appropriation of feminist theory as one Postmodernist strategy among many in Craig Owens' important article 'The Discourse of Others: Feminists and Postmodernism'.[4] Owens presents in a concise and polemical way some of the major issues confronting feminist theory, astutely calling for a recognition of feminist art as explicitly disrupting Modernist configurations of sexual difference, and taking issue, as I do here, with writers who 'assimilat[e feminism] to a whole string of liberation or self-determination movements'.[5] And yet, Owens' discussion, which begins seemingly innocently by placing feminism and Postmodernism in the same space, describing 'women's insistence on incommensurability' as 'not only compatible with, but also an *instance of* Postmodern thought',[6] ends up by collapsing feminism entirely into the 'Postmodernist

critique of representation': 'th[e] feminist position is also a Postmodern condition'.[7] Owens takes up the empowering critical position he believes to be offered by feminism, reading strategies of the latter as part of the Postmodernist critique of 'the tyranny of the signifier'.[8] In attempting to claim a radical agenda for feminism, Owens, like Jameson, reduces the feminist politic to simply another of the 'voices of the conquered', including 'Third World nations' and the 'revolt of nature', that challenge 'the West's desire for ever-greater domination and control'.[9] Owens' article, like many texts discussing the intersection of feminism and Postmodernism from the 1980s, ultimately references the [avant-gardist notion of the] potential of the 'feminine' to disrupt Modernist purity [...]

Underlying [the] dominant Postmodern value system [with its reliance on oppositional, avant-gardist theories of 'good' versus 'bad' Postmodernism] is the stipulation that there is no female pleasure in viewing under the Freudian (nor arguably, the Lacanian) system. In the Mulveyan 'feminist anti-fetishism' or 'puritanism of the eye', where visual seduction is seen to be necessarily complicitous with male fetishism, female pleasure is simply ignored.[10] In this way, Mulvey's theoretical negation of female pleasure seems complicitous with its denial by patriarchy, the disempowering effects of which are described so vividly by Irigaray. Ironically, in overlooking the question of female pleasure, critical texts that privilege feminist appropriation art for its refusal of the desiring 'male gaze' have maintained the boundaries of masculinist critical and viewing authority even as they have worked to celebrate practices that critique it. The post-feminist programme, as it has been defined in Postmodern art discourses, is complicit with both Modernism's general refusal of pleasure, and with the Mulveyan focus on male pleasure (and its prohibition) at the expense of accounting for the possibility of a desiring female spectator [...]

Taking up the work of Solomon Godeau, I have argued that photography is deeply implicated historically and ideologically in the construction of the post- as well as the pre-feminist subject. As we have seen, it is the photographic, with its nonchalant posturing as an index of the real, that bears the onus of responsibility for the visual construction of post-feminism. And photographic practices in the visual arts that have worked most directly to refute the politics of the 'male gaze'. Given its complicity with late-capitalist and still strongly patriarchal regimes of power, and its role in so-called postfeminist, postmodernist critiques of fetishistic representations of the female body, it is worth asking how photography might be seen to provide an eroticizing and sometimes overtly 'disgusting' practice that obviates the rigidly oppositional mechanics of the fetishizing 'male gaze'.

One possible avenue for this eroticization might be through the explicit rendering of the very female genital parts that initiate the anxiety that Mulvey describes as the attempt to defuse the threat of the female body through a fetishizing visual pleasure that is exclusively male. It might at this particular 'post-feminist' moment be through the photographic rendering of these unruly genitalia (unspoken and unseen within normative patriarchal definitions of 'proper' femininity) that the rigidly

hierarchical and discriminatory value systems of post-feminism can effectively be thwarted. By eliciting polymorphous spectatorial pleasures and representing that which is forced to remain invisible within the masculinist economy of sexual difference, photographs evoking the female body might begin to break down to the totalizing system of the 'male gaze'.

While Sherman and Kruger's photographic works operate explicitly within conventional codes of representing the female body in order to deconstruct these codes, a number of feminist photographers, including Jeanne Dunning and Judy Bamber, have begun to produce work that draws on pornographic codes of representation to push the boundaries between pleasure and horror, between desire and repulsion, photographing the female body or its surrogates in eerily close-up fragments to dislocate the hidden fetishism at work in the construction of the feminine (or, as it were, post-feminist) subject. While the so-called post-feminists construct images to confront the putatively always already 'male' gaze, these artists play it out, for a potentially radically different 'gaze' that is marked as reciprocal with that of the maker. While in Modernist 'art' photography and in the photographic advertisement the female body serves to fill in for the loss imagined by the male at his anxious siting of the female genitals, these photographers directly photograph the female body or its surrogates in explicitly genital images. By aggressively enacting through the putatively indisputable evidence of the photograph the very uncanny disgust that Pierre Bourdieu pinpoints as the defence of the bourgeoisie against uncontrollable bodily pleasures, these practices as I interpret them here obviate the structures of domination motivating constructions of post-feminism [...]

In *My Little Fly, My Little Butterfly* (1992), Judy Bamber displays two tiny, pristine photographs of female genitalia. One is covered with flies, the other with butterflies. Freezing the uncanny aesthetic effects of the female genitals through the photographic, Bamber exposes the ideological function of the uncanny with the superimposition of dead insects, fixed to the clinically photographed surface of the cunt with pins. At the same time, the unidirectional propulsive 'male gaze' theorized by Mulvey is subverted by Bamber's doubling of the image ('doubling' being one of the key phenomena related to the uncanny, according to Freud), and by the insect bodies, which flamboyantly signify the repulsiveness of female genitalia – a repulsiveness born of their threat (as clearly 'present' but non-penile, non-male) to the patriarchal male subject; a repulsiveness conventionally averted by forcing the female genitalia to signify the site of fulfilled male desire (in the pornographic beaver shot) or by carefully veiling, de-emphasizing or erasing it (in western 'art' photography and painting). The aggressive repulsion of the mythic 'male gaze' allows a space for the non-masculinist viewing response – offering the female subject an image of self-recognition and a site of female to female desire.

Jeanne Dunning's genital images, which turn out to be close-up photographs of rotting or peeled fruit, also insist on the coexistence of repulsion ('the horror of the female

genitals') and desire as potential spectatorial relations to the photographic fetish." In *Untitled Hole* (1992), Dunning forces the desiccated orifice of a stemless and half-decayed plum to perform as both vagina and, potentially even more threatening to the prohibitive strictures informing the politics of the macho 'male gaze', a potentially male anus. In another image, *Untitled with Tongue* (1990), the normative fetishization of the female face is perverted with the intrusive and 'disgusting' presence of a hideously huge, slimy, red tongue (a piece of red pepper?) that juts from the woman's mouth. The tongue, this monstrous tool of oral sex and French kissing, is exploded out of all proportion, scarring the pristine face of femininity. Like Medusa's snake-covered head, the job of the photographed image of woman is to provide a visual blow job, as it were, to assuage the castration anxiety-ridden by stimulating that which he fears to lose ('the sight of Medusa's head' with its fetish/snakes, Freud writes, 'makes the spectator stiff with terror … reassuring him of the fact [that he possesses a penis]').[12] Dunning exaggerates the role of the tongue in this face/tongue composite, this figure of male sexual fixation, such that the female face (a photographic fetish) is aggressively violated by the very 'tongue' that might have reassured through its phallic shape […]

1 Laura Mulvey, 'Dialogue with Spectatorship: Barbara
 Kruger and Victor Burgin', *Visual and Other Pleasures*
 (Bloomington and Indianapolis: Indiana University
 Press, 1989) 134.

2 Mira Schor introduces this notion of 'aesthetic
 terrorism' in her article 'Figure/Ground',
 M/E/A/N/I/N/G, 6 (1989) 18.

3 I discuss this hegemonic Postmodernism and its attendant
 modes of exclusionism and cultural domination at length
 in my book, *Postmodernism and the En-Gendering of Marcel
 Duchamp* (Cambridge, England, and New York: Cambridge
 University Press, 1994).

4 Craig Owens, 'The Discourse of Others: Feminists and
 Postmodernism', *The Anti-Aesthetic: Essays on
 Postmodern Culture*, ed. Hal Foster (Seattle: Bay Press,
 1983) 57-82.

5 *Ibid.*, 62.

6 *Ibid.*, 62.

7 *Ibid.*, 59, 64.

8 There are feminist cultural theorists who examine the
 feminism/Postmodernism intersection in ways that are
 more sensitive to the specificities of feminist theory.
 See Janet Lee, 'Care to Join me in an Upwardly Mobile
 Tango? Postmodernism and the "New Woman"', *The Female
 Gaze: Women as Viewers of Popular Culture*, ed. Lorraine
 Gamman and Margaret Marshment (Seattle: Real Comet
 Press, 1989) 172; Linda Hutcheon, 'Postmodernism and
 Feminisms', *The Politics of Postmodernism* (London and
 New York: Routledge, 1989) 142, 152; Shelagh Young,
 'Feminism and the Politics of Power: Whose Gaze is it
 Anyway?', *The Female Gaze*, *op. cit.* 173-88; Susan
 Suleiman, 'Feminism and Postmodernism: In Lieu of an
 Ending', *Subversive Intent: Gender, Politics, and the
 Avant-Garde* (Cambridge, Massachusetts: Harvard
 University Press, 1990) 181-205; Laura Kipnis,
 'Feminism: The Political Conscience of Postmodernism';

 the essays collected in *Feminism/Postmodernism*, ed.
 Linda Nicholson (London and New York: Routledge, 1990);
 Barbara Creed, 'From Here to Modernity: Feminism and
 Postmodernism', *Screen*, 28: 2 (Spring 1987) 47-67;
 Meaghen Morris, *The Pirate's Fiancée: Feminism,
 Reading, Postmodernism* (London and New York: Verso,
 1988); and Elizabeth Wright, 'Thoroughly postmodern
 feminist criticism', *Between Feminism and
 Psychoanalysis*, ed. Teresa Brennan (London and New York:
 Routledge, 1989) 141-52.

9 Owens, *op. cit.*, 67.

10 Emily Apter, 'Fetishism and Visual Seduction in Mary
 Kelly's *Interim*', *October*, 58 (Fall 1991) 97.

11 These are the terms in which Freud defines the
 ambivalence of fetishism, in 'Fetishism', trans. Joan
 Riviere, *Sexuality and the Psychology of Love* (New York:
 Macmillan, 1963), 217, 219.

12 Sigmund Freud, 'Medusa's Head', trans. James Strachey,
 Sexuality and the Psychology of Love (New York:
 Macmillan, 1963) 212.

Amelia Jones, 'Feminism, Incorporated: Reading "Post-
feminism" in an Anti-Feminist Age', *Afterimage* (December
1992) 10-15.

Tessa BOFFIN, Jean FRASER

Stolen Glances [1990]

In the summer of 1988, while sitting in a car on the Walworth Road in London, we conceived the idea for this book about lesbian representation by lesbian photographers and writers. Lesbians and gay men in the UK were fresh from the struggle against Section 28 of the Local Government Act,[1] disappointed that we had not succeeded in preventing it from being passed into law, yet exhilarated by the increased sense of lesbian and gay community that those struggles had engendered. We were aware of the irony that, despite its attempts to repress us, Section 28 had given us more visibility in the mainstream media than ever before. We wanted our work to be visible too. We had seen exciting photographic work by lesbians both here and in North America, and we knew there must be more, but this work existed in isolated contexts; we wanted to make it accessible to a wider audience of lesbians and the 'independent' photography sector. We also knew that there were many parallels between the US and the UK in relation to right-wing promotion of traditional family values, repression of diversity and a growing climate of censorship. Section 28 legislates against 'the promotion of homosexuality'; we felt that promotion was precisely what was needed. To the embryonic idea of a book, we added an exhibition.

Our imagination was caught by the inventiveness of lesbian photographers who had 'stolen' and inverted the meanings of mainstream, heterosexual imagery. We therefore set out to produce a book which addressed the representation of lesbianism and lesbian identities in this way. Lesbianism exists in a complex relation to many other identities; concerns of sexuality intersect with those of race, class and the body, and our contributors discuss these issues. When we set out to select contributions, rather than attempting to naturalize a 'lesbian aesthetic', we looked for work which concentrated on constructed, staged or self-consciously manipulated imagery which might mirror the socially constructed nature of sexuality. We have not included much documentary work as the realism of documentary has often been used ideologically to reinforce notions of naturalness. We do not want this book to claim a natural status for lesbianism but rather to celebrate that there is no natural sexuality at all.

SEXUAL DIFFERENCE

Theories of sexual difference which emerged in the early 1980s attempted to counter notions of biological determination which go hand in glove with documentary realism. These ideas gained currency both within theoretical journals and gallery selection criteria. We are, however, concerned that sexual difference theory has almost entirely failed to consider same sex desire, and seems to have concentrated solely on heterosexual difference. A landmark exhibition, *Difference: On Representation and Sexuality*, organized by Kate Linker and Jane Weinstock in 1984, sadly fell straight into this trap […] The word 'reproduction' assumed a focal position in the catalogue, both in its relation to representation and to sexuality. If sexuality and representation are mutually constituted, then it cannot be possible to discuss them as two discrete entities, one existing before the other. Representations do not merely reflect sexuality but play an active role in its production. Sexuality is always mediated and it is through representations that our bodies, and our fantasies, come to be sexually organized.

This stance on sexuality and representation would seem, at first sight, ideally suited to challenge the heterosexual regime produced and reproduced by representations. However, lesbian and gay photographers and writers, on both sides of the Atlantic, were acutely disappointed by the show. William Olander, curator at the New Museum of Contemporary Art in New York City where the show first appeared, referred to it as a 'stunning failure' with regard to homosexuality.[2] A virtual counter-exhibition entitled *Same Difference* curated by Jean Fraser and Sunil Gupta was held at Camerawork Gallery, London, in July 1986, while the American photographic journal *Exposure* carried an article also titled 'Same Difference' by Martha Gever and Nathalie Magnan stating that the *Difference* show had 'framed' representation to reproduce only heterosexual ideology and imagery. This article [reprinted in this book] represented the start of a fight-back in which lesbian and gay cultural producers began to highlight the inadequacies of sexual difference theory […]

Much of the work in this book examines how lesbian identities are forged and enriched through the appropriation of images from mainstream and marginalized discourses. Sue Golding, for example, writes about the identity of a lesbian hermaphrodite, a James Dean look-alike, whose composite image is copied again and again from icons in the public domain. Deborah Bright's photographic series inserts a lesbian presence

into Hollywood movie stills in order to examine how this transforms a conventional heterosexual narrative, and creates deviant readings. Similarly, Lynette Molnar and Linda Thornburg montage into various advertising and journalistic images a photograph of women embracing. The strip cartoon format is used by Kaucyila Brooke to examine through her heroine Badgirl, how lesbian stories intersect with mainstream popular culture.

Other photographers, such as Della Grace, Morgan Gwenwald and Jill Posener, appropriate the visual codes of pornography precisely in order to hijack heterosexual sites and customs. Their work also invades public space and challenges legal and moral assumptions that same-sex desire should only be enacted by 'consenting adults in private'.[3] Jude Johnston, on the other hand, inscribes lesbianism into a public space by the superimposition of text onto the photograph of an everyday street scene, juxtaposed with a private embrace. Cindy Patton compares the 'real', and documented, space of gay male desire – the pornographic cinema where cruising can take place – with the more imaginary and under-represented space of lesbian desire, and calls for a 'safe house' for lesbians which will enable these desires and images to be enacted.

The majority of photographic work in this book consists of manipulated imagery. Some photographers stage scenarios: Alice Austen, Tessa Boffin, Kaucyila Brooke, Jacqui Duckworth, Jean Fraser, Della Grace, Morgan Gwenwald, Mumtaz Karimjee, Rosy Martin, Ingrid Pollard, Jill Posener, Hinda Schuman. Others add text at the post-production stage (Jude Johnston, Connie Samaras) or use solarization (Tee Corinne), positive/negative reversal (Nina Levitt) and photo-montage (Deborah Bright, Lynette Molnar) to undermine the 'naturalness' of the straight image […]

1 For further discussion of Section 28 of the Local Government Act, see Anna Marie Smith's essay 'Which One's the Pretender? Section 28 and Lesbian Representation', *Stolen Glances: Lesbians Take Photographs* (London: Pandora Press, 1991).

2 William Olander, *HOMO VIDEO: Where We Are Now* (New York: New Museum of Contemporary Art, 1986) 1.

3 See Jeffrey Weeks' discussion of *The Wolfenden Report on Homosexual Offences and Prostitution* (1957) in *Sex, Politics and Society: The Regulation of Sexuality since 1800* (London: Longman, 1981) 239–44.

Tessa Boffin and Jean Fraser, 'Introduction', *Stolen Glances: Lesbians Take Photographs*, ed. Tessa Boffin and Jean Fraser (London: Pandora Press, 1991).

Renée GREEN

A Genealogy of Desire: Interview with G. Roger Denson [1991]

G. Roger Denson You currently have a work at P.S. 1 in Queens, New York. Could you start by talking about that?

Renée Green Well, it's an ongoing piece, in three locations at P.S. 1: the boiler room, the attic and some of the stairwells. It's an associative piece about those types of rooms, and I thought of the stairs as the liminal connections between them. I used texts to inform the work.

Denson What are the texts?

Green In the attic I refer to a chapter from the autobiography, *Incidents in the Life of a Slave Girl*, by Harriet Jacobs, and in the boiler room I quote passages from the novel *Native Son*, by Richard Wright. It occurred to me to use these texts because I usually think of literature when I work. When I saw the boiler room at P.S. 1, I immediately thought of *Native Son* because there's a scene in it where Bigger Thomas, the lead character who is a young black man, burns the body of the daughter of the white family he works for. The book was published in 1940 and it was the first bestseller by a black author: it was very controversial. I read the criticism that surrounded the book's release and the things that were said about it were similar to what was said about Spike Lee's film, *Do The Right Thing*. There was a fear of uprisings and riots expressed in many of the reviews. I chose small passages from this and surrounding scenes. These quotations are meant to give the viewer hints that a black man had accidentally killed a white woman and that, afterward, he attempted to dispose of her body by cremating it in the boiler. But I don't give all the details or the names of the characters. Together the spatial signifiers indicate what is about to happen to this black man. The boiler room installation is called *Fear, Flight, Fate*, taken from the three headings in the novel.

Leading up from the boiler room to the attic are stairwells containing six plaques with quotations from different sources ranging from the era of the ancient Greeks to the present, all referring to aspects of *blackness* and *whiteness*. Some of them relate to philosophical distinctions; some are from literature. They're meant to stimulate different kinds of thought regarding colour, including thoughts pertaining to metaphors of 'race'. When you reach the attic, you find a room with wooden floorboards and beams. This part of the installation is called *Loophole of Retreat*, the name of a chapter in *Incidents in the Life of a Slave Girl*. This character, Linda Brent (who is based on the author, Harriet Jacobs), had to live in an attic for seven years to hide from the slave holder who was trying to capture her. It was her grandmother's house (her grandmother was free), located in the same town she's always lived in. A little niche was made for her under the roof; it was very small, something like 274 × 213 × 91.5 cm [9 × 7 × 3 ft]. In the P.S. 1 attic, I blocked off a little garret area and vertically hung a slat fence that has a rubber-stamped text which alternates between slats, quoting parts of the chapter in which she describes being confined to this space. Slats attached to the floor and rubber-stamped with the chapter titles lead to the windows where there are twenty-six jars, labelled from A to Z, containing different substances relating to *whiteness* and *blackness*. I also put up a muslin curtain that covers part of the site from the ceiling to the floor behind three vertical nail-studded posts around which string is

gradually wrapped to create an inner sanctum within the space. Inside the sanctum is a desk which is also a sewing table. I conceived of the entire installation – the boiler room, the stairs and the attic – as being connected. Several kinds of genealogies are being traced. One is that of the terms *blackness* and *whiteness*: the genealogy of these terms is resonant with associations. Another genealogy referred to is that of African-American texts which are used as an index of predicaments which classically have been faced by members of the African diaspora. The history of artists' installations is another genealogy being traced here […]

Denson Could you talk a little about the politics implied by this work and also its relationship to the audience? I want to point out that at Pat Hearn Gallery the audiences that attended were much more racially diversified than is ordinarily seen in the New York art world. I assume that this is somehow a point of the work, its ability – as an interested and content-laden art form – to expand and diversify the art world.

Green I did try to think about who normally sees the artwork and who I would like to see it, especially as the Pat Hearn show was my first one-person show in a commercial space. This kind of thinking about who comes to exhibitions was stimulated by an artist's residency at the Studio Museum in Harlem, in 1988 and 1989. At the Studio Museum I was in contact with a number of people who came into the museum, as that's part of the programme: to be available to talk with the people who come in and look at your work. Here I was thrust into a public position and it affected my production. And because there were reviews of the work in papers that African-Americans read, I was encountering a sector of the population that wasn't ordinarily going to galleries. I didn't want to lose this audience when changing my exhibition location. I've been interested in the ideas of some black British writers, like Stuart Hall, who writes about diasporic 'identities' and the 'burden of representation', and Kobena Mercer, who writes about the diversity within black 'communities'. Hall's thoughts on the burden of representation treat the externally enforced notions of what is considered 'politically correct' in terms of community. Both Hall and Mercer are questioning the whole notion of community in terms of blackness, because there are so many different kinds of blackness that the notion of a rigidly defined 'black community' can become another form of oppression – and therefore a burden of representation – especially for people involved with cultural production […]

Denson It seems that by critiquing white, liberal intellectuals you're clarifying why you work in the centre of the elite, 'white' art world. Often the argument criticizing political art retorts that political artists are merely preaching to the converted. But you obviously aren't preaching to the converted; you're preaching to the very class that discreetly perpetuates aesthetic, ideological and culturally mercantile oppression.

Green Well, I don't feel I'm preaching, but rather presenting my point of view. If this is interpreted as preaching, then obviously the 'converted' have a lot of problems.

12. Tessa Boffin

G. Roger Denson, 'A Genealogy of Desire: Renée Green Explores the Continent of Power', *Flash Art*, 160 (October 1991) 125–27.

Collier SCHORR

Media Kids: A Girl's Own Story [1992]

[...] Sometimes I wonder what would have happened if I had come out in high school. If I had told the girl I sat next to in band that I thought she had the most beautiful hands in the world and I would give anything just to touch them. If I had told people I was gay, would shy girls have crept up to me in the locker room after gym and confessed their desire to be kissed?

As I watched six little video tapes by a nineteen-year-old named Sadie Benning, safely packed up memories came flooding back. Benning's work is nothing less than a time capsule, autobiographical home movies that detail a girl's coming of age. At fifteen she began to weave her diary entries into experimental narratives. All of her tapes use an intermingling of written and spoken dialogue. Little scraps of text function as answers to questions, as deadpan punch lines, or as a second voice with which to argue. Made with no specific audience in mind, they recall the exercise of speaking in front of a mirror or making out with a pillow – practicing before doing it for real. Benning sits perched before her camera as if it were a close friend and talks about falling in love, being a freak, quitting school, touching a boy's dick on a dare.

In *If Every Girl Had a Diary* (1990), a phosphorus fist fills the screen. Opening, stretching and clenching into a ball, it becomes a knot in your stomach. As Benning's hand tenses, she talks about 'crawling the walls'. 'I want so badly to yell', she says, 'but I don't want to cause a commotion. Attention makes me nervous.' While casually eating her lunch in a fictitious restaurant filled with '800 million other faces', she says, 'You know, I've been waiting for that day to come when I could walk the streets and people would look at me and say, 'That's a dyke', and if they didn't like it they would fall into the centre of the earth and deal with themselves ... Maybe they'd return, but they'd respect me.'

Shot mainly within the confines of her bedroom, the tapes suggest the intimacy of a confessional, but one far removed from the arena of guilt. Sitting alone in this room, Sadie Benning is willing to tell you almost everything. It is this need to talk, to assert her newly recognized identity, that propels her forward. She made *Jollies* (1990), as a time line, tracing the evolution of her sexuality. Two Barbie dolls kiss and mount one another, as Benning remembers the first time she wanted to touch another body: 'It started in 1978 when I was in kindergarten / They were twins / and I was a tomboy / I always thought of real clever things to say / Like I love you.' The camera rests on her lips, which part slowly and display a set of braces. She then remembers rolling around naked with an older boy, who later 'jacked off' in her bathroom. 'I never touched his dick again', is

revealed in a childish scrawl. The second hand of a large clock begins a slow revolution, intermittently interrupted by the words 'And then I started / kissing girls', spelled out in baby bracelet beads. The beads, which for some adolescent girls might represent a much treasured boyfriend, become a loaded stop sign. Benning then tapes herself and her girlfriend exchanging a series of unhurried kisses. 'At fifteen I thought about her every day', she states. 'And that meant love.'

Men's underwear sways on a clothesline in the opening shot of *A Place Called Lovely* (1991). Police sirens blare in the background and you are now in Milwaukee, a city that used to be considered emblematic of the working-class American dream, but that, in the last decade, has seen its factories relocate in search of higher profits. *A Place Called Lovely* isn't. Posing under a long blond wig in front of an American flag, Benning gushes, preens and smiles blindly, expressing a hyperpride most often seen on the Republican campaign trail. Her voice replaces the missing national anthem, speaking of her grandmother's wish for her to become this girl, the good girl, because, as her grandmother tells her, 'Bad things only happen to bad people.'

These tapes, most of them made with a Fisher-Price Pixel (kid) camera, sputter and spit like drops of water on a hot iron. Secure and unconquerable one minute, angry and frightened the next, Benning tells the story of a friend who was raped by a 'black man' and then films a handwritten text explaining that the victim became a 'racist, nazi, skinhead'. If you handled her videos you'd be covered in newsprint. They are dark and murky things that seem to ask, though never beg, for allies. There is a sense of controlled craziness in this work, in which the information she extols is still to be processed, and memory is truly a thing of the present.

Although much has been made of Benning's age and of the finesse with which she handles a camera, she is not a *wunderkind*. When, after a recent screening of her tapes at The Museum of Modern Art in New York, she ambled up to the stage to answer questions, she seemed more like a shy kid asked to perform at a family gathering than an artist ready to defend and define a body of work. These tapes may be 'art', but to judge them strictly from within the canon of experimental film and video is, in some ways, to undervalue them. It is important to keep in mind that Benning is representative of a multitude of teenagers who sit alone in their rooms drawing and writing poetry. She could easily be deemed the 'everygirl/tomboy' if gay youth had a voice in any mainstream media. But, of course, they don't. And her messages – anguished, passionate, self-mocking – consequently take on the urgent tone of a survivor.

Collier Schorr, 'Media Kids: Collier Schorr on A Girl's Own Story', *Artforum* (April 1992) 15.

Jutta KOETHER

Out of Character [1993]

[...] In order to understand Rosemarie Trockel's work, it is necessary to start with her public position at the end of the 1970s. Her first exhibition resulted from her friendship with a mixed group of artists from the Rhineland, out of which the (all-male) formation *Mülheimer Freiheit* originated. As with groups in other German cities, these collectives quickly resulted in women (who were still in the minority among young artists) being pushed to the fringes.

At that time Trockel concerned herself mainly with drawings and occasionally with painting. However, she soon decided against this restricted choice of media and thereby removed herself from competition within the group. In contrast to many others, Trockel had no 'master' to reckon with and whom she might rebel against, even in jest. She did not study at an art academy, but at the Werkkunstschule in Cologne, which tended to be regarded in local art circles as 'mediocre' and 'marginal'.

As a consequence, competing with art colleagues was not of primary importance to Trockel. Instead she chose to create a place for art by women, working in close co-operation with her friend and later gallery owner, Monika Sprüth. The idea was to distance themselves from the status quo and to intervene within it, because Sprüth and Trockel did not want to create a ghetto for women artists – a lesson learnt from the history of the women's movement in West Germany. Visibility and presence were their aims [...]

Sprüth started to exhibit the important women artists who dealt with these problems: the Americans Louise Lawler, Jenny Holzer, Barbara Kruger, Cindy Sherman, and also painters Anne Loch and Ina Barfus. Trockel, in the meantime, started to deal with new methods of expressing female work/creativity/representation; defining the choice of material ('pro-choice') and the history of the conditions under which art by women had taken place in Germany – or could not have taken place; the definition of the moments when something could be learned from history. (Trockel also owns a small self-portrait by Gabriele Münter.)[1]

Furthermore, the new method was about allowing the work to reveal indirectly and in an only indirectly didactic sense, the issues that came up when feminism, women's rights and art by women were concerned. Because few were doing this overtly at that time, Trockel can be called a pioneer. This is not to denigrate the merit of major German women artists of the previous generation, such as Katharina Sieverding, Ulrike Rosenbach and the early Rebecca Horn. Instead of being didactic, a lot of Trockel's work is almost erratic and 'un-readable', especially when compared to the work of American women artists in the 1980s. She has also produced works which are exactly the opposite, because they are extremely 'bold' and 'simple'. The construction of this paradox is characteristic of Trockel's methods. Often these methods do just that – they leave questions and doubts open; they make a joke;

DRINK ME HARDER, MY DELIGHT, SWELL TO BURSTING PRETTY SLUICE AND PISS A POSY DEEPER, DEAR, HERE – INTO MY SNOW WHITE RAIN ROGUE ABOUT MY PISTIL SHOT HOT JUICE, AS IF A BUMBLEBEE WOULD LICK MY PETALS, POLLINATE ME FOR CENTRE STAGE'S A GOLDEN CROWN RING-A-RING A DANDELION MOLTEN AMBER ALL FALLS DOWN CALCIFEROUS, HOW NATURE'S ART DOES FREEZE OUR BOLD INDIFFERENCE, VOID NOW VOLUME DAGGLED PLUME, BESPATTERED ALL AROUND LOVE'S SPUME LOCKED TOGETHER, YOU AND I, BIND A HYBRID DAISY CHAIN, ORGANS DOUBLED TWO A BED AND BY A FLORAL RHYMING WED LINNAEUS WHAT WOULD YOU SAY, HOW DEFINE SUCH WANTON PLAY? VAGINAL TOWERS WITH MALE SKIRT, GENDER BENDING WATER SPORT? EACH THE OTHER'S MEASURE WEAR BARED INSIDE-UP CONTRARIWISE, AS IF A CHROMOSOME COULD DARE TO HOST SUCH INVERSE PLEASURES, SQUARED COME SIT ON ME, MY MANDRILL'S ARSE CAST PRIAPIC, FORMER FO LD, SUCK MY PENIS ENVY FARCE LIKE OLD VENUS DE LESPUGUE

they confront the problem of knowing one's place and the possibilities that being out of character can offer. She tentatively holds a position from which she distances herself. For her, a different position would not be tenable. She has not developed a showmanship, nor does she adopt the stance of the 'exceptional' woman, nor is she an artist for men – the ground is historical and hysterical. Merging both characteristics, her work is 'unclean', 'unheroic'. The illustration or merging of these categories' mutual dependence sometimes creates erraticism. It is difficult to decipher this moment; however, over time it is evident that in Trockel's work one can find 'political art', 'women's art', 'poetic art', 'conceptual art' and uncounted other fragments of categories […]

An earlier example of the decisively non-masterly construction of visibility was the 'magazine' with the title *Eau de Cologne*, a project of the Monika Sprüth Gallery which appeared three times and originated with the help of Trockel. The objective was to let the world know of the existence of important contemporary women artists. In order to reach a wide audience, they appropriated the format of the then Warhol magazine *Interview* – at that time a synonym for superficiality, hipness, flashy self-presentation and fashion. *Interview* was itself based on the idea of merging fashion/personality/information/ magazine, and had been seen by the inventor as part of his artistic practice. Similarly transformation/appropriation constructs (which are also partly based on earlier appropriated constructs) make up a substantial part of Trockel's work.

As was already the case with the *Eau de Cologne* magazine, the artist's criticism merges with personal desire; a desire for the cool self-presentation of a model or film star. A desire that returns again and again throughout the years almost obsessively is the preoccupation with clothes, fashion, fabrics and patterns. The 'obsession' is always held, circled and supported by the manifestation of female expression via clothes, but further touches on the problematic nature of the latterly 'typical' women's work (e.g., homeworker, knitter, textile worker).

The best-known and most 'pop-like' works by Trockel are the so-called knitted pictures, which she started to design in the early 1980s, when it was possible to discover Beuysian or poetic qualities in her drawings, and delicate form languages in her sculptures. At first the knitted pictures were perceived as being almost 'vulgar' to people who were just getting used to the 'different' nature of the artist. Supposedly, Trockel's decision to produce her knitted pictures was in part provoked by art critic Wolfgang M. Faust, who commented provocatively on the concept of 'women's art'. He remarked that women could not create art anyway, allowing at best a connection between 'women and weaving'. Trockel used this disparaging, excluding remark as a reason to take action in the discourse about contemporary art. She began proving and validating his bias, over-fulfilling his cynical 'advice'. At the same time she distanced herself from this assertion and turned mere knit-work into 'real art'. One of her first knitted pictures had a 'personal' marking; the markings were the blue-white stripes of French fishermen's jerseys, which Trockel often wears. The knitted pictures are the basic element in that part of Trockel's work history which addresses the household or household technology. Again, this work is connected to personal interest as well as to her convictions.

One of Trockel's special models is Liubov Popova and generally the era of Soviet avant-garde art, when it seemed – for just a moment – possible to be both woman and artist, without contradiction. It was possible to rapidly redesign a large part of life – interiors, clothes, household articles, the world of work – with a simultaneous redesigning of beliefs. Trockel has paid this era homage in a print/motif. Indirectly, there is a reference in many of her works – personal and political interests meet in redesignings, or symbolically in objects. From these meetings, it is possible to draw artistic consequences […]

She is too much of a researcher, and too interested in new visual practices to stick with one of her trademarks (for example 'knitwear'). Her increasing concerns are with scientific questions of anthropology, biology, the perception of and being perceived by mankind and animal, foreshadowed in an edition for the magazine *Texte zur Kunst* (1992): a pair of glasses – a typical, 'normal' frame, with two different lenses: one for extreme long-sightedness and one for short-sightedness. It is these statements, terse at first glance, fastened like perfect aphorisms within the frame of her work, which fascinate me most. Something is set up to address an audience directly; a joke is taken literally and is thus made serious. Conversely a joke or double meaning is extracted from a common but serious form from the art historical or from the everyday visual context. Both processes are thus made themes in the work […]

1　Gabriele Münter is an early twentieth-century German artist.

Jutta Koether, 'Out of Character', *Rosemarie Trockel* (Wellington: City Gallery, 1993) 23-31.

Marina WARNER

Marlene Dumas: In the Charnel House of Love [1993]

'It was the whiteness of the whale that most appalled me', writes Ishmael in *Moby Dick*. Whiteness is the colour of marble and pearls and light, but also of icy wastes, poisonous white lead, leprosy, the blank page, foam on a churning sea, the pallor of fear, ashes, sterility and death. In some cultures, it is the colour of mourning, Ishmael recalls, and everywhere it is the colour of the charnel house. 'There lurks an elusive something in the innermost idea of this hue', continues Ishmael, 'which strikes more of panic to the soul than that redness which affrights in blood'.' Snow White embodies the terrors whiteness holds: when her mother pricked her finger and the red drops fell in the snow, she wished for a child as red as the blood, as white as the snow, with hair the colour of ebony; later, when Snow White lies in her coffin, she is associated with poison, first with the comb, then with the apple given to her by the wicked queen to choke her; and her casket imprisons her in the icy purity of glass. As Primo Levi wrote, this kind of purity is death, because it cannot give rise to 'changes, in other words, to life'.²

Marlene Dumas has put on Snow White like a bitter shroud over her own self; in her painting, *Snow White and the Broken Arm* (1988), the prone figure lies with a camera in her dangling hand, snapshots scattered around her, while old-young children look at her from the other side of her bier, as if through a glass. The painting suggests a narrative – a peepshow in a red light district, a judicial punishment? A crime has been committed, a girl has been beaten. But whose crime is it? Snow White has sinned with the female sin of curiosity, perhaps, by gathering evidence, taking photographs. Dumas has written in a poem:

'My people were all shot
by a camera, framed
before I painted them. They didn't know
that I'd do this to them.'³

But the onlookers, the child dwarfs, those clients at the spectacle, they too are perpetrating an indecency, and we, on the other side of the body, become accomplices in the entertainment too.

Dumas handles the scene with the kind of violence associated with Expressionism, but here the daubs and streaks of the paint, the irresolution of colour in the skin tones seem to struggle to put some distance of abhorrence between herself and the livid flesh. This Snow White has assumed her whiteness, it lies on her body like vernix, a discolouration, rather than the healthy integrity of flesh and skin. Marlene Dumas, who was born in South Africa, brings a special despair to the meaning of being 'White'; the term hardly describes the colour of skin to anyone, let alone a painter, and to a child of apartheid, it represents above all a political category conferring privilege and power. Whiteness thus recurs in Dumas' work as something falsely prized, that traduces and corrupts […]

By contrast to the cosmetic fraudulence of white paint and all the sickliness it conveys on Dumas' brush, black ink becomes her medium for sincerity, and for the imagination actively engaged – oozing, seeping onto and into the paper until it fuses with it, seemingly arising out of it as if from a child's magic colouring book. Works like *Female* (1993), which presents a wall of drawings of women's faces (one for each day of the year), or like *Black Drawings* (1991–92), another wall of studies of black faces (mostly, if not all men), struggle with specific features – with the particularity of faces. The record Dumas compiles here of diversity and individuality, the variety she unfolds within the databank repetitiveness of the form, actually affirms a kind of hope. It is interesting that, again, Hans Holbein comes to mind; a great portrait draughtsman, he levelled with the precise arrangement of his subjects' features to leave an accurate account of many men and women who died on the scaffold or were disgraced, like Thomas More. There is a sense in which all portraits deny death and at the same time anticipate it, setting up memorials to ghosts before they are made such.

Dumas' pornographic sketches, both on small, monochrome canvases, and in wash and ink notebook drawings, again express, through the vital flow and spread of the medium itself, the intensity of her struggle against

the pain of the theme. Women's spread-eagled bodies bring memories of birth as well as sex, the genitals and inner organs turned into machines, a kind of apartheid of affect and sexuality, of heart and sex. They are among her strongest works – they capture the ferocity of erotic encounters without the distance of irony or moralizing, and at the same time manage to appall as they chronicle abuses in social and commercial practice. Like the baby pictures, they too own up to uncomfortable responses – including the wayward masochism (and sadism) of private fantasy.

Snow White may lie dead and bound by the glass coffin, but the artist's spirit is still walking abroad, a refugee from the plot, watching, taking photos, imagining pictures, making paintings, in a restless oscillation between black resistance and bleak (white) despair.

1 Herman Melville, *Moby Dick*, Chapter XLL.

2 Primo Levi, *The Periodic Table*, trans. Raymond Rosenthal (London: Penguin, 1985) 34.

3 'The Eyes of the Night Creatures', in *Marlene Dumas* (Bonn: Bonner Kunstverein, and London: ICA, 1993) 22.

Marina Warner, 'Marlene Dumas: In the Charnel House of Love', *Parkett*, 38 (1993) 76-79.

Eileen MYLES
Nicole Eisenman at Trial Balloon [1993]

When I think about writing about Nicole Eisenman's work, which I've followed for about a year, I get like one of her characters ('Hoo boy!'), and sweat starts popping out of my face in cartoonish drops. On the scribbly left wall of her first solo show at Trial Balloon, New York, there was an agitated female character, and bursting out of her vagina were two little smiling faces, arms outstretched to the world, and their words were splayed too, *sans* balloon: 'Hi Mom, surprise we're twins.' If female creativity has its apotheosis in giving birth, and being female is, as some Postmodern theorists tell us, inherently excessive and outside the law, then Nicole Eisenman has given us a succinct new image of the woman artist – a site of excess creation.

'The Minotaur Hunt and Penelope in the Pit, Mural and video by Eisenklein productions' was how her handwriting announced this show (photographer Diana Klein collaborated on the video). The surrounding wall was bedecked in doodles, trophies, pictures clipped from magazines and drawn on, a knife stabbing the wall, and so much else. In one spot a series of male faces was rubber-stamped on to the surface, and with a pen she blithely added a wig (nicole warhol), a finny posterior (nicole tadpole), endlessly silly, and then the Minotaur head loomed into the frame, abruptly jerking this side of things into seeming like the back of the rug, all stops and starts. The video component of this show simulates the anarchic spectacle of her weaving. 'It's my first animation', she explains. The tape, which shows the artist at work, is punctuated by an assortment of ambiguous sexual

explosions, with penises jumping off and on to figures.

On the second wall was Eisenman's masterpiece (painted over once the show closed). It was a gorgeous wall drawing, a horde of naked writhing female forms brandishing spears, one astride a horse, pushing her brown weapon into the neck of a prostrate form (the Minotaur), but repetition was key, and there was another Minotaur with his throat about to be slit, an amazon yanking his head back. And another and another. It was way classical. As far back as you could see, spears were dancing in the air, all done in a monochromatic brown ink. An ornate trim evolved into tree trunks that shaded and framed the view, lending an air of depravity to the proceedings. Beyond one tree trunk, to its right, as everything was going red and pink, sat Penelope in the racing pit, a Hanna-Barbera cutie with turned-up nose and flipped eyelashes in pink helmet and gear. There was a crowd around her, all women, pumping her up with their sheer presence, yet also gazing off into the as yet uncreated distance.

Eileen Myles, 'Nicole Eisenman at Trial Balloon', *Art in America*, 81: 12 (December 1993).

Joanna FRUEH
Hannah Wilke: The Assertion of Erotic Will [1993]

[...] Wilke's beauty provides her entry into an ideal whose oppressiveness for women threatens to make her work a continuation of the 'tyranny of Venus', which Susan Brownmiller says a woman feels whenever she criticizes her appearance for not conforming to prevailing erotic standards. However, Wilke as usual twists language, in this case the grammar of Venus, the perfect woman. She parses the 'sentence' of the female body into a statement of pleasure as well as pain. While 'modelling' her beauty in *S.O.S. – Starification Object Series* (1974–75), she 'scars' herself with chewing-gum sculptures, suggesting that being beautiful is not all ease, fun, or glamour. Twisting chewed gum in one gesture into a shape that reads as vulva, womb and tiny wounds, she marks her face, back, chest, breasts and fingernails with the gum-shapes before she assumes high-fashion poses. Her 'scarification' is symbolically related to African women's admired keloided designs on their bodies. The Africans endure hundreds of cuts without anesthesia, and Wilke alludes to the suffering that Western women undergo in rituals of beautification.

From Una Stannard in 1971 to Naomi Wolf in 1991, feminists have analyzed the pain women 'choose' in order to meet beauty standards.¹ The beautiful woman suffers, for to be a star as a woman is to bear 'starification', being observed by others as a process of criticism and misunderstanding. To be 'starified' is, in some measure, to be ill-starred, and the 'ornaments' decorating Wilke in *S.O.S.* are not only scars but also stigmata. They make the model woman into a martyr.

Western culture fearfully reveres Venus in the bodies of women, and she must be crucified. Freudian theory kills

the mother, not the father, despite the privileged status of the Oedipal stage; artist Carolee Schneemann says Dionysus stole ecstasy from Aphrodite; and Wilke believes that Venus envy, not penis envy, has caused misery between women and men. If Venus were a contemporary divine ideal for women, rather than a clichéd sex goddess, then women would not have to struggle to invent the meaning and practice of erotic-for-women.²

Erotic-for-women – *for* women meaning that women are producers and consumers – is erotic for oneself, autoerotic autonomy whose power is both self-pleasuring and relational. Autoeroticism is apparent in self-exhibition and in women's gaze at other women unclothed. Erotic-for-women loves the female body without discriminating against its old(er) manifestations. Self-exhibition may demonstrate the positive narcissism – self-love – that masculinist eros has all but erased, and self-exhibition is a commanding statement, 'Here I am. See my body', an attitude apparent throughout Wilke's work [...]

Wilke remembers that as a girl she 'was made to feel like shit for looking at myself in the mirror' and that as a young woman she felt she 'was observed, objectified by beauty'. Her looks made her uncomfortable, and she believes she is 'the victim of my own beauty', for 'beauty does make people mistrust you'. A woman is 'unfeminine', wrong, when she is not beautiful, yet if she is beautiful, she is still wrong. Wilke employs the peculiar inappropriateness of beauty in order to confront its wrongness. By being 'improper', publicly displaying her beauty, she has used her art 'to create a body-consciousness for myself', a positive assertion of her beauty, which is erotic-for-women.

'Why not be an object?' she asks, one who is aware of her I-ness, who is an 'I Object'.³ Wilke's *I Object* (1977–78) critiques Marcel Duchamp's *Etant donnés* (1946–66), one of his two most mythicized works. *I Object* is a fake book jacket, and its subtitle is *Memoirs of a Sugargiver*. On the front and back Wilke lies nude, legs apart, like the naked girl lying corpselike on twigs in *Etant donnés*. The photographs are what Wilke calls 'performalist self-portraits', with artist Richard Hamilton, taken on coastal rocks at Cadaques, Spain, Duchamp's home in Europe during his later years. Two art historians see Duchamp's girl as 'locked into a world of her own, like Sleeping Beauty'.⁴ 'I object', as a declaration, protests the girl's inertness. Wilke seems to respond to the girl's deadness when she says, 'I find *Etant donnés* repulsive, which is perhaps its message. She has a distorted vagina. The voyeuristic vulgarity justifies impotence'⁵ [...]

So Help Me Hannah Series: Portrait of the Artist with Her Mother Selma Butter (1978–81) is a blunt and poignant handling of women's 'perfection' and 'imperfection'. Wilke appears in the diptych's left segment with her breasts and chest displaying found objects that resemble 'raygun' shapes she had collected as gifts for her lover, Claes Oldenburg, in the early 1970s. She scrutinizes the viewer wearing an expression that suggests that pain and sadness underlie her flawless complexion. On the right Wilke's mother has turned her face from the camera, and her body, exposed from shoulders to waist, shows not only an old woman's fragility but also the ravages of

<div style="writing-mode: vertical">14. Hannah Wilke</div>

disease. Selma Butter has had a mastectomy, and the scars of her cancer surgery cover the area where her breast once was [...]

Wilke's indication of trouble in the paradise of beauty – the guns as emotional scars of love lost – becomes real scarification in the portrait of her mother. Wilke uncovers truth – that life is also loss, that beauty changes, that age and illness must not be hidden. We see a deteriorated body that the photographer, Wilke, clearly loves, for it is very much alive with the presence of Selma Butter. Here perhaps is the necessary correlate of Wilke's erotic joy – the reality of death.

Wilke faced both of these in 1987 when she was diagnosed with cancer – lymphomas in her neck, shoulders and abdomen – and from then till her death, in the art she made during her illness. The *Intra-Venus Series* (1992–93) is an astounding assertion of erotic will, which proves that erotic-for-women is courageous and radical. *Intra-Venus* is a rite of passage for illness and aging [...]

Wilke provides erotic security in *Intra-Venus* by confronting and embracing flesh that has moved in an ageing illness. A reclining nude in the series presents Wilke as erotic agent and object. She is a damaged Venus as in *S.O.S.*, this time damaged by cancer and its therapies. Intravenous tubes pierce her and bandages cover the sites, above her buttocks, of a failed bone-marrow transplant. Her stomach is loose, and she is no longer the feminine ideal. 'My body has gotten old', she said a little less than a month before the bone-marrow transplant, 'up to 188 pounds, prednisone-swelled, striations, dark lines, marks from bone-marrow harvesting'. While an art historian could cite Renaissance martyr paintings as sources, she could also understand Wilke's vulnerable Venus, twenty years ago as well as recently, as a warrior displaying wounds and as the dark goddess, Hecate, at the crossroads of life and death. Wilke has called her work 'curative' and 'medicinal', and she has said that 'focusing on the self gives me the fighting spirit that I need' and that 'my art is about loving myself'.[6] The *Intra-Venus* nude shows Wilke within – intra – the veins of Venus, a lust for living in the artist's blood [...]

One myth about feminine beauty is that it is dangerous. A beautiful woman is stunning, striking, a knockout, and a dangerous person is powerful. That power can be radically beneficial. Throughout her career Wilke performed the indispensable power of beauty and the soundness of danger. Beauty attracts, sometimes to such a degree that the viewer feels out of control, overcome by fear or sexual desire, by wonder and sheer enjoyment, or by a magic that disturbs her peace of mind. Beauty is departure from the ordinary, provoking and luring the viewer into uncommon thoughts and feelings. Wilke seduces her audience into terror and pain, the inescapability of death, the suffering behind the mask of lovely flesh, the 'exotic' grace of change. To grow old gracefully is to go into erotic decline, to be the passive beauty who is losing her looks, while to be full of grace is to be at once dangerous and comforting.

Beauty can be dangerous to the status quo, especially when women deal with it, like Wilke, in both grave and playful ways. Society does not encourage women to 'play with themselves', for sexual, political, intellectual or creative pleasure. Obeying fashion's decrees is conformist and therefore highly restricted play, but making a spectacle of oneself may well be an assertion of erotic will. For spectacles do not have to follow orthodoxies. Woman-as-spectacle fascinates and disquiets many feminists, but Georgia O'Keeffe's nun- and monk-like 'habits' and Louise Nevelson's ethnic butch/*femme drag* were a far cry from professional sex queens' regalia whose formulaic eroticism, for some feminists, calls into question the sex icon's erotic inventiveness. Wilke's self-display, which is erotic play, has always been an affront to proper femininity, which is patriarchy's containment of female possibility. Wilke as erotic spectacle verifies female genius.

1 Una Stannard, 'The Mask of Beauty', in ed. Vivian Gornick and Barbara K. Moran, *Woman in Sexist Society: Studies in Power and Powerlessness* (New York: Mentor, 1971) 187-203; and Naomi Wolf, *The Beauty Myth: How Images of Beauty Are Used Against Women* (New York: William Morrow, 1991).

2 Carolee Schneemann, in an interview with the author, 18 June 1992. Wilke first used 'Venus envy' in a 1980 series of Polaroid photographs, and she spoke about Venus envy in conversation with the author (9 June 1988).

3 This and the quoted statements in the previous paragraph come from a conversation I had with Wilke (9 June 1988).

4 Anne d'Harnoncourt and Walter Hopps, *Etant donnés: 1° la chute d'eau, 2° le gaz d'éclairage: Reflections on a New Work by Marcel Duchamp* (Philadelphia: Philadelphia Museum of Art, 1973) 64.

5 Hannah Wilke in conversation with the author (9 June 1988).

6 All Wilke's statements about her illness and *INTRA-VENUS* are from telephone conversations with the author, 11 May 1992 and 9 January 1993.

Joanna Frueh, 'Hannah Wilke: The Assertion of Erotic Will', printed as 'Aesthetic and Postmenopausal Pleasures' in *M/E/A/N/I/N/G*, 14 (November 1993); reprinted as 'The Erotic as Social Security' in *Art Journal*, 53 (Spring 1994); *Erotic Faculties* (Berkeley, Los Angeles and London: University of California Press, 1996) 141-53. First presented in parts at the University of Arizona, Tucson (March 1989); partially printed in Joanna Frueh, *Hannah Wilke*, ed. Thomas H. Kochheiser (Columbia: University of Missouri Press, 1989) 51-61.

Marcia TUCKER
Bad Girls [1994]

'Bad Girls' has its genesis, for me, in an ongoing engagement with feminism, starting way back in 1968 when the Women's Movement hit New York. In recent years I began to see the work of an increasing number of artists who were dealing with feminist issues in new and refreshing ways, and the idea for an exhibition gathered momentum. The work that particularly fascinated me and pushed me to rethink a lot of old issues had two characteristics in common. It was funny, *really* funny, and it went 'too far'.

Word of the exhibition has provoked three main questions about it. The first and perhaps most difficult question I've been asked is, 'Is this a feminist show?' Rumours of feminism's death in the mainstream press have been greatly exaggerated, I'm happy to say. My impression is that for the vast majority of younger women in the arts, feminist issues are paramount; look at the tremendous growth and energy of WAC (the Women's Action Coalition), which began less than two years ago, or the continued vitality and contentiousness of The Guerrilla Girls. None the less, there are wildly differing ideas about what feminism is today, and it's difficult to arrive at any single definition of it, so much so that 'feminisms' has become the descriptive term. What's more, some women who refuse the term categorically have attitudes, ideas and behaviour that I would call entirely feminist, while others who describe themselves as such don't behave as if they are. As for the artists in the show, I haven't stipulated that they call themselves feminists; I'm sure there are some who do and some who don't all for very different reasons.

But finally I want to frame 'Bad Girls' through my own concerns and a lifelong engagement with feminism; this doesn't mean, though, that this is the only way of presenting some of the issues raised by the exhibition, nor is it the only way of seeing them.

The second question is: 'Just what do you mean by "Bad Girls"?' Forty-odd years ago, when my mother would mention that she was 'going out to play Mah-Jong with the girls', she had no idea that 'girls' over eighteen would one day be called 'women', and between puberty and adulthood they would be referred to as 'young women'. It took twenty-five years for grown women to convince men that their use of the term 'girl' was unacceptable to them, but by now the word again has positive connotations in certain circumstances. For example, when African-American women call each other 'girl', it is a term of affection and familiarity. It has also been used frequently in music; like 'sister acts' in the 1940s, 'girl groups' were a fixture in 1950s *doo-wop*, and the term has now been revived for the young, tough, rebellious, independent women musicians who make up post-punk groups like Seattle's Riot Grrrls or the rappers in TLC.'

In entertainment slang, 'bad' girls – originally appropriated from Black English to mean really good – describes female performers, musicians, actors and comedians (among them Bette Midler, Madonna, Sandra Bernhard, Roseanne Arnold, Lily Tomlin, Whoopi Goldberg, Paula Poundstone and Kate Clinton) who challenge audiences to see women as they have been, as they are and as they want to be. In literature, well known and popular writers like Alice Walker, Angela Carter, Toni Morrison, Julia Alvarez, Amy Tan, Jeanette Winterson and Cristina Garcia offer a refreshing antidote to such violent, tough-guy, misogynist writers as Norman Mailer and Bret Easton Ellis.

In the visual arts, increasing numbers of women artists, photographers, cartoonists, performers, video and filmmakers are defying the conventions and proprieties of traditional femininity to define themselves according to their own terms, their own pleasures, their own interests,

in their own way. But they're doing it by using a delicious and outrageous sense of humour to make sure not only that everyone gets it, but to really give it to them as well. That's what we mean by 'bad girls'.

The third question most people ask is: 'Why did you include men in the show?' Besides wanting to transgress the usual premise for an exhibition about feminist issues – that it contains only the work of women – we're not interested in reinforcing a separate category of 'women's art', nor do we insist on women's concerns being inherently different from those of men, no matter how fed up with some of the latter we might be. But there are difficulties in including the work of men in this kind of exhibition, which is why there are so few of them in it. One of the artists, Cary Leibowitz, even pointed out that nowadays most men who are making art about gender issues are really trying to be good boys rather than bad girls. From my own perspective, the historic battle for women's rights hasn't become any easier, although it has evolved in more complex ways, but it seems counterproductive to turn away willing soldiers because of their gender, much less their age, race or class. They might have a different fighting style, but so what […]

1 Says 21-year-old Candice Pederson, head of K Records in Seattle, 'When women do something for themselves, it's construed as being anti-male. Well, if we have to go through five years of reverse sexism so we can have the same thing that men have, that doesn't compare to 2,000 years of sexism against women.' Quoted in Linda Keene, 'Feminist Fury', *The Seattle Times/Seattle Post-Intelligencer* (21 March 1993) 15.

Marcia Tucker, *Bad Girls* (New York: New Museum of Contemporary Art, 1994) 4-6.

Liz KOTZ

Beyond the Pleasure Principle[1] [1994]

I

Years ago I remember hearing about Pat Hearn's tape *Bondage* (1980), a student work in which Hearn had herself videotaped while bound first in rope, then wrapped in sheets of plastic and gaffers' tape. At the point of total confinement, she is only able to breathe through a rubber tube and writhe about a bit, moaning muffled sounds. There was the sense that this had been a dangerous work to make, that Hearn had risked death to subject herself to this grueling 'performance'. My friend who had seen the tape had considered it genuinely disturbing – a real compliment from those of us who'd been influenced by punk and underground gay cultures, and who believed in art pushed towards the kinds of extremes rarely supported in gallery contexts or in the publicly funded world of so-called 'independent' media.

This past spring, I finally saw the tape, an unsettling work that to my knowledge has never been written about. Yet its paradoxical status, as art outside any kind of documented 'art history' or published critical discourse, is far from unusual in contemporary women's artmaking. Although we've come to accept the idea that, in the past three decades, artistic production by women has moved into a centrality and public presence previously denied it, it's nonetheless striking that so much of this history exists as rumour, as hearsay: so many things that you hear about for years before ever seeing them, if you ever do.

Even when discussing relatively well known and well documented 'conceptual' artists of the 1960s and 1970s – Lynda Benglis, Joan Jonas, Shigeko Kubota, Yoko Ono, Gina Pane, Adrian Piper, Carolee Schneemann, Hannah Wilke – their work often takes on an ephemeral quality, consigned to the shadowy realm of art that is talked about but rarely seen, recognized as influential but rarely taught or collected: works that flicker in our historical unconscious, but rarely make it into the history books. So it comes as something of a surprise to see Schneemann's actual scroll from her 1975 performance, or Benglis' 1974 *Artforum* ad. Like many works from the not so recent past, their reputations have tended to circulate informally, generated via word of mouth. Yet there is unexpected power in repression. Produced by erasure from official histories, this shadowy state of rumour paradoxically keeps work open to resignification, to re-use. Their very exclusion from the codified narratives of contemporary art history may allow even relatively recent feminist works to detonate into the present in new and unanticipated ways – at a time when the cultural impact of their better institutionalized male colleagues may seem all but exhausted.

What creates this situation of historical erasure? In part, it is because much of the most compelling work made by female artists in the 1960s and 1970s occurred in ephemeral media-like performance and site-specific installation. Such process-oriented and temporally-based media have always had a curious state of neglect vis-a-vis a traditional art history written as the history of objects, history as connoisseurship. As the art historian Kathy O'Dell has written, performance history in particular has a perverse status as trace, as poorly lit video documentation or grainy black and white photographs reproduced in occasional books and magazines.

Yet the ephemeral nature of the history of contemporary women's artmaking is also due to its systematic suppression. Women artists working with their bodies were central to radical art movements like Fluxus, yet, as O'Dell notes, they have been persistently marginalized from the canon by male artists, curators and critics.[2] In other cases, challenging works by women artists – such as the masochistic self-mutilating performances of Gina Pane – have been marginalized or dismissed within 'feminist' histories or feminist-run institutions as well. Even relatively well known and influential women's artmaking of the past few decades has been consistently under-institutionalized; as a consequence the most basic resource materials remain unavailable. It's no surprise that many American histories of 'body art' start with Acconci.

Thus, one of the most interesting undercurrents in the art world of late has been the return to or re-exploration of the art of the 1970s, especially work done in performance, video, experimental film, body art and other non-object forms. This 1970s/1990s connection is linked, in part, to current efforts to locate a trajectory of female artmaking not bound to the overdetermined histories of feminist postmodernism. Coming on the heels of the partial collapse of the commodity artmarket, this new interest in the recent past has challenged the quintessentially 1980s art world perception that 'nothing much happened' during the 1970s. It's led to a reinvestigation of process-oriented, durational and site-specific work, and perhaps even begun to dislodge visual artists – especially those in New York – from their habitual ignorance about work from other disciplines and other locales. And it's also helped uncover some of the undersides of the feminist artmaking of the 1980s, such as that by experimental film and video-makers like Peggy Ahwesh, Abigail Child and Julie Zando, who made some of the most provocative feminist media art of the decade, work which is only now having widespread impact.

The exhibition 'Coming to Power' attested to that interest, a project motivated by younger women returning to work from the 1960s and 1970s by artists like Ono, Schneemann, Benglis and Wilke, and investigating them as models for an art of the present that would aggressively explore female corporeality and sexuality in all its seductive and problematic excesses. Compelling as such a project is, I myself am hesitant about the liberationist tone of the title, and the use of sexual explicitness as an organizing principle. Yet the question of how women artists handle sex continues to intrigue. And the necessity of the historical project, whether seen as rupture or continuity, is urgent.

One crucial shift in some of the art of the present that interests me is precisely its insistence on inserting itself into art history. While radical art of the 1960s and 1970s was centrally concerned with exiting art history, rupturing the history of Modernism, something very different is going on now. For example, in Zoe Leonard's 1992 installation at Documenta, she placed small black and white photos of women's genitals, modeled on the famous erotic painting by Courbet [*L'Origine du monde*, 1866], in a room of a regional museum filled with portrait paintings from the late seventeenth through early nineteenth centuries. The strangely flat, unerotic images were created for the installation; the siting was designed by the artist as an intervention into the place of the female in the museum.

Likewise, Monica Majoli's small, luminous canvases of gay male S&M scenes and Nicole Eisenman's post-apocalyptic murals and violent cartoons investigate suppressed pictorial content while playing on the repressed, sensual side of artmaking. In a linked project, Majoli has created a series of body fragment self-portraits, including one image of a scratched and bleeding wrist. Lifesized and elliptical, the body fragments are unmistakably erotic paintings, as much as the gay male sex scenes. Yet what is 'sex' here becomes more enigmatic. Rather than localized in certain acts, in certain parts of the body, or in clearly depicted narratives, sexuality seems diffused along the body, absorbed into the flesh, a place where masochism and narcissism converge.

In Eisenman's work, diverse genres and art historical references collide with ferocious energy: comic books, classical perspective, Ash Can school, photomontage, the New Yorker cartoons of Saul Steinberg. With throw-away asides to an omnivorous cultural appetite – a large institutional-looking building with the sign 'Lesbian Bed Death Research Center' or a 'Minotaur Hunt' mural with Picasso figures as prey – Eisenman creates a dystopian space where the nuclear family meets nuclear war. Although Eisenman offers up no fantasy of the 'sex-positive' or the naively 'life-affirming', neither does she push her work all the way towards the grotesque, as if to suppress all pleasure in viewing – as recent work by Cindy Sherman, for instance, seems to do. Instead, her work, like Lutz Bacher's fellatio images from the series *Sex with Strangers* (1986), pushes this territory of female ferocity and aggressive consumption to extremes which are both seductive and uncomfortable.[3]

Something about this project is quite threatening. Perhaps it is the joining of highly sensuous and even beautiful artistic practices with dark, deeply-troubling content – exemplified perhaps by the 'rape' section of *Sex with Strangers*, a body of work which at the moment seems to be virtually un-showable in New York City, present neither at 'Coming to Power' nor last year's Whitney Museum show 'The Subject of Rape'. I keep wondering why this is so. One possible explanation is the present tendency to polarize notions of the abject and the sublime, as if the one precluded the other. Another revolves around a continued feminist discomfort with works which probe the relations between sexuality and violence, reflecting a debate in which a presumably anti-censorship 'pro-sex' position can paradoxically be mobilized to proscribe explicit sexual representations that take on too dark or messy a vision [...]

As so many once radical or disruptive tendencies get re-contained within institutions, even relatively progressive ones, I find myself quite pessimistic about our prospects for more challenging versions of feminism in the art world, since most of what circulates right now seems either repressive, reductive, or simply regressive. That kind of return to the 1970s – a newly-rehabilitated mainstream feminism which suppresses the 1980s legacies of gay activism, racial insurgency, critical theory and the sex debates – holds no interest at all.

In our embrace of the sexually explicit, we continually risk entangling ourselves in simplistic and potentially constricting notions about pleasure, sex and the body. It becomes all too easy to make sexual representation an obligation – no longer an intervention but 'that which is expected' – or to embrace only that work which is somehow 'sex positive' or which promotes a naively liberationist view of female sexuality or sexual pleasure. The exhibition this essay was initially written for provided a welcome opportunity to look at some work by women about sex, work that risks offending or disturbing us, work that risks turning us on. Yet it would be a mistake to imagine it as any kind of liberatory space, free from constraints or censorship.

There is tremendous power in not cutting ourselves off

from that which scares or troubles us. Psychoanalysis, not to mention Foucault, cautions us against any illusions of sexuality as unproblematically 'free' play, any fantasy of pleasure that can be fully extricated from power, pain or the destructive forces of our psyches and lives. After all, that Pat Hearn tape made a stronger impression on me than any feminist 'erotica' ever could. Maligned as psychoanalysis often is amongst feminists, it continues to offer compelling and cautionary tales: all psychic life is structured on repetition, libido is inseparable from aggression, what you most fear is what you most desire. 'The death drives', remarks a friend, 'that's what I call life-affirming'.

II

What problems are posed by positing such a link between present-day visual art and the feminist performance and conceptual art of the late 1960s and 1970s? The most glaring elision in such a narrative is that of work produced in the 1980s which continued the libidinal explorations of the 1960s, but pushed them into far darker and more troubling territories. Pat Hearn's video *Bondage* is itself a sign of this trajectory, one which often moved underground, leaving the increasingly commodity-driven art world to find outlets in performance, writing, the club scene, and experimental film and video.

While the most visible sectors of the independent media community of the 1980s moved towards more mainstream audiences – via MTV, PBS-style documentaries, independently-produced feature films or corporate-looking video art – a quieter current in both film and video continued to pursue the strategies of low budget media and the legacies of cinematic minimalism. Rejecting the increasingly televisual aesthetic of their peers, a number of female film and video-makers worked against the grain to reinvestigate some of the most extreme work of the past two decades: the 1960s avant-garde of Warhol, Jack Smith and the Kuchar brothers; the structural filmmaking of Hollis Frampton, Michael Snow and Tony Conrad; and the performance-based video of Acconci, Bruce Nauman and Paul McCarthy.

Characteristic of this current of renegade cinema, the films and videos of Peggy Ahwesh, Abigail Child and Julie Zando all bring structuralist-informed perceptual concerns to decidedly unorthodox feminist media projects. Like the current reinvestigation of Minimalist and post-Minimalist practices taking place in the visual art world, their works infuse these process-oriented structures with contemporary investigations of narrative, subjectivity and social power. Aggressively reinterpreting this formalist tradition, these artists were able to address more marginal audiences, and more marginal concerns, including those not authorized by more normative versions of feminism or gay politics.

Peggy Ahwesh came out of low-budget Super-8, influenced by underground filmmakers like Roger Jacoby as well as the intense subject-object interplay of Acconci. Starting work in the early 1980s, as one male critic after another proclaimed the 'death' of avant-garde cinema, Ahwesh enjoyed the perversely liberatory experience of

making films after the end of 'experimental film'. Somewhat fortuitously, this 'death' pushed more adventurous women filmmakers out of the moribund and claustrophobic experimental film community. For Ahwesh, like Julie Zando, this exploration beyond the traditions of her medium led to the use of psychoanalysis to probe the mechanisms of psychic entrapment and desire. Abigail Child's work, which addresses similar issues, emerged out of collaborations with dancers, language poets and experimental composers like Zeena Parkins and Christian Marclay.[4]

Yet Child's works such as *Covert Action* (1984) and *Mayhem* (1987), which used archival and directed footage to probe the encodings of gender and sexuality on the cinematic body, not only addressed an audience outside the film community but were controversial within feminist contexts as well. Particularly since Ahwesh and Child have worked between straight and gay contexts, exploring ambiguous desires and relationships in ways which disrupt conventional definitions of sexual identity, their works never fit comfortably into an 1980s feminist media agenda increasingly driven by identity politics. Like Hearn's underground tape and Zando's more masochistically inclined work, Ahwesh's and Child's films expressed a certain pessimism about the possibilities of female self-representation and empowerment. As such, they tended to face difficulty getting support from progressive funding agencies such as the New York State Council on the Arts, which throughout the 1980s privileged feminist work which advocated 'urgent' political positions or provided affirmative and unambiguous representations of previously-marginalized communities.

Even artists working within the gay community found uneven support for more difficult work, although lesbians have been granted a freedom to work with the more troubling vicissitudes of desire and sexuality often denied straight women. Zando's videos, exploring difficult subjects like female masochism, erotic obsession and victimization, were not included in most gay film festivals until the 1990s. Nonetheless, her work has been on the forefront of the concerns of a younger generation of women, especially lesbians, committed to exploring the darker sides of female sexuality and relationships. Not feminist fairy tales, her tapes probe the psychic connections between dependency, love and control, joining these up with more structural investigations of the representational power embedded in video and the viewer's relation to the camera [...]

Darkly comic and disturbing, these works by women artists never fit dominant 1980s paradigms of aesthetic postmodernism or clearly articulated political oppositionality. Murky and obsessive, mining the less comfortable reaches of the psyche, these sexually charged films and videos don't advocate positive programmes or politically viable identities – it's hard to mobilize around masochism. This kind of 'edgy' feminist media perhaps offers the clearest parallels to the projects of visual artists like Lutz Bacher, Nicole Eisenman, Zoe Leonard and Monica Majoli – rather than the earlier, more empowerment-oriented production of Carolee

Schneemann, Lynda Benglis or Hannah Wilke. While the historical project, as I've argued, is urgent, it is crucial to acknowledge moments of rupture and to avoid creating false feminist genealogies for work in the present. To assume continuity between female producers is a mistake. For instance, although committed to an art of the body, feminist work from the 1960s and 1970s tended to revolve around liberatory notions of sex as curative or innately pleasurable that the artists like Bacher or Zando explicitly question. The spiritually-oriented organic tropes of Schneemann's work for example, seem much more aligned with the present-day project of someone like Annie Sprinkle, whose relentlessly upbeat performances disavow the troubling aspects of sex work or sexual display […]

There's a tendency to read this shift towards darker, more problematic materials as generational, particularly among lesbian artists, yet to do so is far from accurate. While in the visual arts, younger lesbians have been at the forefront of a certain movement, many key practitioners are in their forties, even early fifties, suggesting that it is less a question of an artist's age than of how long it takes certain work to find a wider audience. History is always a question of what gets activated in the present, as new generations and constituencies reinvestigate and reinvest the past in unpredictable ways – as suggested by the current resurgence of interest in Jill Johnston's works *Marmalade Me* and *Lesbian Nation*, texts which were all but erased from feminist scholarship, not to mention queer theory.

It comes as no surprise, sadly, that perhaps little of the most challenging work by women artists today will find its way into the ubiquitous 'Bad Girls' exhibitions of 1994. Focused on work which is 'funny and subversive' – according to publicity from New York's New Museum of Contemporary Art – these exhibitions risk offering-up a sort of 'subversion lite', in which work that takes on dark, degrading or difficult subjects is purged in the name of a modestly rehabilitated mainstream feminism that will be acceptable to funders and mainstream press alike. Such recuperative gestures should be questioned, as should the pervasive marketing of the signifiers of transgression by publications like *Research* and the *High Risk* anthologies.

By disseminating underground practices into the mainstream culture, this packaging tends to annex them into the sphere of fashion, figuring extremely codified markers of 'transgression' and cultural dissidence as styles that can be endlessly copied.[5] Even projects address-ing violence and degradation frequently revert to a 1970s feminism of moral outrage, updated with 1990s graphics and style. Revolving around the unexamined trope of the woman as victim, as in the recent work of Karen Finley or Lydia Lunch or the anthologies *Angry Women* and *Critical Condition*, these efforts often read less as reinvestigations of history than as failures to learn from it. By returning to notions of the moral authority of the oppressed, and an over-reliance on autobiography and testimonial, these superficially rehabilitated 1970s feminisms effectively preclude more challenging, and perhaps more honest, positions of moral ambivalence or ambiguity […]

In choosing to concentrate on these far more 'problematic' artists, I've sought to emphasize work occurring at the boundaries of contemporary understandings of gender, power and sexuality. This is work which refuses the supposed moral authority of the female victim role, yet also refuses an analysis of sex and fantasy that would attribute to them some inherent liberatory potential. And, adding to this definition by negation, it is work which resists the ever-pervasive commodification of subjectivity offered by subcultural fashion and identity politics alike. Not basing their projects on left-political fantasies of inherently oppositional identities, these artists' works can't easily be incorporated into conventional programmes of feminist politics, nor can they be easily consumed for classroom use. Instead, driven by the inherent ambivalence of sexuality and sexual identity, their works explore desire, repetition and fantasy as deeply destabilizing forces in our lives, forces not easily recuperable for progressive politics. As another friend remarks, 'the unconscious is not a "corrective"'.

1 Part I of this essay was originally written for the exhibition 'Coming to Power: 25 Years of Sexually Explicit Art by Women', 11 May-12 June 1993, presented at David Zwirner Gallery, New York, and revised for publication here; part II was written in December 1993. My thanks to Lutz Bacher and Judith F. Roderbeck for comments and discussion.
2 Kathy O'Dell, 'Fluxus Feminus', 1993 talk at the Walker Art Center; published in *The Drama Review*, 41:1 (Spring 1997).
3 Other projects of Bacher's - such as her *Playboys* paintings (1991-93) and sessions of *Sex with Strangers*, silkscreened onto canvas - converge with work by Eisenman and Majoli to suggest a new kind of history painting, undertaken by women in the present. For additional information on Bacher, see Kathy O'Dell, 'Lutz Bacher's *Playboys*: The Morphology of Jokes and Other Questions', also in *Lusitania*, 6 (1994) and my 'Lutz Bacher: Sex with Strangers', *Artforum* (September 1992).
4 I have previously written on Child's work in 'An Unrequited Desire for the Sublime: Looking at Lesbian Representation Across the Works of Abigail Child, Cecilia Dougherty and Su Friedrich', in Martha Gever, et al., ed., *Queer Looks* (New York: Routledge, 1993).
5 Somewhat analogously, the subcultural representation produced by photographers like Della Grace and Grace Lau resembles nothing so much as fashion photography, filtered through a Robert Mapplethorpe-style aesthetic formalism. Parveen Adams' recent assertion, writing on the *Three Graces* by Della Grace, that 'these women are beyond recognition' ('The Three [Dis]Graces', *New Formations*, 19 (Spring 1993) 133, must be read as the commentary of someone completely unfamiliar with contemporary urban subculture, particularly gay ones. The assembled articles of this special issue on 'Perversity', including contributions on S&M, fetishism, piercing and sodomy, tend to reinforce Gayatri Spivak's insight regarding the oppressive nature of 'the perversions'.

Liz Kotz, 'Beyond the Pleasure Principle', *Lusitania*, 6 (New York, 1994), 125-136.

Jo Anna ISAAK
Laughter Ten Years After
[1995]

Let me say straight away – this is a retro show, a re-play. Why this urge to repeat? An obsession to revise and rewrite, to get it right? Yes, in part, and along with that the realization that the impulse is utopian in the sense of being both hopeful and infinite – the work being produced is far in excess of what can be included in any one exhibition. A commemoration: something important has happened in the past decade, and this is an occasion for celebration. A chance to take stock: the way we look at the past often determines the way we go into the future. A feeling of solidarity: the ideological self-realization that a number of women – without being part of a group, working in different media and in different countries, addressing disparate concerns – are nevertheless able to speak surprisingly clearly of our collective agenda. Even if we have never met, we have become confident of the shared aims of our collective, and we have come to realize how one woman's work or words leads onto or enables the next woman to work or speak. A sense of loss: the realization that women's history is faintly written and must be continually re-inscribed before it is forgotten again. And then of course, as Gertude Stein knew, one always needs to repeat because, 'Every time it is so, it is so, it is so.'

In 1982 I organized an exhibition entitled 'The Revolutionary Power of Women's Laughter' in an attempt to locate art within the arena of contemporary theoretical discussions on the formation of sexual difference. The fundamental discoveries of modern linguistics and psychoanalysis had radically affected the understanding of how all signifying systems operate. There was growing awareness that a great deal was at stake for women in these new assessments of how meaning is produced and organized in all areas of cultural practice. The death of the author levelled the playing field for women – and play in the new, authority-free zone they did. Over the past decade there has erupted a riot of women artists exploring the potential of laughter, hysteria, the grotesque and the carnivalesque.

To gather a group of women artists together under any rubric is to be forced into an essentialist position. Group shows of exclusively male artists, by contrast, are allowed to address whatever organizing principle the curator has in mind: a geographical location the artists may have in common, a period of time in which they worked, a particular style or medium. Women artists, writers and curators have never been able to masquerade in the Emperor's clothes of universal humanity. Even if only two women artists are exhibited together, the issue of gender inevitably arises. But to engage in a strategic, rather than a predetermined, essentialism is to push the issue of gender

past the point where it can be used to ghettoize women. I am not attempting in this exhibition to present The Most Important contemporary women artists. The artists in the exhibition may or may not be part of what has been mythologized as the mainstream. I am not interested in valorizing a mainstream nor in exploring, validating, and reinforcing hegemony, which, as Raymond Williams points out, is a process that relies upon the mechanisms of tradition and the canons of Old Masters in order to waylay the utopian desires that are potentially embodied in cultural production. It's the waylaid utopian desires that I'm interested in. These are women who did not cede their desire. They began by dismantling 'the prison house of language' through play or laughter or, to use the term the French have reintroduced into English, *jouissance*: enjoyment, pleasure, particularly sexual pleasure or pleasure derived from the body. They explored Bakhtin's theory of laughter and the carnivalesque as potential sites for social insurgency; Barthes's and Kristeva's notion of laughter as libidinal license, the *jouissance* of the polymorphic, orgasmic body; Freud's analysis of the liberation of laughter in the workings of a witticism or a play upon language. They reveled in their primary narcissism – the one characteristic some women have that men lack. They exposed the viewer to the terror of their irreparable difference. They donned the masks of the masquerade, or they went too far and took them all off. They enlisted the hysteric's gesture of resistance, or they became grotesques. They put on gorilla masks and marched on the museums. If, in the process, they have established reputations in the mainstream, they have done so by undermining the very characteristics upon which it is established. Their success is important for the way it has changed contemporary thinking about value systems that extend far beyond the art world. Using the subversive strategy of humour, they have radically reformulated contemporary art and called into question art history's long-held verities concerning creativity, genius, mastery and originality. Their critique of art history and theoretical reflections on gender, sexuality, politics and representation have shattered central assumptions about art and its relation to society.

Laughter, as it is invoked in this exhibition, is meant to be thought of as a metaphor for transformation, a catalyst for cultural change. In providing libidinal gratification, laughter can also provide an analytic for understanding the relationships between the social and the symbolic while allowing us to imagine these relationships differently. In asking for the response of laughter, these artists are engaging in a difficult operation. The viewer must want, at least briefly, to emancipate himself from 'normal' representation; in order to laugh, he must recognize that he shares the same repression. What is requested is not a private, depoliticized *jouissance* but sensuous solidarity. Laughter is first and foremost a communal response and at the same time an acknowledgement of liberation.

Jo Anna Isaak, *Laughter Ten Years After* (New York: D.A.P., 1995).

Anya GALLACCIO
Interview with Marcelo Spinelli [1995]

Marcelo Spinelli Your works are often ephemeral installations whose disintegration is inevitable. How do you feel about not having anything tangible left, when all is said and done?

Anya Gallaccio To me that's a really important aspect of what I do. Maybe it's partly to do with being a woman, but I have a conflict with myself about consuming. I've been brought up to shop, I'm a fantastic shopper, I love it. I have a problem with wanting to own things, and I find that interesting within the context of art. Can you own an idea? Because of the amount of emotional and physical effort I put into my work, I sometimes feel like it's me that's being owned. As a woman, I have a very big problem with that, and it's still not resolved. But basically I feel that if somebody's going to have something of mine, there has to be some notion of commitment, an active participation as opposed to a passive exchange.

My work only exists for a certain period of time, in a sense only when it is being looked at. It can't be bought and sold as a marketable commodity. It must be experienced in reality.

Spinelli And that's partly why you work with materials that change as well?

Gallaccio Yes, I think so, because it's about accepting a lack of power, in a way. For me a lot of the history of art is about men imposing their will on material. Mastering paint, making stone do the impossible. I'm more interested in a collaboration between me and the material. Again, it's like a relationship. When you have a friendship with someone, you can guess what they might think, what they might like. You can anticipate certain things, but often they surprise you. That's what really excites me about the work [...]

Spinelli Your installations need to be experienced firsthand. They're very visceral, which you don't get in photographs.

Gallaccio Yes, they're very much about real experience. A lot of people have dismissed my work because they haven't seen it. In photographs it looks very seductive, and a lot of people think it's too easy. But I think it's a challenge to take something that is really loaded and use it in a new way. When I first started working with flowers, everyone said to me, 'Oh my God, you can't do that. They're far too loaded. They're really female and they're decorative.' So I thought I should embrace that and see if it were possible to flip it over [...]

Marcelo Spinelli, 'Interview with Anya Gallaccio', London (20 March 1995); published in *Brilliant! New Art from London* (Minneapolis: Walker Art Center, 1995).

Silvia KOLBOWSKI
Questions of Feminism [1995]

[...] 'Questions of Feminism: 25 Responses'' and the round-table discussion were formulated so as to tie together the many threads that feminist practices – of art, theory, criticism and activism – have tried to interconnect in the past few decades. The questions were written to address some current tendencies and leanings recognizable within the extended social contexts in which these practices exist. Brief sketches by necessity, the questions suffer from the inevitable shorthand that plagues the initiation of inquiries, in that such initiations require, at least in part, a nominal stance. Nevertheless, the language of the questions is descriptive of some recent directions. One of these directions – a rejection or simplification of psychoanalytic theory or theoretical 'work' in general, can be perceived in art magazines, galleries, museums and art books. The mainstream media is also a register, as in the explicit and repeated theory-bashing in the *New York Times* in favour of 'plain talk' criticism or metaphysical precepts, or the celebration of a 'return to body art' at the expense of the last few years' taste for theoretical art in fashion magazines. And the dismissal of so-called academic feminism in favour of the 'truth' of grass-roots feminism can be read in the 'underground' popular context of a West Coast fanzine. These are some examples of a complex situation in which the polarizations of terms that are outlined in the questions – the polarizations that so many of the respondents want to resist – persist. At the same time, popular or activist discourses and phenomena have often been a blind spot – or fetish – of theoretical discourses, including feminist ones. The two questions in this project attempt to address such disturbing hierarchic dichotomies, recognizing that they cannot be willed away, but only eroded through relentless scrutiny of all kinds. Gauging by some of the responses and the texts in this issue, such practices are already underway [...]

The presence of the texts and projects brought together in this issue will, it is hoped, challenge the formulation of feminism(s) as a thing of the 'past'.

QUESTION 1:
Recent feminist art and critical practices appear to be moving in various different directions: while some artists and writers continue to develop ideas, arguments and forms related to 1980s feminist theories focusing on psychoanalysis, a critique of Marxist and related political theories, and poststructuralist theories of cultural identity, others have forged a return to 1960s and 1970s feminist practices centring on a less mediated iconographic and performative use of the female body. Although significant for feminist practices, the work of the 1960s and 1970s did generate theoretical critiques of its overt or underlying thematic of biological or physical essentialism. In light of this, how can we understand recent feminist practices that seem to have bypassed, not to say actively rejected, 1980s theoretical work, for a return to a so-called 'real' of the

feminine? And what roles do the continuation/elaboration of the 1980s feminist concerns and practices play in the current arena?

QUESTION 2:
Recent art, critical and curatorial practices have renewed the use of the term 'accessibility', which is routinely opposed to 'elitism' in characterizing some feminist art and critical-theoretical pracices. 'Elitist' feminist art and critical writing are typically associated with theory, and in particular with psychoanalytic and semiotic/language-based theories, and are defined as distanced from popoular culture and contemporary politics. In this sense popular culture is broadened to incorporate 'grass roots' feminist politics as well, which is thought to be more capable of crossing distinctions of race, class and sexual orientation. 'Accessible' art and critical writing, and 'grass roots' feminist politics, often employ autobiographical strategies and conceptions of identity – strategies and conceptions that have been criticized for being insufficiently mediated. What are the implications of the renewal of these oppositions of accessibility and elitism, of low and high art, of the real and the semiotic, for feminist art and critical practices in the 1990s? What questions do these alignments and practices pose about the legacies of 1980s feminist theories?

1 These questions were sent to a group of artists and
 writers in the summer of 1994.

Silvia Kolbowski, 'Questions of Feminism', *October*, 71
(Winter 1995) 3-4.

Lisa TICKNER
Questions of Feminism:
Question 1 [1995]

The question opens in a tone of neutral description and ends in one of mounting anxiety. Perhaps *this* is the interesting question. What are we afraid of? There's more than a hint that feminist practices have taken a wrong turn, gone off the rails, turned delinquent; or, reversing the generational thrust, that the adolescent vitality of 1970s feminism matured successfully into a body of rigorous 1980s art and criticism that threatens now to go all to pieces [...]

This is the first significant generation of artist-daughters of artist-mothers. Perhaps only in the last twenty years have women as artists grown up with both parents (and artist-siblings and a feminist audience). This is the landscape that is itself productive of new work (and *new artists*, since practice produces agents as well as objects or 'symbolic goods'). If it's not yet clear how the Oedipal triangle figures, this may be what worries us. Perhaps delinquency hurts because it frames older feminisms as authoritarian and out-of-date. Perhaps the cutting truth is not that feminist art escapes feminism (whatever that's construed to be) but that it hasn't escaped art (or what the art world is under modern conditions). 'Feminist art' insists on its *awkwardness* as

any kind of category but can't altogether escape the nets of fashion – commercial, curatorial or critical – or the deadly formaldehyde of period style. For a moment, the return to the body in some expressive, performative or 'unmediated' form looks like a fresh option but, ironically, it spawns theoretical justification anyway (as the essays for both the US and British 'Bad Girls' exhibitions testify). I don't say this cynically. It's in the nature of the game that art in our culture comes out of discourse and returns to it: each 'unique' and 'unprecedented' move is accorded a catalogue's framing pedigree.

But you never go back to the *same* place. The 1990s are different because of the 1980s and as a result of something more dialectical than a pendulum swing [...] Different art practices at different moments have been linked to an assertion of (biological or social) 'essentialism', 'antiessentialism' or the claim that what women have in common is simply a collective stake in femininity as a masquerade. Yet even that isn't disembodied [...]

The body figures – how could it not? – but the question is how, what, when and for whom? The body is Symbolic, Imaginary and Real. The ego is a bodily ego, and the body has a phantasmatic dimension. Gender is something we embrace but from whose embrace we flee. What would a feminist utopia be like, in gendered terms? (There are some science fiction answers to this question, not all of them consoling.) The impact of a French feminist insistence on the imaginative centrality of the body has been interestingly – provocatively – paralleled by a cyborg-feminist flight from gender (and perhaps maternity). These issues are for me more pressing than the question of whether a new generation has properly rehearsed its feminist litany. Women artists have acquired for the first time in the last twenty years a sense of critical mass and the opportunity to communicate with an intelligent, educated, impassioned, committed and argumentative audience. We ought to be able to trust ourselves to raise the issues and argue the points. In Pierre Bourdieu's terms, the cultural field is a set of 'positions' that offers the artist a set of 'possibles'. The avant-garde game is to change the field of possibles. The feminist game is to make that changed field *count*. But then, of course, if humanity turns out to be an evolutionary blip in cosmic time, a fragile link between animal life and a disembodied cyborg intelligence, then gender as we've struggled to understand and to live it will go the way of all other conditions the flesh is heir to. It's hard to imagine a world of virtual eroticism, unparented reproduction, and desexualized intelligence. I'm not sure I want to. Is that what women want?

Lisa Tickner, 'Questions of Feminism: Question 1', *October*,
71 (Winter 1995) 44-45.

Emily APTER
Questions of Feminism:
Essentialism's Period [1995]

1990s feminism seems to be worried about periodizing essentialism, worried, that is, about essentialism's

periods (its shameless emissions of bodily fluids, menses and tears), as well as its own historical periodicity from the 1960s and 1970s through the 1980s.

1970s essentialism has impinged on the 1990s in the form of a fashion revival – the ideational equivalent of platform shoes, oversized collars, small T-shirts. 1970s essentialism, like these 'period' items retrieved from the recesses of the closet, was already 'back' in the 1980s, but instead of going away in the 1990s, it just continued to assert itself more and more [...]

Mary Kelly tells me that her work from the 1970s (*Post-Partum Document*) is increasingly requested in the 1990s for shows dedicated to re-examining women's art of the 1970s. *Post-Partum Document* employed a Lacanian psychoanalytical framework mediated by feminism to invent new strategies for representing maternal desire. The work was anything but essentialist (the 1970s were, after all, the heyday of theory) but the reasons for interest now seem to smack of essentialism nonetheless. The 1990s view appears focused less on *Post-Partum Document*'s exposure of the social constructedness of maternity and more on its formal and thematic references to 'dirty nappies', infant scrawl, feminine leakages of love and feeling, and the social/psychic seams and lesions connecting female bodies to the workforce – see, for example, the lexical progression from labia to labour to lubricant in entry L7 Index L, Homo sapiens (F), which reads:

'LABIA MAJORA, LABIA MINORA, LABOUR-false labour, length of labour, normal labour (first stage, second stage, third stage), LABOUR PAINS, PROLONGED LABOUR, RAPID LABOUR, LACERATION, LACTATION, LEVATORS, LIFTING, LIGHTENING, LIE OF BABY, LINEA MIGRA, LITHOTOMY, LOOP, LUBRICANT.'

It is perhaps no accident that during the 1980s – a decade of nostalgia, power feminism, and race/class division – Mary Kelly made *Historia*, part three of the four-part project *Interim* documenting the utopian collectivism and fervent egalitarianism of the 1960s and 1970s. It is, however, paradoxical that this move seemed to parallel a mode of historicizing feminism that has become increasingly pronounced in the 'backlash', 'grunge', 'postfeminist' era of the 1990s. A minor boom in commemorative books, special issues and exhibitions has erupted, each in different veins concerned to measure and evaluate 'where we are' vis a vis 1970s essentialism and 1980s theoretical feminism [...]

1990s feminism endorses anti-essentialism by jettisoning gender stereotypes, theorizing the body, queering sexual difference and plugging the ears to the maternal recidivism of friends ('But now that you have a boy ... ') But 1990s feminism, lesbian and straight, white and postcolonial, also suspects that its theories and self-conscious periodizations mask a kind of gynophobia – an aversion to the spectres of femaleness and femininity that will not go away. Perhaps this explains the present attraction of 1970s essentialist feminism, which, embarrassing as it may be, desublimated the female body's unconscious. In retrospect, despite its sororal idealism, biologism and blinkered experiential credo, 1970s essentialism worked rather fearlessly with the

the bite, 'both intimate and destructive ... sums up my relationship to art history'

apparition of womanliness. In retrospect, what Kristeva called 'women's time' and what might otherwise be referred to as 'essentialism's period', appears to have been a rather good time for women. But personally I hope that by the end of the 1990s essentialism as a discursive framework will have permanently gone out of fashion.

Emily Apter, 'Questions of Feminism: Essentialism's Period', *October*, 71 (Winter 1995) 8-9.

ORLAN
Intervention [1995]

In French, 'intervention' also means 'operation'.

Few images force us to close our eyes:
Death, suffering, the opening of the body, certain aspects of pornography (for certain people) or for others, birth.

Here the eyes become black holes in which the image is absorbed willingly or by force. These images plunge in and strike directly where it hurts, without passing through the habitual filters, as if the eyes no longer had any connection with the brain.

When you watch my performances, I suggest that you do what you probably do when you watch the news on television. It is a question of not letting yourself be taken in by images and of continuing to reflect about what is behind these images.

In my performances, in addition to the medical personnel and my team, there is a sign language interpreter for the deaf and hearing-impaired. This person is there to remind us that we are all, at certain moments, deaf and hearing-impaired.

Her presence in the operating theatre brings into play a language of the body [...]

My surgical performances began on 30 May, 1990, in Newcastle, England. It was the logical development of my preceding work, but in a much more radical form.

It was upon reading a text by Eugénie Lemoine Luccioni, a Lacanian psychoanalyst, that the idea of putting this into action came to me (a passage from reading to the carrying out of the act).

At the beginning of all my performance-operations, I read this excerpt from her book, *La Robe*:
'*Skin is deceiving ... In life, one only has one's skin ... There is a bad exchange in human relations because one never is what one has ... I have the skin of an angel but I am a jackal ... the skin of a crocodile but I am a poodle, the skin of a black person but I am white, the skin of a woman but I am a man; I never have the skin of what I am. There is no exception to the rule because I am never what I have.*'
Reading this text, I thought that in our time we have begun to have the means of closing this gap, that, with the help of surgery, it was becoming possible to match up the internal image to the external image.

I say that I am doing a woman-to-woman transsexualism by way of allusion to transsexuals: a man who feels himself to be a woman wants others to see him as a woman.

We could summarize this by saying that it is a problem of communication [...]

My work is not against cosmetic surgery, but against the standards of beauty, against the dictates of a dominant ideology that impress themselves more and more on feminine flesh ... and masculine flesh.

Cosmetic surgery is one of the sites in which man's power over the body of woman can inscribe itself most strongly.

I would not have been able to obtain from the male surgeons what I obtained from my female surgeon; the former wanted, I think, to keep me 'cute' [...]

My work is a struggle against the innate, the inexorable, the programmed, Nature, DNA (which is our direct rival as artists of representation) and God!

My work is blasphemous.

It is an endeavour to move the bars of the cage, a radical and uncomfortable endeavour! It is only an endeavour [...]

Orlan, 'Intervention' (1995) *The Ends of Performance*, trans. Tanya Augsburg and Michel A. Moos, ed. Peggy Phelan and Jill Lane (New York: New York University Press, 1998) 315-27.

Mignon NIXON
The Gnaw and the Lick: Orality in Recent Feminist Art [1996]

I

The work of Janine Antoni engages many questions about the body and how it can be used to make a work of art. Here, however, I would like to concentrate on her oral production: works made via the mouth. And by considering Antoni's oral production in relation to some other instances of recent feminist art that also invoke the mouth in acts of biting, sucking or licking, devouring or expelling, I would like to examine what I will call a turn to the drives in feminist work of the 1990s. Earlier, under the sign of Poststructuralism, the mouth was used by feminist artists primarily for speaking. Or, to repeat the linguistic terminology of the period, the mouth enunciated; it performed speech acts. This is not to say that the mouth literally did these things, for the linguistic model underpinning Poststructuralist production operated not at the literal level, but at the level of the signifier. But the function associated with the mouth was speech, a signifying practice that shifted the body from a biological register (associated in America with 1970s feminism and its concern with essential femininity) to a linguistic one. What was at stake in feminist art practices of the 1980s, conducted under the sign of Postmodernism, was primarily a semiotic analysis of the body, not as a biological given, but as a cultural construct.

When, therefore, in 1992, Janine Antoni exhibited her *Gnaw*, giant blocks of lard and chocolate that the artist gnawed, spitting out the chewed-up stuff and collecting it to fashion such commodities as lipsticks and packages of chocolate candies, this performance/installation offered perhaps the most spectacular evidence of a change that has often been read by critics in terms of regression. For many, *Gnaw* signalled a retreat from the 1980s investigation of the signifier, grounded as it was in poststructuralist theory and a Lacanian account of sexual difference, and towards a literal and essentialist conception of the body. To put it another way, *Gnaw* emblematized a regression of feminist art practice to a prelinguistic, infantile state, a reversion from speaking to biting. Although it was not much noted at the time, this feminist biting recalled a work made some twenty years earlier by the French-American sculptor Louise Bourgeois, a 1974 installation entitled *The Destruction of the Father* in which the social ritual of the family meal, with its sublimated conditions of cutting and biting, is turned into a cannibalistic ceremony as the children drag their father onto the dining table and eat him. According to Bourgeois, this oral-sadistic fantasy of dismembering and devouring her father's body is the double of another one, the desire to eat his words:
'*It is basically a table, the awful, terrifying family dinner table headed by the father who sits and gloats. The mother of course tries to satisfy the tyrant, her husband. The children are full of exasperation ... My father would get nervous looking at us, and he would explain to all of us what a great man he was. So in exasperation, we grabbed the man, threw him on the table, dismembered him and proceeded to devour him.*'[1]
In this scenario, eating takes the place of naming in a substitution of oral sadism for speech as the little girl's desire to speak and her frustration at being silenced is transposed into the desire to bite, to cut, to destroy the one who oppresses with his speech. Framed as an attack on language through biting, on Oedipal naming through pre-Oedipal oral sadism, *The Destruction of the Father* stages an assault on patriarchy from the infantile position.

And when Antoni says of *Gnaw* that the bite, 'both intimate and destructive ... sums up my relationship to art history', she restates this destruction-of-the-father logic in art-historical terms. For the devouring of the Minimalist cube, its substance converted into stereotypically feminine products, enacts an infantile logic of production that has been known to Modernist art history, via Marcel Duchamp, as the bachelor machine.[2]

Gnaw participates in the logic of Duchamp's *Large Glass* (complete with chocolate grinder) by turning the body into a machine, a circuitry of interconnecting parts, or in psychoanalytic terms, part-objects. The body is reduced to a series of organs and operates through the functions of those parts – in the case of the mouth, through acts of biting, sucking, licking and spitting, for example. Like the chocolate grinder, the *Gnaw* chews up the stuff of art history to fashion products that in turn are consumed and made productive, and the process of this enactment is cast as a specifically oral-sadistic exercise. As the title informs us, this is a work made by the mouth in the act of biting.

II

Jacqueline Rose observed in 1988, 'If psychoanalysis is the intellectual tabloid of our culture ("sex" and "violence" being its chief objects of concern), then we have recently privileged – ought indeed to base the politicization of psychoanalysis on that privilege – the first over the second.'[3] I propose to analyse the work of Antoni and other feminist artists who have recently worked within an oral-sadistic model of sculptural production in psychoanalytic terms: namely, as a turn to the drives. Accordingly, I will suggest that while some critics have read this work in terms of regression to a pre-theoretical state, in which the artist is infantilized and artistic production reductively literalized, it is also possible to see it as posing a critique of psychoanalytic feminist work's earlier privileging of pleasure and desire over hatred and aggression.

To put it more simply, recent feminist art has attempted to place violence and aggression on the table for psychoanalytic feminist discourse.

III

If this shift from speaking to biting, from linguistics to orality, can be understood as a turn from the signifier to the drives, for the purposes of this essay I will associate the signifier with the psychoanalytic theory of Jacques Lacan, and the drives with the work of Melanie Klein. And since Lacan's language-based theory of psychoanalysis is well known, I will restrict myself to a very brief summary of relevant features of the less familiar Kleinian model.

Kleinian theory centres on the preverbal experience of the infantile subject. Constructing her model of subjectivity around the infant, and so in relation to an immediate and fragmented bodily experience unmediated by language, Klein places at the centre of her theory not the unconscious but fantasy – fantasy understood not as a work of the unconscious mind, but as a bodily operation.

In effect, Klein argues that subjectivity forms around fantasies that are physically enacted; it is, we could say, formed by the mouth in the act of biting. What interests Klein, then, in contrast to Freud, is not the neurotic symptom that is an effect of sexuality, but the psychoses that arise as effects of the death drive. For Klein, aggression – and especially efforts to suppress it – rather than sexual development, is the pivotal psychic site of struggle. A crucial insight of Kleinian theory thus is her analysis of aggression as deeply structuring unconscious fantasy in both sexes from infancy through life. And through this shift of emphasis from sexual development to aggression and the death drive, the conventional construction of femininity and masculinity as opposed on axes of agency and passivity, aggression and nurturing – axes drawn to diagram the negotiation of the castration complex – is radically, if inadvertently, destabilized.

IV

As Mary Jacobus has recently observed of psychoanalytic feminism, 'the current return to Klein ... feels like eating one's words'.[4] That is, psychoanalytically based feminism has, since perhaps the late 1970s, defined itself in relation to Lacanian theory and its account of sexual difference via the signifier, while Kleinian theory (when considered at all)

has been associated with a literal and essentialist conception of the body. The renewed interest in Klein in the current decade, first in literary theory and criticism and more recently in art, thus risks being read as a regression.

And this putative regression of some feminist psychoanalytic theory from Lacanian to Kleinian modes of analysis therefore coincides with uses of the body in contemporary feminist art practices that also are often framed in terms of theoretical regression. The Kleinian turn in artistic practice can however be understood instead as a repositioning, shifting the body from the semiotic analysis developed in Poststructuralist theory to an object-relations analysis which emphasizes instead the bodily experience of the drives.

To return, then, to Antoni's *Gnaw*, in which aggressive acts of biting and spitting stage a logic of sculptural production, we can compare this oral-sadistic logic with Bourgeois' account of her initiation into sculpture: '*Once when we were sitting together at the dining table, I took white bread, mixed it with spit, and molded a figure of my father. When the figure was done, I started cutting off the limbs with a knife. I see this as my first sculptural solution.*'[5]
The critiques of Antoni's *Gnaw* as regressive, or as infantilizing the female artist-subject, seem to ignore the problematic that a number of other feminist artists, including Bourgeois, have dramatized in their work: the impossibility of enacting aggression from a female subject position. I would therefore suggest that the significance of the Kleinian model for recent psychoanalytic feminist work lies at least in part in its analysis of aggression not as a function of sexual difference, but as structural to all subjectivities. Bourgeois' *The Destruction of the Father* is perhaps the most celebrated example of a work that employs oral sadism to stage an attack on the patriarchal structure of language. More recently, the American artist Rona Pondick's installations have enacted oral-sadistic infantile fantasies, as in the conflation of greedy tearing mouths and persecutory devouring breasts in such works as *Mouth* (1992–93). Strewn across the floor, its hundreds of teethed or nippled, sticky and blotchy balls scattered around the room, *Mouth* evokes the rapacity of the infantile drives in strikingly Kleinian terms. And Maxine Hayt's *Licks* (1993), slippery, lumpy orifices from which foamy tongues slide out, similarly portray the mouth as part-object.

If, then, we consider Antoni's *Gnaw*, formed by biting and expelling, as well as her more recent oral works, made by licking, together with Pondick's *Mouth* and Maxine Hayt's *Licks*, as reworking an earlier model of feminist production represented by Bourgeois' *The Destruction of the Father*, then we may observe a renewed determination to explore female aggression through the infantile body. And this enactment of aggression through the drives, through corporeal fantasies of biting and sucking, the gnaw and the lick, can be seen not in terms of a theoretical regression, but as opening a space in which aggressive female subjects can exist.

1 *Louise Bourgeois*, quoted in Jean Frémon, *Louise Bourgeois: Retrospective 1947-1984* (Paris: Galerie Maeght Lelong, 1984).

2 The analysis I offer here does not address many important aspects of this work, including its enactment of a compulsive behaviour in the form of an eating disorder, its dramatization of female masochism and its specific relation to Minimalism.

3 Jacqueline Rose, 'Sexuality and Vision: Some Questions', in *Vision and Visuality*, ed. Hal Foster (Seattle: Bay Press, 1988) 121.

4 Mary Jacobus, 'Tea Daddy: Poor Mrs Klein and the Pencil Shavings', *Women: A Cultural Review*, 2 (Summer 1990) special issue, 'Positioning Klein', 160.

5 Bourgeois quoted in Christiane Meyer-Thoss, *Louise Bourgeois: Designing for Free Fall* (Zurich: Ammann Verlag, 1992) 53.

Mignon Nixon, 'The Gnaw and the Lick: Orality in Recent Feminist Art', *Janine Antoni* (Barcelona: Fundació 'la caixa', 1996) 30-31.

Sarah J. ROGERS
The Body and the Object: Ann Hamilton 1984–96 [1996]

'*The true artist is connected. The true artist studies the past not as a copyist nor as a pasticheur will study the past, those people are interested only in the final product, the art object, signed sealed and delivered to a public drugged on reproduction. The true artist is interested in the art object as an art process, the thing in being, the being of the thing, the struggle, the excitement, the energy, that have found expression in a particular way. The true artist is after the problem. The false artist wants it solved (by somebody else)*'.[1]
– Jeanette Winterson, 1996

In describing the traits of a 'true artist', writer Jeanette Winterson succinctly articulates the clear yet complex, modest yet aggressive artistic impulses of Ann Hamilton. Hamilton's art questions and animates the processes that link perception, knowledge, expression and experience – regardless of a specific project's material, site or subject. The exhibition titled *the body and the object*, the accompanying CD-ROM publication and Hamilton's activities during her 1994–96 residency at the Wexner Center for the Arts, Columbus, Ohio, come together at a pivotal moment in her career, as she seeks out the interrelationships and essential ingredients of her powerful art.[2]

Mention of Hamilton's name conjures up a myriad of associations. She is the artist who enlists hundreds of hands in the production of an installation, the artist whose work is often described by the enormous quantities of its material making (750,000 pennies; 3,000 ears of corn; 14,000 human and animal teeth), the acclaimed international artist who came of age in the 1980s and became one of the youngest recipients of the MacArthur Foundation's 'genius' awards. She has been described as a multi-media artist whose performances are set in gigantic environments, an installation artist and a performance

artist, a sculptor of large-scale theatrical tableaux. But none of these descriptions clarifies that the theatrical scale and materiality of the installations do not create threatre, and that the human presence in Hamilton's installations does not function as an actor or performer. Because of the site specific, temporary format of much of Hamilton's work, it has been impossible for a wide audience to view a range of her artistic output. (Such is the dilemma of most 'installation' artists.) And because of their complex logistics, unnerving quantities of unconventional materials and sheer material beauty, Hamilton's projects have evoked a mythology that emphasizes a perceived romantic, nostalgic, Midwestern work ethic, overlooking this artist's rigorous passion and invention.

Hamilton's installations have always asked big questions: how is perception changed into knowledge? What social, economic or expressive systems are created in the relationships between humans and animals? In her earlier works, answers (or at least suggestive clues that might point towards them) often were framed in terms of a project's materials – a floor of linotype slugs, layers of smoothed work shirts and pants – and in the way those materials embodied a residual accumulation of gestures. Objects, video, sound and figures also appeared in the installations, but primarily as markers within the larger experience, details that caused the visitor to pause and take notice. More recently, image and gesture, always essential ingredients in her art, have come to the foreground of her thinking in new ways. And Hamilton is now manipulating the traits of video imagery as she had previously manipulated books, objects and organic matter: to reveal the potency of the detail. Her residency was conceived to support these and other apparent changes in Hamilton's thinking: a questioning of the site as a material container, a focus on specific singular gestures, a more overt use of voice as a 'material' within the space.

Amid this general sense of transition, Hamilton began making videos in the Wexner Center's Art and Technology facility. Some of the videos would appear in projects elsewhere before the conclusion of the residency; others were purely experimental and independent of any specific event. The subject of one of her first residency videos was an ink stained finger slowly pushing its way across a transparent surface, erasing the letters of the alphabet. Our point of view is from the other side of the glass (or video monitor), inside the action. Rather than making an artifact as the tactile connector between body and written language (as she had with the erased books from *indigo blue*, 1991), Hamilton captured the process of the gesture, making it both material and artifact [...]

For all their absurdity, however, Hamilton's images reveal the artist's serious preoccupations. The *body object* photographs demonstrate the artist's penchant for studying an object by framing it within a two-dimensional structure, often isolating and silhouetting the form, as she does explicitly in her recent videos. They also show, over a span of years, her continuing impulse to make inanimate what is naturally animate, to confound the senses, to explore those edges and openings of the body where sensorial experiences occur, to camouflage the body,

protect it and transform it into artifact.

To Hamilton, the body is the locus for empirical knowledge: it is through our bodily senses – tactual, aural, visual, olfactory and cognitive – that we find experience and knowledge. The sensory abilities of the figures in both the *body object* photographs and the installations are often altered, denied or extended, at the very sites where information is heard, seen or tasted. And the figures themselves become both objects and living presences in a restructured reality, reminding us of the finite and ultimately artificial conditions of the tableaux.[3] In this subtle way, Hamilton breaks with the heritage of previous installation art that re-enacted aspects of the 'real world', whether in the social actions of Joseph Beuys, the interventions of Robert Smithson and other earth artists, the dream states of Jonathan Borofsky, or the powerful feminist creations of Magdalena Abakanowicz or Louise Bourgeois.

From her earliest efforts, it was clear that the human presence in Hamilton's art did not function as symbol or storyteller. Rather, she used the human figure as a site through which to explore perceptual awareness and 'aspects' of our being. She was, as early as graduate school, seeking new ways to orchestrate body, meaning and material within the container of a room. The format she naturally developed melded 'studio tableaux', imagist theatre and dance/performance. From the work of Meredith Monk and Robert Wilson, she learned to create powerful images of the human figure within monumental spaces, to exploit the accumulation of fragmented meanings rather than to define a continuous narrative. And from Yvonne Rainer, Hamilton gained 'the permission', to exploit, to dissect and to celebrate everyday gesture and movement.[4]

Hamilton's studies in weaving at the University of Kansas are frequently cited to explain her affinity for materially rich situations and her connection to the traditions of women's work. But this training also provided a system of logic, an ability to envision abstract structures on a large scale. Weaving, whether hand-loom, machine or freehand, is a kind of mapping, an overlaying of one set of threads with another. One must be able to conceive the finished design from the abstract system of warps and wefts noted on weaving cards, conceptualizing not just the two-dimensional design but also its tactile presence as an object in space. The carpet of pennies in privation and excesses (1989) and the wall of wrestling dummies in a round (1993) clearly demonstrate the connection to a weaver's sensibility. Equally significant is the basic condition of the weaving process: each thread retains its individuality as it becomes part of the fabric, just as each object, material or action in Hamilton's installations retains its own identity while part of the whole piece. The assertion that Hamilton both celebrates and extends the legacy of women's work and crafts raises interesting questions. It is clear that the nature and history of making – of making by hand, of the kind of making that clothes us, builds our homes, tends our babies and tills our fields – are active ingredients in Hamilton's art. However, her true interests are in the labour or condition of making and in the social and economic, as well as creative, imperatives of labour, and these considerations are not gender specific.

1 Jeanette Winterson, *Art Objects: Essays on Ecstasy and Effrontery* (New York: Alfred A. Knopf, 1996) 12.
2 Hamilton was the recipient of a 1994–95 Wexner Center Residency Award in visual arts; her residency activities continued into 1996. These awards are given each year in the Wexner Center's three main programming areas of visual arts, performing arts and media arts (film/video).
3 For example, the figure in *lids of unknown positions* (1984) sat in a lifeguard chair with its head inserted into a hole in the ceiling. That in *still life* (1988) sat immobile in front of a table piled with 800 folded, singed and gilded shirts.
4 Hamilton refers to the significance of this 'permission' as one of the greatest gifts a teacher can offer a student. In her many years as a teacher and through working with the communities that often assist in making the installations, she is passing on this tradition.

Sarah J. Rogers, *Ann Hamilton* (Columbus: Wexner Center for the Arts, The Ohio State University, 1996) 8–9; 15–16.

N. Katherine HAYLES
Embodied Virtuality: Or How to Put Bodies Back into the Picture [1996]

CROSSING THE VIRTUAL DIVIDE

[...] The cultural constructions that identify masculine subjectivity with the mind, female subjectivity with embodiment, may be responsible for actual physical differences in how men and women react to immersion in Virtual Reality. When a user enters a VR simulation, body boundaries become ambiguous. Body motions affect what happens in the simulation, so that one body marks one kind of presence; the point of view, or pov, that constructs the user's position within the simulation marks another. As a marker of subjectivity, pov is more than an acronym, more even than a noun. In the parlance of VR, it functions like a pronoun, a semiotic container for subjectivity. According to anecdotal evidence from a number of researchers, including Sandy Stone and Brenda Laurel, women are apt to feel more disoriented by the transition to and from VR than men, and they are more prone to motion sickness while in VR.[1] The reason, these researchers conjecture, is that men adapt more readily to the idea that pov can move independently of the body, whereas women are accustomed to identifying pov with the body. Although this informal observation remains to be tested by a systematic study, its performance is already being staged in a variety of cultural documents [...]

Brenda Laurel and Rachel Strickland's *Placeholder* (1993) simulation illustrates one kind of artistic response.[2] Laurel and Strickland wanted to create a simulation that would model for the VR industry a different aesthetic than the violence, sexism and racism that are staples of video game productions. They envisioned a simulation that would situate embodied actions within an interactive

environment. They wanted the aesthetic choices to grow out of a respect for the complex interactions that take place between embodied creatures and the world they inhabit. Reflecting these priorities, the first choices they made were the sites that would serve as models for the environments recreated in the simulation. They explored the breathtaking terrain around Banff and finally settled on three locales: the vertical rock formations known as the hoodoos, revered by native people as the home of spirits; a natural cave; and a mountain waterfall. They shot panoramic videotapes of each site at four different times of the day and used the tapes to lay video tiles onto wireframe models to create the landscapes for the simulation.

Having chosen the sites, they worked with actors from Precipice Theatre, an improvisational troupe, to create narrative material that could be incorporated into the simulation. Some of this work took place in the troupe's regular rehearsal space, but some of it was done on location. The actors hooted at the hoodoos, splashed in the waterfall, dripped in the cave along with the stalactites. As they interacted with the environments, the idea grew that the simulated environments should be animated. Laurel and Strickland commissioned Russel Zeidler, an architect, to come up with an icon, reminiscent of a petroglyph, that could be used to give a local habitation and a name to the simulated landscape. Zeidler created a schematic face that functions as a 'voiceholder', a virtual container that holds recorded messages. When a user touches the face icon, its eyes open. The user can then collect the recorded messages that others have left or leave a calling card herself.

Embodiment in *Placeholder* is enacted through Smart Costumes. To interact with the simulation, a user chooses one of four forms: spider, crow, snake or fish. In the simulation, the user visually appears as her chosen form. Moreover, voice filters are used to alter the user's voice in ways characteristic of the four Smart Costumes. Crow sounds raucous and masculine, spider wise and feminine, whereas snake and fish are gender-indeterminate. Movement functionalities are determined by the form of embodiment the user chooses. Crow can fly, for example, while the other forms cannot. With snake, vision is affected as well, shifting into the infrared. It is important to note that the simulation does not restore a 'natural' connection between the user's pov and the body, most obviously because human beings do not actually have sensoriums that process information in these ways. The person who experiences this simulation is a techno-bio-subject whose body has been resurfaced and reconfigured by its interface with the technology. What the simulation does insist upon, however, is the connection between pov and incorporation. It is not possible, the semiotics implies, to have experiences without a viewpoint constituted through sensory-motor apparatus specific to the form pov occupies.

Designed to foster interaction with the environment, *Placeholder* encourages interaction between participants as well. The simulation can accommodate two users at once. They stand in neighbouring circles formed of river stones. As they interact with the simulation, they move about, learning the limits of the cables connecting them to the simulation through the tactile feedback of stubbing their toes on the stones. Each can see the other in the simulation and hear the voice-filtered comments her or his companion makes. Participants can shapeshift by touching the appropriate totemic icon. Improvising on cues provided by the environment and each other, they create narrative. To further enrich the narrative possibilities, the simulation provides for a Goddess, a role played by someone who watches the simulation on monitors and interjects comments, suggestions and commands. The Goddess' voice is spatially localized over the user's head, giving the eerie sensation of coming from *inside* rather than outside. This role was often played by Laurel, and occasionally by others [...]

Whereas Laurel and Strickland emphasize the materiality that interpenetrates virtuality, the Canadian artist Catherine Richards focuses on the virtuality that interpenetrates materiality. Her work explores the extent to which virtuality has overtaken RL – the real life that VR researchers shorten to an acronym, semiotically declaring its equivalence to VR. In her art video *Spectral Bodies*, Richards focuses on proprioception, the sensory system that uses internal nerve receptors at joints and muscles to give us the sense that we inhabit our bodies.[3] Normally we know, without thinking about it, exactly where our body boundaries are and how to move our bodies to negotiate complex spaces and topologies. Precisely because it is automatic, the importance of proprioception normally tends to be veiled from us. In the video Richards alludes to Oliver Sacks' essay 'The Disembodied Woman', in which he writes about Christine, a patient who lost her proprioception sense as a result of neurological damage.[4] With great effort, Christine was able to relearn how to sit, walk and stand; what she was not able to recapture was the sense that she was inside her body. She felt that she was positioned somewhere outside, forced to manipulate her body through conscious effort as if she were a puppetmaster moving an inert doll [...]

Combined with these images are visual and verbal references to virtual reality. As the video begins, lettering on the screen informs us that Richards is combining 'body illusions with VR to bring to the surface the intervention of VR in the psychological (re)mapping of our bodies'. When I spoke with Richards about the video, she pointed out that all of film, television and video evolved from a single 'perceptual glitch' – the fact that when the human eye is presented with images in rapid succession, it perceives the images as motion. She sees a similar plethora of technologies evolving from the 'perceptual glitch' she explores in her video – the fact that our sense of body boundaries can easily be destabilized and reconfigured by even low-tech interventions. When the intervention consists of stimulating surface muscles while the subject is blindfolded, the reconfiguration is easily detected as a hallucinatory experience. The subjects in the video knew that their experiences were not 'real', because ordinary experience as well as other sensory channels told them that the body was in fact remaining stable. Imagine, however, a VR simulation that would visually reinforce the changing image the subject has of her body [...]

In my conversation with Richards, she remarked that she did not think the interpenetration of materiality by information was primarily due to the development of VR technology. Rather, she sees VR technology developing because we who inhabit first world countries are already convinced of our virtuality. Everything else is becoming virtual – money is displaced by automatic teller machine (ATM) cards, physical contact by phone sex, face-to-face communication by answering machines, an industrial economic base by information systems; why shouldn't our bodies be virtual too? Yet even as she foregrounds this shift and wants to explore it, Richards insists on the continuing importance of our material existence. It is for this reason that she locates her work at the site of the body, because she sees the body as the crossroads where the psychological, material and virtual intersect. The feminist edge to Richard's work comes not only from her insistence on materiality but also from her implicit assumption that body and mind interact and that any reconfiguration of the body must necessarily affect how subjectivity is constituted [...]

Spectral Bodies ends with the voiceover of a subject who experienced radical body distortions asking, 'Can you put me back [the way I was]?' As the VR artists discussed here realize, it is not possible for us in first world countries to return to a state of 'natural' wholeness. I believe Laurel, Strickland and Richards are correct in seeking to find a way *through* these powerful technologies rather than condemning or boycotting them. 'I would rather be a cyborg than a goddess', Donna Haraway proclaims at the end of 'A Manifesto for Cyborgs'.[5] The question for us now is, what kind of cyborg? Dreams of transcendence, of freedom from the flesh, exacerbate rather than solve our problems. Although our bodies may not be 'natural', they are still material, and they are still necessary for our survival on this planet. However resurfaced with virtuality, the physical world is our one and only home.

1 These effects were reported to me in informal conversation with Sandy Stone and Brenda Laurel and anecdotally confirmed by researchers at the University of Washington Human Interaction Laboratory.

2 Rachel Strickland and Brenda Laurel also showed the video on *Placeholder* at the Banff Centre for the Arts Symposium on Art and Virtual Environments in May 1994. I am indebted to the Banff Centre for making it possible for me to attend the conference and for their generous support and encouragement.

3 Quotations from *Spectral Bodies* are used with permission of Catherine Richards.

4 Oliver Sacks, 'The Disembodied Woman', in *The Man Who Mistook His Wife for a Hat and Other Clinical Tales* (New York: Summit Books, 1985).

5 Donna Haraway, 'A Manifesto for Cyborgs: Science, Technology, and Socialist Feminism in the 1980s', *Socialist Review*, 80 (1985) 65-107.

N. Katherine Hayles, 'Embodied Virtuality: Or How to Put Bodies Back into the Picture', *Immersed in Technology: Art and Virtual Environments*, eds. Mary Moser and Douglas MacLeod (Cambridge, Massachusetts, and London: MIT Press, 1996) 1-28.

Gilda WILLIAMS
The Animal Bride [1996]

Femininity is hard to discuss in our culture, which essentially views the posture of childbirth as grotesquely unladylike, and it is not surprising that probing the limits of gender expectations is irresistable to so many women artists. If the women in Lucy Gunning's videos are, on the surface, typically 'girlish' – what with their love for horses, their habit of spending time alone in their rooms, their singing, their long hours in the kitchen, their playfulness – they are always revealed as existing closer to what Gunning calls neither masculine nor feminine: a non-specific third gender. Gunning's subject is not neutral but unconditioned by a phallocentric system; she inhabits a space located 'elsewhere', in between a binary, intrinsically antagonistic view of gendered behaviour.

In Gunning's videos there is always a twist the size of a tornado on the conventions of femininity. In *The Horse Impressionists* (1994) the portrayed women are not merely fond of the animals, but have actually adopted their 'unfeminine', indeed non-human, screeching sounds – remotely reminiscent of a woman in labour. As the title plainly describes, the young lady locked in her bedroom in *Climbing around My Room* (1995) is certainly not busy writing in her diary about her daily disappointments with boys; in the *Singing Lesson* (1994) we are not entertained by a parlour room recital of a woman's melodious singing but witness the untrained, off-key attempts of the artist to mimic her teacher, whose face is not that of an angel but is contorted into an unflattering grimace. In *Mouse Running round the Kitchen* (1994) the unseen woman at hand, the artist herself, spends the afternoon in the kitchen filming a surprising welcome intruder into 'her space', a mouse; and finally, the girlfriends at play in *The Footballers* (1996) are engaged in a combative two-person football match. Expectations of the feminine are hinted at and yet thoroughly denied: the resulting pleasure, the *jouissance*, for the women on screen (often the artist herself) is consequently enormously heightened. Akin to Hélène Cixous' notion of an unhindered *écriture féminine*, Gunning uses gendering as a strategy for a kind of female-based bisexuality wherein both sexes are present without depending on binary logic [...]

Access to language, to a voice, to writing, is always at issue in Gunning's broad subject matter: her sounds might be eerie vocals, like the women in *The Horse Impressionists*; or they are limited to the shuffling of feet and bouncing of a ball (*The Footballers*), or the indefinable, quiet sounds of a body sliding over a shelf (*Climbing around My Room*); or slowed down to unrecognizable baritones in her recent video installation, *Flying* (1996). These women all have no speaking voice. The voice was also partially denied in *Opera Singer* (1995), an installation in the Adam Gallery window in which the image of an opera singer was projected towards the street and yet her voice was inaudible to passers-by. Most emblematic, however, is her double-monitored video installation. *Singing Lesson* (1994), in which a woman is literally being taught to acquire a voice [...]

Formally similar to *Climbing around My Room*, Bruce Nauman's video *Walking in an Exaggerated Manner around the Perimeter of a Square* (1967–68) illustrates the risk of bored fruitlessness during the long lonely hours in an artist's studio. Lucy Gunning seems bent on avoiding that tedium, determined to site her work elsewhere: at a singing lesson or, in her recent work at the Harris Art Gallery and Museum in Preston, Lancashire, at an airplane-flying session. A far more cautious leap into the void than Yves Klein's, *Flying* is a multi-screened installation whose central image is that of the sky framed by hope (Gunning, the student, left); wisdom (the gauges and instruments below); patience (the instructor, right) and infinity above. At one point , the video camera is turned 360 degrees on its tripod, sweeping in sky, landscape and cockpit, mirroring the circular, potentially endless movement in *Climbing around My Room*. The mono-directional trajectory of the plane is transformed into a limitless, all-encompassing alternative; metaphorically, our Emilia Earhart, the artist, has discovered a system to venture in all possible directions without spinning out of control.

Starting with the little red-dressed (though not riding-hooded) monkeyish performer in *Climbing around My Room*, Gunning's works are somehow fable-like, not least because of the incidence of animals in them. Animal metaphors can be both self-evident (*The Horse Impressionists*) or, like *Mouse Running round the Kitchen*, more subtle: in this case a fable about a kind of shrew puttering about in the kitchen. Certainly, being trained, the subject in both *Flying* and *Singing Lesson*, is a distinctly animal occupation: by learning to fly and to sing, Gunning is well on her way to becoming, excuse the pun, convincingly bird-like. The repetitious, uneventful scenes in such videos as *Peeling an Apple* (1995–96) wherein an elderly woman does just that, are like wildlife documentaries: the presentation of their subjects relies on the fascination with these 'distant forms of life' (animals, women) even while engaged in the most ordinary activities.

Denied language or struggling to assert a voice, animals are the perfect analogue for Gunning's Other: neither man nor woman, the 'non-specific third gender' which asserts itself while seeking pleasure.

Gilda Williams, 'The Animal Bride: Lucy Gunning', *Art Monthly* (October 1996) 48-49.

FEMMES DE SIÈCLE

With the millennium approaching, artists and writers reviewed histories of the twentieth century, including the legacies of Modernism and feminism. The metaphor of weaving (familiar from earlier feminist interest in undervalued arts and crafts) was adopted in several critical, curatorial and artistic projects. As a conceit, weaving suggested a simultaneous picking up of old strands, a making visible of previously invisible connections, and the undoing or unravelling of seemingly fixed histories. Taking the loom as her starting point and leitmotif Sadie Plant explored the tangled histories of technology and female creativity, threading together weaving, typing, the World Wide Web and the redundancy of the male sex. With endings in mind, Coco Fusco surveyed responses to the deaths of Latino women artists. Writers and artists looked back at numerous traumatic episodes in recent history.

Joan SIMON
No Ladders; Snakes: Jenny Holzer's *Lustmord* [1994]

[…] *Lustmord* – which has no precise English equivalent but which, as Holzer says, translates roughly from the German as 'rapeslaying' – is the title of a series of texts the artist began to write more than two years ago in response to the violence done to women in the war in Bosnia. In these writings, produced for publication in the magazine section of Munich's *Süddeutsche Zeitung*, Holzer has created a chorus of three voices: victim, perpetrator and observer. And in *Lustmord*, as in the past two years of civil war in the former Yugoslavia, there are no ladders, only snakes.

These texts were also prompted by Holzer's participation in a round-table discussion to develop the Family Violence project for Liz Claiborne.[1] Holzer found herself, along with many others in the twenty-odd member group, so upset by the discussion of violence done to women in their homes that her texts began to be 'peopled by women outside war zones, too'.[2] The psychology and physiology of 'grieving, misery, fury' in these writings were also immediate. 'My mother dying this past year, that let me write about dead women. Indirectly.'

Many, myself included, first found out about these texts via news stories reporting on the scandal that the Holzer cover for the 19 November 1993 issue *Süddeutsche Zeitung* magazine section had provoked. There, affixed to a black background was a white notecard which announced in red lettering, *Da Wo Frauen Sterben bin Ich Hellwach* (I am awake in the place where women die). The cover story consisted of another thirty pages devoted to Holzer's *Lustmord* project.[3] While a substantial artist's contribution to a newspaper may be noteworthy in itself, what made the event newsworthy was the fact that Holzer's words were not symbolically blood-red to denote the violence done to women but rather were printed in ink mixed with the blood of women, which had been donated for this action by eight German and Yugoslav volunteers. In the land of Gutenberg, Holzer had transmuted the most disposable and democratic of printed forms into something evidently both totem and taboo. Here, a familiar enough daily missive (reaching half a million readers), with its strange sacramental offering, had suddenly turned into a creepy uninvited guest, one that was soon perceived by some as a deadly threat.

The work brought forward fears archetypal and immediate: of blood, of women's bleeding, of the unclean, ill or wounded, of death itself, and of the unknown. Here also were reckonings of the past compounded by problems in the present: ethnic cleansing and the 'pure blooded'; blood tests; AIDS transmission; the war in ex-Yugoslavia; and the scandal in Germany over HIV-infected blood supplies. 'When this publication and that synchronized up, what might have been a blip blew up',

according to Holzer. 'The reaction became ridiculous. A major press conference; talk in some regional court of impounding the magazine – public health menace.'

The attention that both the cover and its coverage received indeed provoked discussion of the violence done to women in the former Yugoslavia and elsewhere, as Holzer had hoped it would.[4] It did not, however, always deal with other significant, perhaps even more devastating parts of her own project.[5] For beneath the 'I am awake …' text, written from the point of view of the victim, were two other messages just inside the cover card: the perpetrator's, which read *Die Farbe Ihrer Offenen Innenseite Reizt Mich Sie zu Töten* (The colour of her inside is enough to make me kill her), and the observer's: *Sie Fiel Auf den Boden Meines Zimmers Sie Wollte Beim Sterben Sauber Sein aber Sie War Es Nicht* (She fell on the floor in my room. She tried to be clean when she died but she was not. I see her trail).

These grueling words, an opening salvo to what followed, were quite literally an invitation, printed as they were on a very proper looking piece of stationery, a standard, folded 'informal'. The texts themselves also appeared as if written casually in marker: red message on top, black on the inner faces, each in capital letters in a different (though rather plain) 'hand', banal, even, under a graphologist's scrutiny.

The inside pages of *Lustmord* were, at least to this viewer, far more graphic, more shocking and more violating than the cover. Again, each of the three types of

texts were written out. This time, however, the texts were hand-written in marker on human flesh, and the close-up colour photos, cropped and reproduced as full-page bleeds, were presented as page after page of fields of skin, with hairs, pores, blemishes correspondingly magnified, though individual body parts are unidentifiable. Inked for the most part in black or blue, with occasionally a more artful treatment of red with black, they read as the butcher's markings on cuts of meat, as had the tattooed numbers of concentration camp prisoners before them.

The power of touch is perhaps second only to smell as primal instinct, information sensor and protective mechanism. And the contradictory capacity to signal danger and offer comfort and spiritual strength (the laying on of hands in the service of ordaining priests, healing the sick, offering the essential security and intimate connection between infant and nurturer) is the disjunction between the familiar and foreign into which Holzer's project taps. Indeed, the one-two punch of this project lies with this conceptual inversion of what is seen to be touched and what actually is touched: the photos inside signal an invisible hand having violated the body, triggering memories and associations of other bodies, other times; the printed card without — innocuous-looking until one reads a note on the contents page — and another within the special section — which details what the ink was made of and how it had been secured — is a potential, or perceived violation to a hand: one's own[6] [...]

1 The 'Family Violence Awareness Campaign' is one of the Women's Work projects, initiated and supported by Liz Claiborne Inc., public service collaborations that are planned and executed in co-ordination with government and private agencies, local communities and artists. In San Francisco, for example, the company donated start-up funds for the first centralized domestic violence hot-line; billboards were created by artists Carrie Mae Weems, Margaret Crane, Jon Winet and Diane Tani, Susan Meiselas and Barbara Kruger.

2 Unless otherwise noted, all Holzer quotes are from telephone interviews with the artist, 10 and 14 March and 2 April 1994. Telephone interviews with Christian Kämmerling took place 28 March and 5 April 1994.

3 This was the fourth in a series of yearly artist's contributions to the magazine, following Anselm Kiefer, Francesco Clemente and Jeff Koons. Christian Kämmerling, an editor of the magazine, credits the genesis of the series, called 'Number 46' (appearing as it does in the issue of the magazine published the forty-sixth week of the year), to a question posed to him by Anselm Kiefer when Kämmerling was searching for a way to publish artists' works in a more substantive way than two or three pages. Kiefer asked why cover stories are always told in words and not images.

4 Though some reports dealt only with the sensational aspects, both Holzer and Kämmerling note that it was the tabloid press that gave substantive coverage to the issues. According to Kämmerling, the tabloids every day for a week - under a banner headline - discussed a different aspect of the project, bringing the discussion to a million readers.

5 The news item in Time, for example, reported that the magazine 'tried to bring the violence done to women in war right into 520,000 readers' homes', and noted that the cover was printed using the blood of volunteers and that many found the approach 'too sensational'. 'Repulsive and absurd', was the response of Peter Heimer at the German Red Cross. But Hamburg fashion designer Wolfgang Joop, a financial backer of the project asked, 'What times are these when a single sentence printed in blood donated by volunteers shocks more than the incessant flood of pictures showing real bloodshed?' Only the cover was reproduced. Time (29 November 1993) 12.

6 Where (and, consequently when) in the sequence of using the magazine, one learned about its cover material, is critical to its reception. If one didn't know in advance what one was holding, and only received the information after handling the magazine, a sense of being discomfited, misled or betrayed by information having been withheld further complicates the multiple responses to the cover - the metaphoric sense of culpability, of 'having blood on one's hands'; the actual sense of coming in contact with the blood of an unknown other. The information appeared on the contents page, and also in an explanatory note in the middle of the magazine.
Prior to publication, chemists, medical experts and lawyers were consulted as to medical, ethical and legal issues. Volunteers donated blood, which was hepatitis- and HIV-screened, then cooked to kill infectious agents. (Dr. Marcell Heim, Director of the Centre for Blood Transfusion, University of Magdenburg, served as supervisor; according to Kämmerling, Heim noted that the medieval technology of cooking, actually boiling with water, was the most effective technology of all.) The red hemoglobin was then mixed with printing ink, the cards were printed separately, and affixed by hand to each of the half-million copies.
Joan Simon, 'No Ladders; Snakes: Jenny Holzer's Lustmord', Parkett, 40/41 (June 1994) 79-85.

Gillian WEARING
Signs of the Times: Interview with Caryn Faure Walker [1995]

Caryn Faure Walker We were talking about your relationship to television.

Gillian Wearing When I picked up a video camera in 1990 I knew I was trying to follow what I really enjoyed in 1970s television. There were a lot of 'fly-on-wall' documentaries — *World in Action, Panorama* — that dealt with social rather than government issues. These programmes have since had a shake-up because they were losing ratings. Taking off from the earlier documentaries, I want my videos to be involved with how things are now, but to be more open. I don't look for particular groups of people or particular issues. People must make their own judgements, realize that we are all alike or not. The subtleties are important. People are learning about them through their own use of Camcorders [...]

Walker You don't frame the photographs or videos through extreme camera angles.

Wearing People sometimes decide how they want to be pictured. Frequently I am jostled in the street. Because I hand-hold my Pentax, this also sometimes determines the shots. I find things work better when photography is done quickly; this avoids being stylized, doing what you've done before. Also I want the photographs to be straightforward. However, this does not mean that I am dislodging visual skills. When I decide on the final format what is important is the diversity of people and what they say.

Walker Do you intentionally photograph unacceptable subject matter?

Wearing With *Take Your Top Off* (1993) I wanted to see my own identity in a photograph along with someone who decided to change their sex, because once you've made that decision, it is the biggest thing in your life. Frequently, after this sex change, transsexuals' lives centre around the politics of what it is to be a transsexual. That's why I thought it was the most overt form of sexual identity. I am the constant element in the three photographs. I picture myself holding the camera release button to reduce the element of voyeurism, to prove there was no one else behind the lens. By extension this implied the other people's control over their own bodies.

Walker Was your 1994 video *Dancing in Peckham* putting yourself in the picture in a similar way?

Wearing I asked myself what it would be like to take the fantasy of dancing at home and do it in a shopping centre. Much of it is also about observation of behaviour. When you go out and do something abnormal what do the public do in return? (This question links the work with others of my pieces.)

It is quite common in England to walk past something and pretend not to get involved. I recognize this tendency in myself. *Dancing in Peckham*, 25 minutes completely unedited, had to have that excruciating time go by to understand what people do [...]

Gillian Wearing, 'Signs of the Times: Interview with Caryn Faure Walker', *Creative Camera* (February-March 1995) 36.

Laura COTTINGHAM
Notes on *lesbian* [1996]

An attempt to construct a lesbian history, whether it be sociological or art historical, involves confronting silence, erasure, misrepresentation and prejudice — all of which present formidable obstacles to historical research and writing. How is it possible to reconstruct a story from evidence that is partial, absent, hidden, denied, obfuscated, trivialized and otherwise suppressed? The traditional methodology of historical research, and by extension the value system used to evaluate the quality of texts written in the name of history, is necessarily overdetermined by a prioritization of primary sources. But what if these primary sources do not exist because

governments have not counted or otherwise documented the historical subject(s); or because the social and political persecution of said subject(s) has encouraged them to silence themselves; or because prejudice has enabled families and biographers to destroy documents such as letters and diaries that contain the crucial content that might constitute testimony or evidence? Some lesbian historians understandably believe that more information about lesbians in the past exists than we now know of or have access to and that, therefore, more primary sources and more traditional history is forthcoming. But it might also just as easily be assumed that the availability of written proof of lesbians and lesbianism is significantly less present and existent than lesbians and lesbianism in nineteenth- and twentieth-century European and American history have in fact been.

Although the traditional historical practices of excavation and recontextualization have yielded valuable contributions to the understanding and construction of European and American lesbian history by scholars such as Lillian Faderman and Barbara Smith in the United States, Ilse Kokula in Germany and the Lesbian History Group in the United Kingdom, published texts by these and others invariably begin with an enunciation of the particular problems raised in rendering lesbians visible given how deliberately and successfully patriarchy has made us invisible. Even more often, patriarchal societies have disallowed women the possibility of being lesbian at all, in which case it is extremely difficult to produce and leave behind lesbian documents.

The introduction to a recent work by the London-based Lesbian History Group, *Not a Passing Phase: Reclaiming Lesbians in History, 1840–1985*, outlines some of the distinct problems lesbian historians face:
'*Writing the history of women is difficult because in a patriarchal society (i.e., one organized in the interest of men) fewer sources concerning women exist and those that do have often been ignored as "unimportant", or have been altered. The task of the feminist historian is first to rescue women from oblivion, and then to interpret women's experience within the context of the society of the time.*

'*This is also true for the lesbian historian. In her case, however, the problem of sources is magnified a thousandfold. First, there is relatively little explicit information about lesbian lives in the past, though probably much more than we know about at the moment. Second, much important material has been suppressed as irrelevant, or its significance overlooked by scholars pursuing a different theory. Material may have been omitted as "private" or likely to embarrass the family or alienate the reader. Much of the evidence we do have has been distorted by historians who wilfully or through ignorance have turned lesbian lives into "normal" heterosexual ones. Women can be ignored, but lesbians must be expunged.*

'*Lesbians do not usually leave records of their lives. Those who do may not include any details which would identify them as unmistakeably lesbians.*'[1]

It is after all, one of the central political problems of history, as both a philosophical construct and an academic discipline, that it can only be written – that is, it can only exist – from what has both already existed and still now exists. Additionally, history not only depends on the pre-existence of a material world of (already) lived experience, it also depends on both the existence and the accuracy of documents for and of the already lived, as well as the interpretation of those documents. Given that what history we *do* know is a narrative of male supremacy no matter how subversively or productively we choose to interpret or utilize it, how is it theoretically possible to expect that the documentary evidence left behind could yield lesbian information that is in any way commensurate to or reflective of lesbian experience?

Lesbian history invariably confronts the most profound conundrum of the basic premise of history, for it must address not only what has or has not been left behind by way of documentary remains (and how to decode them through the distorted lens of the present), but must in addition confront the successful assimilation of women into heterosexuality and ask why this has occurred. For to understand lesbians, past and present, we must acknowledge that the lesbian functions within historical parameters that constitute a hard-earned escape from the politically enforced narrative of heterosexuality. The persistence of such neutralized misnomers as 'sexual preference' masks the coercive function of heterosexuality by setting up a false premise that equates same-gender and cross-gender affections (though 'sexual preference' is usually only called in to label gays or lesbians). *Sexual preference* also deliberately disables any full understanding of lesbians and lesbianism by relegating both our histories and our bodies to the limited realm of sexual activity.

Even when lesbianism is consciously and obviously enunciated in textual and visual representation, readers, viewers, and critics often remain determined to ignore it. An example given in Barbara Smith's introduction to *Home Girls: A Black Feminist Anthology* should be familiar to most American readers of this essay, as it concerns the 1982 winner of both the Pulitzer Prize in fiction and the American Book Award for what became a 1985 Hollywood feature that garnered Academy Award nominations across the board: Alice Walker's *The Color Purple*. In her examination of the forces that keep lesbianism, and most especially black lesbianism, unmentionable, Smith writes that 'Alice Walker's novel, *The Color Purple*, is a marvel because it so clearly depicts the origins of contemporary Black feminism in the lives of our mothers, in this case of poor women living in the rural South. It also represents a breakthrough in both the context of trade publishing and Black literature, because of its original and positive portrayal of a Black lesbian relationship. Not surprisingly, in the unanimously positive reviews of *The Color Purple*, Black and white critics have steadfastly refused even to mention the true subject of the book.'[2]

Similar and more recent examples of not seeing and not naming the lesbian could be listed ad infinitum. In a book of Berenice Abbott photographs recently republished in 1990, the foreword by Muriel Rukeyser takes pains to call the reader's attention to Abbott's portraits of James Joyce,

André Gide and Jacques Cocteau but fails to reveal the fact that Abbott photographed high culture's Left Bank lesbian set of the 1920s, and that Abbott's charmed lesbian circle is featured one-by-one in the portraits of Jane Heap, Sylvia Beach, Princess Eugene Murat, Janet Flanner, Djuna Barnes, Edna St. Vincent Millay and – from their countenances and appearances – many of the other women featured in the book.[3] Not to acknowledge Abbott's lesbianism is not to understand her art or her subjects. Such disacknowledgement also functions to deny lesbians access to our cultural history, thus allowing the heterosexual regime to claim it falsely for themselves. Likewise, the lesbian life and art of the French photographer Claude Cahun, a contemporary of Abbott's, was exhibited for the first time in a large retrospective at the Musée d'art moderne de la Ville de Paris in 1995. Cahun's work, which consists mostly of defiant, ironic and direct-gaze self-portraits produced during the 1930s and 1940s, is hardly helped or sufficiently explained by the heterosexualist writings included in the recent catalogues of her work.[4] Some understanding of the lesbian subculture of Paris before World War II should be as necessary as an art historical tool to comprehending Cahun (or Abbott!) as is some knowledge of French – especially considering that Cahun collaborated with her lover Suzanne Malherbe on many of her photomontages. The particularities of lesbian life, as historicized and grounded in social experience, are still not accepted as even appropriate, much less necessary, art-historical tools. How often have I been asked, by heterosexual art historians and critics after a few glasses of wine, whether it really matters at all whether an artist is lesbian or gay? Let me say that for many of us it matters a great deal – and it is obviously of significant importance to governments past and present that have enacted, and continue to enact, laws and other prohibitions against us.

Perhaps, though, as with the silence around *The Color Purple*, the problem of not naming the lesbianism in the art of Abbott, Cahun and others is related to heterosexuality's ideological imperative that lesbianism cannot be mentioned or shown if this is *done with approval*. It appears that lauding lesbianism – not just describing it – is the most unmentionable deed. For Abbott's photographic portraits of friends and lovers, Cahun's self-portraits, and Walker's fictional narrative render lesbianism and the women who live it with dignity and approval.

The disacknowledgement of artists and writers who are lesbians, and of art and literary productions that are lesbian, colludes with the disapproval that lesbianism meets in social and political life. And in academic life. As Marilyn Frye has observed in 'A Lesbian's Perspective on Women's Studies', women's studies departments across the United States are locked into an understanding of women that aggressively accepts the heterosexualization of women as normal and the marginalization of lesbians as natural or inevitable. Frye suggests a reconsideration of what sexual politics in the university might be if it weren't heterosexist politics:
'*Imagine a real reversal of the heterosexualist teaching our programme provides. Imagine thirty faculty members*

15. Berenice Abbott

at a large university engaged routinely and seriously in the vigorous and aggressive encouragement of women to be Lesbians, helping them learn skills and ideas for living as Lesbians, teaching the connections between Lesbianism and feminism and between heterosexism and sexism, building understanding of the agency of individual men in keeping individual women in line for the patriarchy. Imagine us openly and actively advising women not to marry, not to fuck, not to become bonded with any man. Imagine us teaching lots of Lesbian literature, poetry, history and art in women's studies courses, and teaching out of a politics determined by Lesbian perception and sensibility.[5]

Writing about lesbians and lesbian art from a lesbian position that affirms and approves of lesbian existence is itself an act of advocacy, just as the number of dissertations and monographs and the amount of money Europe and the United States heap on white male artists is a form of political as well as cultural approval. Unless more lesbians are willing to accept the necessity of advocating our right to exist and our right to our cultural heritage, our history as well as our present and future will continue to be lost, denied, trivialized and otherwise damaged.

For it is impossible for lesbian history to come into a recognizable cultural space until lesbians are themselves more visible in their/our own time. Unless we insist on our lesbian selves, unless we articulate ourselves visibly as such in the present, history will no doubt continue to erase us, and the lesbian historians of the future will be left with fragments and puzzles not much better than the ones we possess of the past today. Freeing ourselves from the self-censorship imposed on us is perhaps one of the most vital concerns contemporary lesbians face. One need only encounter cultural materials as otherwise dissimilar as the memoirs of French novelist and writer Marguerite Yourcenar or the *New York Daily News* interview with the comedian Ellen Degeneres to witness how pervasive the necessity of lesbian self-erasure is.[6] And I have yet to enter any academic institution or situation in the United States that is free of a hiding, self-silenced, fearful lesbian: women who are unwilling to live heterosexualized lives, but still unable to publicly enunciate themselves as lesbians.

A significant historical turning point for lesbian history in the United States is the period during the 1970s when lesbianism was chosen, celebrated and culturally enunciated within the women's liberationist organizing of second-wave feminism. Although individual lesbians had declared themselves as such before 1970, it was within the public discourse of the women's liberation movement that lesbianism was verbalized, aestheticized, collectivized and otherwise actively demonstrated outside the confines of the personal, the private, the salon and the bar. It was during the Womens Liberation Movement, and despite the efforts of mainstream feminism's self-defined heterosexualists, that lesbianism became, quite simply, an issue, and sought to escape from the taxonomies of personal idiosyncrasy, scandal, gossip or cause for recantation within which lesbianism had previously *dis*functioned.

It is not surprising then, that lesbian history has emerged in academic scholarship only since 1970, after the moment when lesbians, seemingly for the first time in history, announced themselves as a self-recognized group – as a people who could, therefore, *have* a history. Given that the very idea of history relies on the acceptance of a categorical imperative, of an understanding of a sense of continuity through a formal arrangement of things or people – whether it be the concept of a nation (*the United States of America*), a culture (*the Japanese*), a religion (*Christianity*) or an ongoing production of related objects or forms (*abstract painting*) – there could be no history of lesbians if lesbians did not first declare themselves decisively as an entity, as a people who exist across time and space (and, relevant to the paradigm of lesbian identity, across nationalized and cultural boundaries), and as a people for whom a collective identity is accepted as apt despite the invariable differences that exist between any members of an acknowledged group. The personal and collective energies lesbians exerted on behalf of lesbianism during and within the 1970s women's liberation movement also helped produce an increase in the number of women willing and able to live as lesbians.[7]

At the same time, it would appear that the general cultural declaration made by lesbians in the United States during the 1970s is still not considered by many *to be enough* to warrant our inclusion in either history or popular consciousness. Or perhaps it was precisely because lesbianism was so loudly enunciated during the 1970s that subsequent historical accounts have sought and continue to seek to diminish it. I have this assertion on the erasure and minimalization of lesbians and lesbianism from historical accounts of the 1970s; in particular I am concerned here with the heterosexualization of the feminist art movement.

The feminist art movement that emerged in the United States during the 1970s has yet to be historicized or otherwise recognized with any degree of scholarship or other forms of cultural attention equivalent to the actual impact the movement has had on subsequent developments in American artistic practice. Rather than expand this argument, I would like to address a few instances of cultural attention that have been paid to the feminist art of the 1970s in order to situate the problem of lesbian erasure within the context of contemporary art history, as articulated through a few recent productions.

As of 1996, there have been only two museum exhibitions organized by the United States that distinctly featured (and named as such) works produced from the feminist art movement of the 1970s: 'Division of Labor: "Women's Work" in Contemporary Art' (1995), which was organized by the Bronx Museum of Art and traveled to the Museum of Contemporary Art, Los Angeles; and 'Sexual Politics: Judy Chicago's *Dinner Party* in Feminist Art History' (1996), organized by the Armand Hammer Museum at the University of California, Los Angeles. Both of these exhibitions refrained from demarcating the artistic energy of the 1970s as an art movement and included art from the 1980s and 1990s, a curatorial decision that minimizes the generative position of the seventies. Stretching the influence of feminism across three decades avoids announcing the first decade as the movement it was and therefore reduces feminist art to a mere tendency. At the same time, however, the exhibitions inadvertently acknowledged the formative position of the 1970s on subsequent visual products by the simple fact that the earliest dates on the exhibition checklists were of works from the late 1960s and the 1970s. The *Sexual Politics* exhibition charted a more complicated and hotly contested art historical trajectory by situating dozens of women artists from the 1970s, 1980s and 1990s around one late-1970s feminist centrepiece: Chicago's The Dinner Party (1972–79). The curatorial and physical centrality allotted Chicago forced more than a few 1970s feminists to refuse to participate in the exhibition.[8] Both 'Division of Labor' and 'Sexual Politics' overtly heterosexualized the feminist art movement of the 1970s through the omission and miscontextualization of art made by and about lesbians. The eclipse of lesbianism appears in each of the exhibition titles. 'Division of Labor' immediately suggests the heterosexualized division under which women are cast as men's domestic servants, housekeepers and wives – a connotation corroborated by a curatorial emphasis on art that interacts with the tradition of domestic crafts. By including 1980s and 1990s craft-inspired art by men, 'Division of Labor' struck a curatorial position propounding a male-female dialogue, while making no acknowledgement of either the dialogue or the argument between lesbian and nonlesbian women.

Harmony Hammond was the only lesbian included in 'Division of Labor'. Despite her public work promoting lesbian visibility as an artist, a writer and an educator,[9] Hammond's exhibited *Floorpieces* were discussed in the curator's exhibition essay exclusively in the context of Minimalism – specifically, as references to Carl Andre![10] Indeed, as long as historians and critics insist on examining every artwork in relationship to the art of (more) famous (white) male artists, the possibilities for understanding lesbian art – indeed *all* art – will continue to be greatly curtailed. For the 'Sexual Politics' exhibition, the heterosexualization of the title is itself a form of cultural colonization, as 'Sexual Politics' takes its title from Kate Millett's most famous book, a work that is itself an indictment of heterosexuality. Abetted by the general reclamation of the phrase *sexual politics* into a generally neutral ('it means something about gender, right?') rather than heterosexual-critical term, the exhibition disacknowledges both the lesbian authorship and lesbian implications of the eponymous book.

Indeed, both exhibitions relegate lesbianism and lesbians to marginal considerations. Although 'Sexual Politics' includes more lesbian artists (including Tee Corrine, Nicole Eisenman and Cheryl Gaulke), the works are left unelucidated within the exhibition's installation, stranded in the opaque confines of an idea of so-called difference. Perhaps most significantly, both exhibitions refuse to address the critique that 1970s lesbian feminism and its art practitioners posed to both patriarchy and heterosexualized women. The practice of offering just illustrations or description – that is, including usually marginalized artworks but dropping their context – appears to be one of the most popular devices to preclude the real implications of all identity politics. Thus, people

make a nod to lesbianism without acknowledging its persecution, use the word *gender* but forgo discussing sexism, or write the word *race* when the real issue is racism.

The only general art historical text on 1970s feminist art currently in print, *The Power of Feminist Art*, edited by Norma Broude and Mary D. Garrard, refers to lesbians *by name* on just eleven of its 318 pages." All of the direct, but nonetheless fleeting, references to lesbians are made by the four lesbians (including myself) included among the eighteen contributors, as well as by one of the book's editors. One of the book's seventeen essays could and should have been devoted to lesbianism, given that lesbianism as theory and practice was among the most divisive, explosive and radical issues debated among 1970s feminist activists and artists. The editors, as well as the lesbian and nonlesbian contributors, are aware of the central role lesbianism played in the social organizing of 1970s feminism (especially in California, which is the book's primary geographical focus), given that all of the contributors (excluding myself) participated in the feminist movement of the 1970s and therefore had direct experience with the troubled cycle of enunciation and repression that framed lesbian cultural manifestations during that period. But the different strategies of representation employed by visual artists are incapable of surfacing within historical accounts that refuse to investigate hegemony beyond the level of mention, that stay at the level of superficial nods to the complex histories held and suggested by words like *lesbian* (or *woman* or *black*). It appears that lesbianism, one of the most critical engagements of 1970s feminist art and activism, is still unthinkable, undiscussible and unpublishable twenty-five years later.

Of course, a central problem for critics, intellectuals and historians who have sustained engagements with cultural materials deemed irrelevant and not valuable by the dominant culture is that our efforts are not easily rewarded with the resources necessary to conduct our work. We are expected to do more work – find images and documents that do not appear in books and sift through archive material that has not been catalogued – but we are also expected to take for granted that we will receive less money to conduct our work. And frequently when we are given encouragement to do what we do best and are even willing to accept that the resources we have for our work amount to little more than the air we breathe and the time we number among the living, our efforts are still sabotaged. There will be no dramatic shift in the circumstances that constrict lesbian experience and lesbian culture until the political circumstances that normalize misogyny and other forces of exploitation are dramatically altered. One of the most insidious formulations manufactured by the corruption of identity politics is the woman or the African American or the Chicano or the lesbian invited to present a culturally marked body for the photo session, the academic panel, the cover of the college catalogue and other staged representations. Our images are used to mask the reality of our subordination. We know just how much we are being used when we attempt to speak and no one listens and when no one bothers to look at or speak of the work that we have produced.

1 Lesbian History Group, *Not a Passing Phase: Reclaiming Lesbians in History, 1840-1985* (London: Women's Press, 1993) 3.

2 Barbara Smith, ed., 'Introduction', *Home Girls: A Black Feminist Anthology* (New York: Kitchen Table Women of Color Press, 1982) 1. Although it is now dated by over a decade, it remains a spectacular example of lesbian erasure given how otherwise acclaimed *The Color Purple* was as both novel and film in the early 1980s.

3 Muriel Rekeyser, 'Foreword', *Berenice Abbott/Photographs* (New York: Smithsonian Institution/Tenth Avenue Editions, 1990) 11-13.

4 The exhibition is documented in the Musée d'art moderne de la Ville de Paris's catalogue *Claude Cahun Photographie* (Paris: Jean-Michel Place, 1995). See also François Leperlier, *Claude Cahun, l'écart et la métamorphose* (Paris: Jean-Michel Place, 1992).

5 Marilyn Frye, 'A Lesbian Perspective on Women's Studies', *Willful Virgin: Essays in Feminism* 1976-92 (Freedom, California: Crossing Press, 1992) 53.

6 See Marguerite Yourcenar, *Dear Departed: A Memoir*, trans. Maria Louise Ascher (New York: Farrar, Straus, Giroux, 1991); and Tabitha Soren, 'Ellen's New Twist on TV', *New York Daily News*, 24 November 1995, USA Weekend section 4-6.

7 Even just looking at the number of women who 'became' lesbians during/within and subsequent to the Women's Liberation Movement indicates that the dialogue on lesbianism that occurred within the movement had a direct effect on enabling women to identify themselves as lesbians. Although an oral history of the movement in the United States would supply considerable evidence, just a look at famous women offers an indicator. Consider, for instance, that Kate Millett, Robin Morgan and Adrienne Rich were married and considered themselves heterosexual before the advent of the movement.
In terms of the effect the Women's Liberation Movement has had on subsequent possibilities for self-identified lesbians in the United States, I suggest that the gains in relative economic status the movement garnered for women have made it possible for more members of the next generation to choose to live sexually and economically independent from men (especially, if not exclusively, those of us who are white, middle-class and college educated).

8 Some of the 1970s feminist artists who were approached by the curators and refused to participate in 'Sexual Politics' are Mary Beth Edelson, Harmony Hammond, Joyce Kozloff, Miriam Schapiro, Joan Snyder and Nancy Spero.

9 Hammond was on the editorial board for the 'Lesbian Art and Artists' issue of *Heresies: A Feminist Publication on Art and Politics*, 3 (1977). She was also the curator of 'A Lesbian Show' at 112 Greene Street Workshop in New York in 1978. For a discussion of a variety of contemporary lesbian art and artists, see Hammond's 'A Space of Infinite and Pleasurable Possibilities:

 Lesbian Self-Representation in Visual Art', in *New Feminist Criticism*, ed. Joanna Frueh et al. (New York: HarperCollins, 1994) 97-131.

10 See Lydia Yea, 'Division of Labor: "Women's Work" in Comtemporary Art', in the catalogue for the exhibition of the same name (New York: Bronx Museum of the Arts, 1995) 17.

11 Norma Broude and Mary D. Garrard, *The Power of Feminist Art* (New York: Harry N. Abrams, 1994).
Laura Cottingham, 'Notes on *Lesbian*', *College Art Journal* (Winter 1996) 72-77; reprinted in a revised form in Laura Cottingham, *Seeing Through the 1970s: Essays on Feminism and Art* (Amsterdam: The Gordon Breach Publishing Group, 2000) 175-187.

Nancy SPECTOR
The Mechanics of Fluids
[1996]

'*The sea is everything … Its breath is pure and healthy. It is an immense desert, where man is never lonely, for he feels life stirring on all sides. The sea is only the embodiment of a supernatural and wonderful existence. It is nothing but love and emotion.*'
– Jules Verne, *20,000 Leagues Under the Sea*, 1870

Hidden within the labyrinthine basement of Denmark's seaside Louisiana Museum, Pipilotti Rist's projected video installation *Sip My Ocean* (1996) mesmerized its viewers with scenes of maritime pleasure […] Bracketed by room after darkened room of other film and video installations – one more conceptual than the next – Rist's aquatic playland was accompanied by her own rendition of Chris Isaak's hit love ballad 'Wicked Game'.'

Taped almost entirely underwater, Rist's video offers a 'fish-eye' view of swaying seaweed gardens and coral kingdoms. Wafting sybaritically over the ocean beds, the camera records trajectories of household objects as they sink to the depths of the sea; kitsch coffee mugs with heart-shaped patterns, a bright yellow teapot, a plastic toy truck and an old LP settle into the sand. Schools of tropical fish whizz in and out of this ever-shifting marine vista, while a bikini-clad woman cavorts in the waves. In Denmark, the video was projected in duplicate as mirrored reflections on two adjoining walls, with the corner between them an immobile seam around which psychedelic configurations radiated and swirled. This kaleidoscopic imagery was choreographed to Rist's cover version of 'Wicked Game', which she alternately crooned and hysterically shrieked throughout the loop, leaving one to wonder if there might be trouble in Paradise:
'*The River was on fire and no one could save me but you
Strange what desire will make foolish people do
I never dreamed that I'd meet somebody like you
I never dreamed that I'd lose somebody like you
Oh, I don't want to fall in love with you.*'
Rist's video works are often double-edged in their delivery, being at once coquettish and rebellious. Her aesthetic

reference is not so much the real-time, task-oriented video of the 1970s (which is the case for many young video artists working today) as the slickly packaged porno-pop of MTV. In particular, her 1986 *I'm Not the Girl Who Misses Much* – a spectacle of frenzied rock-and-roll dancing glimpsed through technical disruptions – playfully satirizes the commodified eroticism of television's music videos, while exposing their sexist underpinnings. For her projection pieces, which tend to be environmental in scale and immersive in feeling, Rist manipulates the technology of video to emulate cinematic effects. These hybridizations of film and video emit a profusion of captivating audio and visual stimuli that invite corporeal, if not libidinal, identification. Far from being 'politically correct', these installations problematize feminism's interrogation of visual pleasure as it is manifest in the cinema.[2]

If Rist claims a feminist agenda for her work, which I believe to be the case, her theoretical sources lie in the lyrical writings of Hélène Cixous and Luce Irigaray, who each espouse pure female embodiment as the vehicle for psychological and sexual emancipation from the inequities inherent to heterosexual gender difference. Cixous' poetic call for women to inscribe their own history with 'milk' instead of ink, and Irigaray's directive for women to employ a science based on the 'mechanics of fluids' as a methodology for self-analysis, resonate in the leitmotif of aqueous imagery running throughout many of Rist's videos. Visions of water – and the metaphors of mutability and transformation they invoke – abound in the work: from the swimming pool shots in (*Entlastungen*) *Pipilottis Fehler* (*Absolutions: Pipilotti's Mistakes*) [1988], to the floating, interpenetrating bodies in *Pickelporno* (*Pimple Porno*) [1992], to the scenes of the deep blue sea in *Sip my Ocean*.

Rist's saturated, ever-mutating imagery imparts a polymorphous pleasure in the physical. The pervasive sensuality of *Sip my Ocean*, with its multiple screens and hallucinogenic mirroring effects, suggests the elusive state of *jouissance* – unadulterated, boundless, pre-Oedipal pleasure. Associated with the female, this metaphoric realm imagines a body with no boundaries, a body with multiple and autonomous erotic zones, a body in full possession of its own desire. However, Rist's erratic vocals – which range from sweetly lyrical to maniacal screaming – disrupt these utopian dreams of total gratification. For desire always demands an 'other', one who may or may not yield to the seduction, one who may or may not return the favour. As the soundtrack to this deliriously enchanting waterworld, Rist's version of Isaak's tune expresses the dangers (and pleasures) of desire; it also suggests a person trying to maintain control against the rising tides of passion. 'Sip my ocean' is Rist's invitation to participate in this game of desire and fulfillment; yet it is also a dare to survive its perilous undertow.

1 Warner Chappell Ltd., 1989.
2 In her study of women's performance work from the 1960s and 1970s, Amelia Jones examines the polemics of pleasure and desire in contemporary art. She situates feminism's call to disown representations of bodily

desire in Laura Mulvey's highly influential article, 'Visual Pleasure and Narrative Cinema' published 1975 and argues that feminism's refusal to perpetuate the codes associated with male visual pleasure effectively dismissed (and still dismisses) the significance of women's art involving corporeal performance. See her 'Postfeminism, Feminist Pleasures and Embodied Theories of Art', in *New Feminist Criticism*, *Art*, *Identity*, *Action*, ed. Joanna Freuh, Cassandra L. Langer and Arlene Raven (New York: HarperCollins, 1994) 16-41.
Nancy Spector, 'The Mechanics of Fluids', *Parkett* (December 1996) 83-85.

Sadie PLANT
zeros + ones: Digital Women + The New Technoculture
[1997]

TENSIONS

Just as individuated texts have become filaments of infinitely tangled webs, so the digital machines of the late twentieth century weave new networks from what were once isolated words, numbers, music, shapes, smells, tactile textures, architectures and countless channels as yet unnamed. Media become interactive and hyperactive, the multiplicitous components of an immersive zone which 'does not begin with writing; it is directly related to the weaving of elaborate figured silks'. The yarn is neither metaphorical nor literal, but quite simply material, a gathering of threads which twist and turn through the history of computing, technology, the sciences and arts. In and out of the punched holes of automated looms, up and down through the ages of spinning and weaving, back and forth through the fabrication of fabrics, shuttles and looms, cotton and silk, canvas and paper, brushes and pens, typewriters, carriages, telephone wires, synthetic fibres, electrical filaments, silicon strands, fibre-optic cables, pixeled screens, telecom lines, the World Wide Web, the Net and matrices to come [...]

In 1933, Sigmund Freud made his final attempt to solve the riddle of femininity: 'to those of you who are women', he wrote, 'this will not apply – you are yourselves the problem'. Having dealt with its wants and deficiencies and analysed its lapses and absences, he had only a few more points to make. 'It seems', he wrote, 'that women have made few contributions to the inventions and discoveries of the history of civilization.' They lacked both the capacity and the desire to change the world. They weren't logical, they couldn't think straight, they flitted around and couldn't concentrate.

Distracted by the rhythmic beat of a machine, Freud looked up to see his daughter at her loom. She had wandered off, she was miles away, lost in her daydreams and the shuttle's flight. But the sight of her gave him second thoughts. When he took up the thread, he had changed his mind: 'There is, however, one technique

which they may have invented – that of plaiting and weaving.

'If that is so, we should be tempted to guess the unconscious motive for the achievement', he writes. '*Nature herself would seem to have given the model which this achievement imitates by causing the growth at maturity of the pubic hair that conceals the genitals. The step that remained to be taken lay in making the threads adhere to one another, while on the body they stick into the skin and are only matted together.*'
Since she has only a hole where the male has his source of creativity, the folding and interlacing threads cannot be a question of thrusting male desire. Unless she was hiding something else, the processes which so engrossed her must, of course, be a matter of concealing the shameful 'deficiency' of the female sex [...]

If weaving was to count as an achievement, it was not even one of women's own. Their work is not original or creative: both the women and their cloths are simply copying the matted tangles of pubic hair. Should they have pretensions to authority, they would only be faking this as well. Women 'can, it seems, (only) imitate nature. Duplicate what nature offers and produces. In a kind of technical assistance and substitution.' Weaving is an automatic imitation of some bodily function already beyond the weaver's control. She is bound to weave a costume for the masquerade: she is an actress, a mimic, an impersonator, with no authenticity underneath it all. She has nothing to reveal, no soul to bare, not even a sex or a self to please. He pulls aside the veils, the webs of lies, the shrouds of mystery, and the layers of deception and duplicity, and finds no comfort, no there there. Only 'the horror of nothing to be seen'. Good of her to cover it up for him [...]

GENDERQUAKE
'*The idea that a "nothing to be seen" ... might yet have some reality, would indeed be intolerable to man.*'
– Luce Irigaray, *Speculum of the Other Woman*

In the 1990s, Western cultures were suddenly struck by an extraordinary sense of volatility in all matters sexual: differences, relations, identities, definitions, roles, attributes, means and ends. All the old expectations, stereotypes, senses of identity and security faced challenges which have left many women with unprecedented economic opportunities, technical skills, cultural powers and highly rated qualities, and many men in a world whose contexts range from alien to unfamiliar.

This was neither a revolutionary break nor an evolutionary reform but something running on far more subtle, wide-ranging and profound fault lines. Nothing takes the final credit – or the blame – for this shift which, as though in recognition of the extent to which it defies existing notions of cultural change, has been defined as genderquake. But the new machines, media and means of telecommunication that compose what are variously called high, information, digital or simply new technologies which have emerged within the last two decades have played an enormous and fascinating role in the emergence of this new culture. This is far from a

question of technological or any other determinism. If anything, technologies are only ever intended to maintain or improve the status quo, and certainly not to revolutionize the cultures into which they are introduced. It is in spite of their tendencies to reduce, objectify and regulate everything that moves that computers and the networks they compose run on lines quite alien to those which once kept women in the home.

In some respects, the impact of these new machines is direct and very obvious. In the West, the decline of heavy industry, the automation of manufacturing, the emergence of the service sector, and the rise of a vast range of new manufacturing and information-processing industries have combined to reduce the importance of the muscular strength and hormonal energies which were once given such high economic rewards. In their place come demands for speed, intelligence and transferable, interpersonal and communications skills. At the same time, all the structures, ladders and securities with which careers and particular jobs once came equipped have been subsumed by patterns of part-time and discontinuous work which privilege independence, flexibility and adaptability. These tendencies have affected skilled, unskilled and professional workers alike. And, since the bulk of the old full-time, lifelong workforce was until recently male, it is men who have found themselves most disturbed and disrupted by these shifts, and, by the same token, women whom they benefit [...]

Having had little option but to continually explore new avenues, take risks, change jobs, learn new skills, work independently and drop in and out of the labour market more frequently than their male colleagues, women seem far 'better prepared, culturally and psychologically' for the new economic conditions which have emerged at the end of the twentieth century. They are advanced players of an economic game for which self-employment, part-time, discontinuous work, multiskilling, flexibility and maximal adaptability were suddenly crucial to survival. Women had been ahead of the race for all their working lives, poised to meet these changes long before they arrived, as though they always had been working in a future which their male counterparts had only just begun to glimpse. Perhaps they really were the second sex, if seconds come after firsts.

'*"Let the man get some sleep, Armitage", Molly said from her futon, the components of the Fletcher spread on the silk like some expensive puzzle. "He's coming apart at the seams."*'
– William Gibson, *Neuromancer*

But there was much more to come. Abandoned by the economic power and social privilege which once made them such attractive, even necessary, mates, the sperm counts fell, birth rates crashed, and the hormonal energy and muscular strength which once served them so well were now becoming liabilities. Women were becoming mothers on their own terms, or not at all. Heterosexual relations were losing their viability, queer connections were flourishing, the carnival had begun for a cast range

of paraphilias and so-called perversions, and if there was more than one sex to have, there were also more than two to be. Anything claiming to be normal had become peculiar.

'*He was thoroughly lost now; spatial disorientation held a peculiar horror for cowboys.*'
– William Gibson, *Neuromancer*

It was falling apart. They were coming undone. Everything was moving much too fast. What had once seemed destined to become a smoothly regulated world was suddenly running away with itself. Control was slipping through the fingers of those who had thought it was in their hands. Something was wrong. They were losing it all: their sense of security and identity, their grip, the plot, and even their jobs. Couldn't see the point to anything. What else could the masters of the old white world do but redouble their efforts, intensify their drives for security, heighten and perfect their powers? But the more they struggled to adapt and survive, the faster the climate seemed to change. The more they tried to regain control, the more their narrative lost its thread; the closer they came to living the dream, the weaker their grasp on power became. Was it even possible that, regardless of their labours, their hopes and dreams, they had been 'the sex organs of the machine world, as the bee of the plant world, enabling it to fecundate and to evolve ever new forms?' All that time, the effort and the pain, the trouble they had taken to maintain control.

'*And instead they watch the machines multiply that push them little by little beyond the limits of their nature. And they are sent back to their mountain tops, while the machines progressively populate the earth. Soon engendering man as their epiphenomenon.*'
– Luce Irigaray, *Marine Lover*

Sadie Plant, *zeros + ones: Digital Women + The New Technoculture* (London: Fourth Estate, 1997).

Shirin NESHAT
Eastern Values: Interview with Lina Bertucci [1997]

Lina Bertucci Your work deals with very large and complex issues of Islam, women under the veil, fundamentalism and revolutionary fervour. Tell me about your recent video installation *The Shadow Under the Web*, shot in Istanbul, and the meaning of the four images projected on each wall simultaneously.
Shirin Neshat I had been working on the subject of the female body in relation to politics in Islam and the way in which a woman's body has been a type of battleground for various kinds of rhetoric and political ideology. Recently, through some reading, I became very interested in how space and spatial boundaries are also politicized and are designed to lift personal and individual desire from the public domain and contain it within private spaces.

Ultimately, men dominate public space and women exist for the most part in private spaces, and as a woman crosses a public space she conforms by wearing a veil, hiding her body to remove all signs of sexuality and individuality from the public space. So I started to pursue some of these issues through the video.
Bertucci We see the figure of the veiled woman running in slow motion throughout these spaces. What does she signify?
Neshat The presence of a woman's figure, enveloped in a black chador, running against the stoic architecture of a mosque, the dense bazaar, the lonely alleyways and abandoned ruins of a wall, speak about the peculiar relation between a Muslim woman and the spaces that she inhabits which are so heavily coded. Each segment shows how she affects the quality of the space as she moves through it, and how the space affects her. There is a certain amount of anxiety as she moves through the spaces; it is never very clear where she is running to, or from. To me the built architecture represents the authority and the principles of a traditional society and she represents human nature with all its fragility [...]

From the beginning I made a decision that [my photographic] work was not going to be about me or my opinions on the subject, and that my position was going to be no position. I then put myself at a place of only asking questions but never answering them. The main question and curiosity was simply being a woman in Islam. I then decided to put the trust in those women's words who have lived and experienced the life of a woman behind a veil. So each time I inscribed a specific women's writings on my photographs, the work took a new direction. For example, in the first series that I did called *Unveiling*, the poems were by Forough Farokhzad, a woman who felt desperately trapped in the Iranian culture, resented the male dominated structure of the society and the writing became an outlet for these emotions and anxieties.

Her poems were radical at the time, as no other woman had ever dared to speak so freely on subjects of the body, carnal pleasure, love, death, etc.

On the other hand, I have taken the opposite direction and inscribed writings by those women with a strong conviction for Islam and the revolution. Their writing expresses little about their personal desires or conditions and concentrates on the collective, public interests.

Generally, this type of attitude portrays women who feel liberated by the Islamic revolution. According to them, it is only within the context of Islam that a woman is truly equal to a man and they claim that a veil, by concealing a woman's sexuality, prevents her from becoming an object of desire. Also, wearing a veil becomes a political statement, an expression of a woman's solidarity with men, and a rejection of Western values. Tahereh Saffarzadeh is such a poet and I have used her poems, particularly in the *Women of Allah* series [...]

Lina Bertucci, 'Shirin Neshat: Eastern Values', *Flash Art* (November-December 1997) 84-86.

Bill ARNING

Elaine Reichek's Rewoven Histories [1999]

It is perhaps best to approach Elaine Reichek's work as an innovative, revisionist curatorial project, in which familiar histories are retold and translated into new mediums. In the process the emphasis naturally shifts, and previously unquestioned hierarchies are upended. The tale she weaves is familiar but strange in its new form and, as stories go, it's a doozy. Reichek retells much of the history of our material culture, including both high art and domestic crafts. She does not aggressively attack the gendered prioritizing of the male-coded history of high art over the female-associated craft as an evil that we in an era of enlightened sensibilities must depose. Rather, she unemphatically recounts history without that ubiquitous hierarchy, and lets us see what is to be gained by considering her alternative version.

Her medium of choice is the sampler, the form of needlework in which young women once gained expertise to prove their worthiness as wives. It is remarkable that this quaint form, whose charm and irresistably persuasive beauty Reichek employs to her own ends, connects with our standard textbook art history at multiple intersections. The medium-specific qualities of needlework prefigure numerous high points and milestones of the march towards and through modernity. In fact, with thrilling boldness, Reichek makes the case that aspects of the diverse visual strategies of Barbara Kruger, Jenny Holzer, Chuck Close, Jasper Johns, Andy Warhol and even a megaphenomenon like the World Wide Web can be traced to these delicate stitches. Her far-reaching project considers the metaphorical deployments of embroidery, weaving, crocheting, petit point and knitting in literature, with quotations from Ovid, Dickens, Melville and Hawthorne, as well as the movies, with snippets from popular and art films.

These assertions are not as far-fetched as they at first seem. The epigrammatic language employed by Holzer and Kruger derives in part, via a hybridizing tangent through advertising, from the sweet, sentimental sayings embroidered on to pillows, such as Reichek's title for her own 1996–99 series, *When This You See ...* (the viewer is left to fill in the omitted words, 'remember me'). If we recall Holzer's and Kruger's language as being always too forceful to sit comfortably within a sampler, that memory is false. In *Sampler (Kruger/Holzer)* (1998), Reichek has sandwiched their iconic phrases of the 1980s – 'Abuse of power comes as no surprise', 'I shop therefore I am' – between standard sampler alphabets and less enigmatic, traditional phrases such as 'Do as you would be done by' and 'A fool and his money are soon parted'.

Likewise Reichek conjures, through embroidered miniatures of their signature works, Close's and Warhol's amalgam of reproductive mediums and traditional painting. We are urged to re-examine Close's grid and Warhol's repetitions through her craft-based lens, goaded to see that it was the process of making images with accumulated Xs of thread that sowed the seed for modern modes of reproduction. We can understand each repeated stitched mark as a low-tech pixel, a handmade benday dot or a physical counterpart to the grain of a photographic emulsion.

For her Warhol appropriation, *Sampler (Andy Warhol)* (1997), Reichek uses his somewhat obscure 1983 painting of tangled yarn as her source, and the games of 'looks like' and 'functions as' become amusingly complex. Warhol, as has been widely noted, wanted to be taken as a serious artist, which meant for him – an artist just a few years younger than the Abstract Expressionist gods – that he had to make abstractions. He could not, however, allow himself the degree of simple belief required to make an unsourced image. For paintings such as *Yarn* and the shadow and easter egg paintings, Warhol found or made photographic images that mimicked or could pass for AbEx statements while retaining a necessary literalness. As a reference to classic Jackson Pollock drip paintings, *Yarn* is a deliciously fickle image, evincing both profound belief and healthy agnosticism towards the fundamental precepts of abstraction.

When Reichek seized upon Warhol's *Yarn* and embroidered the image at a much reduced scale, she doubled his indirect appropriation of Pollock. We understand her rejoinder, her contribution to the Pollock/Warhol dialogue, as questioning the value of Warhol's transformation of a photograph of yarn back into the realm of painting, for the tangled yarn is already clearly Pollockian. Warhol's choice of yarn, all fuzzy feminine domesticity, was clearly a queering of Pollock. Reichek's embroidery translation regenders both butch Pollock and femme Warhol, her needle piercing the deified personas of these two art-gods with the same stitch [...]

Bill Arning, 'Elaine Reichek's Rewoven Histories', *Art in America*, 3 (March 1999) 90-95.

Coco FUSCO

Better Yet When Dead [2000]

Better Yet When Dead (1997) was my first foray into the territory of women and necrophilia in Latin cultures. I was drawn to this subject by several factors. Despite, or better put, coupled with hosting cultures with an exceptional array of cults to virgins and female saints, Latin America is still a terrain where women do not exercise control over their bodies, whether it be a matter of abortions being illegal, of husbands and brothers having the right to punish 'their' women for adultery, of not having recourse in the case of rape or sexual harassment, of child custody being automatically given to fathers, etc. Latin women gain power over the collective cultural investment in their bodies when they die spectacular deaths, particularly if they die young. I sought to perform this ultimate expression of female will by feigning death – as other women. After more than two years of exhibiting myself in a cage, I was looking for other visual metaphors for containment that might allow me to activate the psychodynamics of cross-cultural attraction. Having been raised as a Catholic, I knew first hand about the drama of open casket funerals, round the clock wakes and cycles of recited prayers that went on for days and days. I knew that physical contact with the dead triggered something very powerful in people's minds. I could vividly recall the combination of terror and fascination that I felt as a child when I would be led up to the body of someone whom I had known, but was suddenly too afraid to touch, as if death were an illness I might contract. I also was quite taken by the American cultural response to several Latin women artists who had died – violently and somewhat spectacularly. Frida Kahlo is perhaps the prototype for this dynamic. First, she almost literally died on canvas throughout her career. Then, that aestheticized and protracted struggle with her own mortality came to stand for Latin America as a beautiful victim. I was also thinking of Evita Perón, the Argentine actress turned politician, the wife of Juan Perón, whose body was embalmed by order of her husband, and then hidden by the Argentine military for forty years, for fear of its charismatic power. The other artist I had in mind was Ana Mendieta, whose brilliant but brief career as an artist was cut short by an early death, and whose death has become central to the interpretation of her artwork, and to her usefulness to American feminist artists in search of a modern day Frida Kahlo. Finally, I was also thinking about Selena, the Tex-Mex singer whose popularity exploded beyond the boundaries of the border regions after she was shot by a disturbed woman who worked for her and was apparently in love with her. I performed this piece twice, once in Canada at YYZ artspace in Toronto, and then again at the International Arts Festival of Medellin. I would be on view for several hours a day over a period of three to four days. I learned how to slow my breathing down to the point that it was barely perceptible, to control muscular twitches and to withstand having limbs fall asleep. As a result I heard the internal workings of my body in operation for the first time in years. The contrast between the reactions in these very different cultural contexts was quite pronounced. The Canadian response was on the whole much quieter, much gentler. Very few people touched me or spoke to me as I lay in my coffin, framed by white satin and roses. Some ran out coughing after having inhaled the smoke created by copal that was burning in corners of the room. The Colombians on the whole were much more physical and playful in their responses. People spoke to me constantly; mostly issuing complements about my body or about how quiet I was. One woman came back each day and read me a poem about death. Others left me notes, poured wine onto my lips, kissed and dropped flowers into my hands.

Coco Fusco, 'Better Yet When Dead', 2000, previously unpublished.

16. Frida Kahlo

ARTISTS' BIOGRAPHIES

Magdalena ABAKANOWICZ [b. 1930, Falenty, Poland] lives in Warsaw. A pioneer of fibre art, in the late 1960s she developed the monumental textile sculptures named *Abakans*. From the mid 1970s medical and anthropological studies led to clay cast and textile forms based on fragmented human figures, such as *Backs* (1981). She was included in three Venice Biennales (1968; 1980; 1995).

Marina ABRAMOVIC [b. 1946, Belgrade] lives in Paris and Amsterdam. She began using her body in performance in 1972, exploring pain and physical resistance. From 1976-88 she collaborated with East German artist Uwe Laysiepen (Ulay) making works which tested bodily relationships. She was included in Documenta 6, Kassel (1977). Solo shows include 'Spirit House', Sean Kelly Gallery, New York (1998).

Eija-Liisa AHTILA [b. 1959, Hämeenlinna, Finland] lives in Helsinki. Her film and video works hover between reportage, soap opera and fantasy genres, performed by actors in Finnish with English subtitles and shown in various formats, from installation to screenings, to broadcasts. She was included in the XLVIII Venice Biennale (1999). Solo shows include Museum Fridericianum, Kassel, Germany (1998).

Chantal AKERMAN [b.1950, Brussels] lives in Paris. An independent filmmaker, from 1971 onwards Akerman developed structural film into her unique cinematic form, often described as 'hyperrealist', which traces the complexities of relationships through observation of everyday actions from a non-privileged viewpoint. A retrospective show of her work was held at the Walker Art Center, Minneapolis, in 1995.

Laurie ANDERSON [b. 1947, Chicago] lives in New York. Her solo musical performances using electronically adapted instruments developed by the end of the 1970s into spectacular multimedia events which explored issues of the gendered and classed subject in technological, urban culture. Her writings and performance documentation, *Stories from the Nerve Bible*, were published in 1994.

Eleanor ANTIN [b. 1935, New York] lives in California. In her photographically documented actions she often presents self-portraits as symbols for explorations of the self and of notions of female identity. She was included in the São Paulo Biennale (1975). A major retrospective was held at the Los Angeles County Museum of Art (1999).

Janine ANTONI [b. 1964, Freeport, Bahamas] lives in New York. Antoni uses her own corporeality in relation to traditional media in order to intervene in and disrupt male-centred art historical forms. She was included in the XLV Venice Biennale (1993). Solo shows include 'Slumber', Anthony d'Offay Gallery, London (1994) and 'Swoon', Whitney Museum of American Art, New York (1998).

Ida APPLEBROOG [b.1929, New York] lives in New York. A painter and book artist, Applebroog questions received notions of the feminine, addressing issues such as male aggression towards women. Her imagery refers both to popular culture and Modernism. She was included in the Whitney Biennial, Whitney Museum of American Art, New York (1993). Solo shows include the Irish Museum of Modern Art, Dublin (1993).

Alice AYCOCK [b. 1946, Harrisburg, Pennsylvania] lives in New York. She is best known for her large scale, semi-architectural projects which address the interaction between structure, site, materials and viewers' responses. She was included in Documentas 6 and 8, Kassel (1977; 1987) and three Venice Biennales (1978; 1980; 1982). A retrospective of her work, 'Complex Visions', was presented at Storm King Art Center, Mountainville, New York (1990).

Alex BAG [b. 1969, New York] lives in New York. A video artist, she acts out personae who comment on struggles towards self-definition and the superficiality of pop culture. She was included in 'Young and Restless', The Museum of Modern Art, New York (1997). Solo shows include Le Magasin, Grenoble (1996).

Judy BAMBER [b. 1961, Detroit] lives in New York. Her work in photography and mixed media explores the feminist political dimensions of seduction and abjection. She was included in 'Sexual Politics: Judy Chicago's *Dinner Party* in Feminist Art', UCLA/Armand Hammer Museum of Art, Los Angeles (1996). Solo shows include Richard Telles Fine Art, Los Angeles (1992; 1994; 1996).

Judith BARRY [b. 1954, Columbus, Ohio] lives in New York. A video and new media installation artist, and a writer on art and technology, she has focused, from a feminist perspective, on the political power structures underlying technologies of representation. She was included in the Whitney Biennial, Whitney Museum of American Art (1987) and 'On taking a normal situation … , Museum van Hedendaagse Kunst, Antwerp (1993). Solo shows include 'Public Fantasy', Institute of Contemporary Arts, London (1991).

Ute Meta BAUER is Director of the Institute for Contemporary Art at the Academy of Fine Arts, Vienna. As a curator she addresses political aspects of documentation, highlighting exclusion. In 1996 Bauer co-curated, with Fareed Armaly, a section of the exhibition 'NowHere', Louisiana Museum, Humlebaek, Denmark.

Vanessa BEECROFT [b. 1969, Genoa] lives in New York. Beecroft explores stereotypes in biographical works and in performances, videos and photographs with participants. She was included in 'Aperto Italia '95', Trevi Flash Art Museum, Trevi (1995). Solo shows include Galerie Analix B & L Polla, Geneva (1995; 1996).

Lynda BENGLIS [b. 1941, Lake Charles, Louisiana] lives in New York. Her 'formless' sculptural works, photographs and video works explore gendered power relationships. She was included in 'Contemporary Women: Consciousness and Content', Brooklyn Museum, New York (1977). Solo shows include Cheim & Read Gallery, New York (1998).

Sadie BENNING [b. 1973, Madison, Wisconsin] lives in New York. Her video works subvert the predominantly heterosexual codes and critical framework of avant-garde film. She was included in the Whitney Biennial, Whitney Museum of American Art, New York (1993; 2000).

Dara BIRNBAUM [b. 1946, New York] lives in New York. Her video works recontextualize imagery derived from media sources to underline its ideological effects. She was included in Documentas 7 and IX, Kassel, Germany (1982; 1992). Retrospectives include Kunsthalle, Vienna (1994).

Lee BONTECOU [b. 1931, Providence, Rhode Island] lives in East Hampton, New York First shown in the early 1960s, her reliefs used worn-out conveyor belts, aeroplane parts and saws in compositions which dispelled equations of the feminine with softness and passivity. She was included in 'The Art of Assemblage', The Museum of Modern Art, New York (1961). Retrospectives include the Museum of Contemporary Art, Chicago (1972).

Pauline BOTY [1938-1966] was the only woman painter associated with the British Pop art movement in the 1960s. Her approach to imagery from popular culture is significant for introducing a female perspective into the Pop lexicon. She was included in 'New Art 62', Festival of Labour, London (1962) and the BBC film *Pop Goes the Easel* (1962).

Louise BOURGEOIS [b. 1911, Paris] lives in New York. She is one of the twentieth century's most acclaimed sculptors, whose work existentially addresses corporeal existence. Retrospectives include The Museum of Modern Art, New York (1982), and touring, and The Frankfurter Kunstverein, Frankfurt am Main (1989), and touring.

Sonia BOYCE [b. 1962, London] lives in London. Her media include drawing, sculpture, photography and installation. Her work explores desire and identity. She was included in 'Five Black Women', Africa Centre, London (1983), and the Havana Biennale, Cuba (1989). Solo shows include Whitechapel Art Gallery, London (1988).

Geneviève CADIEUX lives in Montreal. Her work in both photography and video installation develops theories of film and visual representation into complex investigations of psychological and corporeal states. Retrospectives include the Montreal Museum of Fine Arts (2000).

Sophie CALLE [b.1953, Paris] lives in Paris. A photographer and installation

artist, she documents life situations that evidence desire and loss. She was included in the Whitney Biennial, Whitney Museum of American Art, New York (1993). Solo shows include the Museum Boijmans Van Beuningen, Rotterdam (1994).

Helen **CHADWICK** [1953-1996] was a British sculptor, photographer and installation artist whose works investigate female identity in art history and contemporary culture. Important solo shows include 'Of Mutability', Institute of Contemporary Arts, London (1986) and the Museum of Modern Art, Tel Aviv (1997).

Sarah **CHARLESWORTH** [b.1947, East Orange, New Jersey] lives in New York. Her photographic work addresses photography's role in signifying identities and desires. She was included in 'The Art of Memory', New Museum of Contemporary Art, New York (1985). Solo shows include Tyler Gallery, Temple University, Philadelphia (1988).

Judy **CHICAGO** [b. 1939, Chicago] lives in New Mexico. A key figure in US feminist art, she is renowned for her collaborative sculpture *The Dinner Party* (1974-79). She was included in 'Sexual Politics: Judy Chicago's *Dinner Party* in Feminist Art History', UCLA/Armand Hammer Museum of Art, Los Angeles (1996). Solo shows include 'Trials and Tributes', Florida State University Museum of Fine Arts, Tallahassee (1999).

Abigail **CHILD** lives in New York. A film and video maker and writer, she employs film techniques to reconfigure narrative and representational codes of gender and identity. She was included in the Whitney Biennial (1989; 1997) Whitney Museum of American Art, New York.

Lygia **CLARK** [1920-1988] lived in Rio de Janeiro. From the late 1960s her work was centred on phenomenological perceptions of space, time and relationship, informed by her practice as a psychotherapist. Retrospectives include the São Paulo Biennale (1994) and Fundació Antoni Tàpies, Barcelona (1997).

Betsy **DAMON** lives in St. Paul, Minnesota. An eco-feminist interdisciplinary artist, she performed works such as *7,000 Year-old Woman* in US and European cities between 1976-82. After 1990 water became the focus of her work. Her large scale environmental projects include a six-acre Living Water Garden in Chengdu, China.

Linda **DEMENT** [b. 1959, Australia] lives in Sydney. Working with virtual reality technology she has produced CD-ROM works that explore possibilities of inserting visceral bodily traces into the disembodied arena of virtual simulations.

Marlene **DUMAS** [b. 1953, Cape Town] lives in Amsterdam. Her figurative drawings and paintings are executed in an expressionist style which combines a conceptual approach with sensuous qualities conveying an ambiguous eroticism. She was included in Documentas 7 and IX, Kassel, Germany (1982; 1992). Solo shows include a retrospective at the Museum van Hedendaagse Kunst, Antwerp (1999).

Jeanne **DUNNING** lives in Chicago. Her photographic, sculptural and video work explores our relationship to our own physicality through unfamiliar images. She was included in 'Feminin-Masculin', Centre Georges Pompidou, Paris (1995). Solo shows include the Hirshhorn Museum and Sculpture Garden, Washington, D.C. (1994).

Cheryl **DUNYE** lives in Philadelphia. A video and filmmaker and curator, Dunye often assumes the performer's as well as director's role to address, with ironic humour, the complexities and dilemmas of African-American lesbian identity in films such as *The Watermelon Woman* (1997). She was included in 'NowHere', Louisiana Museum, Humlebaek, Denmark (1996).

Mary Beth **EDELSON** lives in New York. In performances and photographs of the 1970s she evoked ancient goddess mythology as a means of empowerment. In the 1990s she has investigated social aggression. She was included in 'International Feministische Kunst', Stichting de Appel, Amsterdam (1979). Solo shows include Nicole Klagsbrun Gallery, New York (1993).

Nicole **EISENMAN** [b.1963, Verdun, France] lives in New York. Her murals, paintings and installations playfully critique patriarchal culture from a lesbian perspective. She was included in 'From the Corner of the Eye', Stedelijk Museum, Amsterdam (1998). Solo shows include Rice University Art Gallery, Houston, Texas (1998).

Diamela **ELTIT** lives in Santiago, Chile. Primarily a poet, she collaborated with Raúl Zurita during the dictatorship in a group called Colectivo de Acciones de Arte, making protest actions. Self-inflicted wounds symbolize the communal body of suffering, connecting her female body with the socially outcast.

Catherine **ELWES** [b. 1952, St. Maixent, France] lives in London. In the late 1970s she made performances, moving to video from 1981 onwards. She was co-organizer of 'Women's Images of Men' and 'About Time', Institute of Contemporary Arts, London (1980). She has written extensively on time-based and women's art for catalogues and journals, and contributed to the books *Women's Images of Men* (1985) and *Diverse Practices: A Critical Reader on British Video Art* (1996).

Tracey **EMIN** [b. 1963, London] lives in London. Her work centres on communication of personal experiences through actions and installations. She was included in 'Life's a Bitch', Stichting De Appel, Amsterdam (1998). Solo shows include 'I Need Art Like I Need God', South London Gallery, London (1997).

Valie **EXPORT** [b. 1940, Linz] lives in Vienna and Cologne. She is a Professor at the Kunsthochschule für Medien, Cologne. Her 1960s street actions and later video works have investigated the body as a bearer of meaning and communication. She was included in Documenta 6, Kassel, Germany (1977). Solo shows include 'Psycho-Prognose', Neuer Aachener Kunstverein, Aachen, Germany (1998).

Karen **FINLEY** [b. 1956, Chicago] lives in New York. Her performances address dilemmas such as domestic abuse, rape, social intolerance and AIDS. She was included in 'Uncommon Sense', Museum of Contemporary Art, Los Angeles (1997). Key performances include *The Constant State of Desire*, The Kitchen, New York (1986).

Rose **FINN-KELCEY** lives in London. Her work encompasses sculpture, installation, performance, film and video, and has addressed themes ranging from militarism to ephemerality. She was included in Documenta IX, Kassel, Germany (1992). Solo shows include 'Bureau de Change', Matt's Gallery, London (1988).

Andrea **FRASER** [b. 1965, Billings, Montana] lives in New York. Working mainly with performance, she makes interventions into art institutions, uncovering the signs and systems used to legitimate the values and desires that operate within them. Solo shows include The Philadelphia Museum of Art, Philadelphia (1989).

Coco **FUSCO** [b. 1960, New York] lives in Los Angeles. An interdisciplinary artist and writer, she has made performance projects, lectured and curated events internationally, examining cultural relations between North and South America. She is the author of *English Is Broken Here: Notes on Cultural Fusion in the Americas* (1994).

Anya **GALLACCIO** [b. 1963, Paisley, Scotland] lives in London. An installation artist, she uses ephemeral materials to explore transience in relation to specific sites. She was included in 'Freeze', Surrey Docks (1988). Solo shows include Delfina Studios, London (1998).

Rose **GARRARD** [b. 1946, Bewdley, England] lives in Malvern. Her installations and performances make a feminist critique of western art history. A retrospective, 'Archiving My Own History', was presented at Cornerhouse, Manchester (1994), and touring.

Nan **GOLDIN** [b. 1953, Washington] lives in New York. Since the early 1970s, Goldin has created a photographic diary of the lives and experiences of herself and her intimate friends from the alternative scenes of New York, Paris, Berlin and other cities. A retrospective, 'I'll Be Your Mirror', was presented at the Whitney Museum of American Art, New York (1996).

Ilona **GRANET** [b. 1948, Brooklyn, New York] lives in New York. Since the early 1970s, she has made performances, installations, mixed media, graphic and book works which engage with issues such as violence against women, using unconventional wit to convey their messages. She was included in the 'Manifesto Show', New York (1980) and 'The Revolutionary Power of Women's Laughter', Max Protetch Gallery, New York (1983).

Renée **GREEN** [b. 1959, Cleveland, Ohio] lives in New York. Working primarily in installation, she addresses intersections of black and white representations of

diasporan cultural identity. She was included in 'Mirage: Enigmas of Race, Difference and Desire, Institute of Contemporary Arts, London (1995). Solo shows include 'World Tour', The Museum of Contemporary Art, Los Angeles (1993).

GUERRILLA GIRLS [New York] were most active from the mid 1980s to the mid 1990s, using graphics campaigns to reveal deep-seated patriarchal prejudice in public and private art institutions. In public, members wore gorilla masks to maintain anonymity, assuming the names of female artist predecessors such as Lee Krasner. Campaigns of the 1990s have addressed wider issues of social injustice.

Lucy **GUNNING** [b. 1964, Newcastle upon Tyne] lives in London. In video works Gunning orchestrates her subjects, mostly women, to perform activities in exaggerated circumstances, exploring the compulsive nature of everyday actions. She was included in 'Behind Closed Doors: Video in Interior Spaces', Museum of Contemporary Art, Chicago (1996). Solo shows include City Racing, London (1996).

Ann **HAMILTON** [b.1956, Lima, Ohio] lives in Columbus, Ohio. In her site-specific installation works Hamilton highlights intangible traces of existence in time and place, exploring political, democratic and poetic dimensions of physical spaces and materials. Solo shows include 'The Body and the Object: Ann Hamilton 1984-1996', Wexner Center for the Arts, Columbus, Ohio (1996) and the XLVIII Venice Biennale (1999).

Barbara **HAMMER** [b. 1939, Hollywood, California]. An experimental filmmaker engaged with feminist and lesbian issues, she is internationally known for influential works such as her documentary trilogy on lesbian and gay histories, *Nitrate Kisses* (1992), *Tender Fictions* (1995) and *History Lessons* (2000).

Harmony **HAMMOND** [b. 1944, Chicago] lives in Galisto, New Mexico. An artist, critic and curator, she co-founded AIR, New York's first women-only gallery, and organized one of the first lesbian group exhibitions (112 Green Street, New York, 1978). She was co-founder of the journal *Heresies* (1976). She was included in 'Soft as Art', New York Cultural Center, New York (1973). Solo shows include Center for Contemporary Art, Santa Fe, New Mexico

(1992). She is the author of *Lesbian Art in America: A Contemporary History* (2000).

Margaret **HARRISON** [b. 1940, Wakefield, Yorkshire] lives in Manchester and San Francisco. She is Visiting Professor at the University of California at Davis. Working in painting, drawing and mixed media installation, she is a key artist and activist of the British feminist movement. She was included in the first Women's Liberation Exhibition, Woodstock Gallery, London (1971) and 'Lives', Hayward Gallery, London (1977). Solo shows include the New Museum of Contemporary Art, New York (1989) and Intersection for the Arts, San Francisco (2001).

Mona **HATOUM** [b. 1952, Beirut, Lebanon] lives in London. Her work in performance, video, installation and sculpture addresses issues of culture and identity. She was included in 'Foreign Body', Museum für Gegenwartskunst, Basel (1996). Solo shows include the New Museum of Contemporary Art, New York (1998).

Lynn **HERSHMAN** now Hershman Leeson, lives in San Francisco. Her media include photography, film, video and computer-based installations. In 1979 she pioneered the first artist's CD-ROM. She was the first woman to receive a retrospective at the San Francisco International Film Festival (1995).

Eva **HESSE** [1936-1970] lived in New York. Her sculptures evidenced their handmade origin and relation to the body, implicitly questioning the male-dominated Minimalist idiom of grids, industrial materials and serial repetition. She was included in 'Eccentric Abstraction', Fischbach Gallery, New York (1966). Retrospectives include the Solomon R. Guggenheim Museum, New York (1972).

Susan **HILLER** [b. 1940, Tallahassee, Florida] lives in London. An artist, writer and curator, she has worked in media including painting, sculpture, video, photography, installation and artist's books. She investigates cultural phenomena and their undercurrents in projects that are often participatory. Retrospectives include the Serpentine Gallery, London (1976) and Tate Gallery, Liverpool (1996).

Lubaina **HIMID** [b. 1954, Zanzibar, Tanzania] lives in Preston, Lancashire. In her

paintings, collages and assemblages she excavates traces of black women's histories hidden beneath the official histories of colonialism. She was included in 'Five Black Women', Africa Centre, London (1983) and 'The Other Story', Hayward Gallery, London (1989). Solo shows include Tate Gallery, St Ives (2000).

Christine and Irene **HOHENBÜCHLER** [b. 1964, Vienna] live in Vienna. Twins, they have exhibited together since 1988, collaborating with institutionalized groups such as psychiatric patients and prisoners. They provide frameworks for collaborators rather than acting as therapists, using 'feminine' media such as weaving. They were included in 'NowHere', Louisiana Museum, Humlebaek, Denmark (1996). Solo shows include De Vleeshal, Middelburg, The Netherlands (1994).

Jenny **HOLZER** [b. 1950, Gallipolis, Ohio] lives in Hoosick, New York. Her work is language-based, subtly inverting the messages of mass culture. Since 1977 she has distributed messages via media ranging from printed ephemera to electronic sign boards. Retrospectives include the Solomon R. Guggenheim Museum, New York (1989).

Rebecca **HORN** [b. 1944, Michelstadt, Germany] has lived in Berlin, Hamburg and New York. Her early works used the body as a vehicle for sculptural extensions presented in ritualized performances documented on film. Later she developed large scale installation works. She was included in Documenta 8 (1987). Solo shows include the Solomon R. Guggenheim Museum, New York (1993).

Kay **HUNT** [b. 1933, London] now Kay Fido Hunt, lives in London. Since the late 1960s she has made documentary work which reflects personal experience and community history. Since 1975 she has researched women's labour history for anti-war projects. She was included in the John Moores Exhibition, Walker Art Gallery, Liverpool (1962). Solo shows include Courtauld Institute, London (1973).

Joan **JONAS** [b. 1936, New York] lives in New York. Working in live art, video and installation, she uses video in environments which enable audiences to view different aspects of a work simultaneously. She was included in Documenta 5, Kassel (1972). Retrospectives include the Stedelijk Museum, Amsterdam (1994).

Tina **KEANE** [b. 1949, England] lives in London. Working in video, film and installation, she explores issues of personal and collective identity and political freedom. She was included in 'Signs of the Times', Centre d'Art Contemporain, Noisel-Paris (1993). Solo shows include 'Caution - X-Ray', Museum of Installation, London (1994).

Mary **KELLY** [b. 1941, Fort Dodge, Iowa] lives in Los Angeles. Kelly's installations and theoretical texts are informed by her feminist interpretation of psycho-analytic theory. She was included in 'Difference: On Representation and Sexuality', New Museum of Contemporary Art, New York (1984). Solo shows include 'Post-Partum Document', Institute of Contemporary Arts, London (1976). *Imaging Desire*, her collected writings, was published in 1996.

Karen **KNORR** [b. 1954, Frankfurt am Main, Germany] lives in London. Working predominantly in photography, sometimes in collaboration with other artists such as Olivier Richon, she has investigated and critiqued the institutionalized spaces of privileged patriarchal elites. She was included in 'Beyond the Purloined Image', Riverside Studios, London (1983), the Fifth Sydney Biennale (1985) and 'Other Than Itself', Cambridge Darkroom, Cambridge, England (1989).

Alison **KNOWLES** [b. 1933, New York] lives in New York. An artist, composer and poet, she began her involvement in Fluxus in 1962. Retrospectives include 'Twenty Years of Performance Art: Dick Higgins and Alison Knowles', University of Massachusetts Gallery, Amherst (1980) and 'Indigo Island', State Gallery, Sarbrüken (1997).

Silvia **KOLBOWSKI** [b. 1953, Buenos Aires] lives in New York. An artist and former co-editor of the journal *October* (1993-2000), in her mixed media projects she investigates themes such as art's societal status. Her projects include *an inadequate history of conceptual art* (1999).

Joyce **KOZLOFF** [b. 1942, Somerville, New Jersey] lives in New York. Originally a 'hard edge' abstract painter, in the 1970s she began to incorporate female traditions of 'pattern and decoration' from traditional cultures. Her later ceramic tile public commissions include San Francisco Airport. She was included in 'Patterning',

Palais des Beaux Arts, Brussels (1979). Solo shows include University of New Mexico, Albuquerque (1978).

Barbara **KRUGER** [b. 1945, New Jersey] lives in New York. Using photomontage and graphics Kruger recontextualizes fragments of images from media sources with texts that subvert the manipulations of corporate capitalist culture. A major retrospective was presented at The Museum of Contemporary Art, Los Angeles, and Whitney Museum of American Art (2000).

Shigeko **KUBOTA** [b. 1937, Niigata, Japan] lives in New York. Originally involved in Fluxus, she makes innovative video installations. Much of her work re-examines the legacies of Modernism's 'father' figures such as Marcel Duchamp, from a feminist perspective. She was included in Documenta 7, Kassel (1977). Solo shows include the National Museum of Art, Osaka (1992).

Yayoi **KUSAMA** [b.1929, Matsumoto, Japan] lives in Tokyo. All her works share a common vocabulary of dense, repetitive patterns shaped in cell-like clusters or aggregations of phallic forms, which she uses to explore notions of sexuality, self-image and infinity. Solo shows include the Castellane Gallery, New York (1964), the XLV Venice Biennale (1993) and 'Love Forever: Yayoi Kusama 1958-68', Los Angeles County Museum of Art (1998-99) and touring.

Leslie **LABOWITZ** [b.1946, Uniontown, Pennsylvania] lives in California. A conceptual and performance artist, she has collaborated with Suzanne Lacy and other feminists as Ariadne: A Social Network, a nationwide women's organization which staged pioneering events such as the first Women Take Back the Night march (San Francisco, 1978).

Suzanne **LACY** [b.1945, Wasco, California] lives in Oakland, California. A conceptual and performance artist, she has organized large scale participatory actions on urban social issues. She participated in Womanhouse, Valencia, California (1972). Key projects have been *In Mourning and in Rage* (Los Angeles, 1977) in collaboration with Leslie Labowitz, and *The Crystal Quilt* (Minneapolis, 1987). Her survey of new genre public art, *Mapping the Terrain*, was published in 1995.

Ketty **LA ROCCA** [1938-1976] lived in Florence. Her conceptually-based work recorded progressions of subjective awareness and decipherability, through performance, photographs, collage and drawing. She was included in 'Per una Poesia Totale', Studio Artivisive, Rome (1969). Retrospectives include the XXXVIII Venice Biennale (1978).

Brenda **LAUREL** lives in Santa Cruz. A designer, researcher and writer, she has undertaken a series of projects investigating virtual reality and digital technological environments. Her work focuses on interactive narrative, human computer interaction and cultural aspects of technology. She is editor of *The Art of Human-Computer Interface Design* (1990) and author of *Computers as Theatre* (1991).

Louise **LAWLER** [b. 1947, Bronxville, New York] lives in New York. She photographs or recreates arrangements of works of art in private or public collections. Her work provokes consideration of the social and political dimensions of the display and reception of works of art. She was included in 'The Art of Memory/The Loss of History', New Museum of Contemporary Art, New York (1985). Solo shows include The Museum of Modern Art, New York (1987) and the Kunstverein, Munich (1995).

Zoe **LEONARD** [b. 1961, Liberty, New York] lives in New York. She has worked in photography, site specific installation, performance, film and video. She uncovers the viscerality and ethical dilemmas which underlie that which is excluded and repressed as being impure or 'dirty', unfit for the gaze. She was included in 'In a Different Light', University Art Museum, Berkeley, California (1996). Solo shows include Centre National de la Photographie, Paris (1999).

Sherrie **LEVINE** [b. 1947, Hazleton, Pennsylvania] lives in New York. She reproduces and re-appropriates art objects by established figures included in the historical canons of art and photography. Her works question the exclusivity of Modernist aesthetics, drawing attention to contextual frames of reference. She was included in 'Difference: On Sexuality and Representation', New Museum of Contemporary Art, New York (1984). Solo shows include The Museum of Contemporary Art, Los Angeles (1995).

Maya **LIN** [b. 1959, Athens, Ohio] lives in New York. A sculptor, she produces site-specific public projects, informed by her architectural training. Her contemplative environments use natural and recycled materials, harmonizing with rather than disrupting their sites. Solo shows include 'Public/Private', Wexner Center for the Arts, Columbus, Ohio (1993) and 'Maya Lin: Topologies', Southeastern Center for Contemporary Art, Winston-Salem, North Carolina (1998-99), and touring.

Yve **LOMAX** [b. 1952, Dorset] lives in London. A photographer and theorist, Lomax investigates the implications of theories of, for example, cinematic narrative, on photographic representation. She was included in 'Three Perspectives on Photography', Hayward Gallery, London (1979), and 'Difference: On Representation and Sexuality', New Museum of Contemporary Art, New York (1984). Solo shows include The Photographer's Gallery, London (1989).

Sarah **LUCAS** [b. 1962, London] lives in London. Her work includes photography, installation, assemblage, collage and video. Using visual puns and double-take strategies, she confronts social issues such as sexism and addiction, allowing wit and ambiguity to shift closed perspectives into new registers. She was included in 'Freeze', PLA Building, Surrey Docks, London (1988). Solo shows include Museum Boijmans Van Beuningen, Rotterdam (1996).

Ana **MENDIETA** [1948-1986] lived in Iowa and New York. Her work was informed by her youthful exile from her home and culture. She recorded private rituals of reconnection with the earth by carving, sculpting, immersing and burning her silhouette into natural settings. She was a founder member of AIR, the first all-women's gallery in New York, where she exhibited and curated shows of work by other artists. She was included in 'Inside the Visible', Whitechapel Art Gallery, London (1998). Retrospectives include the New Museum of Contemporary Art, New York (1987).

Annette **MESSAGER** [b. 1943, Berck, France] lives in Paris. She works with photography, assemblage and installation. In the mid 1970s her own body was her principal medium. Later installation works explore hidden, often painful facets of women's daily existence, evoking both sadomasochism and humour. She was included in 'Photography as Art', Institute of

Contemporary Arts, London (1979). Solo shows include P.S. 1, Long Island City, New York (1981).

Kate **MILLETT** [b. 1934, St. Paul, Minnesota] lives in New York. She is a writer, artist and activist known internationally for her book *Sexual Politics* (1970) and her autobiography *Flying* (1974). A touring retrospective of her sculptures was presented by the University of Baltimore in 1993.

Trinh T. **MINH-HA** is Professor of Women's Studies and Film at the University of California, Berkeley. An experimental filmmaker, writer and composer, she is renowned for films such as *Surname Viet Given Name Nam* (1989), which address feminist postcolonial issues. Key books include *Woman, Native, Other: Writing Postcoloniality and Feminism* (1989), and *When the Moon Waxes Red: Representation, Gender and Cultural Politics* (1991).

Mary **MISS** [b. 1944, New York] lives in New York. She is a sculptor, filmmaker and environmental artist. Since the 1970s she has played a leading part in redefining public sculpture and the possibilities for sculpture sited in the landscape. She was included in 'Sitings', La Jolla Museum of Contemporary Art, California (1986). Solo shows include 'Mary Miss: Photo Drawings', Des Moines Art Center, Des Moines, Iowa (1996).

Linda **MONTANO** [b. 1942, Kingston, New York] lives in Kingston, New York. Her performance works and life activities often require her self-transformation through various assumed personae, involving endurance, meditation, ritual and healing acts towards others. She began art-life counselling in 1980 and in 1984 began *Seven Years of Living Art*, a personal experiment based on rituals related to the chakras. In the 1990s she has performed in healing institutions such as the Ananda Ashram in Monroe, New York.

Laura **MULVEY** lives in London. She is an experimental filmmaker and theorist. *Riddles of the Sphinx* (with Peter Wollen, 1976) used cinematic devices to shift narrative perspective to the mother in the Oedipal triangle, investigating the repression of women's discourse in patriarchy. Her key essay, 'Visual and Narrative Pleasure' (1973) describes how the representation of woman is structured

by the Hollywood cinematic apparatus of the male gaze. She is the author of *Visual and Other Pleasures* (1989).

Alice NEEL [1900-1984] lived in New York. A distinguished figurative painter, she worked for prominent US organizations such as the Works Progress Administration but received little critical recognition until her first retrospective at the Whitney Museum of American Art, New York (1974).

Shirin NESHAT [b. 1957, Qazvin, Iran] lives in New York. Her photographs inscribed with Arabic text explore the contradictory roles of women in Muslim society. Neshat has also made video works such as *Rapture* (1998), included in the XLVIII Venice Biennale (1999). Solo exhibitions of her work include the Serpentine Gallery, London (2000).

Yoko ONO [b. 1933, Tokyo] lives in New York. Ono composed experimental music and made conceptual installations and perform-ances in Tokyo in the 1950s. By the early 1960s she had settled in the US, becoming associated with Fluxus. She expanded her work to include experimental film. She was included in 'Japanese Art After 1945: Scream Against the Sky', Yokohama Museum of Art, Japan (1994), and touring. 'Yes', a major retrospective, was held at the Japan Society Gallery, New York (2000).

Catherine OPIE [b. 1961] lives in Los Angeles. Working primarily in photography, she is concerned with the representation of urban context and the individual portrait, often working in collaboration with subjects who are exploring diverse gender identities. She was included in 'Femininmasculin', Centre Georges Pompidou, Paris (1995) and 'Rrose is a Rrose is a Rrose: Gender Performance in Photography', Solomon R. Guggenheim Museum, New York (1997).

ORLAN [b. 1947, St. Etienne, France] lives in Paris. In the 1970s she staged *tablaux vivants* parodying historical portrayals of women. Since the 1990s, she has become the site of an ongoing project of self-transformation through plastic surgery. Her work questions the search for perfection embodied in idealizations. Performances include *The Reincarnation of Saint Orlan*, 'Edge 90', Newcastle (1990). Solo shows include 'This is My Body…This is My Software', Cornerhouse, Manchester (1996), and touring.

Thérèse OULTON [b. 1953, Shropshire] lives in London. A painter, she reorients painterly conventions of mark-making to evoke traces of the feminine. Her heavily impastoed surfaces reclaim the landscape genre in art history in terms of women's cultural traditions. She was included in 'Landscape, Memory, Desire', Serpentine Gallery, London (1984). Solo shows include the Museum of Modern Art, Oxford (1985).

Gina PANE [1936-1990] lived in Paris. Working with her body, she began making actions in nature before shifting her focus more exclusively to actions on her body. She presented performances at the Galerie Stadler, Paris, in the 1970s. She was included in Documenta 6, Kassel (1977). Solo shows include 'La Pêche Endeuillée', Galleria Diagramma, Milan (1975), and 'Partitions: Opera Multimedia 1984-85', Padiglione d'Arte Contemporanea, Milan (1986).

Howardena PINDELL [b. 1943, Philadel-phia] lives in New York, where she was Associate Curator at The Museum of Modern Art, 1967-79. Her painting and mixed media work have drawn attention towards African-American women's oppression by white patriarchal society. She was included in 'Race and Representation', Hunter College Art Gallery, New York (1987). A touring retrospective was organized by Exhibits USA, Kansas City (1993).

Adrian PIPER [b. 1948, New York] lives in New York and Wellesley, Massachusetts. An artist and philosopher, her media include performance, drawings, texts, video and installation. From 1970 onwards she abandoned pure conceptualism for interventionist works dealing with political issues of racial, gender and class identity. She was included in 'Contested Histories', Carpenter Center, Harvard University (1998). Retrospectives include the New Museum of Contemporary Art, New York (2000).

Rona PONDICK [b. 1952, Brooklyn] lives in New York. In her sculptures Pondick integrates forms reminiscent of body parts with others that suggest inanimate forms such as shoes. Her work evokes oral and sadistic drives, exploring possibilities of assertive female forms. She was inclu-ded in 'Corporal Politics', MIT List Visual Arts Center, Cambridge, Massachu-setts (1992). Solo shows include The Israel Museum, Jerusalem (1992).

Yvonne RAINER [b. 1934, San Francisco] lives in New York. In the 1960s she was a leading performer and choreographer of the Judson Dance Group in New York. In 1971 she moved from dance to filmmaking, using experimental cinema aesthetics to address issues of sexual difference. Performances include *Trio A* (1966) and *Continuous Project - Altered Daily*, Whitney Museum of American Art, New York (1970). Films include *Film About A Woman Who …* (1974) and *The Man Who Envied Women* (1985).

Aimee RANKIN now Aimee Morgana [b. 1958, Chicago] lives in New York. A video and installation artist and critic, she investigates the complexities produced by advanced technological forms of media, experimentally constructing new relationships between digital media and the workings of perceptual and unconscious faculties. She was included in 'Voyeurism', Whitney Museum of American Art, New York (1987). Solo shows include American Fine Arts, New York (1991).

Paula REGO [b. 1935, Lisbon] lives in London. A figurative painter, she draws on influences from the folklore of her Catholic childhood, and her perceptions of male dominance and oppression in both public and domestic spheres. She was included in the São Paulo Biennale (1976; 1985). Solo shows include a retrospective at the Fundaçio Calouste Gulbenkian, Lisbon, the Casa de Serralves, Oporto, and the Serpentine Gallery, London (1988).

Elaine REICHEK [b. 1943, New York] lives in New York. She uses sewing, weaving and embroidery as a means of continuing the traditions of women's craftwork within art discourse to critique its hierarchical distinctions and values. She was included in 'Division of Labour: Women's Work in Contemporary Art', Bronx Museum of the Arts, New York (1995). Solo shows include 'Native Intelligence', Grey Art Gallery, New York University, and touring (1992).

Catherine RICHARDS lives in Ottawa, Canada. Her work explores the spectator's role in virtual reality technologies. She created *Spectral Bodies* (1991) with the first virtual reality system in Canada at the Computer Science Department, University of Alberta, and the Banff Centre for the Arts. She was included in 'The Body Obsolete', Gemeentemuseum, Arnhem, The Netherlands (1995). Solo shows include the Ottawa Art Gallery (2000).

Su RICHARDSON [b. 1947, South Shields, England] lives in Birmingham. An artist and designer, she has worked and exhibited in both fields as well as engaging in teaching and consultancy for arts projects. She was a principal organizer of 'Feministo: Portrait of the Artist as a Housewife', Institute of Contemporary Arts, London (1977), and touring.

Pipilotti RIST [b. 1962, Schweizer Rheintal, Switzerland] lives in Zurich. She works with video, film and video installation, using popular culture sources and her own body in witty, sophisticated explorations of contemporary female identity. Her work was included in the XLVII and XLVIII Venice Biennales (1997; 1999). Solo shows include 'Himalaya Pipilotti Rist, 50kg', Kunsthalle, Zurich, and, Musée d'Art Moderne de la Ville de Paris (1999).

Ulrike ROSENBACH [b. 1943, Bad Saizdetfurth, Germany] lives in Cologne. She began making video and live performances dealing mainly with feminist subjects in the early 1970s. She was included in Documentas 6 and 8 (1975 and 1987). Solo shows include 'Last Call for Engel', Kunstmuseum, Heidenheim (1996), and touring.

Martha ROSLER [b. 1943, Brooklyn, New York] lives in Brooklyn. An artist and writer, Rosler works in photography, video, performance and installation. A pioneer of politicized video, her work offers a feminist critical analysis of society, politics and the media. She was included in 'Difference: On Representation and Sexuality', New Museum of Contemporary Art, New York (1984). A major retrospec-tive was presented at the Ikon Gallery, Birmingham (2000).

Betye SAAR [b. 1926, Los Angeles] lives in Los Angeles. Much of Saar's work comprises assemblages using found objects that have a personal, ritualistic resonance, addressing race, class, ancestral memory and power. She was included in 'Black Artist Invitational', Los Angeles County Museum of Art, Los Angeles (1972) and 'Ritual and Myth', Studio Museum in Harlem, New York (1982). Solo shows include the Whitney Museum of American Art, New York (1975).

Niki de SAINT-PHALLE [b. 1930, Neuilly-sur-Seine] has lived in New York and Paris. In the early 1960s she explored the

creative freedom of destruction in works made by firing with a gun at painting/ assemblages. Her small decorated female figures (*Nanas*) led to large sculptural projects such as the huge walk-in environment *Hon* (Moderna Museet, Stockholm, 1966). She was included in 'Zero et Paris 1960, et aujourd'hui', Musée d'Art Moderne et d'Art Contemporain de la Ville de Nice (1998). Solo shows include Centre Georges Pompidou, Paris (1980).

Doris SALCEDO [b. 1958, Bogotá, Colombia] lives in Bogotá. She is a sculptor who transforms domestic furniture or clothing into poetic and philosophical meditations on loss, trauma, recovery and healing. She was included in the XLV Venice Biennale (1993) and the Carnegie International (1995). Solo shows include the New Museum of Contemporary Art, New York and SITE, Santa Fe (1998).

Jenny SAVILLE [b. 1970, Cambridge] lives in London. Her paintings depict the female body in monumental scale as a feminist response to objectifications of female flesh in art history. In the late 1990s she made photographs in collaboration with Glen Luchford. She was included in 'Contemporary '90', Royal College of Art, London (1990). Solo shows include 'Territories', Gagosian Gallery, New York (1999).

Miriam SCHAPIRO [b.1923, Toronto, Canada] lives in New York. A painter, she incorporates traditional women's arts and crafts in her works in an act of revaluation and linkage with female traditions, for which she coined the term *femmage*. A leading figure in the women's art movement of the 1970s, she co-founded the Feminist Art Program at California Institute of the Arts with Judy Chicago. She was included in 'Toward a New Abstraction', The Jewish Museum, New York (1963). A retrospective was held at the College of Wooster Art Museum, Ohio (1980), and touring.

Carolee SCHNEEMANN [b. 1939, Fox Chase, Pennsylvania] lives in New Paltz, New York. A germinal figure in 1960s performance and body art, in her works she centred on her own body and her position as female subject and object. Retrospectives include 'Carolee Schneemann: Up to and Including Her Limits', New Museum of Contemporary Art, New York (1998).Her books include *The Body Politics of Carolee Schneemann* (2000).

Mira SCHOR [b. 1950, New York] lives in New York. She is a painter and theorist of painting. She was a participant in the Womanhouse project of the Feminist Art Program at California Institute of the Arts (1972). Her paintings combine seductively crafted surfaces with textual inscription, exploring areas of denial in public and private domains. She is co-editor of *M/E/A/N/I/N/G*, a journal of contemporary art, and author of *Wet: On Painting, Feminism and Art Culture* (1997).

Joan SEMMEL [b. 1932, New York] lives in New York. A figurative painter, since 1970 she has explored the possibilities of constructing female perspectives to replace the viewpoint of the male gaze. Group exhibitions include Matthew Marks Gallery, New York (1999), curated by artist Robert Gober. Solo shows include 141 Prince Street Gallery, New York (1973) and Jersey City Museum, Jersey City, New Jersey (2000).

Cindy SHERMAN [b. 1954, New Jersey] lives in New York. With her *Untitled (Film Still)* series (1977-80), shown at The Kitchen (1978) and Metro Pictures (1979), both in New York, she established an *oeuvre* built on photographing herself in diverse guises and settings to portray aspects of the image of woman in contemporary culture. She was included in 'Four Artists', Artists' Space, New York (1978). Retrospectives include the Whitney Museum of American Art, New York (1998), and touring.

Katharina SIEVERDING [b. 1944, Prague] has lived in Dusseldorf, Hamburg and Berlin. Her early photographic work features large-scale, close-up self-portraits with many variations. In the mid 1970s she began making monumental photographic tableaux which combine image and text and refer to political events. She was included in 'Transformer: Aspekte der Travestie', Kunsthalle, Lucerne (1973). Solo shows include the Stedelijk Van Abbemuseum, Eindhoven (1979).

Shahzia SIKANDER [b. 1969, Lahore, Pakistan] lives in Houston, Texas, and New York. Her study of traditional Asian miniature painting techniques is employed to invent a new hybrid symbolism that allows female assertiveness to be represented in a traditional frame. She was included in 'Global Visions', Deste

Foundation for Contemporary Art, Athens (1998). Solo shows include the Hirshhorn Museum and Sculpture Garden, Washington, D.C. (1999).

Laurie SIMMONS [b.1949, Long Island, New York] lives in New York. She is best known for her staged photographic tableaux in which tiny plastic female figures are posed in everyday activities. She was included in 'Image Scavengers', Institute of Contemporary Art, University of Pennsylvania, Philadelphia (1982). Solo shows include Tyler School of Art, Temple University, Philadelphia (1985).

Lorna SIMPSON [b. 1960] lives in New York. She is a leading African-American practitioner in the use of photography and text to explore issues of cultural identity. Focusing on the intersection of racial, sexual and gender stereotypes, she turns her subjects' backs to the camera, dislocating conventional relationships between the viewer and the viewed. She was included in 'The Body', New Museum of Contemporary Art, New York (1986) and the XLIV Venice Biennale (1990). A touring retrospective was initiated by the Temple University, Tyler School of Art, Elkins Park, Pennsylvania (1992).

Monica SJÖÖ [b. 1938, Härnösand, Sweden] lives in Bristol. A painter and writer, she uses matriarchal symbolism throughout her work. A principal organizer of the first Women's Liberation Movement group exhibition (London, 1971), she is best known for *God Giving Birth* (1969), which depicts God as a woman in childbirth. She was included in 'Five Women Artists: Images of Womanpower', Swiss Cottage Library, London (1973). Solo shows include Casa de Colores, Brownsville, Texas (1999), and touring.

Sylvia SLEIGH [b. 1935, Llandudno] lives in New York. She is a painter, producing predominantly portraits. Her paintings of the 1970s were informed by feminist theories of representation; portraits of male subjects investigated ways of suggesting the eroticism of the male body for the female viewer. Solo shows include 'Sylvia Sleigh: Invitation to a Voyage and Other Works', Wisconsin Art Museum, Milwaukee (1990), and touring.

Jaune Quick-to-See SMITH [b. 1940, St. Ignatius, Montana] lives in New Mexico.

She works in paint, collage and mixed media, combining figuration and abstraction to address themes such as environmental destruction, oppression of Native American cultures, and American cultural mythology. She was included in 'The New Feminism', Ohio State University, Columbus, Ohio (1983). Solo shows include Bernice Steinbaum Gallery, New York (1992).

Kiki SMITH [b. 1954] lives in New York. She is a sculptor and mixed media installation artist. In the late 1980s and 1990s she created full scale female figures which investigate dilemmas of representing female embodiment. She was included in 'Feminin-Masculin: le sex de l'art', Centre Georges Pompidou, Paris (1995). Solo shows include The Museum of Contemporary Art, Los Angeles (1995).

Jo SPENCE [1934-1992] lived in London. She used photography to explore issues raised by feminism. With Terry Dennett she founded the Photography Workshop (1974) and *Camerawork* journal. The diagnosis in 1982 of breast cancer led to her therapeutic photo series, in collaboration with Rosy Martin, and book, *Putting Myself in the Picture: A Political, Personal and Photographic Autobiography* (1986).

Nancy SPERO [b. 1926, Cleveland, Ohio] lives in New York. In her work she questions the way images of the female body have been used by a male dominated culture by juxtaposing and rearranging existing images of women from diverse historical sources, evolving new symbolic associations and messages. Spero became a member of WAR (Women Artists in Revolution) in 1969 and was a founder member of AIR (Artists-in-Residence), the first all-women artists' gallery in New York. A major retrospective was presented at the Ikon Gallery, Birmingham (1998).

Jana STERBAK [b. 1955, Prague] lives in Montreal and Paris. Her media include sculpture, photography, video and installation. She addresses struggles to establish individual freedom from social constraints, focusing on the body as site and metaphor. She was included in 'NowHere', Louisiana Museum, Humlebaek, Denmark (1996). A retrospective was presented at the Musée d'Art Moderne de Saint-Etienne (1995), and touring.

Rachel **STRICKLAND** is a member of the research staff at Interval Research Corporation in Palo Alto, California. Her work with digital technologies focuses on the cinematic dimensions of architectural space. Her 'portable Portraits' are a video work in progress, exploring participants' designs for miniature environments which they are enabled to carry around with them.

Mitra **TABRIZIAN** [b.1952, Iran] lives in London. She is a photographer and theorist whose work explores issues of race, sex and class from a feminist perspective. She was included in 'Beyond the Purloined Image', Riverside Studios, London (1983) and 'The Body Politic', Photographer's Gallery, London (1987). Solo shows include Cornerhouse, Manchester (1988).

Rosemarie **TROCKEL** [b. 1952, Schwerte, Germany] lives in Cologne. Her media include drawing, sculpture, works in wool, video and installation. Her work places art historical formalism in relation to notions of the feminine and domestic. Solo shows include Galerie Monika Spruth, Cologne (1983), a retrospective at the Institute of Contemporary Art, Boston (1991-92), and touring, and 'Rosemarie Trockel: Bodies of Work 1986-1998', Hamburger Kunsthalle (1999), and touring.

Cosey Fanni **TUTTI** [b. 1951, Hull, England] lives in Norfolk. Her improvised actions and collaborative projects investigate life experiences and the fragile bounda-ries between artist, work and audience. With Genesis P. Orridge she co-founded the group COUM which performed actions, exhibited and produced films, 1969-79. She was included in 'Prostitution', Institute of Contemporary Arts, London (1976) and 'Out of Actions: Between Performance and the Object, 1949 to 1979', The Museum of Contemporary Art, Los Angeles (1999).

Mierle Laderman **UKELES** [b. 1939, Denver, Colorado] collides opposing Western cultural systems - free raw creation and its maintenance - revealing surprising rigidities and flexibilities in the search for expanded limits. Her key works include *Touch Sanitation* (1978-84), a citywide action in collaboration with 8,500 sanitation workers and solo exhibition at Ronald Feldman Fine Arts, New York. She was the recipient of a Percent for Art Commission as 'Artist of the Fresh Kills Landfill', New York, from 1990 onwards.

Solo shows include 'Unburning Freedom Hall', The Museum of Contemporary Art, Los Angeles (1997).

VERUSCHKA [Vera Lehndorff] studied art in Hamburg and then Florence in the early 1960s, where she was asked to model at the Palazzo Pitti collections. She became one of the most celebrated fashion models of the period, photographed by Irving Penn and Diana Vreeland. In the early 1970s she retired from modelling and collaborated with the photographer Holger Trulsch to make works in which she 'worked against' her modelling career by making her body merge with its background and 'disappear'.

VNS MATRIX [formed 1991, Australia] is a group of four Australian women artists: Francesca da Rimini, Josephine Starrs, Julianne Pierce, and Virgina Barratt, whose mission is to remap cyberspace by subverting gender stereotypes and introducing polymorphously perverse sexuality into digital games and virtual reality environments.

Kara **WALKER** [b. 1969, Stockton, California] lives in Providence, Rhode Island. From her initial studies in painting, her practice has evolved into making large wall-mounted installations of small silhouettes made from cut black paper which re-present historical narratives from an African-American perspective. She was included in 'Into the Light, 1992 Nexus Biennale, Nexus Contemporary Arts Center, Atlanta (1992) and 'No Place (Like Home)', Walker Art Center, Minneapolis (1997). Solo shows include San Francisco Museum of Modern Art, San Francisco (1997).

Kate **WALKER** [b. Leeds, England] lives in London. An artist and teacher, from 1972 she was active in the Women's Art Movement, involved in initiating collaborative projects such as A Woman's Place at the South London Women's Centre (1974). Her career in education has included serving as Curriculum Organizer for Arts in a men's high security prison.

Gillian **WEARING** [b. 1963, Birmingham] lives in London. Working primarily with video and photography, her work uses an approach superficially similar to TV documentary to explore, with participants, the boundaries of public and private life. She was included in 'Incertaine Identité', Galerie Analix B & L Polla, Geneva (1994).

Solo shows include 'Western Security', Hayward Gallery, London (1995), Kunsthaus Zurich (1997) and Serpentine Gallery, London (2000).

Carrie Mae **WEEMS** [b. 1953, Portland] lives in Northampton, Massachusetts. Her photographic works and books focus on African-American representation, using the genres of reportage and self-portraiture. Often ironic humour is used to uncover the ideological underpinnings of attitudes both within and across cultural divides. She was included in 'Black Male: Representations of Masculinity in Contemporary American Art', Whitney Museum of American Art, New York. Solo shows include the Contemporary Arts Museum, Houston (1996).

Rachel **WHITEREAD** [b. 1963, London] lives in London. A sculptor, she casts directly from familiar, everyday objects. She makes manifest spaces in, under, on and between things, examining structures among which we live. She was included in 'Doubletake: Collective Memory and Current Art', Hayward Gallery, London, and Documenta IX, Kassel (both 1992). Solo shows include 'Ghost', Chisenhale Gallery, London (1990) and 'Rachel Whiteread: Shedding Life', Tate Gallery, Liverpool (1996).

Faith **WILDING** [b. 1943, Primavera, Paraguay] lives in Pittsburg, Pensylvannia. She was an important member of the Calfornian women's movement in art in the 1970s, making performances and installations, teaching and writing critical texts. She was included in 'Sexual Politics: Judy Chicago's *Dinner Party* in Feminist Art History', UCLA/Armand Hammer Museum of Art, Los Angeles (1996). Solo shows include 'Embryoworlds', State University of New York, Old Westbury (1999).

Hannah **WILKE** [1940-93] lived in New York. Originally a sculptor, she invented her own iconography based on vaginal imagery, using clay, latex and then chewing-gum. Her own body became increasingly the focus of her work, and featured in 'performalist portraits'. Her posthumous exhibition 'Intra-Venus' was shown at Ronald Feldman Gallery, New York (1994), and the Santa Monica Museum of Art, California (1996). A retrospective of her work was held at the Copenhagen Contemporary Art Centre and Helsinki City Art Museum (1999).

Sue **WILLIAMS** [b.1954, Chicago Heights, Illinois] lives in New York. She is a painter whose early 1990s work addressed violence towards women with a disturbing combination of rage and humour. Later paintings comprise abstract, lyrical patterns that explore female eroticism. She was included in 'Sex Show', Cable Gallery, New York (1985) and 'Bad Girls', Institute of Contemporary Arts, London (1993). Solo shows include San Francisco Art Institute, San Francisco (1993).

Martha **WILSON** lives in New York. Primarily working in performance, she has enacted the personae of many prominent political figures including Barbara Bush and Tipper Gore. She is Founding Director of Franklin Furnace Archive, New York, which since its inception in 1976 has presented and preserved documentation of ephemeral art: artists' books and multiples, temporary installations and performance art.

Francesca **WOODMAN** [1958-1981] lived in New York and Italy. Most of her work was produced while a student at the Rhode Island School of Design, Providence, and while working in Rome, and features black and white photographs of her own body in decaying interiors. Retrospectives include Wellesley & Hunter College Art Gallery (1986), and the Fondation Cartier pour l'art contemporain, Paris (1998), and touring.

Marie **YATES** [b. 1940] lives in Greece. Originally an abstract painter, since the late 1960s she has made conceptual work, engaging with feminist critiques of representation and the possibilities for social change. She was included in 'Issue: Social Strategies by Women Artists', Institute of Contemporary Arts, London (1980) and 'Difference: On Representation and Sexuality', New Museum of Contemporary Art, New York (1984).

AUTHORS' BIOGRAPHIES

Parveen ADAMS is Convenor of the MA and phD programmes in Psychoanalytic Studies at Brunel University, Uxbridge, England. She was a founder of the journal *m/f*, and is author of *The Emptiness of the Image: Psychoanalysis and Sexual Difference* (1995).

Lawrence ALLOWAY [1926-90] was a British writer and critic. His published works include *Abstract Expressionists* [1954] and *American Pop Art* [1974].

Emily APTER [b. 1954, Princeton, New Jersey] is Professor of Comparative Literature, University of California, Los Angeles. Her books include *Feminizing the Fetish: Psychoanalysis and Narrative Obsession in Turn-of-the-Century France* (1991).

Bill ARNING is Curator at MIT List Visual Arts Center, Cambridge, Massachusetts, and a regular contributor to art journals including *Art in America*.

Jan AVGIKOS is an art historian based in New York. She is a contributing editor of *Artforum* and a faculty member of Columbia University and the School for the Visual Arts, New York.

Jean BAUDRILLARD [b. 1929, Reims] was Professor of Sociology at the University of Paris X/Nanterre from 1966 to 1990. His influential works of cultural theory include *The Object System* (1968) and *Simulations* (1981).

Tessa BOFFIN [1960-93] was a British photographer who addressed issues of lesbian representation, history and AIDS. In 1991, with Jean Fraser, she published *Stolen Glances: Lesbians Take Photographs*.

Judith BUTLER [b. 1956] is Professor of Comparative Literature and Rhetoric at the University of California, Berkeley. Her key writings include *Gender Trouble* (1990) and *Bodies that Matter* (1993).

C. CARR is a critic whose writings on performance art and culture are published in *The Village Voice* and *Artforum*. She is author of *On Edge: Performance at the End of the Twentieth Century* (1994).

Hélène CIXOUS [b. 1937, Oran, Algeria] is an influential feminist writer of poetic fiction, drama and critical studies. She is Director of the Centre d'Etudes Féminines, University of Paris VIII, where she created the first and only French doctoral programme in Women's Studies.

Eva COCKCROFT [d. 1999] was an artist, writer and art historian, who both produced and wrote on the subject of murals as instruments of progressive social change. She was co-author of *Toward a People's Art: The Contemporary Mural Movement* (1977).

Laura COTTINGHAM teaches contemporary art and criticism in the College of Art at the Cooper Union, New York. She is author of *Seeing Through the Seventies: Essays on Feminism and Art* (1999) and director of the video *Not for Sale: Feminism and Art in the USA during the 1970s* (1998).

Rosalind COWARD was one of the founders of the journal *m/f* and is the author of *Language and Materialism: Developments in Semiology and the Theory of the Subject* (1977), *Patriarchal Precedents: Sexuality and Social Relations* (1983) and *Female Desires: How They Are Sought, Bought and Packaged* (1985).

Elizabeth COWIE is Senior Lecturer in Film Studies in the School of Arts and Image Studies at Kent University, England, and one of the founding editors, in 1978, of the feminist theory journal *M/F*. She is author of *Representing the Woman: Cinema and Psychoanalysis* (1997) and editor, with Parveen Adams, of *The Woman in Question: M/F* (1990)

Simone DE BEAUVOIR [1908-1986], a French essayist and novelist, was a pioneering feminist and, with Jean-Paul Sartre, a leading proponent of existentialism. *Le Deuxième Sexe (The Second Sex)* (1949) was a scholarly and passionate plea for the abolition of what she described as the myth of the 'eternal feminine'. Her other writings with a feminist theme include the novel *L'Invitée (She Came to Stay)* (1943).

Rosalind DELMAR [b. 1941, Redcar, Yorkshire] lives in London. Her writings

are included in feminist anthologies such as *The Body Politic* (ed. Micheline Wandor, 1972) and *What Is Feminism?* (eds. Juliet Mitchell and Ann Oakley, 1986).

Diane DI PRIMA [b. 1934, Brooklyn, New York]. A poet, writer and activist, she was one of the few female Beat generation writers to attain prominence. Her first poetry collection, *This Kind of Bird Flies Backwards*, was published in 1958. Her biographical writings, such as *Memoirs of a Beatnik* (1969) focus on the political struggles of her time. Her later writing has reflected her interest in alchemy, female archetypes and Eastern thought.

Jean FISHER is a London-based freelance writer on issues of contemporary art practice. The former editor of the journal *Third Text*, she edited the anthologies *Global Visions: Towards a New Internationalism in the Visual Arts* (1994) and *Reverberations: Tactics of Resistance, Forms of Agency* (2000).

Jean FRASER [b. 1946, the Midlands, England] lives in London. A freelance photographer addressing gender issues, she co-curated with Sunil Gupta 'Same Difference' (1986) one of the first British shows of lesbian and gay photographers.

Betty FRIEDAN [b. 1921, Peoria, Illinois] lives in Washington, D.C. A prominent feminist writer and activist, she is author of *The Feminine Mystique* (1963), *The Fountain of Age* (1993) and *Beyond Gender: The New Politics of Work and Family* (1997).

Joanna FRUEH [b. 1948, Chicago] is a performance artist, critic, and Professor of Art History at the University of Nevada. She is author of *Erotic Faculties* (1996) and *Monster/Beauty: Building the Body of Love* (2000).

Sandra M. GILBERT [b. New York] is Professor of English at the University of California, Davis. She was co-author, with Susan Gubar, of *The Madwoman in the Attic: The Woman Writer and the Nineteenth-Century Literary Imagination* (1979).

Germaine GREER [b. Melbourne, 1939] is Professor of English and Comparative

Literary Studies at the University of Warwick, England. Among her many feminist cultural studies are *The Female Eunuch* (1969) and *The Obstacle Race: The Fortunes of Women Painters and Their Work* (1979).

Susan GUBAR [b. 1944, Brooklyn, New York] is Distinguished Professor in the Department of English, Indiana University, Bloomington. In addition to *The Madwoman in the Attic* [see Sandra M. Gilbert] she is author of *Racechanges: White Skin, Black Face in American Culture* (1997).

Donna J. HARAWAY [b. 1944, Denver, Colorado] is a professor in the History of Consciousness Department at the University of California at Santa Cruz. She is the author of *Primate Visions: Gender, Race and Nature in the World of Modern Science* (1989) and *Simians, Cyborgs and Women: The Reinvention of Nature* (1991).

N. Katherine HAYLES [b. 1943, St. Louis, Missouri] is a Distinguished Scholar of the University of Rochester and teaches at the University of California, Los Angeles. She writes on the relations of literature and science in the twentieth century. Her books include *How We Became Posthuman: Virtual Bodies in Cybernetics, Literature and Informatics* (1999).

Luce IRIGARAY [b. Belgium, 1930] lives in Paris, where she is Director of Research at the Centre National de la Recherche Scientifique. She is an influential feminist figure in Continental philosophy. Her key works include *This Sex Which Is Not One* (1985) and *An Ethics of Sexual Difference* (1993).

Jo Anna ISAAK lives in New York. She was the curator of the exhibitions 'The Revolutionary Power of Women's Laughter' (1983), and 'Laughter Ten Years After' (1995). Her books include *The Ruin of Representation in Modernist Art and Texts* (1986) and *Feminism and Contemporary Art: The Revolutionary Power of Women's Laughter* (1996).

Jill JOHNSTON [b. 1929, London] has written and edited criticism and essays on art, dance and performance from feminist and lesbian perspectives since the early 1960s, when she was closely associated

with the Judson Dance Group in New York. Her books include *Marmalade Me* (1971) and *Lesbian Nation* (1973).

Amelia JONES is Professor of Art History at the University of California, Riverside. She curated 'Sexual Politics: Judy Chicago's *Dinner Party* in Feminist Art History' at the UCLA/Armand Hammer Art Museum (1966). Publications include *Body Art/Performing the Subject* (1998) and *The Artist's Body* (2000).

Kellie JONES is Assistant Professor of History of Art and African-American Studies at Yale University. She is best known for her curatorial work, which includes exhibitions for the São Paulo Biennale (1989) and the Johannesburg Biennale (1997).

Diana KETCHAM is an art historian and critic who has contributed to periodicals including the *Village Voice*. She is the author of *Le Desert De Retz : A Late Eighteenth-Century French Folly Garden: The Artful Landscape of Monsieur De Monville* (1994).

April KINGSLEY [b. 1941, New York] is Curator at the Kresge Art Museum, Michigan. She has been an art critic, curator and professor since the early 1970s, contributing to periodicals including the *Village Voice* and *Newsweek*. She is the author of *The Turning Point: The Abstract Expressionists and the Transformation of American Art* (1992).

Anne KOEDT, a German-born feminist writer and activist, originally presented her essay 'The Myth of the Vaginal Orgasm' at the First National Women's Liberation Conference, Chicago (1968). It was reprinted in the anthology she edited, *Radical Feminism* (1973).

Jutta KOETHER [b. 1958, Cologne] is an artist and writer who has contributed to periodicals including *Artforum*, *Index*, *Texte zur Kunst* and *Parkett*. She was included in 'I Love New York', Museum Ludwig, Cologne (1998). Solo shows include Daniel Buchholz, Cologne (1998; 2000).

Liz KOTZ [b. 1962, Los Angeles] teaches in the Department of Cultural Studies and Comparative Literature at the University of Minnesota. A critic and curator, she has contributed to journals including *Artforum*, *October* and *Texte zur Kunst*.

Max KOZLOFF [b. 1933, Chicago] is a photographer and art critic. He was a contributing editor to *Artforum* (1963-74). Books include *Photography and Fascination* (1979) and *The Privileged Eye* (1987).

Rosalind KRAUSS [b. 1940] is Meyer Schapiro Professor of Art and Theory at Columbia University, New York. A founding editor of the journal *October*, she is also an independent curator. Publications include *The Originality of the Avant-Garde and other Modernist Myths* (1985) and *The Optical Unconscious* (1993).

Julia KRISTEVA [b. 1941, Bulgaria] is a literary theorist, writer and teacher at the University of Paris-VII. She has been a practising psychoanalyst since 1979. Important publications include *Desire in Language* (1980) and *Powers of Horror* (1982).

Rosa LEE [b. 1957] is a painter who lives and works in London. Her work has been exhibited in Britain, Canada and Europe.

Ulf LINDE [b. 1929, Stockholm] was Curator at the Moderna Museet, Stockholm, in 1966, when *Hon*, by Niki de Saint-Phalle and others, was exhibited. A former Professor at the Royal Academy of Arts in Stockholm, he is also the author of several studies on the work of Marcel Duchamp.

Kate LINKER is an independent critic based in New York. She contributes to *Artforum*, *Flash Art* and other international art journals. She is author of *Love for Sale: The Words and Pictures of Barbara Kruger* and *Vito Acconci* [1994].

Lucy R. LIPPARD [b. 1937, New York] is a freelance writer, curator and activist based in New York. As a critic and curator she has been a central figure in the feminist art movement. Her recent work has examined cultural diversity in the arts. Publications include *Six Years: The Dematerialization of the Art Object from 1966-72 …* (1973) and *The Pink Glass Swan: Selected Essays on Feminist Art* (1995).

Audre LORDE [1934-1992] lived for much of her life in New York. She was an African-American, lesbian poet and activist whose resistance to marginalization has been influential worldwide. *Sister Outsider: Essays and Speeches* (1984) is one of the key publications that represent her work as a feminist theorist as well as a poet.

Joseph MASHECK teaches at Hofstra University, New York. He was an editor of *Artforum* in the late 1970s. Publications include *Marcel Duchamp in Perspective*.

Annette MICHELSON is Professor of Film Studies at New York University. She has written influential essays on Duchamp, Surrealism and Minimal art. A founding editor of the journal *October*, Michelson has also edited *Kino-Eye: The Writings of Dziga Vertov* (1984).

Eileen MYLES [b. 1949, Cambridge, Massachusetts] is an art writer, novelist and poet. She contributes to *Bookforum*, *Art in America*, *The Village Voice*. With Liz Kotz, she co-edited *The New Fuck You/Adventures in Lesbian Reading* (1995).

Mignon NIXON [b. 1961, Anniston, Alabama] lives in London where she teaches art history and theory at the Courtauld Institute of Art. She has written extensively on feminist art and co-edited, with Silvia Kolbowski, a special issue of *October*, *Feminist Issues* (Winter 1995).

Linda NOCHLIN [b. 1931, New York] lives in New York where she is Professor of Modern Art at the Institute of Fine Arts, New York University. She is considered the founder of feminist art history in the US. Key books include *Women, Art and Power, and Other Essays* (1989) and *Representing Women* (1999).

Gloria Feman ORENSTEIN is a Professor of Gender Studies and Comparative Literature at the University of Southern California, Los Angeles. Publications include *The Theater of the Marvelous: Surrealism and the Contemporary Stage* (1975).

Craig OWENS [1950-90] was an American critic whose writings are integral to Postmodern critical debates. During the 1980s he was Editor of *Art in America*. He was Associate Editor of *October*, 1979-80.

Rozsika PARKER [b. 1945, London] lives and works in London as a psychoanalytical therapist and writer. With Griselda Pollock, she is a key writer on British art of the women's movement and was a founder member of the *Spare Rib* magazine collective. Her publications include *The Subversive Stitch: Embroidery and the Making of the Feminine* (1989) and *Torn in Two: The Experience of Maternal Ambivalence* (2000).

Sadie PLANT is a freelance writer on contemporary cultural issues and former Research Fellow and Director of the Cybernetic Culture Research Unit at the University of Warwick, England. Her books include *Zeros + Ones: Digital Women + the New Technoculture* (1997) and *Writing on Drugs* (2000).

Griselda POLLOCK [b. 1949, Bloemfontein, South Africa] is Professor of Social and Critical Histories of Art at the University of Leeds. She occupies a central role in the British development of feminist art theory. Her books include *Differencing the Canon: Feminist Desire and the Writing of Art's Histories* (1999), *Mary Cassatt* (1998) and *Looking Back to the Future* (2000).

RADICALESBIANS were a collective based in New York in the early 1970s whose members included March Hoffman (Artemis March), Ellen Bedoz, Cynthia Funk, Rita Mae Brown, Lois Hart, 'Barbara XX' and other members who maintained anonymity.

REDSTOCKINGS was the name taken in 1969 by one of the founding Women's Liberation groups of the 1960s to represent the union of two traditions: red for revolution combined with the 'blue stocking' label disparagingly pinned on nineteenth-century feminists. Redstockings today is a grassroots think tank established by movement veterans for defending and advancing the women's liberation agenda.

Adrienne RICH [b. 1929, Baltimore, Maryland]. A poet and writer, she explores multiple sites of self-definition, reflecting upon women's literary traditions, Jewish identity and the erasure and recovery of lesbian existence. Her books include *On Lies, Secrets and Silence: Selected Prose 1966-1978* (1995).

Faith RINGGOLD [b. 1930, New York] lives in Englewood, New Jersey. One of the most influential African-American women artists of the late twentieth century, she is a painter, sculptor, installation, mixed media and performance artist, writer and activist. Her autobiography, *We Flew Over the Bridge: The Memoirs of Faith Ringgold*, was published in 1995.

Sarah J. ROGERS is a curator and writer and former Director of Exhibitions at Wexner Center for the Arts, Ohio State

University. Exhibition catalogues she has published include *Maya Lin: Public/Private* (1994) and *Lorna Simpson: Interior/ Exterior, Full/Empty* (1997).

Monica ROSS [b. 1950, Lancashire] is an artist and teacher based in London. She was centrally involved in collective projects including the *Women's Postal Art Event* (1975-77); *FENIX* (1978-80) *Sister Seven* (1980-85) and *Feminist Arts News* (1980-85). Her book work, *valentine*, is published by Milch Gallery, London (2000).

Anne-Marie SAUZEAU BOETTI [now Anne-Marie Sauzeau] teaches the history of modern and contemporary art and contributes to periodicals such as *Il Manifesto* and *Data*. She collaborated for over twenty years with the artist Alighiero Boetti (1940-1994), whom she married in 1964.

Collier SCHORR [b. 1963, New York] lives in Brooklyn, New York. She is an artist and writer. Her photographic work and her art criticism have been widely influential in discussions of gender representation during the 1990s. She has been an editor of *frieze* in New York and has regularly contributed to *Artforum*, *frieze* and *Parkett*. She was included in 'From the Corner of the Eye', Stedelijk Museum, Amsterdam (1998). Solo shows include 'Neue Soldatem', Partobject Gallery, Carrboro, North Carolina (1999).

Joan SIMON [b. 1949, New York] is a Paris-based writer and curator. From 1974-83 she was Managing Editor of *Art in America*. She organized Jenny Holzer's first solo exhibition (Des Moines Art Center, 1986-87). Her books include *Susan Rothenberg* (1991/99), *Ann Hamilton* (2001) and the edited collection *Joan Jonas: Documents* (2001).

Valerie SOLANAS [1936-1988] wrote the *SCUM Manifesto* in 1967, originally selling mimeographed copies on the streets. The powerful invective of this text reflected her personal experience of abuse. In the same year she met Maurice Girodias of Olympia Press, who published the manifesto in 1968, after Solanas had been arrested for shooting Andy Warhol. He had lost her only copy of the original manuscript for her other work - a play she had offered him for publication.

Nancy SPECTOR is Curator of Contemporary Art at the Solomon R. Guggenheim Museum in New York, where exhibitions she has curated have included a retrospective of Felix Gonzalez-Torres (1995). She is a regular contributor to *Artforum*, *Parkett* and *frieze*.

Lisa TICKNER [b. 1944, London] is Professor of Art History at Middlesex University. She is the author of *The Spectacle of Women: Imagery of the Suffrage Campaign, 1907-1914* (1987) and *Modern Life and Modern Subjects: British Art in the Early Twentieth Century* (2000).

Marcia TUCKER [b. 1940, New York] lives in New York. She was a founding director and curator of the New Museum of Contemporary Art, New York (1977-91). Publications include *Robert Morris* (1970) and *Bad Girls* (1994).

Carole S. VANCE is an anthropologist who teaches at Columbia University, where she also directs the Program for the Study of Sexuality, Gender, Health and Human Rights. She is the editor of *Pleasure and Danger: Exploring Female Sexuality* (1993).

Marina WARNER [b. 1946, London] is Visiting Professor in the Visual Arts Department at Birkbeck College, London. She is both a writer of fiction and of historical and cultural studies of literary and visual representation. Her books include *From the Beast to the Blonde* (1994) and *No Go the Bogeyman* (1998).

Gilda WILLIAMS [b. New York] is Commissioning Editor for Contemporary Art, Phaidon Press, London. Also an art critic and curator, she has contributed to *Parkett*, *Art in America* and *Art Monthly*. Curatorial projects include 'London Orphan Asylum', (co-curator, Milan, 2000); *cream* and *fresh cream: Contemporary Art in Culture* (Phaidon Press, 1998; 2000).

BIBLIOGRAPHY

Adams, Parveen, *The Emptiness of the Image: Psychoanalysis and Sexual Differences* (London and New York: Routledge, 1996)

Allara, Pamela, *Pictures of People: Alice Neel's American Portrait Gallery* (Hanover and London: Brandeis University Press, 1998)

Anderson, Laurie, *Stories from the Nerve Bible: A Retrospective 1972-1992* (New York: HarperCollins, 1994)

Appignanesi, Lisa (ed.), *Desire: ICA Documents* (London: Institute of Contemporary Arts, 1984)

_____ (ed.), *Identity: The Real Me* (London: Institute of Contemporary Arts, 1987)

Applebroog, Ida, 'The I Am Heathcliffe, Says Catherine, Syndrome', *Heresies*, 2 (May 1977) 118-24

Atkinson, Ti-Grace, *Amazon Odyssey* (New York: Links Books, 1974)

Baert, Renee, 'Desiring Daughters', *Screen*, 34 (Summer 1993)

Banes, Sally, *Greenwich Village 1963: Avant-Garde Performance and the Effervescent Body* (Durham and London: Duke University Press, 1993)

Barry, Judith, *Public Fantasy: An Anthology of Critical Essays, Fictions and Project Descriptions*, ed. Iwona Blazwick (London: Institute of Contemporary Arts, 1991)

Battersby, Christine, *Gender and Genius: Towards a Feminist Aesthetics* (Bloomington and Indianapolis: Indiana University Press, 1989)

Betterton, Rosemary, *Looking On: Images of Femininity in the Visual Arts and Media* (London: Pandora, 1987)

Bird, Jon; Isaak, Jo Anna; Lotringer, Sylvère, *Nancy Spero* (London: Phaidon Press, 1996)

Blocker, Jane, *Where is Ana Mendieta?, Identity, Performativity and Exile* (Durham: Duke University Press 1999)

Boffin, Tessa; Gupta, Sunil (eds.), *Ecstatic Antibodies: Resisting the AIDS Mythology* (London: Rivers Oram Press, 1990)

Braidotti, Rosi, *Nomadic Subjects: Embodiment and Sexual Difference in Contemporaray Feminist Theory* (New York: Columbia University Press 1994)

Brennan, Teresa (ed.), *Between Feminism and Psychoanalysis* (London and New York: Routledge 1989)

Brett, Guy, 'To Rid the World of Nuclear Weapons: Greenham Common', in *Through Our Own Eyes: Popular Art and Modern History* (London: GMP Publishers, 1986)

_____; Archer, Michael; de Zegher, Catherine, *Mona Hatoum* (London: Phaidon Press, 1997)

_____; Herkenhoff, Paulo, et al., *Lygia Clark* (Barcelona: Fundació Antoni Tàpies 1997)

Broude, Norma; Garrard, Mary D., (eds.), *The Power of Feminist Art: The American Movement of the 1970s, History and Impact* (New York: Harry N. Abams, Inc., 1994)

_____; Garrard, Mary D. (eds.), *Expanding Discourse: Feminism and Art History* (New York: Icon Editions, 1992)

Buchloh, Benjamin H.D., 'Allegorical Procedures: Appropriation and Montage in Contemporary Art', *Artforum*, 21:1 (September 1982)

Buhler Lynes, Barbara, 'Georgia O'Keeffe and Feminism: A Problem of Position', 1991, published in *The Expanding Discourse: Feminism and Art History*, ed. Norma Broude and Mary D. Garrard (New York: Icon Editions, 1992) 437-49

Burgin, Victor, *Between* (Oxford: Basil Blackwell, 1986)

Butler, Judith, *Gender Trouble: Feminism and the Subversion of Identity* (New York and London: Routledge, 1990)

_____, *Bodies That Matter: On the Discursive Limits of 'Sex'* (New York and London: Routledge, 1993)

Calvert, Gill; Morgan, Jill; Katz, Mouse (eds.), *Pandora's Box* (London: Trefoil Books, 1984)

Carr, C., *On Edge: Performance at the End of the Twentieth Century* (Hanover and London: Weslyan University Press, 1993)

Carter, Angela, *The Sadeian Woman: An Exercise in Cultural History* (London: Virago Press, 1979)

Chadwick, Helen, *Enfleshings* (New York and London: Aperture, 1989)

_____, *Still Lives* (Edinburgh: Portfolio Gallery, 1996)

Chadwick, Whitney, *Women Artists and the Surrealist Movement* (Boston: Little, Brown and Company, 1985)

_____, *Women, Art and Society* (London: Thames and Hudson, 1990)

_____; de Courtivroon, Isabelle (eds.), *Significant Others: Creativity and Intimate Partnership* (London: Thames and Hudson, 1993)

Champagne, Lenora, (ed.), *Out From Under: Texts by Women Performance Artists* (New York: Theatre Communications Group, Inc., 1990)

Chave, Anna C., 'Minimalism and the Rhetoric of Power', *Arts Magazine* (January 1990)

Chicago, Judy, *The Dinner Party: A Symbol of Our Heritage* (New York: Doubleday, 1979)

Cixous, Hélène, *The Hélène Cixous Reader*, ed. Susan Sellers (New York and London: Routledge, 1994)

Corris, Michael, 'Fuzzy Bourgeois', paper delivered at the Museum of Modern Art, Oxford (1995)

Cottingham, Laura, *How Many "Bad" Feminists Does It Take to Change a Lightbulb* (New York: Sixty Percent Solution, 1994)

Crow, Thomas, *The Rise of the Sixties: American and European Art in the Era of Dissent, 1955-69* (London: Weidenfeld and Nicolson, 1996)

Cullum, Jerry, 'Landscape, Borders and Boundaries', *Artpapers* (1995)

Curiger, Bice, *Meret Oppenheim: Defiance in the Face of Freedom*, trans. Catherine Schelbert (Zurich: Parkett, 1989)

Davis, Angela Y., *Angela Davis: An Autobiography* (New York: Random House, 1974).

_____, 'Afro Images: Politics, Fashion and Nostalgia', in *Names We Call Home: Autobiography and Racial Identity*, ed. Becky Thompson and Sangeeta Tyagi (New York and London: Routledge, 1996)

Deepwell, Katy (ed.), *New Feminist Art Criticism: Critical Strategies* (Manchester: Manchester University Press, 1995)

_____ (ed.), *Women Artists and Modernism* (Manchester: Manchester University Press, 1998)

de Lauretis, Teresa, *Alice Doesn't: Feminism, Semiotics, Cinema* (Bloomington: Indiana University Press, 1984)

_____, *Technologies of Gender: Essays on Theory, Film, and Fiction* (Bloomington: Indiana University Press, 1984)

Dexter, Emma; Bush, Kate, *Bad Girls* (London: Institute of Contemporary Arts, 1993)

de Zegher, M. Catherine (ed.), *Inside the Visible: An Elliptical Traverse of 20th Century Art* (Cambridge, Massachusetts: MIT Press, 1996)

DiMassa, Diane, *The Complete Hot-Headed Paisan: Homicidal Lesbian Terrorist* (San Francisco: Cleis Press Inc., 1999)

Doane, Mary Anne, 'Film and the Masquerade: Theorizing the Female Spectator', *Screen* 23:3-4 (September-October, 1982)

Dumas, Marlene, *Sweet Nothings*, ed. Mariska van den Berg (Amsterdam: Galerie Paul Andriesse, Uitgeverij De Balie, 1998)

Duncan, Carol, 'Virility and Domination in Early 20th-Century Vanguard Painting', *Artforum*, 4 (December 1973)

_____, *The Aesthetics of Power: Essays in Critical Art History* (Cambridge: Cambridge University Press, 1993)

Dunn, Nell, *Talking to Women* (Bristol: McGibbon & Kee, Ltd, 1965)

Dworkin, Andrea, *Our blood: prophecies and discourses on sexual politics* (London: The Women's Press Limited, 1982)

_____, *Intercourse* (London: Arrow Books, 1988)

Dyer, Richard, *Now You See It: Studies on Lesbian and Gay Film* (London and New York: Routledge, 1990)

Echols, Alice, *Daring to be Bad: Radical Feminism in America, 1967-1975* (Minneapolis: University of Minnesota Press, 1989)

Ecker, Gisela (ed.), *Feminist Aesthetics* (London: Women's Press, 1985)

Elwes, Catherine, 'The Pursuit of the Personal in British Video Art', *Diverse Practices: A Critical Reader on British Video Art*, Julia Knight ed. (London: Arts Council of England, 1996)

Export, Valie, 'Interview with Ruth Askey', *High Performance*, 13 (1981)

_____; Neswesda, Peter, 'In Her Own Image: Valie Export, Artist and Feminist', *Arts Magazine*, 65 (September 1991)

Faludi, Susan, *Backlash: The Undeclared War Against Women* (London: Vintage, 1992)

Féminin-Masculin: Le sexe de l'art [cat.] (Paris: Gallimard/Electra, Editions du Centre Pompidou, 1995)

Fer, Briony, 'Bordering on Blank: Eva Hesse and Minimalism', published in *Art History*, 17:3 (September 1993)

Ferguson, Russell; De Salvo, Donna; Slyce, John, *Gillian Wearing* (London: Phaidon Press, 1999)

Firestone, Shulamith, *The Dialectic of Sex: The Case for Feminist Revolution* (New York: William Morrow & Co. Inc., 1970)

Frueh, Joanna; Langer, Cassandra L; Raven, Arlene (eds.), *New Feminist Criticism: Art, Identity, Action* (New York: Icon Editions, 1994)

Fusco, Coco, *English Is Broken Here: Notes on Cultural Fusion in the Americas* (New York: The New Press, 1995)

Fuss, Diana, *Essentially Speaking: Feminism, Nature and Difference* (New York and London: Routledge, 1990)

Gallop, Jane, *The Daughter's Seduction: Feminism and Psychoanalysis* (Ithaca:

Cornell University Press, 1982)

Garrard, Rose, *Rose Garrard : Archiving My Own History, Documentation of Works, 1969-1994* (Manchester: Cornerhouse, 1994)

Gever, Martha; Parmar, Pratibha; Greyson, John (eds.), *Queer Looks: Perspectives on Lesbian and Gay Film and Video* (New York and London: Routledge, 1993)

Goldin, Nan, *The Other Side*, eds., Liz Heron and Val Williams (London and New York: I.B. Taurus, 1996)

Graham, Dan, *Rock My Religion: Writings and Art Projects, 1965-1990*, ed. Brian Wallis (Cambridge, Massachussets: MIT Press,1993)

Greer, Germaine, *The Obstacle Race: The Fortunes of Women Painters and Their Work* (London: Secker and Warburg, 1979)

Grubb, Nancy (ed.), *Making Their Mark: Women Artists Move into the Mainstream, 1970-85* (New York: Abbeville Press, 1989)

Guerrilla Girls, *Confessions of the Guerrilla Girls* (London: Pandora, 1995)

Hall, Doug; Fifer, Sally Jo (eds.), *Illuminating Video: An Essential Guide to Video Art* (Aperture; Bay Area Video Coalition, 1990)

Harris, Ann Sutherland; Nochlin, Linda, *Women Artists, 1550-1950* (Los Angeles: Los Angeles County Museum of Art, 1977)

Harrison, Margaret, 'Notes on Feminist Art in Britain 1970-77', *Studio International*, 193:987, (London, 1977)

Hart, Lynda (ed.), *Making a Spectacle: Feminist Essays on Contemporary Women's Theatre* (Ann Arbor: University of Michigan Press, 1989)

Hart, Lynda; Phelan, Peggy (eds.), *Acting Out: Feminism Performances* (Ann Arbor: The University of Michigan Press, 1993)

Heath, Stephen, *The Sexual Fix* (London: Macmillan, 1982)

Heck-Rabi, Louise, *Women Filmmakers: A Critical Reception* (Metuche, New Jersey: The Scarecrow Press, 1984)

Hess, Thomas B; Baker, Elizabeth C. (eds.), *Art and Sexual Politics: Women's Liberation, Women Artists, and Art History* (New York: Collier Macmillan Publishing Co., 1973)

hooks, bell, *Ain't I a Woman: Black Women and Feminism* (London: Pluto Press, 1982)

_____. *Art on My Mind: Visual Politics* (New York: The New Press, 1995)

_____. *Black Looks: Race and Representation* (Boston: South End Press, 1992)

_____. *Outlaw Culture: Resisting Representations* (New York and London: Routledge, 1994)

Indiana, Gary, 'Ex-Model Found in Wall', *Artforum*, 9 (May 1985)

Jaudon, Valerie; Kozloff, Joyce, 'Art Hysterical Notions of Progress and Culture',

Heresies, 4 (1978)

Johnston, Jill, *Lesbian Nation: The Feminist Solution* (New York: Simon and Schuster, Touchstone Books, 1973)

Jones, Amelia, *Postmodernism and the En-gendering of Marcel Duchamp* (Cambridge: Cambridge University Press, 1994)

_____ (ed.), *Sexual Politics: Judy Chicago's Dinner Party in Feminist Art History* (Berkeley: University of California Press, 1996)

_____. *Body Art/Performing the Subject* (Minneapolis: University of Minnesota Press, 1998)

_____; Stephenson, Andrew (eds.), *Performing the Body/Performing the Text* (London and New York: Routledge, 1999)

Juno, Andrea; Vale, V. (eds.), *Angry Women* (San Francisco: Re/Search Publications, 1991)

Kappeler, Susanne, *The Pornography of Representation* (Cambridge: Polity Press, 1986)

Kelly, Mary, *Imaging Desire* (Cambridge, Massachusetts: MIT Press, 1996).

Knight, Julia, *Women and the New German Cinema* (London and New York: Verso, 1992)

Koedt, Anne; Levine, Ellen; Rapone, Anita (eds.),'Radical Feminism', *Quadrange* (New York: The New York Times Book Co., 1973)

Kotz, Liz, 'The Body you Want: Interview with Judith Butler', *Artforum* (November 1992)

Kozloff, Joyce, 'Negating the Negative (an answer to Ad Reinhardt's "On Negation"', *Heresies* (May 1977)

Krauss, Rosalind E., *Bachelors* (Cambridge, Massachusetts: MIT Press, 1999)

Kristeva, Julia, *Desire in Language: A Semiotic Approach to Literature and Art*, ed., Leon S. Roudiez; trans. Thomas Gora, Alice Jardine and Leon S. Roudiez. (Oxford: Basil Blackwell Ltd, 1981)

Labowitz, Leslie, 'Evolution of a Feminist Art', *Heresies*, 6 (New York: 1978)

Lacan, Jacques, *Feminine Sexuality*, (eds.) Juliet Mitchell and Jacqueline Rose, trans. Jacqueline Rose (New York and London: W.W. Norton and Co., 1982)

Lanchner, Carolyn, 'The Later Adventures of Dada's Good Girl', in *The Photomontages of Hannah Höch* (Minneapolis: Walker Art Center, 1996)

Langer, Cassandra L., *Feminist Art Criticism: An annotated bibliography* (New York: G. K. Hall, 1993)

Lavin, Maud, *Cut With the Kitchen Knife: the Weimer photomontages of Hannah Höch* (New Haven: Yale University Press, 1993)

Lingwood, James (ed.), *Rachel Whiteread: House* (London: Phaidon Press, 1995)

Lippard, Lucy R. (ed.), *Six Years : The Dematerialization of the Art Object from*

1966 to 1972 (New York and Washington: Praeger Publishers, 1973)

_____. *Eva Hesse* (New York: New York University Press, 1976)

_____. *From the Center* (New York: E.P. Dutton, Inc., 1976)

_____ (ed.), *Issue: Social Strategies by Women Artists* (London: Institute of Contemporary Arts, 1980)

_____. *Get the Message? A Decade Of Art For Social Change* (New York: E.P. Dutton, Inc.,1984)

_____. *The Pink Glass Swan: Selected Essays on Feminist Art* (New York: The New Press, 1995)

_____. *The Lure of the Local: Senses of Place in a Multicentered Society* (New York: The New Press, 1997)

Loeb, Judy (ed.), *Feminist Collage: Educating Women in the Visual Arts* (New York and London: Teachers College Press, 1979)

Lloyd, Fran (ed.), *Contemporary Arab Women's Art* (London: Women's Art Library, 1999)

Lovelace, Carey, 'Weighing In On Feminism', *Art News* (New York, May 1997)

'Lusitania: A Journal of Reflection and Oceanography', 6, *Vulvamorphia* (New York: Lusitania Press, 1994)

Mama Collective, *MAMA* (Birmingham, undated: photocopy at the Women's Art Library, London)

McQuiston, Liz, *Suffragettes to She-Devils: Women's Liberation and Beyond* (London: Phaidon Press, 1997)

Marks, Elaine; de Courtivron, Isabelle (eds.), *New French Feminisms: An Anthology* (Amherst: The University of Massachusetts Press, 1980)

Mellencamp, Patricia, *Indiscretions: Avant-Garde Film, Video and feminism* (Bloomington and Indianapolis: Indiana University Press, 1990)

Merck, Mandy (ed.), *The Sexual Subject: A Screen Reader in Sexuality* (London and New York: Routledge, 1992)

Meyer, Melissa; Schapiro, Miriam, 'Femmage', *Heresies*, 4 (Winter 1977)

Miller, Lynn F; Swenson, Sally S., *Lives and Works: Talks with Women Artists* (New Jersey and London: The Scarecrow Press, Inc., Methuen, 1981)

Millett, Kate, *Sexual Politics* (Garden City, New York: Doubleday, 1970)

_____. *Flying* (St Albans: Paladin, 1976)

Minh-ha, Trinh T., *Woman, Native, Other: Writing, Postcoloniality and Feminism* (Bloomington: Indiana University Press, 1989)

_____. *When the Moon Waxes Red: Representation, Gender, and Cultural*

Politics (New York and London: Routledge, 1991)

_____, 'Speaking Nearby: Interview with Nancy N. Chen, *Visualizing Theory* (New York and London: Routledge, 1995)

Mitchell, Juliet, *Woman's Estate* (New York: Pantheon, 1971)

_____. *Psychoanalysis and Feminism: Freud, Reich, Laing and Women* (London: Vintage Books, 1975)

Moi, Toril (ed.), *French Feminist Thought: A Reader* (Oxford: Basil Blackwell Ltd, 1987)

Moore, Suzanne, 'Getting a bit of the other: The pimps of postmodernism', in *Male Order: Unwrapping Masculinity*, (eds.) Rowena Chapman and Jonathan Rutherford (London: Lawrence and Wishart, 1988)

Morgan, Robin (ed.), *Sisterhood Is Powerful* (1970); revised edition: *Sisterhood Is Global* (New York: Feminist Press, 1996)

Morris, Meaghan, *The Pirate's Fiancée: Feminism, Reading, Postmodernism* (London and New York: Verso, 1988)

Moser, Mary Anne; MacLeod, Douglas (eds.), *Immersed in Technology: Art and Virtual Environments* (Cambridge, Massachussets: MIT Press, 1996)

Mulvey, Laura, *Fetishism and Curiosity* (London: British Film Institute, Bloomington, Indiana: Indiana University Press, 1996)

_____; Wollen, Peter, 'Frida Kahlo and Tina Modotti', in *Frida Kahlo and Tina Modotti* (London: Whitechapel Art Gallery, 1983)

Munro, Eleanor, *Originals: American Women Artists* (New York: Simon and Schuster, 1979)

Nead, Lynda, *The Female Nude: Art, Obscenity and Sexuality* (London and New York: Routledge, 1992)

Nemser, Cindy, *Art Talk: Conversations With 15 Women Artists* (New York: Harper Collins, 1995)

Next Generation: Southern Black Aesthetic [cat.] (North Carolina: Southeastern Center for Contemporary Art (SECCA), Winston-Salem, 1990)

Nochlin, Linda, *Women, Art and Power, and Other Essays* (New York: Icon Editions, Harper & Row, 1998)

O'Dell, Kathy, 'The Performance Artist as Masochistic Woman', *Arts Magzine*, 62:10 (June 1988)

O'Grady, Lorraine, 'Olympia's Maid: Reclaiming Black Female Subjectivity', *Afterimage* (Summer, 1992)

Oh Boy, It's a Girl! Feminismen in der Kunst [cat.] (München: Kunstverein, 1994)

Olsen, Tillie, *Silences* (New York: Delta/Seymour Lawrence, 1989)

Orenstein, Gloria Feman, 'Women of

300

Surrealism', *The Feminist Art Journal*, Brooklyn, New York (Spring 1973)

Paglia, Camille, *Sexual Personae: Art and Decadence From Nefertiti To Emily Dickinson* (New Haven: Yale University Press, 1990)

Pane, Gina, 'Interview with Ezio Quarantelli', *Contemporanea* (1988)

Parker, Rozsika, *The Subversive Stitch: Embroidery and the Making of the Feminine* (London: Women's Press, 1984)

_____; Pollock, Griselda, *Old Mistresses: Women, Art and Ideology* (London: Routledge & Kegan Paul, 1981)

Passages de l'image (Barcelona: Centre Cultural De La Fundacio Caixa De Pensions, 1990)

Peabody, Richard (ed.), *A Different Beat: Writings by Women of the Beat Generation* (London: Serpent's Tail, 1997)

Penley, Constance, *The Future of an Illusion: Film, Feminism and Psychoanalysis* (London and New York: Routledge, 1989)

Phelan, Peggy, *Unmarked: The Politics of Performance* (London and New York: Routledge 1993)

_____, *Mourning Sex: Performing Public Memories* (London and New York: Routledge, 1997)

_____; Lane, Jill (eds.), *The Ends of Performance* (New York: New York University Press, 1998)

Pollock, Griselda, *Vision and Difference: Femininity, Feminism and Histories of Art* (London and New York: Routledge, 1988)

_____ (ed.), *Generations and Geographies in the Visual Arts: Feminist Readings* (London and New York: Routledge 1996)

Potter, Sally, *et al.*, *About Time: Video, Performance and Installation by 21 Women Artists* (London: Institute of Contemporary Arts, 1980)

Pribram, E. Deidre (ed.), *Female Spectators: Looking at Film and Television* (London and New York: Verso, 1988)

Puerto, Cecilia, *Latin American Women Artists: Kahlo and Look Who Else* (Westport, Connecticut: Greenwood Press, 1996)

Rainer, Yvonne, *Work 1961-73* (The Press of the Nova Scotia College of Art and Design, and New York University Press, 1974)

_____, *The Films of Yvonne Rainer* (Bloomington and Indianapolis: Indiana University Press, 1989)

_____, *A Woman Who … Essays, Interviews, Scripts* (Baltimore: Johns Hopkins University Press, 1999)

Raven, Arlene, *Crossing Over: Feminism and Art of Social Concern* (Ann Arbor: UMI Research Press, 1988)

_____; Langer, Cassandra L; Frueh, Joanna

(eds.), *Feminist Art Criticism: An Anthology* (Ann Arbor: UMI Research Press, 1988)

Reynolds, Simon; Press, Joy, *The Sex Revolts: Gender, Rebellion and Rock 'n' Roll* (London: Serpent's Tail, 1995)

Rich, B. Ruby, *Chick Flicks: Theories and Memories of the Feminist Film Movement* (Durham: Duke University Press, 1998)

Richard, Nelly, 'The Rhetoric of the Body', *Art & Text*, 21 (1986)

Ringgold, Faith, *We Flew Over the Bridge: The Memoirs of Faith Ringgold* (Boston: Little, Brown and Co., 1995)

Riviere, Joan, 'Womanliness as a Masquerade', *The International Journal of Psychoanalysis*, 9: 303-313; reprinted in *The Inner World and Joan Riviere: Collected Papers, 1920-1958*, ed. Athol Hughes (London and New York: Karnac Books, 1991) 90-101

Robinson, Hilary (ed.), *Visibly Female: Feminism and Art, an Anthology* (London: Camden Press, 1987)

Robbins, Trina, *From Girls to Grrrlz: A History of Women's Comics From Teens to Zines* (San Francisco: Chronicle Books, 1999)

Rose, Jacqueline, *Sexuality in the Field of Vision* (London and New York: Verso, 1986)

Rosler, Martha, 'The Private and the Public: Feminist Art in California', *Artforum* (New York, September 1977)

Rubinstein, Charlotte Streifer, *American Women Artists: from Early Indian Times to the Present* (Boston, Massachussets: G.K. Hall & Co., 1982)

Ruddick, Sara; Daniels, Pamela (eds.), *Working It Out: 23 Women Writers, Artists, Scientists and Scholars Talk About Their Lives and Work* (New York: Pantheon Books, 1977)

Schneemann, Carolee, *More Than Meat Joy*, McPherson, Bruce R. (ed.) (New York: Documentexts/McPherson & Co., 1997)

Schneider, Rebecca, *The Explicit Body in Performance* (London and New York: Routledge, 1997)

Schneir, Miriam (ed.), *The Vintage Book of Feminism: The Essential Writings of the Contemporary Women's Movement* (London: Vintage, 1995)

Schulman, Sarah, *My American History: Lesbian and Gay Life During the Reagan/Bush Years* (London and New York: Routledge, 1994)

Semmel, Joan, 'Sex to Hang Art On', *New York Magazine*, 7:6 (1974)

Siegel, Jeanne (ed.), *Art Words 2: Discourse on the Early 80s* (Ann Arbor, Michigan: UMI Research Press, 1988)

_____ (ed.) *Art Talk: The Early 1980s* (New

York: Da Capo Press, 1990)

_____ (ed.), *Mutiny and the Mainstream: Talk That Changed Art, 1975-1990* (New York; Midmarch Arts Press, 1992)

Silverman, Kaja, *The Acoustic Mirror: The Female Voice in Psychoanalysis and Cinema* (Bloomington: Indiana University Press, 1988)

Sims, Lowery Stokes, 'The Mirror of the Other', *Artforum* (March 1990)

Smyth, Cherry, *Damn Fine Art: By New Lesbian Artists* (London: Cassell, 1996)

Speak Art!: The Best of BOMB Magazine's Interviews with Artists (New York: New Art Publications, Inc., 1997)

Spivak, Gayatri Chakravorty, *In Other Worlds: Essays in Cultural Politics* (New York: Methuen, 1987)

Stiles, Kristine, 'Between Water and Stone: Fluxus Performance: A Metaphysics of Acts', *In the Spirit of Fluxus* (Minneapolis, Minnesota: Walker Art Center, 1993)

_____; Selz, Peter (eds.), *Theories and Documents in Contemporary Art: A Sourcebook of Artists' Writings* (Berkeley: University of California Press, 1996)

Stoops, Susan M. (ed.), *More Than Minimal: Feminism and Abstraction in the '70s* (Waltham, Massachussets: Brandeis University, Rose Art Museum, 1996)

Suleiman, Susan Robin, *Risking Who One Is: Encounters with Contemporary Art and Literature* (Cambridge, Massachussets: Harvard University Press, 1994)

Tickner, Lisa, *et al.*, *Difference: On Representation and Sexuality* (New York: New Museum of Contemporary Art, 1984)

_____, *The Spectacle of Women: Imagery of the Suffrage Campaign, 1907-1914* (London: Chatto and Windus, 1987)

Tucker, Marcia, *et al.*, *Bad Girls* (New York: New Museum of Contemporary Art, 1994)

Tutti, Cosey Fanni. 'Prostitution', *October/December Bulletin* (London: Institute of Contemporary Arts, 1976)

Vance, Carole S., (ed.), *Pleasure and Danger: Exploring Female Sexuality* (London: Routledge and Kegan Paul, 1984)

Wagner, Anne Middleton, *Three Artists (Three Women): Modernism and the Art of Hesse, Krasner and O'Keeffe* (Berkeley: University of California Press, 1996)

Walker, Alice, 'In Search of Our Mother's Gardens', *Ms.*, 2:2 (New York, May 1974)

Wallace, Michele, *Invisibility Blues: From Pop to Theory* (London and New York: Verso, 1990)

Waller, Susan (ed.), *Women Artists in the Modern Era: A Documentary History*

(Metuche, New Jersey: Scarecrow Press, 1991)

Warner, Marina, *Monuments and Maidens: The Allegory of the Female Form* (London: Weidenfeld and Nicolson, 1985)

Wedge Number 6, 'Sexuality: Re/Positions (New York: Wedge Press, Winter/Spring 1985)

Wedge, 7/8, 'The Imperialism of Representation, The Representation of Imperialism' (New York: Wedge Press, Winter/Spring 1985)

Wilding, Faith, *By Our Own Hands: The Women's Art Movement, California, 1970-1976* (Santa Monica, California: Double X, 1977)

Wittig, Monique. *Les Guérrillères*, trans. David Le Vay (London: Peter Owen Limited, 1971)

_____, *The Lesbian Body*, trans. David Le Vay (Boston: Beacon Press, 1975)

Witzling, Mara R. (ed.), *Voicing Today's Visions: Writings by Contemporary Women Artists* (London: Women's Press, 1994)

Wollen, Peter, *Raiding the Icebox: Reflections on Twentieth-century Culture* (Bloomington: Indiana University Press, 1993)

Zelevansky, Lynn, 'Sense and Sensibility: Women Artists and Minimalism in the Nineties' (New York: The Museum of Modern Art, 1994)

INDEX

PUBLISHER'S ACKNOWLEDGEMENTS

We would like to thank all those who gave their kind permission to reproduce the listed material. Every effort has been made to secure all reprint permissions prior to publication. However, in a small number of instances this has not been possible. The editors and publisher apologize for any inadvertent errors or omissions. If notified, the publisher will endeavour to correct these at the earliest opportunity.

We would like to thank the following for their kind assistance: 303 Gallery, New York; Eija-Liisa Ahtila, Helsinki; American Fine Arts, Co., New York; David Teacher and The Barbican Centre, London; Judith Barry, New York; Ute Meta Bauer, Stuttgart; Vanessa Beecroft, New York; Dara Birnbaum, New York; Galerie René Blouin, Montréal; Mary Boone Gallery, New York; Louise Bourgeois and Cheim & Read, New York; British Film Institute, London; Leo Castelli Gallery, New York; The Estate of Helen Chadwick, London; Cheim & Read, New York; Abigail Child, New York; Cinenova, London; Lygia Clark Collection and Museu de Arte do Rio de Janeiro; Sadie Coles HQ, London; Maureen Connor, New York; Paula Cooper Gallery, New York; Betsy Damon, Saint Paul, Minnesota; Deitch Projects, New York; Linda Dement, Sydney; Anthony D'Offay Gallery, London; Jeanne Dunning, Chicago; Cecilia Edefalk, Stockholm; Mary Beth Edelson, New York; Catherine Elwes, London; Valie Export, Vienna; Ronald Feldman Fine Arts Inc., New York; Rose Finn-Kelcey, London; Coco Fusco, New York; Gagosian Gallery, New York; Anya Gallaccio, London; Rose Garrard, West Malvern, Worcestershire; Marian Goodman Gallery, New York; Nan Goldin, New York; Gorney Bravin + Lee, New York; Ann Hamilton, Columbus, Ohio; Barbara Hammer, New York; Harmony Hammond, Galisteo, New Mexico; Margaret Harrison, Carlisle; Mona Hatoum, London; Galerie Hauser & Wirth, Zürich; Pat Hearn Gallery, New York; The Estate of Eva Hesse and Robert Miller Gallery, New York; Susan Hiller, London; Lubaina Himid, Preston; Rhona Hoffman Gallery, Chicago; Jenny Holzer and Cheim & Read Gallery, New York; Maureen Paley/ Interim Art, London; Joan Jonas, New York; Tina Keane, London; Mary Kelly, Los Angeles; Sean Kelly Gallery, New York; Nicole Klagsbrun Gallery, New York; Yves Klein Archive, Paris; Karen Knorr, London; Alison Knowles, New York; Robert Koch Gallery, San Francisco; Sylvia Kolbowski, New York; Yayoi Kusama, Tokyo; L.A. Gallery, Frankfurt am Main; Suzanne Lacey, Oakland, California; Maya Lin, New York; Yve Lomax, London; Luhring Augustine Gallery, New York; Anne Marchand, Paris; Marlborough Fine Art, London; Matt's Gallery, London; The Estate of Ana Mendieta and Galerie Lelong, New York; Annette Messager, Paris; Metro Pictures, New York; Metropolitan Museum of Art, New York; Middlesbrough Museums and Galleries, Middlesbrough; Kate Millett, New York; Trinh T. Minh-ha, Berkeley, California; Mary Miss, New York; Moderna Museet, Stockholm; Linda Montano, Kingston, New York; Aimee (Rankin) Morgana, New York; D.C. Moore Gallery, New York; The National Gallery of Art, Canberra; The Estate of Alice Neel and Robert Miller Gallery, New York; Shirin Neshat, New York; New Museum of Contemporary Art, New York; Cady Noland, New York; Yoko Ono, New York; The Organization for Visual Arts Ltd., London; Orlan, Paris; PaceWildenstein, New York; Irene Perez, Oakland, California; Kathleen Petyarre and Gallerie Australis, Adelaide; Howardena Pindell, New York; Adrian Piper, New York; P.P.O.W., New York; Yvonne Rainer, New York; Regen Projects, Los Angeles; Catherine Richards, Ottawa; Su Richardson, Birmingham; Galerie Thaddaeus Ropac, Paris; Ulrike Rosenbach, Bornheim-Rosberg, Germany; Michael Rosenfeld Gallery, New York; Salander O'Reilly Gallery, New York; Doris Salcedo, Bogotá, Columbia; Carolee Schneemann, New Paltz, New York; Mira Schor, Provincetown, Massachusetts; Joan Semmel, New York; Robert J. Shiffler Foundation Collection and Archive, Greenville, Ohio; Katharina Sieverding, Düsseldorf; Brent Sikkema Gallery, New York; The Gilbert and Lila Silverman Fluxus Collection Foundation, New York; Monica Sjöö, Bristol; Sylvia Sleigh, New York; The Jo Spence Memorial Archive and Terry Dennett, London; Nancy Spero, New York; Monika Sprüth Galerie, Cologne; Bernice Steinbaum Gallery, Miami; Jana Sterbak, Montréal; Mitra Tabrizian, London; Richard Telles Fine Art, Los Angeles; Through the Flower Archives, Belen, New Mexico; Jack Tilton Gallery, New York; Cosey Fanni Tutti, King's Lynn, Norfolk; Michelangelo Vasta, Florence and Emi Fontana Gallery, Milan; Video Data Bank, Chicago; VNS Matrix, Sydney; Kate Walker, London; John Weber Gallery, New York; Galerie Barbara Weiss, Berlin; Jay Jopling/ White Cube, London; Faith Wilding, Pittsburgh; Martha Wilson, New York; Betty and George Woodman, New York; Marie Yates, Kissamou, Crete; Zeno X Gallery, Antwerp.

PHOTOGRAPHERS

Leslie Barany: p. 149(top); Kelly Barrie: p. 90; Ray Barrie: pp. 91, 93; David Bourdon: p. 4; Marcia Bricker: pp.28(right),128(middle); Paula Court: p. 120; Peter Dako: p. 176; D. James Dee: pp. 107, 132(below); Érro: p. 62; Allan Finkelman: p. 59(top); David Goddard: p. 127(top); Arthur Gordon: p. 102(top); Al Giese: p. 64; Hans Hammarskiöld/ Tiofoto p. 55(top); Lloyd Hamrol: p. 86(top); eeva-inkeri: p. 112; Marin Karras: p. 126; Kleineffen: p. 144; Jennifer Kotter: p. 150; Ellen Labenski: p. 33(left); Steve Lehmer: p. 140; Raphael S. Lobato: p. 76; Louis Lussier: front cover, p. 135; George Maciunas: p. 65; F. Masson: p. 101(top); Dona Ann McAdams: p. 148; Anthony McCall: p. 82; Robert McKeever: p. 46; J. McPherson: p. 133; Klaus Mettig: p. 108(below); Peter Moore: p. 59(below); Sue Ormerod: p. 164(below); Mitchell Payne: p. 83; Adam Reich: pp. 43, 136; David Reynolds: back cover; Werner Schulz: p. 64(middle); Harry Shunk: pp. 28(middle), 52(below); Felix Tirry: p. 159; Esther Thylmann: p. 157(top); Markus Tollhopf: p. 166; Stephen White: pp. 42(left), 125(top); Donald Woodman: pp. 37, 97(below), 111; Helen Chadwick and Edward Woodman: pp. 142, 143; Edward Woodman: p. 164(top).

AUTHOR'S ACKNOWLEDGEMENTS

Working outside an academic institution poses particular challenges to the researcher. I am grateful to all those who helped make my job easier, including librarians at the Atlanta College of Art; Emory University; Georgia State University and the University of Georgia at Athens in Georgia; the British Library; the Institute of International Visual Arts; the Tate Gallery Library and the Women Artists Slide Library in London.

I have been lucky to work with a crack team at Phaidon Press. I was commissioned by Iwona Blazwick and was grateful for the enthusiasm of someone who has done so much, as a curator and publisher, to promote feminist work. Working on this project took me longer than I had anticipated and I thank Gilda Williams, who took over from Iwona as commissioning editor, for her patience. I am grateful to Elizabeth Manchester, for research on the Documents, Mo Throp, for researching the captions, and Maria Walsh, for compiling the valuable artists' biographies. As Project Editor, Audrey Walen worked with dedication on the book and I appreciate all her efforts. I am also indebted to Ian Farr, who succeeded Audrey, for his consistently sensitive editorial guidance and for the informative captions written in collaboration with Clare Manchester. Picture researcher Clair Joy excelled in tracking down hard-to-find images. John Stack and Ariella Yedgar secured the numerous text permissions. Phaidon's reputation for innovative design can be seen in the superb work of designers Stuart Smith and Adam Hooper, and production controller Veronica Price.

Jo Anna Isaak provided critical responses to an early outline and also acted as outside reader for the book. I would like to thank Peggy Phelan for for her riveting Survey; I continue to learn much from Peggy's writing about feminist ethics and aesthetics. I owe a debt to all the critics, curators and art historians who have kept the records of feminist art, including individual writers and art historians such as Lucy R. Lippard, Rozsika Parker and Griselda Pollock, and contributors to feminist art journals. I thank the authors who have given permission for their work to be reproduced here, sometimes in abbreviated form. My biggest debt is, of course, to the artists in the book. It has been inspiring, to say the least, to work in such company.

I became a feminist before knowing the word, through friendship and play with my sister and subsequent best friends – Laura Brindley, Ruth Noys, Sophie Braimbridge and Yvonne Kuprat. My instinctive feminism was bolstered by the discovery of feminist literature and theory. Theory was put into practice working with the all-female cast and crew of Medusa Theatre Company. I have had numerous feminist role models such as Jane Armstrong at Routledge and the late, lamented Linda Brandon at the Institute of Contemporary Arts in London. Collaborations with colleagues in the ICA Talks Department – Jo Labon, Alan Read, and John Zeppetelli – were exhilarating; John's sense of humour and aesthetics forever changed me. I have learnt much from the work of former ICA colleagues including Kate Bush, Emma Dexter, Nicky Gallani, Lisa Haskell, Lois Keidan, Shelley Malcolm, Sholto Ramsay, Deborah Salter, Andrea Tarsia and Catherine Ugwu.

In Atlanta I have valued the advice of Teresa Bramlette and James Meyer. Felicia Feaster's sassy feminism and powerful friendship have been a shot in the arm. Rob Baird, Rebecca Dimling Cochran, Ruth Dusseault, Nancy Floyd, Miriam Peskowitz, Chris Scoates, Debra Wilmer and all at the Atlanta Contemporary Art Center have shown that Southern hospitality is alive and well. Friendships with Paul Allain, Julian Barlow, Leila Bouheiry, Sophie Braimbridge, Miranda Carter, Nicole Eisenman, Mai Ghoussoub, Albyn Hall, Sallie Hudson, Helen Markey, Jessica Pearce, Jane Shaw, and Stephen Woolford have sustained me.

Thanks to my sister, Josephine Reckitt, my father, David Reckitt and his wife, Rosie Reckitt, for their love. My mother Gillian Reckitt's joie de vivre seems limitless; to say she has been supportive is an understatement. At home, Scooter, Boris, Ruby and Tang provided all-too much playful distraction. Above all I thank Diana Klein who lived with me throughout this project's gestation. I owe her more than I can say.

THEMES AND MOVEMENTS The development of modern and contemporary art has been dominated by fundamental, revolutionary movements and recurring themes. The Themes and Movements series is the first fully to examine twentieth century and recent art by combining expert narrative, key works and original documents. Each book is introduced by a comprehensive Survey from a distinguished scholar who provides a thorough analysis of the theme or movement. The second section is dedicated to numerous illustrations of the Works themselves. This selection of key images is accompanied by extended captions which describe the principal ideas, processes and contexts underlying each artwork. Finally, with the Documents section, the series also offers direct access to the voice of the artist and to primary texts by critics, historians, curators, philosophers and theorists. A unique archive of the innovations, discourses and controversies that have shaped art today, these books are as exhaustive as a full-scale museum overview, presenting many of the most significant works of art associated with a particular tendency.

THEMES AND
MOVEMENTS

Since the late 1960s, many of the major innovations of contemporary art, theoretical and practical, have been indebted to feminism. Moreover, feminism's most important political achievements have been indebted to artists, who have inspired new ways to think about the public and the private, the art object and the art subject. Exposing assumptions about gender, feminism has also stressed the implications of the marks of race, age, class and sexuality on art production and reception. Both critical of the art world and central to it, feminist artists have revised the possibilities of art as a political and aesthetic practice.

Edited and compiled by Helena Reckitt, this collection presents the experiences, ideas and voices of key practitioners within their original time frame, while also identifying continuing relationships between women artists of different generations. Among the most acclaimed feminist theorists of art and performance, Peggy Phelan re-examines the established histories of women's art in her Survey, opening up new perspectives on the shifting relationship between ideas and ideals of feminism and practices of art. The Documents section comprehensively surveys the key critical positions that have informed feminist practice over four decades, including artists' original statements, polemical texts by writers and activists, and landmark essays by critics and cultural commentators.